SMITHSON'S GAMBLE

SMITHSON'S GAMBLE

**THE SMITHSONIAN INSTITUTION
IN AMERICAN LIFE, 1836–1906**

TOM D. CROUCH

Smithsonian Books
WASHINGTON, DC

© 2025 by Smithsonian Institution

All rights reserved. No part of this publication may be reproduced or transmitted in any form or by any means, electronic or mechanical, including photocopying, recording, or information storage or retrieval system, without permission in writing from the publishers.

Published by Smithsonian Books
PO Box 37012, MRC 513
Washington, DC 20013
smithsonianbooks.com

Director: Carolyn Gleason
Senior Editor: Jaime Schwender
Production Editor: Julie Huggins
Editorial Intern: Hadley Robbins

Edited by Sharon Silva
Designed by David Griffin

This book may be purchased for educational, business, or sales promotional use. For information please write the Special Markets Department at the address or website above.

Library of Congress Cataloging-in-Publication Data

Names: Crouch, Tom D., author.
Title: Smithson's gamble : the Smithsonian Institution in American life,
 1836–1906 / Tom D. Crouch.
Other titles: Smithsonian Institution in American life, 1836–1906
Description: Washington, DC : Smithsonian Books, [2025] | Includes
 bibliographical references and index.
Identifiers: LCCN 2024051663 (print) | LCCN 2024051664 (ebook) |
 ISBN 9781588347916 (hardcover) | ISBN 9781588347923 (ebook)
Subjects: LCSH: Smithsonian Institution—History—19th century. | Smithsonian
 Institution—Influence. | United States—Civilization—1783–1865. | United States
National Museum—History. | Scientific expeditions—History—19th century.
Classification: LCC Q11.S8 C76 2025 (print) | LCC Q11.S8 (ebook) |
 DDC 069/.09753—dc23/eng/20241223
LC record available at https://lccn.loc.gov/2024051663
LC ebook record available at https://lccn.loc.gov/2024051664

Hardcover ISBN: 978-1-58834-791-6
Friends of the Smithsonian ISBN: 978-1-58834-808-1
Ebook ISBN: 978-1-58834-792-3

Printed in the United States of America, not at government expense

29 28 27 26 25 1 2 3 4 5

For permission to reproduce illustrations appearing in this book, please correspond directly with the owners of the works. Smithsonian Books does not retain reproduction rights for these images individually, or maintain a file of addresses for sources.

TABLE OF CONTENTS

FOREWORD BY LONNIE G. BUNCH III vii

INTRODUCTION ix

CHAPTER 1
Our Patron Saint 1

CHAPTER 2
A Difficult Birth 21

CHAPTER 3
Laying the Foundation 39

CHAPTER 4
Shaping an Institution 59

CHAPTER 5
Trials and Tribulations 83

CHAPTER 6
A Secretary's Castle Is His Home 99

CHAPTER 7
War Clouds 119

CHAPTER 8
Henry's Tools of War and Baird's Collectors 139

CHAPTER 9
An Institution for a Growing Nation—Looking North 159

CHAPTER 10
An Institution for the Nation—Looking West 181

CHAPTER 11
New Directions 204

CHAPTER 12
Baird Takes Command 223

CHAPTER 13
A Museum for the Nation 238

CHAPTER 14

An Imperial Institution 255

CHAPTER 15

The Bureau 269

CHAPTER 16

The Third Secretary 287

CHAPTER 17

The Chief 298

CHAPTER 18

Ad Astra per Ardua 313

CHAPTER 19

The Aerodrome 326

CHAPTER 20

The End of an Era 343

Epilogue 357

A BIBLIOGRAPHIC NOTE 359

NOTES 361

INDEX 397

FOREWORD

FOR MORE THAN 175 YEARS, the Smithsonian Institution has been witness to the nation's history. It has been at the forefront of many defining moments, from the Civil War to the civil rights movement punctuated by the March on Washington. During that time, it has developed into a trusted scientific, cultural, artistic, and historical resource. But how did this influential organization get its start? What determined the direction of an institution vaguely described in its donor's bequest as "an establishment for the increase and diffusion of knowledge?" Who was the man who gambled on such an improbable endeavor, despite never having set foot in the country?

The incredible tale of the Smithsonian's formative years—how it came into existence, who was behind its success, what helped shape it into the organization it is today—could only have been told by someone dedicated to meticulous research, someone with an insider's understanding of the Smithsonian and an unending curiosity. Thankfully, my friend Tom Crouch, the esteemed longtime curator at the National Air and Space Museum and the National Museum of American History, decided to take on the daunting challenge of piecing together and narrating this illuminating story. The details he uncovered help explain the history of the nation's beloved cultural institution; they also help foreshadow its possible future.

I had the good fortune to work with Tom starting when I was just a twenty-six-year-old kid. From the beginning, I was inspired by the breadth of his interests and expertise. Whether explaining the colorful and fascinating history of aviation, curating the *A More Perfect Union* exhibition about Japanese Americans in World War II detention camps, or researching the secretaries of the Smithsonian, Tom's attention to detail and rigorous scholarship have always been impressive. And, like me, Tom found his calling as a museum professional thanks to his deep reverence for American history.

In 2018, I joined a small club by becoming only the fourteenth secretary of the Smithsonian. Since then, I have come to understand and appreciate the contributions of previous secretaries even more than I had before. That is especially true of those in the Institution's early years who conceived of it, created its intellectual underpinnings, and staked their reputation on originating an institution worthy of James Smithson's vision. Their actions often reflected the nation's biases and prejudices, none more so than the decision by anti-abolitionist Secretary Joseph

FOREWORD

Henry to bar Frederick Douglass from giving an antislavery lecture at the Castle. Still, these flawed men created a template to follow, setting the parameters of what the Smithsonian could one day become. They and so many others were instrumental in allowing the Institution to succeed beyond Smithson's loftiest expectations.

Much like the nation, the Smithsonian is the product of debate, of experimentation, of changing needs and expectations. As the country has evolved, so too has Smithson's gift. And more than just being witness to American history from its unique vantage point, the Smithsonian has been integral to the development of a nation seeking to become a more perfect union, one driven by scientific exploration, curiosity about the universe, and the ideals of liberty and justice for all. This volume provides invaluable insight into an age of optimism when science promised seemingly unending wonders and hope for a brighter future.

Keeping the Institution vibrant and relevant has always been a balancing act between tradition and innovation. It requires being respectful of the past, of what the Smithsonian has been. But it also means being willing to do what is necessary to navigate the present and chart a course to the future. *Smithson's Gamble* reveals an organization that was dynamic and innovative from the beginning. There was fierce debate and disagreement, with adherents of various schools of thought pulling the Smithsonian in different directions, even decades after the Castle opened its doors. Still, the pressure of that crucible produced an institution able to weather any storm, one that continues to grow and thrive.

The year 2026 marks the nation's 250th anniversary. For the Smithsonian, it will not only serve as a celebration of what Smithson's gift has meant but also give a glimpse into all we can be: a nimbler, more relevant, and more effective institution that makes a difference to Americans across the country. We will have programming that contemplates who we are as a nation and the Smithsonian's place in it. The commemoration will be an invitation to all Americans to explore our complex histories and find ways to attain a better shared future. In short, it will be the perfect moment to recognize all the ways Smithson's gamble has paid off and will continue to pay off for our country.

Lonnie G. Bunch III
Secretary of the Smithsonian

INTRODUCTION

THE SMITHSONIAN INSTITUTION IS UNIQUE. There is nothing quite like this sprawling complex of buildings, programs, and people dedicated to generating new knowledge and sharing it with the world. It has been described as the octopus on the Mall and a megalopolis of museums, yet its enlightened tentacles stretch far beyond our national front lawn, and the twenty-one museums in the Smithsonian constellation rest on the work of nine research centers, twenty-one libraries, and an assortment of archives that remain largely hidden from public view.

As of 2023, the Smithsonian employed 6,229 individuals who conducted research, planned exhibitions, managed collections, and supported those activities in myriad ways. The employees were joined by 3,845 on-site volunteers, 1,691 interns, 1,036 research associates, and 869 fellows. Across the organization, curators and specialists managed collections totaling 157.3 million specimens and objects, ranging from fossils 3.5 billion years old to 35 million preserved insects, George Washington's false teeth, twenty-seven dresses worn by the nation's First Ladies, the Star-Spangled Banner, world art treasures, rock musician Chuck Berry's candy-apple-red Cadillac Eldorado, and flying machines, from the world's first airplane to the spacecraft that first carried human beings to the moon and brought them home again.

That year, 30 million visitors walked through one of the Smithsonian's many doors. In addition to museum exhibitions, the Institution manages a media empire that shares its research and collections through scholarly publications and papers, books for specialists and general readers, a magazine, broadcast programs, and dozens of websites, blogs, and digital offerings.[1]

These impressive statistics tell us something of the scale, scope, and diversity of the Institution's activities, but they don't describe the nature of the place. In precise terms, it is a trust instrumentality of the United States government. Translated from the legalese, this means that Congress created the Smithsonian to manage the bequest of James Smithson, a talented and somewhat eccentric Englishman who instructed that should his nephew and sole heir die without issue, the estate would go to the United States to fund an institution to be named in his honor to support "the increase and diffusion of knowledge among men."

The subsequent history of the Smithsonian can best be understood as a prolonged experiment designed to determine just what sort of knowledge was

INTRODUCTION

intended and how it was to be diffused. Could Joseph Henry, the first secretary (head) of the Smithsonian, be transported to the Mall today, he would find that the Institution bears little resemblance to the small, highly focused organization run by scientists, for scientists that he envisioned. He was vehemently opposed to the large building that symbolizes the Institution and expended considerable time and energy attempting to find a buyer for the Castle so he could move the Smithsonian into smaller quarters.

Forced by political pressure to accept responsibility for the United States National Museum, Henry made repeated unsuccessful efforts to pass that activity to another government agency. While an active supporter of government science, he was vehemently opposed to participating in any activity that would require congressional funding and the political control that he feared would come with it.

Joseph Henry nursed the Institution through its difficult early years, jealously guarded its limited resources, and developed niche programs to support American scientists and link them to colleagues at home and abroad. His successor, Spencer Fullerton Baird, offered a far more expansive vision of what the Institution could and should be. His goal was the democratization of knowledge. He dispatched young naturalists, most of whom he had trained, to participate in the scientific exploration of the Far West and the Far North. He cast an even wider net, enlisting scores of volunteer citizen scientists across the nation who contributed to a growing collection documenting the natural and human history of a continent. The American conservation movement had roots in Baird's Smithsonian.

Baird redefined the role of the Institution, offering the riches of the collection and the results of research to the citizens of a democracy through a national museum worthy of the name and regional exhibitions that would educate, inspire, and entertain two generations of Americans. Under his successor, Samuel Langley, the Smithsonian acquired its first research center, the Smithsonian Astrophysical Observatory; established the National Zoo; and launched an expansion program that included an additional museum building under construction and an art museum on the drawing board.

Smithson's Gamble traces the evolution of this American institution from the congressional agreement to accept James Smithson's bequest to the death of the third secretary seventy years later. It is a story of twists and turns filled with fascinating individuals, many of whom are worthy of a more detailed consideration than they receive in these pages. There are uncomfortable moments here and there, as may be expected in any treatment of an institution and a nation swept along in racist currents. By 1906, however, the modern Smithsonian, committed to research and public outreach, had taken shape. Those three generations of

INTRODUCTION

Smithsonian staff members, identifying and reacting to the needs of the nation, had woven their Institution into the fabric of American life.

ACKNOWLEDGMENTS

In a real sense, this book began half a century ago when I first arrived at the Smithsonian as a short-term fellow researching a small, diverse group of late nineteenth-century engineers convinced that human beings could take to the air in winged craft. The Smithsonian Institution Archives, and the professionals who worked there, eased the way for an apprentice scholar.

None of them were more helpful than Pamela Henson, the undisputed dean of Smithsonian historians. No one will ever know more of the history of the Institution from the beginning through the first quarter of the twenty-first century. During my own oral history retirement interview, she suggested the need for a cultural history of the Institution and did not seem too outraged when I set out to fill that gap. Pam has been a patient adviser during the long development of this book and has served as my principal reader. Her thoughtful critique of my treatment of the early years of the Institution reshaped my own thinking. This is not the book she would have written, but of all future readers, her opinion means the most.

I owe an enormous debt to the archivists who support and guide those who mine the riches of their collections. At the Smithsonian Institution Archives (SIA), Deborah Shapiro, Tad Bennicoff, Richard Gilreath, and Ellen Alers deserve double gold stars for their assistance and advice on this book. Bill Deiss and Kathy Dorman, Smithsonian archivists of years past, contributed their own scholarship on the history of the Institution. Marguerite Roby of the SIA was of enormous help in suppling illustrations, as were the photo archivists of other Smithsonian archives and museums. At the National Air and Space Museum (NASM) archives, Marilyn Graskowiak, Melissa Keiser, Patti Williams, Elizabeth Borja, and Brian Nicklas have offered friendship and support for half a century. Allan Janus did a masterful job organizing, curating, and digitizing the Samuel Langley Collection. Russel Lee, chair of the NASM aeronautics department, and Jeremy Kinney, NASM's associate director for research and curatorial affairs, provided management support for an old colleague. The staff of the Freer archives and the National Anthropological Archives were most helpful. All students of the nation's past owe a debt to the staff of the Manuscript Reading Room of the Library of Congress. Smithsonian librarians, the late Nancy Gwinn, David Christopher Cottrill, and Catherine "Kitty" Scott, and the still very much alive Leah Smith and Phil Edwards, never failed to supply hard-to-find books, and journal articles, friendship, and a chat. The staff of the Smithsonian Institution Libraries offered extraordinary

INTRODUCTION

support. The staff of Shepherd University's Scarborough Library extended themselves to assist an unaffiliated scholar.

This book rests solidly on the work of the generation of scholars who produced the twelve volumes of *The Papers of Joseph Henry*, begun under the leadership of Nathan Reingold, who laid the foundation for studies of the history of nineteenth-century science in America. Marc Rothenberg, Kathleen Dorman, Frank Millikan, Deborah Jeffries, and Sarah Shoenfeld produced six volumes covering Henry's Smithsonian years. Their notes to the selections define scholarship and erudition. This book, begun just before the onset of the pandemic, would not have gotten off the ground but for their fine work.

Over the course of half a century, I have participated in discussions formal and informal with colleagues who have illuminated aspects of Smithsonian history. My thanks to Heather Ewing, William Bird, Pete Daniel, David DeVorkin, Douglas Evelyn, Cynthia Field, James Goode, Richard Kurin, Art Molella, Bob Post, Richard Stamm, Steven Turner, Wilcomb Washburn, Helena Wright, and the late Ellis Yochelson. Michael Neufeld, friend and colleague, was my first reader, and a most perceptive one. Robert M. Peck was kind enough to provide a copy of his fine book on Benjamin Waterhouse Hawkins. Felix Lowe, who built a great scholarly press at the Smithsonian, supplied his carpool buddy with one volume after another that he was publishing on Smithsonian history, little realizing that one day I would put them to good use. Carolyn Gleason and Julie Huggins, the staff of Smithsonian Books, and editor Sharon Silva transformed a very long manuscript into the volume you hold in your hands.

My wife, Nancy, to whom this book is dedicated, was surprised to find that retirement brought total immersion in another huge book project. My thanks for her love, patience, support, and forbearance. And to my family—Bruce, Abby, Nathan, John, Emma, Alex (my trusted tech support), Kari, Lily, and Lalo—thanks to all of you for your willingness to accept a loving husband, father, father-in-law, and grandfather whose mind was all too often adrift in the past.

xii

CHAPTER 1

OUR PATRON SAINT

ON NOVEMBER 25, 1903, *The Times* of London carried a small front-page announcement of seemingly narrow interest:

> NOTICE is hereby given to all whom it my concern,
> and with whom it has been found impossible to communicate
> privately, owing to addresses being unknown, that the OLD
> BRITISH CEMETERY at SAN BENIGNO, GENOA, has been
> EXPROPRIATED by the ITALIAN AUTHORITIES, and will
> soon be demolished.
>
> The remains of all persons buried there will shortly be removed
> To the new British Cemetery, unless otherwise desired by
> representatives of the deceased.
>
> Any communication on this subject should be addressed before
> January 1st, 1904 to
> NOEL LEES, Esq.
> care of H.B.M.'s Consul-General, Genoa
> from whom full particulars can be obtained.[1]

The closure of the cemetery, however, was of considerable interest to the leaders of a unique and somewhat peculiar scientific and cultural organization in Washington, DC. James Smithson, a naturalized Englishman who had lived much of his life abroad, had died in Genoa on June 27, 1829, and was buried in the cemetery in San Benigno. A gentleman of leisure with a deep command of aspects of chemistry and mineralogy, he had willed his considerable estate to his nephew, Henry James Dickinson. However, Smithson's will stipulated that, should said nephew die without heirs, the money was to go to "the United States of America, to

found at Washington, under the name of the Smithsonian Institution, an Establishment for the increase and diffusion of knowledge among men."[2]

Dickinson died at twenty-seven, just six years after his uncle, unmarried and childless. While there were those who argued against accepting a gift originating from a nation with whom the United States had fought two wars, Congress voted to accept the trust and dispatched a representative to England to bring suit for the bequest in the Court of Chancery and return home with Smithson's fortune. The House and Senate, with the help of many interested Americans, spent the next decade debating what to do with the money before passing legislation establishing the Smithsonian Institution on August 10, 1846.

Joseph Henry, the first secretary of the Institution, beatified James Smithson as "our Patron saint," with tongue only slightly in cheek. Like those who followed him, Henry was aware that the Institution he led was the result of an uncertain, even improbable origin story. At any point along the way, events could have spun in any number of directions that would not have resulted in the Institution he had in mind.

Generations of Smithsonian leaders would puzzle over why this naturalized Englishman would will his fortune to the United States. The least that the Institution could do was take an interest in the condition of the lovely neoclassical tomb that Smithson's nephew and original legatee had commissioned to house his uncle's remains.[3] The problem of Smithson's grave first appeared in 1880 when the American consul in Genoa informed Spencer Fullerton Baird, the second secretary, that the stone pillars and iron railing surrounding the tomb required attention. The secretary raised the issue with the Institution's governing Board of Regents, who accepted responsibility and funded the repairs.[4]

But the ultimate responsibility for dealing with Smithson's last resting place would fall on the shoulders of the third secretary, Samuel Pierpont Langley. On June 29, 1891, while preparing to escape a sweltering Washington summer with a European trip, Langley asked Secretary of State James G. Blaine to obtain a report on the present condition of Smithson's grave. James Fletcher, the American consul in Genoa, replied to the secretary on July 25, noting that "the tomb of the deceased Philanthropist" was in perfect condition, with trees and flowering shrubs in the enclosure that were "full of life and beauty." Fletcher enclosed a pen-and-ink sketch of the monument along with some leaves that he had gathered at the site.[5]

Arriving in Genoa in August, Langley spent two days at the cemetery in consultation with both Fletcher and the British consul. He was pleased with the condition of the grave but noted that the Smithson tomb lacked the floral tributes found

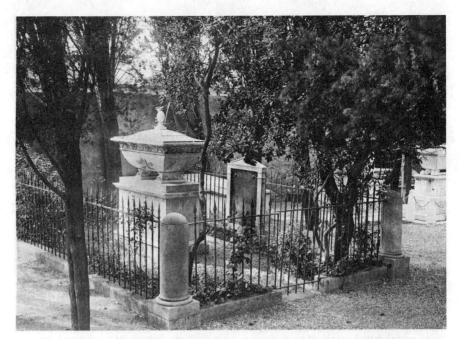

James Smithson's tomb in the British cemetery, outside Genoa, Italy, c. 1897. The Smithsonian paid to repair the iron fence in 1880 and add the memorial plaque (*center*) in 1891. Alexander Graham Bell and his wife, Mabel, transported Smithson's body from this site to the Institution in January 1904. The tomb followed by the end of the year. Smithson was reinterred near the north entrance of the Castle in March 1905. *Smithsonian Institution Archives*

on adjacent graves, "which testify to the continued interest by others in the resting place of one still honored and cared for." Nor was there any indication at the grave site of Smithson's connection to the Institution. Langley gave thirty pounds to the British consul, requesting that it be invested and the annual interest used for the perpetual care of the grave. In addition, the Board of Regents commissioned three large bronze tablets bearing a bas relief profile of Smithson and text identifying him as the founder of the Institution. One of the tablets would be displayed at the tomb, another at the adjacent Anglican church, and the third at Pembroke College, Oxford, Smithson's alma mater.[6]

There Smithson would remain until November 1900, when Secretary Langley received a letter from the British consular office in Genoa informing him that blasting to extend a neighboring quarry was encroaching on the British burial ground. Within five years the cemetery committee would have to transfer the graves to a new site. The time has come, the consul continued, "for us to ask you to prepare your decision as to what is to be done with James Smithson's remains."[7]

SMITHSON'S GAMBLE

On January 23, 1901, Langley asked the Board of Regents to agree to the eventual transfer of Smithson's remains and his memorial to a new cemetery to be selected by the British officials in Genoa. Alexander Graham Bell, a citizen regent, disagreed, arguing that their benefactor's remains ought to be brought to Washington for internment on the Smithsonian grounds. On March 2, Bell wrote to his wife describing his effort to inter Smithson at the Institution. "Unfortunately," he wrote, "I couldn't get the Regents to see it. I knew beforehand that my Resolution would not pass, but all the same I offered it in order to put myself on record. The proposition to bring Smithson's body here received ONE VOTE—my own—and that was all."[8]

A quarter of a century after the invention of the telephone, Alexander Graham Bell had emerged victorious from a nasty patent suit, firmly established as one of the most famous and admired Americans of the new century. Having cofounded both the Bell Telephone Company (1877) and the American Telephone and Telegraph Company (1885) with his father-in-law, Gardiner Greene Hubbard, he was among the richest as well.

As the moment for a final decision regarding James Smithson's new resting place approached, most of the regents were content to cooperate with the British authorities in Genoa, who planned to transfer the remains to a new location in the city. Bell, determined that Smithson should be interred at the Institution that he had envisioned in his will, finally offered to personally fund the disinterment and transport of the body to Washington.

Why did he care so much about the last resting place of a naturalized Englishman who had died in Italy seventy-five years before? Like Smithson, Bell was a philanthropist who saw the value of private support for research. In 1880–81, he established the Volta Laboratory for the development of telecommunications technology. In 1887, he invested the profits realized by the laboratory to create the Volta Bureau, dedicated to the "increase and diffusion of knowledge relating to the deaf," a clear allusion to Smithson's will.[9]

In the spring of 1903, Bell enlisted the services of Gilbert Grosvenor, his son-in-law and editor of the National Geographic Society's magazine, to build public appreciation for the importance of Smithson's gift and support for bringing him home to the institution his fortune had created. Grosvenor's full-page article, "Shall the Tomb of James Smithson Be Brought to America?" appeared in the *New York Herald* on Sunday, March 1, 1903. "James Smithson, the founder of the Smithsonian Institution, is about to be turned out of his grave," he began. The long article carried multiple portraits of Smithson, his father, and his tomb under a large image of the Smithsonian Castle.[10]

4

The campaign caught fire. Scores of articles on Smithson and the need to find a final burial place appeared in newspapers across the nation, from New York and Washington to the mining camps of Montana and on to large cities and small towns on the West Coast. They ranged from long pieces offering biographical sketches to short squibs noting that the Smithsonian was wrestling with the question of where to rebury its founder. Clearly, the mystery of James Smithson and the puzzle of his bequest to the nation piqued the curiosity of a great many Americans.[11]

On November 24, 1903, William Bishop, US consul in Genoa, wrote to inform Langley that Italian authorities had finally expropriated the cemetery. Two weeks later, on December 8, 1903, the regents named Bell a committee of one "to take charge of the matter of the removal of the remains of James Smithson from Genoa to Washington with the request that the negotiations and removal be conducted quietly and privately." Bell would have to solve any legal complications that arose. If everything went well, however, the regents promised reimbursement.[12]

Bell and his wife, Mabel, reached Genoa just before Christmas. The difficult winter crossing of the Atlantic was followed by steady, cold rains on the train journey from Paris. Battling a bad cold, Bell remained in their rooms at the Eden Park Hotel preparing letters to local officials, while Mabel braved the damp and chilly weather. She first called at a bank to withdraw the funds required to cover the costs of the project and then visited the cemetery with Consul Bishop and the workmen who would be responsible for the exhumation and preparation of the body for its final journey to the United States.

The Bells faced one bureaucratic hurdle after another. "There seemed to be no end to the red tape necessary to remove the body," Mabel Bell explained. "A permit to export the body beyond Italian limits, a permit to open the grave, a permit to purchase a coffin, permits from the National government, city government, the police, the officers, etc., etc."[13] Bell belatedly wished that he had consulted an attorney experienced in such matters before his departure.

To complicate matters further, Bishop discovered an injunction from the 1870s sought by George Henry de la Batut, the half-brother of Smithson's nephew, forbidding the removal of the remains from Genoa without his consent. The American consul pointed out to officials that de la Batut was likely dead, and that the document itself contained erasures, handwritten changes, and other problems that threw its legal status into question. Local authorities turned the matter over to William Keene, British consul general, who replied that his office had no objection to the removal of Smithson's remains.

With that note in hand, Bell insisted that the Smithsonian, as the late Mr. Smithson's beneficiary, was a more suitable caretaker for his mortal remains

than someone who was not a blood relation. President Theodore Roosevelt, he added, was personally interested in bringing Smithson to America—at least he hoped that was the case. His arguments, and the liberal distribution of lire to local authorities, carried the day.[14]

Accompanied by Consul Bishop and a small party of local authorities and workmen, the Bells made their way back to the cemetery on the morning of December 31. "In a snow storm . . . with strong wet wind," Mabel Bell wrote to their daughter, "James Smithson's grave was this morning opened, his bones carefully collected and placed in a zinc coffin." The Bells agreed that they would not feel themselves in secure possession of the sacred remains until they were safely aboard the ship home and "out of reach of interdict by Italian or French warrant." They would leave the empty tomb behind. Any attempt to make off with that structure, which had been funded by Smithson's nephew, would have been pushing their luck.[15]

The coffin remained in the cemetery chapel under the care of Giovanni Battista Firpo, the local gardener who had watched over the tomb since Langley's 1891 visit. A ceremonial party gathered at the chapel on January 2, 1904. Bell, Bishop, and Noel Lees, a representative of the British Cemetery Committee, offered remarks. Bishop then sealed the coffin using the consular seal and draped it with an American flag. Mabel Bell placed a few leaves and flowers from the grave site on the coffin, after which workmen carried it aboard the North German Lloyd steamship *Princess Irene*. The Bells and their cargo sailed for New York on January 7, with stops in Naples and in Gibraltar where Bell telegraphed Grosvenor asking that he arrange a suitable welcome for Smithson's remains. Grosvenor obtained President Roosevelt's approval to enlist the participation of the navy, army, and marine corps in a grand welcome.[16]

The Bells arrived in Hoboken, New Jersey, with Smithson's coffin on the morning of January 21, 1904. Grosvenor and his wife, Elsie, the Bells' daughter, met them, along with Secretary Langley and a naval guard of honor that escorted them to the USS *Dolphin*.[17]

Members of the Board of Regents and a large party of spectators gathered at the Washington Navy Yard to greet the *Dolphin* at 10:00 a.m. on Monday, January 25. The Marine Band played "Nearer, My God, to Thee" as workmen carried the coffin, housed in a white box, from the deck to a caisson, where it was draped in both the British and the American flag. A detachment of the Fifteenth Cavalry from Fort Myer joined the cortege at the outer gates of the navy yard. Bystanders doffed their hats as the parade passed up Eighth Street to Pennsylvania, then south down Twelfth Street to the west end of the Smithsonian Castle.[18]

Pallbearers drawn from the various departments of the Institution carried the coffin into the center of the Great Hall. With Sir Mortimer Durand, the British ambassador; Assistant Secretary of State Francis Loomis, President Roosevelt's representative; and an assortment of senators, representatives, and other government and Smithsonian officials in attendance, Bell and Senator William P. Frye, president pro tempore of the Senate, offered remarks. They walked the coffin up the north stairs to the Regents' Room, where it would remain until a decision could be reached as to the founder's final resting place.[19]

Bell presented his report to the Board of Regents on January 27, along with a statement of the expenses directly related to the retrieval of Smithson's body, which totaled 957.68 lire. Having voted on a resolution expressing "profound appreciation" to Bell for his "voluntary service," they turned their attention to the final disposition of James Smithson. Following a spirited discussion, Senator Thomas C. Platt offered a resolution charging the secretary and the members of the Executive Committee with selecting Smithson's final resting place and proposing the design of a monument.[20] The committee recommended on March 4 that a suitable tomb be erected on the grounds of the Institution and suggested that, "after consideration of the character and cost of such tomb, Congress be requested to make an adequate appropriation."[21]

At the request of Secretary Langley and other members of the Board of Regents, several leading sculptors and architects submitted designs for Smithson's new resting place. But as hope for a congressional appropriation faded by the summer of 1904, Smithsonian officials reconsidered the possibility of obtaining the original tomb from the English cemetery in Genoa. On August 9, 1904, lawyer Frank W. Hackett sent a letter to Assistant Secretary Richard Rathbun in which he detailed the Smithsonian's legal authority to bring the original tomb to Washington. "Viewing the peculiar character of this marble, and the propriety, not to say necessity, of it's [sic] accompanying the ashes of Smithson," he noted, "I think I am safe in advising that there is no reason for not removing it to this country."[22]

The regents agreed to pay the expense of shipping the tomb to Washington. On December 8, 1904, the *Princess Irene* sailed for New York once again, this time with sixteen crates containing the Smithson tomb aboard. Langley hired the Washington architectural firm of Hornblower & Marshall to design a small mortuary chapel on the left side of the north entrance to the Smithsonian Castle. The gates that had guarded the entrance to the tomb at San Benigno served the same function in the new location. At the conclusion of the regents meeting on March 6, 1905, the members proceeded to the new sepulcher. The coffin, now housed in a mahogany casket, was once again placed in the base of the tomb, which was then

sealed. The long and circuitous journey of James Smithson's remains was over at last.[23]

But what of the man in the tomb? The men who built and led the Institution, and who had worked so hard to ensure that his mortal remains be honored, were naturally curious as to what sort of man James Smithson had been and why someone who had never expressed any interest in America or Americans would identify the United States as the possible recipient of his considerable fortune. The few notices of his passing were short and of little value to anyone interested in Smithson's life. The *Gentleman's Magazine* questioned his ancestry and reported the wrong death date. The longest remembrance, offered a year following his death by his college friend Davies Gilbert, focused on a single anecdote and provided few biographical details.[24]

A considerable amount of information on Smithson's life and work was found in the eight cases and one trunk that were delivered to the United States along with the bequest in 1838. They held some of his worldly possessions, including his mineral collection, library, unpublished scientific papers, correspondence, notebooks, and travel journals. While Congress was debating what sort of organization would satisfy the terms of Smithson's will, this material was deposited with the National Institute for the Promotion of Science, the leaders of which hoped to be selected as the beneficiary of the Smithson fortune. Walter R. Johnson, the corresponding secretary of the Academy of Natural Sciences of Philadelphia, drew from the papers to present the first American account of James Smithson to his fellow institute members on April 6, 1844. Although he included notes on an early geological trip undertaken while the subject was still an Oxford undergraduate, he focused on Smithson's published scientific papers and offered little insight on the man himself.[25]

Having himself sorted through Smithson's papers, first Secretary Joseph Henry concluded that the man had been "a person of rather eccentric habits and opinions." Smithson's library would survive, but the papers, notebooks, mineral collection, and much else would be lost to history when fire swept through the Smithsonian Castle on January 24, 1865.[26]

In 1850, the Institution had purchased a portrait of Smithson from the widow of his servant, John Fitall. Aware that his colleague, the botanist Asa Gray, would be traveling to London, Henry asked if he could visit Fitall's widow and "collect from her . . . an account of all she knows and all she remembers of Smithson." Two years later, Henry wrote to ask the English mathematician and engineer Charles Babbage, who had known Smithson, "If it is not too much a tax on your time, that you will give me any information in your possession relative to the

founder of the Institution which may be of importance to preserve." Then he proceeded to the questions: "What were his political opinions? Why did he choose the government of the United States as the trustee of his bequest?"[27]

In 1878, Spencer Baird, Henry's successor, commissioned John Robin McDaniel Irby, a young mineralogist with a recent doctorate from the University of Virginia, to prepare an assessment of Smithson's scientific work. With that study in hand, Baird launched a campaign to gather additional information about Smithson. In the spring of 1880, he asked William Wesley, the Smithsonian's European agent, to distribute a leaflet requesting information for use in the preparation of a biographical memoir of Smithson. "Any Original Letters, or Personal Reminiscences," he noted, "will be received thankfully." Baird added a series of specific questions to his circular: "What can be learned of Mr. Smithson's mother, Mrs. Macie?" Is there "information relative to the College life of James Lewis Macie, a graduate of 26th May 1786 of Pembroke College, Oxford University?" Although *Nature*, the leading British scientific journal, urged cooperation with the Smithsonian's quest, Baird's queries drew few useful responses.[28]

Ultimately, Baird admitted that his efforts to gather additional information had failed. "The materials for a biography of Smithson," he reported, "are exceedingly scanty." That being the case, William Jones Rhees, chief clerk of the Institution, who had written short pieces on Smithson as early as 1858, made use of what information was available to prepare a concise biographical article, "James Smithson and His Bequest," which appeared along with a republication of Smithson's scientific articles, two earlier biographical accounts, and an appreciation of Joseph Henry in a volume of the *Smithsonian Miscellaneous Collections* published in 1881. The lack of solid biographical information available at the time is indicated by the fact that Rhees provided the wrong birthday, adding eleven years to Smithson's age, and had him born in the wrong country.[29]

Samuel Langley and his friend Cyrus Adler, the Institution's librarian, corrected some of the long-standing errors during a visit to England in 1894. The pair obtained access to unpublished papers relating to the Hungerfords, Smithson's mother's family, and examined the records of Oxford University's Pembroke College, Smithson's alma mater. The secretary wrote his own account of Smithson's career, which he published as a chapter in a history of the first fifty years of the Institution.[30]

The search for additional information that would shed new light on James Smithson continued into the twentieth century, sometimes inspiring the researchers to go to extraordinary lengths. In the summer of 1973, James M. Goode, the historian responsible for the study and historic preservation of the Smithsonian

Castle, obtained Secretary Sidney Dillon Ripley II's approval and funding to undertake a restoration of the old mortuary chapel. The dark floor and walls were repainted a light tan, period lighting was installed, and an exhibit case displaying a portrait of the young Smithson and stray items that had survived the 1865 fire was added.

During the process, Goode became curious as to what part of the tomb housed the casket. Workmen discovered that the top of the monument was empty. The remains were not in the floor, nor in the solid midsection that carried the inscription. The marble base proved to be hollow, and solidly sealed. "Because of the lack of information on James Smithson," Goode explained, "I felt that documents or manuscripts relating to his life and work might be encased in the coffin." The notion that Langley, who had scoured English archives in search of Smithson materials, might have hidden precious manuscripts in the coffin when it was placed in the monument in 1905 required a huge stretch of the imagination. Still, it occurred to the curator that opening the tomb would at least provide the opportunity for a forensic analysis of Smithson's bones.

At 10:00 a.m. on Wednesday, October 3, 1973, Goode greeted eleven Smithsonian leaders, including Acting Secretary Robert Brooks (standing in for Secretary Ripley, who was absent on a research trip to Bhutan), a string of assistant and deputy secretaries, and several office directors. Physical anthropologist J. Lawrence Angel and several of his colleagues joined the suits in the Smithson crypt. Workmen broke into the base, removed the mahogany casket, and discovered the zinc coffin containing Smithson's remains. Things took an unfortunate turn when the blowtorch used to melt the solder set fire to the silk lining. Fearing that a fire extinguisher would scatter the bones and pieces of wood inside the 1829 coffin, William Wells, the foreman, told his workmen to run to a nearby drinking fountain, fill their mouths with water, and spit the fire out.[31]

The group found Smithson's bones scattered among wooden fragments of the original coffin, nails, plaster, and debris. The anthropologists covered the open box with a black tablecloth from the Commons restaurant in the Castle and walked the remains across the Mall to their laboratory in the National Museum of Natural History.

That afternoon, an anonymous staff member passed the story of Smithson's disinterment to the Washington Star-News. Angel invited the inquiring reporter, John Sherwood, to visit the lab. "There is not much we know about him, really," the scientist explained, with Smithson's skull in hand. Noting that the coffin had contained 99 percent of Smithson's bones, he outlined something of what the remains were telling him. Sherwood informed his readers that the remains had been

"cleaned, photographed, x-rayed and catalogued, sorted, weighed and measured." He offered a short overview of the deceased, explained plans for the reburial that afternoon, and offered a closing wish: "Rest in Peace, James Smithson."[32]

At 1:00 p.m. on the afternoon of October 5, 1973, Goode and Angel met in the lab with another group of Smithsonian leaders, placed copies of each of their reports in the zinc box, and watched as the lid was soldered shut. They made the return trip to the north door of the Castle in a station wagon. The metal box was placed back in the elegant mahogany casket with sterling silver handles and a plaque identifying the occupant as James Smithson and returned to the base of the tomb. Secretary Ripley arrived back from his trip to find Lawrence Angel's report on his desk, as well as a citation from the District of Columbia medical examiner pointing out that the exhumation of a body without the appropriate permits was a serious offense. "How," Ripley penned on Angel's memo, "did we get into this study?" Ripley assured the medical examiner "that nothing like it would ever happen here again," at least not on his watch.[33]

Lawrence Angel's analysis of the bones added to an understanding of the physical James Smithson but contributed little beyond what Langley and those before him had unearthed about his life and personality. It remained for Heather Ewing, a scholar of the Smithsonian, to complete the task of preparing a satisfying biography. With most of Smithson's correspondence destroyed in the 1865 fire, she retraced his path across Europe, searching the records of Smithson's friends, colleagues, and bankers and scientific societies and government archives for the missing details. Her book, *The Lost World of James Smithson,* finally answered the questions that Smithsonian leaders had posed for more than a century and a half.[34]

ANY ATTEMPT TO UNDERSTAND James Smithson must begin with the fact that he was the illegitimate son of Hugh Smithson, the first Duke of Northumberland. Reputed to be the handsomest man in England, the duke fathered three children by his wife, Lady Elizabeth Seymour, Baroness Percy; two sons with James's mother, Elizabeth Hungerford Keate Macie Dickinson; and two daughters with his other mistress, Margaret Goodwin Marriott, fourteen years younger than Elizabeth Hungerford. The duke recognized and supported his illegitimate daughters and approved their being given family names. He refused, however, to recognize or support James or his younger brother, Henry Louis. His father's refusal to acknowledge him shaped James Smithson's life.

James's mother, Elizabeth, has been described as "a dominating presence in her son's life, an intoxicatingly fiery woman—twice married, twice widowed, twice

a single mother, and mistress to a Duke."[35] Born a Hungerford, she could trace her lineage to Edward I. At the time of her affair with Smithson, she was the widow of John Macie, and she christened her first son James Louis Macie. He would change his name to Smithson at the age of thirty-six, following his mother's death in 1800.

James Louis Macie was born in France, probably in Paris, in 1764 or 1765. There is no record of his birth. He was six years old when his mother presented the duke with a second son, Henry Louis Dickinson, who carried the name of his mother's second husband, who had deserted her. Having been born abroad, young James was not naturalized as an English citizen until he was almost ten years old. Even then, the peculiarities of English law offered only limited citizenship to those born abroad, under the terms of which he was prohibited from election to Parliament, holding a civil or military commission, or inheriting property from the crown.

The illegitimate son of a father who rejected him and the citizen of a nation that limited his choices, young Macie came of age as something of a resentful outsider. "The best blood of England flows in my veins," he proudly insisted. "[On] my father's side, I am a Northumberland, on my mother's I am related to Kings, but this avails me not." He would spend the rest of his life determined to prove that he was a gentleman of the highest order, more than worthy of a noble father's regard and the respect of his nation and the world.[36]

Macie's relationship with his father was so distant that he hid his only mention of having met him in a single unpublished citation in the manuscript of one of his scientific papers housed in the library of the Royal Society. In that brief note, he mentions that William Lewis's 1746 volume, *A Course of Practical Chemistry*, was "dedicated to my Father, who was well informed in chemistry and from whose conversation I imbibed when a child my taste for it."[37]

James Macie matriculated at Pembroke College, Oxford, in 1782 as a gentleman-commoner, a recognition that, while he came from a distinguished background, he was not entitled to wear the colorful robes reserved for students from the peerage. He was the first student enrolled in Pembroke in two decades to leave blank the space provided on the entry roll for the name of his father. It was at Pembroke, however, that Smithson transformed a childhood interest in chemistry and mineralogy into a passion. He would pursue work in those fields for the rest of his life, building a noteworthy mineral collection and developing techniques and equipment that enabled him to conduct chemical analyses of small quantities of material. The scholar preparing the university's first course in mineralogy admitted that the teenaged Smithson's knowledge of the field was "already much beyond what I have been able to attain."[38]

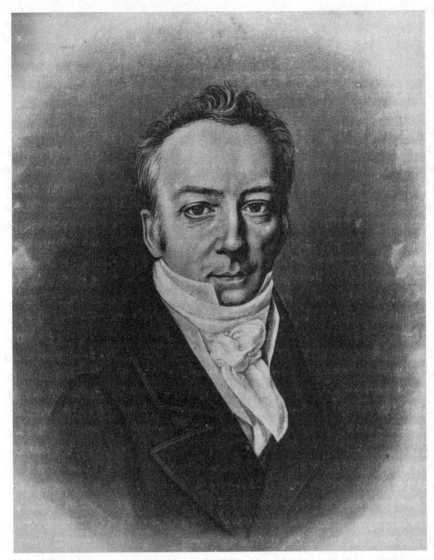

James Smithson (1765–1829), around age fifty. Smithson, whom the Smithsonian's first secretary Joseph Henry regarded as "our Patron saint," willed his fortune to the United States to found "at Washington, under the name of the Smithsonian Institution, an establishment for the increase and diffusion of knowledge." This engraving was based on a miniature portrait by Henri-Joseph Johns finished May 11, 1816, in Aix-la-Chapelle. *Smithsonian Institution Archives*

He launched his career as a gentleman natural philosopher in 1784 while still an eighteen-year-old student, joining a party exploring the geological features of Scotland and the Hebrides. Barthélemy Faujas de Saint-Fond, the leader of the party, was a French savant who had just rushed into print one of the first books on the invention of the balloon. He was accompanied by Count Paolo Andreani, who had made the first balloon flight in Italy, and William Thornton, a Quaker physician and draftsman who would one day immigrate to America, design the Capitol of the United States, and head the US Patent Office. Smithson proved more courageous than the expedition leader, braving heavy seas to visit features on the island of Staffa when Faujas de Saint-Fond held back. The budding naturalist eventually lost confidence in his companions and left the group—not, however, before taking the opportunity to meet and impress such Scottish luminaries as the chemist Joseph Black, who introduced the young visitor to the use of an analytical balance, and James Hutton, who revolutionized geology and provided Smithson with samples for his mineral collection.[39]

Smithson's first expedition set the pattern for his career. He quickly established himself as a contributing member of the community of science. He made the acquaintance of Henry Cavendish, famed for his discovery of the gas that the French chemist Antoine Lavoisier would later name hydrogen. As a young Oxford graduate, he was an active member of the Society for Promoting Natural History, the Coffee House Philosophical Society, and the Royal Society Club. Smithson achieved a major career landmark on April 18, 1787, when he was elected to membership in the Royal Society. Aged twenty-two, he was the youngest member then on the rolls. Sir Joseph Banks, president of the Royal Society for forty-one years (1778–1820), would remember young Smithson as a talented, ferociously ambitious young man who was blessed with a good deal of warmth and charm.[40]

A small portrait of James Macie done by the Oxford drawing master John Roberts in 1786 shows the young man in his Oxford robes. He is handsome and well dressed, with powdered hair peeking out from under his mortarboard, a master of arts collar around his neck, and crossed legs clad in white stockings. In later portraits, the young graduate's shock of hair would give way to a receding hairline and high forehead rising above deep-set eyes, a long Roman nose, and a strong chin.

Lawrence Angel's analysis of his bones revealed that the adult Smithson stood five feet five to five feet six, shorter than the average Englishman of the period. "This man's build is rather small and slight," Angel reported, "but athletic, with a . . . big chest, and strong arms and hands." He was right-handed, with fingers indicating the possibility that he played the piano or violin. Skeletal features

suggested "an active and vigorous man, sometimes climbing, sometimes using his hands for hard work, sometimes bending over desk work"—just what might be expected in a man who divided his time between collecting mineral specimens in the field and writing notes or preparing scientific reports. Advanced periodontal disease must have kept him in constant discomfort. He had lost seventeen teeth and had five active abscesses at the time of his death. Angel also reported indications that Smithson might have been malnourished as a very small child.[41]

Smithson's circle of close friends included young men of his own station in life who shared his passion for chemistry, mineralogy, and travel. William Thomson offered the first lectures on mineralogy at Oxford before fleeing England to escape prosecution for "sodomy and other unnatural and detestable practices with a servant boy." Davies Gilbert would rise to the presidency of the Royal Society. Charles Greville, one of Smithson's favorite traveling companions, built a mineral collection for which the British Museum would pay the small fortune of £37,727 in 1810.[42] He would be better remembered, however, for having introduced his mistress, the beauty Emma Hart, to his uncle, Sir William Hamilton, who married her, then introduced her to Horatio Nelson. His broader circle of acquaintance included some of the leading chemists and geologists of the day, from Antoine Lavoisier, who led a revolution in chemistry, to René-Just Haüy, a professor of mineralogy who introduced Smithson to crystallography, inspiring him to alter his collecting goals from the acquisition of big, brilliant mineral specimens to small examples illustrating crystal structure.[43]

The young Smithson turned a scientific grand tour of the continent into a lifetime abroad. Although he would periodically return to England, his wanderlust kept him on the move for long periods of time. Davies Gilbert, encountering Smithson after many years abroad, remarked that his friend had developed "manners and habits more foreign than English."[44]

The onset of revolution in France, followed by the Napoleonic Wars, presented hardships and dangers for a generation of English travelers. In 1805, a French policeman, suspecting Smithson of espionage, detained him and seized his papers. Two years later, in August 1807, he was arrested as a suspicious person and held in a Danish warehouse-prison until he was able to obtain travel papers in the spring of 1808. He immediately set out for Hamburg, where he hoped to arrange passage to England. When that city fell to the French, however, Smithson was once again trapped and held under house arrest. His health deteriorating, he contacted Joseph Banks, pleading for any assistance the Royal Society might provide. Banks responded with a letter to the French Institute expressing the wish that Smithson "will in some way or another find an amelioration of his destinies through the

intercession of those who as friends of science must also be friends of him." Napoleon approved Smithson's release in June 1809, twenty-two months after his initial arrest.[45]

Free again, he returned to England in 1810 and resumed the process of research and publication interrupted by his troubles abroad. Smithson published nine papers in *Philosophical Transactions*, the journal of the Royal Society, four between 1791 and 1808 and then five more between 1810 and 1817, following his return from the continent. Two scientific contemporaries, Louis Agassiz and Charles Wheatstone, suggested that Smithson became upset over the treatment of a paper submitted for publication in *Philosophical Transactions*, probably his 1817 offering, "A few Facts relative to the Colouring Matters of some Vegetables." Whatever the reason, he published his final eighteen papers in *Annals of Philosophy* in just six years, between 1819 and 1825. At the time of his death, he had amassed an additional two hundred notes on which articles could be based.

In his 1878 assessment of Smithson's contributions to science, mineralogist John Irby remarked, "We could wish Smithson's name to have been coupled with some great discovery, or with the apprehension of some far-reaching law that would have formed a worthy inscription for the portal of the Institution." Steven Turner, a modern student of Smithson's scientific contributions, is far more generous, demonstrating the extent to which his work contributed to larger scientific questions and arguing that no "scientific amateur" would be elected to the governing council of the Royal Society. If James Smithson did not earn a place in the first rank of contemporary researchers, he was a serious contributor, befriended and admired by the scientific luminaries of the day.[46]

Smithson entered the fields of chemistry and mineralogy at a time when they were developing research equipment, procedures, and an emerging theoretical base. Most of his research papers are reports of his analysis of chemical compounds and natural materials. His mastery of the blowpipe, a device that enables an experimenter to subject test material to very high temperatures, enabled him to study the reaction of various substances to extreme heat. Examining Smithson's skull, Lawrence Angel noted a space in his teeth that was probably the result of his frequent use of a blowpipe. The information produced by that process, combined with the use of a very small and accurate balance, opened the way to the analysis of chemical compounds.

Hans Christian Ørsted, the pioneering student of electromagnetism, met Smithson in Paris in 1823. "Recently, I spent 3 hours with him," he informed his wife, "in order to understand his method of experimenting with very small amounts. The tools he uses cost hardly a Daler [two Danish crowns]. Some of them

are so small that children would regard them as toys, but he uses them with the greatest skill. He often yields the constituents of amounts that do not weigh ½ gram."[47]

Perfecting his technique, Smithson analyzed the composition of calamines, zeolites, and the sulphurets of zinc, lead, and arsenic. In his obituary notes on Smithson, Davies Gilbert shared one of his friend's favorite stories about his own obsession with chemical analysis. Noticing a tear gliding down a lady's cheek, Smithson caught it on a crystal, applied reagents, and determined that it was composed of a variety of salts held in solution. The reason for the tear was unexplained, and the reaction of the startled lady in question was not recorded.[48]

His studies were often inspired by, or designed to test, contemporary theory. He demonstrated that biological processes could produce inorganic minerals like silica, a discovery that supported geological theories as to the origin of the Earth's crust. Other experiments supported British scientist John Dalton's atomic theory, which he had presented in full in 1808. Smithson was also determined to apply the lessons of chemistry to practical ends. His most important paper, an analysis of calamines, or ores of zinc, had important implications for the brass industry. His tests for the presence of metallic poisons of arsenic and mercury supported efforts to improve environmental health. He applied his analytical techniques to an archaeological puzzle, discovering the nature of paint colors found in Egyptian tombs. He suggested the best method of brewing coffee and the means of fixing pastels on portraits. He contributed to advances in scientific instrumentation, offering his design for a superior lamp for use with blowpipes and sharing advice on an improved laboratory balance with fellow researchers.[49]

In his longest published paper, and one of his last, Smithson stepped away from his narrowly focused description of experimental results to comment on the larger geological questions of the day. In 1821, workmen discovered the bones of a hippopotamus, an elephant, and cave hyenas, all animals long extinct in England, in Kirkdale Cave, North Yorkshire. Both veterinarian Granville Penn and leading geologist William Buckland were determined to reconcile science with biblical religion, arguing that the remains had been entombed under a layer of mud deposited by Noah's flood. Smithson, suggesting that "a book held by a large proportion of mankind to have been written from divine inspiration" might not be the ideal arbiter of scientific questions, took great delight in marshaling arguments against the possibility of a universal flood.[50]

In addition to his own research and publications, Smithson was an active participant in scientific organizations. In April 1799, he accepted Sir Joseph Banks's invitation to become a proprietor, or financial supporter, of the new Royal

Institution, which provided public lectures and offered workingmen an opportunity to become familiar with the practical application of scientific and technical research. The following year, Smithson joined his friend Charles Greville on the governing council of the Royal Society. Three years after Smithson's death, the French mineralogist François Beudant paid him the ultimate scientific compliment, renaming zinc carbonate ($ZnCO_3$), a mineral ore of zinc, smithsonite.[51]

French physicist François Arago recalled that science was not Smithson's only passion. "Some years ago," he explained, "I made the acquaintance of a distinguished foreigner, of great wealth, but in wretched health, whose life . . . was regularly divided between the most interesting scientific researches and gambling. It was a source of great regret to me," he concluded, "that this learned experimentalist should devote the half of so valuable a life to a course so little in harmony with an intellect whose wonderful powers called forth the admiration of the world around him."[52]

Appalled, Arago calculated the amount of money his friend was losing every three months. Confronted with the sum, Smithson stepped away from the gaming tables for two weeks, then relapsed. "I shall continue to play," he explained, "because the superfluous 50,000 francs expended in any other way would be unable to excite my feeble frame, undermined by suffering, as the lively sensations alone aroused by the various combinations, fortunate and adverse, displayed every night on the green carpet!"[53]

Smithson returned to London in 1825 and focused on his finances. His father did not include James in his will. Fortunately, his mother, Elizabeth, was a tenacious litigator who refused to accept anything less than her share of a family estate. Her brother, Lumley Hungerford Keate, died intestate and without heirs in 1766. Elizabeth and her sister, Henrietta Maria, brought a series of legal actions to obtain their brother's share of the Hungerford lands. In 1782, the Court of Chancery finally resolved issues relating to the division of property between the two sisters.

At the time of his mother's death in 1800, James Smithson shared her estate, totaling only £10,000, with his brother, Henry Louis Dickinson. His bequest to the Smithsonian was over ten times that amount. He had received a bequest of £3,300 from his half sister, Dorothy Percy. He also inherited money from his brother, with the understanding that it would go to his son, who was also to be Smithson's principal heir. The bulk of his estate, however, totaling a bit over £100,000 at his death, was the result of wise investments over the years. His gambling suggests a financial risk-taker, and his records indicate that he remained in close touch with his bankers and was fully aware of the bonds and other financial instruments in which he was investing.[54]

Aged sixty-one, he drafted his will in the fall of 1826. Rather than turning the matter over to an attorney, he prepared the document himself. He opened the will in unconventional fashion by announcing his noble lineage. "I James Smithson Son to Hugh, first Duke of Northumberland, & Elizabeth, Heiress of the Hungerfords of Studley & Niece to Charles the Proud Duke of Somerset . . . do this twenty-third day of October, one thousand, eight hundred and twenty-six, make this last will and testament." After providing an annuity to his servant, John Fitall, and dealing with the terms of a loan extended to another ex-employee, he proceeded to the heart of the matter.[55]

He gave "the whole of the income arising from my property of every nature & kind whatever" to his nephew, Henry James Dickinson. After Dickinson's death, his children "legitimate or illegitimate" were to inherit the estate. If Dickinson should die unmarried and childless, Smithson's fortune was to go to "the United States of America, to found at Washington, under the name of the Smithsonian Institution, an Establishment for the increase and diffusion of knowledge among men."[56]

How are we to explain James Smithson's bequest? He must have assumed that his nephew, only eighteen years old in 1826, would live a normal life, probably marry, and perhaps have children. Just in case, however, it made sense to Smithson to endow an organization dedicated to the increase and diffusion of knowledge as a secondary legatee.[57]

As a young student touring Scotland and the islands, James Macie made the acquaintance of John Anderson of Glasgow University, who was particularly interested in the scientific and technical education of workers and tradesmen. Upon his death, the professor instructed that his estate be used to found what became known as the Andersonian Institution, dedicated to "the good of mankind and the improvement of science." Smithson had also taken a personal interest in the Royal Institution, aimed at the development of new knowledge and the education of workingmen. Surely those are clues as to the type of institution he hoped the Smithsonian would become.[58]

Rejected by his father, offered only circumscribed citizenship by his nation, James Smithson was an outsider with a sense that he had been unfairly barred from his proper station in life. He was determined to set things right. "The best blood of England flows through my veins . . . but it avails me not," he explained. His goal in life, he once remarked, was to ensure that "my name will live on in the memory of men when the titles of the Northumberlands and Percys are extinct or forgotten."[59]

Smithson's library included the two volumes of Isaac Weld Jr.'s *Travels through the States of North America and the Provinces of Upper and Lower Canada* (1799), which

offered a decidedly mixed report of the author's travels through the new United States and Canada. Whatever Weld's opinion, Smithson and many other intellectuals looked to America as the future. Like his fellows, young James Macie had applauded the coming of the French Revolution. As the bright promise of government by the people gave way to terror imposed by the few, however, the gentlemen intellectuals turned away in disappointment.[60]

For many, likely including James Smithson, the United States retained its bright promise of possibility. Here was a blank slate where science might help to provide a solid foundation for a rational society. Under those conditions, Smithson's largess might have a far greater impact than in Europe with its wide range of organizations. The inveterate gambler prepared a will offering a wager that, sent to America, his fortune might not only have a major impact on an evolving society but would also ensure that his name would indeed be remembered. It was a bet he would win, with results surpassing his wildest expectations.

CHAPTER 2

A DIFFICULT BIRTH

ON NOVEMBER 4, 1829, just five months after the death of James Smithson, the Prerogative Court of Canterbury considered his will and granted probate to Messrs. Drummond, Smithson's bankers. Just over a month later, on December 10, the London *Morning Post* called attention to the peculiar features of the document, from the opening sentences in which Smithson called attention to his aristocratic lineage to the fact that, in the event of his nephew's death without issue, the estate was to go to the United States "for the purpose of founding an Institution at Washington, to be called *The Smithsonian Institution* for the increase and diffusion of knowledge among men." The will attracted attention in the United States as well. On February 6, 1830, just three months after the appearance of the article in London, the *Western Recorder*, in far-off Utica, New York, described the will and the remote possibility of a Smithsonian Institution in Washington.[1]

Smithson's nephew and beneficiary, Henry James Dickinson, successfully concluded the legal processes by 1831 and received the first payment of the annual £4,000 annuity from his uncle's bequest. He was entitled only to the interest. The principal was reserved for his children, if any, or for the secondary legatee. Henry shared a substantial sum with his mother, Mary Ann Coates Dickinson, who had two young children by Théodore de la Batut. Contrary to Smithson's wishes, Henry James took his stepfather's name, styling himself the Baron Henry de la Batut. Like his uncle, Henry was a traveler, moving from France to Italy, and, like his uncle, he struggled with ill-health. Still in his mid-twenties, he died in Pisa in May 1835, deeply in debt and without the money to cover his funeral expenses.[2]

On July 20, 1835, representatives of the legal firm of Clarke, Fynmore & Fladgate called at the residence of Aaron Vail, chargé d'affaires of the US legation in London. With the death of Smithson's nephew, the solicitors explained, the accountant general of the Court of Chancery was holding £100,000 worth of stocks. If the United States was to accept the bequest, it would have to petition the court for

the disposition of the estate. Vail immediately forwarded a letter from the solicitors explaining the situation to Secretary of State John Forsyth, who informed the White House. On December 17, President Andrew Jackson shared news of the bequest with Congress, which would decide whether to accept the funds.

On January 5, 1836, Virginian Benjamin Watkins Leigh, representing the Senate Judiciary Committee, submitted a report outlining the details and recommending that it was proper for the government to pursue a claim to the bequest in English courts, providing Congress authorized the funds with which to prosecute the claim. On January 19, Representative John Quincy Adams, speaking for the nine members of a House select committee appointed to consider the question, urged that the president be authorized to pursue the bequest. "Your committee are fully persuaded," Adams noted with some passion, "that with a grateful sense of the honor conferred by the testator upon the political institutions of this Union, the Congress of the United States, in accepting this bequest, will . . . carry into . . . execution the noble purpose of an endowment for the increase and diffusion of knowledge among men."[3]

South Carolina Senator William C. Preston opened the debate in the Senate on April 30, 1836, noting that "he had no idea of [the nation] . . . being used as a fulcrum to raise foreigners to immortality by getting Congress . . . to accept donations from them." He would ultimately change course and support the notion of using the bequest to establish a great national university in Washington. John C. Calhoun, the senior senator from South Carolina, remained steadfastly opposed to accepting the bequest, claiming the Constitution did not allow for such a national establishment. In any case, it seemed to him "beneath the dignity of the United States to receive presents of this kind from anyone." If such an institution was thought desirable, Congress should consider an appropriation for that purpose, an action he would certainly oppose as a constitutional overreach by the national government.[4]

Notwithstanding those views, on April 30 the Senate voted "to authorize and enable the President to assert and prosecute with effect the claim of the United States to the legacy bequeathed to them by James Smithson." It passed with a vote of thirty-one to seven, with Calhoun and Preston in the minority. "It was hoped," the *Daily National Intelligencer* reported, "that the welfare, happiness, and intelligence of this District [of Columbia], and of the country at large, would be increased by having the benevolent intensions [*sic*] of Mr. Smithson carried out by the instrumentality of Congress."[5]

The House passed the Senate resolution on June 25. On July 1, 1836, Andrew Jackson Donelson, President Jackson's adopted son and secretary, reported that the

president had signed the bill, opening the way to pursue the bequest. The long and tangled legislative history leading to the establishment of an institution "for the increase and diffusion of knowledge" was underway.[6]

President Jackson's selection of a representative to negotiate the acquisition of the Smithson bequest required him to put his trust in a political opponent, the uniquely qualified Richard Rush. Rush had served as attorney general of Pennsylvania (1811), comptroller of the US Treasury (1811–14), attorney general of the United States (1814–17), acting secretary of state (1817), minister to Britain (1817–25), and Treasury secretary (1825–28). He was also John Quincy Adams's running mate against Jackson in Adams's unsuccessful drive for reelection to a second term in the White House. Eight years later, Jackson set politics aside and recognized Richard Rush as the person best prepared to bring the Smithson money home.[7]

Secretary of State Forsyth's letter of July 11 informing Rush of his appointment included the news that he would be required to post a $500,000 bond, the approximate value of the bequest, to ensure performance of his duties. He would receive a salary of $3,000 per year plus an additional $2,000 contingency fund, a small sum in view of the size of the bond he was required to post. Legal fees would be covered by a letter of credit for $10,000, the amount appropriated by Congress, drawn on M. de Rothschild, the banker handling the financial affairs of the United States in London.

Rush arrived in England on August 31 but was unable to meet with the solicitors until September 20, as all "professional and official business of every kind is much at pause in London" due to traditional late-summer vacations. The Court of Chancery had invested the bequest in public stock accumulating interest, waiting for a claimant. The solicitors dashed Rush's hopes of bypassing a time-consuming suit in the Court of Chancery, where the term *red tape* was inspired by red ribbon used to tie the files of cases heard there.

Hearings in the case of the *President of the United States v. Drummond*, the executors of Smithson's estate, began on February 1, 1837. During that first session, the executors informed Rush that Mary Ann de la Batut, Smithson's sister-in-law, had filed a claim on the estate. Her husband, Henry Louis Dickinson, had willed his fortune to his brother, James Smithson, to hold in trust for his son, but asked that his wife enjoy a portion of interest during her lifetime. Smithson complied, and his nephew, in turn, had continued supporting his mother during his short life. Rush initially assured the secretary of state "that nothing will be taken from the United States to which they are rightfully entitled."[8]

As the case went into the Court of Chancery, Rush dispatched an agent to France to investigate the de la Batut claim and the possibility that either

Smithson's brother or his nephew might have fathered illegitimate children who could claim the estate. By the spring of 1838, in the interest of reducing court costs and speeding the legal process, Rush agreed to a compromise. A total of £5,015 would be withdrawn from the estate and invested to produce an annual payment of £150 for Madame de la Batut. With that agreement in place, Rush's two-year pursuit of the Smithson bequest came to a successful conclusion. On May 9, 1838, the Court of Chancery issued a ruling "adjudging the Smithson bequest to the United States." The total cost of the chancery suit was more than covered by the interest accumulated since Smithson's nephew's death in 1835.[9]

Now Rush faced the problem of maximizing the value of the estate. By June 5, the attorney general of the Court of Chancery had transferred the investments comprising the Smithson trust to Rush's account: £64,535 in British government-funded securities, £12,000 in reduced annuities, £16,100 in bank stock, and a small cash balance. Rush decided that the best course of action was to sell the investments and return to the United States with British gold sovereigns, which could be melted and struck into American gold coins at a US mint.

Rather than cash in everything at once and leave for home immediately, Rush thought strategically, selling in small lots when prices were rising. He disposed of the government securities at the highest price, "as far as I have been able to examine the London Mercantile Price-Current, for nearly eight years before." The sale of the securities netted a total of £104,960. The bequest would continue to grow in years to come. Following the repayment of unspent legal funds, the trust increased to £106,374, or $515,169. The return of £5,169 following the death of Madame de la Batut in 1861 raised the total amount of the bequest to $550,000.[10]

The Bank of England packed 1,000 gold sovereigns into each of four bags, with 960 sovereigns and 8 shillings sixpence in change wrapped in paper and tucked into the fifth bag. Rush loaded the money and two large boxes, eight cases, and a trunk containing Smithson's personal effects on board the packet ship *Mediator* on July 14, 1838. He sailed from London three days later and landed in New York on August 29. Rush deposited the sovereigns with the Bank of America until September 1, when, accompanied by two armed guards, he transported the funds to the United States Mint in Philadelphia. Once the process of recoining was complete, the Smithson bequest totaled $508,318.46. Secretary of the Treasury Levi Woodbury invested the funds in state bonds. When the bonds failed to pay dividends by 1846, Congress agreed to guarantee the principal and pay at least 6 percent interest on $538,000, even if the actual returns on investment were less than that. Congress would continue to pay the guaranteed dividends for years to come.[11]

A DIFFICULT BIRTH

On December 10, 1838, President Martin Van Buren, noting that the Department of the Treasury had received and invested the Smithson funds, invited "the attention of Congress to the obligation now devolving upon the United States to fulfill the object of the bequest." It would not prove to be a simple task. Even with the bequest in hand it would take eight years, five Congresses, and four presidential administrations to establish the Smithsonian Institution.[12]

Congress faced more immediate concerns than the question of the Smithson bequest. The Panic of 1837 had given way to a depression that would last into the mid-1840s. Cotton prices and land values plummeted, banks failed, and unemployment soared. As one historian noted, "From time to time the bill establishing the Smithsonian Institution kept coming up when either house had a moment to spare." When the members of the House and Senate did turn their attention to the bequest, Smithson's broad statement of purpose became a problem. Divergent views as to how best to achieve "the increase and diffusion of knowledge among men" inspired lengthy debates that stretched the legislative process.[13]

The Twenty-Fifth Congress offered the first proposals for using the fund, calling for the establishment of a university specializing in agriculture and other practical subjects of value to an expanding nation. Senator Asher Robbins of Rhode Island offered a vague proposal for an idealized "institution of which there is no model either in this country or Europe, to provide such a course of education and discipline as would give to the faculties of the human mind an improvement and power far beyond what they could obtain from ordinary systems of education."[14]

Seventy-two-year-old John Quincy Adams, who chaired the House special committee on the bequest, was adamantly opposed to such proposals, pointing to the "95 universities and colleges, besides high schools, academies, and common schools without number" scattered across the nation. A major university, he warned, with the need for a large campus and ongoing expenses, would exhaust the bequest. He insisted, as a "fundamental principle," that "the capital amount of the bequest should be preserved entire and inviolate," with the annual interest of 6 percent funding the operation of the Institution.[15]

As the close of the Twenty-Fifth Congress approached in the fall of 1839, Adams noted in his diary that the Smithson legacy "weighs deeply on my mind. The private interests and sordid passions into which that fund has already fallen fill me with anxiety and apprehensions that it will be squandered upon cormorants or wasted in electioneering bribery." He accused Asher Robbins of attempting "to make a university, for him to be placed at the head of," and noted that John Calhoun, who had served as vice president during his own administration, continued to argue that any use to which the bequest might be put would represent an

25

unconstitutional "enlargement of our [congressional] grant of power derived from the states." Having opposed accepting the funds in 1836, Calhoun now insisted that "the second thoughts of Congress are better than the first, and I believe there will now be a decided vote against this measure after full reflection." Fellow South Carolinians William Preston and Waddy Thompson Jr. joined their senior colleague in arguing that the Smithson bequest should be returned to Great Britain.[16]

Richard Rush had successfully obtained the Smithson bequest and maximized its value. John Quincy Adams now struggled to ensure that the fund would be wisely spent. While serving as president a decade before, he had argued unsuccessfully for a national observatory, the scientific exploration of the West, and other projects that would permit the United States to take its place alongside the intellectual and cultural powers of Europe. Still the leading spokesman for science in American public life, Adams saw the Smithson bequest as a second chance to realize some of those bright ambitions. During a meeting with President Van Buren, Adams "urged upon him the deep responsibility of the nation to the world and to all posterity worthily to fulfill the great object of the testator."[17]

Adams decided that a lecture at the Lyceum in his hometown of Quincy, Massachusetts, offered the perfect opportunity to fine-tune his arguments for the best use of the Smithson legacy. Hoarse with a hacking cough, Adams delivered the first lecture to an overflow crowd gathered in the town hall at 7:00 p.m. on November 13, 1839. After offering a history of the Smithson bequest, he warned that "a single error in judgement, a single false step now made in organizing the administration of the funds, or in laying the foundation for the future application of them, might totally defeat one of the noblest benefactions ever made to the race of men." He repeated the lecture the following evening to a small group of the Mechanic Apprentices' Library Association gathered in Boston's Masonic Temple. A Boston reporter in attendance was impressed. "Every one that listened to this lecture," he noted, went away convinced that Smithson's bequest was "expressive of the highest confidence in our character as a people . . . and anxious that his confidence be justified."[18]

On March 5, 1840, Adams presented an amended bill, shaped in part by his two lectures, arguing that the creation of a national astronomical observatory would be the most appropriate use for the Smithson bequest. Basing his proposal on Britain's Royal Observatory, he included a detailed budget, thoughts on a research program, and the results of his correspondence with Sir George Airy, Britain's astronomer royal. A master politician, Adams was, however, willing to

negotiate with a colleague like Secretary of War Joel Roberts Poinsett, who offered an alternative proposal.

In May 1840, nine Washington, DC, residents, most of them either politicians or federal officials, met at Poinsett's home to form the National Institution for the Promotion of Science. The organization's primary goal was to acquire the Smithson bequest and use it to create a museum and a broad-based intellectual organization. Chartered by Congress as the National Institute in 1842, the group took charge of government collections, from the natural and ethnographic treasures gathered by the United States Exploring Expedition to the papers and property of James Smithson, which Richard Rush had brought to America with the bequest. The somewhat chaotic collection was displayed in the basement of the Patent Office.[19]

Adams met with the leaders of the National Institute on June 11, 1842, to discuss a recently introduced Senate bill that would place a Smithsonian Institution under the management and control of the National Institute. The organization not only asked for control of the Smithson fund but also requested an additional appropriation of $20,000. Adams's response was both firm and politic. "I said I had the warmest disposition to favor them, and . . . there was only one difficulty in the way. . . . I had believed that the Smithsonian Institution should be exclusively confined to itself, and not entangled or commingled with any national establishment requiring appropriations of public money."[20] The bill was tabled, and a final attempt by Senator Levi Woodbury of New Hampshire to amend and resuscitate the proposal failed.

The National Institute gradually lost any chance of maintaining a leadership role in American science. Its membership was composed of scientific amateurs and politicians at the very moment when the leaders of emerging organizations such as the American Association for the Advancement of Science, founded in 1848, emphasized professional experience and credentials. Joseph Henry, a Princeton University professor of natural science, spoke in opposition to "the plan of uniting science and party politics" and denounced the institute as the "Host of Pseudo-Savants."[21]

On June 6, 1844, Senator Benjamin Tappan of Ohio, who led the opposition to the National Institute's bill, reported his own proposal from the Committee on the Library. He called for a graduate school for teachers, with professors who would have strong research responsibilities in fields such as agriculture, astronomy, chemistry, geology, and the branches of natural history. An associated museum would manage the government's natural and civic history collections. Many in Congress, including Adams and Massachusetts senator Rufus Choate, opposed

Tappan's plan for a teacher's college. Choate proposed instead that the Smithsonian should establish "a grand and noble public library."

Forced back into committee, Tappan's bill was amended to include a generous budget for library books, after which it was passed by the Senate but remained on the table in the House when the Twenty-Eighth Congress closed on March 4, 1845. Rather than reintroduce the Tappan bill in the new Congress, Representative Robert Dale Owen of Indiana offered his own bill, closely patterned on Tappan's proposal, complete with the graduate school for teachers, a grand building, research program, and library. The son of Robert Owen, who had founded a utopian community at New Harmony, Indiana, in 1825, Robert Dale Owen had assisted his father, worked on several newspapers, and served in the Indiana legislature before his election to Congress in 1840. John Quincy Adams proposed an amendment to Owen's bill, approved by a vote of seventy-two to forty-two, that removed the graduate school from the original legislation.[22]

Congress had appropriated additional funding for the Naval Observatory in 1842, and Adams had traveled to Cincinnati in 1843 to help lay the cornerstone of the first public observatory in the Western Hemisphere. With those achievements in hand, he dropped his campaign to fund an astronomical facility from the Smithson bequest. Instead, he focused on marshaling support for a key amendment calling for a federal guarantee of the principal of the Smithson bequest and an annual appropriation providing the equivalent of the 6 percent interest that should have been earned by the state bonds in which the fund was unwisely invested.[23]

Representative William Jervis Hough of New York introduced a new version of the bill on April 29, 1846. Representing the final compromise, it established the Smithsonian Institution as a trust instrumentality of the federal government, a term describing an organization responsible for managing a trust accepted by the government—in this case, the fortune that James Smithson had bequeathed to the nation. The legislation incorporated the amendments approved to date, including Adams's safeguards protecting the bequest and the promise of annual interest payments. The $242,129 in interest accrued since 1838 would fund the construction of a building to house a museum, art gallery, library, chemical laboratory, and lecture rooms.[24]

The statute called for an entity named the Establishment composed of the president, vice president, chief justice, and members of the president's cabinet. Their primary duty involved the "supervision of the affairs of the Institution and the advice and instruction of the Board of Regents."[25] The business of the Institution was to be conducted by said Board of Regents composed of fifteen members,

including the vice president and chief justice of the United States, the mayor of Washington, three members each from the House and the Senate, and six additional citizen regents, two of whom were to be members of the National Institute and no two of whom were to be citizens of the same state. The regents were to elect a chancellor and three of their own number who were to serve as the Executive Committee. The board was also empowered to select a secretary, who would serve as secretary of the board and chief executive of the Institution.

After a day of discussion, the bill was approved in the House on April 29 by a vote of eighty-five to seventy-six. Months passed without action in the Senate. As the end of the term drew near, Owen launched a final push to rally support for the bill in the upper house. On the morning of August 10, 1846, the last day of the session, Senator George Evans of Maine moved that the Smithsonian bill be considered first. It passed with twenty-six senators approving and thirteen, including Calhoun and his strict constructionist colleagues, opposed. President Polk signed the measure into law that afternoon.[26]

The long congressional struggle to establish the Smithsonian Institution had produced a bill that did not fully satisfy anyone. Time would prove, however, that circumstance and political maneuvering had crafted a workable compromise, providing a governing structure for an organization whose basic nature would be shaped over time by the regents, the secretary, and the needs of the nation.

The year 1846 was filled with events that would shape American history. On May 11, three months before the passage of the Smithsonian bill, President Polk signed a resolution declaring war on Mexico. The victory and subsequent treaties added California, Arizona, and New Mexico to the national map. The promise of a fresh start in the West lured a generation of restless Americans in search of new lives over the horizon. Brigham Young led the first of thousands of Latter-day Saints across the Mississippi on the initial stage of their epic journey to the shores of the Great Salt Lake. In contrast, roughly half of the members of the Donner and Reed families who set out from Independence, Missouri, in May suffered a far more tragic fate.

Far from being overshadowed by these events, the establishment of the Institution attracted favorable notice in American newspapers, which had followed the Smithsonian story since the arrival of the bequest. "The most gratifying act of the whole session," the *New York Evening Post* commented, "was the unexpected passage of the Smithsonian Institution bill." The *New York Evangelist* applauded the measure as "an event calculated to excite the liveliest pleasure in the minds of all who place a proper estimate upon national honor and the interests of science."[27]

In a rush to complete the business of the Twenty-Ninth Congress, the Speaker of the House, the vice president, and a joint committee named the members of the Board of Regents immediately following the passage of the bill. John Quincy Adams's name was not on the list. Robert Owen, who spearheaded the final drive for passage of the legislation, had replaced him as head of the House select committee on the bequest. Seventy-eight years old and in ill-health, Adams was incapacitated by a paralytic stroke just three months later, on November 20, 1846. He recovered and returned to Congress but suffered a cerebral hemorrhage on the floor of the House on February 21, 1848, and was carried to the Speaker's chamber, where he died two days later.

The statute named Vice President George Mifflin Dallas, Chief Justice Roger Brooke Taney, and William Winston Seaton, the mayor of the city of Washington and coproprietor of the city's most important newspaper, the *Daily National Intelligencer*, to the board. Convinced that "nothing has occurred calculated to exert so important an influence on the fortunes of this city . . . as the founding of this great and annually growing Institution," Seaton would remain as treasurer of the Smithsonian long after he left the board.[28]

The other members included some familiar names. Who more appropriate to assist in guiding the Institution into the unknown future than Richard Rush, who would serve as a citizen regent from Pennsylvania until his death in 1859. Representatives Owen and Hough, who between them had crafted the compromise legislation establishing the Smithsonian, represented the House along with Henry Hilliard of Alabama, an active participant in the debates and a future general in the Confederate States Army. Rufus Choate and William Preston, both of whom had lost their congressional seats, joined Rush and William Hawley of New York as citizen regents. Two of the most distinguished scientific and technical minds in the nation's capital, Alexander Dallas Bache, superintendent of the United States Coast Survey, and Joseph Gilbert Totten, the US Army's chief of engineers, represented the National Institute. Senator George Evans, whose "few well directed and effective words" on the morning of August 10 had sparked Senate action, and his Senate colleagues, Isaac S. Pennypacker (Virginia) and Sidney Breese (Illinois), rounded out the board.

The Board of Regents met for the first time on a sweltering September 7, 1846, in the General Post Office, a Greek Revival building on Washington's F Street designed by architect Robert Mills.[29] For the next two days, they moved into a "large and airy" room in the finished portion of the neighboring Patent Office. The members elected Vice President Dallas as chancellor and William Hough as acting

Alexander Dallas Bache (1806–67), photographed by Mathew Brady, c. 1860. Bache, a renowned physicist, superintendent of the US Coast Survey, and charter member of the Smithsonian's governing Board of Regents, fought to secure the post of secretary for his friend and colleague, Joseph Henry. *National Portrait Gallery*

secretary. Benjamin Brown French, clerk of the House of Representatives, agreed to serve as acting secretary and recording clerk of the Institution. The board then hired William McPeak to serve as doorkeeper and messenger at an initial salary of a dollar a day. The first Smithsonian employee, he remained with the Institution until his death in 1862.[30]

Then it was on to other organizational issues. Robert Owen, Mayor Seaton, and Colonel Totten were elected to serve on the Executive Committee. The chancellor then named Owen, Hilliard, and Bache to an organization committee "to digest a plan to carry out the provisions of the act to establish the Smithsonian Institution" and instructed them to present their plan at the next meeting of the board. Choate and Pennybacker were added to the committee the next day. Choate, whose personal library included some eight thousand volumes, would work with Hawley and Rush to prepare a report on the importance of a library for the Smithsonian.[31]

The board considered the matter of a suitable building for the Institution on the final day. The organizing legislation appropriated $242,129, the 6 percent interest accumulated since the arrival of the funds, for the "erection of suitable buildings, and for other current incidental expenses of the Institution." The board met with President Polk and members of his cabinet on the open ground south of the White House at 9:00 a.m. on September 9. The president had rejected the possibility of locating the Smithsonian on Patent Office Square, suggesting that "the public mall offers a much more eligible site for an establishment of the magnitude which the Institution must in a few years attain." The members of the board agreed that the Mall was the ideal site for their building.

Congressman Owen was determined to take the lead when it came to the design of the Smithsonian building. He saw architecture as an expression of values and ideals and was determined that the structure housing the Institution would be impressively large and communicate something of the Institution's goals. As early as the summer of 1845, he had opened a discussion on the design of such a building with his brother David Dale Owen and architect Robert Mills. A South Carolinian, Mills was a veteran of important church commissions in Philadelphia, Baltimore, and Augusta, Georgia. He had shaped the look of the federal city, contributing to the design and construction of the Treasury Building, General Post Office, and Patent Office. Called upon to design an impressive Smithsonian building for the National Institute's attempt to capture the bequest, he had stepped away from the classic revival style in favor of towers, turrets, and other medieval or Gothic elements. Congressman Owen regarded the style, reminiscent of the architecture of English and French universities, as particularly appropriate for the Smithsonian.[32]

A DIFFICULT BIRTH

When the members of the board returned to the Patent Office following their discussion with the president and visit to the Mall, Owen presented two specific sets of plans, drawings, and specifications for the building to be, one prepared by his brother David and the other by Robert Mills. The board instructed the chancellor, secretary, and members of the Executive Committee to consider the matter and present plans for a building, as well as a report on the best building materials and "modes of warming, lighting and ventilating the same," at the next meeting of the full board.[33]

On September 14, 1846, Owen and Hough boarded a train for Philadelphia, the first stop on a tour that would also include Trenton, New York, and Boston, to interview a dozen prominent architects, inspect important buildings, and visit stone quarries to consider and price various building materials. Owen would visit a final group of architects in Cincinnati on his way home to Indiana. Owen and Hough were particularly impressed by the youngest architect they met, twenty-seven-year-old James Renwick Jr., best known for two Gothic-style New York churches: Grace Church and the Church of the Puritans. He and several others were invited to submit plans through the Building Committee for presentation at the next meeting of the Board of Regents.[34]

While Owen focused on the building, Alexander Bache was determined to choose a secretary who shared his vision of the future of the Institution. At forty, he was the youngest member of the board and one of the best connected. The great-grandson of Benjamin Franklin, Bache was the nephew of Vice President Dallas and brother-in-law of Secretary of the Treasury Robert Walker. Prior to coming to Washington, he had overseen the establishment of Philadelphia's Girard College, a university preparatory school endowed by a bequest from financier Stephen Girard. He had also been the superintendent of the US Coast Survey since 1843 and was seen as the most important scientific figure in the nation's capital.

Bache recognized that the selection of a Smithsonian secretary was both the key to the success of the new Institution and an opportunity to acquire an ally to represent the best of American science. The legislation provided only a loose job description for a man to head the library and museum and manage the staff, so Bache worked with other members of the board to strengthen the qualifications for a man who would offer "eminent scientific and general acquirements capable of advancing science and promoting letters by original researches and effort."[35]

He had someone in mind. In 1835, he had supported the publication of a scientific paper by Joseph Henry, a Princeton University professor of natural philosophy, and spent time with him in Europe the following year when Henry was enjoying a sabbatical and Bache was touring European preparatory schools while

33

SMITHSON'S GAMBLE

planning the curriculum for Girard College. Henry had emerged as the leading American contributor to the growing field of electromagnetism, and had played a key role in the official inquiry into the tragic explosion of a large gun on board the USS *Princeton* at the Washington Navy Yard on February 24, 1844.

The disaster had occurred during an inspection tour of the vessel by President John Tyler, members of his cabinet, and guests. The climax of the event was the firing of two enormous twelve-inch naval guns, the largest in service. One of the guns burst, killing the secretary of the navy, the secretary of state, and several members of Congress. Henry led the study of the strength of materials involved in the construction of the weapon and published the results of his experiments in European and American journals. It was an impressive example of the role that science could play in shaping public policy.[36]

Henry shared Bache's view of science as an elite enterprise. He particularly admired the "aristocratical" character of the British Association for the Advancement of Science. "Those who have some reputation for science," he argued, "ought to be in command. Lesser lights have no voice." In the years leading up to the Civil War, the two would head up an informal group of American scientific professionals who called themselves the Lazzaroni, a jocular homage to a legendary band of Neapolitan street beggars. As a group, they were determined to encourage professionalism and standards in American science, raise the status of scientists, ensure support for serious research, and manage government involvement in science.[37]

Following the passage of the Smithsonian bill, Bache asked his friend to comment on the legislation and suggest an appropriate course for the new Institution. Henry replied on September 5, 1846. "The increase of knowledge," he wrote in the most direct terms, "is much more difficult and, in reference to the bearing of this institution on the character of our country and the welfare of mankind, much more important than the diffusion of knowledge." In no other country, he continued, "is . . . less encouragement . . . given than in our own to original investigations, and consequently no country of the same means has done and is doing so little in this line."[38]

He also weighed in on what sort of knowledge should be increased. "James Smithson," Henry noted, "devoted his life principally to scientific pursuits . . . that . . . increased the sum of human knowledge by a number of valuable scientific communications." It stood to reason, then, that "he intended by the expression 'for the increase and diffusion of knowledge' an organization that would promote original scientific researches." While some support had been given to the study of "descriptive natural history" in the United States, there had been no such encouragement for "science properly so called which is a knowledge of the laws of

34

phenomena." Henry believed that should be the primary role of the Smithsonian. The goal could be achieved, he suggested, by funding a small number of "scientific men" who had distinguished themselves in various fields and publishing the results of their research in a series of volumes that the Smithsonian would share with the world.[39]

Having described a very different Institution from that outlined in the legislation, Henry proceeded to reject the possible roles for the Smithsonian that Congress had suggested. While he agreed that the Smithsonian would need a working library, he argued that the Library of Congress was far more suitable to meet the need for a great national library. He rejected a lecture series and a museum as purely local features of little value to those outside the nation's capital, and of little importance to an organization charged with diffusing knowledge to all mankind. Finally, he remarked, "I really hope that but a very small part of the present interest will be expended putting up a building." Perhaps the operations of the Smithsonian could be accommodated in an existing public building. "It should be remembered," he concluded, "that the name of Smithson is not to be transmitted to posterity by a monument of brick and mortar, but by the effects of his Institution on his fellow man."[40]

There was public support for such a radical step away from the legislative mandate. "The law [creating the Smithsonian] is a very defective one,—we might even say absurd," suggested an editorial in the *North American*, a Philadelphia newspaper. The writer pointed to "the manifest tendency . . . among the good people of Washington . . . to expend Smithson's money in the construction of grand buildings and magnificent gardens . . . entirely subversive of Smithson's objects." Bache, a Philadelphian, may have read the editorial and the extended "A Memoir of the Smithsonian Institution," published in the paper two days later. In any case, he was sure that he had found a man who would ally with him in correcting such defects and lead the new Institution down a useful path.[41]

Bache shared Henry's long letter with the board and began gathering letters of support for his friend's candidacy. Henry had been teaching at Princeton for fourteen years and had recently turned down two other opportunities. The trustees of the University of Pennsylvania had offered him the chair of natural philosophy and chemistry that Bache had vacated when he moved to Washington, and Harvard had invited him to accept the prestigious Rumford Chair of the Application of Science to the Useful Arts. Now, Henry assured his friends, perhaps a bit disingenuously, that there was no truth in the rumors that he had applied for the position of Smithsonian secretary. "A step of this kind," he explained, "is of too much importance to my family and myself to be taken without due consideration."[42]

At the same time, he was quick to correct a correspondent who assumed that the position would be a sinecure. On the contrary, he remarked, "it does appear to me that under a proper organization of the smithsonian [sic] Institution, the office of Secretary would give me a wider scope—enable me to do much more for Science in both the way of its increase and diffusion." In the end, Henry decided that the opportunity to join forces with Bache in Washington, encouraging the growth of professional science in America and working to shape government science policy, outweighed the extent to which an administrative post would reduce the time he could devote to his own research.[43]

Bache worked to ensure that Henry was the favored candidate, but there was considerable competition. Representative Owen considered Richard Rush. Caleb Cushing, a lawyer, newspaper editor, linguist, and four-term congressman, suggested to Colonel Totten that he was willing to serve. Francis Markoe, a State Department clerk and corresponding secretary of the National Institute, informed Rush that, however unworthy, he would be honored to be considered. John H. Young, a recent graduate of Union College and a newly minted lawyer, was on Hough's list of potential candidates.[44] Charles Pickering, a Harvard-trained physician, librarian, and curator of Philadelphia's Academy of Natural Sciences who had accompanied the United States Exploring Expedition as a naturalist, was also mentioned as a potential secretary. By December 4, the *Newark Daily Advertiser* claimed there were "nearly a hundred applicants."[45]

The regents reconvened in Vice President Dallas's office in the US Capitol on November 30, 1846, and continued to meet for the next five days. Following the presentation of letters of recommendation for various candidates for the office of secretary and the announcement of a private library for sale, the chancellor presented the report of the Building Committee. In addition to describing their five-city tour, the group announced their choice of an area on the Mall between Seventh Street and the Potomac River as the site for the Smithsonian building. While the competition for the design of the building would remain open until December 25, 1847, the members of the committee announced that, of the thirteen proposals in hand, they had unanimously selected a submission by James Renwick Jr. for a structure "in the later Norman, or, as it may, with more strict propriety, be called, the Lombard style, as it prevailed in Germany, Normandy, and in Southern Europe, in the twelfth century."[46]

In Renwick's plan, the building would consist of a central structure with a wing on either side, connected by low ranges. It would be large, measuring over 420 feet across the front with a maximum depth of over 150 feet at the deepest point, with a carriage porch. The design included space for all the functions

suggested in the legislation: a museum, library, art gallery, chemical laboratory, room for the regents, office for the secretary, and two lecture rooms, one large enough to accommodate eight hundred to one thousand persons.

The report of the organization committee, which Owen presented on December 1, bore no resemblance to the suggestions offered by Henry, which Bache had shared with the regents. First and foremost, the committee argued that the Institution should house a library with a suggested appropriation of $20,000 for books and furnishings. There was to be a museum, lecture halls, chemical laboratory, conservatories, botanical garden, and zoo. The needs of agriculture and industry were to be emphasized, with a possible model farm. The professional staff would offer lectures, both in Washington and in other parts of the nation, where they would be expected "gradually to stir up a love of science" and "substitute for the deleterious excitements sought in haunts of dissipation the healthful and humanizing interest to be found in scientific research." The new organization would also be concerned with "the theory and practice of public education, and, especially, of common school instruction." Clearly, despite the defeat of his bill, Owen had not given up on the notion of a normal school in the big building he was planning for the Smithsonian. Wisely, the board postponed consideration of the report.[47]

The plan was widely publicized but not universally applauded. The editor of the *North American*, who criticized the legislation, reminded his readers that the Owen's congressional bill had been the "wildest and strangest of all, being no less than a project of converting the Smithsonian Institution into a college to train-up *Common-School Teachers*." Now he was at it again, the editor continued.[48]

On December 3, Owen offered the resolution that he and Bache had developed, insisting that the secretary "be a man capable of advancing science and promoting letters by original research and effort, well qualified to act as a respected channel of communication between the institution and scientific and literary individuals and societies in this and foreign countries." The twelve members present then cast their votes for secretary from among the candidates whose credentials had been available for study. Discussion among the regents had clearly winnowed down the pool of candidates. Henry received seven votes, Markoe four, and Pickering one.[49]

With just over half the votes cast, Joseph Henry was elected. He would have a salary of $3,500 per annum, with a housing allowance of $500 until such time as he and his family could occupy living quarters in the planned building. He would earn $500 less than the attorney general but $500 more than the superintendent of patents.[50]

His election was well received. "By this choice to the . . . highest scientific post in the country, the Trustees have given utterance to the universal voice of the scientific world," reported the *New York Observer and Chronicle*, concluding that "no man in the country has all the qualifications for this high trust, in a greater degree than Professor Henry." Most commentators agreed. "With a truly scientific institution thus amply endowed," the *Daily National Intelligencer* noted, "with such a man as Henry as its guiding and pervading spirit, with his eminent colleague and fellow laborer, Professor Bache, at the head of our national coast survey, the science of the country may hope to make a progress commensurate with the progress of the country in all the other elements of national greatness."[51]

Bache had managed Henry's election by striking a deal with Rufus Choate and the other board members who supported a large library. In return for their votes, Henry was obligated to accept Charles Coffin Jewett, a Dartmouth graduate, linguist, and bibliophile, as assistant secretary with responsibility for what he hoped would be a very large Smithsonian library. In accepting the post, the new secretary was forced to make an uncomfortable compromise with those who planned for a grand building, a great library, and an unwieldy program. It was a price he was willing to pay for the opportunity to establish a unique institution dedicated to meeting his vision of James Smithson's goal.[52]

CHAPTER 3

LAYING THE FOUNDATION

"THE DIE IS CAST," JOSEPH HENRY TOLD his friend, the Harvard botanist Asa Gray. "I am sold for the present to Washington . . . with the hope of saving the generous bequest of Smithson from utter waste." The new secretary stepped from a Baltimore and Ohio Railroad carriage onto the station platform at Second Street and Pennsylvania Avenue at 8:00 p.m. on Monday, December 14, 1846. Alexander Bache and his wife, Nancy, welcomed the newcomer into their home, where he stayed until he took lodgings in the National Hotel on December 18, following a snowstorm that "rendered the streets impassable."[1]

Those streets were not much better in the best of weather. When twelve-year-old Henry Adams visited his grandmother Louisa Catherine Adams in May 1850, F Street was "an earth-road, or village street, with wheel tracks." The Treasury Building, Post Office, and Patent Office were "like white Greek temples in the abandoned gravel-pits of a deserted Syrian city." Unlike his native Quincy, Massachusetts, there was a "want of barriers, of pavements," with pigs running loose in the streets. Viewing the city from the Capitol building that year, Charles Dickens remarked that its principal features were "spacious avenues, that begin in nothing and lead nowhere; streets, miles long, that only want houses, roads and inhabitants; public buildings that need but a public to be complete; and ornaments of great throughfares that only lack throughfares to ornament."[2]

The young, Boston-bred Adams was appalled by another aspect of the city. "Slavery struck him in the face; it was a nightmare; a horror; a crime; the sum of all wickedness! Contact made it only more repulsive. He wanted to escape, like the negroes, to free soil."[3]

Indeed, Washington was a Southern city, both the capital of the nation and a center of the "peculiar institution" of slavery. The auction of men, women, and children was a familiar sight, as were coffles of shackled Black people shuffling through the streets. Two years after Joseph Henry's arrival in Washington, on the

evening of April 15, 1848, seventy-seven slaves attempted the largest recorded non-violent escape of enslaved people in American history. Aboard the schooner *Pearl*, they sailed down the Potomac toward the Chesapeake Bay until pursuers overtook them and returned them to Washington. The failed escape sparked a three-day proslavery riot in the capital, culminating in an attack on the offices of the *New Era*, an abolitionist newspaper.[4]

In making their way to the *Pearl* that evening, groups of fleeing slaves crossed the bridge over the city canal and proceeded down Seventh Street, past the piles of rusty red sandstone blocks where the Smithsonian building would rise. They crossed Avenue B (now Independence Avenue) and passed by the notorious slave prison operated by Joseph Gannon. Just one block east, at the corner of Seventh and Maryland, William Williams ran the Yellow House, a slave prison where free man Solomon Northup, the author of *Twelve Years a Slave*, was held and forced into bondage in 1841.[5] The building was innocuous—it appeared as a "quiet private residence." But, as Northup wrote, it represented the hypocrisy of slavery: "The voices of patriotic representatives boasting of freedom and equality, and the rattling of the poor slave's chains, almost commingled. A slave pen within the very shadow of the Capitol!"[6]

Despite his protests that he was a free man, Northup walked the path of thousands of enslaved human beings before and after him, from Williams's prison through the streets of Washington, passing "hand-cuffed and in silence . . . through the Capital of a nation, whose theory of government, we are told, rests on the foundation of man's inalienable right to life, liberty, and the pursuit of happiness!"[7] From there, he and other enslaved people were put aboard a ship down the Potomac River, transferred to stagecoaches for transit to Richmond, and then sold into slavery in the Deep South.

While the Compromise of 1850 would prohibit the importation of slaves into the capital for resale or transportation elsewhere, it continued to allow the sale of enslaved residents. As a result of this restraint on their trade, many of Washington's leading slavers, including those in the Smithsonian neighborhood, shifted operations farther south, including some who simply moved across the Potomac to Alexandria, Virginia. The dark pall of slavery ended in the District of Columbia, at least officially, on April 16, 1862, with the passage of the Compensated Emancipation Act, which freed some three thousand individuals from bondage, reimbursed their owners, and offered the newly emancipated men and women a bounty to emigrate.[8]

JOSEPH HENRY turned forty-nine years old on December 17, 1846, three days after arriving in the nation's capital to take up his new duties. He cut an imposing

Slave House of J. W. Neal & Co, Washington, DC, as depicted in a broadside from the American Anti-Slavery Society, c. 1836. The slave house shown was operated by Washington Robey (1799–1841). When the Smithsonian was founded, enslaved persons were held captive, bought, and sold near the National Mall. Slavery remained legal in the nation's capital until 1862. *Library of Congress, Prints and Photographs Division*

figure, solidly built, with broad shoulders, a thick neck, and full face. Henry kept his thick mop of brown hair combed back from his broad forehead. "Byron at his best," one of his students commented, "could not have been a handsomer man." His piercing blue eyes gaze out through the silvered surface of a daguerreotype. It is the face of a man who is determined, and very sure of himself.

He was born in Albany, New York, probably on December 17, 1797. His father, an alcoholic day laborer, died when Henry was eight. After only a few years of primary schooling, young Joseph worked in a grocery store, apprenticed to a watchmaker and silversmith, and joined a local amateur theater group in which he acted, wrote plays, and designed and built stage sets. Half a century later, botanist Asa Gray commented that "our future philosopher was in a fair way to become an actor, perhaps a distinguished one."[9]

As Henry told it, his life changed at age sixteen when he picked up a small book that one of his mother's boarders left on a table: *Lectures on Experimental Philosophy, Astronomy, and Chemistry, Intended Chiefly for the Use of Students and Young Persons* by English clergyman George Gregory. "This book, although by no means a

profound work," he remarked to a friend, "has, under Providence, exerted a remarkable influence on my life." It "opened to me a new world of thought and enjoyment," he continued, "invested things before almost unnoticed with the highest interest; fixed my mind on the study of nature, and caused me to resolve at the time of reading it that I would immediately commence to devote my life to the acquisition of knowledge."[10]

Henry, who described himself as "principally self-educated," enrolled in night school before entering the Albany Academy, a local preparatory school. He earned his tuition by teaching at a local school, tutoring, and directing a road survey across New York State from West Point to Lake Erie. Henry made a smooth transition from student to instructor at the academy, delivering his first scientific paper in 1824, a study of temperatures in an operating steam engine, at the age of twenty-six.[11]

Promoted to professor of mathematics and natural philosophy in 1826, Henry's annual income of $1,000 enabled him to marry his cousin, Harriet Alexander, four years later. The couple produced six children, two of whom died in infancy. Their only son, William Alexander (1832–62), and three daughters, Mary Anna (1834–1903), Helen Louisa (1836–1912), and Caroline (1839–1920), would enliven the Henry living quarters in the Smithsonian Castle.[12]

The young professor with growing family responsibilities struggled under a heavy teaching load, spending as much as seven hours a day in the classroom. During his early years at the academy, his only free time for extended research came during the August recess. Undaunted, he continued to pursue his own education in science, spending time with Amos Eaton, who taught at the Rensselaer School less than seven miles away in Troy, New York, and scouring the state library for scientific books and journals. He also gathered and processed meteorological data on behalf of the regents of the State University of New York, a project that he would expand to a national level at the Smithsonian.[13]

His real attention, however, was focused elsewhere. Between 1826 and 1832, as historian Robert Bruce notes, Henry was able to carry out "the most notable series of physical experiments undertaken in America to that time."[14] The problems of unlocking the relationship between the linked forces of electricity and magnetism were issues of central concern to contemporary physicists, and particularly appealing to a young experimenter like Henry, who was looking for a field in which he could make a mark. "The subject of electromagnetism," he wrote in 1827, "although one of the most interesting branches of human knowledge and presenting at this time the most fruitful field for discovery, is perhaps less generally understood in this country than any other."[15]

LAYING THE FOUNDATION

He began by experimenting with batteries, ranging from single cells with zinc or copper plates immersed in acid to multicell combinations producing various currents and voltages. With an understanding of power sources in hand, he proceeded to experiment with the electromagnet, which the Englishman William Sturgeon had introduced in 1824. Henry saw an example in New York in 1826. Originally these devices were constructed by connecting a battery to widely spaced coils of copper wire loosely wound around a horseshoe-shaped piece of iron. The resulting magnet demonstrated the link between electricity and magnetism but was quite weak.[16]

Henry wrapped the wire in calico insulation and wound tight coils around the iron. He discovered that wrapping ever-longer lengths of wire resulted in decreasing power because of impedance, or resistance. He overcame that problem by wrapping shorter segments of insulated wire parallel circuits around the iron, which he then attached to the most effective battery for the purpose. The result was a revolutionary innovation, an electromagnet capable of lifting great weight. One of his magnets, built for Benjamin Silliman of Yale, could lift a ton. At the outset of his scientific career, Henry had produced a key piece of apparatus that would enable experimenters in Europe and the United States to continue probing the mysteries of electromagnetism.[17]

The young professor had used electricity to produce magnetism. Might not magnetism produce electricity? In August 1830, Henry devised an experiment employing one of his electromagnets, an armature with a coil, and forty feet of copper wire connected to a galvanometer, which registered an electrical charge when the magnet was energized. Henry had demonstrated induction, using magnetism to generate electricity. Other than the use of batteries and solar cells, induction remains the most effective and efficient means of generating electricity.

At around the same time, or perhaps a bit later, English experimenter Michael Faraday also demonstrated induction. However, unlike Henry, Faraday had published his results. In view of Henry's virtually simultaneous discovery, though, his name is traditionally linked with Faraday's. Carrying his work beyond Faraday, Henry was the first to discover the phenomenon of self-induction, the property of a coil to oppose a change in the direction of the current flowing through it. In modern physics, a *henry* is a measure of self- or mutual inductance. Still in his midthirties and largely self-educated, Joseph Henry was internationally recognized for his fundamentally important contributions to the study of electromagnetism.[18]

The practical implications of his work did not escape him. In the summer of 1831, he sold a powerful electromagnet to a firm that employed it to separate iron

ore. More importantly, that year he built a small "philosophical toy," an electric motor producing reciprocal rather than rotary motion, pointing the way to future direct-current motors. Henry then turned his attention to the potential of his work to revolutionize communications. As early as 1824, Peter Barlow, an English experimenter, had speculated that electromagnetism could be used to send messages over distance. Applying his studies of battery design and induction, Henry used a multicell higher-voltage device to ring a bell at the end of a single insulated wire a mile and a half long.[19]

In 1832, Henry accepted a position as a professor of natural philosophy at the College of New Jersey (Princeton University after 1896). While the college could only match Henry's Albany salary, it sweetened the bargain with housing, a reduced teaching load, improved laboratory facilities, and increased prestige. The young professor continued his work in electromagnetism, constructing his largest electromagnet, capable of lifting 3,500 pounds. His experiments in communications involved stringing wires across the campus so he could send a signal from his laboratory and ring a bell in his house to let his wife know that he was heading home. He developed the first relay, essentially an electromagnetic on-off switch, in 1835.[20]

During a college-supported sabbatical visit to Europe in 1837, Henry discovered that English physicists were familiar with his name and work. He met Michael Faraday, Peter Barlow, William Sturgeon, Charles Babbage, Charles Wheatstone, and others. He attended Faraday's lecture series at the Royal Institution and conducted some serious experiments in thermoelectricity with Wheatstone, who held the chair in experimental physics at King's College. Busy as he was, Henry still found time to enjoy the usual London tourist sites with his American friends, the Baches.[21] Returning from his travels, Henry published the results of his research in a series of five articles titled "Contributions to Electricity and Magnetism," which appeared in *Transactions of the American Philosophical Society* between 1837 and 1843.[22]

While Joseph Henry helped to lay the foundation for revolutionary technologies, he had little interest in exploiting his own discoveries. He was, however, willing to assist and advise those who pursued the practical applications of recent experimental work in electromagnetism. Henry met Thomas Davenport not long after his return from Europe. A Vermont blacksmith, Davenport had bought one of the magnets that the Penfield Ironworks was using to separate ore and incorporated it into the design of a rotary electric motor. Henry approved the design, offered him advice, introduced him to acquaintances who might provide financing, and wrote a letter of support. The inventor was able to secure a patent, but his

LAYING THE FOUNDATION

work was superseded by that of Charles Grafton Page, who had also been inspired by Henry's research.[23]

Henry would have a longer and far more difficult relationship with Samuel Finley Breese Morse. A successful artist trained in Europe, the Massachusetts-born Morse attended Benjamin Silliman's lectures on electricity while a student at Yale. A shipboard discussion during a voyage home from Europe in 1832 inspired him to launch his earliest experiments in telegraphy. Facing initial disappointments, he consulted with Leonard Gale, professor of chemistry at the College of New York, who advised that he study Joseph Henry's early papers. The two met in 1837, and Henry "freely gave him [Morse] information in regard to the scientific principles which had been the subject of my investigations." Morse visited Henry at the College of New Jersey for the first time in 1839, admitting that he came as a "learner." Henry provided the details of a relay that enabled Morse to transmit a signal over longer distances.[24]

Against the advice of colleagues, Henry supported Morse's petition requesting congressional funding for an experimental long-distance telegraph line. At the same time, he made his attitude toward the telegraph clear. The inventor of such a device was due "little credit," he commented. "Science is now fully ripe for this application," he continued, adding that the invention "was one which would naturally arise in the mind of almost any person familiar with the phenomenon of electricity." In short, Henry argued that he and his colleagues had laid the scientific foundation for the achievement. Morse and other experimenters were simply applying their research to achieve a technological goal. America, Henry explained, "has produced only one Franklin to five hundred Fultons."[25]

On May 24, 1844, Morse sent the first telegraphic message from Washington to Baltimore. The quotation from Leviticus—"What hath God wrought?"—launched the telecommunications industry. Henry was stunned when, in 1845, Alfred Vail, Morse's partner and fundraiser, published *The American Electro Magnetic Telegraph: with the Reports of Congress, and a Description of All Telegraphs Known, Employing Electricity or Galvanism*. While tracing the history of relevant science, Vail emphasized Morse's work and ignored the contributions of Joseph Henry, offering only a mention of the electromagnet. Henry assumed that Morse was responsible for Vail's dismissal of his work. His sense of injury would fester for the next decade before he achieved vindication.[26]

IN ACCEPTING THE Smithsonian position, the new secretary realized he was moving away from a successful research career. He believed, however, that a man of science had a broader moral obligation to society. "When a man devotes his

whole life to a single pursuit," he explained, "he has less chance of doing anything *great* than by taking a wider range." In stepping into the new post, Henry was choosing to represent the cause of science in America. Like Richard Rush and John Quincy Adams, he was committed to realizing James Smithson's vision. "The most prominent idea in my mind," he wrote to a friend in the spring of 1847, "is that of stimulating the talent of our country to original research—in which it has been most lamentably difficient [*sic*]." The goal of the Institution, he argued, was "to produce results in the way of increasing and diffusing knowledge, which cannot be produced either at all, or so efficiently by the existing institutions in our country." Realizing that goal would not be easy.[27]

Secretary Henry faced a Board of Regents divided into three factions, each of which nursed a very different vision for the Institution. Robert Dale Owen led a group determined to construct a grand building to house a museum, library, lecture hall, and all of the other possible activities discussed to date. Rufus Choate and George Perkins Marsh headed a second faction focused on the creation of a great library. Alexander Bache feared that those expensive projects would drain the Institution's coffers and favored Henry's narrow interpretation of the purposes of the Institution as encouraging scientific research and publication as the best means of achieving Smithson's goal.[28]

Before taking office, Henry had begun developing his own plan for guiding the Smithsonian in response to a request from Bache. It would, he assured the chemist Robert Hare, contain a set of objectives that "will render the Institution of great importance to the country and the world." He rejected the broad goals of the enabling legislation in favor of an organization that would fill a gap in American intellectual life by narrowly focusing on the support, publication, and broad dissemination of quality scientific research. Should he fail to convince the regents to accept his plan, he concluded, "I shall withdraw from the office." It was an empty threat. While several university positions remained open to him, Henry would choose to accept a series of uncomfortable compromises to remain at the Smithsonian.[29]

Through 1847, he continued threatening to resign if he could not exercise a degree of control over key decisions. Henry told Asa Gray that he would depart "if money is to be squandered on brick and mortar in Washington . . . and leave to others the honor of the perversion of a noble bequest." In June, he informed Bache that he saw the possibility of opposition from the board, "which may cause me to resign." The newspapers occasionally reported that he planned to leave the Smithsonian. Owen took the possibility seriously enough to discuss with Bache the process for selecting a replacement.[30]

46

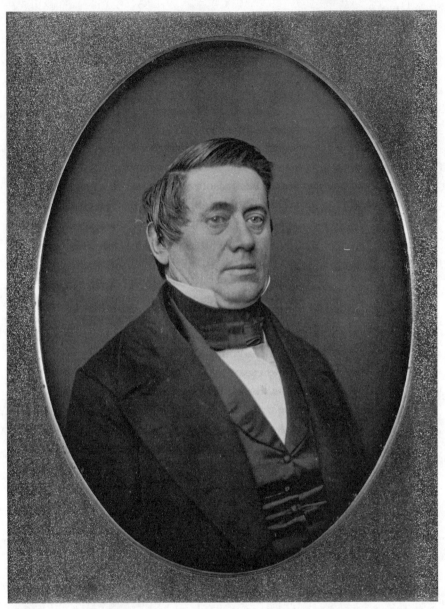

Joseph Henry (1797–1878), c. late 1840s, around the time he was appointed the first secretary of the Institution. After serving as chair of natural history at the College of New Jersey (now Princeton University) from 1832 to 1846, Henry accepted the position of secretary of the Smithsonian, which he held from 1846 to 1878. *National Museum of American History Archives Center*

Henry didn't hesitate to use rumors of his imminent departure as a bargaining chip in discussions with the regents during the month between his appointment and his first full board meeting in late January 1847.[31] The new secretary and Bache worked behind the scenes to negotiate fundamental changes in the plan of organization that Owen had presented on December 1, 1846. Both the legislation creating the Institution and Owen's plan had focused almost entirely on the diffusion of knowledge through a library, museum, lecture halls, and art gallery. There had been no mention of support for original scientific research to generate new knowledge, or the publication of the results of such research.[32]

The new secretary arrived back in Washington on Saturday, January 16, 1847, a month after accepting his post and four days before his first board meeting as secretary. He lodged at the Saint Charles Hotel, close to the Capitol, where he had a desk in Vice President Dallas's office. When the regents convened on January 20, Rufus Choate presented a modified plan of organization that Henry and Bache were willing to accept. While no record of the talks undertaken in December and early January remains, the effect of those discussions was apparent in the revised plan. It opened with a resolution noting that "it is expedient and demanded by the will of the testator, that in our plan of organization the increase of knowledge by original research should form an essential feature." In addition, the revised plan offered the assurance that new research would be published "in transactions of the Institution to be entitled Smithsonian Contributions to Knowledge."[33]

Other features of Choate's revised plan included the concessions that the secretary accepted as the price for inserting his priorities at the head of the document. The Institution was to be organized in two divisions. One would be responsible for building a great library, a lecture hall, a museum displaying government collections, and a gallery filled with examples of "elegant art." The other division would pursue research and publication. Once the building was complete, the annual budget was to be split, with $15,000 going to the library, art gallery, and museum and $15,910 funding research, publications, and lectures. This arrangement was far from what Henry had in mind, but as the library and museum were specifically mentioned in the legislation, to have ignored those aspects of the proposed institution would have required returning to Congress, which only narrowly passed the Smithsonian bill.[34]

As part of the price of obtaining his position, Henry had bowed to the will of Choate and Marsh and accepted Charles Coffin Jewett as assistant secretary for the library. A founder of the library profession in America, Jewett was as distinguished in his field as Henry was in his. A graduate of both Brown and Andover Theological Seminary, he had served as university librarian at Brown, during which time

he developed a printed catalog of the holdings. In 1843, he embarked on a European tour, buying books for the university and studying the procedures in place at the British Library. Returning to Brown, he was appointed head librarian and professor of modern languages. With a noteworthy lack of enthusiasm, the secretary nominated him on January 26.[35]

Jewett's vision for the Smithsonian was as grand as Henry's. He saw the Institution as an opportunity to create "a great national library" that would enable him "to carry out what he understood to be the expressed wish of Congress in regard to the expenditure of the Smithsonian funds." Clearly, some congressmen had intended the primary function of the Institution to be a grand research library for the nation. Section 10 of the enabling legislation required that "the author or proprietor of any book, map, chart, musical composition, print, cut, or engraving, for which a copyright shall be secured . . . should present a copy of that work to both the Library of Congress and the Smithsonian." It was as though Congress was seeing which organization would earn the status of a national library.[36]

When the Smithsonian was created in the summer of 1846, the Library of Congress had reached, as librarian and historian David C. Mearns explains, "a new and strange and unpleasant level of despair." The library consisted of fifty-five thousand books managed by an inadequate staff housed in a cramped space in the Capitol. Senator James A. Pearce, a Southern sympathizer from Maryland who chaired the joint congressional oversight committee for the library, was determined to maintain the political neutrality of his charge, refusing to allow the acquisition of books by Harriet Beecher Stowe, Henry David Thoreau, Frederick Douglass, or anyone else whose work would excite partisan sentiment. Furthermore, over half of the collection burned in a fire in 1851, including two-thirds of Thomas Jefferson's books, which had been the seedbed for a rebuilt library after the British burned the Capitol in 1814.[37]

During his eight years at the Smithsonian, Jewett spent substantial sums on book purchases and aggressively developed a cataloging initiative that would lay the foundation for the more efficient operation of all American libraries. While Henry was pleased to see his colleague take a national leadership role in the field, he was deeply disturbed by the rising expenditures for books and by his impression that some members of the board seemed to regard Jewett as his equal rather than his subordinate. An internal tension developed from their disparate visions of the Smithsonian. Matters would come to a head in 1855, in the first of the great controversies that would shape the future of the Institution.[38]

Henry's immediate concern, however, was that the construction of a building far too large for the narrowly focused activities he had in mind would consume the

entire bequest. It was certainly clear that Owen and members of the Building Committee were convinced that a spectacular building was the key to the Smithsonian's success. "I fear . . . nothing but a large building immediately erected will satisfy the Washingtonians," Henry wrote to his wife, Harriet, on January 26. First, the board would have to deal with what the secretary described as "a tempest among the architects."[39]

The Building Committee urged the board to approve the selection of the medieval Norman design offered by James Renwick Jr., reflecting David Owen's floor plan and amended and reduced from three stories to two as a cost-saving measure. A "premium" of $250 would go to the other architects who had submitted proposals: Joseph Wells, David Arnot, John Norman, John Haviland, and Owen Warren. When the disappointed competitors complained that the process had been unfair and agreed to reduce their estimated construction costs, Mayor Seaton offered a resolution inviting six architects, including Renwick, to present their designs to the board in two groups on January 21 and 22. The board was not moved by the presentations. Clearly, the committee had been wedded to the Renwick plan before even considering the other proposals.[40]

Meeting in Chancellor Dallas's offices in the Capitol on the evening of January 27, however, Bache and Henry reached yet another compromise with the Building Committee on funding the construction of Renwick's "Castle." The interest accumulated on the bequest to date ($242,129) would be reinvested, and that sum's interest would be used to pay construction costs. The construction of the building would be spread over five years, with roughly one-fifth of the total cost funded each year. Some $15,000 would be drawn annually from the 6 percent interest on the bequest and added to the interest on the building fund. At the end of the project, the funds remaining in the building fund would be added to the principal of the bequest.[41]

As part of the compromise, Renwick's design was selected, although he was not officially named superintendent of the building project for another month. While the compromise was not everything Henry had hoped for, he was satisfied. "I have kept myself quite cool and, though difficulties innumerable have beset my path," he reported to Harriet, "yet all things have gone as well as I could have hoped."[42]

Even with the agreement in place, the secretary had not given up hope of drastically reducing the size of the building. "I have met with the Building Committee this morning," he wrote to his wife on March 15, "and I find them much modified in their views." Owen, he was now convinced, was "quite willing to give up his fantasy of the building." Henry had badly misread the situation. The

50

members of the committee received sixteen bids for construction of the building on March 18 and were authorized to sign a contract with a local firm, James Dixon and Company, the low bidder with a price of $205,250. At least Bache and Henry managed to insert an addendum that would allow the secretary, through the board, to alter the plans during construction at prorated costs.[43]

AT THE CONCLUSION OF THE January 1847 meeting, the board instructed the secretary to have five thousand copies of the Report of the Organization Committee of the Smithsonian Institution printed and distributed to "each of the principal Scientific and Literary Societies, both in this and other countries." He was also to supply ten copies to each representative and senator, who were to be "respectively requested to transmit these to newspapers and individuals, in his district or elsewhere, who may be likely to take an interest in the proceedings of the Institution." The report, authored or at least overseen by Rufus Choate, included some of Henry's language relating to research and publication, the text of Smithson's will (almost certainly Henry's suggestion), and the authorizing legislation. Interested readers would have had a difficult time making much sense of the thirty rambling pages, however.[44]

As part of the January compromise, the board passed a resolution proposed by Bache instructing the secretary to present to the organization committee a plan for research and publication after communicating with men "eminent in science and literature" as to appropriate areas of research for the Institution. Henry took command of the process, developing a fresh set of objectives for the Institution that would sweep the much-publicized Choate plan aside.[45]

Henry's vision for the Institution was firmly rooted in his view of James Smithson's intent. He used the founder's words to narrow the focus of the Institution. Surely, he argued, a man who had devoted so much of his time and effort to the pursuit of science and the publication of his findings intended the Institution to focus on the encouragement of research and publication of the results. When someone remarked, "Congress has enacted laws in regard to the Institution which must be obeyed," Henry responded that "the resolutions of Congress may be changed, but the will of a dead man should be inviolate."[46]

He spent most of 1847 commuting between Princeton and Washington. When in the capital, he lodged at the National Hotel and worked in a small, borrowed room in the Patent Office. While the process of managing the production of the all-important first volume of Smithsonian Contributions to Knowledge consumed much of his time through the spring and summer, Henry put a high priority on preparing a first draft of his Programme of Organization for the Smithsonian

Institution. He shared his early thoughts with John Quincy Adams on May 5 during their only meeting. The two "conversed in a very edifying manner upon the proposed management of the Institution," Adams noted in his diary.[47]

Henry sent a handwritten first draft of his document to the English astronomer and explorer Edward Sabine in August, and a four-page printed copy to Adams on October 13. Adams's response has not survived, although a skeptical diary entry for October 16 notes that "this Mr. Joseph Henry has been appointed Secretary, but . . . has a different plan of organization which is evidently sliding into a job." It is noteworthy, however, that among the alterations the secretary made to the final document was the reduction of the suggested number of employees to be immediately hired from three—secretary, librarian, and naturalist—to two, the naturalist not being required until space for the museum was available.[48]

Having circulated his program to "a number of persons in whose knowledge and judgement I have confidence," Henry presented the document to the board on December 8, 1847. The secretary prefaced the plan with thirteen principles drawn from the will of James Smithson, which would provide the foundation for the operations of the Institution. Those fundamental points can be summarized in a single sentence: the principal object of the Smithsonian was to increase knowledge through the promotion of research in a variety of fields and its diffusion through publication in ways that were not duplicated by any other American organization. Having established objectives and guidelines, Henry added a fourteenth guiding principle, admitting that "regard must be had to certain requirements of the act of Congress establishing the Institution. These are a library, a museum, and a gallery of art, with a building on a liberal scale to contain them."[49]

In his report to the regents, Henry's four-page preliminary document grew to seventeen pages. The document was divided into three sections, the first dealing with the goals of the Institution, the second describing the organization through which those goals were to be achieved, and the third providing greater detail. The plan suggested ways to stimulate research, including financial awards and the promise of publication in a prestigious series, Smithsonian Contributions to Knowledge. Those volumes would be distributed to libraries and learned institutions around the globe in exchange for their scholarly publications.[50]

The secretary identified several areas of research that seemed particularly appropriate for the Institution. Meteorology, for example, could contribute to "solving the problem of American storms," while the support of exploration and descriptive studies of natural history and geology as well as topographic and magnetic surveys could result in a "physical atlas" of the United States. Experiments in physics and chemistry were recommended, and historical, literary, and statistical

studies were possibilities. Ethnographic research would aid in understanding the languages and cultures of Native Americans still living on the land, while a survey of the mysterious mounds dotting the Mississippi Valley would answer questions regarding ancient Americans.

Having described how research in a wide range of fields could be encouraged and diffused, the secretary turned his attention to administration in the second section of his document. He accepted the regents' decision to create two divisions of the Institution, one to manage research and publications and the other to supervise the library, museum, and public functions. He listed projects that the library might undertake and thoughts on the natural history collections, suggesting that the secretary may have discussed these issues with Charles Jewett. Henry must certainly have recognized that such consultation would be required to create a document acceptable to factions of the regents. The final ten pages of the report, titled Explorations and Illustrations of the Programme, were devoted to an extended explanation and justification of the plan.[51]

With little apparent discussion, the regents offered provisional approval of the document on December 13, on a motion by Alexander Bache. "The programme was provisionally adopted in full with a few unimportant additions and corrections made by the committee on organization to whom the article had to be submitted," a jubilant Henry reported to Asa Gray. He also admitted that prior to the meeting, Bache and George Hilliard were the only regents with whom he had shared the document, and that he had taken his plan directly to the board without having gone through the organization committee, as instructed. Despite this, he had assessed the Owen and Choate factions so well that he was able to craft an acceptable compromise. It also seems likely that he discussed the plan in detail with Jewett, who might have shared it with his supporters on the board.[52]

Historian Wilcomb Washburn, in his masterful account of Henry's leadership, remarked that "every decision during his tenure as Secretary of the Smithsonian Institution, from 1846 to 1878, was governed by his famous 'Programme.'" The plan would indeed guide the Institution into the future using Henry's objectives, but it is important to recognize that, from the outset, the evolving document also represented the compromises that enabled him to continue in office. His ability to negotiate and success in maintaining the confidence of the Board of Regents enabled him to survive and ensured that, while his own goals would remain in place, the Institution would be able to grow beyond his relatively narrow objectives.

The document began reversing the direction proposed by the regents' organizing committee the year before. It enabled Henry to begin moving the

Institution in his desired direction. It underscored the importance of original research and publication and relegated those aspects that he was less than enthusiastic about to the end of the document. The secretary would bide his time. Seven years later, in a much stronger position, he was able to force a radical change regarding the library, at which point he would modify his program to bring it more fully in line with his views. That final version, completely accepted by the Board of Regents, would be printed in every Smithsonian Annual Report from 1855 to the time of Henry's death in 1878.

CONSIDERING HIS LESS-THAN-ENTHUSIASTIC attitude toward the building, the secretary wondered if the Building Committee might prefer that he not attend the Smithsonian's first great public event, the ceremonial laying of the cornerstone on May 1, 1847. That, at least, is the rumor that Alfred Vail shared with Samuel Morse. As Henry explained to his wife, however, Vice President Dallas, the chancellor of the Institution, "expected me," adding, "[if] I had not come there would have been . . . dissatisfaction."[53]

Since 1793, when George Washington and eight other Freemasons laid the cornerstone of the US Capitol, members of the Masonic order had been front and center in ceremonies as new buildings rose in the federal city. At 9:00 a.m. on May 1, 1847, members of the Grand Lodge of the District of Columbia and eight other Washington lodges gathered at the Masonic Hall on the corner of E and Tenth Streets. They were joined by two lodges from Alexandria, Virginia, and representatives of the Grand Lodges of Virginia, Maryland, and Pennsylvania, who arrived by train. The conferees of nineteen local lodges of the Independent Order of Odd Fellows arranged themselves behind the Masons.[54]

It was, the *Daily National Intelligencer* reported, "a day of public rejoicing." Government offices and many businesses were closed for the day, and a crowd that would follow the official procession was already gathering. Volunteer militia companies were on hand in full uniform. The Marine Band, Mr. Massoletti's newly formed National Brass Band, and Garcia's Band from Alexandria provided the musical accompaniment for the proceedings.

At 11:00 a.m., Marshall-in-Chief William Beverly Randolph of the Virginia Randolphs, wearing a white scarf and blue rosette, turned his horse toward the President's House (as the White House was known at the time), followed by Vice President Dallas, Joseph Henry, members of the Board of Regents, and a procession that was now fully a mile long. At the President's House, President Polk, members of his cabinet, and officials and representatives of the diplomatic corps took their places behind Randolph. The column then moved east down Pennsylvania

Avenue, turned south on Twelfth Street and on to the Mall, where a large, elevated platform decorated with evergreen boughs and festooned with flowers stood on the building site.[55]

In addition to his congressional and Smithsonian duties, B. B. French, grand master of Washington's Masonic fraternity, presided over the morning's ceremony wearing the Masonic apron that President Washington had worn while officiating the laying of the US Capitol cornerstone. Following introductions and prayers, French proceeded with the ritual required for the occasion. The Smithsonian cornerstone was hollow and contained fifteen items, including a Bible; copies of the Declaration of Independence and the Constitution; three engraved plates from the regents, the House of Representatives, and the Senate; and a variety of reports and local newspapers. In his letter to Morse, Vail reported that a copy of his own history of the telegraph was to have been included, but that Henry removed it before the stone was sealed.[56]

Vice President Dallas, in his role as Smithsonian chancellor, closed the ceremony with a half-hour oration extolling the purposes of the Institution and the wonders of the building that would rise on the spot. Henry, seated behind Dallas, provided Harriet with a favorable report of the talk, adding that "had I seen him a litler [sic] earlier, I could have given him a few hints which might have modified some points."[57]

THE BUILDERS RESPONSIBLE for the first generation of Washington public buildings, including the Capitol, President's House, the Treasury, and Patent Office, had chosen a light-colored sandstone from quarries near Aquia Creek in Stafford County, Virginia, on the lower Potomac. However, the best bid to supply building materials for the Smithsonian project came from John Parke Custis Peter, the great-grandson of Martha Washington, who owned a series of sandstone quarries near Seneca, Maryland, some twenty-five miles west of Washington. When Renwick, Robert Dale Owen, and David Owen inspected the Seneca quarries in early March, they found a mile-long series of sandstone cliffs towering over the Potomac shore producing stone in a variety of shades. Renwick and the Owen brothers favored sandstone from an area of the cliffs known as the Buckeye Quarry, which produced a dark crimson stone of the sort that was, the architect noted, "highly esteemed by the architects of the middle ages."[58]

The quarrying process would have been familiar to Michelangelo. Three men would pound drills into the top section of rock, then break a block loose with wedges. The individual blocks were roughly shaped with hammers and chisels at the base of the cliff, then moved to an on-site, water-powered mill where the stone

was cut to size and finished. While it is unclear whether slaves worked in constructing the building on the Mall, they were certainly employed at the quarry. Gilbert Cameron, who was responsible for obtaining the stone as well as overseeing work on the Castle, seems to have rented workmen from Peter, including some slaves.[59]

The Chesapeake and Ohio (C&O) Canal, a 184½-mile-long waterway paralleling the Potomac River from Cumberland, Maryland, to Georgetown, DC, was essential to the operation of the Seneca Quarry. Large cranes, fitted with pulleys at the top and securely guyed, lifted the blocks from the base of the quarry wall and moved them to the mill, then onto a canal boat. The first load of stone blocks for the Smithsonian project left the quarry on *Scow No. 1* and passed through Georgetown on June 1, 1847. The boat then entered the Washington Branch of the C&O Canal, a tidal channel a little over a mile long built in 1833 to connect the C&O Canal to the Washington City Canal. Cameron had narrow-gauge rails laid from the latter across the Mall to move the stone blocks to the building site.[60]

Interest in the Smithsonian's construction project was high. By mid-May, a large model of the building was on display at Mr. Lee's Picture Gallery, just west of John Gadsby's National Hotel on Pennsylvania Avenue at Sixth Street. In early August, newspapers were reporting that the stonework on the east wing, where construction had begun, had reached the top of the basement story. When a flood closed the C&O Canal that October, twelve to fifteen thousand feet of stone remained at the quarry, ready for transport. As the canal was closed in winter, Cameron did his best to stockpile enough stone at the construction site to carry him through to spring.[61]

Despite the difficulties, the exterior of the east wing and range was complete by the end of 1847. While interior work was underway, the walls of the west wing and west range were rising by August 1848, along with the foundation of the massive central structure. There were problems, perhaps results of the rapid progress. In June 1848, twenty local contractors complained to Congress that shoddy materials were being incorporated into the structure, which, they predicted, would result in "a tottering, rotten dilapidated Wreck, a disgrace to the age." Indeed, on February 26, 1850, a section of the interior framing and floors of the main building collapsed into the basement, killing an Irish workman. A report pointed to the use of lower-grade wood and other materials in the interior as the cause of the collapse. Henry dismissed Renwick as supervising architect in 1852. Captain Barton S. Alexander of the United States Army Corps of Engineers would oversee completion of the project using iron and brick, apart from the existing wooden roof frame, which remained as a cost-saving measure.[62]

The exterior of the Castle and the interiors of the two wings were complete by the end of 1851. The Building Committee reported that visitors to Washington judged it "a very beautiful edifice." In 1851, Henry finally moved from his cramped temporary quarters at the Patent Office to an office in the east range, which he shared "with three persons, sometimes more . . . and [was] subjected . . . to interruption, from visitors and calls of business." He was delighted to move into the top-story room of the south tower, immediately above the Regents' Room, in the fall of 1852. He would eventually have an office in the north tower.[63]

HENRY WAS DEEPLY INVOLVED in board politics in the spring of 1848. The retirement or death of regents led to the appointment of Representative George Marsh, a friend of Jewett and a library enthusiast, and Senator Jefferson Davis, a close friend of Bache who would become one of the secretary's strongest supporters. Representative Robert Dale Owen, who had missed the December meeting while electioneering in Indiana, had been defeated. Henry worked hard to ensure that Owen would not be appointed as a public member of the board. Horace Greeley, publisher of the *New York Daily Tribune*, applauded, commenting that Owen's reappointment in that fashion would have reduced the board to a "hospital for destitute politicians."[64]

Owen had played a critical role in the early history of the Smithsonian. As a member of the House, he had drafted the legislative foundation, then succeeded in urging the Senate into last-minute action to create the Institution. As a member of the Board of Regents, he convinced his colleagues to accept his plan for a large and impressive building, selected the architect, managed the funding process, and remained on the board until construction had reached the point where the project could no longer be stopped or its size reduced.

Owen won a final concession. In February 1847, David Arnot—one of the dissatisfied, unsuccessful architectural competitors for the Smithsonian contract—published a pamphlet complaining about the bidding process. Bache suggested that the Building Committee publish a book defending their decision and Renwick's approach, illustrated by his architectural designs. That month, the board approved $1,000 to publish one thousand copies of such a volume. Robert Owen wrote the text for *Hints on Public Architecture*. In magisterial terms, he explained and justified the decision behind the design of the Smithsonian building. Form should follow function, and the medieval style, reminiscent of Oxford, Cambridge, and European universities, was preferable to the classicism that had dominated earlier public architecture in the capital. He concluded the book by suggesting to others responsible for the design of public buildings in the United States that the

look of the edifice rising on the Mall "shall deserve to be named as a National Style of Architecture for America."[65]

Henry mildly disapproved, arguing that the publication would set a bad precedent. "My own conviction," he wrote to Charles Jewett, "is that nothing should be published with anything like an official sanction excep [sic] it has gone through a regular course of inspection and approval by competent judges." The secretary's opinion notwithstanding, Owen's book was published by the George Putnam Company in 1848, with the first Institutional seal on the title page. It was the last time Robert Owen would have his way at the Smithsonian. The secretary was already pursuing the plan outlined in his program, including a project to marshal volunteers across the nation in the service of American science, and arranging for the publication of the first volume of the Smithsonian Contributions to Knowledge, which would set the standard for the solid results of research worthy of the Smithsonian imprimatur. The work of the Institution was underway at last.[66]

CHAPTER 4

SHAPING AN INSTITUTION

ON WEDNESDAY, MARCH 24, 1847, Ephraim George Squier, editor of the *Scioto Gazette* of Chillicothe, Ohio, wrote to Secretary Henry explaining that, for the past two years, he and a local physician, Dr. Edwin Hamilton Davis, had been "pretty actively engaged . . . in investigating the ancient remains of the . . . Ohio Valley." Henry was already aware of their project; he had read an account of this effort to survey and map the scores of earthen mounds dotting the midwestern landscape in the September 1846 issue of the *American Journal of Science and Arts*. George Marsh, one of the most influential members of the Board of Regents, had met and been much impressed by Squier and urged Henry to take an interest in the mound research.[1]

The secretary responded to Squier on April 3, noting that "it would give me much pleasure to publish an account of them in the first number of the Smithsonian Contributions to Knowledge." Henry realized that his decision to publish a manuscript on archaeology, rather than something closer to his own field, would puzzle some colleagues. He was anxious, however, to demonstrate the breadth of the Smithsonian's interests. Anthropology occupied "a kind of ground between literature and science," he reasoned, "on which men of letters and the investigators of nature may meet with mutual interest."[2]

Beyond that, he recognized that a study of the mysterious earthworks scattered throughout the Ohio and Mississippi Valleys detailing clues as to their age and the identity of their builders would occasion considerable debate in both professional and popular circles. If carefully presented, the Squier and Davis manuscript was sure to attract wide interest and favorable comment, something he wanted to achieve with the first Smithsonian publication.

European colonists had arrived from an "old world" with storied histories in which medieval castles, cathedrals, Roman walls, and prehistoric hill forts and barrows were familiar landmarks. They regarded America as a "new world," a

blank canvas whose inhabitants left few marks on the landscape. Spanish conquistadors had taken note of the large temple mounds in the Southeast, and Thomas Jefferson had gone so far as to excavate a single mound along the Rivanna River, near Monticello. When pioneers began to push west, however, they discovered, dotted along the great river valleys draining the center of the nation, the rich variety of conical mounds, geometric embankments, animal effigies, and occasional clusters of earthworks so dense that they could only be described as "cities."

While Jefferson and others assumed the earthworks to be the work of the ancestors of Indigenous people, others, as Samuel Haven reported in his Smithsonian publication *Archaeology of the United States* (1856), insisted that such "proofs of skill and refinement" could only have been the work of "a superior native race, or more probably a people of foreign and higher civilization, [that] once occupied the soil."[3] Surely the "primitive" people whom the Europeans encountered were incapable of designing the impressive geometric earthen structures found in the Ohio Valley. Caleb Atwater, an early student of the mounds, suggested that the location of the structures near (perhaps sacred) rivers indicated that the ancient builders were "Hindoos." Others argued that they were the work of one or another of the far-farers of medieval legend— Henry Sinclair, the Scottish Earl of Orkney; Brendan, the Irish saint; or Madog ab Owain Gwynedd, the Welsh prince. The Lost Tribes of Israel were favored candidates, as were the survivors of Atlantis. Then there were the Nephites, Lamanites, Jaredites, and Mulekites, Near Eastern emigrants whose stories were recorded on the golden plates of the Book of Mormon.[4]

Henry was firmly opposed to all such wild speculations. He saw the work of Squier and Davis as an opportunity for the Smithsonian to replace the myths and romantic guesswork surrounding the mounds with solid research. He insisted that their upcoming volume, *Ancient Monuments of the Mississippi Valley*, provide a firm foundation of information, precise measurements of earthworks, and accurate descriptions of artifacts and skeletal remains found buried in the mounds, richly illustrated with maps and engravings of the mounds and artifacts.[5]

Conscious that he would set a precedent with this first official Smithsonian publication, the secretary established a careful peer review process. He sent the manuscript to Albert Gallatin, president of the American Ethnological Society, on June 2, 1847, requesting that the members of the organization read and comment on the work. Gallatin, who had served in the Senate (1793–94), in the House (1795–1801), and as fourth secretary of the US Treasury (1801–14), US minister to France (1816–23), and US minister to the United Kingdom (1826–27), was a pioneering

student of Native American culture. The author of two foundational books on the subject, he had cofounded the American Ethnological Society in 1842 and served as its first president.[6]

Gallatin responded ten days later, commending Squier and Davis on their "thorough love of truth which renders their researches worthy of entire confidence," and enclosing the report of a five-man committee of the organization appointed to consider the manuscript, which agreed that the "work is worthy of the subject and highly creditable to the authors." George Marsh sent the secretary a separate note affirming that the "Smithsonian Institution could not begin with a more creditable essay." Henry was delighted with such solid endorsements from specialists in the field.[7]

He also wanted to ensure that everyone who had contributed to the manuscript receive appropriate credit. In producing their comprehensive report, Squier and Davis had supplemented their surveys of the mounds with the work of others in the field, some of whom complained that they had not received sufficient acknowledgment in a prior article. Worse, Davis expressed resentment that Squier, who had written most of the manuscript, was receiving the major credit for their joint project. He noted that the resolution of support for the publication offered by the American Ethnological Society credited Squier as the author and ignored Davis. Referring to Squier, Davis commented to Henry that he had "almost come to the conclusion that impudence and perseverance will accomplish most things." The breach would not be healed. The two men exchanged letters in the fall of 1847 and ended the historic partnership that had established a baseline for American archaeology.[8]

Henry had conducted the negotiations leading to publication with Squier and had used his considerable influence to persuade the trustees of Princeton to grant the author of the manuscript an honorary doctorate. Now the secretary had to postpone publication while assuring himself that proper acknowledgments were in place. Determined to manage every detail of the process, he peppered Squier with questions and demands about deadlines and financial matters.[9]

Squier shared his frustration with others, complaining that the secretary was "altogether the reverse of a business man, and of what the Sect. of the Smithsonian Inst. Should be." Gallatin remarked to Marsh that while Henry was "a first-rate man in his line," he was "not at all a man of business." Gallatin complained that he had advanced $170 to support the engravings for the finished book, which Henry promised to repay. "More than twelve months have elapsed since that time," Gallatin complained to Marsh, "and . . . we have not yet been paid." Marsh repeatedly "begged" the secretary to reimburse Gallatin, without apparent result.[10]

While Marsh was closely identified with the library faction of the board, Henry regarded him as "one of his most trustworthy & judicious advisors." Marsh, on the other hand, shared Gallatin's opinion of the secretary's managerial shortcomings. "In all matters of business," he confided in a letter to historian and linguist John Russell Bartlett, a fellow member of the American Ethnological Society, "Professor H. is as imbecile a person as I ever met & a man more utterly unfit for his place as I ever met."[11]

Despite the controversies, *Ancient Monuments of the Mississippi Valley* was published in September 1848. Although disputes regarding the distribution of credit would continue for several years, the publication drew high praise. In his review for the *Proceedings of the American Philosophical Society*, the Swiss naturalist Adolph von Morlot applauded the book for being "as glorious a monument of American science, as Bunker's Hill is of American bravery," noting that "the work of Mr. Squier [Dr. Davis went unmentioned] constitutes the most valuable contribution ever made to the archeology and ethnology of America." A reviewer for the *Literary World* echoed other American periodicals when it congratulated the Smithsonian regents for having "secured the work in question, for none could have been more appropriate."[12]

Henry's choice of a groundbreaking study of American prehistory was the first step in establishing the Institution as the leader in an emerging field of great interest to the public. The physical sciences, with their requirement for laboratories and expensive equipment, would find a home in American universities and in the industrial laboratories of the future. Anthropology, ethnology, and archaeology relied on fieldwork and collections, a natural fit for the Smithsonian.

Building on his initial success, Henry included Squier's article on the "Aboriginal Monuments of the State of New York" in the second volume of Smithsonian Contributions to Knowledge. I. Allen Lapham's study on the antiquities of Wisconsin followed in 1855, and Samuel Haven's *Archaeology of the United States* the following year. The secretary insisted that authors of ethnological and archaeological papers for the Smithsonian make precision their watchword. He reminded Lapham, "We are as yet only collecting the bricks of the temple of American antiquities, which are hereafter to be arranged in a durable edifice; it is therefore of the first importance that our materials be of the proper kind."[13]

Henry published pioneering works in North American philology as well. In 1851, the secretary asked William Wadden Turner, an English-born student of languages at Union Theological Seminary, why the Smithsonian should consider publishing missionary Stephen Riggs's *Grammar and Dictionary of the Dakota Language*. Such a study, Turner responded, was a window into the thought processes of

the speakers, "offering new and curious phases of the human mind." The book appeared as a Contribution to Knowledge the following year.[14]

Sixteen of the thirty-five volumes published in the series by 1916, when the original Smithsonian Contributions to Knowledge came to an end, dealt entirely or in part with anthropology. One of those volumes, Lewis H. Morgan's *Systems of Consanguinity and Affinity of the Human Family*, is generally regarded as a foundational work in the history of anthropology and exercised a profound impact on Karl Marx's view of historical materialism. Under Henry's leadership and that of the secretaries who followed him, the Institution became a national center for the study of the past and present of Native American peoples.[15]

Publication of *Ancient Monuments of the Mississippi Valley* and other works on American archaeology and ethnology proved less persuasive than the secretary had hoped, however. His friend Henry Rowe Schoolcraft, an ethnologist, suggested that an incised tablet from the Grave Creek Mound was evidence that the ancient Celts had reached western Virginia. A set of "Holy Stones" said to have been found in an Ohio mound included a portrait of Moses, while a ten-foot-tall stone figure unearthed in a Cardiff, New York, farmyard was touted as a petrified representative of a prehistoric race.[16]

In 1882, thirty-four years after the publication of *Ancient Monuments of the Mississippi Valley*, the Smithsonian's Bureau of Ethnology established the Mound Survey Project with a $5,000 congressional appropriation. Under the command of Cyrus Thomas, Smithsonian archaeologists undertook excavations that would finally demonstrate that the mound builders of ancient America were not emigrants from Europe or the Middle East. Unconvinced, officials of the Davenport Academy of Natural Sciences continued to defend the authenticity of several platform pipes in the shape of elephants and tablets engraved in what must surely have been the language of a vanished race. The dream of establishing old-world roots for new-world civilizations proved difficult to extinguish.[17]

HENRY REALIZED THAT THE simple fact of publication did not fully satisfy the admonition to diffuse knowledge. "The worth and importance of the Institution are not to be estimated by what it accumulates within the walls of its building," the secretary explained in 1851, "but by what it sends forth into the world." From the outset, the secretary regarded the exchange of publications as a central element of his plan for the Smithsonian. It was to be the means of connecting the Institution with the international scientific community while simultaneously drawing the varied scientific threads represented by local colleges, libraries, and "learned societies" into the Smithsonian fold.[18]

Henry did not invent the notion of publications exchange. For almost half a century, the American Philosophical Society and the American Academy of Arts and Sciences had been involved in small-scale exchanges of their publications with several European scientific societies. In addition to cooperating with that project, Congress instructed the librarian of Congress to exchange copies of important government documents with the French minister of justice in return for similar French documents.[19]

Secretary Henry intended to replace those early, scattered efforts with a comprehensive Smithsonian exchange program initially focused on Smithsonian publications. In 1850, building on his European contacts and those forged by the Library of Congress, he launched the Institutional program by distributing 173 copies of *Ancient Monuments of the Mississippi Valley* to institutions in twenty-six nations, in cities as distant as Constantinople and Caracas. "In addition," Henry noted, "the volume was liberally distributed to numerous institutions throughout our own country." In return, the Smithsonian received 878 volumes, pamphlets, and tracts from abroad.[20]

As a result of the first exchange, Henry discovered that the process of transmitting books through customs was costly and time-consuming. Informed of the problem, the Congress appropriated $2,000 to cover the costs of the exchange program in 1851 and agreed to waive fees and duties for publications coming from abroad addressed to the Smithsonian.[21] The British minister to the United States agreed that Smithsonian packages addressed to the Royal Society would be admitted duty-free. The Royal Society agreed to handle the distribution of books coming from the Smithsonian to other international organizations that were part of its own exchange network at no charge. Finally, the secretary negotiated agreements with shipping firms to provide free or reduced-cost transportation for books and documents sent from or bound for the Smithsonian Institution. By the end of 1852, Henry reported that the Institution had received 4,744 publications through the exchange program, which "in many cases consist of entire sets of transactions . . . of use in carrying out the various investigations of the Institution, and of value to the country as works of reference."[22] Henry issued a circular in 1853 informing American educational institutions, museums, and scientific organizations that the Smithsonian would undertake the international exchange of their publications. Within a year, the secretary reported that "the number of societies availing themselves of the facilities thus offered has largely increased, including among others, nearly all of the State agricultural societies."[23]

Between 1851 and 1881, shipments of books and other exchange materials going abroad increased from 40 boxes weighing 6,900 pounds to 407 boxes

SHAPING AN INSTITUTION

weighing 100,750 pounds. By 1881, three years after Henry's death, the Smithsonian was distributing its own and other American publications to fifty-four nations around the world. In exchange, the Institution received 165,631 books, pamphlets, maps, and engravings during that period, and distributed 94,765 packages of material to thousands of local libraries, government agencies, and local organizations in forty-seven states and territories. The effort that had begun with the distribution of the first Smithsonian publication had spread the name of the Institution across the nation and around the globe and become one of its major contributions to the national and international scientific community.[24]

WHILE STRUGGLING TO MANAGE THE Smithsonian's first scholarly publication and working to establish a comprehensive publication exchange system, Secretary Henry was also launching the Institution's first long-range research project. On December 18, 1847, just five days after the regents had given provisional approval to his Programme of Organization for the Smithsonian, Joseph Henry responded to a letter from minister Tryon Edwards who suggested that the Institution gather weather information from across the nation "for the comparison of climates." Henry assured him that "while the details of the plans have not yet been fully settled," the Smithsonian intended to "establish several observers in each state of the Union, and to ask the cooperation of the British government, so that simultaneous observations must be made from the Gulf of Mexico, to the region of the Arctic Circle." They would begin simply, he explained, collecting information on weather conditions, air temperature, and wind direction.[25]

Henry's interest in meteorology dated to his years at the Albany Academy, where he participated in a program to collect and analyze weather data from across the state. As secretary, he recognized that such a research program conducted on a national level offered a strategic opportunity for the Smithsonian to demonstrate the practical value of science without employing a large staff. As a result of free public education and widespread libraries in the United States, he realized, "there exists a greater diffusion of elementary scientific knowledge, and . . . more activity of mind directed in the line of scientific thought" than in other nations. Henry would harness that pool of knowledgeable "citizen scientists" to forward information on local weather conditions to the Smithsonian, enabling him to present a picture of weather across the nation.[26]

This initial experiment in the democratization of science would have profound consequences for the future of the Institution and for the role of science in American life. In devising a relatively inexpensive means of gathering information on changing weather patterns, Henry was broadening the definition of the scientific

community, demonstrating that there was an important national role for ordinary men and women with an interest in science. In the process of inviting citizen participation in a continent-wide meteorological effort, the secretary was encouraging an interest in science at the local level, providing an incentive for the organization of local scientific societies and building interest and support for the Smithsonian.[27]

The secretary began the meteorological project by employing small sums of Institutional funds to leverage a floundering government program. As early as 1842, James Espy, who was serving as meteorologist to both the Department of War and the Department of the Navy, suggested to John Quincy Adams that the proposed Smithsonian Institution pursue climate research. Espy was struggling to maintain a small network of military weather observers with inadequate resources. In preparing the Institution's first annual report, Henry included a long essay on meteorology by Elias Loomis, a professor of mathematics and natural philosophy at Ohio's Western Reserve College, and a letter from Espy in which he once again expressed his hope that the Smithsonian would undertake a national program for the collection of weather data.[28]

In 1847, the secretary of the navy ordered Espy to cooperate with Henry. Soon after, the regents approved the expenditure of $1,000 to launch the effort. Henry and Espy prepared a recruiting circular for distribution to local universities, museums, and scientific societies. Over the winter of 1848–49, members of Congress distributed the document to interested people in their districts, and by February 1849, Espy's corps of 143 correspondents increased to 412 in the Smithsonian network of meteorological volunteers.[29] As the program grew, Henry continued to contribute a small but critically important research fund to supplement the government meteorology program, creating a larger and far more effective network.

The secretary established three categories of observers. The first could do little more than report what they saw outside their windows. The second group was equipped with at least a thermometer and wind vane, while the third, military veterans of Espy's operation, were equipped with a suite of instruments. Henry spent the small Smithsonian fund to dispatch six sets of instruments—a barometer, thermometer, hydrometer, wind vane, and snow and rain gauge—to volunteers in California, Oregon, New Mexico, and Colorado.[30]

While much of the weather reporting system operated via the mail, the secretary pointed to the "advantage to agriculture and commerce to be derived from a knowledge of the approach of a storm, by means of the telegraph." During the first year of operation of the expanded network, Henry negotiated Smithsonian use of several major telegraph company lines at specific hours of the day for the transmission of weather information from the field volunteers to the Institution. In

SHAPING AN INSTITUTION

addition, when an observer reported the approach of a storm, Henry would telegraph a warning to other volunteers in the area, requesting that they pay special attention to the developing situation.[31]

By January 1849, the rapid rise in correspondence relating solely to the meteorology program convinced Henry to hire a specialist to lead the effort. Edward R. Foreman, a Baltimore native who had served as an assistant professor of natural philosophy at the University of Pennsylvania for twelve years, accepted the secretary's offer to serve as an assistant in charge of organizing meteorological communications and reports. In addition, he would manage a Smithsonian lecture program while also serving as a professor of chemistry at the National Medical College. Initially, Espy paid half of Foreman's salary from Department of the Navy funds. In July 1850, when the regents agreed to allow the secretary to hire an assistant at $1,200 a year, Foreman became a full-time Smithsonian employee.[32]

In 1850, Foreman began plotting incoming weather information on a large map of the United States. Within six years, Henry and his assistants had perfected the system. Incoming weather information was received at 10:00 a.m. each day and pinned onto a large map on public display in the Castle. Colored disks represented local conditions, with arrows indicating the direction of movement. "This map," Henry reported in 1856, "is not only of interest to visitors in exhibiting the kind of weather which their friends at a distance are experiencing, but is also of importance in determining at a glance the probable changes which may soon be expected."[33]

Through the 1850s, Henry continued to partner with government agencies to extend the utility and impact of the limited funds he expended on meteorology. In addition to the information supplied by his existing network of observers, reports requested by the army surgeon general from officers at military posts across the nation as well as those funded by New York, Massachusetts, Pennsylvania, Maine, and Missouri flowed into the Smithsonian. The secretary had succeeded in establishing the Institution as a major center of American meteorological research. By bringing smaller government efforts under the Smithsonian umbrella, the secretary directed climate studies in America until 1874, when the Army Signal Corps took over the task as a fully funded government responsibility. This was the first occasion on which Smithsonian leaders chose to spend a relatively small sum to support a promising but underfunded area of research that would eventually give birth to a critically important federal agency.[34]

BY 1850, THE AMOUNT OF WORK falling on Henry's shoulders was growing exponentially. Charles Jewett was focused on the library. Foreman handled most of the

meteorological correspondence with the assistance of Lorin Blodget, a physicist hired in 1851 as a second meteorological assistant but whose primary duty was dealing with copyright matters on behalf of the library. Beyond that, the secretary's only assistants were William McPeak, who served as doorman, janitor, and messenger, and Charles P. Russell, a clerk hired in March 1847. A larger staff was required to keep pace with expanding activities.

George Perkins Marsh was certain that he knew just the man to solve Henry's personnel problem and help him guide the Smithsonian into the future.[35] Marsh was an extraordinary figure. Appointed to the Board of Regents in 1847, the Vermont congressman was an ethnologist, linguist, philologist, and fluent in half a dozen European languages. He also had broad interests in science, literature, and art and was a pioneering American collector of European fine art prints. The depth of his understanding of the public importance of scientific issues inspired his 1864 book, *Man and Nature*, a prescient study of ecology and the impact of human beings on climate and the environment. "Man cannot at his pleasure command the rain and the sunshine, the wind and frost and snow," he noted in 1847, "yet it is certain that climate itself has in many instances been gradually changed and ameliorated or deteriorated by human action."[36]

Marsh left the Board of Regents in 1849 when President Zachary Taylor appointed him minister resident to the Ottoman Empire. Unable to clear his debts before accepting the post, he offered to sell portions of his print collection and art history library to the Smithsonian. Charles Jewett complained that Henry's presentation of the possible purchase at a meeting of the regents' Executive Committee on June 27, 1849, was marked by "caution misplaced." Fortunately for Marsh, Alexander Bache stepped in and convinced the Board of Regents to offer $3,000 for the prints and part of the library. Marsh would return from Constantinople to Vermont in 1854 and serve in a variety of public capacities until 1861, when President Lincoln appointed him the first US minister to Italy, a post he would hold for twenty-one years, until his death in 1882.[37]

During the sixteen months that he served on the Board of Regents, Marsh exercised a considerable influence on the early history of the Institution. He brought Squier and Davis to Henry's attention, did his best to resolve misunderstandings as they arose, and played a role in editing and proofreading *Ancient Monuments of the Mississippi Valley*. While the Smithsonian acquisition of his print collection enabled Marsh to launch his diplomatic career, it was also the first of millions of collections that would flow into the Institution in years to come.

Clearly, however, his most important contribution came on July 11, 1848, when Marsh introduced Henry to his young friend Spencer Fullerton Baird. Prior to the

Spencer Fullerton Baird (1823–87), c. 1850, around the time he joined the Smithsonian. Originally hired as assistant secretary for the natural history department, Baird mentored three generations of natural scientists and assembled a network of interested citizens who supported his effort to build a collection of specimens documenting the natural and human history of North America. As the second secretary of the Institution (1878–87), he oversaw the creation of the National Museum and sought new ways to share Smithsonian collections and research with all Americans. *Smithsonian Institution Archives*

meeting, Marsh had encouraged Baird to "lay aside a little of your modesty, and swagger enough to make a proper impression." Baird made a positive impression on the secretary during their three-hour meeting and tour of the finished sections of the Castle. The encounter would have a profound impact on the future of the Institution.[38]

At the time of his first meeting with Secretary Henry, Spencer Baird was twenty-five years old. He was clean-shaven, with a broad face, clear, pea-green eyes, and a downturned mouth. He stood five feet eleven and three-quarter inches and weighed 150 pounds, most of it the solid muscle of an outdoorsman. The secretary was impressed.[39]

A native of Reading, Pennsylvania, born on February 3, 1823, Baird was ten years old when his father, Samuel, died in a cholera epidemic and his mother, Lydia, moved her four sons and three daughters eighty miles west to her family home in Carlisle, the site of Dickinson College and a major army post. After attending a boarding school in Port Deposit, Maryland, Spencer entered a preparatory school operated by Dickinson, then moved on to the college, graduating at the age of seventeen. In 1841, eighteen-year-old Baird walked 420 miles in three weeks, covering 60 miles on the final day. The following year he traveled 2,100 miles wearing "one pair of laced boots, half-soled three times." Along the way he killed 650 birds, prepared the skins for his collection, and visited half a dozen fellow naturalists.[40]

Following his graduation from Dickinson, he acquired a reading command of French, German, Spanish, Italian, and Danish. He continued his mathematical studies and read widely in European literature in the original languages. In the fall of 1840, Baird enrolled in the College of Physicians and Surgeons in New York to master anatomy and related biological studies but left after a year. Deeply interested in natural history, he began his long collecting trips with his oldest brother, Will, while still a youngster. An amateur ornithologist, Will introduced his younger brother to the art of preserving bird and small animal skins.[41]

The brothers Baird were the latest in a long line of amateur naturalists stretching back to the earliest European encounters with America. In his *New Atlantis* (1624), English scholar Francis Bacon emphasized that in reaching a solid understanding of the world, the primary need was to gather facts that could be arranged to point to larger truths.[42] Suitably inspired, Spanish, French, and English colonists sent a steady flow of those facts back to Europe in the form of observations and specimens. The work of the Swedish naturalist Carl Linnaeus was the culmination of the resurgence of interest in natural history that began with the first European voyages to the Americas. His *Systema Naturae* (1735) outlined a system of

binomial nomenclature through which plants and animals could be organized by the identification of their genus and species. The work went through twelve editions by 1768 and served as the foundation for systematic taxonomy.

Following the Revolutionary War, the natural history tradition took root in the new nation through the medium of learned societies, publications, private collections, museums, and a handful of university teaching positions. By 1843, Spencer Baird was finding his place in that developing community. With his brother, he began publishing articles in such major journals as the *Proceedings of the American Academy of Arts and Sciences* and Silliman's *American Journal of Science*, as well as in such local publications as the *Gettysburg Linnaean Journal*. Baird also developed an acquaintance, both in person and through his extensive correspondence, with fellow naturalists. For example, he began exchanging letters with the painter and naturalist John James Audubon in 1840, when Baird was only seventeen, and continued until the artist's death in 1851. Audubon enjoyed their correspondence. The painter provided specimens for Baird's collection and offered his young admirer advice on his drawings. During his travels, Baird not only made the acquaintance of leading naturalists but also visited the most important American natural history collections.[43]

By 1843, Baird was a museum man in search of a museum. That November, he traveled to Washington where he met Lieutenant Charles Wilkes, commander of the US Exploring Expedition, which had returned just the year before from its four-year voyage around the globe, and James Dwight Dana, who had served as expedition mineralogist and geologist. The young naturalist spent two months serving as a volunteer curator, identifying and arranging the crustaceans collected by the expedition. In July 1845, Baird's alma mater appointed him honorary professor of natural science and curator of Dickinson's cabinet of natural history specimens. A year later, he accepted the college's offer of a position as a full professor.[44]

In 1846, newspapers were filled with reports of the congressional debates swirling around the possibility of a Smithsonian Institution. Dana urged Baird to apply for the position of assistant secretary managing the collections of the proposed museum. The newly fledged professor wrote to Secretary Henry on February 6, 1847, and again on February 25, expressing interest in the post, outlining his qualifications and experience at length, and enclosing letters of recommendation from James Dwight Dana; John James Audubon; John Cassin, curator of the Academy of Natural Sciences of Philadelphia; Samuel G. Morton, one of the nation's leading physical anthropologists; and Asa Gray, a Harvard luminary and leading botanist.[45]

Henry did not respond to Baird's first note and sent only a brief response to the second, promising to file his letter but warning him that the board would probably not approve hiring a curator for the museum until the building was sufficiently complete to house natural history specimens, which "will probably not be the case for five years." In the spring of 1848, Titian Ramsay Peale, the artist who had served as a naturalist on the Wilkes expedition, also expressed an interest in a position with a Smithsonian museum. Henry repeated his response to Baird, noting that he had no intention of accepting responsibility for government collections until additional space was available.[46] "The Smithsonians," Peale wrote to friends in Philadelphia, "are opposed to a museum."[47]

Other teaching offers would come Baird's way over the next few years, but he chose to wait until he could grasp the Smithsonian prize.[48] He could afford to be patient. His salary as a Dickinson professor made it possible for him to marry. He met Mary Helen Churchill in 1844 when her family moved to Carlisle. For Mary, the young naturalist took some getting used to. During a romantic stroll by a stream, he borrowed Mary's bonnet to catch an unfamiliar species of fish. William Healey Dall, who worked under Baird's leadership in later years, described Mary as "a well-educated, highly intelligent, and tactful young woman" with "a charming smile, a face lighted up by intelligence and cordiality, aided by a delicate sense of humor and a wit which enlivened conversation without stinging." Married on August 8, 1846, the couple would produce a daughter, Lucy.[49]

Mary, probably at her husband's request, wrote to George Marsh, a family friend, regarding Baird's interest in the Smithsonian position. Marsh discussed Baird with several fellow regents and his friend, Assistant Secretary Jewett. In addition, he suggested the young man for the chair in chemistry and natural history at the University of Vermont, which Baird turned down. He also arranged for Baird to translate a German encyclopedia, *Bilder-Atlas zum Conversations-Lexicon* by F. A. Brokhaus, for an American publisher. Baird's translation, published in 1852 as the *Iconographic Encyclopaedia of Science, Literature, and Art*, paid the young family man the princely sum of one dollar per finished page. In 1848, Baird accepted an honorary degree from the Philadelphia College of Medicine and agreed to coauthor a volume on American fish with the distinguished Swiss immigrant Louis Agassiz, a Harvard professor and leader of the international natural science community.[50]

The Spencer Baird who met with Joseph Henry through the good offices of George Marsh on July 11, 1848, was a much more impressive figure than the young man who had written a letter of inquiry just a year before. In the summer of 1849, the secretary agreed to contribute seventy-five dollars to defray the costs of Baird's

proposed collecting trip through western Virginia and southern Pennsylvania in support of his book project with Agassiz. In addition, the Smithsonian would pay for the illustrations and publish the finished catalog of American fish.[51]

Henry wrote again in November 1849, praising Baird's translation of the sections of the German encyclopedia relating to natural history, commenting that "the execution is beautiful," and asking to reprint that material as an appendix to his next annual report. That December, when Baird raised the issue of employment once again, Henry assured him "that it would give me much pleasure to nominate you to the office of naturalist," but urged him to be patient until the board was certain to approve the appointment.[52]

Henry's reluctance to appoint an assistant secretary for the museum was not a judgment on Baird's qualifications. From the outset, the secretary had been determined to restrict Smithsonian activities to the direct support of research in those fields he deemed most appropriate and to disseminate the results to the world. He insisted on managing the fine details of the program himself and resented some of the compromises he had been forced to make. The acceptance of a large library program and the regents' choice of Charles Jewett as assistant secretary for the library had been conditions of his selection as secretary. Given the enthusiasm for the library function on the part of both congressional supporters and a faction of the Board of Regents, Henry had little choice but to agree to provide half of the available program funds to an aspect of the organization he opposed and was effectively beyond his control.

The secretary planned to maintain better control over museum and collections functions. In truth, Henry regarded taxonomy as a lower form of scientific enterprise and did not see the need to duplicate collections held by other institutions. He was, however, willing to approve "special collections of new objects, appropriations for original explorations and researches, and, above all . . . in the preparation of the necessary drawings, and by presenting to the world, in proper form, the labor of naturalists."[53]

By 1850, the west wing and range of the Castle were complete, the main building had a roof, and the towers were under construction. With additional space available, Henry decided that the time was right to bring a new assistant on board to handle collections and museum issues. The secretary was impressed by Baird's outstanding record as a naturalist and his experience in publishing and skill at translation. He wrote to Baird again on April 23, 1850, asking him to come to Washington so they "should have a full understanding with each other before our connection is finally settled that there may be no cause for difficulty in the future."[54]

Having struggled with Jewett over library expenditures, the secretary wanted to be certain that his potential new assistant secretary fully understood who was in charge. While Baird's vision of the role that collections and the museum would play in the future of the Institution was far more expansive than Henry's, the young man was more than willing to accept the secretary's leadership, counting on his own political and interpersonal skills, and the will of Congress and the regents, to steer things in the direction of growing collections and a museum in which to display them.[55]

The Board of Regents approved Henry's nomination of Baird as assistant secretary with a salary of $1,500 on June 5, 1850. Charles Jewett offered to send Henry's telegram to his new colleague, followed by a warm letter of congratulations. Henry wrote three days later, welcoming Baird on board and assuring him that the position would permit him "an opportunity of prosecuting your favorite study to the best advantage," while adding that it would also "enable you to render important service . . . by the assistance and co-operation you will render me in the line of our publications."[56]

Baird shipped his collection to the Smithsonian in two railroad boxcars. The items included twenty-five skins of North American birds; 250 European birds; eggs and nests of 150 species of North American birds; five hundred "glass jars, and numerous barrels, kegs and tin vessels containing reptiles and fish of the United States"; the "Embryos of many Birds, Mammals, and Batrachian Reptiles"; the "Skulls and Skeletons of many North American vertebrates, amounting to about six hundred specimens"; and a "Collection of fossil bones from various caves in Pennsylvania and Virginia."[57]

By October 5, 1850, Baird's collection was safely stored in the Castle basement. Mary, her parents, Lucy, and a nurse for the baby arrived in Washington on November 2. Like the Henrys, the Bairds spent their first few years in the capital living in rented rooms. Four years later, they moved into what one of Baird's scientific friends would describe as "a plain brick box of a house" at 332 New York Avenue NW. "Every available wall inside was lined with shelves for books and pamphlet cases," the young naturalist recalled, "but there was a homelike atmosphere about it which was most enjoyable." Two decades later, the then-distinguished scientist moved his family to a larger home on Massachusetts Avenue, where he remained until his death in 1887.[58]

When Baird joined Henry in a tower office that fall, he found his desk piled high with work. He was expected to handle all publishing arrangements, including the annual reports. Baird also accepted responsibility for the international exchange program, which involved packing and shipping all outgoing publications as well as

accepting and distributing incoming publications to libraries, museums, and participating organizations across the nation. In June 1852, with some assistance, Baird packed and shipped 3.6 metric tons of books, including the second volume of Smithsonian Contributions to Knowledge as well as publications from other learned American societies and congressional documents relating to science. In addition, he was serving as secretary of the American Association for the Advancement of Science, which, he informed George Marsh in 1851, "has taken much of my time."[59]

With those tasks out of the way, Baird turned to his own priorities, which involved nothing less than the scientific exploration of the continent and the establishment of a collection that would open the way to a deep understanding of the geology, paleontology, biology, ethnology, archaeology, and natural resources of North America. Joseph Henry certainly appreciated the possibilities offered by American expansion. "Our new possessions in Oregon, California and Mexico," he wrote in 1849, "offer interesting fields for scientific inquiry, particularly in the line of natural history." It was Spencer Baird, however, who took full advantage of those possibilities.[60]

BETWEEN 1850 AND 1880, the Smithsonian annual reports provided the most comprehensive record of American expeditions dispatched by the US military, government agencies, and civilian explorers. In the volume for 1877, Spencer Baird provided a summary of 248 of those "explorations and expeditions," most of which had supplied material to the national collection since 1850. The Institution usually supplied those expeditions with instructions as to the most useful scientific observations and collections desired, furnished the required instruments and supplies for the preservation of specimens, and often suggested competent naturalists to accompany a party. Without expending large sums from his own budget, Baird managed to position the Smithsonian as an indispensable partner in the scientific exploration of North America.[61]

Even before his official employment, Baird was working with Henry to collect paleontological material that would enable American scientists to address some of the central scientific problems of the day. Few questions were more puzzling, or engaging, than the nature of the large fossil bones only recently identified as the remains of extinct mammals and reptiles. How old were these creatures and what had they looked like? Was the extinction of species the result of natural catastrophes such as Noah's flood, or was change in living things a long, slow, uniform process? What mechanism drove such change?

The answers to those and other questions were to be found by studying the fossils themselves. While significant American fossil beds, including Kentucky's

Big Bone Lick, were known and studied in the eighteenth century, scientific attention in the early nineteenth century largely focused on European sites. That began to change in 1850 when Thaddeus Culbertson, a twenty-seven-year-old College of New Jersey graduate, offered to undertake a collecting trip along the upper Missouri on behalf of the Smithsonian.[62]

Suffering from the early stages of tuberculosis, Culbertson hoped that a western trip would be good for his health. He would partner with his brother Alexander, who supervised American Fur Company operations on the Yellowstone and Upper Missouri Rivers. As early as 1843, Alexander Culbertson had discovered the bones of large prehistoric mammals in the Badlands along the White River, just west of the Black Hills, in what was then the Nebraska Territory. His original finds had gone to Joseph Leidy at the Academy of Natural Sciences of Philadelphia. In 1849, Dr. John Evans, a physician and naturalist employed by David Dale Owen, set out on a geological survey that included the Badlands. "At every step," Evans reported of the area, "objects of the highest interest present themselves. Embedded in the debris, lie strewn, in the greatest profusion, organic relics of extinct animals."[63]

Aware of the rich opportunity for important collections, Henry accepted Thaddeus Culbertson's offer to undertake a collecting trip. He provided the young man with $200 to cover packing and shipping expenses and asked Baird to prepare an extensive set of notes and instructions, including advice on the preservation of specimens. Alexander Culbertson, who knew the area well and was concerned about his younger brother's health, would fund the expedition.[64]

The Culbertson brothers set out in April 1850, traveling by steamboat from Saint Louis to Saint Joseph, Missouri, where they assembled a mixed party of Native Americans and American Fur Company employees and started for Fort Pierre, Alexander's post on the Upper Missouri. On May 7, Thaddeus left the fort with two companions and a pair of mules, headed for the Badlands. The party arrived in the heart of the fossil beds on May 14, 1850, a day when "the sun was broiling hot, and we had no water except for a very little brought with us to cook." Nevertheless, in one day, the trio collected bushel baskets of teeth and small fossils and overloaded the wagon with fossil skulls and large bones. When the mules gave out on the way back to Fort Pierre, Culbertson was forced to cache most of the fossils, planning to return for them with a larger wagon. Some days after his arrival at the fort, a band of Cheyenne delivered the collection, which they had found along the trail.[65]

After several days recovering at the fort, Thaddeus Culbertson and Mr. McKenzie, one of his two companions on the trek to the Badlands, boarded a

SHAPING AN INSTITUTION

View of Fort Pierre on the west bank of the Missouri River in what is now South Dakota, print of a watercolor by Karl Bodmer, c. 1832–34. An American Fur Company post, Fort Pierre was the starting point for Thaddeus Culbertson's 1850 fossil-collecting trip for the Smithsonian. *Library of Congress, Prints and Photographs Division*

steamboat and continued upstream past the junction of the Missouri and the Yellowstone to a point where the Milk River enters the Missouri. Along the way, they continued collecting flora and fauna for the Smithsonian, and met John Evans, once again in the field, who was impressed by Culbertson's fossil collection. Culbertson was also fascinated by Native American villages along the Upper Missouri and kept a careful record of the ceremonies, customs, and way of life of the Sioux, Blackfeet, and other tribes he encountered. Baird published Culbertson's tabular analysis of the various Sioux tribes and the journal he kept of the trip in the fifth Smithsonian annual report.[66]

Baird, now on hand as assistant secretary for collections and a museum-to-be, reported that the young explorer returned east in August 1850 "in renewed health to gladden the hearts of his parents and friends." Ironically, having "withstood the privations and exposures of the wilderness," Thaddeus Culbertson died a few weeks later of dysentery. His collection would be his memorial. He delivered 116 birds, thirty-one mammals, and seventy-three plant species to the Smithsonian. Baird turned the most important items in the collection, the fossils, over to the nation's leading paleontologist, Joseph Leidy of the Academy of Natural Sciences of Philadelphia, for identification and analysis. Leidy identified a dozen species in the group and seven genera new to science. Leidy summarized the findings in a short letter appearing in the Institution's annual report for 1850 and published his long report and analysis of the Badlands fossils as a Smithsonian Contribution to Knowledge.[67]

Henry's strategy of investing small sums of money in support of volunteer efforts, whether to obtain weather data or a collection of fossils, was paying dividends. As Baird put it, Evans's and Culbertson's discoveries established "for the first time, the existence in this country of an Eocene deposit rivaling in the number of species the celebrated basin of Paris." For an investment of only $200, Henry and Baird had taken an important step toward establishing the Smithsonian collection as a world resource for paleontological research.[68]

Even before he arrived in Washington, Baird had taken a major step that would generate a steady flow of specimens into what he already regarded as the national collection. In 1850, at the suggestion of his father-in-law, Sylvester Churchill, the inspector general of the US Army, the new assistant secretary prepared a circular "to the friends of science generally" seeking the assistance of military officers in posts scattered across the nation in collecting natural history specimens. Henry approved the plan, recognizing it as a natural extension of his own approach to collecting meteorological data. It is unlikely, however, that he had any idea how wide a collecting net Baird would cast.[69]

Baird's invitation to the officers of the army and navy, complete with instructions on the preservation of specimens, appealed to a considerable number of gentlemen soldiers with an interest in natural history, many of whom served with the Army Corps of Topographical Engineers, which operated two dozen exploratory surveys of the vast new territory acquired by the United States during the thirteen short years between the Mexican-American War and the American Civil War. Baird's soldier volunteers included Lieutenant Gouverneur K. Warren, Captain George B. McClellan, Captain David G. Farragut, and Commander John Rogers. In 1853, Captain Darius N. Couch took a year's leave of absence from the army to lead a collecting trip into northern Mexico on behalf of Baird and the Smithsonian. Baird had also begun attaching young naturalists to military expeditions. John H. Clark, for example, who had been one of his students at Dickinson, joined Baird in Washington in 1851 and soon left as a naturalist with the Mexican Boundary Survey Commission.[70]

Managing the process was a daunting task. Baird supervised the identification, cataloging, and study of material coming into the collection. In view of Henry's instructions, he initially kept only holotypes or the original examples of new taxa. Excess material went to other collectors and institutions. He published on the findings as well, including four impressive volumes on the zoological collections returned by the five Pacific Railroad Surveys dispatched between 1853 and 1855 to investigate potential routes for a railroad to the Pacific. The *Catalogue of North American Reptiles*, prepared by Baird and an assistant based on Smithsonian

collections and published in 1853, was especially noteworthy. Finally, he was a prolific correspondent. During 1860 alone, Baird wrote 3,090 letters, only 190 of which were drafts for Henry. Most of the rest were to his far-flung network of volunteers. While Henry remained the figurehead and dealt with the regents, Baird was managing day-to-day operations and had begun the process of altering the course of the Institution.[71]

RECOGNIZING THE GROWING WORKLOAD resulting from the expansion of the exchange system, Henry approved an assistant for Baird. Charles Frédéric Girard, a French student of Louis Agassiz, had accompanied his professor to Harvard in 1847. Three years later, Baird hired him as a general assistant. While he wrote important papers with Baird and cataloged the growing collection of fish, reptiles, and amphibians, he also assisted with the hard work of packing, shipping, distributing, and otherwise managing the exchange system. Although fully occupied at the Smithsonian, he managed to earn a medical degree from Georgetown University in 1856.

When the needs of the exchange program became overwhelming, Edward Foreman took time from his meteorological duties to assist Baird as well. Baird also called on the services of volunteers, students, and young naturalists for help with both the heavy lifting and the scientific work with the collections. Alfred A. H. Ames, for example, a student of Baird's at Dickinson, spent time in Washington assisting his former professor. Baird also noted that Dr. Samuel Washington Woodhouse, a physician and naturalist who had recently returned from a US Army Corps of Topographical Engineers mapping expedition of the Colorado and Little Colorado Rivers country, was at the Smithsonian to study the collections and helped to pack the 1852 exchange shipment.[72]

Despite his own deep-seated racism, the secretary hired the Smithsonian's first African American employee, Solomon Galleon Brown, in 1852. Born in Washington, DC, in 1829 to free parents, Brown was entirely self-educated. Lambert Tree, a senior post office clerk, arranged for the fifteen-year-old to assist Samuel Morse, Alfred Vail, and Joseph Henry in establishing the first long-distance telegraph line between Washington and Baltimore in 1844. Impressed, Henry remembered the young man eight years later and hired him as a laborer. Intelligence and hard work were the keys to Brown's early success at the Smithsonian. He quickly earned promotion to clerk, was provided with lodgings in a tower room of the Castle, and was credited with "rendering services to [the] museum."[73]

Brown spent much of his time on the exchange program, where the comfortable patron-and-protégé relationship he developed with Baird blossomed into a

79

personal connection. Within three years of his arrival in the Castle, he was sending a steady stream of letters to the assistant secretary, who was absent from Washington during the ferocious summer heat and season of contagious diseases that plagued the nation's capital. Baird supported and protected Brown from Henry's vagaries and advocated his promotion, while Brown warned the absent Baird of the secretary's occasional moves against the collection and museum programs.[74]

Over time, Solomon Brown would also work for the National Museum, the Bureau of American Ethnology, and the National Zoo. He was usually listed as a clerk, a step up from laborer. Beyond his service to the Smithsonian, Solomon Brown was a poet and artist who assisted in the preparation of illustrations for Smithsonian lectures. He offered scientific lectures to local African American groups and was a leader in the Anacostia neighborhood, representing the area in the District of Columbia House of Delegates for three terms beginning in 1871. He was a member of the congressionally established Board of Trustees for Colored Schools and a trustee of Wilberforce University, established by the African Methodist Episcopal Church. He remained with the Institution until his retirement in 1906.[75]

James Thomas Gant, the second African American employee, had worked for John Varden at the National Institute. He was hired as a messenger in 1858 and augmented his salary of twenty dollars a month by supplying soap, towels, water, and other items to the budding scientists that Baird had lodged in the tower rooms. Over time, he worked as a janitor. As he grew older, Uncle Jimmy, as he was known, was given lighter duties as "Doorkeeper to the Secretary," earning sixty-five dollars per month. Like Solomon Brown, he remained at the Institution through three secretaries.[76]

If Spencer Baird was Henry's most consequential hire, William Jones Rhees was his second. A native of Philadelphia born in 1830, Rhees was educated in local schools before working as a clerk and draftsman in the Meadville, Pennsylvania, office of a major real estate firm. At the age of twenty, he moved to Washington, where he took a position as a lead clerk in the Census Office. In addition, he served as secretary to the Executive Committee of the United States for the 1851 international industrial exposition, a committee on which Henry served.

As early as 1849, the English commissioners of the Great Exhibition of the Works of Industry of All Nations, soon to be universally known as the Crystal Palace Exhibition or Great Exhibition, began issuing invitations to the nations of the world to display the products of their industry. Secretary of State John M. Clayton placed the business of planning American participation in the exhibition in the hands of the National Institute. Peter Force, now head of the virtually moribund

80

Solomon G. Brown (1829–1906), shown at the far right in this 1891 photograph of the Smithsonian International Exchange Service Program staff. The Smithsonian's first African American employee, Brown was close to Spencer Baird and worked various jobs for the Institution from 1852 until 1906. *Smithsonian Institution Archives*

organization, appointed a twenty-one-person committee to oversee the effort, with five of the members serving as an executive committee: Force, a newspaper editor, manuscript collector, and archivist; Joseph C. G. Kennedy, head of the Census Office; Charles Wilkes, of the US Exploring Expedition; Walter D. Johnson, a natural philosopher who advised coal and mineral producers; and Joseph Henry.[77]

Henry was so opposed to the involvement of the National Institute that he initially declined to participate. The scientific reputation of the nation had "suffered much on account of the operations of this society, and indeed though it has apparently been dead for some time past, its malign influence still exists," he complained to his friend Asa Gray, then living in London. He was, however, "overruled and made one of the committee of five to attend the affair."[78]

Henry reported to Alexander Bache that the central committee, "of which I have the honor (?) to be one," met on the evening of June 13, 1849, and decided to ask the governor of each state to establish a local committee to select articles that would be displayed at the exhibition. The process succeeded. The United States sent a wide range of items to the Great Exhibition, including Colonel Colt's revolver, Cyrus McCormick's reaper, a sewing machine, Mathew Brady

daguerreotypes, and Charles Goodyear rubber products, along with such questionable innovations as a "patent double grand piano, upon which two performers at a time can execute compositions arranged for eight hands and two pianos"; an air-exhausted coffin to slow decay; and a model of the floating chapel built for the Churchman's Missionary Society of Philadelphia. Whatever Henry's compunctions, the United States' contribution to the Crystal Palace Exhibition drew considerable positive attention and marked the emergence of the United States on the world's industrial stage.[79]

For Henry, however, the opportunity to meet William Rhees was the most important consequence of the experience. The secretary wrote to Bache in July 1853, informing him that Edward Foreman had left the Smithsonian to accept a higher salary at the Patent Office. In the same letter, he added that he had taken on Rhees.

"I find my quarters here at the Smithsonian quite pleasant & feel almost as good as if I were in the Metropol in N.Y," Rhees commented to Spencer Baird. Within two years, the young man would become chief clerk, an office he would hold through the administrations of Secretaries Henry, Baird, and Langley, apart from a few months in 1870 when he left in an ill-advised effort to establish a stationery business. Rhees authored three decades worth of guidebooks to the National Museum. Territorial of his profits from that activity, he drove his only competitor from the field in the 1880s.[80]

In 1891, Rhees asked Secretary Samuel Pierpont Langley to relieve him of his clerical duties and name him the first Smithsonian archivist. He would continue in that role until his death in 1907, producing a two-volume legislative history of the Institution, a volume of the proceedings of the Board of Regents, biographical essays of the three secretaries under whom he served, and other narrative accounts of Smithsonian history. All subsequent accounts of the first half century of the Smithsonian rest on the foundation of the work of William Jones Rhees.

CHAPTER 5

TRIALS AND TRIBULATIONS

DETERMINED TO BE A GOOD STEWARD of the Smithson trust, Henry's guiding principle was to limit operations to the publication and distribution of research and the support of projects that could be funded with the annual 6 percent interest from investments. Defending that limited view required a continual struggle with those who pursued other goals or who sought to expand the responsibilities of the Institution.

In January 1851, Senator Isaac P. Walker introduced a Senate resolution requiring the Board of Regents to explain why they had not yet complied with section six of the legislation creating the Smithsonian, which called for the Institution to receive and appropriately house and display the US government collections stored in the Patent Office. It was in large measure for that purpose, after all, that Congress had authorized the construction of a large building.[1]

Senator Jefferson Davis, one of the secretary's strongest supporters on the board, and an opponent of attempts to extend government power into the private sector, responded by pointing out that the Smithsonian was not a government agency, and that the provision of the legislation regarding government collections had been intended as a gesture inviting the new institution to accept the collections whenever it chose. Given the costs involved, he compared the situation to that of a courtier whose monarch presents him with an elephant. "The minister can not [sic] refuse the present, because it comes from the King, but the expense of keeping the present crushes the minister." For the moment, at least, the matter rested.[2]

Senator Stephen A. Douglas sought to graft a government agricultural program onto the Institution in 1852. The senator launched a full-scale attack during a meeting of the United States Agricultural Society, held June 24–25, 1852, in the original Smithsonian lecture hall in the east wing of the Castle. Addressing the group, the senator repeated his complaint that the Institution had produced "no

SMITHSON'S GAMBLE

practical results." When Henry rose to refute these comments, Douglas remarked that the secretary "would object to anything but the publication of sea weeds and such trash." Henry countered that "all knowledge was *practical, how abstruse soever it might to the uninitiated appear."[3] His success in holding his own in a public debate with an eloquent opponent may have dissuaded other politicians who contemplated dipping into Smithsonian funds to support their projects.[4]

For Henry, the worst of the "outcrops" impeding his program was the notion of a great library. Assistant Secretary Charles Jewett hoped to create an American national library, and things had gone well for him at the Smithsonian. By 1851, "the magnificent library room, already containing about 5,000 volumes," as one reporter noted, was housed in the west wing of the Castle and open to the public daily from nine to five "and sometimes later." General readers were advised that the Washington Library or the library of the Young Men's Christian Association would better meet their needs, however. The Smithsonian was a reference library "to which men from all parts of the country and all pursuits may apply and find works which cannot be got in their vicinity, and which may prove valuable to them in their labors."[5]

The secretary recognized the need for a working scientific library to support Smithsonian research. Material flowing in from other learned organizations via the exchange system would more than meet that need. Moreover, the exchange system allowed the Smithsonian to supply the nation's leading libraries with the latest scientific information from abroad. By the end of 1852, Jewett reported that the collection had grown to 21,701 items that included books, pamphlets, parts of books, engravings, maps, sheet music, drawings, and other pieces. More than 40 percent of the items came into the library through the exchange system. While the size of the library collection doubled in 1853, the number of items received through the exchange increased five-fold, including journals and scientific publications from across the nation and around the world. Furthermore, by December 1852, a total of 4,539 items had been received from publishers seeking a copyright.[6]

In addition to managing the library's growth, Jewett focused on another central goal, the creation of a union catalog, including a record of all books in American libraries. Early library catalogs were bound blank books in which librarians entered information by hand on each volume in the collection. Obviously, such a catalog would have been of little value to anyone in search of a particular book on the shelves. Jewett established a standard bibliographic description that would include complete details of a book, its assignment to a subject category, and

Print from an 1857 guidebook of an engraving of the library in the west end of the Smithsonian Institution Building. The library held books from the Smithsonian exchange program and, at the time, was also the repository for all the books receiving copyright protection in the United States. *Smithsonian Institution Archives*

minimal author information. As one of his successors, Cyrus Adler, later explained, "a publication was to him as much an object of careful study as is a natural history specimen to a naturalist. His annotations were of great value. . . . He felt that the library catalogue should give some of the information which was in theory appropriate only to the bibliographical dictionary."[7]

Information on individual volumes would be entered on a metal stereotype plate of type that could be used to print and supply a copy to any library holding that volume for entry into their catalog. Jewett's system was only one step away from the distribution of printed cards, a service eventually provided by the Library of Congress. In the spring of 1852, Henry approved the employment of Willard

SMITHSON'S GAMBLE

Cowles, a stereotyping specialist, to assist with the project at a salary of sixty dollars per month. Unfortunately, rather than using thin metal, Jewett attempted to produce his plates from an Indiana clay that, when baked, tended to distort, or fall apart. The material failure prevented the implementation of his plan.[8]

Henry's relationship with the assistant secretary for the library was never comfortable. The regents had further complicated the matter early on by appointing Rufus Choate and George Marsh, the leading library supporters on the board, and Alexander Bache to a committee overseeing Jewett's activities in "conjunction" with the secretary. This limitation on his authority grated on Henry, whom, Jewett realized, "seems to have been under the impression that some power had been taken from him."[9]

Henry noted that Jewett's work was attracting increased positive attention in both professional circles and the press. Matters would take an even more serious turn when work on the Castle was complete. At that point, as per the regents' compromise of January 1847, the annual 6 percent interest income from the Smithson trust, roughly $30,000, would be split, half going to research and publication and half to the library and museum. Careful to ensure that he would have the support of a majority of the regents, the secretary set out to unilaterally abrogate that agreement. Henry spoke bluntly to his friend Asa Gray: "I regret more and more that I was obliged to give way, in accordance with the law of Congress, to the establishment of a museum and library, and I am determined while I have any direction in the operations that they shall be entirely subordinate to the publications and other active operations."[10]

He took the first step toward establishing what he regarded as an appropriate balance at a meeting of the board on March 12, 1853, asking that the regents set the compromise of January 1847 aside in favor of allowing the secretary, with their approval, to control the distribution of funds to various operations of the Institution. The board accepted a resolution offered by Representative Graham Newell Fitch referring the matter to a special seven-member committee instructed to offer their recommendations at the next annual meeting of the board in January 1854.[11]

Sensing that Henry, with the support of most of the regents, would take full command of the budget, Rufus Choate wrote to Attorney General Caleb Cushing, once a candidate for the post of secretary and now a member of the Smithsonian Establishment, announcing that business in Boston would prevent him from attending the board meeting and asking him to express his views to the group. "I know that Congress . . . thought that the establishment of a great library, ultimately the best in the world, would be one of the safest, most permanent, and

86

most splendid uses of the money." He asked the attorney general to communicate his view that the compromise of 1847 should continue in place and that the funds "shall be expended by the officers in charge of the various departments, under the supervision of special committees appointed for each," which would effectively put Henry and Jewett on an equal footing.[12]

At a board meeting on January 28, 1854, Representative James Meacham, who filled the seat vacated by George Marsh in Congress and on the Board of Regents, offered a resolution stating that the secretary "and other officers" would be required to present budgets for the coming year. Action on the distribution of income was postponed. The issue was back on the table on February 18, when Senator James Pearce moved to amend Meacham's resolution to instruct the secretary and the Executive Committee of the board to present a budget, rather than the "Secretary and the other officers." Indiana representative William Hayden English moved that the resolution and the amendment be referred to the special committee created the year before for consideration and resolution. That group reported on March 11, 1854, recommending that the secretary and the Executive Committee be charged with developing and submitting the budget. The resolution passed. A report on the division of income was to follow.[13]

If the secretary and the Executive Committee had responsibility for developing budgets, things were leaning in Henry's direction. Before presenting a final report, however, the special committee invited both Baird and Jewett to comment on the situation "through the Secretary." Spencer Baird, who had forged a good relationship with Jewett, offered a strong comment to George Marsh in early February 1854. "How they can report in favor of removing the restrictions in favor of the Library [and] Museum," he asked, "with the plain law before them I cannot see."[14]

When asked to offer a public comment to the board, however, he provided only a brief statement that Henry regarded as "sophistical, but not offensive." Baird was, he thought, "at heart a good fellow" whose collecting efforts represented "inordinate ambition . . . and, to me, considering the promises he made to me before his appointment, a dishonest course." He hoped, however, to bring the young naturalist "to a sense of his duty" once "I have settled with Jewett."[15]

In responding to the regents' invitation, Jewett submitted a sixty-page document that Henry described as "filled with quibbles, false statements and abuse of myself and my plans." The librarian began with a straightforward argument: The secretary and the regents "had no power to consider the will of Smithson." Rather, they were obligated to follow the intention of Congress to create an institution that would have a library, museum, art gallery, laboratory, and lecture hall. If funds

were limited, preference should be given to the activities called out in the legislation and not to a publication program. The Library of Congress, he continued, existed solely to serve the legislature, and could never become "the great central library of reference and research which scholars need." The Smithsonian could fill that requirement.[16]

Having stated a strong case for adhering to the will of Congress, Jewett turned to a personal attack on Henry, claiming that the secretary and his allies on the board unfairly established the special committee to reconsider an established compromise that had served the Institution well. He took strong exception to a publication policy in which the secretary made the basic decisions, rather than establishing formal procedures and creating a standing review committee, as the Royal Society and most European scientific organizations had done. He closed by arguing that the future of the Institution depended on spreading authority beyond the secretary to include the heads of the departments.[17]

Jewett delivered his long statement to the secretary on the evening before a March 20 meeting of the special committee, the members of which agreed not to receive the paper, or Baird's short note, until Henry had an opportunity to present his response. The secretary had been waiting for just such an opportunity. "I am not surprised at the general character & tone of Mr. Jewett's remarks," he began. He carefully underscored the fact that Jewett not only accused the secretary of "dishonesty" and conduct "unworthy of a gentleman" but also portrayed the members of the board as being either "dupes of the Secretary or . . . his accomplices in wrongdoing." All decisions, he insisted, had been made or approved by the regents.[18]

In terms of any deviation from the legislation, Henry argued who better to interpret that law than the congressionally mandated leadership of the Institution, which included the chief justice of the United States, six members of Congress, and the president of the Senate, "who may be considered as the legal representatives of the very legislature that enacted the law, and therefore well fitted to interpret its provisions." Point by point, page by page, the secretary led his readers through a refutation of Jewett's arguments and charges. The secretary presented Baird's short statement, Jewett's document, and his own response to the special committee on April 29, 1854.[19]

News of the storm brewing in the newly completed halls of the Smithsonian soon spread across the nation. As early as January 18, 1854, an anonymous correspondent signing himself "One 'Among Men'" offered his thoughts to the readers of the *Washington Sentinel*. Identifying himself as "a plain common sense man," he asked "whence the board of regents derive the right to expend the money of the

institution in publishing the luxurious volumes which we hear of, bearing the imprint of the institution, and distributed with stately liberality to the 'principal libraries' of Europe and America?"[20]

"Iamblicus," presumably an odd reference to an obscure third-century Syrian Neoplatonist, countered on January 21, defending the "widely known, and . . . desirably celebrated" Smithsonian Contributions to Knowledge, "the distribution of which has contributed so much to advance the American name, and to gain a high reputation for the institution in foreign countries." He concluded with a warning to "One 'Among Men'" not "to suffer his meddlesomeness to expose him again to rebuke for a degree of inaccuracy and want of due inquiry wholly inexcusable in one who forces himself before the public in matters which it is evident in no way concern him."[21] The pair volleyed back and forth in this fashion for the rest of the month. "One 'Among Men'" closed the exchange with a vicious attack, accusing Henry of having succumbed to "the allurements of ambition, the love of power . . . the gratification of vanity."[22]

The arguments on both sides spread across the nation. The *New-York Daily Tribune* described the Institution as "a sort of lying-in asylum for luxurious authors, where their still-born offspring are arrayed in useless splendor, at the expense of a fund given for no such purpose." The *Boston Atlas* countered that nothing "can well be more obvious than that the foundation of a *mere* library at Washington was never contemplated by the founder of the Institution." The *Ohio Observer* concurred, noting that "the politicians and placeholders who frequent the city [of Washington]" would be the sole beneficiaries of Jewett's library. A long article in *Putnam's Monthly* noted that the secretary "has demonstrated how much may be done, even with limited means, by active operations, and the publication of their results."[23]

Whatever the public reaction, Joseph Henry was sure of his ground. He was careful to maintain a solid majority of the regents on his side of the dispute. Rufus Choate, Jewett's principal supporter, did not attend a single board meeting during the period of the controversy until May 20. Representatives James Meacham, William English, and David Stuart, library supporters, unsuccessfully attempted to force the issue at a meeting on April 26.[24]

James Pearce, chair of the special committee, presented the finished report to the board on May 20, recommending the repeal of the compromise and placing the leadership of the Institution in the hands of a secretary accountable to the Board of Regents. James Meacham presented a minority report, continuing to argue that "a compliance in good faith with the letter and spirit of the charter" required adequate funding for a large library under the direction of a librarian

SMITHSON'S GAMBLE

and a special library committee. The resolution approving the report was tabled until the next meeting, and both the report and the minority document were to be printed.[25]

On July 8 the board announced that a final decision on the special committee and minority reports on the distribution of income would be made at the annual meeting in January 1855. Henry was confident of the outcome and willing to wait for the decision. In terms of "dealing with Jewett," however, his patience was at an end. John Murray Mason, a Henry supporter, offered a resolution maintaining that the secretary had the right to dismiss any of the assistants. Amendments suggesting that the motion be altered to require the approval of the board and that a decision on the motion be postponed until the next meeting were both defeated by a vote of five to four. Mason's resolution was passed, six to four.[26]

On July 10, just two days after the meeting, Henry dismissed Jewett. The librarian responded to the board rather than Henry, arguing that Congress had vested the power to dismiss an officer of the Institution in the regents, adding that "no authority exists, or has been confirmed, to delegate such power." The board reiterated its approval of the secretary's action at its meeting on January 13, 1855.[27]

Although aware of the widespread public interest in their meeting on January 12, 1855, the Board of Regents denied the request of the *New-York Daily Times* to attend. A record fourteen members of the board were present. The first resolution considered, repealing the compromise of 1847, passed with a vote of eight to six. James Meacham then offered two resolutions. The first, calling for the expenditure of "a large portion of the income . . . on the formation of the library," failed with a vote of four to nine. The second, calling for a library committee to guide that branch of the Institution, fell with a vote of three to ten against.

The dispute rooted in the birth of the Institution was resolved at last. On January 13, with the final defeat of the library faction, Rufus Choate sent a letter of resignation from the board to both the House and the Senate. His decision, he explained, was a result of an action of the board counter to what he regarded as the clear will of Congress. In the Senate, Choate's letter was assigned to the Judiciary Committee, while in the House, James Meacham called for the creation of a five-member special committee headed by Charles W. Upham of Massachusetts to consider the issue.[28]

James Pearce managed the matter in the Senate, which quickly and unanimously resolved that "no action is necessary and proper in regard to the Smithsonian Institution." The House Select Committee, on the other hand, met seventeen times between January 17 and adjournment on March 30. James Meacham led the opposition to the Henry administration, while William English spoke in support of

90

Charles Coffin Jewett (1816–68). Accepting Jewett's appointment as assistant secretary in charge of the Institution's library was a precondition for Joseph Henry's own appointment as secretary. Henry regarded Jewett as a rival for control of the Institution and worked to achieve his dismissal in 1854. *Smithsonian Institution Archives*

the secretary. Jewett testified before the committee, as did Pearce, Joseph Henry, and a nervous Spencer Baird who said as little as possible.[29]

English presented letters from eminent scholars supporting Henry and the Institution. Cornelius Conway Felton of Harvard, an esteemed professor of Greek literature, noted "the high estimation in which the Smithsonian Institution under its present management is held everywhere in Europe." Louis Agassiz, the distinguished Swiss-born naturalist working in the United States, noted that "the progress of science in America" depended "in a very great measure" on Henry and his program. Mathematician Benjamin Peirce concurred, expressing warm approval "of Professor Henry's plan of conducting the Smithsonian Institution."[30]

The House Select Committee presented its findings on March 3, 1855. Chairman Upham offered a report finding that Henry and the regents were innocent of wrongdoing, but recommending the restoration of the compromise, an increase in funding for the library, and a division of responsibility between the secretary and the librarian. Upham did not recommend legislative action, however, and could not persuade any other member of the committee to sign the document. Two other members, William Witte and John Taylor, issued a separate report that completely exonerated the secretary and regents. In view of the positive report in the Senate and a similar majority report by the House Select Committee, the secretary felt safe in reporting that the "investigation . . . amounted to little or nothing."[31]

WITH THE DEFEAT OF THE library faction there could no longer be any doubt as to who was in charge at the Smithsonian. Joseph Henry had swept away the compromises, rid himself of a rival for power, welcomed the resignation of unfriendly regents, and taken personal command of the Institution. He was not the best of managers. Henry insisted on absolute control and was unwilling to delegate even minor authority. "All through the troubled years of the early existence of the Institution and during the Civil War," one staff member recalled, "no expenditure was made without the personal approval of the Secretary. Not a whiskbroom could be bought without a full explanation of the necessity for it and the Professor's approval of the order."[32]

Henry's approach to managing the staff was uneven. He could be generous with favored employees. For example, William Rhees, his chief clerk, was allowed to prepare, print, and sell guidebooks to the Smithsonian as a private venture for decades, pocketing the profits. John Connor, a gardener with fifteen years' service, died in 1865, leaving "a family of daughters in destitute condition." The secretary paid his funeral expenses from the Smithson fund and allowed the widow to earn

92

a living selling "articles of refreshment, exclusive of intoxicating liquors, to the visitors of the museum."[33]

Nor was Henry a mentor to the scientific staff, holding even Spencer Baird at arm's length. He could be impatient and demanding, as his treatment of Lorin Blodget demonstrates. He hired Blodget in December 1851 to manage correspondence with meteorological observers scattered across the nation and take charge of the collection and analysis of the resulting data. In April 1853, Blodget presented three important papers on climatology at a meeting of the American Association for the Advancement of Science, failing, Henry believed, to give the Smithsonian appropriate credit.[34]

The ill feeling between the two festered until October 11, 1854, when Blodget failed to submit the materials Henry had requested with which to prepare the section on meteorology for the coming annual report. The secretary waited until the meteorologist left the building for dinner, then had the locks changed, the windows nailed shut, and a letter of dismissal dispatched to Blodget's boardinghouse, A Missouri paper described Henry's extraordinary treatment of Blodget as "one of the most cowardly and arbitrary measures ever known." The *Boston Atlas* pronounced the Smithsonian "a scientific dictatorship." The secretary was, another reported, "an absolute ruler, supreme over all, from spire to foundation stone, irresponsible and unrestricted in power of removal."[35]

Other commentators were less interested in the internal squabbles than in the role that the secretary and regents were playing in the larger controversy that threatened to divide the nation. Some members of the board, the editor of the *New-York Daily Tribune* charged, were nothing more than "ill-bred and insulting representatives of the slave driving chivalry." The rhetoric was overheated, but there can be no doubt that the regents leaned toward a conservative proslavery viewpoint.[36]

In January 1854, as the Smithsonian dispute was being considered in Congress, Senator Stephen A. Douglas, who had supported Jewett, Blodget, and Choate as a regent, proposed what would become the Kansas-Nebraska Act. Passed on May 30, the act replaced the Missouri Compromise, which since 1820 had restricted the extension of slavery to areas of the United States north of latitude 36°30′. Under the terms of the legislation, the residents of newly organized territories would be able to choose whether to enter the Union as free or slave states. The result was a conflict dubbed Bloody Kansas, a bitter, extended guerrilla war between free- and slave-state settlers that raged for the rest of the decade.

Senator Douglas had opened the door to the extension of slavery in the West. Another regent, John Murray Mason, a staunch defender of slavery and a white

supremacist, drafted the Fugitive Slave Act of 1850. Abolitionists considered James Pearce, Henry's staunch defender, among "the originators and promoters of the Fugitive Slave Act." In 1857, Chief Justice Roger Brooke Taney, chancellor of the Institution, would hand down the Dred Scott decision, indicating that African Americans were "of an inferior order and altogether unfit to associate with the white race, either in social or political relations, and so far inferior that they had no rights which the white man is bound to respect." Jefferson Davis, the future president of the Confederacy, was a regent and one of Henry's strongest supporters. With some reason, the *New-York Daily Tribune* regarded the "Smithsonian clique" as elitists "condemning to an eternal inferiority and debased civilization the colored portions of the human race."[37]

IMMEDIATELY AFTER WALKING AWAY from the most important controversy of his career, Henry faced another personal attack. The secretary's old nemesis, Samuel Morse, noticed an article on the Smithsonian controversy in the July 18, 1854, edition of the *New-York Daily Times* in which "our Secretary himself induced the theory of the Magnetic Telegraph." In a letter to the editor, Morse insisted that "the *Magnetic Telegraph* owes little if anything to Professor Henry's labors or discoveries."[38]

The secretary had nursed a sense of injury against Morse since their disagreement a decade earlier. Now he was convinced that "Mr. Jewett and his friends" had enlisted Morse to launch a fresh attack, accusing Henry of lying in a deposition and falsely claiming to have contributed the scientific principles on which the telegraph was based. Outraged that Morse had assailed his "moral and scientific character," Henry wrote to Chancellor Taney threatening to sue. Having survived congressional investigations and criticism from the press, the chief justice strongly urged against such action "until the public mind should be more settled in regard to the policy of the Institution."[39]

It would take four years to lay the matter to rest. On April 10, 1858, the Board of Regents conducted a study and concluded that Morse's charges were "entirely unproved" and vindicating Henry as the "discoverer of the principle" and the creator of early electromagnetic communication systems. Twenty years later, at the time of his death, several obituaries recalled the secretary's battle with Morse, one remembering him as the "John the Baptist of the telegraph."[40]

Nor could Henry escape Lorin Blodget, who had been working with meteorological data in the office of the US Army surgeon general since being dismissed in 1854. In 1855, he published a record and analysis of twelve years of observations submitted by officers in military posts across the nation, a more complete compendium than the Smithsonian had been able to produce. Henry was outraged, insisting that

the meteorologist had incorporated Smithsonian data without attribution. "Blodget is utterly without principle and has not the slightest regard for truth," Henry complained to James Dwight Dana, a friend and pioneering earth scientist. "The only charitable view that can be taken is that he is not of sound mind."[41]

In an August 1855 article in the *American Farmer*, Matthew Fontaine Maury praised Blodget's volume as "one of the most valuable and interesting reports concerning the . . . climates of the country that has ever appeared." A naval officer, Maury had pioneered the study of oceanography and meteorology, charting winds and currents and developing new principles of navigation that reduced sailing times in the North Atlantic. As director of the US Naval Observatory, he was the navy's chief scientist, and at odds with Bache, Henry, and their circle, the arbiters of government science. They complained that Maury was not a trained astronomer and had placed practical research of value to the navy above contributions to astronomical science.[42]

Maury harbored a particular grudge against Henry. On September 23, 1847, Johann Galle of the Berlin Observatory announced the discovery of the planet Neptune. Maury assigned an assistant, Sears C. Walker, to calculate the orbit of the new planet. When Maury dismissed Walker for insubordination, Walker took his data to Joseph Henry, who, recognizing an opportunity to put his new Institution on the international scientific map, sent the material to a leading German astronomical journal and prepared to publish the discovery in the second volume of Smithsonian Contributions to Knowledge.[43]

When the notice appeared in the journal, Maury wrote a brief and angry note to Henry, demanding to know if Walker had freely offered the "discovery made at this obsy. or at your invitation as stated." Henry responded that Walker had brought his work to the Smithsonian. "I see no cause for controversy between us," he continued somewhat disingenuously, "and I regret that you have considered it necessary to adopt in your letter an unpleasant categorical form unusual in scientific correspondence."[44]

Maury, whose climatological credentials were far stronger than Henry's, saw an opportunity to replace the Smithsonian's primary scientific project. In an article republished in the *Baltimore Sun*, Maury suggested the creation of a national weather reporting system, perhaps centered in the surgeon general's office or the agricultural section of the Patent Office. Farmer volunteers could be enlisted to supply weather observations, which, combined with his existing sources of information on weather at sea, might even lead to the possibility of forecasting the weather.[45]

At the fourth annual meeting of the US Agricultural Society held at the Smithsonian in January 1856, a Mr. Beechman suggested that "agriculture and other

great interests" would be "materially benefitted by extending to the land the system of meteorological observations and research which has done so much for commerce and navigation at sea." Maury worked with Senator James Harlan to produce a bill introduced in April 1856 calling for a $20,000 appropriation to fund a national weather service. When that bill failed to come to a vote, a second bill introduced in December called for the establishment of a system based on farmer volunteers, with weather information being telegraphed to Maury at the Naval Observatory. It failed in the Senate.[46]

In the aftermath of the quarrel, Henry lost no time in solidifying the role of the Smithsonian as the center of American meteorological research by forging his most important partnership with the Patent Office's agricultural division. Congress established the division in 1839 to identify more efficient farm equipment, distribute improved seeds, and encourage better farming practices across the nation. Beginning in 1854, the division began to spend a portion of its funds to assist the Smithsonian meteorological effort and allowed the Institution to use the Patent Office's franking privilege to mail weather-related correspondence without postage.[47]

The problem, however, was that weather information had been piling up in the Smithsonian meteorological office, unanalyzed and unpublished, since 1848. Anxious to counter criticism that he had failed to make use of the wealth of information, Henry ignored the backlog, enlisting the services of professor James H. Coffin of Lafayette College in Easton, Pennsylvania, to begin the analysis of more recent data. Coffin, who had contributed a volume, *Winds of the Northern Hemisphere*, to Smithsonian Contributions of Knowledge, employed "from twelve to fifteen persons, many of them female," to reduce and analyze incoming Smithsonian data. The first analytical volume based on Smithsonian information, published jointly with the Patent Office, appeared in 1860 and covered the years 1854–59. A second volume was issued in 1864. Back on a solid footing, the Smithsonian would remain the principal source of American weather information until the creation of a weather service in the US Army Signal Corps in 1870.[48]

HAVING SATISFACTORILY RESOLVED the multiple crises of the 1850s, the secretary reached a decision that probably surprised even himself. Since arriving in Washington, his opposition to a large public museum at the Smithsonian was equaled only by his refusal to accept responsibility for a national library. He appreciated the role that museums could play in American life. Early museums in Charleston, South Carolina, and Salem, Massachusetts, opened in 1773 and 1799, respectively, patterned themselves after the British Museum, offering a mixture of art, natural

history, and what were generally known as cabinets of curiosity. Charles Willson Peale presented the natural and human history of the new nation in ways that would both entertain and educate visitors to his Philadelphia Museum (1784). The Smithsonian staff worked closely with that of the Academy of Natural Sciences of Philadelphia (1812), which was exhibiting its scientific riches to the public, and with Louis Agassiz, who began the tradition of university museums at Harvard in 1859.[49]

Henry did not believe that the Institution should be in the museum business, however. Accepting federal funding to maintain government collections would, he argued, "annually bring the institution before Congress as a supplicant for federal patronage, and ultimately subject it to political influence and control." His hope that Congress might purchase the Smithsonian building for use as office space, allowing the Institution to find smaller quarters, were dashed when such a proposal failed passage by a narrow margin in August 1852.[50]

The pressure was mounting, however. By the early 1850s, the newly established Department of the Interior as well as the General Land Office, Pension Office, Census Office, and Bureau of Indian Affairs had been shoehorned into the Patent Office building, while the collection of patent models continued to grow. The availability of empty space at the Castle, coupled with Henry's indebtedness to Charles Mason, the commissioner of patents, for assistance with the meteorological program, made it difficult for him to continue to refuse.

Historian Joel Orosz has suggested that Henry purchased Baird's cooperation in dealing with Jewett by agreeing to support the establishment of a national museum. While Baird's change of tone was striking, it seems more likely that he simply recognized that time and congressional pressure were on his side. The collection had been steadily growing since his arrival. In 1857 alone, he and his staff made fifteen thousand entries in their collection records. The items ran the gamut from anthropological to geological, paleontological, and zoological specimens. They came from military and civilian explorers participating in government expeditions and from the legion of amateur naturalists Baird was recruiting across the nation.[51]

The collection was attracting researchers who published on its contents. Baird was playing by the secretary's rules, sharing duplicate specimens with colleagues in other museums. Henry, anxious to build and retain Baird's loyalty, was reluctant to restrain a collecting effort that was paying scientific dividends. Recognizing that he risked losing the support of his board and Congress, the secretary gave way, proposing to the regents on March 22, 1856, that the Institution accept control of government collections.

On March 3, 1857, Congress appropriated $3,450 for the "keepers, watchmen and laborers" required to maintain the national collection; $15,000 for the construction of new display cases; and $2,000 for the transfer and installation of the collections at the Smithsonian. On June 6, Attorney General Jeremiah S. Black, responding to a query from Secretary of the Interior Jacob Thompson, suggested that there was no reason why government collections "should not eventually be transferred to the National Museum at the Smithsonian Institution when Congress supplies appropriations . . . for their care." A year later, on June 2, 1858, the House appropriated an additional $5,000 to the Institution "for the preservation of the collections of the exploring and surveying expeditions of the Government." Each year for decades to come, the Smithsonian would submit a request for an appropriation to the secretary of the interior, who would pass the funds back to the Institution to support what was now recognized as the National Museum.[52]

This reversal of his position on collections and museums was one of Joseph Henry's most consequential decisions, fundamentally altering the course of the Institution. Patient and determined, Spencer Baird had won the day. In reluctantly bowing to the inevitable, the secretary was opening the door to Baird's vision for the Smithsonian. Secretary Henry would spend the rest of his life in a futile effort to push that door closed again.

CHAPTER 6

A SECRETARY'S CASTLE IS HIS HOME

AFTER MONTHS OF COMMUTING from Princeton, Joseph Henry was anxious to relocate his family to the nation's capital. His wife, he admitted to his friend Alexander Bache in the spring of 1847, "greatly prefers Philadelphia to Washington." She would, he was sure, grow fond of Washington. "I think when you are once settled here you will be pleased with the place," he wrote early in 1847. He assured her that she could "go into society or not as you may think fit and as there is always something going on during the session of congress there is no want of excitement."[1]

The Henrys moved to Washington the next year, lodging with the family of Henry Rowe Schoolcraft at Tenth and E Streets NW for the first six months of 1848. It did not go well. Schoolcraft, an ethnologist working on his multivolume study *The Indian Tribes of the United States*, had recently married Mary Howard, a slaveholding South Carolinian more than twenty years his junior. The young mistress of the house was incensed that Harriet Henry treated her "as a landlady" and allowed the household slaves "to take liberties in conversing & sitting in rocking chairs in her presence." They became "so insolent," Mrs. Schoolcraft reported, that she sent them back to South Carolina after the Henrys' departure. The family would spend the next seven years lodging with others or living in rented quarters. Finally, in 1855, Joseph and Harriet moved into a newly renovated eight-room suite on the second floor of the east wing of the Castle with their four children: William (age twenty-two), Mary Anna (age twenty-one), Helen Louisa (age nineteen), and Caroline (age sixteen).[2]

"I am now living in the Institution," Henry informed Bache that August. The secretary who had opposed the construction of the Castle would make his home here for the rest of his life. Their rooms had undergone a great many changes since Henry had accepted this first complete section of the building on behalf of

the regents on April 10, 1849. The east wing originally housed a small lecture hall designed by Robert Owen and James Renwick Jr., with the few offices and workspaces of the Institution in the east range. Less than a month before the opening of the first section of the building, the Smithsonian had sponsored several lectures on classical history held at Carusi's Saloon, a popular event space at Eleventh and C Streets. Henry, who had originally doubted the value of lectures, was impressed by the attendance. "I think courses of lectures in Washington will tend to do much good," he reported to Asa Gray on April 2. There "are in the several offices of the city many intelligent gentlemen with small salaries who will attend with their families provided the lectures are free."[3]

On April 30, 1849, Edward Hitchcock, who served as both president and professor of chemistry, natural philosophy, and natural theology at Amherst College, christened the lecture hall in the east wing with the first in a series of three talks on geology. Those who wished to attend were instructed to approach the building from either Seventh or Fourteenth Street "and by paths from there which will be lighted by lamps." While these first lectures were well attended, Henry was disappointed in the lighting, seating, and acoustic qualities of the new room. He met with Renwick on the morning after the inaugural lecture, suggesting major improvements to which the architect agreed.[4]

The original room was a rectangular hall with the lectern at the short end facing some listeners, but with the majority arranged on the long wall to the speaker's right. Henry redesigned the space using the full two stories, with the speaker on the long side of the room facing up to nine hundred persons seated in a semicircular tier rising toward an arched roof.[5]

The Institution had hosted twenty-five lecture series by the end of 1850. The secretary admitted, although he disagreed with the sentiment, that "the lectures appear to the public to be one of the most prominent objects of the Institution." Topics ranged from the history of colonial America to a "course of lectures on the relations of Time and Space—the vastness of the Visible Creation—and the Primordial Arrangement of Existing Systems" by Professor Stephen Alexander, his brother-in-law.[6]

On occasion, the secretary made use of the lecture series to advance his research agenda. On the evening of December 31, 1851, thirty-one-year-old Lieutenant Elisha Kent Kane gave the first in a series of three talks on the recent American expedition to the Canadian Arctic. The weather was so bad on the afternoon of the talk that Henry had considered canceling the event. By seven o'clock, conditions were moderating, however, and the order was given to light the lecture room and open the doors to a crowd that "comfortably filled" the space.[7]

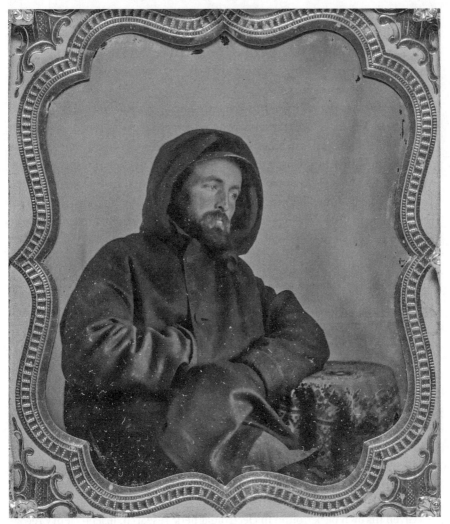

Elisha Kent Kane (1820–57), c. 1855, shown in clothing supplied by Canadian First Nations people. Kane was a medical officer in the US Navy as well as an Arctic explorer. He led the second Grinnell expedition to the Arctic northwest of Greenland, a journey supported by the Smithsonian that captured the public's imagination. *National Portrait Gallery*

A naval surgeon, Lieutenant Kane had served on an early US mission to China, with the Africa Squadron in the suppression of the slave trade, and with distinction in the Mexican-American War. His rise to fame, however, began when he was named chief medical officer of an 1850–51 US Arctic expedition dispatched in search of English explorer Sir John Franklin, who had vanished into the Arctic mists in 1845 with two ships and 129 men. The disappearance of Franklin and his

crew was one of the great mysteries of the mid-nineteenth century. A public campaign launched by the commander's widow, Lady Jane Franklin, and a rich reward offered by Her Majesty's government for information as to the fate of the party, inspired some thirty expeditions to set sail for the Canadian Arctic over a twenty-year period in search of an answer.

Sponsored by the New York merchant Henry Grinnell and led by Captain Edwin De Haven, the US Arctic expedition Kane was part of succeeded, in conjunction with a British party, in finding the graves of three Franklin men and the remains of a winter camp on desolate Beechey Island, evidence that the missing expedition had passed this way.[8] Kane had no doubt what had happened to the Franklin expedition, or where to find them, as he reported to the crowd gathered in the lecture room that evening. The Englishmen, he argued, had made their way through the great barrier of ice ringing the polar region and sailed out into an open sea at the top of the globe. The notion that there might be open water over the North Pole was shared by many, if not most, geographers of the period. Kane announced to his Smithsonian audience that he intended to launch a fresh expedition aimed at breaching the icy barrier and rescuing Franklin and his men from the polar sea.[9]

In late January 1853, Kane returned to the Smithsonian to deliver another talk, "The Physical Aspects of the Arctic Regions, in Conjunction with the Search for Sir John Franklin, and the Discovery of the Open Arctic Sea." This time the newspapers reported that "every inch of sitting and standing room" in the east wing lecture room was occupied by a "brilliant and highly intelligent" audience that included Washington Irving and regent Richard Rush. Impressed by the explorer and the scientific potential of the second Grinnell expedition, which Kane would command, the secretary persuaded the regents to appropriate $500 for the purchase of instruments with which to measure the direction and intensity of terrestrial magnetism in the Arctic Ocean.[10]

Given his own background in electromagnetic research, Joseph Henry recognized Kane's Arctic venture as an ideal opportunity to gather new data and contribute to the international geophysical effort. A decade before the founding of the Smithsonian, Edward Sabine and other members of the British Association for the Advancement of Science had launched the Magnetic Crusade, an effort to gather data on magnetic variation and intensity at various points around the globe.[11]

The British had encouraged the establishment of magnetic observatories across Europe and in distant corners of the Empire. Early in 1853, Henry and Bache agreed to construct such a facility in the area immediately south of the Castle, jointly supported by the Smithsonian and the US Coast Survey. The regents approved $1,100 to cover construction costs.[12] The magnetic observatory, in

operation from 1853 to 1860, was located underground in a shed built of iron-free materials. A mirror reflected the movement of a suspended magnet onto a roll of photographic paper driven by a clockwork mechanism, providing "a continuous record of the variations in the direction and intensity of the earth's magnetic force." Sabine had also gathered magnetic data while serving on Arctic expeditions in the 1820s and played a key role in planning an 1839 Royal Navy expedition to Antarctica with a similar objective.[13]

In December 1852, Henry dispatched a letter to the secretary of the navy suggesting that the US government support the Grinnell expedition. Even if Kane failed to find Sir John Franklin and his men, Henry argued, "it cannot fail to solve . . . problems of very considerable interest to science." Specifically, he pointed to the opportunity to make magnetic observations, gather meteorological information, collect samples of Arctic flora and fauna, study ocean currents in the Far North, and solve geographic riddles, including the existence of a polar ocean. In view of the funds already provided by Grinnell and others, "a moderate aid from Congress and such facilities as the . . . Navy could provide would enable it to realize important scientific results."[14]

Kane and seventeen fellow members of the second Grinnell expedition sailed from New York aboard the brig *Advance* on May 31, 1853. While Henry had failed to persuade government officials to provide financial support for the project, the secretary of the navy approved Kane's participation and instructed him to pay close attention to those "objects of scientific inquiry" outlined by the Smithsonian. The trip did not go as planned. Kane and the members of his expedition returned to New York on October 11, 1855, having succeeded in reaching the farthest point north to date, and suffering the loss of their ship, three members of the party, and thirty months of privation.[15]

Joseph Henry remained one of Kane's most influential supporters. While the natural history collections destined for the Smithsonian had to be abandoned in the interest of survival, the secretary was pleased to report that the instruments for the study of terrestrial magnetism had been returned in working condition, having "done good service in the cause of science in the hands of this intrepid explorer." Kane also donated the multilayered set of garments constructed of bear and bird skins by Indigenous women that had protected him from subzero temperatures. Spencer Baird placed the outfit on public display in the west wing museum in 1858, where it remained on view into the 1870s.[16]

Kane's book on the first Grinnell expedition had been published during his absence. The Smithsonian also published Kane's "Magnetical Observations in the Arctic Seas," as a Contribution to Knowledge. He died of a stroke in Havana, Cuba,

in February 1857. Joseph Henry remained a devoted admirer to the end. "Where had there been recorded, at sea or on shore," he asked, "any memoir of a man of a more refined sensibility, of more daring intrepidity, or of more heroic devotion than that which characterized Dr. Kane."[17]

Popular lectures like Kane's convinced Henry of the need for a new, larger auditorium. In apportioning space in the central section of the Castle, the secretary discarded Renwick's original scheme, which called for both stories of the building to serve as museum space. Instead, the second floor would be subdivided into three spaces: an art gallery, a room for the display of scientific instruments, and a new lecture hall that Henry regarded as "by far the best in this country." Working with Alexander Bache, Henry conducted acoustical experiments in great halls and churches in New York, Philadelphia, and Boston and studied Montgomery Meigs's approach to acoustical planning in the redesigned House and Senate chambers.[18]

The finished two-tiered amphitheater sat 1,500 comfortably, 2,000 with some crowding. Completed in the fall of 1854, the room would not only serve for lectures but would also host the meetings of the United States Agricultural Association, the American Association for the Advancement of Science, and other scientific, medical, and educational organizations and the occasional musical performance.[19]

AS EARLY AS MARCH 12, 1853, the Board of Regents agreed to study the secretary's proposal that a portion of the east wing be redesigned to serve as living quarters for the Henry family. Such a step would save the Institution the $500 annual housing allowance to which the secretary was entitled. Moreover, the requirement for a larger lecture room would free space in the east wing. By 1855, with the museum, art gallery, and lecture hall housed on both floors of the main building and the west wing devoted to the library and a reading room in the west range, the east wing could be repurposed.[20]

The original section of the building was converted into two floors. The first floor was devoted to the exchange service and storage of publications. The east range housed the Institution's chemical laboratories, taxidermy shops, and collection preparation and preservation areas. The second story of the east wing would serve as the Henry family living quarters. Initially, there were four bedrooms, Henry's study, and a dining room, music room, and water closet. A steep set of stairs led down to the east door. During building modifications in 1872, the family quarters were extended to include three additional bedrooms and an art studio for daughter Mary in the east range.[21]

THE SMITHSONIAN INSTITUTION.

THE LECTURE ROOM.

Engraving of the lecture room on the second floor of the Castle from an 1857 guidebook. The lecture room was used for scientific demonstrations, free public lectures, meetings, and concerts and could hold more than one thousand people. In 1865, a fire destroyed the upper rooms of the west wing of the Castle, including this space. *Smithsonian Institution Archives*

There were some initial problems with the new quarters. In the fall of 1853, a year after moving into the Castle, Henry woke with a headache and general malaise that he blamed on the foul smells drifting up from the "fish room" on the first floor where preserved ichthyological specimens were stored. Disheveled, he rushed downstairs and ordered three workmen, William De Beust, Roger Sullivan, and John Connor, to dispose of the material. Charles Frédéric Girard, the naturalist overseeing the fish collections, arrived a few minutes later with Solomon Brown, Baird's eyes and ears when he was away from Washington. They persuaded Henry to allow them to move the offending barrels and jars to another part of the building, after which the floor of the fish room was washed and the walls whitewashed.[22]

Then there were the fleas. In the summer of 1857, Henry instructed Solomon Brown to remove all hides and skins in the collection to a space over the lecture room in the main building and "arrest and kill every flea," for, he added, "I am tormented." The secretary and his family were not the only sufferers. Brown

encountered William McPeak soon thereafter, "with one hand down his back and the other in his bosom." The original Smithsonian employee, McPeak lived in the Castle with his wife, who cooked for the Henrys. "Solomon," he complained, "do you know anything that keeps away the confounded animals—if I do not get something soon[,] they will eat me and my old woman up."[23]

The problem remained, despite the creation of a "poisoning workroom" aimed at the destruction of the vermin. In 1867, Henry informed Nancy Bache that, while he had been spending time by himself in the Castle, "I have had more company than desired in the way of visits from fleas and mosquitoes." He described his ultimate victory in a letter to his absent wife. "As the enemy did not scruple to attack me when least prepared for defense, and in the midst of darkness, I felt justified in adopting a similar kind of warfare, and had recourse to a poisonous atmosphere of the vapor of camphor. I strewed this substance in a pulverized condition over the field of conflict," he concluded, "and by this means put the enemy to flight."[24]

During the storied heat of Washington summers, conditions in the Castle grew insufferable. "The walls of the Smithsonian Building are exposed to the south to the direct rays of the sun," Henry complained, "and on account of their thickness and the thickness and color of the stone, continue to grow hotter and hotter from the beginning to the end of the hot term until they become like the sides of an oven in a condition to cook whatever they may contain. The temperature in our bedroom at midnight was ninety-one."[25]

The Henrys shared both the charm and the difficulties of life in the Castle with others who had apartments, rooms, or large closets scattered here and there around the building. Some, like William McPeak and his wife, were employees. William De Beust, a blacksmith and machinist who had worked with Dr. Robert Hare at the University of Pennsylvania and whom the secretary regarded "a very ingenious and skillful workman," shared a room near his workshop with his wife, Margaret, who eventually replaced Mrs. McPeak as the Henry family cook. Theodore Gill, an ichthyologist, resided in the Castle, as for a time did William Rhees, who began work at the Smithsonian as the secretary's personal assistant.[26]

William Wadden Turner was also a resident. The secretary's adviser on matters of philology, he had given up a distinguished teaching career in New York City in 1852 when he moved to Washington to organize the Patent Office Library. Spencer Baird hired him as Smithsonian librarian in 1858. When he died the following year, Joseph Henry celebrated Turner as "a ripe scholar, a profound philosopher, and an honest man."[27]

Jane Wadden Turner, Turner's sister and the first female professional employee, moved into the Castle in 1858 when her brother hired her as a library clerk in charge of cataloging. Secretary Henry promoted Jane Turner to librarian following her brother's death, commenting that she "vindicates by her accuracy and efficiency the propriety of employing her sex in some departments of the government." She later took charge of the exchange system. Although her rise was limited by the judgment that a woman should not exercise authority over professional men, she remained an employee of the Institution for twenty-nine years.[28]

Then there were those whom Mary Henry described as "the young men of the building." In 1853, members of the navy's North Pacific Exploring and Surveying Expedition were housed and trained at the Castle while the Institution tested instruments, procured scientific equipment, and prepared scientific instructions for their trip. It was Spencer Baird, however, who began the practice of housing a string of young men, both naturalists-in-training and seasoned explorers following their return from expeditions. Unlike the secretary, Baird was mentor to two generations of budding scientists who would remain connected to the Institution for decades to come and linked the Smithsonian to the scientific exploration of the nation.[29]

This first generation of Baird's scientific boarders in the mid-1850s began referring to themselves as the Megatherium Club, in honor of the extinct South American giant sloth, a plaster cast skeleton of which would dominate the growing museum display that greeted visitors in the 1870s. Bostonian William Stimpson, the founder of the Megatherium Club, had studied with Louis Agassiz (1850–52) at Harvard. In 1852, he became one of the first of several student assistants to escape their professor's tight control, signing up as a naturalist with the North Pacific Exploring and Surveying Expedition.[30]

Baird invited Stimpson to join the coterie of young naturalist collectors gathered around him at the Smithsonian in 1856. That invitation fueled Agassiz's resentment against Baird. Stimpson's best friend and fellow Megatherian, Robert Kennicott, a talented, self-trained naturalist with a taste for adventure, was one of Baird's regional collectors before arriving in Washington to study specimens from Hudson's Bay. Henry Bryant, a Harvard ornithologist, had served as a surgeon with the French army in Algeria, while Prussian-born Henry Ulke had gathered "one of the largest and most perfect collections of the beetles of North America."[31]

Ferdinand Vandeveer Hayden had trained under paleontologist James Hall before he captured Baird's attention. Born in Massachusetts in 1829, he was

107

Megatherium Club, c. 1862–63. The four young men in this photograph (clockwise from top left)—Robert Kennicott, Henry Ulke, Henry Bryant, and William Stimpson—were members of the Megatherium Club, an informal fellowship of Smithsonian naturalists mentored by Spencer Baird and living in the Castle. *Smithsonian Institution Archives*

raised by relatives and worked his way through Oberlin and the Albany Medical College. "A jolly good fellow Hayden is, who always falls desperately in love several times a month," one friend quipped. Others found him deceitful and self-serving.[32]

He participated in fossil-collecting trips through Kansas, Nebraska, and South Dakota from 1854–58, several under the command of Lieutenant Gouverneur K. Warren. Hayden made important contributions to the Smithsonian collection each year, including additional fossils from the Badlands of the Nebraska Territory where John Evans and Thaddeus Culbertson had collected, and at least occasionally stayed with the Megatheria in the Castle between trips. In 1857, the one year he was not accompanied by his friend Fielding Bradford Meek, Hayden shipped that year's collection to Meek, who was working in a Smithsonian laboratory. Attempting to evade a party of Sioux, he discarded a large bag of fossils. Astounded, the Sioux dubbed him "The Man Who Picks up Stones Running."[33]

"By the kindness of Professor Henry," Lucy Baird explained, "many of the unused rooms, too high up for business purposes, and situated conveniently for

access to their work, were assigned to such young students as lodgings." The young naturalists supplied their own furnishings and linen and either dined at a boardinghouse or paid Mrs. McPeak to furnish their meals. For a small fee, several of the African American employees of the Institution supplied cleaning services.[34]

Professor and Mrs. Baird kept watch over the "budding scientists roosting in the Smithsonian towers by night and digging away at specimens by day." Sunday evenings frequently found them gathered in the Bairds' home, often to meet men already distinguished in science or war, hear of the latest discoveries in the Far West, or debate disputed scientific questions. Many years later, Lucy Baird would fondly recall that they "formed an interesting and somewhat unique household."[35]

Some of the Megatheria accompanied the US Army Corps of Topographical Engineers expeditions surveying a continent; all of them would be involved in cataloging its wonders. But they had a lighter side, as Kennicott recalled. It was at five o'clock in the afternoon, he explained, "when the Megatherium takes up its prey, that the most interesting character of the animal are seen—Then it roars with delight and makes up for the hard work of the day by much fun." Professor Baird, he concluded, was "the keeper of it and allows it full swing—though he keeps one eye always open to its movements and behavior."[36]

Kennicott's younger brother Bruno was surprised to discover how boisterous the Megatheria could be. "They are . . . Doctors and Professors and all that," he noted, but "after all they are just like a parcel of boys—Why tonight they ran races and hopped and jumped in the big museum hall . . . some of them are big naturalists, but they act mighty like small boys." Brother Bob, he recalled, hid behind a group of mummies and made groaning noises to scare the others.[37]

Baird would cycle other young naturalists who had participated in federal scientific surveys through the Castle in decades to come. He provided a training ground for the scientific explorers who would catalog the natural wonders of the Far West and the Arctic north and fill the Smithsonian collections with scientific treasure. One of them, Caleb Kennerly, had studied under Baird at Dickinson College, earned a medical degree, and participated in the Pacific Railway Survey along the thirty-fifth parallel (1853–54), the United States and Mexican Boundary Survey (1854–55), and, after some time arranging his own collections at the Smithsonian, the Northwest Boundary Survey (1857–61). Following Kennerly's death at sea in 1861, Baird commented, "No one of the gentlemen who have labored so zealously to extend a knowledge of the natural history of the west within the last ten or twelve years has been more successful than Dr. Kennerly."

Baird arranged for James Graham Cooper, another army physician-naturalist, to join Captain George McClellan on a Pacific Railroad Survey in Washington

Territory. A decade later, he would coauthor a book on the birds of California with Baird. Addison Emery Verrill studied under Agassiz at Harvard and participated in collecting trips in wilderness areas of New England and Labrador, Canada, before being dispatched to the Smithsonian in 1861 to cement the relationship between the Institution and Harvard's Museum of Comparative Zoology. His decision to remain at the National Museum, however, only increased Agassiz's animosity toward Baird. In a similar fashion, paleontologist Edward Drinker Cope spent time with Baird at the Smithsonian during the Civil War, representing the Academy of Natural Sciences of Philadelphia. During the 1870s, he worked as a member of US Geological Survey teams and emerged as a scientific celebrity, rivaling Yale's Othniel Charles Marsh in the pursuit of dinosaur fossils across the West.[38]

Henry was less sure of the value of Baird's provision of aid, comfort, and shelter for fledgling naturalists. "I have concluded that the making of the smithsonian [sic] building a caravansary has been carried a bit too far," he wrote to Baird in August 1863.[39]

Ultimately, Henry was unable to stem the tide. The flow of young students and assistants through the halls of the Smithsonian was an essential element of the Institution's operation and a critically important contribution to the future of geology, biology, and anthropology in the United States. Lists of the addresses of Smithsonian personnel as late as the 1880s featured a number of leading researchers living in the Castle, including Elliott Coues, ornithologist and American pioneer of taxonomy; Frank Hamilton Cushing, the anthropologist who introduced the practice of embedding a researcher in an Indigenous culture; William Dall, who would spend the early years of his career exploring Alaska with Robert Kennicott and later decades at the Institution as the world's authority on fossil mollusks; Robert Ridgway, whom Baird lured to the Smithsonian in 1880 and who would spend the rest of his life as the Institution's first curator of ornithology; and Henry Wood Elliott, environmentalist, watercolorist, and Alaskan explorer.[40]

THE THOUSANDS OF CURATORS, conservators, collections managers, and exhibition designers who have walked the halls of the Smithsonian since 1855 can trace their professional roots to one man, John Varden. A longtime resident of Washington, Varden was a dedicated collector and born showman. In 1829, he began collecting items that interested him. In the summer of 1836, he invited the citizens of the district to inspect his collection, known as the Washington Museum, which included four hundred to five hundred objects arranged in a large room of his

house at the corner of John Marshall Place and D Street, near City Hall. The National Institute acquired the entire collection in the summer of 1841 and appointed Varden the superintendent of the museum in the Patent Office, where he worked for sixteen years.[41]

When the Smithsonian acquired the National Institute collection in 1858, it had grown far beyond the historic specimens deposited by the Wilkes expedition. The acquisition ranged from such American treasures as Gilbert Stuart's portraits of Washington, Adams, Jefferson, and Monroe to hair clippings from noteworthy Americans, including every president from George Washington to Franklin Pierce, a reflection of the P. T. Barnum aspect of Varden's personality. The sixty-eight-year-old Varden moved with the collection. Reporting to Henry and working directly with Baird, he supervised the five-year process of transferring the collections from the Patent Office to the Castle, helped to create the Smithsonian Museum, and remained with the Institution until his death in 1865.[42]

By 1858, visitors in search of the museum in the Castle walked under the porte cochere, up a short flight of steps, and through the great north door. They passed through a foyer with grand curving staircases on the right and left leading to the lecture hall, art, and apparatus rooms on the upper floor. Continuing through a set of inner doors, they found themselves in what was already unofficially known as the national museum.[43]

As William Rhees noted in the first guidebook to the public spaces of the Smithsonian, the thousands of objects on display "constitute the largest and best series of minerals, fossils, rocks, animals, and plants of the entire continent of North America in the world." Most of the collection came from twenty-five of the thirty exploring expeditions dispatched by the United States since the 1820s. In addition to the items returned by the Wilkes expedition and the various surveys of the United States, specimens had been provided by the United States Naval Astronomical Expedition to Chile, Commodore Perry's voyage to Japan, an official visit to Paraguay, and Lieutenant William Herndon's exploration of the Amazon.[44]

Under Spencer Baird's direction, the collection was housed in eighty-four display cases. A long line of white, slant-topped cabinets transferred from the Patent Office ran east and west along the main corridor, with new vertical cases designed by architect of the Capitol Thomas Ustick Walter placed on the floor of the nave, in the bays, and on the deck, or mezzanine, so, as the *Washington Union* explained, "the contents of the cases when they are filled can be more easily examined."[45]

Visitors entering and turning left into the east gallery encountered cases filled with mammals, birds, fish, reptiles, and amphibians. A door at the far east end of the gallery led to the room in which taxidermist C. Drexler prepared specimens for display. "Any persons having a pet bird or animal they wish to preserve," the guidebook advised, "can have it beautifully mounted at a moderate charge."[46]

The west gallery housed displays on Native Americans and the peoples of South America, the Pacific, Asia, and the Arctic. There were mummies from Egypt and Peru, weapons, clothing, domestic items, tools, and ceremonial objects. Geological and mineral specimens were exhibited on the mezzanine. Cases on the upper level also contained 150 animal skulls and a wide range of human and animal skeletal material.[47]

A small menagerie room housed the liveliest exhibits in the museum. Varden instructed one of his young assistants to "get young birds, bull frogs or live fishes for the water snake." The salamander, he added, "will eat earth worms freely and has been fed twice this week. Whatever is got," he continued, "will not be lost as the alligator . . . is ravenous as a wolf and eats everything that is put to him."[48]

Having taken in the museum proper, visitors could climb the stairs to the second floor to tour the Apparatus and Art Rooms on either side of the lecture hall. A set of scientific instruments donated by chemist Robert Hare formed the original core of the Apparatus Room. In addition, there were instruments for investigating gases, heat, light, sound, and electromagnetism. A Fresnel lens of the sort operated by US lighthouses was also on view, a reminder of Secretary Henry's long service as one of two civilian members of the US Lighthouse Board and the scientific adviser who urged the adaptation of the specialized lens.[49]

A large marine aquarium was the centerpiece of the Apparatus Room. The Smithsonian aquarium, planned by Megatherium Club member William Stimpson, contained "about three hundred specimens of animal vitality, belonging to some thirty-eight species of fishes, Molluscae, Crustacea, and Polyeps." A reporter for the *Washington Union* wondered at the variety of creatures, from the clams buried in the white sand with their syphons protruding to the "belligerent" crabs and the transparent jellyfish. "It is next to impossible . . . to give an idea of the inhabitants of the Smithsonian aquarium," he concluded, advising all who can to pay it a visit.[50]

The exhibition of art at the Smithsonian dates to 1850, when Charles Jewett displayed sample engravings from the George Perkins Marsh collection in the library.[51] The dedicated Art Room, on the west side of the lecture hall, opened to the public in 1855, three years before the museum. Initially, Henry and Baird,

underscoring their commitment to the study and presentation of Native American cultures, selected more than 150 paintings of Indians and Indian life by John Mix Stanley. The artist painted his first Native American subjects at Fort Snelling, Minnesota, in 1839 and spent two decades traveling the West, capturing images representing forty-three tribes. Henry pressed Congress to appropriate funds to acquire this "faithful ethnological record of the characteristics of the aboriginal inhabitants of the western portion of the continent." The effort was unsuccessful, and the paintings remained on display as loan items.[52]

After 1858, an additional 147 Native American portraits by New York artist Charles Bird King were crowded chockablock on the walls of the Art Room along with the Stanley paintings. Thomas L. McKenney, who served as superintendent of Indian Affairs in the War Department from 1824 to 1830, began commissioning portraits of the members of Indian delegations visiting the capital in 1822 and continued the effort for two decades. Most of the paintings in the collection were by King, but works by James Otto Lewis and George Cooke were also included. The works were displayed for many years in the War Department as the National Indian Portrait Gallery. The Stanley and King paintings remained on display in the Art Room until 1865, when most were destroyed in a great fire that swept through the Castle.[53]

THE NATIONAL MUSEUM WAS Baird's creation. Henry continued to complain that the Smithsonian ought not be in the business of public exhibitions. "Our principal incumbrance [*sic*] is the Museum and the building connected with it," he reported to a German friend as late as 1868. "Could I succeed in transferring these to the government, my mission . . . would be fulfilled. In this, however, I find considerable opposition."[54]

Recognizing that Congress was unlikely to relieve the Institution of a task it was performing so successfully, Henry was determined that the displays in the Castle would support the research goals of the Institution. "It is no part of the plan of the Institution to form a museum merely to attract the attention and gratify the curiosity of the casual visitor to the Smithsonian Institution," Henry explained. Rather, "it is the design to form complete collections in certain branches, which may serve to facilitate the study and increase the knowledge of natural history and geology."[55]

The secretary was pleased to report that, thanks to Spencer Baird, "no collections . . . in the United States, nor, indeed, in the world, can . . . pretend to rival the richness of the museum of the Smithsonian Institution in specimens which . . . illustrate the natural history of . . . North America." Baird had convinced

the secretary that collections were the essential foundation for serious work in natural history. That resource would be of little value, however, unless the individual specimens were identified, analyzed, and suitably arranged.[56]

Baird saw the museum as a means of illustrating the rich diversity of the natural world while also helping naturalists and the public visualize relationships between living things. The arrangement of the flora and fauna in the cases reflected the principles of systematic taxonomy, representing the way in which individuals of one species differed from those of another as well as suggesting ways in which they were related. Baird began as a systematist, devoted to taxonomy, the identification of those morphological characteristics of a specimen that marked it as belonging to a specific kingdom, class, family, genus, and species.[57]

The connection between organisms was the subject of the great mid-nineteenth-century debate in the natural sciences, and one of the great intellectual revolutions in the history of science. In 1859, Asa Gray, who was in correspondence with Charles Darwin, published a study of similarity of some plant species in eastern North America and Japan, introducing one of the earliest expressions of Darwinian evolution. Under his influence, Baird shifted from a pure systematist to a nuanced Darwinian view. The proof of evolution, Baird recognized, lay in the steady stream of collections flowing into the Smithsonian from volunteer naturalists.[58] The central importance of museum collections as evidence of biological relationships and change in the natural world was apparent.[59]

Joseph Henry paid close attention to the heated debate over evolution, moving toward Gray's point of view. "I sent for a copy of Darwin's book as soon as . . . it was announced in England," Henry assured Gray. In a letter promising to send Representative Thaddeus Stevens a copy of *On the Origin of Species*, the secretary expressed his own view. He remarked, "I consider his book as one of [the] prominent productions of the day—destined to have a great influence on the study of the animal and vegetable productions of the earth as well as on the tendency of the human family so far as its members are influenced by external nature."[60]

The 150 skulls on the mezzanine were quite another matter. Based on his measurements of a large collection of skulls, Samuel George Morton, a Philadelphia physician and naturalist, argued for a separate creation of the individual human races and established a hierarchical ranking based on cranial capacity. Caucasians were on the top of his human pyramid, with other races cascading down to Africans at the bottom. Morton's *Crania Americana* (1839) set the stage for later writers, notably Josiah C. Nott and George Gliddon, whose *Types of Mankind* (1854) rejected both biblical creation and evolution, arguing that the human races

were created separately and intended to function in the particular environments in which they were born. Proslavery advocates pointed to this growing tradition as a "scientific" basis to justify slavery and virulent racism.

Henry had often expressed his views on the question of race, and he had gratefully accepted Morton's positive comments on *Ancient Monuments of the Mississippi Valley*, which included illustrations and discussions of Native American skulls from mound graves. As historian Curtis Hinsley Jr. notes, however, the secretary rejected attempts to gauge intelligence on the comparison of brain cases as "politically explosive and morally repugnant." He was careful not to commit the Smithsonian to a position on the origin of races or the work of Morton and his followers. "We shall be obliged to be very careful on two points," he warned archaeologist Samuel Haven, "namely not to commit ourselves on the vexed question of the unity of the races, and not to be too free in our remarks on living authors." When Haven continued to discuss the work of Morton, Nott, and Gliddon, Henry responded more forcefully, warning that "several of the writers which you have cited have but little or no authority in the scientific world."[61]

WHEN THE CASTLE BEGAN TO RISE, the National Mall was a nondescript field with patchy shrubs and the occasional tree. "The story of The Mall from 1800 until the Civil War," one commentator has noted, "is largely one of neglect." Joseph Henry devoted considerable effort to improving matters. "I have taken every opportunity," he explained, "of expatiating on the capacity of the mall to be made one of the most beautiful drives in the world." His opportunity came in 1850 when, in cooperation with William Wilson Corcoran, the Smithsonian's banker, and city officials, he approached President Millard Fillmore for assistance in funding the services of landscape architect Andrew Jackson Downing to prepare a plan for the beautification of the ellipse, Lafayette Square, and the Mall.

Downing and his partner, Calvert Vaux, were well-known writers on horticulture and landscape gardening. Henry wrote the letter of invitation to Downing and escorted him to the President's House for a visit with President Fillmore. Downing presented his plan for the improvement of the entire Mall at a meeting of the Board of Regents on February 27, 1851. The board approved Downing's vision on March 21. "When it is completed," the members of the Building Committee noted, "the whole of the area known as the mall . . . will be converted into a beautiful park adorned with evergreen and other ornamental trees, and traversed with carriage drives and gravel walks. During this variegated landscape the Smithsonian building will occupy a prominent position, and with its picturesque architecture will produce a harmonious effect."[62]

Downing's plan called for the creation of six "scenes": a President's Park facing the President's House, the Washington Monument grounds, an Evergreen Garden from Fourteenth to Twelfth Street, a Smithsonian Pleasure Ground from Twelfth to Seventh Street, a Fountain Garden from Seventh to Third Street, and a Botanical Garden at the foot of Capitol Hill. In all, he called for planting 130 varieties of trees capable of flourishing in Washington. The Smithsonian Pleasure Garden was to be a picturesque area "thickly planted with the rarest trees and shrubs, to give greater seclusion and beauty to its immediate precinct." Curving gravel paths would loop through the entire area, providing a natural contrast to the straight streets and sharp angular corners of Pierre L'Enfant's city plan. Downing called for striking architectural features, including a triumphal arch framing the view of the President's House and an ornate bridge replacing the simple iron span then providing a walkway over the city canal on Tenth Street.[63]

Work on the transformation of the Mall and other public areas had scarcely begun when Andrew Jackson Downing lost his life in a steamboat accident on July 28, 1852. His looping paths were in place, shaded by many of the trees he had selected. Most of the plan died with him, however, and with it, Joseph Henry's vision for the Mall.

Because of this, pedestrians headed for the Smithsonian to attend a lecture or stroll through the museum on a hot Washington summer day in 1860 would have passed through an area of the city that was, Henry admitted, "exceedingly bad." Approaching from the north, they had to brave Murderer's Bay, a triangular area between Ohio and Pennsylvania Avenues along the northern edge of the city canal. Recognized as the city's worst neighborhood, it was dominated by decaying houses, bars, and brothels and would grow far worse with the influx of tens of thousands of soldiers over the next five years.[64]

Visitors would then cross over one of the four small bridges spanning the city canal at Fourteenth, Twelfth, Tenth, and Seventh Streets. The canal, which Downing had planned to reposition, ran along the northern edge of the Mall and cut off "the island," the area including the Mall and the southern and southwestern neighborhoods, from the rest of the city. New sewer lines discharged the untreated waste of a growing population into the canal. Sewage intended for the river would be forced back up the canal toward the Mall at high tide. Black clouds of flies and mosquitoes rose from the fetid water during the sweltering Washington summers to spread misery and disease across the city. On bad days, the stench of the canal carried across the Mall to the Smithsonian.[65]

A SECRETARY'S CASTLE IS HIS HOME

The walk across the Mall was no more pleasant. The secretary admitted that "complaints have frequently been made against the Institution, on account of the bad condition of the walks leading to the building." In his defense, he pointed out that while care of the grounds was the responsibility of the government, a "plank walk has . . . been laid down along the principal throughfare and lighted, on nights of lectures, at the expense of the Institution."[66]

BY THE END OF THE 1850S, the secretary and his staff had turned their attention to the world beyond their declining neighborhood. "I am pleased to be able to inform you that all of the affairs of the Institution are in a prosperous condition," he reported to Edward Sabine, soon-to-be president of the Royal Society, "and that every part of the plan of organization originally proposed by myself is in successful operation." The building was complete. The meteorology program could count some five hundred volunteer observers reporting directly to the Smithsonian, another seventy-five submitting their reports through the War Department, and additional information coming from fourteen Canadian stations and 166 US lighthouses. The exchange program reported the receipt of one thousand packages of publications and shipped 888 bundles to recipients abroad and across the nation.[67]

Baird and his assistants recorded the acquisition of a grand total of 55,389 new specimens into the collection in 1860, from 29,875 birds to 550 ethnological items. Many of the "young men of the building" were far from their Smithsonian home. Robert Kennicott was collecting in the Hudson's Bay region and exploring what was still known as Russian America. Elliott Coues was gathering birds and eggs and preserving specimens in alcohol on the coast of Labrador. Ferdinand Hayden was attached to an army expedition traveling through the Upper Missouri and Yellowstone country.[68]

The officers assisting the Institution in 1860 included Captain John Pope, who led a party into New Mexico and returned a variety of specimens in alcohol to Baird. Captain Charles Stone forwarded a collection of shells from the Gulf of California. General Joseph Totten of the Board of Regents contributed minerals from California, while Commander David Dixon Porter provided fish from the west coast of Central America. Noncommissioned officers contributed as well. Sergeant John Feilner, who would become a great favorite of Baird's, was forced to abandon most of the items he had collected for the Institution during a running battle with hostile Indians. "His gallantry," Baird noted in the annual report, had "been made the subject of especial commendation in a general order from the War Department."[69]

Over the next twelve months, those officers and men and tens of thousands like them would face a very different set of challenges that would determine the fate of a nation at war with itself. Secretary Henry and his colleagues would wrestle with problems of their own, struggling to continue their pursuit of the "increase and diffusion of knowledge" while navigating difficult political waters and, occasionally, finding new ways in which the Institution could be of service to the government. Like the rest of the nation, the Smithsonian Institution faced a time of crisis.

CHAPTER 7

WAR CLOUDS

THE ANTEBELLUM SMITHSONIAN WAS no hotbed of abolitionist sentiment. With the approach of the sectional crisis, racist attitudes were common among the Institution's leaders. Since 1846, at least nineteen regents had been slaveholders. Regent Jefferson Davis believed that slavery "elevated" African Americans "from brutal savages into docile, intelligent, and civilized agricultural laborers." In 1857, Chief Justice and chancellor of the Institution Roger Taney ruled in the Dred Scott case that persons of African descent were "so . . . inferior that they had no rights which the white man was bound to respect and that the negro might justly and lawfully be reduced to slavery for his benefit." Even Alexander Bache remarked, "I do not like dusky company."[1]

Joseph Henry shared those attitudes. He put the matter bluntly in a November 1860 letter to botanist John Torrey: "I am convinced that while the negro retains his peculiarities he never can exist in juxtaposition with the white man, but in a state of servitude."[2] Writing to Asa Gray just over a week later, Henry commented that he had "little hope that the black man can ever be civilized unless by selection over the course of geological periods." Nor did he think "that the negro can ever exist in close approximation with the white man except in a state of slavery." While historian Robert V. Bruce underscores the prevalence of racist views among antebellum scientists, he calls particular attention to Joseph Henry as one of the most outspoken on the subject.[3]

With Darwinian evolutionary theory in mind, Henry argued that the truth of white supremacy rested on the principle of survival of the fittest. He believed all human beings were grouped along a natural gradation. Anglo-Saxons, "those who have descended from . . . Old England," were the most highly developed of the world's peoples. At the bottom of the scale stood "the most degraded race with which we are at present acquainted," the isolated tribesmen of the Andaman Islands, "who were but very little above animals of marked sagacity." Even these,

he insisted, "must be classed with *Homo Sapiens*." Inspired by the controversial position of Thomas Henry Huxley, "Darwin's Bulldog," Henry went so far as to suggest that the scale might continue down from the "most degraded race" to the monkey.[4]

From Tasmania to the American West, he noted in 1860, the "more barbarous races in the temperate zones are destined to be driven from the great field of contest by the civilized portions of the globe. Thus, the wars of humanity tend to improve the race." Enslaved Africans and their descendants had prospered in the temperate climate of America, Henry concluded, only because they "have been cared for as the cattle have been cared for by the agriculturalist."[5]

The end of slavery, Henry predicted, would spell disaster for emancipated persons. Left "to themselves to carry on the battle of life with the whites they will like the Indians be driven to the wall and in time go out of existence." He applied Darwinian terminology to explain that the relatively successful free African Americans living in the North were "merely retained on the principle of natural selection. The stronger and more intellectual continuing the battle a little longer than their less persistent brethren."[6]

Morally opposed to slavery but unwilling to accept the possibility of freed slaves as fellow citizens, the secretary pointed to colonization as the solution to the national dilemma. "I would make the experiment on a grand scale," he told a friend, "and expend millions under the direction of the colonization society in establishing an empire in Africa." Such a colony, he explained, "will be so attractive to the negro that under the repulsive influence of caste in this country he will be voluntarily impelled in that direction." If leadership proved to be a problem, the settlement might be ruled "by the half-breeds that we could constantly furnish for many years to come."[7]

As the 1860s approached, and the nation became more divided on the issue of slavery, Henry recognized that the war was inevitable. "While from the rapid increase of population by immigration the north was constantly becoming more and more democratic," he explained, "the south with the advancing value of cotton was continually becoming more aristocratic and the feelings of the two sections even more adverse than those of England & France."[8]

At the same time, he doubted that the conflict would settle the issues. "Is there any proper grounds for a civil war?" he asked his brother-in-law Stephen Alexander. "After the southern states are conquered will they then be the obedient loving members of the brotherhood of free men?" His own view, he explained to Asa Gray, was to admit "that our union as a whole cannot be permanent, and that it

will be far better to separate peacefully than to deluge the country with blood, and then in the end be as far from a harmonious union as we are now."[9]

Spencer Baird agreed that war would fail to save the Union. "I was averse to coercion," he wrote to a colleague, "and rather in favor of letting the South try it's [sic] experiment." When he learned that an acquaintance had referred to him as a secessionist, Baird assured him that he was a Pennsylvanian "with strong unionist feelings." Perhaps, but when war came, the thirty-eight-year-old assistant secretary would pay $278 to hire an African American substitute so he could avoid the draft, and consistently advised friends and relatives contemplating enlistment to consider signing up with the home guard instead.[10]

Both men sometimes spoke without appreciating how their words might be interpreted. If war came, Baird assured a Southern colleague, "as long as the Smithsonian is in existence and a free agent, there will be no difference in its relations to different parts of the continent." Far from expressing dismay at the election of his ally Jefferson Davis to the presidency of the Confederate States, the secretary naively remarked that his friend's "talents and integrity" would serve the South well.[11]

"WE ARE JUST NOW ON the eve of an election for a President of the U.S.," Henry remarked to a Canadian friend in late October 1860. "The prospect is that Abraham Lincoln, the candidate opposed to the extension of slavery, will be elected and there is some fear that that there will be some difficulty in the southern states." Henry voted for John Bell and the Constitutional Unionists and was, John Torrey recalled, bitterly opposed to the new president at the time of his inauguration.[12]

The election, as Henry had predicted, did occasion some difficulty in the Southern states. "The papers today give a full account of the bombardment of Fort Sumter," Mary Henry noted in her diary on April 15, 1861. "The President has issued a proclamation calling forth seventy thousand militia for the preservation of the Union, or rather for the vain attempt to restore to its pristine glory the temple whose columns lie prostrate." Rumors circulated throughout the city. Troops from Rhode Island were said to be on their way to protect the capital. While Pennsylvania supported the president, it was feared that New Jersey might secede. Henry's friend Dorothea Dix, the New England social activist who had come to Washington to offer her services as a nurse to the surgeon general, called on the family in the Castle, predicting that the nation "was soon to be devastated by a war too dreadful to imagine."

"Virginia, the home of Washington, is no longer in the Union," Mary reported. As if to confirm that fact, the Henry family climbed the stairs to the top of the tall north tower and saw "the secession flags waving in Alexandria, while every public building in Washington was surmounted by the Stars & Stripes."[13] Given the proximity of those enemy flags and the isolated location of the Smithsonian, close to the Potomac, the government took a serious interest in the Castle. Newly appointed Secretary of War Simon Cameron ordered the delivery of twelve muskets and 240 rounds of ammunition "for the protection of the Institute from lawless attacks." During the first weeks of the war, the government proposed to quarter some of the thousands of troops who would soon arrive to defend the capital in the Castle. Henry responded that the Board of Regents had no authority to approve the use of the building for such a purpose, but if the War Department insisted on the necessity for such action, he would "cheerfully" arrange to house the soldiers while protecting Smithsonian property. In the end, the government would not require the Castle as either a barracks or an infirmary, but the Smithsonian would not escape the impacts of war.[14]

As early as June 1860, six months before South Carolina seceded from the Union, a Senate debate over a $4,000 appropriation to the Smithsonian for the support of government collections revealed vocal opposition to the very existence of the Institution. While Henry's supporters in the upper chamber argued the wisdom of the expenditure, John P. Hale of New Hampshire remarked that in ignoring James Smithson's "sublime conception of a democratic university," the leaders of the Smithsonian were guilty of "perverting Mr. Smithson's benevolent and sagacious purposes [and] defeating one of the greatest ideas that ever entered into the head of a benevolent scholar—instead of making such an institution as he wanted, you have founded the great humbug of the land."[15]

Senator Simon Cameron remarked that he was "tired of all this thing called science here. . . . We have spent millions in that sort of thing for the last few years, and it is time it should be stopped." He was referring to the expenditures on a series of military-supported survey expeditions, which usually included a scientific component. "When we are talking about the distresses of the country; when we do not know how much country we shall have in a few days; when the treasury is empty . . . we are asked to appropriate $6,000 or $10,000 to preserve what you call scientific specimens." Toads and snakes, he concluded, "are of no use to anybody now; they have served their day." Cameron and Hale were outvoted. The appropriation passed with a vote of twenty-nine to six.[16]

The conflict of which Senator Cameron warned would, however, exact a financial penalty from the Smithsonian. The Institution's primary source of

income was the roughly $31,000 received annually as the 6 percent interest earned by the Smithson bequest. While the US Treasury continued to provide those funds throughout the war, the sum was paid in paper currency, rather than specie, during the years 1862–64, effectively reducing the Smithsonian's purchasing power. By 1864, $2.84 in paper currency purchased only $1 in gold. Henry and the staff found it especially difficult to convince European suppliers to accept even heavily discounted US notes. The 1861 discovery of the death of Mary Ann de la Batut, James Smithson's sister-in-law, meant the addition to Smithsonian coffers of the $25,000 principal left with English bankers to provide her with an annuity. Although that sum was slow to arrive, it offset some of the wartime losses.[17]

Henry also lost part of the Institution's second income stream. The bequest had earned $242,000 in interest between the time of its arrival in the United States in 1838 and the foundation of the Institution in 1846. The construction of the Castle, the expenses of building a library, and the cost of publishing and operating the exchange system had reduced that amount to $141,000. Invested in state bonds issued by Indiana, Virginia, Georgia, and Tennessee, this fund had produced $7,700.16 in 1860. The secession of the Southern states reduced this annual income by some $4,000.[18]

Finally, Congress provided an annual sum of $4,000 to support Smithsonian management of government collections. When a semiannual payment was overdue in January 1861, Henry suggested that "if the appropriation is not made, we shall be obliged to close the door [of the museum] or charge an admission to visitors." While sometimes delayed, congressional funds continued to arrive during the war, and the museum remained open, playing an ever-more-important role in a capital city growing beyond expectation and filled with newcomers in need of diversion and intellectual sustenance.[19]

"It has been considered advisable," Henry reported, "to curtail the expenditures of the Institution." Baird reported to Felix Flügel, the Smithsonian's agent handling exchange business in Leipzig, Germany, that the secretary had ordered "all superfluous expenses . . . to be lopped off, and the most rigid economy exercised." Indeed, expenses fell from $37,138.30 in 1860 to $27,961.07 in 1862. Two years later, for the first time in its history, the Institution finished the year with a deficit, having spent $2,869.82 more than it took in.[20]

Elements of the basic program suffered during four years of war. The meteorological program, Henry noted, "has been much deranged." The Institution no longer received weather reports from the South, and while many women volunteers continued to send reports, the response from Northern volunteers slowed because of military service, the distraction of current events, and government

preemption of telegraph lines. Baird's military collectors now had more pressing things to do, while government support of the scientific exploration of the West had ceased for the duration.[21]

The publication program, the keystone of Henry's plan, was also the Institution's largest expense, costing $7,000 in 1861. Shrinking revenues and the rising cost of paper and printing supplies forced some economies. The Smithsonian had published one volume of the Contributions to Knowledge series each year since 1851. Only two volumes of that series appeared during the war years. *Smithsonian Miscellaneous Collections*, which offered special reports across a wide variety of fields, first appeared in 1862. While the Contributions series was intended to present "what are believed to be new truths . . . constituting positive additions to the sum of human knowledge," the new Collections series focused on "reports on the present state of our knowledge of particular branches of science," as well as printed instructions for collectors, lists of species, and museum catalogs. Despite the economics of wartime, five volumes of *Smithsonian Miscellaneous Collections* appeared by 1865.[22]

The secession crisis took a heavy toll on the Board of Regents. John C. Breckinridge, defeated by Abraham Lincoln for the presidency, left the board to join the Confederacy, first as a general and then as secretary of war. Regent John Murray Mason, grandson of George Mason, served as a principal Southern emissary to England and France. Regent Lucius Jeremiah Gartrell was appointed a general in the Confederate States Army, as was Howell Cobb, who, as former secretary of the Treasury, had served as a member of the Smithsonian Establishment. Secretary of the Interior Jacob Thompson, listed as an honorary member of the Establishment, ended the war as the shadowy head of the Confederate secret service in Canada.

While Henry and Baird were Union men, their primary loyalty was to the Institution. They agreed that it was in the best interests of the Smithsonian to claim international status as a scientific organization, rising above conflicts between nations. At the beginning of the war, Henry concluded that as "the Institution was a purely scientific establishment the endowment of which was the gift of an Englishman to men of all nations, it was best to stand on this [ground]." In the event of a Southern invasion, he believed such a stance would protect the Smithsonian.[23]

The notion that the scientific enterprise transcended national boundaries and international rivalries was an eighteenth-century ideal that survived into the early nineteenth century. The ability of the president of the Royal Society to persuade the emperor of France to release James Smithson from captivity was proof

View of the south side of the Smithsonian Castle looking east up B Street (now Independence Avenue) toward the Capitol building with an unfinished dome, c. 1863–64. This image of Civil War Washington was taken before the January 1865 fire that destroyed the upper floors of the Castle. *Smithsonian Institution Archives*

that the ideal retained some power even during the bitter Napoleonic Wars. As a gesture of neutrality, Henry refused to fly the American flag over the Smithsonian throughout the war.[24]

As Mary Howard Schoolcraft, who had once been the Henrys' landlady, warned, the secretary might pay a considerable price for that gesture. "We are living in times where the public mind is kept in a boiling cauldron of passionate and unreasoning excitement," she noted, "so that it is the better part of wisdom to furnish no extra fuel to the flame." She concluded by explaining that she had "the whole family of flags in our house," should Henry wish to borrow one.[25]

Rumors and questions regarding the secretary's loyalty to the Union circulated throughout the Civil War. A correspondent to the *National Republican* in the spring of 1861 charged that "several secessionists are in office at the Smithsonian Institution." Henry's scientific friends were genuinely concerned. "What is the meaning of extraordinary stories in circulation about [Henry's] disloyalty," chemist Oliver Wolcott Gibbs asked Alexander Bache. "I have heard through two entirely different & independent sources that his sentiments are no secret & even acts indicating disloyalty are cited." While he supposed that the rumors circulating were

the result of the secretary's "want of tact," they were, he warned, a serious problem.[26]

The most famous anecdote regarding the Smithsonian during the conflict turned on those suspicions. As Carl Sandburg told it, an army officer brought Joseph Henry under arrest to the White House, charged with signaling the enemy from a Smithsonian tower. President Lincoln, after joking with the secretary regarding the penalty for treason, informed the officer that he had been in the tower with Henry, testing new army signals.[27]

A master storyteller, Sandburg was "improving" an older account by journalist Noah Brooks. A friend of Lincoln, Brooks described being in the White House with Lincoln and Henry when a citizen was admitted who claimed to have seen strange signals from the Castle tower the night before. While the visitor admitted he did not know the secretary, he had heard "that Professor Henry is a Southern man and a rebel sympathizer." The president then introduced the accuser to Henry, who explained that he was simply checking the meteorological instruments housed in the tower.[28]

Both Brooks and Sandburg spun their tales out of a wild and baseless accusation by Charles Frederick Anderson, a disappointed architect who claimed that Montgomery C. Meigs, engineer of the US Capitol and quartermaster general of the US Army, had pirated his design for improvements to the Capitol building. Henry told his friend and ally Meigs that he had been "accidentally" visiting the president in the White House in the fall of 1861 when Anderson accused Meigs of "exhibiting lights to the enemy from the Capital [sic]," adding that Henry had been guilty "of the same treason," presumably by exhibiting lights from the tower of the Castle.[29]

In fact, Henry was involved in testing signal systems from the north tower on at least two occasions in 1863 and 1864, although President Lincoln does not seem to have been present on either occasion. While these accusations occurred early in the war, the spread of various versions of the story, despite the humorous note, underscored doubts as to Henry's patriotism.[30]

As all versions of the story indicate, the new president was growing on the secretary. "I have lately met him four or five times," he remarked to a friend in 1862. "He is producing a powerful impression upon me. It increases with every interview. . . . If I did not resist the inclination, I might even fall in love with him."[31]

THE SECRETARY REALIZED THAT guarding the popular Smithsonian lecture program from any hint of "sectarianism in religion, discussions in Congress and

partisan politics" would be an important step in preserving the neutrality of the Institution. Given his own deep-seated conservative views, however, he sometimes found it difficult to strike an appropriate balance. On February 13, 1860, Albert T. Bledsoe, a University of Virginia professor and leading proslavery apologist, took the Smithsonian podium to offer the first in a series of lectures attacking the excessive zeal of abolitionists and predicting that, unchecked, they would surely lead to secession and war.[32]

By 1861, recognizing the danger of rising political tensions, the secretary announced that the lecture hall would no longer be used "for other purposes than those of the Institution" and began rejecting lecture requests that he might once have approved. That summer, following the Union defeat at Bull Run, a group of local abolitionists formed the Washington Lecture Association (WLA). Their aim was to pressure the president to issue an emancipation proclamation and redefine the war as an antislavery crusade. Promising that their projected series of talks would represent "a higher plane in regard to Literature, Loyalty, and Liberty," they petitioned Henry to allow them to use the Smithsonian lecture hall, the finest auditorium in the city. The secretary rejected the request, fearing that such a series would offer the Smithsonian lectern to "an avalanche of strong-minded *women* and weak-minded *men* . . . from the north."[33]

Unwilling to accept defeat, William Croffut, a treasury department clerk serving as secretary of the association, shared Henry's response with Representative Owen Lovejoy, an Illinois abolitionist whose brother Elijah had been murdered by a proslavery mob in 1837. Congressman Lovejoy remarked that Henry was "an old traitor" who could be "brought to terms." While the secretary still had friends on the Board of Regents, he had lost allies through death, failure to be reelected, and refusal to take the congressionally mandated loyalty oath. Republican legislators, including Senators Lyman Trumbull and William Fessenden, Representative Schuyler Colfax, and Vice President Hannibal Hamlin—some of whom questioned Henry's judgment and loyalty—took their places on the board. Given the political pressure from Congress and the board, Henry approved the association's second request while disavowing the Smithsonian's connection to the series.[34]

The WLA, without Henry's approval, expanded the program from twelve to twenty-two lectures offered between December 1861 and April 1862. The speakers included some of the nation's most distinguished intellectual figures, such as philosopher and essayist Ralph Waldo Emerson; Oliver Wendell Holmes, who wrote *The Autocrat of the Breakfast-Table*; poet and professor James Russell Lowell; Henry Ward Beecher, the charismatic pastor of Brooklyn's Plymouth Church;

SMITHSON'S GAMBLE

Harvard University president Cornelius Felton; and the poet, critic, travel writer, and diplomat Bayard Taylor. While the planners had promised Henry a presentation of diverse views, twenty of the twenty-two lectures presented strong abolitionist messages.[35]

Unlike the free lectures sponsored by the Smithsonian, which continued to be offered, ticket prices for the WLA series were expensive: $3.00 for a couple attending the entire series; $2.00 for a single gentleman and $1.50 for an unaccompanied lady attending in full; and $0.25 for a single ticket to one lecture. Nevertheless, newspapers reported that at least a thousand visitors crowded into the room for each talk.[36] Republican leaders made a point of supporting the series and attended many of the lectures. When Horace Greeley, editor of the *New-York Daily Tribune*, spoke on January 3, 1862, President Lincoln, Secretary of the Treasury Salmon Portland Chase, and ten Republican congressmen joined him on the platform.[37]

Henry intervened in the planning process on two occasions. A member of the WLA informed the secretary that Representative Charles Sumner had requested that Frederick Douglass, the celebrated Black activist, journalist, and orator, be invited to give the final lecture in the series. When confronted, Sumner told the secretary that, while he had not made such a suggestion, "he thought that Douglas [*sic*] ought to be allowed to lecture in every city of the Union." Henry explained to Sumner and the association that although he "had endeavored to keep out of a quarrel with them," he "would not permit the lecture of a colored man to be given in the room of the Institution." Henry also vetoed the appearance of famed abolitionist William Lloyd Garrison. Clearly, the secretary's racial views were much closer to those of President Jefferson Davis than to those of President Abraham Lincoln, who welcomed Frederick Douglass to the White House on several occasions, publicly referred to him as a friend, and sought his comment and advice.[38]

The leaders and speakers of the association were fully aware of Henry's attitude toward their program. In introducing the first lecturer, transcendentalist Orestes Brownson, on the evening of December 14, 1861, John Pierpont, the president of the association, remarked, "I am requested by Professor Henry to announce that the Smithsonian Institution is not in any way responsible for this course of lectures. I do so with pleasure and desire to add that the Washington Lecture Association is in no way responsible for the Smithsonian Institution." The crowd roared approval, and the jibe was repeated in introducing each subsequent lecture.[39]

Reaction to the lectures split along party lines. Republican newspapers from New York to Chicago, ignoring the long history of talks sponsored by the Smithsonian, applauded the WLA series as "the first course of popular lectures delivered in Washington." The *New-York Times* credited the Union army and the lectures with

transforming the capital into a Northern city. The *New York Herald*, on the other hand, alluding to the goals of the Institution, charged that the lecturers presented only "the science of violence and disseminate only knowledge of their treason." Local conservatives defaced posters announcing the talks and threatened to resort to "mob violence" to bring an end to the program.[40]

While divisive, the Washington Lecture Association series had an important impact. Abolitionist lawyer Wendell Phillips's two lectures (March 14 and 16, 1862) attracted the largest audiences of the series. As many as two thousand people, including some African Americans, crowded into the lecture hall. Newspapers credited the lectures with sparking the final push toward a congressional bill abolishing slavery in the District of Columbia. Phillips was in the Senate chamber to hear debate on the bill before proceeding to the Smithsonian to deliver his final talk. President Lincoln signed the bill into law just a month later, on April 16, 1862.[41]

The secretary expressed his frustration in his 1861 annual report to the Board of Regents. He had succumbed to political pressure and a lecture series that he could not control, only to find that the WLA had then broken its word to him in offering politically divisive content. "The evil of this," he continued, "was soon manifest in acrimonious attacks upon the Institution by members of Congress and editors of papers holding different political opinions." The answer, he decided, was to restrict the lecture room to the Institution's use. He would hold firm to that decision despite new requests, including a proposal for a series countering the WLA presentations.[42]

WHILE THE IRONY WAS almost certainly lost on Joseph Henry, the man who struggled to maintain the neutrality of the Smithsonian was also determined that the Institution and its leaders should play a role in marshaling the forces of science and technology in support of the federal government. The secretary's long service as a science adviser began in 1852, when President Fillmore appointed Henry and Alexander Bache as the first two civilian members of the newly constituted United States Lighthouse Board.[43]

The secretary's service on the Lighthouse Board represented a major commitment of his time and energy over a period of more than twenty-five years. The board was a major national enterprise, with an appropriation of $500,000 in 1852, an amount roughly equal to the original Smithson bequest and some sixteen times more than the annual interest income from the principal. Henry initially took charge of all scientific and technical research, resulting in an enormous improvement in the functioning of American lighthouses. While the secretary had less

time to pursue his own work in electromagnetism, the needs of the Lighthouse Board inspired him to undertake fundamentally important research in optics, acoustics, thermodynamics, and chemistry.[44]

Henry began with a series of tests designed to improve lighthouse efficiency, resulting in a campaign to introduce Fresnel lenses, which produced four times the focused light of the old lamp and reflector system. By 1858, 448 American lighthouses had converted to Fresnel lenses. He then turned his attention to finding an efficient illuminant to replace the expensive sperm oil then in use. The secretary established a test facility at the Lighthouse Depot on Staten Island, New York, where he conducted a series of experiments testing substitute oils from 1852 to 1864, finally determining that cheap lard oil could be used as effectively as sperm oil with high-temperature Argand lamps. To develop an effective sound warning system for use in fog, he set up a research station at New Haven, Connecticut, where he pursued acoustical experiments, demonstrating that a low-pitched horn was far more effective than higher-pitched bells and whistles.[45]

The work of the Lighthouse Board was demanding. Henry averaged six weeks to two months a year on experimental research and other board business. During the Civil War, he attended almost one hundred board meetings, served on special committees to answer congressional queries, and did a great deal of traveling on lighthouse business. The workload increased after 1871, when he accepted chairmanship of the board, a post that he held until his death.[46]

The US Lighthouse Board was, as Henry noted with justifiable pride, "an establishment of great importance and may be said to hold in its hands the fortunes and lives of thousands of individuals." From the foreign commerce of the United States to the lives of individual seamen and ship passengers, much depended on the efficient operation of lighthouses. The secretary was fulfilling one of the essential goals that he had set for the Institution, that of supplying the government with the scientific and technical expertise required to meet the needs of the nation and its people. In the years to come, other Smithsonian workers would follow his lead, establishing and leading federal committees, commissions, and agencies in areas from conservation to spaceflight.[47]

THE SECRETARY'S FIRST OPPORTUNITY to make a direct contribution to the war effort began four months before the attack on Fort Sumter. In December 1860, Thaddeus Sobieski Constantine Lowe, a twenty-eight-year-old balloonist, called on Henry. He carried a letter signed by a dozen leading Philadelphians, including John Cresson, president of both the Franklin Institute and the Philadelphia Gas

Works, and Isaac Lea, a major publisher who had served as vice president of the American Philosophical Society and president of the Academy of Natural Sciences of Philadelphia. Their letter posed the question, Is it possible for a free balloon to cross the Atlantic Ocean?

Fascinated by science, Lowe had overcome a limited formal education with wide reading. At age twenty, he took to the road, traveling and giving chemical demonstrations and lectures. Lowe acquired his first balloon in 1856, and within two years, he had joined the small number of peripatetic aerial showmen, "professors," who made their living staging balloon ascents at fairs and celebrations across the eastern and midwestern United States and Canada.

By the fall of 1859, Lowe was exhibiting a large gas balloon he hoped to pilot across the Atlantic. He launched his effort to fund the record flight in New York City, where he lectured, flew smaller balloons, and exhibited the basket of his large balloon, *The City of New York*. After a few weeks, however, it became apparent that the local gas works could not supply city gas at the pressure required to inflate the huge envelope. Accepting an invitation offered by John Cresson, he shifted his operation to Philadelphia, where he made some special flights, including an ascent in honor of the first Japanese embassy to the United States and test flights with the big balloon, which he had renamed the *Great Western*, a play on the name of the first giant steamship to cross the Atlantic. Lowe's dreams of a flight to Europe came to a sad end on September 8, 1860, when the big balloon burst during inflation.

The aeronaut's self-confidence and charismatic personality convinced Cresson, Lea, and others that he was worthy of continued support. Before investing additional funds in the venture, however, the group approached Joseph Henry for advice. The secretary was a natural choice. Not only was he an authority on meteorology, a matter of central concern to an aeronaut traveling through the air, but he had also given considerable thought to ballooning as a scientific tool.

Henry had witnessed his first balloon ascent in Philadelphia on May 2, 1835, when he and a friend joined thousands of spectators crowding the neighborhood around Ninth and Green Streets to watch the very first ascent of John Wise. The novice aeronaut had worked as a cabinet- and piano maker in his native Lancaster, Pennsylvania, before launching his career as a balloonist. Over the next two decades, he would emerge as the best known and most successful of American aeronauts. Between 1835 and the time of his disappearance during a flight over Lake Michigan in the fall of 1874, Wise would complete 1,450 ascents. He was an innovator as well, introducing the ripping panel, a lightly stitched section of fabric that could be pulled loose to empty the envelope quickly upon landing.[48]

Henry's next encounter with a balloon came on July 24, 1837, when he witnessed one of the most publicized aeronautical tragedies of the era while visiting London. The famed English aeronaut Charles Green, accompanied by his friend Edward Spencer, agreed to carry the painter Robert Cocking aloft from the Vauxhall Pleasure Gardens to test a new parachute design. Looking something like an inverted umbrella, the device featured three metal hoops to maintain the shape of the fabric and weighed some 223 pounds. "The parachute desended [sic] . . . rapidly towards the Earth," Henry explained to his wife, "broke in its desent [sic] and precipitated the unfortunate adventurer head long to the ground."[49]

The tragedy did nothing to discourage Henry's interest in the possible scientific applications of the balloon. Once established at the Smithsonian, his meteorological research brought him into contact with balloonists. John Wise wrote to the secretary in the spring of 1849, inquiring as to the possibility of employing experiments carried aboard a balloon to prove or disprove the hollow Earth theory originally proposed by Captain John Cleves Symmes Jr. As gently as possible, the secretary explained to Wise that he could not imagine any such experiment.[50]

However, Henry also recognized the aeronaut as a practical student of meteorology who confirmed his own suspicion that an upper-level current of air moved across the United States from west to east. At Henry's invitation, Wise visited the Smithsonian in April 1858. The nation's most experienced aerial traveler, Wise told Henry, "all I knew about thunderstorms and atmosphere phenomena, so far as I had observed and experienced the workings of nature, both in and outside of the clouds." Having sparked the secretary's curiosity, the aeronaut proposed to build a balloon expressly designed for atmospheric research, "to be conducted under the auspices of this learned philosopher."[51]

Wise later recalled that the secretary was especially interested in "the practical idea of appropriating natural electricity as a motor for engines." A natural force "capable of pulverizing rocks, splitting up trees, knocking down masonry, and ploughing up the earth," he noted, "wants only to be properly harnessed to make it subservient to human purposes." In fact, Henry doubted the practicality of harnessing lightning. At the same time, he assured Wise, "I think the investigations you propose are more interesting than any in the whole domain of meteorology and I am acquainted with no person better qualified than yourself to undertake them."[52]

Henry immediately agreed to furnish the lifting gas and associated equipment required to inflate a balloon as well as the scientific instruments to be carried aloft. Wise completed work on the new balloon in May 1859. It was named *Smithsonian* and bore the motto *Pro Scientia et Ars*. He first flew the balloon from the

WAR CLOUDS

Centre Square of Lancaster that month, rising into the teeth of a thunderstorm. Upon reading Wise's report of the inaugural voyage of the balloon *Smithsonian*, Henry informed the balloonist that he would have "a few weeks of vacation" in the summer of 1859 and suggested that he "would be pleased to make some of the experiments with you which we contemplated last summer." It was not to be, however. Wise spent the summer of 1859 preparing to fly a balloon from Saint Louis to the Atlantic coast, while Henry, whatever his dreams of aerial adventure, continued to struggle with his administrative burdens. Addressing a scientific meeting in June 1859, however, the secretary expressed full confidence that Wise's dream of riding that great eastbound current of air across the Atlantic "was by no means improbable."[53]

Henry extolled the potential of John Wise and his balloon to advance meteorological knowledge to colleagues for some years to come. The scientist and the aeronaut would remain friends for almost three decades. In his last letter to Wise in July 1874, the secretary commented on the balloonist's continued plans for a transatlantic flight, this one sponsored by the New York *Daily Graphic* newspaper. While assuring Wise that he remained convinced that such a trip was possible, he was also quick to point out the risks. "While I would be delighted to learn that you had successfully accomplished the feat," he explained, "I would prefer that someone in whom I am less interested were subjected to the risk." Wise clearly appreciated Henry's support over the years. He dedicated his 1873 magnum opus, *Through the Air*, to the secretary "as a tribute of respect and admiration."[54]

Now a newcomer appeared seeking advice on an aerial crossing of the Atlantic. Henry brought Thaddeus Lowe's letter to the attention of the Board of Regents on February 16, 1861, and was instructed to offer whatever advice he thought appropriate, but to inform the Philadelphians that, in view of the hazardous nature of the venture, the Smithsonian could not support the effort. The secretary responded on March 11, informing Cresson and the others that, given the general flow of air from west to east across the Atlantic, such a flight should be possible "provided the balloon itself can be improved as to render it a safe vehicle of locomotion." He wrote to Lowe on the same day, concluding with a prediction that "it will be impossible for you to secure the full confidence of those who are best able to render . . . assistance except by a practical demonstration, in the form of a successful voyage from some of the interior cities of the continent to the seaboard."[55]

Lowe took the secretary's advice, traveling to Cincinnati with one of his larger balloons, *Enterprise*. Befriending Murat Halstead, a local newspaper editor, the aeronaut was able to fund his long-distance balloon voyage through a series of lectures. On April 19, 1861, just a month after receiving Henry's letter and nine days

SMITHSON'S GAMBLE

after the Confederates had fired on Fort Sumter, Lowe lifted off and headed southeast. Nine hours later, the aeronaut, with his thick Yankee accent, landed near Unionville, South Carolina. He was detained twice and arrested once by Southerners who doubted that the Yankee who had descended into their midst could be up to any good.[56]

Finally arriving back in Cincinnati on April 26, Lowe was determined to offer his aeronautical services to the federal government. Armed with a letter of reference from Halstead to Ohioan Salmon Chase, secretary of the Treasury, he made several ascents to raise travel money. In replying to Halstead, Chase explained that while there was interest in military ballooning, "there is some difference of opinion as to the balloonists to be employed."[57]

Indeed, with war at hand, several aeronauts had volunteered their services to the government. In May, James Allen arrived in Washington with two balloons, a gas generator, and five thousand feet of rope to join Governor William Sprague IV and the First Rhode Island Regiment. Henry's friend John Wise was also on hand, having contracted with Major Hartman Bache to serve as an aeronaut with the US Army Corps of Topographical Engineers. New Yorker John LaMountain had also been in touch with Secretary Cameron.[58]

Urged by Halstead to get to Washington, Lowe wrote to Henry in mid-May. The secretary replied on May 28, congratulating the balloonist on his long flights, suggesting that he might be able to fund his Atlantic flight by offering rides in a tethered balloon, and closing with the offhand suggestion that his efforts "might be of advantage to the government in assisting their reconnaissance of the district of country around Washington."[59]

Lowe arrived in the capital on June 6 with his wife, Leontine, and balloon *Enterprise* and immediately presented himself at Henry's office. Secretary Cameron had spoken to Henry earlier that day, asking him to interview Lowe and assess his judgment. With an affirmative answer, Cameron arranged for Henry and Lowe to meet with President Lincoln on June 11. Impressed, the president instructed Cameron to provide the Smithsonian with $250 to fund a demonstration flight by the aeronaut.[60]

Secretary Henry instructed chief clerk William Rhees to provide Lowe with a crew and arrange the demonstration on the far southeastern section of the Smithsonian grounds, across Seventh Street and directly in front of the Columbia Armory, which housed the District of Columbia's store of small arms and military equipment. The Washington Gas Light Company generating plant was immediately east of the armory, along with a large domed gasometer storage tank for the coal gas produced by the plant, with which Lowe would inflate his balloon.[61]

134

WAR CLOUDS

Accompanied by telegrapher Herbert Robinson and by George Burns, supervisor of the telegraph company, Lowe made his first and most important tethered demonstration flight on June 18, 1861, rising five hundred feet from a spot just in front of the armory. With a clear view of the nation's capital spread before him, Lowe sent a telegram from the basket, carried on a line down the Mall to the War Department for delivery to the White House. In it, he noted he took "pleasure in sending you this first dispatch ever telegraphed from an aerial station and in acknowledging indebtedness to your encouragement for the opportunity of demonstrating the availability of the science of aeronautics in the military service of the country."[62]

Lowe then ordered his balloon winched down to the ground and walked to the White House. The president greeted the aeronaut from an upper-story window and, according to Lowe's account, invited him inside, where the two stayed up to the early hours of the morning discussing the military potential of balloon reconnaissance. Lincoln insisted that Lowe spend the night at the White House so the pair could continue their discussion over breakfast.[63]

Even with Lincoln's support, Lowe struggled to convince military officials of the potential of the balloon. Despite Henry's enthusiastic report to Secretary Cameron in support of Lowe and a series of successful observation flights made with army units in northern Virginia, the Corps of Topographical Engineers dispatched their own man, John Wise, to conduct aerial observations during the fighting along Bull Run on July 21. The opportunity was lost when the balloon was caught in trees and ripped before Wise could reach the battlefield. A disappointed President Lincoln intervened and insisted that Lowe have the opportunity to create an experimental unit to conduct aerial observations with the Union armies in the field.[64]

Within months, Lowe was in command of the newly formed Aeronautic Corps, which included seven balloons, nine aeronauts, a dozen specially designed wagons fitted with tanks to generate hydrogen lifting gas in the field, and the world's first aircraft carrier, the *George Washington Parke Curtis*, a 122-foot-long coal barge fitted out at the Washington Navy Yard with a flat deck and hydrogen-generating apparatus to enable the members of Lowe's team to make observations up and down the tidal Potomac. In addition to active service in northern Virginia, Lowe and his balloonists saw real action during the Peninsula campaign of 1862, at the battles of Fredericksburg (1862) and Chancellorsville (1863), and with federal forces on the Atlantic Coast and the Mississippi River.

As a civilian, Lowe had great difficulty dealing with military bureaucracy and integrating his corps into the organization of the Union army. Whenever possible,

Composite image of Thaddeus S. C. Lowe's balloon observation flight at the Battle of Fair Oaks, Virginia, c. 1862. The balloon was used for reconnaissance during the Civil War, providing commanders on the ground with information on Confederate troop movements and artillery positions. Secretary Joseph Henry, who supported Lowe's early demonstration flights, advised the government on scientific issues during and after the war. *National Air and Space Museum Archives*

Henry interceded on his friend's behalf. He wrote to Secretary of War Edwin Stanton on July 21, 1863, noting that he had had "much intercourse with Mr. Lowe, [and] have formed a very favorable opinion of his skill and knowledge as an aeronaut, & of his trustworthiness as a man." He informed Stanton that Lowe "has had to contend with considerable prejudice, yet I doubt not that he has frequently obtained important information as to the position of the enemy for the use of which the officers alone were entirely responsible."[65]

Convinced that army officials failed to appreciate his services, Lowe resigned in 1863 when a request for increased funding was refused. The Union balloons continued to be operated by members of Lowe's corps for a few more months but would never again see action. In 1864, Henry supported a request from Lowe to demonstrate his balloons before a federal commission appointed to study new inventions on which the secretary served. He also agreed that Lowe could once again ascend from the Smithsonian grounds. Government officials decided against giving the aeronaut a second chance, however.[66]

Joseph Henry's interest in the application of aeronautics to the support of the Union cause was not limited to Lowe and his balloon corps. In the fall of 1861, he called the attention of General George Brinton McClellan, commander of the Army of the Potomac, to the work of William H. Helme, a Rhode Island dentist who had experimented with aerial photography before the war. Helme suggested that hot-air balloons inflated by burning alcohol would be easier to move, inflate, and manage than Lowe's gas balloons. When Lincoln's secretary, John Hay, also suggested that the general consider the idea, calling attention to Henry's commendation, McClellan instructed the War Department to provide Helme with $500 with which to build a demonstration craft. After a series of trials produced only mixed success, the idea was dropped.[67]

While the Aeronautic Corps of the Union army was disbanded a year and a half before the end of the conflict, it remained a significant experiment in the application of technology to achieve a critically important military advantage. European military attachés operating with the Union army returned to their nations anxious to share the lessons taught by Thaddeus Lowe. Beginning with the Franco-Prussian War of 1870–71 through the colonial wars fought in Africa and Asia to the end of the century, aerial reconnaissance was employed by major European powers. From tethered balloons through reconnaissance aircraft to sophisticated spacecraft of the twenty-first century, the ability to use altitude to gather intelligence remains essential to military success and national survival, a fact that Joseph Henry was among the first to recognize.

SMITHSON'S GAMBLE

In the first months of the American Civil War, Joseph Henry had played a major role in calling the attention of political and military leaders to the advantages of aerial reconnaissance and helped to broker the first military aeronautical unit in American history. Over the next three terrible years of war, the man whose loyalty had been questioned by so many would emerge as one of the most important voices offering advice on science and technology to a government at war.

CHAPTER 8

HENRY'S TOOLS OF WAR AND BAIRD'S COLLECTORS

THE FALL OF 1862 BROUGHT TRAGEDY for the nation and the Henry family. On September 17, the Army of Northern Virginia, General Robert Edward Lee commanding, met General George Brinton McClellan's Army of the Potomac across a series of farmers' fields, a simple church, and a rustic stone bridge over Antietam Creek, near Sharpsburg, Maryland. When dusk fell that evening, 22,717 men of both armies were dead, wounded, or missing. It was the bloodiest single day in American history.

Exactly one month later, on October 17, William Alexander Henry, the oldest child and only son of Joseph and Harriet Henry, died at age thirty-one surrounded by his family in a corner bedroom in the east wing of the Castle. That summer, the Henrys, like all sensible Washingtonians of means, had fled the heat and what daughter Mary described as the "malarious atmosphere" of the city for more comfortable climes. The secretary, wife Harriet, and daughter Mary retreated to Sykesville, Maryland, while Helen (Nell), Caroline (Cary), and brother Will lodged with friends on Long Island.

Henry had arranged employment for Will as a clerk and copyist in the Smithsonian library. He admitted to James Hall, however, that the position neither suited his son's "sensitive and retiring nature" nor did him justice "in the way of salary and demands on his time." The secretary had decided to suggest that Will attend medical school, but that proposal would come too late. Will returned to the capital before the others to resume his duties. In early October, chief clerk William Rhees sent a note to Henry covering normal business and noted that his son was "slightly indisposed." Four days later, the secretary received a telegram advising him that Will was much worse. The family rushed home by train only to watch helplessly as Will succumbed to what was described as a bilious attack.[1]

SMITHSON'S GAMBLE

Devastated, Henry confided to James Hall, his Albany mentor and close friend, that Will's death "lessened my desire to live[,] and were it not that I am anxious as to the future condition of my family[,] I would scarcely wish to continue longer to fight the battle of life[,] particularly in the present unhappy condition of our country and the darkness which rests on the future." He would carry on, however. As Marc Rothenberg, editor of *The Papers of Joseph Henry*, notes, "The demands of war were incessant, and requests for scientific advice from various branches of government allowed for no decent period of mourning." Less than a month after writing to Hall, the secretary found himself proposing the creation of a commission designed to assist the government in accessing proposals for new military technologies, and being caught up in the establishment of a second organization that would shape the future relationship of science and the federal government.[2]

In the spring of 1861, the editor of the *Scientific American* predicted that the "inventive faculty of the country, roused to extraordinary activity . . . will now be directed to an unusual extent to improvements in the instruments of war." To assess properly the flood of inventions that would surely overwhelm hapless government officials, the editor suggested that the administration appoint "a competent commission for this purpose . . . that would contribute immensely to the efficiency of our naval and military operations, and would save its expense to the country a thousandfold."[3]

Secretary of the Navy Gideon Welles saw value in the suggestion. While the army was learning to take military advantage of existing innovations, including railroads and the telegraph, the navy was involved in a technological revolution. The introduction of steam propulsion, iron-clad ships, and related equipment required officers and men capable of operating and maintaining the complex mechanical systems that were now at the heart of naval operations.

The navy faced a formidable technological threat as well. The South, unable to create a navy to match that of the Union, developed innovative weapons designed to close the gap. Matthew Maury, Henry's rival for a national meteorological program, was now a commander in the Confederate States Navy and head of the Naval Bureau of Coast, Harbor, and River Defense. In that capacity, he led a successful effort to design and produce underwater mines that could be electrically discharged from the shore. Used in combination with other mines that exploded on contact, these new weapons represented a serious threat to Union naval operations on western rivers. During the war, mines destroyed twenty-nine Union vessels and damaged fourteen more. An even more startling

Joseph Henry with his wife, Harriet (*center*), and their daughters (*left to right*), Caroline, Helen, and Mary, c. 1865. Artist Titian Ramsay Peale captured this image of the Henry family following a game of croquet on the National Mall. *Smithsonian Institution Archives*

undersea weapon, the Confederate submarine CSS *Hunley* was the first such craft in history to sink an enemy warship, although it took its own crew to the bottom in the process.[4]

Anxious to take advantage of new technology, Secretary Welles established the Naval Examining Board late in 1861 to consider and advise on proposals for new weaponry. That effort, and a second that followed, failed to meet the need. Early in 1863, Joseph Henry found himself on the receiving end of many such unsolicited proposals and began to consider the creation of a "competent commission" to regularize the process of assessing technical ideas submitted by the public.

He discussed the notion with his closest scientific colleagues in government: Alexander Bache of the US Coast Survey and Admiral Charles Henry Davis, the new head of the US Navy's Bureau of Navigation, which included the Naval Observatory, the Naval Almanac Office, and what would become the Hydrographic Office.[5]

The three met with Assistant Secretary of the Navy Gustavus V. Fox on January 26, 1863. Henry followed up on February 7, submitting a formal proposal suggesting that Bache, Davis, and himself be appointed to serve without compensation as a three-man commission "to which all subjects of a scientific character on which the Government requires information may be referred." Secretary Welles accepted Henry's proposal on February 11, appointing the three scientists to the newly formed Permanent Commission of the Navy Department that would evaluate and report on technological ideas submitted to the military.[6]

On March 3, 1863, less than a month after Welles had authorized the Permanent Commission, President Lincoln signed a bill creating a National Academy of Sciences whose business it would be to "investigate, examine, experiment, and report upon any subject of science or art" as requested by any government department. Since the mid-1840s, the circle of elite scientists identifying themselves as Lazzaroni, responding to what they regarded as the messy "democratic" spirit of the American Association for the Advancement of Science, had dreamed of a congressionally mandated American equivalent of the French Academy, a government-sanctioned organization composed of a small and select group of professional scientists who could advise the government and shape policy. Oddly, Joseph Henry, one of the original Lazzaroni who had long argued for a means of recognizing and honoring scientific talent, defining the scientific mainstream, and advising government, rejected the notion. He argued that Congress would not accept a proposal establishing an elite scientific organization that would smack of aristocratic pretension and offend those who were not selected for membership.[7]

Without informing Henry, Bache, Davis, or Agassiz, Harvard mathematician Benjamin Peirce and astronomer Benjamin Apthorp Gould met with Massachusetts senator Henry Wilson on February 19, 1863. Two days later, Wilson introduced a bill establishing the National Academy of Sciences, which passed with little comment or opposition on March 3. The legislation limited membership in the new academy to fifty, all of whom were named in the bill.[8]

Taken by surprise, Henry argued that the proponents of the academy had "no moral right . . . to choose the members." The reaction of others in the scientific community ranged from surprise to outrage. The biases of the planners were

apparent. Thirty-two of the appointees, including Henry, were physical scientists. Only eighteen were from the natural sciences. Henry's friend Elias Loomis was not included, nor was Spencer Baird, whom Bache privately suggested was "too mean to bring into our Academy." Louis Agassiz was particularly opposed to his inclusion, which solidified the rift between the two men growing from the antebellum disputes over Darwinian evolution and the decision of several Harvard researchers to migrate to the Smithsonian.[9]

Had the secretary and others refused appointment, the new organization might well have failed. Despite his reservations, however, Henry decided to take his place and work to redress the initial oversights from the inside. After chairing the first meeting of the academy, he declined the office, pleading lack of time and potential conflict with his Smithsonian duties. In time, however, he changed his mind. Bache served as the first president of the academy until his death in 1867, followed by Henry, who led the organization for the next decade. "I think it becomes the friends of science," he explained to Stephen Alexander, "to make an effort to give the association a proper direction and to remedy as far as possible the evils which may have been done."[10]

Had Henry known that the establishment of the National Academy of Sciences lay less than a month in the future, he might never have suggested the creation of the Permanent Commission. Secretary Welles shared the widespread doubts about the academy and preferred to rely on the organization answering directly to his office. In the end, the Permanent Commission would prove to be temporary, functioning from February 1863 to the fall of 1865.[11]

During the life of the commission, the members, or a subset, met 109 times, with 82 of those meetings occurring in the first year. At the peak of its operation, they met as often as three times a week, rotating between the Smithsonian, the Bureau of Navigation, and the offices of the Coast Survey, with occasional trips to the Washington Navy Yard or New York harbor where experiments were conducted. The commission considered perhaps three hundred proposals, which ranged from improvements to existing weaponry to communications devices, submarines, and mechanisms for exploding underwater mines. From these, they issued 257 formal reports. The proposals varied from those so impractical that they could be rejected out of hand to some worth further investigation.[12]

In 1863, the centuries-old dream of a practical underwater warship was just out of reach. Stretching just a bit further might enable an inventor to grasp the prize of a revolutionary craft. The Confederacy pushed the limits of the possible with the CSS *Hunley*. While this small, man-powered craft became the world's first

submarine to sink an enemy ship, it went to the bottom three times during its development and use, carrying twenty-one men, including its final crew, to watery graves. Other Confederate and Union inventors also nursed the dream of a submersible craft and developed several that were tested.

One such inventor was Eben Norton Horsford. Horsford had resigned his position as an agricultural chemist at Harvard's Lawrence Scientific School to pursue a career as an entrepreneur, manufacturing baking powder, condensed milk, and army rations under contract. He previously proposed a means of preventing the corrosion of iron ship hulls to the committee, and returned to the commission on August 3, 1863, with a radical design for a submarine capable of clearing harbor obstructions and attacking enemy shipping. Henry rejected the plan, noting, "There were so many difficulties to be overcome that there are fifty chances to one against its success."[13]

By the high summer of 1864, the pace of work for the Permanent Commission was slowing. On July 30, Henry assured the absent Alexander Bache that meetings were continuing. Henry was signing his friend's name, taking "good care that your reputation shall not in any way be compromised by my acts." He also noted that he had sent their joint report on Solomon Andrews's proposal for a navigable airship to the secretary of war, a project that fell outside their work for the Permanent Commission.[14]

Solomon Andrews, a physician and three-time mayor of Perth Amboy, New Jersey, had written to President Lincoln on August 9, 1862, offering to build an airship propelled by gravity and capable of sailing "five or ten miles into Secesia and back again." In France, ten years before, engineer Henri Giffard had built and flown a steam-powered, hydrogen-filled airship capable of navigating the air on a calm day. Andrews believed that his scheme was simpler and more practical.[15]

His plan called for linking three cigar-shaped, hydrogen-filled envelopes horizontally, forming a platform that could be angled up or down. At takeoff, the pilot, suspended beneath the aerostats, would move toward the rear of his machine while angling the envelopes slightly up, so that instead of rising straight up, the pressure of the air on the bottom of the bags would cause the craft to move forward, climbing diagonally. At altitude, the pilot would valve some gas, move toward the front of his craft, angle the envelopes down, and continue moving forward while descending. Dropping ballast to lighten the craft, he would then angle back up into a climb. As long as the craft was moving forward, the pilot could use the rudder to turn or even spiral up or down. An experienced pilot, Andrews suggested, might be able to make several cycles up and down, navigating his way through the air before he ran low on ballast and gas.[16]

A spokesman for the Corps of Topographical Engineers responded to Andrews's letter to the president, reporting that, while the plan seemed "ingenious in a high degree," the examining officers doubted the practical utility of Andrews's craft. Undeterred, Andrews returned home and built a full-scale craft to demonstrate the validity of his principle, naming it *Aereon*. He claimed to have made two flights with his new airship on September 4, 1863, and presented sworn testimony to that effect from local citizens and reporters who witnessed the scene. "She went upward and forward against the wind," one of them reported. "She minded her helm perfectly, and the rudder was very small for such a large vessel. He turned her around, and came back to the place of starting and came down to the ground. Then he went off to the westward, and turned her head to the east and came down again."[17]

Andrews claimed that his craft was destroyed in a final unmanned test at the end of the day, which increased the skepticism of government officials. The inventor then constructed a small flying model consisting of three inflated cylinders of India rubber, the middle cylinder measuring four feet long by eight inches in diameter. In February 1864, he convinced Ohio congressman Robert C. Schenck, of the House Committee on Military Affairs, to sponsor a demonstration flight in a large open area of the US Capitol building. It was an impressive trial in which the model rose and fell, moving forward and even turning to the right and left as the rudder was set. At least marginally impressed, the members of the committee ordered the secretary of war to appoint "a scientific commission" to examine the little airship and report to them.[18]

On March 16, 1864, Assistant Adjutant General Edward D. Townsend issued War Department Special Order No. 119, appointing Joseph Henry, Alexander Bache, and Major Israel C. Woodruff of the Army Corps of Engineers to a committee to examine Andrews's model. Henry and Woodruff met with Andrews on March 21 and witnessed a demonstration of the model in the library on the west end of the Smithsonian building. "The inventor proved that the balloon can be steered, can be made to move in an oblique direction while ascending or descending," Henry noted. "The balloon moved horizontally in still air. The power to stem a wind will depend on the amount of ascensional power which the vehicle has to start with."[19]

The committee was confident that Andrews could fly a short distance over the enemy in still air and return to a point of safety. Henry admitted that they had only seen the model, however, and did not feel that they could accept the "second hand testimony" of those who had witnessed the full-scale test in New Jersey. Henry and his colleagues concluded, however, "there is sufficient possibility of the success of the plan of Dr. Andrews, to warrant . . . an appropriation" that would permit the inventor to construct a second full-scale vehicle for an official test.[20]

So near and yet so far. In spite of Henry's report, Congressman Schenck was unable to arrange an appropriation. Having failed to market his airship as a weapon, Solomon Andrews set out to demonstrate its commercial value. He established a joint-stock company and built *Aereon II*, with which he made two flights over New York City on May 27 and June 5, 1866, to the delight of the public and the press. The absence of a suitable power plant stood in the way of both a practical airship and a submarine, but the number of sophisticated proposals for such visionary technologies indicated the direction in which the future lay.[21]

While there were those who questioned Joseph Henry's patriotism, there could be no doubt as to his contributions to the Union. He was a major figure on the US Lighthouse Board, an essential institution to a navy blockading Southern ports and managing coastal invasions. He played a central role in the creation of a balloon observation corps for the Union army. His service on the Permanent Commission of the Navy Department relieved serving officers of the need to weigh a flood of technological proposals, most of which were of no military value. Finally, despite his original resistance, he would ultimately help to shape the National Academy of Sciences—in the long run, perhaps the single most important government institution established during the war years. All this activity was a result of Henry's determination to underscore the role of science in support of the government.

WHILE JOSEPH HENRY SPENT THE Civil War years looking beyond the Castle's Gothic walls, Spencer Fullerton Baird focused on building and managing Smithsonian collections. The multiple surveys and expeditions that had kept junior officers occupied before the war were at an end. However, a few commanders who had cooperated with Baird before the war continued to allow men under their command to indulge their scientific interests. Colonel Richard Drum, for example, assured a soldier that scientific pursuits that did not interfere with his official duties would speed his promotion, while William Tecumseh Sherman provided special passes enabling scientists to cross the battlelines. Fielding Meek, who had escaped the draft because of his deafness, talked his way aboard naval vessels traveling through areas of geological interest.[22]

Stimpson, Kennicott, Hayden, and Meek remained in the capital, and Baird kept his young naturalists busy cataloging the backlog of specimens. He continued to expand the collection by arranging support for a small number of men who essentially served as full-time volunteer collectors. He regularly used his influence to place talented naturalists in positions where they could devote most, if not all, of their time to collecting activities and would reward them by arranging

promotions and ensuring that their names and contributions were prominently noted in the annual report and other publications.

John Xántus de Vesey was an early recruit. A veteran of the Hungarian army, he fled to the United States in 1851 following the uprising of 1848–49. After a series of failed attempts to establish himself as a druggist, bookseller, and teacher, he enlisted in the US Army and was assigned duty as a hospital orderly at Fort Riley, Kansas, working under Dr. William Alexander Hammond, one of Baird's collectors. Encouraged by Hammond, Xántus began to submit specimens under his own name and, in February 1857, opened a correspondence with Baird, who recognized his ability as a naturalist.[23]

The assistant secretary, perhaps with the influence of his father-in-law, General Sylvester Churchill, inspector general of the US Army, arranged for Xántus to transfer to Fort Tejon, California, a more promising collecting area than the Kansas prairie. When his superiors complained that a soldier under their command was neglecting his military duties in favor of collecting expeditions, Baird pulled his family strings, resulting in a letter to the post commander that allowed Xántus to continue. Supplied with collecting equipment and funds to cover shipping costs, Baird's "volunteer" began forwarding a steady stream of specimens to the Smithsonian. In 1859, the assistant secretary arranged for Xántus to be discharged from the army and persuaded Alexander Bache to employ him on the US Coast Survey at Cabo San Lucas, in Baja California. Two years later, Baird again used his influence to have his favorite collector appointed US consul in Manzanillo, Mexico.[24]

The collections continued to flow to Washington. In the 1861 annual report, Baird noted that Xántus's labors in the field had been "truly remarkable." That year the collector sent sixty large boxes of specimens to the Institution that illustrated "almost every branch of natural history," including "a large number of species never before described." Unfortunately, Xántus's career as both a diplomat and Smithsonian collector ended when he offered diplomatic recognition to a local bandit rebelling against the Mexican government.[25]

The secretary was by no means sure that Xántus was deserving of support. "From all the impressions I have received relative to the moral character of this man," he remarked to Baird, "I think he is not to be trusted, and that it will be safest in the future for the inst. to let him slide." It was the end of the collector's time with the Institution. He returned to Hungary in 1864 and spent the next three decades as an official of the Budapest zoo and the Hungarian National Museum.[26]

At some point in late 1858, Xántus urged Sergeant John Feilner, an enthusiastic amateur naturalist stationed at Fort Crook in Northern California, to contact Spencer Baird. Feilner wrote to Baird on February 30, 1859, enclosing a letter of

introduction from Xántus and explaining, "My own collection of bird skins reaches now the No. 300, not including mammals and other sundry specimens."[27] At the time of his long-distance introduction to Baird, Feilner was twenty-nine years old and, according to army records, stood five feet, seven inches tall, with blue eyes and light brown hair. Trained as a cartographer in his native Bavaria, he had immigrated to the United States and enlisted in the army in 1856. Three years later, he was serving as an orderly sergeant and topographer with Company F of the First Regiment of Dragoons.[28]

"I hope that it will be in your power to make full collections in all departments of natural history," Baird responded, "especially in that of eggs." Accepting the invitation, Sergeant Feilner promised that his "constant labor will justify your belief in my capability." Baird immediately sent several volumes of the annual report, a set of instructions for collectors, three gallons of alcohol, five pounds of arsenic, specimen jars, salt, a bag of #10 shot, another of #7, and an ample supply of labels for shipping his finds to Washington. Having received Feilner's initial shipment, Baird reported that he had sold the duplicates for forty dollars and suggested that perhaps he would use the proceeds to send his new collector a double-barreled shotgun with which to bring down winged specimens.[29]

A collecting trip planned for the fall of 1859 to the Klamath and Rhett Lakes, just north of the Oregon line, had to be postponed because of Indian trouble. The following spring, Captain John Adams, commander of Fort Crook, approved the expedition, providing his sergeant-naturalist with a twenty-day furlough, the use of two mules, and the services of a companion, Private Alexander Guise. The pair set out on May 13, 1860. They were back in the fort two weeks later, having gathered enough bird and mammal skins, eggs, and other items to satisfy even Baird's appetite, only to abandon most of their scientific treasure to escape hostile Modoc.[30]

Just as he had worked to promote the career of John Xántus, Baird took a personal interest in Sergeant Feilner's future plans. In July 1860, Baird's new correspondent admitted that he would apply for a commission "if I could only pronounce [English] a little better than I do." Baird raised the issue of a commission for the sergeant with Joseph Holt, President Buchanan's secretary of war, and again with Simon Cameron, who replaced Holt in Lincoln's cabinet. He called attention to Feilner's courage under fire, noted that his superiors at Fort Crook regarded him as a soldier of "extraordinary merit," and assured Cameron that the sergeant was "of very gentlemanly deportment, well educated, an accomplished topographical draftsman, and a thorough soldier." Convinced, Cameron had Feilner commissioned a second

lieutenant on April 26, 1861, followed by a promotion to first lieutenant just over a month later, on May 30.[31]

The new officer quickly demonstrated his martial skills.[32] Ordered east, Feilner saw action during the Peninsula campaign. On July 3, 1862, Colonel George Blake, commander of the First US Cavalry, commended Lieutenant Feilner for his actions near Harrison's Landing, Virginia. He was promoted to captain two weeks later, on July 17, 1862. On November 6, 1863, General John Buford, one of the heroes of Gettysburg, noted that Captain Feilner, while commanding the reserve of the First Cavalry Regiment, had supported General Sumner during a crucial fight at Kelly's Ford on the Rappahannock River.[33]

In the spring of 1864, Spencer Baird seized an opportunity to reclaim the services of one of his most valued collectors. What would become known as the Dakota War of 1862 began on August 17, 1862, when four young Dakota, or Eastern Sioux, warriors attacked and killed a party of white settlers in Acton Township, Minnesota. The problems were the result of a failure of the federal government to deliver promised food and supplies and make payments guaranteed by treaty for the use of Indian lands. On the day following the initial attack, Little Crow, a Dakota chief, led a raid on a government agency, while other war parties swept through the Minnesota River valley, burning farms and villages in raids that spread into Iowa. The attacks on settlements and military forts continued into early September, when President Lincoln ordered General John Pope, who had been defeated at the Battle of Second Manassas, to take command of the situation.

The presence of large numbers of troops led to a climactic fight, the surrender of most of the Sioux, and the release of 269 white captives by the end of September. Local outrage resulted in more than four hundred trials, some lasting all of five minutes, which condemned 303 Dakota to death by hanging. President Lincoln commuted 265 death sentences, allowing the execution of 38 Sioux on December 26, 1862, still the largest mass execution in American history.

Determined to pursue and punish Sioux who had fled west following the fighting in Minnesota, General Pope sent two columns into the Dakotas in 1863 and planned another punitive expedition under the command of General Alfred Sully for 1864. Spencer Baird exercised his considerable influence in the War Department to see that Captain Feilner was attached to the 1864 Northwestern Indian Expedition, with special instructions to concentrate on collecting specimens for the Smithsonian. He succeeded, and wrote on April 2 to assure Pope that the soldier-naturalist "will do good service in every way, as he is a man of no ordinary ability in both military and scientific [endeavors]."[34]

Feilner's orders left no doubt as to his primary duties. In addition to serving as a topographical engineer, General Pope, a friend of Baird's, ordered the captain to make a "full report . . . upon the geology, botany, natural and physical character of the region" as well as meteorological observations. He was to be assigned two or three enlisted men who were to be kept "constantly employed" in making collections. "I need not remind you," the general concluded, "of the important results to science which will ensue from even a partial success."[35]

The 1864 expedition set out from Fort Sully, on the east bank of the Missouri in what is now central South Dakota, on June 26. The following evening, General Sully called Captain Feilner to his tent and cautioned him to take care and not move too far in advance of the main column in his search for specimens. The next morning, despite the warning, Feilner and his two assistants pressed ahead of the main body to visit Medicine Rock, a sacred boulder marked with petroglyphs near the Little Cheyenne River. While Feilner waited for the arrival of the column, three Minnesota Sioux opened fire on the party. The two enlisted men were unharmed, but Feilner, shot in the arm and the chest, "died in agony two hours later," as Sully reported.[36]

A cavalry company sent in pursuit captured the three Indians. Sully ordered the bodies decapitated and their heads mounted on stakes as a warning to other hostiles. "I am thus deprived of my engineer officer," he noted, "and the country is deprived of the services of one of its most valuable and efficient officers." No one was more deprived than Feilner's wife, Coralie L. De Loynes, and their daughter, Coralie Estelle De Loynes Feilner, born in New York on October 6, 1864, just three months after her father's death.[37]

Baird must have felt considerable responsibility for the death of the collector of whom he had grown fond, although his report of the loss in the Institution's 1864 annual report seems a bit cool: "In this untimely death of Captain Feilner the Institution loses one of its most valued correspondents." In the wake of the loss, however, Baird received a note from S. M. Rothhammer, one of Feilner's assistants, who remarked, "Nothing could give me more satisfaction than an opportunity to do my part in adding to the development of Natural History, the mother of all Sciences." Collections from the Dakotas would continue to flow to the Smithsonian.[38]

Baird would urge yet another young protégé to make a career in the army to better serve the Institution's needs. The assistant secretary recruited seventeen-year-old Elliott Coues, based on an enthusiastic letter from him, to participate in an expedition to Labrador in 1860. At the conclusion of that adventure, the budding ornithologist worked with Baird on the collection while attending the National Medical College. Enlisting as an army assistant surgeon in 1864, he spent

a quarter of a century moving between posts from Arizona to Maryland and forwarding collections to Baird.[39]

From 1876 to 1880, Coues served as secretary and naturalist with Ferdinand Hayden's US Geographic and Geological Survey of the Territories. He found time during these years to publish widely and to help found the American Ornithologists' Union. He dedicated his most important work, *Key to North American Birds*, to his mentor, the "Nestor of American Ornithologists."[40]

Biographers E. F. Rivinus and E. M. Youssef aptly characterize Spencer Baird as "a collector of collectors." Baird used his broad connections in science and government to attract amateur naturalists interested in supporting the Institution. Xántus, Feilner, and Coues were among his most valued correspondent-collectors, talented men whom Baird could position to build collections at small cost to the Smithsonian.[41]

His professional relationship with Robert Kennicott, however, would be that of a mentor to a protégé and valued junior colleague. Born in New Orleans in 1835, Kennicott grew up at The Grove, a large estate in Cook County, Illinois, some eighteen miles northwest of Chicago. His father, like so many physicians, was a devoted student of natural history. In view of his son Robert's poor health, Dr. Kennicott took his education in hand, hiring an Oxford scholar to teach the usual subjects while employing the rich diversity of life on their bucolic estate as a living textbook. The young man shared his father's enthusiasm for the natural world and began to develop a broad understanding of botany, zoology, and geology, as well as mastering the practical art of preserving specimens and building collections. His father arranged advanced training for seventeen-year-old Robert with Jared P. Kirtland, an Ohio physician known for his discoveries regarding freshwater bivalves. As a correspondent of Baird's and a regular contributor to Smithsonian collections, Kirtland suggested that his young apprentice contact the Institution.[42]

The teenaged naturalist wrote to Baird for the first time on July 31, 1853, and was soon contributing specimens of fish, reptiles, and living snakes from the neighborhood of The Grove. When Kennicott expressed embarrassment over his lack of formal education, Baird offered reassurance. "After all," he argued, "you have the great Book of Nature from which to learn your daily lessons." As for his lack of access to scientific books, Baird noted, "A patient and persevering watching of nature will cause her to reveal her most cherished secrets."[43]

While most of Baird's collectors were knowledgeable amateurs capable of recognizing items worth collecting and making preliminary identifications of the species that they prepared and forwarded to the Institution, Kennicott's vision was

broader than simple taxonomy. Robert had spent hours, days, and years observing the web of life on his own patch of midwestern prairie. While he learned to distinguish individual species, he also focused on understanding their life histories and the complex relationships of living things making up the natural community. It was a practice he recommended to others. "Every farmer's son and daughter should be naturalists," he remarked, "for they have the best opportunities for it." If farmers themselves would spend "a few idle half hours observing the habits of the animals," he continued, they would rid themselves of some of their "bad and unusual prejudices against some of our fellow-creatures."[44]

He was particularly disappointed that Illinois farmers failed to appreciate the massasauga rattlesnake, a creature that he found fascinating. "The rattlesnake was[,] for a time, our national emblem," he noted, "and it is to be regretted that it was so soon thrown aside for the bald eagle." The snake, he continued, "is by far the nobler animal of the two. He is no impotent and cowardly robber, like our emblematic bird—makes no unprovoked attacks—and always sounds his warning rattle, a sure precursor of the deadly blow that follows." Kennicott captured rattlers, milked their venom into a spoon, and used it to conduct a series of experiments, demonstrating, for example, that a few drops of venom administered orally would not harm a kitten.[45]

In 1855, his father, as secretary of the Illinois State Agricultural Society, arranged for Robert to take charge of a broad survey of the state's natural resources sponsored by the Illinois Central Railroad. Kennicott managed the project and instructed railroad employees how to gather specimens from across the state. Baird arranged for "a small appropriation" from Smithsonian coffers to support the effort headed by his young friend. He was particularly proud of the fact that, as a result of the survey, Kennicott had assembled the "finest cabinet of Illinois specimens ever brought together," a display that won a medal, diploma, and cash prizes at the state fair. He was publishing extensively as well, identifying new species of reptiles, and expanding his network of scientific friends and colleagues.[46]

Early in 1857, he worked with the trustees of Northwestern University to found a natural history museum and helped to establish the Chicago Academy of Sciences. Kennicott, now age twenty-two, spent the summer and fall of 1857 on a collecting trip along the Red River, which runs from North Dakota into southern Manitoba, emptying into Winnipeg Bay. In December, he traveled to Washington, accepting Spencer Baird's invitation to spend time helping to identify and arrange the Smithsonian's collection of reptiles and amphibians. William Stimpson, who was earning a government salary while working up the collections of the North

152

Robert Kennicott (1835–66), c. 1863. Kennicott, a naturalist and herpetologist, collected natural history specimens for the Smithsonian. Here, he is shown in the Hudson's Bay Company outfit that he wore during his collecting expeditions to the Canadian wilds between 1859 and 1862. *National Portrait Gallery*

Pacific Expedition, welcomed the newcomer into the Megatherium Club, where he quickly became the unofficial master of the revels. Another colleague remembered him as "bubbling over with fun and wonderful plans for the future."[47]

He spent the winters of 1857–58 and 1858–59 working on collections under Baird, whom he regarded as "just about the best and most wonderful man I ever did see." Recognizing Kennicott's unique potential, Baird raised $2,000 to finance a major collecting expedition into northwestern Canada and up the Yukon River into Russian America. In addition to the Smithsonian, the sponsors included the University of Michigan, the Audubon Society of Chicago, the Chicago Academy of Sciences, and a "number of liberal-minded persons interested in natural science."[48]

Joseph Henry, with the endorsement of Lord Francis Napier, British ambassador to the United States, requested permission for Kennicott to operate in areas controlled by the Hudson's Bay Company (HBC). Sir George Simpson, governor of the HBC, which had long supported scientific travelers, agreed to provide what support he could to this one-man expedition. Kennicott set out in May 1859, traveling north toward Fort Simpson in the Mackenzie River district, where he would spend his first winter. He recruited volunteer collectors from among Hudson's Bay employees, missionaries, and Native Americans along the way. William Dall, a friend of Kennicott's who would one day join him in the north, explained: "The life of the Scots and Orkney men who composed the force of the Company in these remote and desolate trading posts . . . was most dull and tedious. In the more distant posts mails arrived once a year. They lived on the game of the country . . . flour, sugar and tea were luxuries. . . . The advent of Kennicott,—young, joyous, full of news of the outside world . . . was an event in their lives."[49] Kennicott used Baird's carefully prepared instructions to teach his volunteers what was worth collecting and how to preserve their finds, and promised that their names would appear in the Smithsonian annual report. "They seized on the project with enthusiasm," he wrote.[50]

While Sir George Simpson insisted on following company rules that would limit the support offered to Kennicott, local officials, notably Bernard Ross, chief trader at Fort Simpson, went well beyond his instructions, providing lodging, supplies, and transportation at little or no cost to the American naturalist. Kennicott, however, became upset when Ross began sending collections directly to the Smithsonian, taking credit for all of the material coming from the Mackenzie River district. Rather than confronting his benefactor, which might threaten the flow of collections to Washington, Kennicott remained silent.[51]

Roderick MacFarlane, a clerk at the HBC post at Fort Anderson in the Northwest Territories, was a close second to Ross in terms of his collecting efforts. When company officials began to suspect that his long trips away from the post on Kennicott's behalf were made at the expense of HBC business, MacFarlane responded that his growing familiarity with local water routes was of benefit to the organization. Between 1860 and 1865, he sent more than five thousand specimens to the Smithsonian.[52]

Baird kept careful track of his protégé's progress, forwarding supplies and acknowledging the growing number of subarctic collectors whom he had recruited. Now a veteran Arctic traveler, Kennicott, equipped with a visa from the czarist government, crossed the mountains and spent his second winter at Fort Yukon, in Russian America, and his third at La Pierre's House, an isolated HBC post near the Arctic Circle. At 9:00 a.m. on Christmas Day 1861, with the temperature at 40 degrees below zero, he "stopped and smoked the last of my cigars to the health and conduction of the family circle gathered at 'The Grove' and to the 'Megatheria,' and then sang, 'Do They Miss Me at Home.'"[53]

During his three years in the northern wilderness, Kennicott traveled more than 2,500 miles. Finally, in October 1862, he returned, enjoying a visit with his family at The Grove and continuing to Washington for a reunion with his Megatherium friends in December 1862. Studio photographs taken upon his return show a handsome fellow with dark eyes and dark flowing locks, dressed in the costume of an HBC voyageur. Baird could not have been more pleased. His young enthusiast had emerged a veteran explorer-naturalist who had opened an entirely new territory to science. Once back at the Smithsonian, Kennicott spent his time organizing the wealth of material he and his volunteers had sent to the Institution.[54]

Much to his surprise, Bernard Ross, the Hudson's Bay Company factor who had both supported Kennicott and taken credit for the work of other volunteers, visited the United States and called at the Castle not long after Kennicott's return. While wary of Ross, Kennicott recognized his contributions to the collection, put him to work organizing Canadian materials, and arranged for lodging in the Castle during his ten-day visit.[55]

In the months to come, Baird would continue his support for Ross, MacFarlane, and the other HBC trappers and traders recruited by Kennicott. He sent encouraging letters, supplies for the preservation of specimens, books, tobacco, and more. "The greatest present you can confer on these gentlemen," Ross wrote in 1860, "is to send a good stock of spirits for preserving, *one half not medicated*—as we

must get liquor in sub rosa—with this *stimulant* there is no doubt you will obtain lots of things." Baird complied, sending whiskey marked as denatured alcohol into the Mackenzie district, where it was forbidden.[56]

Kennicott had inquired of Baird in November 1859, "Are Indian dresses and implements wanted? I'm getting a few things of the kind." Indeed, Baird was interested. The Smithsonian collection contained a few anthropological items from the Pacific Island material returned by the Wilkes expedition to an assortment of Native American items of dress, weaponry, and ritual and other objects. It was a collection in search of a curator.[57]

In 1861, Baird recruited George Gibbs IV as the Smithsonian's first dedicated researcher on ethnology and linguistics. A Harvard-educated lawyer, Gibbs had traveled west in 1849, where he participated in a series of treaty negotiations, wrote on the language and culture of northwestern tribes, and served as an ethnologist and naturalist with both George McClellan's Pacific Railway Survey and the Northwest Boundary Survey. In addition to managing the anthropological collections, Baird asked his new employee to prepare two new sets of instructions for collectors: "Instructions for Archaeological Investigation in the United States" (1861) and *Instructions for Research Relative to the Ethnology and Philology of America* (1863). Through his work with the collection and his contributions to linguistic studies, Gibbs, who remained at the Institution for a decade, laid the foundation for the future work of John Wesley Powell and the Bureau of Ethnology.[58]

ROBERT KENNICOTT RETURNED to a city, and an Institution, that had been reshaped by war. The population of Washington had nearly doubled since his departure. The city was now surrounded by a thirty-seven-mile ring of sixty-eight forts defended by eight hundred heavy cannons and linked by miles of trenches and rifle pits. Herds of cattle destined to feed an army grazed around the stub of the Washington Monument just west of the Castle. The Amory Square hospital complex—line after line of tents housing a thousand wounded soldiers at any one time—lay just to the east where Thaddeus Lowe had made his demonstration flights in June 1861.[59]

The Smithsonian grounds had suffered during the war. "The canal is a vile nuisance," Joseph Henry reported, "and growing worse." It was, he remarked, "an immense cesspool, constantly emitting noxious fumes."[60] The approaches to the Smithsonian were dark and foreboding, with looming trees, overgrown brush, and deteriorating walkways. "It is said that several men have been forcibly robbed, and a number of women assaulted," Henry noted. In the summer, thieves and

worse crossed the bridge over the canal at Tenth Street onto the Smithsonian grounds to lay in wait for the unwary. In the fall of 1865, the *Washington Star* declared that the Mall was the resort of "the worst characters of the city." There were reports of attacks on a couple by two men claiming to be policemen, and a gang that set upon two men, perhaps soldiers, napping on the Smithsonian grounds.[61]

However, soldiers and civilians alike often braved the dangers of the worst neighborhood in Washington to visit the Smithsonian. "The museum has . . . been continually thronged with visitors," Henry commented during the first year of the Civil War. The display in the Castle "has been a never-failing source of pleasure and instruction to the soldiers of the army of the United States quartered in the vicinity," he explained to readers of the annual report. "Encouragement has been given them to visit it as often as their duties would permit." The guest book placed at the entrance to the museum recorded the names of the "thousands of persons, who have been called by business or pleasure to the national capital."[62]

As late as 1865, Henry expressed his appreciation for a national museum "as a means of intellectual improvement, of national enjoyment, and as a receptacle of interesting materials for the use of the student in any branch of learning." At the same time, the secretary warned that "the imperfect attempt to found a museum by means of the [inadequate] Smithsonian bequest will in time be abandoned and the whole of the income [once again] devoted to the more cosmopolitan objects of the Institution." In short, if Congress wanted to create a national museum, the members should establish it as an operation independent of the limited resources of the Smithsonian. Public education was not in Henry's brief for the Institution.[63]

Spencer Baird's view was quite different. Since surviving his brief flirtation with the library faction in 1855, he had scrupulously followed the secretary's lead. He managed the exchange program and other duties to Henry's full satisfaction and pursued his own goals at minimal expense to the Institution. He created and managed an expanding network of military and civilian volunteers, building the most important collection of American natural, geological, and ethnographic specimens without burdening the Institutional budget, and established the museum as one of the capital's most popular attractions. Whatever the secretary's views, Baird knew that Congress would not relieve the Smithsonian of functions that it was performing so successfully.

Joseph Henry spent the war years looking beyond the walls of the Institution, using his position as secretary to demonstrate the role that science might one day

SMITHSON'S GAMBLE

play in American public life. Spencer Baird focused on reshaping the Smithsonian, working to ensure that a world-class collection—and a museum in which to display it—were as important to the future of the Institution as its role in the research, publication, and distribution of scientific information. While the Civil War did not mark the full emergence of the modern Smithsonian, it can be said to have been, thanks to Baird, the end of the beginning.[64]

CHAPTER 9

AN INSTITUTION FOR A GROWING NATION— LOOKING NORTH

AT 2:45 P.M. ON JANUARY 24, 1865, Joseph Henry and chief clerk William Rhees were working in the secretary's third floor office on the north side of the Castle when they heard a crackling overhead. Henry stepped out and encountered William De Beust, the Institution's mechanic, and asked him to investigate. Henry then activated the telegraphic fire alarm near his office, alerting the fire station on Capitol Hill to an incident at the Smithsonian. As smoke filled the area, the secretary and Rhees covered their mouths and rushed back into the office to retrieve official documents. De Beust and watchman Henry Horan began to remove pictures from the art gallery. All four men were driven out of the central portion of the building by the heat and smoke seconds before the ceiling collapsed.[1]

Mary Henry was reading in the west wing library when she noted the room growing darker. Glancing out the window, she saw smoke pouring out of the upper stories and was informed that the building was on fire. She rushed to the east wing, intent on saving her father's private library from the flames, and after doing so, she supervised local citizens who assisted in the removal of the Henry family furniture as well as stuffed birds and taxidermy supplies from the adjoining preparation room. Other volunteer "helpers" made their way to the Apparatus Room, where they tossed precision instruments out the window to destruction on the ground below before that ceiling gave way.

The fire department, which had hired its first paid professional firefighter just a year earlier, arrived promptly but was able to pump only a limited amount of water onto the blaze from a city canal that was more mud than water. Moreover, several of the firemen broke into William Stimpson's living quarters in the northeast tower, rifled through his possessions, and consumed the alcohol that he used

to preserve specimens, unaware that it contained dissolved sulphate of copper. Henry reported that "several of them became deadly sick and would have died had they not vomited freely."

Chief A. C. Richards, superintendent of the Metropolitan Police, arrived on the scene and took command of the men from the Ninth Regiment of the Union Veteran Reserve Corps, who were deployed to guard the building and control a crowd estimated at a thousand spectators. They caught one fellow attempting to depart the scene with Henry's boots under his arm and several small scientific instruments hidden in his shirt.[2]

Major Generals Winfield Scott Hancock, a hero of Gettysburg, and Christopher C. Augur, commander of the XXII Corps of the Union army and the Department of Washington, walked from the War Department to observe the situation. Prominent photographer Alexander Gardner was there as well and took several photos of the burning building from the southeast. "Truly," Mary Henry wrote that evening, "it was a grand sight as well as a sad one, the flames bursting from the window[s] of the towers rose high above them curling around the stonework through the arches & trefoils, as if in full appreciation of their symmetry, a beautiful friend tasting to the utmost the pleasure of destruction."[3]

The family spent the night with friends and returned to survey the damage the next day. Climbing the stairs and entering what had been the Apparatus Room, now open to the sky, Mary noted that the "walls and towers rose above us, reminding us of the ruins of some English abbey." The lecture hall and the art gallery were gone, as were the Regents' Room and the offices on the third floor and in the central towers. Apart from four or five canvases, all of the Charles Bird King and John Mix Stanley paintings had been destroyed, as had Robert Hare's collection of scientific instruments, a great deal of official paperwork, and most of James Smithson's papers and collections, which had been stored in the Regents' Room.[4] The east and west wings and ranges were relatively undamaged. The museum on the first floor of the central section of the main building had also survived, protected by a layer of fire-resistant bricks separating it from the floors above.

The chain of events leading to the fire had begun eight days earlier, on January 16. Henry and Baird had decided to supplement the paintings in the Art Room by adding a series of cases displaying Native American artifacts. Curator John Varden had supervised the removal of the paintings and the installation of the cases and was in the process of rehanging the art. When he complained of the cold on January 16, De Beust and Tobias N. Woltz, the Institution's carpenter, moved a stove from the Apparatus Room into the picture gallery, connecting the stovepipe to what they assumed was a flue leading to a chimney. Instead, it simply emptied into

Retouched photograph by Alexander Gardner, published in *Harper's Weekly*, February 1865. On January 24, 1865, the Smithsonian Castle caught fire after workmen in the art gallery on the second floor incorrectly installed a stove by inserting the stovepipe into a wall space rather than a flue. The fire destroyed much of the second floor of the west side of the building. *Smithsonian Institution Archives*

the wooden rafters. Coal-fired stoves produce few sparks, so it was assumed that a spark from the wood tinder used to ignite the coal was responsible for the fire.[5]

After the fire, the first priority was to prevent further damage from the winter weather. Henry appealed directly to President Lincoln, who approved an order for the War Department to construct a low temporary roof. The work was completed in three days and remained in place until 1867, when the full reconstruction began. Barton Stone Alexander of the Army Corps of Engineers, who had designed the temporary roof and the fire-resistant brick layer that had spared much of the building, estimated that reconstruction with increased fireproofing and better materials would cost $150,000.[6]

Henry outlined his ideal solution in his 1865 annual report. Congress, he argued, had passed an "improvident or defective" bill requiring a grand building that was "far from being necessary to the most efficient realization of the intentions of the founder." It was only reasonable that the government be asked to purchase

and restore the building, renting office space to the Smithsonian and housing the newly established Department of Agriculture, the Army Medical Museum, and a national museum to be run by an agency other than the Smithsonian.[7]

It was apparent, however, that federal officials had no interest in accepting responsibility for the Smithsonian building or the supervision of a museum. That being the case, Henry and Chief Justice Salmon Chase preferred not to obligate the Institution to federal authorities by requesting congressional funding for the rebuild. Instead, Henry devised a plan to fund the reconstruction. The first step was to convince the Treasury secretary to allow the board to return an amount equal to the six interest payments received in devalued paper money since 1862. In return, the Treasury would repay the full 6 percent sum in specie to the Smithsonian account at Riggs Bank, resulting in a profit of $27,081.75.[8]

The secretary then seized an opportunity to increase the principal of the bequest. Early in 1861, Charles Francis Adams, the American minister to Great Britain, had informed the Institution of the death of Mary Ann de la Batut. After three years of diplomatic negotiations, the Smithsonian finally deposited $26,210.63 in the Treasury, the amount of the bequest retained in England to provide for Smithson's sister-in-law. At the request of the secretary and the board, Congress approved the addition of this residuary legacy to the principal held by the Treasury, along with an additional $8,620.37, raising the total sum to $550,000.[9]

Finally, in February 1867, Congress approved the board's recommendation that the proceeds of the sale of the state stocks, in which the accrued interest earned on the principal prior to the foundation of the Institution was invested, be added to the bequest, raising the total endowment to some $650,000. The 6 percent annual interest on this new sum would enable the board to fund the rebuilding project without curtailing normal operations.[10]

The disastrous fire offered an opportunity to improve the Castle. "The accident, though much to be lamented," the secretary confided to Agassiz, "will I think in the end be of advantage to the Institution." New construction would allow a reconfiguration of the interior of the Castle with new fire-prevention measures. The secretary envisioned a building with a "metallic roof and a rearrangement of the whole upper story, placing within the fireproof portion of the building all articles of value and cutting these off from the wings by means of iron doors."[11]

The museum area in the lower hall had escaped serious damage, and by 1867, following the repair of water damage and the addition of some stenciled decorations, the original museum space was reopened to the public. While Henry continued to doubt that the public exhibition of collections was an appropriate use of Smithsonian funds, he recognized that Congress and the public had come to

regard the museum as an essential feature of the Institution and suggested that the new design of the central part of the building do away with the large lecture hall to create a two-story open space for the museum. Since this refurbished area would be dedicated to the display of government collections, it seemed only reasonable to him that Congress should pay for the renovation. The new museum remained mostly empty until 1870, when Congress appropriated $10,000 for the preservation and display of the collection and $10,000 for work on the exhibition space.[12]

On the recommendation of Washington mayor Richard Wallach, Henry and the board selected the architectural firm of Cluss & Schulze to handle the design and repair of the building. A native of the German state of Württemberg, born in 1825, the young Adolf Cluss met Karl Marx and joined the Communist League and the Mainz Worker Council while working as an itinerant carpenter and builder. The failure of the German revolutionary movement in 1848 led Cluss to flee to the United States. Moving between New York, Baltimore, Philadelphia, and Washington, he corresponded with Marx and Engels, published political articles, and supported the abolitionist cause. He settled in Washington by 1860 and worked as a designer at the navy yard before establishing a private architectural practice with a partner in 1862.

While he restored James Renwick Jr.'s exterior, Cluss made the interior his own. His plan resulted in additional office space, particularly in the towers, as well as an expanded museum. Working with the Phoenix Iron Company of Philadelphia, the building contractor, he increased the level of fireproofing by replacing the wooden structure with iron framing and a slate roof. The project was successfully completed near the end of 1867, and Adolf Cluss continued as the Smithsonian's architect of choice until 1890. Beyond that, he put his stamp on the face of late nineteenth-century Washington with a series of churches, schools, government buildings, markets, and offices, usually in his distinctive red-brick style.[13]

The fire also provided an opportunity to deal, once and for all, with the library. Early in 1859, the secretary had begun the process of reducing the flood of books pouring into the Smithsonian by persuading Congress to repeal the requirement that the Institution receive an example of every item submitted for copyright. The secretary and the board used the fire as an opportunity to take a much larger step early in 1866, asking that the legislators approve the transfer of the Smithsonian library to the Library of Congress.[14]

"The wing and connecting range in which the books are now deposited are not fireproof," Henry explained to Asa Gray in February 1866, "and are therefore not only unsafe, but cannot be heated in winter." Moreover, the transfer would

solve a growing space problem and save the expense of cataloging, binding, and a librarian's salary. The Institution would maintain a considerable library to support its own research; the rest of the volumes in the collection would become part of "the Smithsonian Deposit." The joint congressional committee on the Library of Congress agreed that the books would be bound at public expense, housed in a new section of the library under the care of a dedicated librarian, and available year-round to officers of the Institution, who would have the same access as members of Congress. Approved by the House on April 5, the measure provided $500 to cover the cost of the transfer.[15]

Henry was convinced that institutions should cooperate, building on their peculiar strengths. "It was in the spirit of this policy," he explained, "that the books of the Institution were incorporated with those of Congress," resulting in "a library worthy of the National Capital," while "the capacity of the Smithsonian fund to advance knowledge has been materially increased." At a more personal level, the secretary could take satisfaction in having finally resolved the issue of the library after twenty years of struggle.[16]

In 1868, with the same goal in mind, the Institution transferred its herbarium of fifteen thousand to twenty thousand plant species, which had been identified and arranged by Asa Gray and John Torrey, to the newly established Department of Agriculture, with the understanding that Smithsonian researchers would have free access to the collection. That year, the secretary also approved the transfer of the collection of human crania and other osteological material to the Army Medical Museum in exchange for all the collections held by the Office of the Surgeon General that "more properly relate to ethnology."[17]

Henry admitted that, aside from the library, "the only other requirement of Congress that has not been fully met is that of a gallery of art." The Institution held the George Marsh collection of old master engravings "and some articles of painting and sculpture, which may be considered to be the commencement of a gallery of art." He pointed out that in 1969 William Wilson Corcoran had established a gallery of art in the nation's capital with an endowment of $900,000, one-third larger than the Smithsonian trust fund. When the gallery opened in 1874, Henry, who served as a member of the Corcoran board, deposited the appropriate Smithsonian items with the new institution.[18]

The secretary was pleased to report that the dispersal of the library and select collections resulted in an annual savings of $10,000. "These cooperations," he noted, enabled the Institution "to more vigorously prosecute its researches, to publish a larger number of contributions . . . to extend its system of international exchanges, [and] tend also to increase the amount of scientific material in the

AN INSTITUTION FOR A GROWING NATION—LOOKING NORTH

capital of the United States, as well as to facilitate its employment in the advance and diffusion of knowledge."[19]

Determined to streamline Smithsonian operations, Henry admitted that the postwar Institution was no longer the most suitable home for a national meteorological program. Since his earliest days in office, the secretary had forged alliances, fought political battles, and acquired corporate support to develop a means of gathering, analyzing, and distributing information on changing American weather conditions, but the war had delivered a serious blow to the effort. The prewar roster of six hundred weather observers was cut in half, prewar military participants were otherwise occupied, and telegraph stations no longer forwarded reports.[20]

In his 1865 report, the secretary called attention to the national weather reporting systems using telegraphic communication being established in England, France, Holland, and Italy, and pointed to a weather forecasting and warning network established by the British government in India following the devastation caused by a typhoon in the fall of 1864. "But the expense of the proper establishment of a system of this kind can only be defrayed by the general government," he noted, "or some organization in possession of more ample means than can be applied by the Smithsonian Institution to such purpose." A useful system, he estimated, would cost perhaps $50,000 a year, as opposed to the $4,000 expended by the Institution during the peak years before the war.[21]

Drawing on the support of the War Department and the new Department of Agriculture, Henry attempted to reestablish his network and resume posting national weather information on a map in the Castle while emphasizing that the Smithsonian would "willingly relinquish the field of meteorology" to a dedicated government program. Thanks in part to the secretary's urging, Representative Halbert Eleazur Paine introduced a bill in December 1869 calling for the secretary of war "to provide for taking meteorological observations at the military stations in the interior of the continent, and for giving notice on the northern lakes and Atlantic seaboard of the approach and force of storms."[22]

In addition to Henry, letters of support for the bill came from mathematician Elias Loomis, Surgeon General Jospeh K. Barnes, and Albert Myer, chief of the moribund US Army Signal Corps. Myer was especially enthusiastic, seeing the proposal as a popular and useful program that would increase his budget and reinvigorate the corps. On February 2, 1870, Paine introduced a joint resolution calling for the creation of a telegraphic weather service in the War Department. The bill passed and was signed by President Grant. On July 15, Congress approved an annual appropriation of $50,000 to support the Army Signal Corps Weather

Service. Secretary Henry had succeeded in transplanting a seed that had germinated in the earliest days of the Smithsonian into the richer soil of the federal government, where it would flourish.

THE CIVIL WAR HAD BROUGHT emancipation and citizenship for African Americans, but it had not inspired Joseph Henry to reconsider his fundamentally racist views. On April 15, 1866, the District of Columbia hosted a great celebration marking the fourth anniversary of the abolition of slavery in the nation's capital. Henry noted that the city was overflowing with "the coloured population." Should they be given the right to vote, he remarked, "we shall in the course of time have a black mayor and exofficio a coloured member of the Board of Regents of the Smithsonian Institution. This in a moral point of view may be all right," he admitted, "but it will sadly grate upon my prejudices."[23]

The secretary need not have concerned himself with any threat to his prejudices. On March 9, 1871, he reminded the regents that the District of Columbia Organic Act, passed earlier that year, replaced the elected office of mayor with a congressionally appointed territorial governor who, he suggested, should replace the mayor on the board. Eleven days later, the House approved a Senate bill amending the Smithsonian's enabling legislation by enacting a change that would preserve the racial sanctity of the Board of Regents. It would be over one hundred years before the first Black regent, A. Leon Higginbotham Jr., was appointed to the board on December 9, 1971.[24]

Politically astute, Henry tempered his own views in correspondence and public statements after 1865. Through the pages of his daughter Mary's diary, however, we can catch a glimpse of political attitudes in the Henry family circle during the critical months of 1866. She commented that a bill passed by the House on January 20 gave the vote to African Americans living in the District of Columbia, "greatly to the disgust of all residents therein." The Civil Rights Act of 1866, which provided citizenship to all persons born in the United States except Native Americans, was "calculated to increase rather than diminish the hostility between northerners and southerners and the hatred of the negro." President Andrew Johnson was a "brave man" for having vetoed the bill, and "well able to guide the ship of state." Thaddeus Stevens, who led the fight for African American civil liberties, was characterized as "the tyrant of the House." Mary Henry returned to the subject of suffrage for African Americans in the District at the end of the year, remarking that the better class of capital society would "soon be inundated by the coloured race, and probably soon rejoice in a black Mayor." Perhaps, she suggested,

Congress should amend the District Suffrage Act "in such manner as to put all whites of the Caucasian race . . . on an equal footing with the negros [*sic*]."[25]

While Henry was less vocal on the question of race following the war, his actions suggest that his prejudices were still in place. In 1868, he arranged for his close friends, John and Joseph LeConte (alternative spelling, Le Conte), major slaveholders and ardent supporters of the Confederacy, to escape Reconstruction South Carolina for prize teaching positions at the new University of California. While rising to leadership roles in American science, the LeConte brothers would continue spreading a virulent brand of white supremacy through speeches and publications for the rest of their lives. "The Negro race as a whole is certainly at present incapable of self-government and unworthy of the ballot," Joseph LeConte remarked in 1892, concluding that "their participation . . . in public affairs can only result in disaster." With a growing twenty-first-century recognition of the impact of racism on American life and culture, the University of California, the Sierra Club, and other California institutions have removed some of the honors accorded the brothers.[26]

As his own words and actions demonstrated, Joseph Henry remained a white supremacist. Looking toward the postwar future, the secretary realized that the validity of his convictions would be tested "with a series of experiments, relative to the mingling of races more interesting and instructive than perhaps has ever before been exhibited." A wide range of people from various corners of Europe as well Native Americans, Asians, and Africans "are all propagating themselves on the same soil," he observed. The important question, he suggested, "is will these diverse elements peacefully fuse into one homogenous whole or will the antagonism of races lead to internal commotions, and the violent extermination of the feeble?" Science had played a significant role in justifying the pervasive racism and widespread assumptions of white supremacy that would poison American society for the next century, and beyond. Joseph Henry assumed African American inferiority, argued that position in his correspondence, based Smithsonian policy on those prejudices, and promoted the interests of colleagues who were virulent racists. Whatever his other achievements, those attitudes and actions must be considered in assessing his role in the history of the Institution and American intellectual life.

THE SECRETARY MAINTAINED CONTROL over management decisions relating to funding, the reconstruction of the Castle, and efforts to streamline operations and reduce costs through the dispersal of the library, select collections, and programs more suited to other agencies. At the same time, his external responsibilities were

increasing. He became chairman of the Lighthouse Board in 1871, with responsibility for a budget of $1.6 million and personnel that included more than eight hundred lighthouse keepers alone.[27]

After the resignation of Vice President James Dwight Dana in the summer of 1865, Henry was elected vice president of the National Academy of Sciences in January 1866. The president of the academy, Alexander Bache, had been severely incapacitated, meaning that Henry effectively stepped into the role of acting president. Elected president of the academy in his own right in 1868, he would lead the organization until his death, discouraging attempts to create a more democratic rival organization, working successfully to overcome the academy's early problems, and providing a foundation for an organization that would play a major role in shaping the relationship of professional science and the government.[28]

As secretary of the Smithsonian and president of the National Academy of Sciences, Henry was, effectively, the most important voice for science in government and the unofficial leader of the American scientific community. He used that position to suggest promising directions for research. He supported Darwinian evolution and recognized the value of collections as a means of identifying relations between families, genera, and species. The Institution was a major American center of paleontological research and had pioneered research and publication in American archaeology and ethnology.

The Smithsonian was moving in directions Joseph Henry had not envisioned two decades before. The Institution's most visible and important research program now involved support for the scientific exploration of the continent and the maintenance of what had become the world's premier collection of specimens documenting the geological, biological, and ethnographic history of North America. With the return of peace, the secretary fully supported Spencer Baird's efforts to identify new sources of funding that would enable him to send experienced explorers and naturalists back into the field.

The opportunity came in 1864, following continuing problems with the transatlantic telegraph cable. The original cable, laid along the floor of the Atlantic Ocean in 1858 under the direction of Cyrus West Field, functioned for only three weeks. A second attempt in 1863 also ended in failure. In 1864, Perry McDonough Collins, an entrepreneur with commercial contacts in Russia, convinced Hiram Sibley of Western Union to consider the possibility of achieving an intercontinental telegraph link by extending the lines up the West Coast of the United States and Canada to Alaska, across the Bering Strait to Siberia, and on to Europe through the back door. In search of information on the territory through which the telegraph lines would pass, as well as suggestions as to individuals familiar with the area,

Sibley sought the advice of a close friend, Professor Sewell Sylvester of Rochester University, who suggested the company consult his brother-in-law, Spencer Baird. Without hesitation, the assistant secretary proposed his one-time protégé, Robert Kennicott, as their man.[29]

By 1864, Baird's young friend was back at The Grove, his family estate, determined to transform the Chicago Academy of Sciences into a "Smithsonian of the West," as one commentator remarked. Threatened with the draft that year, he hired a substitute to continue working to improve the academy museum. Still, as he admitted to his Hudson's Bay colleague Roderick MacFarlane, the subarctic wilderness retained a hold on him. "It's all very well to talk of the delights of the civilized world," he wrote, "but give me the comfortable north where a man can have some fun, see good dogs and smoke his pipe unmolested. Damn Civilization."[30]

At Baird's request, Kennicott made several trips east in the summer of 1864 to discuss matters with Sibley and other Western Union officials, finally accepting an appointment as chief of exploration in charge of determining the route that the telegraph lines would follow through Canada and Alaska. He hired his old friend and fellow Megatherian William Stimpson to replace him at the academy.[31]

This would be a paramilitary expedition, complete with uniforms and ranks. Major Kennicott wore the blue uniform of the Union army he had chosen not to join, with a badge on his forage cap showing a canoe over a *W* and *U* for the company name, topped by lightning bolts piercing a star. He would serve under Colonel Charles Bulkley, in command of the entire operation in North America. As a condition of employment, Kennicott insisted that the company hire a Scientific Corps that included thirty-year-old Charles Pease, his boyhood friend, and a string of other young naturalists in training.[32]

Kennicott recruited Henry Martyn Bannister, a student who had worked with him on the museum at Northwestern; taxidermist Ferdinand Bischoff; twenty-six-year-old Joseph Trimble Rothrock, a Harvard student of Asa Gray; nineteen-year-old Henry Wood Elliott, one of Baird's young naturalists; and nineteen-year-old William Healey Dall, who had studied with Louis Agassiz at Harvard and had worked as Kennicott's personal secretary at the academy. He was the son of Charles Dall, a Unitarian missionary, and Caroline Wells Healey Dall, a teacher as well as a pioneering feminist and transcendentalist associate of Margaret Fuller and Elizabeth Peabody. Dall was appointed a lieutenant and served as second-in-command of the Scientific Corps.[33]

Kennicott and his young naturalists met with Baird and Henry in Washington, then left for New York on March 21, 1865. "We had quite a clearing out at the Institution yesterday," Henry informed a friend. "Kennicott and five men left for

SMITHSON'S GAMBLE

Russian America to join the telegraph company. . . . They are full of energy, enthusiasm and excitement. I fear however that they will not be able to do as much in the way of Natural History as they anticipate because the essential object of the expedition is the exploration and establishment of the telegraph line and the conditions will scarcely allow any other object to interfere with this."[34]

The members of the Scientific Corps sailed to Greytown, Nicaragua, aboard the sidewheel steamer *Golden Rule*, struggled across the isthmus on foot, and continued their journey aboard a second ship to their meeting with the rest of the expedition in San Francisco. After their arrival, Dall requested permission to make a collecting trip to Monterey, which "succeeded beyond expectations." While Kennicott and the others proceeded north, Dall remained in San Francisco for a time, organizing the shipment to the Smithsonian of fifteen large boxes containing ten thousand specimens collected so far on the voyage.[35]

As Henry predicted, however, there would be little enough time for natural history in the immediate future. Rothrock, Elliott, and Bannister were assigned to Major Frank Pope, who was establishing the lines through British Columbia. Kennicott led the group exploring the route through Russian America, which included Dall, following his initial stay in San Francisco; Pease; and Bischoff. They were joined by the English artist Frederick Whymper (brother of mountaineer Edward Whymper), whom Baird dispatched to document the expedition. As Yukon streams froze with the approach of winter, Dall, the marine biologist, returned to San Francisco to continue his collecting and maintain contact with the world on behalf of the expedition. Kennicott spent the winter of 1864–65 at Nulato, a Russian American post deep in Alaska on the Yukon River, preparing detailed maps of the areas he had surveyed on behalf of Western Union. He planned to push upstream to Fort Yukon the next spring.[36]

On the morning of May 13, 1866, Kennicott told Charles Pease, who had wintered with him, that he was going for a walk. His friend found his body on the riverbank later that morning. Robert Kennicott was just thirty years old. The cause of death was long in dispute. Some of those who were with Kennicott at Nulato believed that he had committed suicide, probably by ingesting the strychnine used to preserve bird and animal skins. Others suggested that he died of a hardening of the aorta, but there was no evidence that he had ever suffered from rheumatic fever, which often caused that condition. In the end, the chief surgeon of the expedition, Dr. Henry Fisher, attributed the death to "organic heart failure." His heart simply stopped beating.[37]

Kennicott's body was a long way from home. Word of his death in the Arctic wilds did not reach California until September 1866. The *New-York Times* reported

"The Sudden Death of the Persevering Naturalist" in mid-October. Kennicott's remains would be buried or stored three times during the difficult journey from Nulato to The Grove, where he was finally laid to rest on January 28, 1867, 261 days after his death.[38]

Even then it was not a final rest. In 2001, Stephan Swanson, the director of The Grove, now a historic site and nature preserve, asked Smithsonian physical anthropologist Douglas Owsley to autopsy the remains and determine the cause of death. The study demonstrated that, while Kennicott's body contained harmful substances from strychnine to mercury, Dr. Fisher was almost certainly correct. The naturalist died of sudden heart failure. Among the discoveries revealed by the examination was the fact that Kennicott's teeth, like those of James Smithson, exhibited a space, in this case resulting from the abrasion of a clay pipe stem. And, like Smithson, his mortal remains were retained by the Institution, and are now in storage at the National Museum of Natural History. Surely, he would prefer to rest under a carpet of prairie grass in his beloved Grove.[39]

On July 26, 1866, almost two months after Kennicott's death, Cyrus Field's third try at a transatlantic cable succeeded. Early that fall, the second cable was retrieved from the ocean floor, repaired, and put into service. Western Union recalled the members of its expedition. William Dall, with Smithsonian support, continued the scientific exploration of Alaska, returning to the Smithsonian in 1869 to process Arctic collections for Baird and to complete work on his book, *Alaska and Its Resources* (1870). Signing on as acting assistant to the director of the US Coast Survey, he made several additional trips north, surveying the Alaskan and Siberian coasts between 1870 and 1880 and then returning to Alaska in 1899 as a member of the Harriman Expedition. Transferring to John Wesley Powell's US Geological Survey in 1884, he was assigned to the Smithsonian, where he would serve as honorary curator of paleontology until his death in 1927.[40]

THE ATTENTION THAT HENRY AND BAIRD had paid to the geography, geology, natural history, and ethnology of the Arctic wilds of Canada and Russian America would have a major impact on American policy in the early spring of 1867. On March 8, Secretary of State William Henry Seward met with Baron Edouard de Stoeckl, the Russian minister to the United States, to discuss a California proposal for a joint trading operation with Russian America as well as a Washington State request for fishing rights in Russian waters. When the baron refused both requests, Secretary Seward, aware that the Russian government was anxious to dispose of a distant colonial outpost that it could not defend and that provided few resources, suggested that perhaps Czar Alexander would consider selling the

territory to the United States. Baron de Stoeckl responded that the czar would be pleased to consider any proposal that the United States might offer. On March 30, after less than a month of discussions with President Johnson and members of the cabinet, Secretary Seward concluded a treaty acquiring 586,412 square miles of new territory for the United States at a cost of $7.2 million in 1867 dollars.[41]

On the day he signed the treaty, Seward asked Senator Charles Sumner, chair of the Foreign Relations Committee, to call on him at his home. It was the first time that Sumner, or any member of Congress, was informed that the government was considering the acquisition of Alaska, let alone that a treaty effecting the purchase had been negotiated and signed. Persuading his Senate colleagues to ratify the purchase of the huge frozen territory in the far north, negotiated by an unpopular administration without any warning or discussion, would not be an easy task. Still, the treaty would mean the expulsion of a colonial power from North America and would open whatever resources Alaska could offer to the United States.

With Secretary Henry away from Washington on business, Sumner's first step, on the day he learned of the treaty, was to contact Spencer Baird. As the focal point for reports and collections received over the past eight years from Arctic Canada and Russian America, he was perhaps the best-informed American on the subject. Moreover, a young veteran of the Western Union expedition was on hand. Twenty-year-old Henry Bannister, who was one of the handful of Americans who had spent time in Alaska and could also translate Russian documents, was back at the Smithsonian working with Baird on the collection.[42]

Sumner planned to rush the treaty through the Senate before serious opposition could develop. The key to selling the acquisition would be a long speech by Sumner focusing on the economic potential of Alaska, and Baird would be his most important source of information. Between March 30, when Sumner enlisted Baird's assistance, and April 9, when the treaty was ratified by the Senate, Baird and the senator met at least five times. In addition, Baird conferred with Secretary Seward, Senator George F. Edmunds of Vermont, and Baron de Stoeckl. Baird also instructed Henry Bannister to unpack and inventory the specimens returned from Alaska, translate Russian documents for the Senate Foreign Relations Committee, and offer first-person testimony to the committee regarding the geography and natural history of the region.[43]

Sumner reported the treaty to the Senate on April 8, followed by a three-hour oration the next day underscoring the climate, soil, agricultural potential, and rich resources of fish, timber, and minerals, including copper and "washings of gold . . . discovered on the headwaters of the streams on the East side of the coast range of mountains." In closing, he offered a tribute to Baird. "Sometimes

individuals are like libraries," Sumner began, "and this seems to be true of Professor Baird of the Smithsonian Institution, who is thoroughly informed on all questions connected with the natural history of Russian America." After a short debate on August 9, the treaty was ratified with a vote of twenty-seven in favor and twelve opposed. In preparing the final copy of his speech for publication, the senator asked Baird to continue submitting information and to correct proofs of the document.[44]

Senate ratification of the treaty was only the first step in the purchase of Alaska. Persuading members of the House of Representatives to fund the acquisition would be a more difficult task. The situation was complicated by both the need to deal with existing war debt and growing Republican opposition to President Johnson's liberal Reconstruction policies, which would culminate in his impeachment by the House and Senate in April and May 1868.

Secretary Seward, planning his campaign to win support in the House, turned to Joseph Henry on April 10, 1867, asking if the Smithsonian could undertake a survey of the resources of Russian America "for the use of several branches of the government so that a report upon the subject may be communicated to Congress at the opening of the Session in December next." Away from Washington at the time, the secretary consulted with Baird upon his return. Baird informed him of his ongoing relationship with Sumner and his continuing effort to provide the senator with what information he had on the subject.[45]

Henry responded to Secretary Seward that the Smithsonian held a wealth of publications, manuscript materials, and collections that could provide the basis for "a general report . . . [to] be prepared, under the direction of the Institution, giving an account of the history of the country, the relation of it to the Russian American Company, its geology, natural history, ethnology, statistics, and general resources, all properly arranged and indexed." Such a report, he continued, would be provided "free of cost to the government other than that of the necessary translations and other clerical services."[46]

Baird suggested to Henry that for $5,000 or $6,000, a small party might be dispatched to gather information that would fill in gaps in their knowledge regarding timber, animal, and mineralogical resources and the inhabitants. Instead, on June 4, 1867, Secretary of the Treasury Hugh McCulloch ordered Captain W. A. Howard of the US Revenue Cutter Service to sail to Alaska and "acquire a knowledge of the country for the information of Congress and the people." The expedition was to be guided by instructions prepared by Henry on meteorological observations, by Baird on natural history and resources, and by the Smithsonian's George Gibbs on ethnology.[47]

Baird, Bannister, and Henry Elliott, who had returned from Alaska and taken a job as Joseph Henry's private secretary, continued to support the effort in the House. Nathaniel Banks, chairman of the House Foreign Affairs Committee, credited Baird with providing "remarkable . . . and perfectly reliable" reports on Alaskan resources. On July 23, 1869, the House passed the bill funding the purchase of Alaska with a vote of ninety-one to forty-eight, with seventy abstentions. President Johnson signed the bill into law four days later.[48]

THANKS TO SPENCER BAIRD'S YOUNG naturalists and his far-flung network of Hudson's Bay Company volunteers, the Smithsonian had pioneered the scientific exploration of the Canadian Arctic and the Alaskan wilderness. In the wake of Elisha Kane's 1853–55 expedition, Joseph Henry continued to encourage subsequent American polar explorers to include a research component in their plans. "That there is a very interesting field of investigation still open to the [Arctic] explorer," he wrote to a colleague in 1860, "must be evident to any one [sic] who will attentively study the present condition of science, in regard to this region."[49]

Isaac Israel Hayes, who had served as a surgeon under Kane on the second Grinnell expedition, announced his intention to make his own try for the North Pole in two talks on Arctic exploration, held in the Smithsonian lecture hall on January 6 and 24, 1858. The goal of the new expedition, Henry explained, was to "extend the exploration of Dr. Kane towards the north, and to make such observations of a scientific character as might tend to increase the existing knowledge of the Physical Geography, Meteorology, and Natural History of the region within the Arctic circle." At a meeting on May 17, 1860, the regents approved the secretary's recommendation that the Institution provide Hayes with fundraising support, instruments with which to gather meteorological data and measurements of terrestrial magnetism, dredge nets, and other collecting supplies.[50]

Hayes departed for the Arctic with twenty men aboard the schooner *United States* in June 1860. He enlisted the services of several Inuit to instruct the members of the expedition in the techniques of survival in the Far North. The party pushed north to Ellesmere Island in an unsuccessful search for a path over an open Arctic sea to the pole. Hayes returned to Upernavik, Greenland, on August 12, 1861, on his way back to the United States, convinced that he had reached the nonexistent polar ocean. With the Civil War underway, he enlisted in the federal army, rising to the rank of brevet colonel in command of a hospital.[51]

Hayes turned his collections over to the Smithsonian, along with his data on meteorology, terrestrial magnetism, and tides, but he did little to assist in preparing the scientific results of this expedition. Henry hired Charles Schott, a

researcher with the US Coast Survey, to reduce, analyze, and comment on the data published as *Physical Observations in the Arctic Seas* in the 1867 volume of Smithsonian Contributions to Knowledge. Hayes preferred to spend his time writing a popular account, *The Open Polar Sea: A Narrative of a Voyage of Discovery Towards the North Pole in the Schooner "United States."* The secretary complained that the explorer had neither given the Institution appropriate credit in his book nor returned the scientific instruments loaned by the Smithsonian.[52]

In the spring of 1870, when Charles Francis Hall, a small-time Cincinnati businessman and a veteran of two Arctic journeys, attempted to persuade Congress to fund his proposed expedition to the North Pole, Isaac Hayes asked Secretary Henry to support his own plan for a return north. Hall called at the Smithsonian as well, "in great distress on account of the probability that his enterprise would be stopped by the intermeddling of Dr. Hayes." Henry refused Hayes's request and, on March 18, wrote a three-page letter of support for Hall to Henry Dawes, chair of the House Appropriations Committee.[53]

Broad shouldered and muscular, having worked as a blacksmith as a young man, Hall sported long, dark hair, a full, bushy beard, and a mustache shrouding his upper lip. Thirty-three years old in 1855, he was living in Cincinnati with his wife, Mercy, and their two children and operating a store selling engraved seals for use on business and personal documents and presses for embossing stationery. As a sideline, he launched a one-page newspaper, the *Cincinnati Occasional*, which he filled with items on his adventurous interests, and particularly the extended series of long-distance balloon flights and races being staged in the city.[54] In December 1858, Hall ceased publication of the *Occasional* and began issuing a new journal, the *Daily Press*, running stories on another of his interests, Arctic exploration. There were editorials suggesting that Sir John Franklin's men, missing now for over a decade, could still be alive, and accounts of others who had braved the northern wilds. His growing obsession led him to camp out in the winter near the Cincinnati Observatory, as close as he could come to an Arctic experience. That year, he joined the search for the Franklin expedition and, for the next twelve years, Mercy Hall and their children would teeter on the edge of poverty while Charles journeyed across the north country.[55]

Hall succeeded in raising only $980, $343 of it from Henry Grinnell, who was also funding Isaac Hayes's larger-scale venture north. Booking passage aboard the New Bedford whaler *George Henry*, Hall wintered with the crew on Baffin Island, where he befriended a band of First Nations peoples. He hired an Inuit couple, Ipirvik and his wife, Taqulittuq, to serve as guides and translators. The pair, whom Hall referred to as Joe and Hannah, had traveled to England aboard a whaler in

175

1853, where they attracted considerable attention and dined with Queen Victoria and Prince Albert before returning to Baffin Island. With their assistance, Hall was not only able to gather Inuit stories regarding the lost Franklin expedition but also collected oral testimony that led him to a much older site, the remains of a mining camp established on Baffin Island by the Elizabethan explorer Martin Frobisher in 1578. The Inuit couple returned to New York with Hall in 1862, appearing at P. T. Barnum's American Museum that fall.[56]

Determined to solve the mystery of the Franklin expedition, Hall and his Inuit companions departed on a second northern voyage as passengers aboard the whaler *Monticello* in July 1864. Convinced that Native accounts offered vital clues to the fate of the lost explorers, Hall and his companions spent four difficult years together in the Arctic, living and traveling with Inuit bands. Hall occasionally hired the services of whalers to assist him. At one point, short-tempered and edging toward paranoia, he shot and killed one of those sailors for what he regarded as mutinous behavior.

Hall returned to the United States in 1869, once again accompanied by Ipirvik and Taqulittuq, with the skeletal remains of one of Franklin's men discovered on King William Island and some small items connected to the lost explorers. Native testimony, he announced, convinced him that none of the Franklin party survived. He sent the remains of the single Franklin expedition member whom he had retrieved to England, where the Royal Navy interred the bones in a sarcophagus in the chapel of the Royal Naval hospital at Greenwich. The artifacts relating to both the Frobisher and Franklin expeditions remain in the collection of the Smithsonian.[57]

On March 8, 1870, Representative Job E. Stevenson of Ohio introduced a joint resolution to fund a third Arctic expedition, this time with the intention of reaching the North Pole. Both Hall and Hayes would testify in the weeks to come. On July 12, 1870, Congress passed an amended version of the bill appropriating $50,000 for the project. As Secretary Henry advised, President Grant chose Hall over Hayes to lead the expedition. Congress placed responsibility for developing a scientific program for the venture in the hands of the National Academy of Sciences. As the president of the organization, which met at the Smithsonian and depended on the Institution to publish its proceedings, Henry reminded the legislators that "the procuring of scientific instruments and the organization of the scientific corps" for such expeditions was "principally effected in connection with the Smithsonian Institution."[58]

While recognizing that the primary goal of the enterprise was geographic exploration, Henry and Baird prepared detailed instructions for research to be

AN INSTITUTION FOR A GROWING NATION—LOOKING NORTH

undertaken. Hall hoped to appoint an acquaintance, English physician David Walker, as surgeon-naturalist with the expedition. Henry and Baird overruled him, insisting that a German, twenty-four-year-old Emil Bessels, be named to the post. The secretary, who had met Bessels during his 1870 European sabbatical, argued that, with his Heidelberg education and experience on an 1869 German Arctic expedition, Bessels was a much stronger candidate than Walker.[59]

On July 3, 1871, Hall and the twenty-five members of his expedition, including Ipirvik and Taqulittuq, set sail from New London, Connecticut, aboard the USS *Polaris*, a steam-powered veteran of the Civil War that had been modified at the Washington Navy Yard for Arctic service. Things did not go well. When the party met with a navy supply vessel, the USS *Congress*, at Disco Bay on the Greenland coast, the group had already splintered into three factions, each of them at odds with Hall. By late August, the *Polaris* was skirting the ice pack and continuing in open water, further north than any other ship had ventured. As ice began to close in, one officer reported that some crewmen feared that they were venturing "to the very lip of the known world." On September 10, they were iced in for the winter at a spot on the Greenland shore that they christened Thank God Harbor.[60]

A month later, Hall pushed north with a sledge and three companions, determined to identify a route that he could take north to the pole in the spring. Returning to the ship after only two weeks, he commented that, "I can go to the pole, I think, on this shore." The commander fell ill immediately, however, suffering from nausea and complaining of a burning feeling in his stomach. Descending into delirium, he began to accuse everyone of poisoning him, particularly Dr. Bessels, who had been feeding him and administering medicine. Charles Francis Hall died on the morning of November 8, 1871, and was buried next to the ship.[61]

The tragedy of the *Polaris* expedition had only begun. Nineteen people were off the ship on the ice on October 12, 1872, when the *Polaris* broke free of its moorings and was blown out of sight, with a second group still aboard. The party stranded on the ice, a mix of crewmen and Inuit men, women, and children, including Ipirvik and Taqulittuq, moved slowly south, shifting from one floe to the next, until August 30, 1873, when they were rescued by the crew of a Newfoundland sealer. The crew of a Scottish whaler discovered the individuals remaining aboard the *Polaris*, including Emil Bessels, and took them to Great Britain.[62]

Secretary of the Navy George Robeson convened an initial court of inquiry only hours after the first group of survivors arrived in Washington on June 5, 1873, and went back in session at the Washington Navy Yard on October 11, following the return of the men who had remained aboard the *Polaris*. The court exonerated the ship's captain of any responsibility for the collapse of the expedition, and,

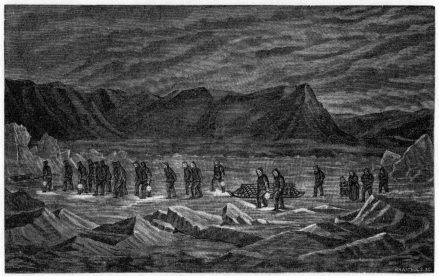

Funeral of Captain C. F. Hall, Nov. 10, 1871.

Depiction of the funeral of explorer Charles Francis Hall, c. 1870s. Hall led an expedition to the North Pole on the USS *Polaris* in 1871. One of the goals of the expedition was to carry out scientific research for the Smithsonian. While the expedition continued until 1873, Hall died on November 8, 1871, five months after departing New York City. *Library of Congress*

following Bessels's testimony, ruled that, while his symptoms could suggest arsenic poisoning, "we are conclusively of the opinion that Captain Hall died from natural causes."[63]

Yet the questions remained. The *New York Herald* headlined the matter this way: "Dr. Bessel [sic] . . . on the Death of Hall . . . An Emphatic Denial of the Poison Rumors." While the papers seem to have accepted Bessels's diagnosis of a stroke as the cause of Hall's death, the doctor was said to have spoken of Hall "in a sneering and contemptuous tone" and to have "secretly conspired against him." The *Alexandria Gazette* carried a short rebuttal of the poisoning allegations, quoting Bessels's comment that "it was only during the delirium of illness that he manifested great fears of being shot or poisoned." In spite of his best efforts and the judgment of the naval court of inquiry, Bessels was never able to completely escape suspicion.[64]

Whatever his role in creating the divisions that marred the Hall expedition, Emil Bessels had devoted himself to his scientific duties. He led a scientific party that included meteorologist Frederick Meyer and astronomer R. W. D. Bryan. In October 1871, once the expedition had entered winter quarters, the three men constructed a small wooden observatory where they began weather and tidal

observations, conducted studies of changes in terrestrial magnetism with instruments supplied by the Smithsonian, and carried out measurements of gravity using a pendulum. Bessels also undertook sledging trips to collect minerals, fossils, and zoological specimens, as per Baird's instructions. In spite of the difficulties faced in the months to come, he continued to record meteorological and geophysical data and to pursue collecting activity. While he could preserve his tables of data, all but a small portion of his collection was lost when the *Polaris* was abandoned and the party escaped aboard the whaler.[65]

In addition to those few specimens, the Institution also became the official repository of Charles Hall's papers. On June 23, 1874, Congress directed Secretary Robeson to provide the long-suffering Mercy Hall with the salary earned by her husband while in command of the *Polaris*, and appropriated an additional $15,000 to purchase all of Hall's notebooks, scrapbooks, correspondence, and other materials from her to be deposited with the Smithsonian, where they remain today in the collection of the Archives Center of the National Museum of American History.[66]

Reminders of Ipirvik and Taqulittuq can be found in the collection as well. They returned to the United States with the *Polaris* survivors who had been stranded on the ice. The couple sat for Thomas Smillie's camera while in Washington for the 1873 hearing. Newly hired as the Smithsonian's first official photographer, he captured images of the pair in Inuit garb and then another set in their best Western clothes. They had lost two young children during their travels with Hall. They settled in Groton, Connecticut, where their adopted daughter died in 1875. Taqulittuq followed her in death a year later and was buried with her children in a local cemetery. Ipirvik returned to the Arctic with yet another expedition in search of answers to the Franklin mystery. He died on King William Island, probably in 1881.[67]

Following the inquiry, Baird provided Bessels with an office, where he went to work on the publication of a planned three-volume report on the scientific results of the expedition. The first volume, covering the physical observations, was published by the Department of the Navy in 1876. A second volume on the natural sciences and a third on the ethnology of the Inuit were to follow. In 1880, Bessels, with Baird's support, requested that Congress fund the completion of the project and reimburse him for personal possessions lost on the expedition. By joint resolution, he received $10,233.70 to cover his personal losses, personal funds spent on the publication of the first volume, and back salary from August 1876 to March 1880. The request for the funds with which to complete the publications was rejected. As a result of errors in the text, the first volume was not reprinted. He did, however, publish a narrative history of the experience in German.[68]

179

SMITHSON'S GAMBLE

Bessels remained controversial to the end. In 1880, a New York reporter interviewed him regarding plans for another polar expedition as America's contribution to the first International Polar Year. Puffing away on a cigar, Bessels dismissed the proposed expedition out of hand. The publication of the interview outraged Baird, who sent a letter to Bessels advising him to practice civility in interactions with the press.[69] By 1883, Baird had had enough. He ordered William Rhees to evict Bessels from his office. Two years later, his Maryland home burned, and with it his papers, including the unpublished volumes of results from the Hall expedition. He returned to Germany, where he died of apoplexy in 1888.

In 1968, Chauncey Loomis, a Dartmouth English professor fascinated by the story of Charles Hall, led an expedition to exhume the explorer's body to solve the mystery of his death. Forensic studies of the hair and fingernails revealed that "Charles Francis Hall had received toxic amounts of arsenic during the last two weeks of his life."[70]

Did Emil Bessels, as a newspaper had once suggested, know more about his commander's death than he cared to tell? He was not the only member of the expedition who had disagreements with Hall. In 2004, however, researcher Edward Cooper suggested a possible motive. In the weeks before the departure of the *Polaris*, Vinnie Ream, an attractive eighteen-year-old sculptor, met both Hall and Bessels in Washington and New York. She shipped Hall a bust of Lincoln and other mementos that he kept in his cabin.[71]

Bessels seems to have been genuinely smitten with her, writing to her on June 28, 1871, "I will never forget the happy hours, which kind fate allowed me to spend in your company."[72] Whatever the depth of Bessels's romantic feelings, it must have been difficult for the doctor to visit Hall's cabin decorated with evidence of Vinnie Ream's affection. While the proverbial "smoking gun" is absent, the fact remains that Charles Francis Hall died of poison, and, as Chauncey Loomis notes, Dr. Bessels remains "the prime suspect."[73]

CHAPTER 10

AN INSTITUTION FOR THE NATION—LOOKING WEST

THE SMITHSONIAN INSTITUTION came of age in the era of Manifest Destiny. The territorial gains that followed the Mexican-American War produced a nation that stretched to the Pacific coast. Inspired by dreams of a fortune in gold, the promise of an agricultural paradise, or the simple desire to see what was over the next hill, thousands of Americans—citizens and immigrants alike—uprooted their lives and set out for the far western edge of the continent via overland trails, a sea voyage around Cape Horn, or a dangerous trek through the disease-ridden jungles of Central America.

Joseph Henry certainly appreciated the possibilities that American expansion offered to the Smithsonian. "Our new possessions in Oregon, California and Mexico," he wrote in 1849, "offer interesting fields for scientific inquiry, particularly in the line of natural history." It was Spencer Baird, however, who took full advantage of those possibilities. During the decade leading up to the Civil War, he had recruited adventurous civilian naturalists, as well as the scientifically inclined officers and men of the US Army Corps of Engineers, to undertake scientific collecting efforts on behalf of the Institution.[1]

Americans emerging from the tragedy of the Civil War turned their attention to the center of the continent, where rolling prairies beckoned potential homesteaders. Before 1860, Southern congressmen had opposed any attempt to extend the offer of inexpensive western land to settlers, fearing that an influx of foreign immigrants and Northern free staters would block the extension of slavery into the new territories. With the removal of Southern opposition in 1862, Congress passed the Homestead Act, "the hope of the poor man," as writer Mari Sandoz, the daughter of a homesteader, proclaimed. Earlier policy offered public land at $1.25 an acre, "too rich for the penniless," who stood to lose the land and the money if

they failed to improve the place within five years. The new legislation offered 160 acres under the same terms with no outlay beyond a $14 filing fee.[2]

The settlers would soon have a means of traveling to their new homes and sending their crops to eastern markets. Just as President Lincoln had decreed that work would continue on the unfinished Capitol dome despite the war, the first transcontinental railroad began pushing west in 1863. Towns would follow the tracks, as would a new generation of settlers in search of a homestead and a fresh start. But what was the nature of the vast open spaces between the Kansas frontier and the Rocky Mountains?[3]

The antebellum surveys conducted by the US Army Corps of Topographical Engineers were of little practical value to potential homesteaders. The army had pursued limited and very specific goals: the survey of five potential routes for a transcontinental railroad, the establishment of the borders separating both Mexico and Canada from the United States, and the exploration of the lower Colorado River. Almost as an afterthought, these expeditions usually included a young naturalist or two, often graduates of elite universities, usually mentored and recommended by Spencer Baird. Useful as they were to science and the military, the multivolume survey reports had little to say about climate, growing seasons, soil types, the availability of water, or a host of other matters that would spell success or failure for a farmer.

If solid information was in short supply, opinions were readily available. Early reports painted a bleak picture. In 1810, explorer Zebulon Pike suggested that "these vast plains of the western hemisphere may become in time equally celebrated as the sandy deserts of Africa." In the report of his 1820 expedition, Major Stephen Long described the rolling prairies dominating the center of the continent as the "Great American Desert." Edwin James, a member of his party, remarked that the area "is almost wholly unfit for cultivation, and, of course, uninhabitable by a people depending upon agriculture for their subsistence."[4]

Boosters like William Gilpin, however, were quick to assure potential settlers that the Great Plains and the Great Basin beyond were anything but uninhabitable. Gilpin had accompanied John Charles Frémont on his 1843 expedition across the Rockies, helped to organize a provisional government in Oregon's Willamette Valley, and participated in the occupation of New Mexico in 1846. Established as a lawyer in Saint Louis by 1860, he published his own glowing account of the West aimed at prospective homesteaders.[5] The Great Plains, he insisted, were the "Pastoral Garden of the world." Plowing this rich land would scarcely be necessary. With a "fine calcareous mold" covered in "thick nutritious grasses," one had only to scatter the seeds and harvest a crop. Everywhere, the ground was

"soft arable and fertile," capable of supporting "agriculture on a large scale, comparatively a new order of industry to our people."[6] The Great Basin, stretching from the western edge of the plains to the mountains, was, Gilpin admitted, "universally an arid region, and nowhere is arable agriculture possible without artificial irrigation." Fortunately, the soil could be "easily and cheaply saturated by all the various systems of artificial irrigation, acequias, artesian wells, or flooding by machinery." Irrigation ditches would serve as fences, enabling the production of "a prodigious yield . . . of grain, grass, vegetable, the grape and fruits, flax, hemp, cotton, and . . . flora."[7]

There was a clear need for practical, trustworthy information on the agricultural and economic potential of the West. The approach adopted by the federal government to meet that need involved a new round of scientific appraisals reflecting the lessons and experience of the state geological surveys that had played such an important economic and intellectual role in Jacksonian America. While the movement to identify and map a state's topography, geology, and economic resources began in the South in the 1820s, Edward Hitchcock and James Hall provided models of what could be accomplished with the geological surveys of, respectively, Massachusetts (1830–33) and New York (1836–41).[8] Both men took a broad view of their task, providing accurate maps and detailed geological studies of value in planning transportation improvements. They reported on soils, rivers and lakes, minerals, building materials, and other economic resources and cataloged the zoological, botanical, and paleontological features of their regions. Hitchcock produced a richly illustrated seven-hundred-page report, while the New York survey issued twelve volumes.

Recognizing the value of these studies, other states established their own geological surveys during the antebellum years. The California survey, running from 1860 to 1874, was the result of almost half a century of experience at the state level and served as a springboard to broad national surveys. William H. Goetzmann, the preeminent historian of the scientific exploration of the West, noted that "the California Survey . . . deserves to be ranked as the first in a series of great surveys that characterized the post–Civil War exploration in the Far West."[9]

Joseph Henry played a key role in selecting Josiah Dwight Whitney as the director of the California survey. A native of Massachusetts and an 1839 Phi Beta Kappa graduate of Yale, Whitney accepted a position with a geological survey of New Hampshire under Charles T. Jackson in 1840. He moved on to a survey of the mineral resources of the Lake Superior region; worked on the geological surveys of Iowa, Illinois, and Wisconsin; and published *The Metallic Wealth of the United States* (1854). As Joseph Henry was certainly aware, he also translated *The Use of the*

Blowpipe in Chemistry and Minerology by J. J. Berzelius, a work describing the scientific contributions of James Smithson.[10]

The legislation establishing the California Geological Survey, signed on April 21, 1860, named Whitney as head of the project. The survey would provide accurate topographic maps of the state as well as catalog its geology, natural history, and resources. Whitney also intended to nurture talent. His most consequential hire, Clarence Rivers King, joined the survey in 1863. The son of a frequently absent father engaged in trade with China, King was educated in elite New England schools and graduated from Yale's Sheffield Scientific School in 1862, where he studied chemistry, geology, and physics. In May 1863, having declined either to register for the draft or pay $300 to hire a substitute, he turned his back on the war and traveled west with friends to California armed with letters of introduction to Whitney. William Brewer, Whitney's assistant, noted that the twenty-one-year-old geologist combined a scientific background with physical strength and endurance, an adventurous nature, and a romantic appreciation for the sublime mountain landscape.[11]

Clarence King remained with the California survey until 1867, building practical experience equivalent to a graduate education. In addition to his solid geological work, which included a survey of the Yosemite Valley, he participated in ascents of Mount Tyndall, Mount Shasta, and Mount Whitney, chronicling his experience in what remains a masterpiece of the literature of the West, *Mountaineering in the Sierra Nevada*. King traveled to Washington, DC, in 1866, confident that he could apply the principles demonstrated on the California survey to a study of a 450-mile strip along the fortieth parallel, from the high Sierras of California, east through Nevada and Utah, and on to the Colorado Rockies. He would, as one admirer remarked, parallel "the Continental Railway in Geology."[12]

With his experience, Ivy League background, and more than a dash of charisma, King was ready to take his place on the national stage. On March 2, 1867, Congress authorized the War Department to undertake geological surveys of the West. Despite his status as a civilian, King was named US geologist of the Geological Exploration of the Fortieth Parallel.[13]

The Smithsonian would support the scientific exploration of the West as it had before the war. Both Henry and Baird exercised influence with Congress and the executive departments in support of King's survey and those that followed. At King's request, Henry and Baird provided scientific instructions and supplied the materials and supplies required for the preservation of natural history specimens. They maintained a considerable talent pool of young naturalists primed for a

AN INSTITUTION FOR THE NATION—LOOKING WEST

western adventure. They would also reap the scientific reward, receiving, housing, and supervising the study of the collections gathered by the survey.[14]

King's initial crew, including the camp support staff and military escorts, numbered thirty-five. Four geologists, four topographers, two botanists, a zoologist, and a meteorologist made up the professional staff. Recognizing the impact that images of the western landscape would have on the American imagination, he hired famed Civil War photographer Timothy O'Sullivan to create a visual record of the project.[15]

King also hired one extraordinary young man recommended by Spencer Baird. Fourteen-year-old Robert Ridgway had written to Baird in 1865, asking him to identify a bird he had drawn. Always ready to encourage talent when he found it, Baird was soon on the receiving end of more drawings, bird skins, nests, and eggs from the budding naturalist. Baird wrote to his young friend in March 1867, offering Ridgway the choice of working with him at the Smithsonian or the opportunity "to go to the Rocky Mountains and California for a year or two as a collector of specimens." At Baird's suggestion, King issued an official invitation to the teenaged ornithologist, who, with parental consent, signed on at a salary of fifty dollars per month, plus expenses. After a few weeks of training with Baird in Washington, young Ridgway was off to join King and launch what would become a great career in science.[16]

Through a congressional extension in 1869, King's team was funded to operate in the field for another six years. Collections flowed into the Smithsonian. As the survey moved from west to east along the route to be followed by the Central Pacific Railroad, young Ridgway grew accustomed to the rough life on the trail. Assigned to ride a tall, rawboned mule prone to bucking, the youngster "felt very much as if I were straddling a high peaked roof." Several days later, "the cantankerous brute" saved his life. The mule insisted on charging far ahead of the group. Feeling ill, Ridgeway dismounted to rest in the animal's shadow. He awoke in the ambulance, O'Sullivan's rolling photographic studio. Had "my steed's preference been for the rear of the line," he noted, "it is easy to see that I might not have lived to relate the incident." Along with his fellows, he would face bouts of malaria, Indian raids, nests of rattlesnakes, clouds of mosquitoes dense enough to snuff out candles, and drinking water "so sulphureous that it smelled like rotten eggs." With the completion of fieldwork, Ridgway returned to the Smithsonian as the Institution's first curator of ornithology in 1874, where he would remain until his death in 1929.[17]

KING'S SURVEY WAS NOT YET UNDERWAY when Spencer Baird recognized an opportunity to launch a similar endeavor in another part of the West. In 1867, when

Spencer Baird, c. 1867. Baird, the second secretary of the Smithsonian, was a naturalist and man of science. As secretary, he was a wise manager whose vision laid the foundation for the modern Smithsonian. *Smithsonian Institution Archives*

drafting the legislation authorizing Nebraska statehood, Congress included $5,000 to fund a survey of the geology and resources of the area. "If you want the place," Baird urged ex-Megatherian Ferdinand Hayden, "you had better come at once and see about it." Hayden responded that he could "accomplish so much if I can get that place," and immediately asked his prewar comrades, including Major General Gouverneur K. Warren, for letters of support.[18]

Hayden had spent the war years as an army surgeon, rising to the brevet rank of lieutenant colonel, after which he had accepted a position teaching geology and minerology at the medical school of the University of Pennsylvania. Finding academia too tame for his adventurous spirit, he took a leave of absence in 1866 and spent that summer and fall back in the Black Hills and Badlands of the Dakota Territory, once again filling wagons with the remains of prehistoric turtles and other fossils. Hayden extended his leave the following year when he accepted the post of geologist in charge of the Nebraska Geological Survey, reporting to Joseph S. Wilson, the commissioner of the General Land Office. In addition to reporting on geological features, he would focus on economic resources from soil and water conditions to potential mineral wealth.[19]

With a limited budget, Hayden initially operated with a small staff, including both James Stevenson—who had accompanied him on an 1856 US Army Corps of Topographical Engineers expedition—and fellow Megatherian Fielding Meek. The new survey would draw all supplies, weapons, animals, and other support from the army. He also reached out to Spencer Baird with a detailed list of required collecting equipment and supplies. While the official collections went to the General Land Office, Hayden conducted an "independent survey" on behalf of the Institution from Denver south into New Mexico. Baird arranged the transportation of the resulting collection to the Smithsonian. When Hayden visited in December 1868, Henry explained that much of the material he had contributed had already been passed on to other institutions, for, he cautioned, "my policy in regard to collections is that the Smithsonian Inst fund must be guarded from absorption in a museum."[20]

Congress renewed funding in 1868 for Hayden's survey and doubled it to $10,000 in 1869, redesignating the operation as the US Geological and Geographical Survey of the Territories, now operating under the oversight of the Department of the Interior. With the increased funds, Hayden began to expand his staff. While he would be accused of padding the survey payroll with congressional relatives, the scientific caliber of the staff was very high. He hired Cyrus Thomas, who would one day produce a major study of mound archaeology for the Smithsonian, as botanist and entomologist. Henry Elliott, who had been serving as Joseph

SMITHSON'S GAMBLE

Henry's private secretary since returning from the Western Union Telegraph Expedition, signed on as an artist and naturalist. William Henry Holmes would replace Elliott in 1870. Holmes had come to Washington to study painting under Theodore Kaufmann but attracted the attention of Mary Henry, who urged him to paint studies of items in the collection. When Elliot decided to leave the Hayden survey, Fielding Meek hired him as a replacement.[21]

Stories of the natural wonders of the Yellowstone valley had been circulating since John Colter, a veteran of the Lewis and Clark Expedition, had wintered in the area in 1807–8. Inspired by a short report of an army visit to the area in 1870, Hayden decided to devote his 1871 season to a formal survey of Yellowstone while dispatching Stevenson to explore the Teton Range. Like King, Hayden recognized the importance of a visual record of the areas being surveyed. Photographer William Henry Jackson joined the survey in 1870 and remained for nine years, producing scores of iconic images.[22]

Thomas Moran, a thirty-four-year-old Philadelphia painter who had never ridden a horse, also accompanied the expedition. "I have always held," he remarked to Hayden, "that the grandest, most beautiful, or wonderful in nature, would, in capable hands, make the grandest, most beautiful, or wonderful pictures." Indeed, Moran's large canvases of the Grand Canyon, along with William Jackson's photographs, including his famous *Mountain of the Holy Cross*, are among the outstanding representations of the western sublime. In his finished seven-by-twelve-foot painting *The Grand Canyon of the Yellowstone*, Moran portrayed two small figures, Hayden and Stevenson, standing on a rock in the foreground, dwarfed by the grandeur of the scene. Hayden's report, along with Jackson's images and Moran's art, resulted in the creation of Yellowstone as the first national park in 1872.[23]

WITH TWO FEDERAL SURVEYS UNDERWAY, both led by civilian scientist-explorers, General Andrew Atkinson Humphreys, chief of the US Corps of Engineers, was anxious to reassert army leadership in the exploration and mapping of the West. The postwar army, reduced from a wartime strength of some 1,045,000 men in uniform to only 57,000 troops in 1866, had two primary tasks: enforcing congressionally mandated reconstruction in the South and supporting and protecting Americans on the western frontier. The King and Hayden surveys were focused on describing geological features and identifying resources. Humphreys was certain that both military commanders and civilians would find detailed topographic maps far more useful. In 1871, Lieutenant George Montague Wheeler accepted command of what would become the US Geological Survey West of the One Hundredth Meridian.[24]

188

AN INSTITUTION FOR THE NATION—LOOKING WEST

An 1866 graduate of West Point, Wheeler had spent the early years of his career establishing routes for the transfer of troops from the Northwest to posts in Arizona. Based on that experience, General Humphreys ordered Wheeler and his team to "obtain topographical knowledge" of eastern Nevada and Arizona, "and to prepare accurate maps of that section." While they were at it, the new survey was to gather meteorological data and collect natural history specimens on behalf of the Smithsonian. Wheeler was also directed to collect information on the "numbers, habits, and disposition of the Indians who may live in this section," as well as identify "such sites as may be of use for future military operations."[25]

Wheeler led his survey party from California's Death Valley through Nevada and Utah into southern Arizona. It was dangerous territory. Three members of the party died in an Indian attack on their stagecoach following the conclusion of the initial season. At the end of his 1871 expedition, Wheeler convinced his superiors in the corps to approve an expansion of the project to include a massive effort to use triangulation to map some eighteen thousand square miles of the American Southwest over a period of fifteen years.[26]

Spencer Baird helped Wheeler gather a talented staff, including army surgeons Walter James Hoffman and Henry Crécy Yarrow, both of whom would later work for the Smithsonian, with Yarrow serving as the Institution's first curator of herpetology. Photographer Timothy O'Sullivan, on leave from his post with Clarence King, signed on with Wheeler. Edward Cope, who had worked with Baird at the Smithsonian, and Fielding Meek dealt with paleontological collections. By 1873, Wheeler's enterprise was the largest of the surveys in the field, with a professional staff of eighty-nine and a military escort of seventy-nine men.[27]

ON JUNE 10, 1872, CONGRESS, as the result of a misunderstanding, charged the Smithsonian with responsibility for a fourth study of western lands, appropriating $20,000 to support what would become the Geographical and Geological Survey of the Rocky Mountain Region. John Wesley Powell, who headed the enterprise, had less experience and less formal education than King, Hayden, or Wheeler, yet just three years before, he had led one of the great exploratory journeys in American history, filling in the largest remaining blank space on the American map. In time, he would emerge as the authority on the fragile balance among land, water, and climate west of the one hundredth meridian, play a major role in managing Smithsonian ethnographic research, and personify the scientist in federal service shaping public policy.[28]

A native of Mount Morris, New York, Powell was born in 1834 and grew up in rural communities in Ohio, Wisconsin, and Illinois. His father, a circuit-riding

189

Methodist preacher with radical abolitionist sympathies, expected his oldest surviving son to help mind the family and manage the family farm while he made the rounds of country churches and worked with like-minded folk to move escaping slaves north toward freedom.[29]

When the Powells were living in Jackson, Ohio, a friend of his father, George Crookham, captured ten-year-old John's imagination with his large library and private museum housing a mastodon tusk and the remains of other megafauna that had once roamed the area. When the youngster was removed from school for fighting with boys from proslavery families, Crookham took over his education, combining classroom work with extended nature walks and visits to local earthworks. Rather than using standard textbooks, he introduced Powell to Charles Lyell's *Principles of Geology*, a three-volume work that established that the surface of the Earth had been shaped over hundreds of millions of years by natural processes.[30]

As the family moved on, Powell continued his self-education. He attended three colleges, including the prestigious Oberlin, over a six-year period in the 1850s, but dropped out of each after a semester, rejecting his father's pressure to pursue theology and dissatisfied with the limited offerings in the sciences. He paid his tuition and managed to stay afloat by teaching and filled his summers with collecting activity. In 1855, he walked across Wisconsin. The following year, deciding to focus on collecting freshwater bivalves, he rowed a skiff south from Saint Anthony, Minnesota, to the Mississippi Delta. In 1857, he traveled from Pittsburgh down the Ohio River, then upstream against the Mississippi current to Saint Louis. Finally, in 1858, he rowed down the Illinois River, up the Mississippi and Des Moines Rivers, and into central Iowa.[31]

By 1859, Powell had amassed one of the nation's finest collections of freshwater mollusks, representing 350 species. Such an accumulation, carefully analyzed and arranged, was the entry point into serious biological research. Powell's collection demonstrated the differentiation of species gathered in different environments. The neatly arranged specimens earned him first prize in the Illinois Agricultural Society's 1860 fair as well as membership in the Illinois Natural History Society and a position as secretary of the society's committee on conchology. His experience as a teacher resulted in his selection as head of the Hennepin, Illinois, school system.[32]

A committed abolitionist like his father, Powell enlisted as a private in the Twentieth Illinois Infantry on May 8, 1861. Elected sergeant major by his fellows, he was promoted to second lieutenant when the unit was federalized a month later. He learned about fortifications and gunnery, overseeing the construction of

fortified positions at Cape Girardeau, Missouri, gaining attention of Generals John C. Frémont and Ulysses S. Grant. After being allowed personal leave to get married, he was recruited to an artillery unit, Battery F, Second Illinois Light Artillery.[33] On April 6, 1862, Captain Powell ordered his men into action near Shiloh Church, on the heights above Pittsburgh Landing on the Tennessee River. Pointing forward while ordering his gunners to fire, his right arm was struck by a minié ball, shattering bones and necessitating an amputation. Undeterred, Powell worked as a recruiting officer while his wound healed. He was promoted to major and saw action during the Vicksburg campaign, alongside William T. Sherman at Atlanta, and with George Thomas at Nashville.[34]

Out of uniform, Powell accepted a post teaching geology at Illinois Wesleyan University, lectured at Illinois State Normal University, and served as curator of the museum of the Illinois State Natural History Society. He had no intention of spending the rest of his life in a classroom, however. Having collected along the great river systems of the Midwest and South, he was determined to extend his reach into the West. Early in 1867, Powell convinced the members of the Illinois legislature to appropriate $1,500 to pay his salary as curator for the state museum and $1,000 to fund a western collecting trip.[35]

Traveling to Washington in search of additional funds, Powell introduced himself to Joseph Henry, who would play a major role in shaping his subsequent career. Impressed by the young man, Henry wrote a letter of support to Secretary of War Edwin Stanton and promised to provide Powell's expedition with the usual set of scientific instruments and instructions for the collection and preservation of specimens. With the War Department's permission to purchase supplies from western army posts at government rates, $1,700 worth of railroad passes, and an agreement from Wells Fargo and American Express to ship collections back to Illinois for distribution to sponsoring institutions, Powell was ready to set off.[36]

Three college seniors, two clergymen, and several teachers paid $300 each for the honor of accompanying the professor, his wife, and his brother-in-law in collecting specimens in the Dakota Badlands. Powell encountered General Sherman at Council Bluffs, Iowa, in June 1867, who advised him that, in view of Indian trouble, they should make for an alternative collecting area, North Park, a basin 8,800 feet up in the Colorado Rockies.[37]

Passing through Denver, Powell met William Byers, founding editor of the *Rocky Mountain News,* and his printer, Oramel Howland. Byers wrote a letter of introduction to his brother-in-law, Jack Sumner, an outdoorsman with a cabin in the area where the Illinois naturalists were collecting. Intrigued by his discussions with the westerners, Powell and his wife remained behind when their

charges returned to Illinois in mid-August. They spent two more months traveling along the Grand River as it flowed southwest of Denver toward the Green River in Utah. From there it fed into the Colorado, which flowed west through unexplored areas of the Arizona Territory before reappearing on the map and draining into the Gulf of California.[38]

Back in Illinois, Powell's grand vision took shape. He would mount a two-part expedition culminating in a small-boat journey down the Colorado through the Grand Canyon, filling in one of the last important blank areas on the American map. He would return to the Rockies in June 1868. While a second generation of twenty volunteer collectors was gathering additional specimens with which to repay the Illinois institutions providing another year of partial support, Powell would extend his exploration of the region and meet with Sumner, Howland, and other members of the team that he would lead down the Colorado in 1869.

Arranging for extended leave from his teaching duties, Powell returned to Washington in the spring of 1868, seeking additional support. He feared, however, that his project was in danger of being swamped by a looming constitutional crisis. On August 5, 1867, President Andrew Johnson had dismissed Secretary of War Stanton after long-standing disagreements over the terms under which Southern states could reenter the Union. Johnson's action was in violation of the Tenure of Office Act, which required Senate approval for such a step. On February 24, 1868, the House voted to impeach the president. The final vote in the Senate on May 26 fell a single vote short of conviction.

To help move the project along despite political turmoil, Secretary Henry enlisted Representative James A. Garfield's support. A prewar college president with a reputation in politics as an intellectual, Garfield was an ex-Union general who, like Powell, was a veteran of Shiloh. The expedition, Henry explained, "is purely one of science," and would "give special attention to the hydrology of the mountain system in relation to agriculture." Garfield shared Henry's letter with Senate colleagues. Massachusetts Senator Henry Wilson introduced a resolution authorizing the secretary of war to provide rations for twenty-five members of the expedition. With General Grant's agreement that Powell's proposal was in the "national interest," the authorization was approved, twenty-five to seven, despite objections from senators who asked why federal dollars should go to a private expedition.[39]

On June 29, eighteen days after the Senate vote, the members of the Colorado River Exploring Expedition, including Powell's wife, Emma, and brother, Walter, a survivor of a Confederate prison camp, boarded a train for Cheyenne, Wyoming. Meeting the Illinois contingent for the first time, Jack Sumner suggested they

6-cent John Wesley Powell single, 1969. This US postage stamp commemorates Powell's 1869 expedition down the Colorado River and through the Grand Canyon. Powell (1834–1902) was the founding director of the Bureau of Ethnology, a unit of the Smithsonian, and led it from 1879 until his death. *National Postal Museum*

looked as though they would be "more comfortable behind a dry goods counter" than in the Rockies. However, Schuyler Colfax, a Republican politician who visited Powell's North Park camp while on a political junket in August 1868, commended the management of the enterprise.[40]

The western members of the party may have also been a bit uncertain about the five feet six, one-armed, soft-spoken professor who proposed to lead them on a journey down a wild river into the unknown. Powell removed any doubts they may have had by leading them across the Colorado range and on to the historic first ascent of rugged Longs Peak. By December, when most of the eastern party headed back to Illinois, Powell established a winter camp on the White River and toured the canyon country of Colorado and Utah, gathering all the information he could in preparation for the descent of the Colorado in the spring of 1869. Before returning east to make final arrangements for the river trip, he also made the acquaintance of a band of Ute Indians and began the study of their language and culture.[41]

In addition to his own survey of the area, Powell paid close attention to accounts of the few men who knew something of the Grand Canyon of the Colorado, including John Strong Newberry, a physician turned geologist who had visited the lower end of the Grand Canyon as a member of the 1857–58 US Army Corps of Topographical Engineers Colorado River expedition led by Lieutenant Joseph Christmas Ives. Newbury combined scientific detail with soaring descriptions of a sublime landscape that bore "a singular resemblance to the spires and pyramids which form the architectural ornaments of the cities of civilized nations, except that the scale of magnitude . . . is such as to render the grandest monuments of human art insignificant in comparison with them."[42]

Newberry had glimpsed the exit of the canyon, leaving Powell unsure as to even the distance that his expedition would travel as they descended the unknown

twists and turns of the river. He knew that the Colorado dropped over three-quarters of a mile between their starting point at Green River, Wyoming, and the Mormon settlement at Callville, Nevada, where they would exit the canyon. The Yellowstone River passed over two great waterfalls as it dropped through its canyon. Powell was confident, however, that the heavy load of sand and silt carried by the Colorado would have eroded any substantial falls into rapids.

The Powells returned east in March. Emma visited relatives in Detroit while John traveled back to Washington, where, despite Joseph Henry's best efforts, he failed to gather additional financial aid. Making one more fundraising swing through Illinois, he and Walter proceeded to Chicago and commissioned four special boats in which his expedition would descend the Colorado. Three were built of oak, were twenty-one feet long, and included floatation chambers. The fourth was a lighter-weight sixteen-foot pine boat that would precede the others, scouting the way down river. Powell tested them on Lake Michigan, then visited the offices of the *Chicago Tribune*. Initially, the paper predicted success for the expedition but soon suggested a less optimistic outcome. "We think that . . . any attempt to descend the Grand Canyon in boats—or, indeed, in any other way—savors of foolhardiness."[43]

On May 7, 1869, the brothers left to join the crew at Green River and launch the great adventure with the ten men John had persuaded to accompany him down the Colorado. Most were hunters and trappers. Six were Union veterans. Powell named the lighter scout boat in which he would lead the way downriver *Emma Dean*, in honor of his wife. The men assigned to the larger boats named them *Maid of the Canyon*, *Kitty Clyde's Sister* (in honor of a popular song), and, from the least imaginative of the boatmen, *No-Name*.[44]

They set off on May 24. Fifteen days into the trip, the *No-Name* struck a boulder and sank in a stretch of whitewater, carrying with it one-third of their supplies, clothing, and personal belongings and several of the Smithsonian's scientific instruments. Time and experience taught them which rapids they could safely run in the boats and when they would have to unload and walk them through with ropes from the shore.[45]

The work was arduous, supplies ran short, and the dangers were very real. On July 8, Powell had to be rescued when he became trapped high on a canyon wall. When he and two others hiked to an Indian reservation in the canyon for supplies, one of the men abandoned the expedition, preferring to stay with the Indians. In late August, hungry, discouraged, and unwilling to risk life and limb in one more stretch of whitewater, three more men chose to hike out of the canyon and head for a settlement but were murdered by Indians en route.[46]

On August 30, ninety-eight days, a thousand miles, and 360 rapids from the starting point, six men in three battered boats encountered a group of Nevada Mormons fishing near the mouth of the Virgin River. Alerted by Brigham Young to the possibility of the Powell party emerging from the canyon, the fishermen treated the bedraggled river men to their first good meal in weeks. The *Deseret News*, the newspaper of the Church of the Latter-day Saints, announced the return of the Powell expedition to civilization on September 7. Within a month, other newspapers had spread the details of the trip across the nation. That fall and winter, Powell lectured in Ohio, Michigan, Illinois, and Minnesota. He was emerging as a national hero.[47]

The first descent of the Colorado had been far more than an adventure. Powell offered a concise account of his observations on the geology of the canyon in newspaper interviews and lectures, being careful to note that the area was "barren beyond description" and "not susceptible of cultivation, even with irrigation." Along the way, he had carefully supervised compass and astronomical observations, calculated latitude and longitude, and prepared a rough map of the river indicating where tributaries enter the Colorado. He also postulated the geological forces of uplift and erosion that created the canyon.[48]

While he maintained his teaching position, Powell was determined to undertake a more complete survey of the river and the surrounding area. He was back in Washington in March, outlining his plan in a meeting with Joseph Henry and Spencer Baird. Once again, Secretary Henry turned to Salmon Chase, chief justice and chancellor of the Board of Regents, and James Garfield, a regent and one of Henry's strongest supporters in the legislature. Henry emphasized that "the chasm . . . in depth, extent and the geological section it exhibits, is . . . more remarkable . . . than any other on the face of the earth." The effort succeeded. On July 12, 1870, the Congress appropriated $12,000 to fund the Survey of the Colorado River of the West, under the supervision of the Department of the Interior and with Powell in command.[49]

The fall of 1870 found Powell back in the Southwest arranging for supplies to be deposited along the Colorado to support a second descent of the river in 1871. With the assistance of a Mormon guide, he explored several ancient and modern pueblos and participated in a peace conference with the Navajo. Returning to Chicago, Powell ordered three larger and heavier boats from the Bagley boatyard, which had built the craft for the 1869 expedition. Rather than drawing the personnel for the 1871 expedition from the veterans of his first trip downriver, he populated the government party with relatives, friends, students, acquaintances, and a photographer.[50]

They set off from Green River on May 22, 1871, each man equipped with a life jacket and Powell seated in a chair lashed to the deck of the new *Emma Dean*. The requirement for careful observations, mapping, and attention to the geological features guaranteed that the journey downriver would take far longer than in 1869. Powell frequently abandoned the river party to survey the land on either side of the canyons and to continue his research among the Utes. The rapids presented the same difficulties, however, and the effort required to line the boats through whitewater too difficult to run or, worse, to carry them over the rocks was the same. Despite an emphasis on logistics, supplies ran low.[51]

Powell established camp in the winter of 1871 at the new Mormon settlement of Kanab, Utah. His wife, Emma, came to introduce him to their infant daughter, Mary, the couple's only child. As the members of the expedition worked to transfer their topographic data onto maps, the Powells returned to Washington. In response to a question as to the disposition of his collections, Powell replied that everything was destined for the Institution. Congress extended the survey for another year, increased the appropriation to $20,000, and transferred supervision of the survey to the Smithsonian.[52]

CLARENCE KING BROUGHT SIX YEARS OF fieldwork to an end in late 1872, earning national headlines in the process. Early that year, a pair of grizzled prospectors appeared at a San Francisco bank with a poke full of diamonds that they claimed to have extracted from a secret mine. The potential for a mining boom to dwarf the Comstock Lode sparked the incorporation of the New York and San Francisco Mining and Commercial Company, with Generals George McClellan, Benjamin Butler, and George S. Dodge on the board of directors. When Henry Janin, a famously skeptical mining engineer, visited the site and pronounced it genuine, excitement reached a peak, with the company attracting hundreds of thousands of investment dollars.[53]

King was concerned that the gems might have been found within the hundred-mile-wide strip of land covered by the Fortieth Parallel Survey. A mining engineer, he had paid special attention to mineral resources along the route of his survey and had not found any diamonds. Following a variety of clues, King and his team located the site of the supposed diamond field in northwest Colorado, where gems were randomly scattered about. Clearly, the "mine" had been salted and the story a fraud. When he reported his findings to the public, King emerged as a scientific hero who had uncovered the "Great Diamond Hoax." The *Mining Review* of Georgetown, Colorado, pointed to the practical value of the geological surveys,

AN INSTITUTION FOR THE NATION—LOOKING WEST

noting that "this one act has certainly paid for the survey of the Fortieth Parallel and has brought deserved credit to Mr. King and his assistants."[54]

In the spring of 1873, with the fieldwork complete, King transferred the headquarters of his survey from San Francisco to New York, where he and his team would focus on producing seven volumes of research, covering topics from geology and mineral resources to botany, zoology, and paleontology. Smithsonian staff members helped analyze collections and publish the scientific reports. In addition to assembling the botany volume, Sereno Watson, King's specialist in the field, produced a long-awaited checklist of plants to be found west of the Mississippi, published by the Institution. Fielding Meek authored portions of the survey's paleontological volume, while Robert Ridgway prepared the ornithological report and provided lyrical descriptions of various survey campsites and activities.[55]

THE HAYDEN, WHEELER, AND POWELL SURVEYS continued to send parties into the field, each anxious to demonstrate its value. Disagreements were inevitable. On September 16, 1871, thirty-five members of George Wheeler's survey, including photographer Timothy O'Sullivan, pushed up into the lower Colorado, an area already surveyed by Ives and Powell. During the summer of 1873, a group of Hayden's men clashed with members of Wheeler's party when both were working near the headwaters of the Arkansas River in Colorado. Hayden remarked to a colleague, "You can tell Wheeler that if he stirs a finger or attempts to interfere with me or my survey in any way I will crush him—as I have enough congressional influence to do so and will bring it to bear."[56]

Since 1872, Powell had argued for the consolidation of the surveys to improve efficiency and allow for better planning and coordination. Now the War Department requested congressional action, hoping to assume control of all four surveys. Powell, Hayden, Wheeler, and General Humphreys of the Army Corps of Engineers were among those testifying when the House Committee on Public Lands considered the issue in 1874. The committee ruled that the four surveys were to continue operations as before, without the War Department's oversight.[57]

The one step toward consolidation was to return Powell's operation to the Department of the Interior. While his survey was now designated as a separate unit of Hayden's survey, the major continued to operate with complete independence. Most observers noted that Powell had, in fact, made a better showing during the hearings than either Hayden or Wheeler. In June 1876, Congress removed him from any further connection to the Hayden survey, establishing him as the head of the Geographical and Geological Survey of the Rocky Mountain Region.[58]

SMITHSON'S GAMBLE

Powell recognized that the visibility afforded by publication was critical to maintaining public and congressional support for government science. He published a report on his Colorado River explorations in 1874. The first section of the report offered an account of the trip through the canyons, followed by more technical discussion of geological features. With his major publication in hand, Powell wrote a series of popular articles titled "The Canons of the Colorado" for the January, February, and March 1875 issues *of Scribner's Monthly*, capturing the public imagination. Within two years, he produced a scientific treatise on the geology of the Unita Mountains and his first publications on Native American linguistics and ethnology.[59]

Powell's resignation from his position at the Illinois State Normal University and as curator of the Illinois State natural history museum in June 1872 marked his transition from a regional figure to a rising leader of the government scientific establishment. The Powells moved to Washington, DC, establishing themselves in a house on the 900 block of M Street NW, where they would live for the remainder of their lives.[60]

Powell immediately made his voice heard through active participation in the Philosophical Society of Washington. Established in the spring of 1871, the group was dedicated to "those branches of knowledge that relate to the positive facts and laws of the physical . . . universe," as Joseph Henry, the first president of the organization, explained. In addition to Henry, the forty-three charter members included Spencer Baird, William Dall, Fielding Meek, Ferdinand Hayden, Salmon Chase, and others with strong Smithsonian ties. Powell offered a paper on the geology of the Colorado River soon after joining the group in 1872, the first of scores of contributions he would present to the group over the next decade.[61]

In 1878, Powell, now recognized as a leader of a new generation of intellectuals in the nation's capital, organized what was initially known as the Scientific Club of Washington, a private gentleman's club with membership restricted to those who could claim distinction "in science, literature, the arts, learned professions or public service." Beyond hosting the meetings of the Philosophical Society of Washington, the club offered a congenial space in which scientists, academic leaders, politicians, military officers, and government officials could meet informally and discuss issues that would shape national policy. The Cosmos Club, as it was quickly renamed, remains today a venerable Washington institution, with Powell's portrait greeting those entering the front door.[62]

Powell was now spending more time in Washington than in the field. His Geographical and Geological Survey of the Rocky Mountain Region, the least

198

AN INSTITUTION FOR THE NATION—LOOKING WEST

expensive of the four surveys, employed only six to eight men during the years 1874–79. By June 30, 1879, Congress had appropriated $259,000 to support Powell, as opposed to $368,000 for King, $449,000 for Wheeler, and $690,000 for Hayden. His determination to apply science to public policy distinguished him from the other survey directors.[63]

Hayden assured Americans that the Southwest was destined to become an agricultural paradise. If that part of the country seemed arid, he argued, "rain would follow the plow." Powell ridiculed the notion that the arrival of the railroad and a wave of settlers to break prairie soil would mysteriously result in increased rainfall, noting in a testimony before Congress in 1876 that about "two-fifths of the entire area of the United States has a climate so arid that agriculture cannot be pursued without irrigation."[64]

Powell offered a detailed survey of the problem and his suggestion for a sensible public land policy for the arid West in his 1879 *Report on the Lands of the Arid Regions of the United States*. Over the next two decades, he would remain the most powerful voice arguing the critical importance of wise stewardship of land and water resources. It would take the Dust Bowl of the 1930s to validate his dire warnings.[65]

RUTHERFORD HAYES, HAVING WON the disputed presidential election of 1876, promised fiscal retrenchment and reform. Few individuals in the new administration were more committed to those goals than Carl Schurz, the incoming secretary of the interior. An idealist who had fled Germany in the wake of the failed revolutions of 1848, he had served as a Union general, and opposed the Grant administration while serving as a senator from Missouri. Soon after taking office, Schurz turned his attention to the Hayden and Powell surveys, both of which reported to the Department of the Interior. Following a meeting with Schurz in which Powell and Hayden exchanged harsh words, the secretary instructed the pair to reach a division of labor. Powell agreed to focus on ethnology, and Hayden continued to concentrate on geology.[66]

Powell, in an effort to shore up his position, asked professional friends for letters of support. John Newberry responded with copies to Representatives James Garfield and Abram Hewitt of the House Committee on Appropriations, praising Powell and his crew as "men of first-rate ability . . . inspired by true scientific enthusiasm." Hayden, on the other hand, was judged to be "so much of a fraud that he has lost the sympathy and respect of the scientific men of the country." Newberry, Hayden's one-time friend, now doubted "whether he and his enterprises should be generously assisted as they have been."[67]

Newberry's attack underscored his support for Powell, but Hayden could point to real achievements. Always anxious to demonstrate the value of his work, he emphasized the timely publication and distribution of research. Each year his survey produced an annual report, which, by 1871, had grown to 511 pages. In addition to those volumes, which contained detailed scientific reports covering that year's fieldwork, paleontologist Edward Cope convinced Hayden to issue smaller publications called bulletins, produced on short notice. While drawing some criticism for carelessness and the presentation of less than fully digested findings, the bulletins enabled Hayden's scientific staff to report their results in a timely fashion. As the survey drew to a close, Hayden also produced monographs in which leading specialists, including both Cope and Meek, summarized their findings and provided useful overviews of their fields of study.[68] Finally, Hayden's *Geological and Geographical Atlas of Colorado and Portions of Adjacent Territory*, illustrated with William Holmes's detailed panoramic drawings of the Grand Canyon and other geological features, stood above similar offerings by the other surveys. His achievements were balanced, however, by his vaunting ambition, penchant for the spotlight, and unwillingness to negotiate a mutually beneficial understanding with Powell.

On the afternoon of June 20, 1878, Congress accepted Abram Hewitt's amendment to the Sundry Civil Act for 1879, requesting that the National Academy of Sciences "take into consideration the methods and expenses of conducting all surveys of a scientific character under the War or Interior Department." The members of the academy were more than pleased to resolve the problem of conflicting surveys. With scientists making the decisions, however, the War Department's *United States Geological Surveys West of the One Hundredth Meridian* was unlikely to fare well. George Wheeler had covered an enormous area and had a good publication record. From the outset, though, the scientists working with his operation had struggled under army rules and discipline. The members of the academy committee were determined to remove the army from responsibility for scientific work.[69]

The committee, which included John Newberry, also offered little support for Hayden. The new president of the academy, paleontologist Othniel Marsh of Yale, had published his studies of the evolution of the horse and the extinct toothed birds of North America with King's reports. His great rival, Edward Cope, had worked with the Wheeler survey and contributed his research to Hayden's publications.[70]

The Cope-Marsh feud remains one of the classic interpersonal conflicts in the history of American science. The problems began in 1869 when Marsh embarrassed Cope by pointing out that, in both a museum reconstruction and a

publication, he had placed the fossil head of a dinosaur at the end of its long tail, rather than on the end of its long neck. Cope pointed to errors in Marsh's work, and in his original reports for the Wheeler survey, he included open attacks on his rival. While working with Hayden, Cope had battled with Powell as well as Marsh. For a quarter of a century, from 1872 to the time of Cope's death in 1897, Cope and Marsh waged what amounted to open warfare, competing for excavation sites, new species, and more impressive specimens.[71]

The academy committee invited each of the survey directors to submit a report on his activities with recommendations for the future. Powell submitted his report through Secretary Schurz on November 1, 1878. In just sixteen pages, he attacked the War Department, Hayden, and the General Land Office, urging support for a rational approach to government land policy and ethnological studies. Above all, he recommended a single consolidated geological survey. The committee forwarded a report reflecting Powell's thinking to the president of the Senate and Speaker of the House.[72]

An original bill was heavily opposed by western legislators who hoped to continue offering cheap land to settlers without regard to the environmental impact. Recognizing Powell's influence on the proposal, Representative Thomas Patterson of Colorado attacked him as a "charlatan of science and meddler in affairs of which he has no conception." Congress passed a compromise bill on March 4, 1879, as part of the Sundry Civil Act for 1879. Still based in part on the academy suggestions, it added two new organizations to the Department of the Interior. The four surveys were combined into a single US Geological Survey (USGS) responsible for "the classification of public lands, and examination of geological structure, mineral resources, and products of the national domain." A second provision created a US Coast and Interior Survey, which would be responsible for all land measurement systems. There would be one geological survey, but the debate over public land policy would continue.[73]

The great surveys provided an understanding of conditions, possibilities, limitations, and resources of the American West, setting the stage for the expansion of the nation. In the twenty-one years from 1869 to 1890, the average gross national product per year climbed from $7.4 billion to $13.1 billion and soared to $18.7 billion by 1900. When America entered World War I in 1917, the nation's economic output exceeded that of England, France, and Germany combined. This explosive growth was in part fueled by extractive industries, the potential for which had been identified by the state geological surveys and the great western expeditions. The agricultural boom resulting from the Homestead Act of 1862 also fueled economic growth. The number of Americans living on farms doubled from 10 million

in 1860 to 22 million in 1880 and soared to 33 million by 1905. In all, 270 million acres, 10 percent of the area of the United States, would be claimed and settled under the act. Optimism and politics had buried the critical lessons offered by John Powell, however, leading to issues like the Dust Bowl in the 1930s and western water issues today.[74]

The Smithsonian had played a supporting role in the era of the surveys, supplying key members of the expeditions, providing political assistance, publishing the results, and preserving the physical evidence of the geological, natural, and ethnographic history of a continent.[75] The consolidation of the surveys worked to the advantage of the Smithsonian. Ferdinand Hayden had made a practice of distributing the collections gathered by his survey to individual scholars whom he selected and who held them at their institutions. The new bill ordered that all government collections would go to the Smithsonian National Museum. Congress also appropriated $20,000 to be managed by the Institution in support of a series of published contributions to North American ethnology prepared by members of Powell's survey. It was the foundation of the Bureau of Ethnology. Baird appointed Powell to manage the bureau, and Powell responded to Baird with a note outlining the areas of research to be pursued, which included physical anthropology, linguistics, mythology, sociology, habits and customs, technology, archaeology, and the history of Indian affairs. He wanted Baird to understand that, while he would operate under the umbrella of the Institution, he would control the operation of the organization, a point of view Baird did not share.[76]

President Hayes appointed Clarence King to head the new USGS. Ferdinand Hayden, who had campaigned for the position, chose to serve the new agency as a geologist. Hayden died in Philadelphia on December 22, 1887, of locomotor ataxia, a Victorian euphemism for syphilis.[77] King, restless and anxious to pursue a fortune in mining ventures, remained in office for less than two years. At Secretary Baird's suggestion, President Garfield appointed Powell as the second director of the USGS in March 1881. For the next thirteen years, he would wear two hats, reporting to the Smithsonian as the director of the Bureau of Ethnology and to the secretary of the interior as director of the USGS.

Mineral riches would elude King. When in Washington, he was the fifth member of a social clique, the Five of Hearts, with his friends, Washingtonians Henry and Marian "Clover" Adams and John and Clara Hay. Not even his closest friends, however, were aware that King had met Ada Copeland, a formerly enslaved woman in her late twenties in New York in 1887–88. The blond, blue-eyed King introduced himself as James Todd, an African American Pullman railroad porter. Their common-law marriage would produce five children, four of whom

AN INSTITUTION FOR THE NATION—LOOKING WEST

lived to adulthood. Their two daughters married white men; their two sons married African Americans. With her husband working as a Pullman porter, Ada could expect him to be away from home much of the time.[78]

When King died in Phoenix on December 24, 1906, he wrote his wife a note of explanation and apology. Near the end, he shared his secret with John Hay and asked that his friend dispose of King's assets and establish a trust fund for his family. Hay decided that it was enough to provide Ada and the children with a house and a small annuity. In her seventies in 1934, Ada Copeland Todd King brought a suit for access to the trust fund that King had promised. The case of an African American woman secretly married to a well-known scientist made headlines, but the decision went against her.[79]

CHAPTER 11

NEW DIRECTIONS

WHILE THE FOUR GREAT SURVEY TEAMS moved across the western landscape during the decade of the 1870s, the Smithsonian was turning a historic corner. Since the library crisis of 1855, Spencer Baird struggled under Joseph Henry's stifling control of the Institution. "All through the troubled years of the early existence of the Institution and during the Civil War," William Dall explained, "no expenditure was made without the personal approval of the Secretary." As late as 1873, Baird complained to a regent that "I would greatly prefer to be permitted to send the Bills, directly, for payment, instead of having to wait for Prof. Henry's convenience."[1]

In October 1870, the secretary returned from a four-and-a-half-month European sabbatical and immediately turned his attention to the National Museum. Throughout his career at the Smithsonian, the secretary struggled with an ambivalent attitude toward the operation of a museum. He recognized the value of such an establishment but did not believe the Smithsonian was responsible for educating the general public. He expressed his fundamental doubts in an 1876 letter to his friend Asa Gray.

> I have not changed my mind as to the propriety of the separation of the national museum and the Inst., although I do not intend to urge immediate action unless there is a prospect of success. I think it is highly probable that if the connection continues and large appropriations are called for by the Institution for the support of the museum, the former [the Smithsonian] will be in danger of falling into difficulties and of finally becoming merged in a great establishment with a politician at its head.[2]

In his final annual report (1877), Henry repeated one of the basic principles that had guided his administration: "The functions of the Institution and the Museum are entirely different." He had spent thirty-one years insisting that none

of James Smithson's largesse would be spent on a museum. Even after 1857, when he finally agreed to accept a federal appropriation to support the preservation and display of government collections, he continued to hope that Congress might purchase the Castle, appoint another organization to manage the museum, and allow the Smithsonian to rent workspace.[3]

As Congress had entrusted the National Museum to the Smithsonian, however, Henry planned to honor the obligation. "Congress having made an appropriation for the better display of collections belonging to the government," he noted, "it becomes a matter of importance to carefully consider the character which is to be given to a national museum." While the Institution would continue "to devote a portion of its own funds" to the pursuit and publication of research, he now agreed that the Smithsonian, supported by federal funds, would manage the museum, which should "be an object of interest to the large numbers of visitors who are annually drawn to Washington by curiosity or otherwise, and . . . who cherish a patriotic pride in whatever redounds to the reputation of the national capital."[4]

During the restoration of the Castle following the 1865 fire, Adolf Cluss had repaired the water damage so that the original first floor museum space could be reopened with existing funds. In addition, Henry asked the architect to triple the size of the National Museum by transforming the second-floor area that had housed the lecture room and the art and apparatus galleries into a single large exhibition space, which would remain empty until Congress appropriated additional funds to support the cost of constructing casework and other elements required to mount exhibitions in the new Grand Gallery.[5]

On July 15, 1870, as part of the Sundry Civil Act for 1871, Congress finally provided $20,000 for the preservation of collections and the fitting out of the new gallery. With those funds and an additional $9,000 from the Smithsonian coffers, Henry rearranged the Castle to separate what he regarded as the central functions of the Institution from the operation of the National Museum. The taxidermy and chemical laboratories moved from the first floor of the east wing and range, beneath the Henry family living quarters, to a refurbished basement area that now ran the length of the building.[6]

Administrative offices and the packing, shipping, and storage operations of the exchange service were shifted to the first floor, east end. After 1872, this work was, as Henry remarked in an unpleasant tone, "under the special care of the 'Hon. Solomon Brown,'" who had been reelected to the district legislature. The two-story west wing and the west range, which had been devoted to the library, now housed geological and mineralogical cases. Visitors would find displays on

human cultures at the top of the grand staircase leading to a refurbished second-story space.[7]

Henry had displayed paintings of American Indians by John Mix Stanley and Charles Bird King, hung floor to ceiling, in the original second-story art gallery. To inaugurate the new gallery, he chose an exhibition of the work of George Catlin, a well-traveled, highly productive artist also known for his portraits of Native Americans. The secretary had encouraged the photography of Indian visitors to the nation's capital, and by 1869, he had directed the mounting of photographs of Indians along the walls of the west range, accompanied by ethnographic articles in the cases. Catlin's paintings, he now explained, like the earlier collections lost in the fire, were "not valuable as works of art . . . [but] are very interesting as ethnological illustrations."[8]

From the outset, Henry had insisted that anthropological research was worthy of Smithsonian attention. He launched the Contributions to Knowledge series with a benchmark study of American archaeology and continued to issue important ethnographic and anthropological studies in Smithsonian publications. The "ancestors of the most civilized races of the present day," he argued, "were at one time savages of whom the manners and customs can only be understood by a comparative study of the lives of savages now existing in different parts of the world." For Henry, the paintings of Stanley, King, and Catlin provided a visual record of the lives and customs of the American "savages."[9]

A Philadelphia lawyer turned painter, Catlin made five trips up the Missouri between 1830 and 1835, visiting eighteen tribes. In later years, he visited tribes east of the Mississippi and in Central America, completing some six hundred portraits and scenes of Native American life and amassing a collection of related cultural objects. By 1838, he was traveling the nation lecturing and exhibiting his Indian Gallery. Crossing the Atlantic, he displayed his work in London, Paris, and Brussels from 1839 to 1851. In 1852, Catlin sold the collection to Joseph Harrison, a Philadelphia entrepreneur who stored the paintings in the basement of his boiler works.[10]

In July 1846, New York congressman William W. Campbell, a Catlin admirer, suggested amending the bill then under consideration to establish the Smithsonian to include a sum for the purchase of the Indian Gallery and its presentation to the Institution-to-be. The amendment was tabled. The following February, Senator John M. Clayton of Delaware reopened the issue, proposing that Congress fund the purchase of the more than six hundred paintings, "now at the Louvre . . . where they met with unqualified approbation." Florida senator James Westcott objected. "What great moral lesson are they intended to inculcate?" he asked,

adding that he would "rather see the portraits of the numerous citizens who have been murdered by these Indians."[11]

During the mid-1860s, Secretary Henry responded to several suggestions that the Smithsonian seek an appropriation to take possession of the collection. In March 1866, he assured Catlin's daughter Elizabeth that "your father's valuable collection of Indian portraits ought to be purchased by the General Government and carefully preserved as a memento of the race to which our encroachments upon their territory have consigned to premature extinction." Between 1848 and 1852, Catlin had used a camera lucida to make tracings of the works in this collection, which he finished in oil paints. A Smithsonian employee visited an exhibition of these cartoons, as they were termed, in a New Jersey gallery in the fall of 1871. The secretary wrote the artist on November 21, offering to host the display in the new second-floor museum space. George Catlin opened the final exhibition of his life at the Smithsonian on February 27, 1872.[12]

The artist invited the public to visit any weekday from 9:00 a.m. to 4:30 p.m., admission free, where they would find six hundred paintings, including "full length Figures, illustrating Games, Hunting Scenes, Religious Ceremonies, &c." Catlin had prepared the display himself, mounting his works on screens, and insisted on being present to greet visitors each day. When the secretary returned from his annual sojourn away from the sweltering Washington summer, he found that the seventy-six-year-old artist had been trudging over a mile each day from his boarding house to the Castle. Henry, who had invited Catlin to use his office as a "painting studio" during his absence, immediately provided him with lodging in the north tower. That fall, a party of Dakota Indians visited "their old acquaintance" at the Smithsonian. Another group of "scalpers" were expected the following week.[13]

Catlin remained at the Smithsonian until November 2, 1872, when a failing heart and kidney trouble led his daughters to move him to Jersey City, where he died on December 23. Secretary Henry reported that "the object of this exhibition is to induce the Government to purchase the whole collection of Indian paintings, including sketches and portraits, the result of the labors of upwards of forty years of this enthusiastic and indefatigable student of Indian life." His letters to congressional leaders and personal appeals to Joseph Harrison failed to achieve results. In 1879, however, following the death of Harrison, his widow donated the entire original collection to the National Museum.[14]

SECRETARY HENRY INSISTED THAT Spencer Baird, responsible for the museum, steer clear of sensationalism in planning displays for the first-floor gallery. Both were determined to avoid the excesses and fakes employed by some "museums" to

increase visitation. They rejected the Cardiff Giant, a crude stone carving purported to be the petrified body of a prehistoric giant, as a hoax. When P. T. Barnum obtained a copy of the giant to join the other questionable wonders in his American Museum, Henry warned a correspondent to avoid "the humbugs of Barnum . . . who has had a very bad effect on the morals of the community."[15]

In 1871, however, Henry considered mounting an exhibition so spectacular as to put Barnum to shame. The proposed display was rooted in discoveries like that of Massachusetts farm boy Pliny Moody, who, in 1802, uncovered a sandstone slab imprinted with footprints, "three-toed like a bird's," he reported. Between 1818 and 1830, English geologists and naturalists reported the fossil remains of several large reptilian creatures. Ten years later, in 1840, anatomist Richard Owen coined the term *Dinosauria* to describe the creatures who had made the prints and left the bones.[16]

The notion that huge reptilian beasts had once roamed the landscape transfixed the popular imagination. How many species of these "terrible lizards" were there, and what had they looked like? Benjamin Waterhouse Hawkins began the process of bringing these monsters to life. A native of Bloomsbury, London, born in 1807, he trained as a painter and sculptor. Fascinated by natural history, he illustrated the volume of Charles Darwin's *The Zoology of the Voyage of H.M.S. Beagle* dealing with reptiles and amphibians.[17] In 1852, Hawkins accepted the challenge of producing full-scale sculptures of "antediluvian beasts" for an outdoor display in connection with a larger version of the famous Crystal Palace to be constructed in the southeast London district of Sydenham, essentially creating a dinosaur theme park for Victorians.[18]

Paleontologist Richard Owen, Hawkins's scientific adviser, visualized dinosaurs as great lizards lumbering on all fours.[19] Following Owen's template, Hawkins put clay on the fossil bones, creating the first full-scale models of the ancient creatures. In some cases, the artist worked with nearly complete fossil skeletons; in others, he estimated the scale of a creature by comparing the size of a fossil bone to a similar bone of a living animal. Hawkins began each re-creation with a small clay model, then progressed to a full-scale sculpture composed of up to thirty tons of clay, which became the mold for the concrete exterior pieces fitted to an iron armature.[20]

Queen Victoria opened the park in June 1854, with some forty thousand people in attendance. Visitors encountered thirty-three fearsome creatures, representing fifteen genera of dinosaurs and prehistoric mammals, lurking among the trees on two marshy islands set in a lake on the grounds, waiting, as *Punch* suggested, to frighten both adults and children. While many colleagues argued, correctly, with

Owen's anatomical decisions, the overwhelming popularity of Hawkins's display is apparent in the fact that the creatures still lurk on Sydenham Hill and are now regarded as national treasures.[21] With his work at the Crystal Palace complete in 1855, Hawkins returned to painting.

Early in 1858, Philadelphian Joseph Leidy, who identified fossils for Spencer Baird, announced that a series of bones Ferdinand Hayden had found in the Montana Badlands proved that Europe did not have a monopoly on the large fossils. Later that year, William Parker Foulke, a member of the Academy of Natural Sciences of Philadelphia, supervised the recovery of the entire skeleton of a dinosaur that Leidy named *Hadrosaurus foulkii*. Given the creature's muscular legs and small forelimbs, Leidy suggested that, unlike Owen and Hawkins's portrayal of lizards lumbering about on all fours, the hadrosaur had walked upright, "kangaroo-like."[22]

Hawkins was aware of growing American interest in paleontology. Hoping to market his unique talents in America, he stepped ashore in New York on March 14, 1868, and two days later addressed the Lyceum of Natural History, describing "the manner in which he restored to the fossils of the past their living significance, reclothing as it were the dead bones with muscles and sinews . . . in accordance with strict scientific principles." The talk was so successful that the members of the lyceum arranged a repeat performance for Hawkins at the Cooper Institute.[23]

Two months later, on May 1, the Board of Commissioners of Central Park "engaged" Hawkins to produce a Paleozoic menagerie of "the original forms of life inhabiting the great continent of America." To select the creatures to be portrayed, Hawkins set out on a two-month grand tour of institutions in Washington, DC; New Brunswick; Albany; New Haven; Philadelphia; and Chicago to inspect the fossil evidence and discuss the project with American colleagues. He found a treasure trove at the Academy of Natural Sciences of Philadelphia, roughly 30 percent of a complete *Hadrosaurus* skeleton. With Leidy's permission, Hawkins hired a team to prepare plaster casts of the bones, sculpting those that were missing. He then assembled the world's first dinosaur skeleton on a metal armature. The academy unveiled the completed hadrosaur on November 21, 1868, standing upright and ready to meet his public.[24]

By December 1868, Hawkins was back in New York with casts of the Philadelphia dinosaur bones that the academy had allowed him to make for himself. When the upper floor of the Arsenal Building, where the New York militia stored its arms and equipment, proved unsuitable, he crafted a small herd of dinosaurs and prehistoric mammals in a temporary shed near the location in Central Park chosen for his Paleozoic Museum. A new city charter approved by the state legislature in

SMITHSON'S GAMBLE

1870 enabled William Magear Tweed's political machine to take command of the Central Park commission. Peter Sweeny, now in charge of park projects, announced that the $30,000 allocated for the Hawkins enterprise "was too great a sum to expend upon a building devoted wholly to paleontology." On December 22, 1870, the new commissioners announced that Hawkins's project was canceled.[25]

Fortunately, Hawkins had another option: repurposing his creations for use at the Smithsonian. He had been corresponding with Joseph Henry since the summer of 1868. Hawkins wrote to Henry in March 1871, noting that a group of New York scientists were prepared to submit resolutions to city officials urging the resumption of work on the Paleozoic Museum. However, Tweed's patience with Hawkins's Paleozoic Museum, a project initiated by his political opponents, was at an end. On May 3, 1871, Henry Hilton ordered a gang to break into Hawkins's shed, smash the finished creatures with sledgehammers, and bury what was left. Most of Hawkins's sketches, molds, and models were destroyed as well.[26]

Hawkins wrote to Henry again on June 17, asking if "there be any chance of profitable employment in making designs or models for your zoological Gardens or a series of instructive models (if life size so much the better)." Henry responded on June 30, promising that his offer would receive "due attention." Later that summer, the secretary informed the regents that he had contracted with Hawkins "to prepare illustrations of extinct animals . . . to decorate the walls" of the new second-story gallery, an arrangement altered to include the production of "a series of designs" for the entire space that could be populated with his "restorations."[27]

Hawkins sent conceptual drawings and detailed descriptions of his plans to Henry in March and April 1872, and a note of thanks for prompt payment of the money owed him for preliminary work on the project. Paintings showing three American dinosaur species—one each from three genera, *Hadrosaurus, Laelaps,* and *Elasmosaurus*—each in their natural environment, would be arranged on the upper portion of the north wall of the second-floor gallery. Fossil remains of the creatures, still in the matrix, were to be mounted beneath the paintings. Visitors would encounter fully fleshed sculptures of the beasts, including a *Megatherium* species on a forty-foot-long platform in the center of the room.[28]

Elephants, ancient and modern, would inhabit another long platform. A moa, with a representation of a New Zealand native of the sort who had hunted the giant bird to extinction, would share another riser with an Irish elk and its huntsman, an ancient Hibernian. Cases filled with fossils, dinosaur trackways, and stuffed birds and animals in their natural settings would be scattered around the gallery. Hawkins would dedicate a final section of the display to ethnology, focusing on

A proposal for a Smithsonian exhibition by Benjamin Waterhouse Hawkins (1807–94), c. 1871. Hawkins, an English sculptor and natural history artist, became famous for his work on the life-size dinosaur sculptures at Crystal Palace Park in London. Later in his career, he proposed this design for a natural history exhibition to Joseph Henry; however, his plan was rejected in favor of a less expensive approach. *Academy of Natural Sciences, Drexel University*

paintings, cases, and life-size figures illustrating the material culture of Native Americans.[29]

In April 1872, Hawkins followed up with a request for measured drawings of the second-floor space so he could prepare a finished layout of his planned exhibition. He also noted that he and Joseph Palmer, the taxidermist who had worked for him since Sydenham, had completed a "restoration" of a large Irish elk, which he had suggested for inclusion in the Smithsonian exhibition. If Henry was interested, he would place that specimen "on deposit" with the Institution and send Palmer (and his family) to Washington to supervise the installation of the elk while he continued on the National Museum payroll preparing work on the major exhibition. Henry agreed to the arrangement.[30]

The scale and probable cost of realizing Hawkins's vision likely came as a surprise to Henry, who knew that Congress would not be in a hurry to fund the project. Spencer Baird took command of the project, proposing a scaled-back and far less expensive approach. Sensing the secretary's enthusiasm waning, Hawkins wrote on May 17, reminding the secretary of his comment in the 1870 annual report that the better kind of museum "ought to be established at the public expense in every city or community." Henry responded, reminding Hawkins that the expenditure of the Smithsonian's own funds was limited to the support and publication of scientific research. The National Museum operated on funds allocated by Congress to support the preservation and display of "government collections."[31]

Tensions rose in June when the secretary sent a note to thank Hawkins for the donation of the Irish elk. Hawkins responded immediately, pointing out that the

SMITHSON'S GAMBLE

gift was only a loan, unless the Smithsonian cared to purchase it. Henry responded with a letter of apology. In August 1873, Hawkins accepted $500 to close the transaction, ending his business with the Smithsonian.[32]

In 1875, Hawkins accepted a commission from Princeton professor Arnold Guyot to prepare a hadrosaur skeleton and a series of seventeen large paintings of ancient life for the university, then helped to prepare another hadrosaur for the Centennial Exposition of 1876 in Philadelphia. Hawkins was with his first wife when she died in England in 1880. He died in Putney, a storied district of southwest London, in 1894.[33]

SPENCER BAIRD HAD KEPT himself busy during his first two decades at the Smithsonian, literally doing the heavy lifting and managing the shipping and receipt of tons of publications as part of the exchange program. Maneuvering within Henry's bounds and stretching them when he could, he mentored a generation of young naturalists, built collections that defined the natural and ethnographic history of North America, and shared those collections through reports, catalogs, and displays in the National Museum. Baird handled all correspondence with the meteorological observers as well, many of whom doubled as contributors to the collection.[34]

Just as Joseph Henry put his experience as a physicist to work on behalf of the Lighthouse Board, Baird, the naturalist, stretched beyond the walls of the Castle to create and command the first conservation agency established by the federal government.[35]

His entry into wildlife conservation was a result of his summer vacations. Each year, he fled the capital for the seashore with his family. His daughter, Lucy, explained that, while fish had been included in his private collecting activity as a young naturalist, his drive to catalog both freshwater and saltwater species "greatly strengthened when he ceased to collect simply for himself and began to bend his energies toward his ideal of the public museum he wished to bring together." The annual vacation in 1869 found the family in Eastport, Maine, where local watermen complained of diminishing catches. Concerned, Baird decided to investigate the problem in 1870. With one hundred dollars provided by Secretary Henry and the use of the Department of the Treasury schooner *Mazeppa*, he operated out of Woods Hole on Cape Cod, where sport fishermen blamed smaller catches on the commercial use of huge nets, traps, and weirs to haul in tons of migrating species.[36]

Convinced of the reality of the problem by his summer of research, in 1871 Baird worked with Senator George F. Edmunds, whose family summered with the

NEW DIRECTIONS

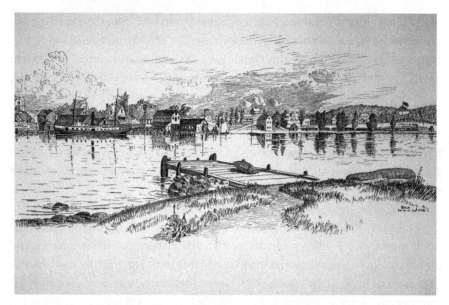

Landscape view of the United States Fish Commission station at Woods Hole, Massachusetts, by Henry Wood Elliott, c. 1882. Spencer Baird established the first US Fish Commission station in Woods Hole, where he often spent summers engaged in research. The laboratory and research vessels provided an early focal point for American oceanographic research. *Smithsonian Institution Archives*

Bairds, in crafting a bill creating the US Commission of Fish and Fisheries charged with conducting investigations on "any diminution in the number of food fishes of the coast and lakes of the United States . . . and what protective, prohibitory, or precautionary measures should be adopted."[37]

Baird accepted the post of commissioner and would serve for the rest of his life at no salary. Under his direction, the commission would conduct ongoing studies of fluctuations in freshwater and saltwater fish populations. The organization also pioneered the development of fish hatcheries to restock carp in lakes and streams. From Baird's point of view, marine research was at the heart of the commission's business. From the outset, his work attracted scientific collaborators, including zoologist Addison Verrill, botanist William G. Farlow, and zoologist Alpheus Hyatt. For several years, Baird pursued his research at temporary laboratories along the Atlantic coast, finally settling for good at Woods Hole in 1875. Students and young scientists were invited to stay in a rough dormitory at Woods Hole each summer.[38]

During the early 1880s, Baird expanded the laboratory, established a fish hatchery, and improved the harbor. The commission operated research vessels as

well. The steamboat *Fish Hawk*, which remained in service from 1880 to 1884 gathering species for the hatcheries, was repurposed for deep-sea dredging, revealing, Baird noted, "a most wonderful fauna, vastly exceeding in richness and extent anything known to science." In 1880, he requested funds for a dedicated research vessel, which, he explained to Congress, would be employed in locating new fishing grounds for commercial operators. The resulting *Albatross*, proudly flying the banner of the commission—a red diamond with a white fish—may well have been the first purpose-built deep-sea research craft. Naval historian Dean Allard remarked that the ship "probably did more significant work in oceanic research than any other vessel."[39]

Like Joseph Henry, who devoted an enormous amount of time and energy to the US Lighthouse Board, Baird was committed to the US Fish Commission (formally known as the US Commission of Fish and Fisheries). Each summer found him at the shore overseeing the work of the laboratory and his tiny research flotilla. Even at his desk in Washington, he reported spending many mornings on commission business. Each year, he persuaded Congress to increase commission funding; the total appropriation for the years 1871 to 1886 was over $2 million. Baird initially housed the commission office in his Washington home. As the business of the organization grew and correspondence increased, Congress funded the purchase of the house next door to allow for expansion. Between 1884 and 1887, Baird and George Brown Goode published an eight-volume report on the work of the commission.[40]

Baird recruited Goode as his assistant for Fish Commission business in 1872. A native of New Albany, Indiana, Goode was born in 1851 and grew up in Cincinnati and Amenia, New York, before attending Wesleyan University. In 1871, Orange Judd, editor and publisher of the *American Agriculturist*, endowed a natural history building and museum at Wesleyan. Selected as the first curator, Goode spent time with the aging Louis Agassiz at Harvard's Museum of Comparative Zoology before returning to Connecticut to take up his new duties, and to begin his courtship of Judd's daughter, Sarah Ford Judd.[41]

Baird's favorable impression of the young naturalist, whom he first met in Eastport, Maine, in 1871, was reinforced by a second encounter at a meeting of the American Association for the Advancement of Science in Portland in 1872. Baird recruited him as an assistant curator at the Smithsonian in 1873, with the understanding that he would split his time among Wesleyan, the Fish Commission, and the National Museum.[42]

Goode spent the winter of 1873 living at the Smithsonian and arranging the ichthyology collection. He drew no salary from either the Institution or the

NEW DIRECTIONS

commission. Goode lived on his income from Wesleyan, in exchange for which he could donate duplicate specimens from the national collection to the university museum. The arrangement would continue until 1877, when Goode finally accepted full-time employment as a Smithsonian curator, enabling him to marry Sarah Ford Judd that November. The couple would produce four children: Margaret Judd, Kenneth Mackarness, Francis Collier, and Philip Burwell.[43]

Baird regarded Goode as his junior partner in all things. Samuel Langley, who knew and admired both men, remarked that "Professor Baird singled him out almost from the first as his chief pupil, his intimate friend, his confidential adviser, and his assistant in all the . . . work in which he was engaged." Goode, Langley continued, "said once that he would lay his life down for such a man." Theirs was a partnership that would move the Institution in new directions.[44]

ON SATURDAY, DECEMBER 30, 1871, Spencer Baird presented a proposal suggesting that Secretary Henry place him in full command of the National Museum, with the title of director and a budget of $1,000 per month, for which he promised to keep a precise accounting. Henry recognized that he would simply be formalizing a situation that already existed. In addition, he felt the burden of having been appointed head of the Lighthouse Board less than three months before. The secretary accepted Baird's terms in an all-day meeting on January 6, 1872. Three days later, Baird wrote to the secretary, outlining his plans to spruce up the museum with fresh paint, new labels, and a new approach to the displays. In addition, he agreed to give thought to items in the collection that might be candidates for transfer to other institutions.[45] Joseph Henry, admitting the reality of the situation, officially passed control of collections, exhibition programs, and management of the museum staff to Spencer Fullerton Baird, who had effectively been managing those functions for over two decades.[46]

The two men had very different visions of the Smithsonian. The secretary was a frugal manager with a relatively narrow goal, the encouragement of research and the publication of the results. Henry's reputation, and Smithsonian publications distributed by the exchange service to learned societies across the nation and around the world, established the Institution as an important presence in American science. It was a considerable achievement for an organization with a paid staff that never numbered more than eighteen individuals, including the janitor, during Henry's tenure.[47]

Baird nursed more ambitious plans for the Institution. The tide of history and the opportunities presented by a nation spreading across a continent worked in his favor. While the secretary urged restraint, there was no stopping the steady stream

215

of specimens flowing into the Castle from military expeditions, the government surveys, and Baird's wide-ranging network of collectors. The presence of the nation's most comprehensive collection documenting the geological, natural, and human history of North America guaranteed that both senior scientists and their most promising students were drawn to the Smithsonian. Henry came to accept the critical importance of the collection in situating the Institution at the focal point of natural science in America.[48]

Baird's view of the Smithsonian's role in the life of the nation was not limited to supporting scientific research or communicating with professional colleagues. "As Assistant Secretary of the Smithsonian Institution," he explained, "I feel it a duty to the community to assist in the efforts of popularizing science and increasing the number of its votaries." In 1870, he became science editor of the *Philadelphia Public Ledger* as well as *Harper's Weekly, Harper's Bazaar,* and *Harper's Annual Record of Science and Industry.*[49]

That passion for communicating science to the widest possible audience underpinned Baird's commitment to establishing one of the world's great museums at the Smithsonian. By 1874, he had installed an impressive display of ancient creatures in the lower west hall. Scientific entrepreneur Henry Ward had donated the cast of a skeleton of a giant ground sloth, *Megatherium cuvieri.* Hawkins's associate Joseph Palmer, now firmly established with his family in Washington, created the world's second fully articulated hadrosaur, presumably using Hawkins's molds. Hawkins's Irish elk and a glyptodon, a heavily armored mammal the size and weight of a small automobile, completed the group. Baird could take pride in the exhibition. Stereoscopic images produced and marketed nationally allowed those citizens unable to visit the capital to marvel at the skeletal prehistoric creatures roaming the halls of the Smithsonian.[50]

BAIRD AND GOODE WERE TAKING their place in an age of museum builders. Richard Owen had launched the era in 1856 when, after twenty-one years as anatomist and curator with the Hunterian Museum at the Royal College of Surgeons, he became head of the natural history collections at the British Museum. Tall and thin, with bulging eyes and long, stringy hair, he was the very image of a Victorian undertaker. Despite his mastery of anatomy, he was not a favorite with his colleagues. Repeatedly accused of claiming credit due others, he launched direct attacks on both Charles Darwin and Thomas Huxley. "I used to be ashamed of hating him so much," Darwin once commented, "but now I will carefully cherish my hatred & contempt to the last days of my life."[51]

Henry Ward (1834–1906) with a *Megatherium* replica, photographed by Thomas W. Smillie, 1872. The cast of the skeleton of the extinct South American ground sloth was part of an exhibition on prehistoric animals at the Castle. The display was a gift to the Smithsonian from Ward, the proprietor of Ward's Natural Science, a supply house providing materials to museums, universities, and collectors, and the man shown in this stereoscope card. *Smithsonian Castle Collection, Gift of Richard E. Stamm*

Whatever his colleagues thought of him, Owen deserves credit for championing a new view of the social functions of museums. Many regarded such institutions as nothing more than places to store research collections. A century after its opening in 1759, the British Museum remained a stodgy, elitist institution not fully open to the public. When Owen arrived, the natural history collections, hidden away on an upper floor, had outgrown their allotted space. As a well-connected acquaintance of prime ministers and a natural history tutor to the royal children, he launched a drive to create a separate Natural History Museum. The grand Romanesque "cathedral to nature," as architect Alfred Waterhouse described it, opened in Kensington in 1881. Owen insisted that the new building, like all museums, had an obligation to educate and inspire all of society, and made special efforts to craft labels and other elements to attract and welcome working-class families.[52]

Albert S. Bickmore shared Owen's vision of the museum as an institution that bridged social and cultural divides. A Dartmouth graduate and an assistant to Louis Agassiz, he convinced leading New Yorkers of the civic value of creating a natural history museum open to all citizens. In January 1869, the commissioners of Central Park approved Bickmore's plan for what was to become the American Museum of Natural History. Almost eight years later, on December 22, 1877,

President Rutherford B. Hayes dedicated the core of the iconic building on the upper west side of Manhattan, facing Central Park.[53]

Like the Smithsonian Castle, the London Natural History Museum and the American Museum of Natural History were cathedrals of science, the nineteenth-century equivalent of the great Gothic cathedrals that towered over the cities of medieval Europe. Just as the imposing size of Notre Dame, Chartres, Canterbury, Nuremburg, and so many other great churches epitomized a culture dominated by religion, so these museums, so often emulating the medieval style, were cathedrals of science and learning. Their imposing size signified their cultural importance.

BAIRD AND GOODE RECOGNIZED evolving plans for a grand exposition in Philadelphia, to celebrate the centennial of American independence, as a golden opportunity to realize their vision of a United States National Museum worthy of the name. Professor John L. Campbell of Wabash College first suggested the notion of a centennial fair in an aside during his lecture on Galileo at the Smithsonian on the evening of February 18, 1864. As the date of the centennial grew closer, the notion of a great national fair was seen as a solution to deep and growing social problems.[54]

In the last quarter of the nineteenth century, class and racial tensions were on the rise. Americans who had once expressed discomfort with immigrants fleeing the potato famine and harsh conditions in Ireland faced a flood of newcomers arriving from far more distant lands. Between 1880 and 1920, 2 million immigrants, many from southern and eastern Europe, arrived in search of a fresh start in the United States. Immigration was soon linked to labor unrest, from the prosecution of the Molly Maguires in the Pennsylvania coalfields in 1875 to the Haymarket Riot of 1886, the Homestead steel strike of 1892, and the Pullman Strike of 1894. On top of this, the Grant administration, plagued by a series of scandals, was helpless to combat the Panic of 1873. The nation approached its centennial year sinking into one of the longest and deepest depressions in American history, with no solution in sight.[55]

The notion of spectacular expositions underscoring national productivity dates to the Great Exposition of 1851. Similar fairs had followed in Europe and America. Clearly, however, business, political, and intellectual elites regarded support for a series of great industrial fairs in cities across the nation and abroad during the closing decades of the nineteenth century and the early years of the twentieth as a means of confirming American exceptionalism, reinforcing traditional values, and building social cohesion. These celebrations of progress in American agriculture, industry, and technological mastery would, they believed, instill pride in American achievements and help to stabilize society during a period of social and financial uncertainty.

NEW DIRECTIONS

By 1870, Campbell and others succeeded in convincing the members of the Select Council of Philadelphia, the Franklin Institute, and the Pennsylvania legislature to seek federal support for their proposed centennial fair. Congress complied on March 3, 1871, creating a governing commission composed of representatives from each state appointed by the president with the advice of the governors. By 1873, a separate Centennial Board of Finance had sold $1,784,320 worth of $10 shares provided by the Department of the Treasury. Philadelphia raised an additional $1.5 million, while Pennsylvania provided another $1 million. Congress appropriated a $1.5 million loan, which had to be repaid after the fair. A final accounting indicated that the total cost of the fair was $6,275,000.[56]

On January 23, 1874, President Grant issued an executive order creating a board composed of representatives of the executive departments of the government that would provide displays for the exposition: the Smithsonian, the US Fish Commission, the Post Office, and the Departments of War, of the Navy, of the Interior, of Agriculture, and of the Treasury. The following March, Congress appropriated $505,000 in support of the effort, to be divided among the participating offices.[57]

Baird recognized the fair as the key to the Smithsonian's future. Secretary Henry appointed him to represent the Institution on the board of executive departments, placing him in command of planning the Smithsonian's contribution to the fair. Baird launched the largest collecting effort of his career, not only to gather the best geological, zoological, and ethnographic specimens to fill the cases at the exposition but also to bolster the collections of the National Museum for his planned future expansion. Both the Wheeler and Powell surveys responded, as did Baird's usual network of military and civilian collectors.[58]

The assistant secretary planned a display broken into five sections. The first and smallest unit would describe "the history, condition, functions, workings and general results of the Institution itself." In addition to a set of publications and a description of the exchange service, a large map of the United States would present the mean temperature, rainfall, barometric pressure, and average winds over the past twenty-five years.[59]

The remaining four exhibits would focus on the work of the National Museum. For the second, Baird persuaded William Phipps Blake, a geologist who had supervised the display of American mineral resources at two European fairs, to do the same for the Centennial Exposition. The third exhibit was of the animal resources of the country and would include mounted specimens of a wide range of American mammals, birds, reptiles, and amphibians, along with firearms, traps, and tackle and examples of leather, fur, and other animal products. For the fourth exhibit,

Goode created a major display representing the Fish Commission.[60] Finally, for the fifth exhibit, there would be a joint display with the Department of the Interior on American ethnology and archaeology.

Baird accepted Joseph Henry's judgment that Charles Rau was just the man to take charge of planning that portion of the Institution's contribution to the exposition. A native of Belgium born in 1826, Rau had studied geology and mineralogy at Heidelberg University and developed an interest in prehistory before joining the exodus of young intellectuals fleeing to America following the failed European revolutions of 1848. He struggled through the next quarter century in fruitless pursuit of a professional scientific position while teaching, and complained he was "continually disappointed" that he was not allowed to "occupy a position of any importance."[61]

Uncongenial employment was the price he paid to pursue his interest in archaeology. While living in the Midwest, he collected material from the mound cultures. During a return trip to Europe in 1860–61, he collected extensively from the prehistoric Swiss lake dweller sites. Between 1859 and 1882, he published almost fifty papers in European and American journals, ten of them in Smithsonian publications. Over two decades, Rau exchanged close to one hundred letters with Joseph Henry, beginning with a discussion of their shared interest in debunking archaeological hoaxes. Over time, he became Henry's principal adviser on European and American prehistoric stone tools and weapons.[62]

The secretary paid close attention to European developments in archaeology. The recognition that chipped, flaked, and polished stone implements found in France, England, and Denmark since 1830 were the work of prehistoric human brains and hands had established the foundation of professional archaeology. Henry published Adolph von Morlot's summary of research in the field, including the technological categorization of human cultures into the Stone, Bronze, and Iron Ages, in his 1860 annual report. Additional articles on European archaeology followed, some of them by Rau, while George Gibbs, the Institution's staff ethnologist, urged renewed excavations in prehistoric shell mounds and other American sites with European models in mind.[63]

On May 10, 1875, the secretary wrote to Rau informing him, "You are hereby invited to take charge of the selection and arrangement for Exhibition at the Centennial in 1876, of such a series of Ethnological objects from the National Museum, as may best serve to illustrate the present condition of Ethnology in the United States."[64] Baird drew on his own roster of talented young scholars to support Rau. He commissioned Otis Tufton Mason, a Smithsonian collaborator teaching at Columbian College (now George Washington University), to prepare a detailed list

of ethnological and archaeological objects required for the exposition and to fill gaps in the Smithsonian collection.[65]

The assistant secretary also assigned nineteen-year-old Frank Hamilton Cushing to assist Rau. A native of Erie County, Pennsylvania, Cushing had scarred his hands learning to knap flint arrowheads (using his bone toothbrush as a flaking tool), published his first scientific article at seventeen, and was studying at Cornell University when Baird, who had not lost his eye for talent, hired him in 1875 and set him up with living quarters in the south tower of the Castle. Finally, Edward Foreman, who had assisted Henry with meteorological work in the 1850s, returned to the Institution to work with Rau and Cushing on the ethnology display.[66]

Charles Rau arrived in Washington and was deep in the planning process by July 1875. "I am now entirely established, books and all, in the Smithsonian building," he informed Baird. "I leave only once a day—toward evening for taking a meal. My whole time—day and night, I may say—is in some way devoted to the work for which I have been appointed, and my sole amusement consists in trapping mice, of which my rooms harbor an astonishing abundance."[67] Rau peppered Baird with a steady stream of letters detailing the collections he was surveying for inclusion in the Philadelphia display, commenting on incoming specimens, and correcting the misidentifications of collectors in the field.[68]

Baird's one great disappointment came when rising costs forced him to abandon a plan to transport scores of Native Americans from a wide range of cultures to Philadelphia, where they would serve as living exhibits. In their place, Joseph Palmer would oversee work on full-scale papier-mâché and wax figures dressed in the fashion of various tribes. "The amount of material thus obtained from all sources has been very great, and is continually increasing," Baird assured the secretary, "so that there is little question that, so far as inanimate objects are concerned, scarcely any thing will be wanting in the elements of a satisfactory exposition."[69]

The Smithsonian gained its second building in 1875 when the secretary agreed to the construction of a two-story brick building next to the Castle. The basement and first floor of what would be known as the Natural History Laboratory housed Palmer and his taxidermists preparing displays for the exposition. Photographer Thomas William Smillie used the second floor as his darkroom and workspace. A Scottish immigrant, Smillie studied chemistry and medicine at Georgetown University before accepting a position as the Smithsonian's first photographer in 1870. He would remain with the Institution until his death in 1917, providing a visual record of the next half century of Smithsonian history and serving as the first curator of photography.[70]

On April 20, 1876, the first of twenty-two boxcars left Washington bound for Philadelphia. Nearly twenty more cars would arrive directly from various collection points. "Things are moving satisfactorily," George Goode assured Baird on May 6. "Glass came in yesterday and several cases are already fitted up." Under Goode's supervision, Blake, Rau, and Cushing proceeded with unpacking and filling the cases with the help of "many laborers and other assistants."[71]

There were disputes to adjudicate and problems to solve. "Dr. Rau and Professor Blake are both laying claim to our six remaining 'hip-roof cases,'" he reported. "The stuffed animals came through in excellent shape, but the space assigned to them is occupied by tons and tons of heavy coal" intended for use in constructing a black obelisk forty feet tall in the geology section. Goode was also careful to keep Baird apprised of the other exhibits taking shape in the government building. "The Agriculture Dept. cases look very well," he noted, while "those of the Patent Office are fearfully ugly and the collection is going to look badly."[72]

As the Smithsonian team struggled to complete their work by opening day, Goode took time to walk a *New-York Times* reporter through the exhibition-in-the-making. The reporter found the presentation of the mineral resources of the nation "so unparalleled as to make the heart of every man who loves his country dance within his bosom." No "collection in the world could compare to" the hand-colored plaster casts of over four hundred fish species common to American waters. The "absolutely superb collection of stuffed representatives of the animal kingdom" was "as attractive . . . as their space will admit of." Rau and Cushing had just begun installing what the reporter assured his readers was the Smithsonian's "magnificent collection of Indian curiosities." Delighted with Goode's tour of the displays, the newsman predicted that the Smithsonian contribution would be the most interesting and valuable of the fair.[73]

Planning a major Institutional presence at the Centennial Exposition had been a strategic decision. Spencer Baird and George Goode intended that a grand display at a major international fair would establish the National Museum as an organization capable of mounting exhibitions that would educate, inspire, and perhaps even provide thoughtful and "uplifting" entertainment for the public. Rather than the Smithsonian divesting itself of the museum, as Joseph Henry had hoped, an expanded National Museum would provide effective public exhibitions as a means of achieving James Smithson's goal of disseminating knowledge to the broadest possible audience. The Centennial Exposition was one of the most important turning points in the history of the Smithsonian, launching the Institution into an expansive future that Joseph Henry had not envisioned.

CHAPTER 12

BAIRD TAKES COMMAND

SOME ONE HUNDRED THOUSAND PEOPLE gathered in Philadelphia's Centennial Park at noon on May 10, 1876, to hear President Ulysses S. Grant's ten-minute address opening what was officially known as the International Exhibition of Arts, Manufactures, and Products of the Soil and Mine. They were the first of an estimated 10 million visitors who would stream through the gates over the next 184 days before the Centennial Exposition closed on November 10. Fairgoers could visit 638,127 square feet of exhibits presented by thirty-seven nations in 250 buildings scattered across 285 acres. The Main Hall, with twenty-one acres under its roof, and the Machinery Hall were said to be the largest buildings in the world at the time.[1]

Most visitors arrived by train. When the Pennsylvania Railroad ran short of passenger cars, they delivered visitors in freight cars outfitted with seats. A Centennial Lodging House Agency stood ready to direct the crowd to the ten thousand hotel rooms under contract. Despite the impressive attendance figures, the fair failed to break even and disappointed its financial investors. However, it achieved the larger goals of the planners. It heralded the emergence of the United States as a technological powerhouse, inspired visitors with confidence in traditional American values, and celebrated the unity of the nation just eleven years after the end of the Civil War.[2]

It was not, however, an exposition for everyone. Federal Reconstruction was at an end, replaced by state policies restricting the civil liberties of African Americans and imposing rigid racial segregation. They were all but excluded from representation at the fair except as minstrel entertainers at the Southern Restaurant on the grounds. Moreover, ticket prices and the cost of travel and lodging limited the participation of working-class families.[3]

Baird, Goode, and their colleagues had achieved a triumph, producing what one leading journal regarded as "decidedly the best part of the International

Exhibition. . . ." Occupying 40 percent of the floor space in the Government Building, the Smithsonian display included an exhibit of geological resources, from huge blocks of building stones to impressive samples of gold and silver. There were cases of animal skins and stuffed American mammals, from a vole to a polar bear "with great breadth of chest, enormous limbs and long sharp claws."[4]

With the installation complete, Baird would handle things in Philadelphia, allowing Goode to escape to less strenuous duties with the Fish Commission in New England and Bermuda. "I hope that you have not been driven to distraction by the crowds," Goode wrote to Baird on October 6, a month before the close of the fair. "I honestly believe that ten thousand . . . of the twelve thousand citizens of Middletown [Connecticut] have been to Philadelphia and now they are beginning to go again—not satisfied by a single effort at suicide."[5]

By closing day, Baird and Goode were more than pleased with the reception of their contributions to the fair. The judges appointed by the US Centennial Commission commended the Smithsonian participants on the "very high merit" of their displays and presented ten specific citations for publications and collections. Joseph Palmer, John H. Richard, and Thomas Smillie received special awards for producing, painting, and photographing American fish. "There is, I believe, no question as to the satisfaction of the American people with the United States exhibition made in the government building," Baird noted. "It was universally considered the best part of the Centennial display."[6]

The Fish Commission contribution, with its colorful sculptures of fish and models of larger sharks and whales as well as salt- and freshwater aquariums, preserved specimens, and photos, was, the *New-York Times* reported, "the great attraction of this Exhibition." Combining good science with imagination and artistry, the presentation demonstrated what Baird and Goode, supported by talented craftspeople, could accomplish in the exhibition format. It was the trial run of a process of developing and mounting a new sort of thoughtful exhibition that would change the public's view of the very nature and purpose of the Smithsonian.[7]

The ethnographic display, however, proved to be the most controversial of the Institution's offerings. The exhibit had come together haphazardly, as materials arrived from Washington and collectors in the West. When complete, it offered an impressive, if somewhat confused, picture of Native American cultures. A Plains Indian tipi was pitched beneath a sixty-five-foot-long Haida canoe. Close by was a skin-covered South American boat and a pair of towering totem poles from the Northwest coast.[8] The plaster figure of Elisha Kane in Inuit garb, long a feature of the National Museum, was joined at the exposition by life-size Native American

Native American display at the Centennial Exposition, published in *Frank Leslie's Illustrated Historical Register of the Centennial Exposition, 1876*. Participation in the Centennial Exposition that took place in Philadelphia, Pennsylvania, marked the emergence of the Institution as a leader in the presentation of educational displays and provided the foundation for the US National Museum. The Smithsonian contribution to the 1876 exposition included a display of Native American cultures. These two poles were carved especially for the display. The pole in the foreground was carved of Western red cedar by Haida artisans in Kasaan, Alaska. *Smithsonian Institution Archives*

figures clad in tribal dress lining the aisles, replacements for the live Indians that Baird could not afford to transport, house, and feed. Rau and Cushing had filled case after case with tools and weapons, pottery, basketry, and ceremonial objects drawn from South, Central, and North America.

Visitor comments indicated that some citizens of a nation that had been at war with one tribe or another since its foundation found it difficult to sympathize with Native American cultures. "Here are . . . the most grotesque idols . . . all with big misshapen heads, and a severe burlesque on the human body," remarked one commentator. There were clay pots, stone hammers, flint hatchets, spears, arrowheads, and "some things that would puzzle any one [sic] to guess what they were made for, except for the purpose of bewildering and befogging the minds of speculative antiquarians."[9]

This incredible array of objects from two continents were not grouped by region or culture, "so that in one case, we may find articles from Mexico, California, or Michigan." Rau, following Otis Mason's lead, had organized the display based on the level of artistry and the complexity of the technology, arranging the material culture of the peoples of the Americas on an ascending scale from savagery to merely barbarous. As one scholar has noted, the display portrayed Native Americans as "the very antithesis to the forces of progress."[10]

The arrangement reflected the underlying principle of white supremacy that marked the Smithsonian view. "Of all the present inhabitants of the earth," Joseph Henry wrote in 1862, "how few are destined to leave behind them a permanent posterity. The American Indian is going out of existence . . . giving place to the Anglo-Saxon race." Spencer Baird was of the same mind. "So far as the ethnological display is concerned," he noted, "it is quite reasonable to infer that by the expiration of a second hundred-year period of the life of the American republic, the Indians will have ceased to present any distinctive characteristics and will be merged in the general population." Native Americans were regarded as living fossils and seen as unable to hold their own against a superior race, doomed to extinction or assimilation. Given the mindset providing the intellectual underpinnings of the display, the reaction of visitors is not surprising.[11]

The Smithsonian presentation of Native Americans in the 1876 exposition, and in the long string of exhibitions to come, has been a focus of considerable scholarly discussion. Nineteenth-century scientific attitudes rooted in white supremacist assumptions also shaped collecting policy, as demonstrated by Edward Palmer, a collector employed as a physician at army posts and Indian agencies, in his attempt to obtain the body of an Apache child for the Smithsonian in 1867. "The females of the camp laid it out after their custom & covered it with

flowers and carried it to the grave. . . . They hid it so completely that it's [*sic*] body could not be found, as I had a wish to have it for a specimen. . . . No persuasion could induce them to tell the secret, so I did not get the specimen."[12]

There is nothing to suggest that Spencer Baird, dedicated to building a national collection second to none, was upset by Palmer's approach. He demonstrated his commitment to one of his favorite collector-assistants in the summer of 1873, when Palmer was working for the Fish Commission and living in the Castle between collecting trips. Secretary Henry discovered that for a long time Palmer had been "corrupting boys who visit the Institution and those who are in its service, and inducing them to administer to the gratification of the most depraved and disgusting appetite which the imagination . . . could ever suggest." When the evidence of Palmer's sexual predation proved overwhelming, Henry ordered him out of the building and asked Baird to "dismiss the Dr. from your service, and send him to the Indian wilds never again to mingle with men of civilized life."[13]

While admitting that Palmer's activity was "disgusting," "sickening," and perhaps the product of a "diseased mind," Baird suggested that the man's forthcoming marriage might "cure" him. In any case, he continued, Palmer was "indispensable" as a collector, and he promised to dispatch him to the West in the hope that he "would be able to make a fresh start . . . and eventually be cured." Palmer continued as one of Baird's collectors for another decade.[14]

LOOKING BACK FROM THE perspective of 1903, Assistant Secretary Richard Rathbun noted that the "Centennial Exhibition . . . established an epoch in the history of the [National] Museum . . . only second in importance to its foundation." The success of the Philadelphia Exposition had demonstrated that the Institution not only supported quality research, but that Baird and Goode could produce fine exhibitions. They had pioneered new approaches to exhibition design and proven their ability to attract visitors and communicate messages. The Institution had earned an international reputation that would invite requests to participate in fairs and expositions to come.

As early as 1875, with preparations for the Philadelphia display dominating business in the Castle, Secretary Henry predicted that the event would "probably have a much greater effect on the future of the establishment than is at first apparent." He hoped that the emphasis on creating public displays outside the capital would be the occasion for creating "a more definite distinction" between the Smithsonian and the National Museum, "if not a complete separation."[15]

He put the question more directly to his friend Asa Gray, asking, "Is not an entire separation between the Institution and the Museum advisable?" Gray

agreed to chair a committee of three regents (himself, Senator Aaron A. Sargent, and Representative Hiester Clymer) to consider the question. Reporting to the board on February 1, 1877, Gray's committee agreed with the secretary that the ideal solution to the problem would be "an entire separation" of the National Museum from the Smithsonian.[16]

Always careful to offer public support for the secretary's view of the matter, Spencer Baird commented that "the Museum constitutes no organic part of the Institution, and that whenever Congress so directs, it may be transferred to any designated supervision." He was confident, however, that Congress would not strip the Smithsonian of a function that it was performing so effectively under his leadership.[17]

The immediate impact of the great fair was a sudden expansion of the collection. Most of the material that the Institution displayed in Philadelphia had been gathered especially for that event and was then added to the existing collection of the National Museum. That was only the tip of the exposition collection's iceberg. "Some time before the close of the exhibition," Baird explained, "intimations had been made by numerous exhibitors, both foreign and domestic, of a design to make various donations of material to the United States; but the magnitude of these accessions . . . was far from being anticipated."[18]

In fact, Baird worked hard to ensure that other exhibitors were aware of the Institution's desire to accept all the items on display. He deputized Thomas Corwin Donaldson, an especially well-connected Ohio lawyer who had helped gather materials for the geology display, to approach foreign and domestic exhibitors expressing the Smithsonian's interest in securing "various articles illustrating the technical arts and industries." He was instructed to identify himself as an agent of the Institution and "explain more fully the plan of the Smithsonian . . . in connection to the National Museum, and show in what way the contribution desired may be of benefit to . . . [the donor] as well as to the cause the Smithsonian has at heart."[19]

Most of the state commissions and thirty-four nations from six continents announced plans to turn over the entire contents of their exhibitions to the US government. While Congress directed the navy and agriculture departments to accept some elements of the donation, the bulk of the material was earmarked for the Smithsonian. As the displays in the Government Building were dismantled, Baird used the space to gather and pack the donated material in preparation for shipment to Washington.[20]

Recognizing that the Castle could not accommodate the incoming material, Congress provided $4,500 to cover the cost of refurbishing the four-story District

of Columbia Armory, a block east of the Castle between Sixth and Seventh Streets. Empty since the end of the Civil War, the building, without heat or water, would temporarily house collections, cases, and equipment shipped from Philadelphia that could not be shoehorned into the Castle. Twenty-two railroad cars had transported display material to Philadelphia. Forty-two cars were required to carry some 812,000 pounds of specimens and exhibitry home to the Smithsonian. In 1876, staff members cataloged 23,675 new objects coming into the collection, as opposed to 12,578 for 1875 and 10,332 in 1874.[21]

Since accepting the hodgepodge of material from the National Institute in 1858, the National Museum had focused on building a collection that would illuminate the geology, natural history, history, and ethnography of North America. In addition to scientific specimens, the boxcars arriving from Philadelphia carried raw materials, industrial products, commercial goods, machines and machine tools, military uniforms, weapons, ship models, and cultural objects from across the nation and around the world.

The Chinese Imperial Centennial Commission, for example, offered "a complete representation of the manners and customs of the Chinese, including examples of their foods, medicines, clothing, domestic and household utensils, objects used in their plays and festivities, &c." There were life-size figures dressed to represent "the different ranks and classes in the community" as well as "hundreds of clay figures, about one foot in height, illustrating the different races of the empire." The collection included three ceremonial gateways, two pagodas, and forty-three ceremonial kites, the first flying artifacts to enter the Smithsonian collection. "The Government of the United States," the Board of Regents explained to Congress, "is now in possession of the materials of a museum, exhibiting the natural products of our own nation, associated with those of foreign nations, which would rival in magnitude, value, and interest the most celebrated museums of the old world."[22]

By the winter of 1876, the armory building was overflowing, and additional crates lined the basement hallway of the Castle and the spaces between the exhibits in the museum area. While preliminary consideration was given to transferring the fair's Government Building to Washington or to constructing an annex to the Castle, the obvious answer was a dedicated building for the National Museum.

On October 8, 1877, the secretary, as both head of the Institution and president of the National Academy of Sciences, petitioned President Rutherford Hayes for a dedicated National Museum building. In his message to Congress on December 3, the president recommended that Congress fund the construction of just such an adjunct to the Smithsonian. An original bill passed the Senate but arrived in the House too late in the session for passage. A second effort also failed to pass. Finally,

on March 3, 1879, following Secretary Henry's death, the House and Senate passed an amendment to the Sundry Civil Act for 1880 appropriating $250,000 "for a fireproof building for the use of the National Museum."[23]

With that decision, Congress confirmed that the public exhibition of America's natural and human treasures was and would remain the responsibility of a National Museum managed by the Smithsonian. The Smithson bequest would continue to fund the research, publication, and exchange programs, while congressional funds would support collections and exhibitions. When he was named assistant secretary in charge of research, publication, and the exchange programs in 1886, Samuel Langley inquired as to Asa Gray's recommendations regarding the separation of functions. George Goode responded with a forty-nine-page letter-memorandum tracing the roots of the National Museum back to the enabling legislation, indicating that Congress had settled the issue. There would be no more talk of divorcing the National Museum from the Institution.[24]

JOSEPH HENRY DIED IN HIS quarters in the Castle at 12:10 p.m. on Monday, May 13, 1878, at the age of eighty. Six months before, on December 4, 1877, while on Staten Island conducting experiments for the Lighthouse Board, the secretary suffered paralysis in his right hand, shortness of breath, and "paroxysms of pain through the regions of the heart." Originally thought to have been caused by a stroke, the symptoms were diagnosed as kidney problems resulting from Bright's disease.[25]

Realizing that Henry had not grown rich as secretary, twenty-five of his closest friends and colleagues contributed $40,000 "secured for investment in Trust," the income of which would go to the secretary and to his immediate family after his death. With the death of Caroline, the secretary's last surviving child, in 1920, $47,000 was returned to the National Academy of Sciences, where, as the Henry would surely have wished, it formed the basis for the Joseph Henry Fund, which provides research grants.[26]

The trust for his family was announced at the April 1878 meeting of the National Academy of Sciences, held, as usual, at the Smithsonian. With difficulty, Henry left his rooms to preside, resigning the presidency because of ill-health. The astronomer Maria Mitchell visited the secretary that month. "He has been ill & seems feeble," she reported, "but is still the majestic old man, unbent in figure and undimmed in eye." Henry's condition deteriorated after he took a chill during a carriage ride on May 10. Spencer Baird visited on May 11 and 12, but arrived five minutes after the secretary's death on May 13.[27]

At a regents' meeting that evening, Chancellor Morrison R. Waite announced that the family had asked the board to arrange the funeral and appointed Baird,

General William Sherman, and Dr. Peter Parker, a Washington-based surgeon-missionary, to manage the event. Washington was "A City in Mourning" on May 16. The services began that morning in the Henry family quarters, from which a party of family and friends, regents, and employees then escorted the body to an army caisson that transported it to the New York Avenue Presbyterian Church, where the Henrys worshiped. Twelve marines carried the casket up the aisle. President Hayes, his cabinet, and the members of the Supreme Court and the National Academy of Sciences were present, as were diplomats, city officials, and members of the House and Senate, Congress having adjourned in honor of the occasion. The event concluded with a procession to the interment at Oak Hill Cemetery.[28]

The press lavished praise on Henry. He was the "Nestor of American Science," its "grandest ornament," and "one of the brightest exemplars of all that is pure and noble in manhood." On June 1, 1880, Congress, agreeing that Henry was worthy of memorialization, appropriated $15,000 to commission a larger-than-life (nine feet tall) bronze statue of the secretary to stand in front of the Castle. Baird supplied sculptor William Wetmore Story with photos, a death mask prepared by Clark Mills, and academic robes of the sort Henry had worn while teaching at Princeton. The statue, standing on a granite base, was dedicated on April 19, 1883, with President Chester A. Arthur and most of official Washington, down to and including the members of the Lighthouse Board, in attendance.[29]

THE REGENTS ELECTED SPENCER BAIRD the second secretary of the Smithsonian Institution on May 17, 1878. The unanimous vote was an expression of approval of the changes already underway.[30] A reporter once described Baird as "a noble looking man, over six feet high . . . with broad shoulders, and all together massive. He was careless in dress, farmer-like in appearance, and abstracted in carriage." Baird dispatched two generations of young naturalists on collecting trips into the far reaches of the continent but turned down offers to accompany expeditions to the West and to South and Central America. Unlike Joseph Henry, he declined opportunities to visit Europe. His need to care for his wife prevented him from satisfying any taste for personal scientific adventuring. Mary Baird's health, always fragile, grew much worse in the 1850s, with constant and severe abdominal pain that would plague her for the rest of her life. Beginning in 1866, she resorted to morphine, to which she became addicted. From that point, Baird refused to travel away from his wife, dedicating himself to her care and to monitoring her medication.[31]

He was a complex and contradictory man. While as much a public figure as Henry had been, he hated public speaking, admitting to a friend that "I would not

know how to conduct myself or what to say before an audience of about three people." Nevertheless, as George Goode noted, his public-speaking abilities were never better than when "in the presence of Congressional committees."[32]

Baird was a compulsive worker. Goode remarked that "his industry was phenomenal, he really seemed never to waste a moment." His daughter, Lucy, agreed, commenting that "he worked after hours, during meals and in fact to the limit of his capacity." Lucy also reported that "his favorite recreation was novel reading," his taste running from the excitement of *King Solomon's Mines* and *Treasure Island* to his favorite, Frances Hodgson Burnett's *Little Lord Fauntleroy*.[33] Solomon Brown, who worked closely with Baird for years, commented on his poor eating habits, "taking his coffee with one hand while he held his notes in the other." At the same time, Baird referred to himself as a gourmet and even loved ice cream. He had a marvelous sense of humor.

The Smithsonian was in the throes of change that he had set in motion. Newsmen were aware of Baird's impact on the Institution and the nation. Joseph Henry's Smithsonian, the *Washington Post* editorialized, had supported research that was "incomprehensible to the ordinary man." Spencer Baird, on the other hand, had "gathered around him a colony of young scientists," "swept the dust and cobwebs away," and "made at Washington the finest museum in the world."[34]

Indeed, Joseph Henry's legacy was mixed. His great achievement was to husband the Smithson trust, ensuring the initial survival of the Institution. He had achieved his goal of identifying and publishing examples of solid American research and had prevented the establishment of a national research library at the Smithsonian rivaling the Library of Congress. Henry had established himself as a spokesman for science policy in the halls of government. At the same time, he had, fortunately, failed to prevent the creation of a large and iconic building, or to forestall the efforts of his brilliant assistant secretary to create an ever-expanding collection that defined the nature and resources of a continent and a National Museum building to house it. Joseph Henry seemed cool and impersonal and sought to limit the role of the Smithsonian. Spencer Baird recruited and mentored two generations of natural scientists and put them to work on behalf of the nation. He sought to expand the reach of the Institution, weaving it into the very fabric of American life.

There was no doubt as to where growth would occur in the Spencer Baird administration. In 1874, under Secretary Henry, the Institution spent $47,699.75 on Smithsonian operations and just $703 to supplement the congressional appropriation of $20,000 for the National Museum. By 1880, the sum expended on Smithsonian programs had dropped slightly to $42,283.18, while the congressional

appropriation, not including building expenses, had climbed to $47,500. Four years later, Institutional expenditures held steady at $43,613.18, while the National Museum spent $100,359.24 of a $107,000 appropriation.[35]

Baird's friend John Billings pointed out that the Smithsonian expenditures for original research, which averaged over $2,000 annually from 1850 to 1877, fell to $802.80 between 1878 and 1880 "and then ceased entirely, while . . . expenditures for collection and research [of the National Museum] more than doubled." The money spent on the Contributions to Knowledge series fell from an 1870–77 average of $8,140.70 to $3,270.88 in 1878–88. The cost of the annual reports, which appeared as one volume for the Smithsonian and one for the National Museum after 1884, doubled during that period. Research did not decline at the Institution; it in fact increased but shifted to the National Museum.[36]

The new secretary's first challenge was to manage the construction of the National Museum Building. On March 7, 1879, the regents appointed General William Tecumseh Sherman chairman of a National Museum Building Commission that included both citizen regent Peter Parker and Secretary Baird. Quartermaster General Montgomery Meigs, who had been involved in repairs to the Castle following the 1865 fire, would serve as consulting engineer along with architect Adolf Cluss.[37]

The National Museum Building would rise just east of the Castle. The Romanesque architectural style complemented its more distinctive neighbor. The red-brick exterior worked well with the rusty Seneca sandstone of the Castle. As Cluss explained, "The building starts on the ground in the form of a square with sides of 327 feet extreme length . . . surmounted by a cross and a dome." A three-story pavilion stood at each corner, with four pairs of towers flanking the four doors located at cardinal points of the compass. The first-floor galleries offered 80,300 square feet of floor space, supplemented by an additional 4,000 square feet of exhibition space on the mezzanines. Ample windows allowed natural light to stream into the building.[38]

Construction moved quickly after the groundbreaking on April 17, 1879. By late July, workmen had laid 2 million bricks, with another 3 million to go. One hundred and thirty "mechanics and laborers" were at work. The *Washington Post* announced that the slate roof would be in place before winter set in. Work continued through 1880, with a separate appropriation covering the installation of steam heat, gas, telephones, electrical wiring to synchronize the clocks and operate the alarm system, and a second connection to the city sewer on B Street to prevent flooding in the basement.[39]

National Museum Building Commission, c. 1880 (*left to right*): General Montgomery C. Meigs, General William Tecumseh Sherman, Regent Peter Parker, Secretary Spencer Baird, architect Adolf Cluss, chief clerk William Rhees, and clerk Daniel Leech. The National Museum Building Commission was tasked with overseeing the construction of the National Museum Building (now the Arts and Industries Building). *Smithsonian Institution Archives*

Secretary Baird was pleased to approve a request to hold President James Garfield's inaugural ball in the National Museum Building. Work on the structure was nearing completion, although the marble flooring had yet to be installed by the inauguration day, March 4, 1881. The ball would bring national attention to the new museum building and support the new president. No national political figure since John Quincy Adams had been a more ardent supporter of the Smithsonian. An intellectual in politics, Garfield had served as a congressional regent from 1865 to 1873, and again from 1878 to 1881. Secretary Henry had repeatedly turned to him for assistance in the House. He had been especially helpful in supporting John Wesley Powell and other scientist explorers.[40]

Five thousand guests entered the north door of the National Museum Building that evening, strolling past sculptor Caspar Buberl's towering *Goddess of Liberty*, clad in classical drapery and holding aloft "a lamp in which burned the new light, the great electric light, which is to revolutionize the world and make dark places to shine with the all-effulgence of noonday." Tropical foliage, patriotic bunting, flags, and festoons of flowers decorated the space. Several bands, totaling one hundred musicians, entertained the crowd as they made their way

through receiving lines for both the incoming and outgoing chief executives and first ladies. Dancing was underway by 11:00 p.m. and continued into the early morning hours.[41]

Not everyone was pleased with the direction in which Spencer Baird was steering the Institution. In 1884, anxious to better understand how the staff was responding to the changes happening in the organization, the secretary distributed a memorandum asking each employee to describe their duties and offer suggestions for improvement.[42] Chief clerk William Rhees responded with thirteen pages of "Remarks relative to the Organization of the Smithsonian Institution," announcing, in effect, that he preferred Joseph Henry's vision of an Institution narrowly focused on "the promotion of scientific investigations and original research." At present, he complained, "there is . . . no well-defined scientific object to which the Institution gives its attention," while the National Museum "has grown so enormously in magnitude and importance that its management absorbs the greater part of the time of the officers of the [Institution] . . . as well as a large proportion of its building." The Smithsonian, which should, he believed, be the core of the operation, had been reduced to "simply a bureau with me [at] its head and a few clerks and assistants, paid meager salaries and having no independent functions."[43]

Having outlined his view of the errors of the current administration, Rhees provided a list of sixty-six duties traditionally assigned to the chief clerk, along with an account of the role he had played as the executive officer of the Institution for the past thirty-two years. "Not only the theory but the practice has been, until recently, to entrust the Chief Clerk with ample powers to act on all matters of routine . . . where no new line of policy or unusual expenditures were involved." Now, however, "the Secretary . . . has thought it proper to deprive the Chief Clerk of the power to make any expenditure whatever, even for the simplest and most necessary articles, or to exercise many of the functions hitherto believed to pertain to his office." Assuring the secretary that his comments were offered "not with a view of criticizing or condemning any person," Rhees asked that his prerogatives be restored and he be given a raise. Baird did not respond.[44]

While Rhees retained his post and continued to represent the Institution in the secretary's absence, Baird was regularly required to settle disputes between the chief clerk and his subordinates or officials with the National Museum, Fish Commission, and Bureau of Ethnology. When Rhees asked him to intervene in a disagreement with a correspondence clerk, the secretary responded, "You may

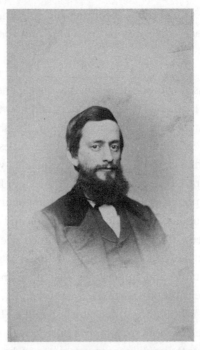

William J. Rhees (1830–1907), c. 1860s. Rhees was employed by the Smithsonian from 1853 until his death. He served as chief clerk for more than four decades and compiled the documentary history of the Institution. In 1891, he was appointed the first keeper of the Smithsonian's archives. *Smithsonian Institution Archives*

rest assured that knowing the feelings entertained by yourself and Mr. Leech towards each other, I shall not take sides, but where any action on my part is necessary, hear both parties out before coming to a conclusion."[45]

Baird and John Powell were often at odds over the management of the Bureau of Ethnology. Nor was the Fish Commission free of problems. Baird had to referee a running dispute between Thomas Ferguson, the assistant commissioner, and a subordinate, James W. Milner. As in the case of William Rhees, Ferguson was occasionally critical of Baird's management. He was also primarily responsible for charges brought through the secretary of the navy by Lieutenant W. M. Wood, who had been dismissed from command of the Fish Commission steamer *Fish Hawk* in December 1884.[46]

Charges of extravagance and the misuse of appropriated funds brought by the first auditor of the Department of the Treasury in 1885 initially seemed more serious. Anxious to make his mark, James Q. Chenoweth, a Texas judge and legislator appointed to office by President Grover Cleveland earlier that year, launched an

investigation of the accounts of both Powell's US Geological Survey and the Fish Commission. Admitting that "I have not been able to put my hands on anything tangible" regarding the Geological Survey, he focused on government funds spent on housing for visiting scientists and a laboratory building at Woods Hole.[47]

Baird immediately dispatched multiple, detailed responses to Chenoweth, the Treasury secretary, and congressional friends, pointing out that the tiny village of Woods Hole had only limited lodging and boarding facilities. The commission had no choice but to provide housing and dining areas for visiting staff and researchers on hand to pursue the work for which Congress had chartered and funded the organization. The secretary's suggestions of a presidential panel to investigate the commission were dismissed as unnecessary. Neither the Department of the Treasury nor Congress took Chenoweth's charges seriously.[48]

Secretary Baird accepted that the demands of managing the day-to-day operations of the Institution and struggling to resolve the crises, large and small, that came with the job meant that his personal contributions to natural history were at an end. He would take pleasure in the summer weeks spent at the Woods Hole facility and in supporting the efforts of his friend and colleague George Brown Goode, who was in the process of publishing eight scholarly volumes on the fisheries industry of the United States as well as filling the new National Museum Building with exhibitions that would redefine the role of the Smithsonian and museums in general.

CHAPTER 13

A MUSEUM FOR THE NATION

GEORGE GOODE WAS PROMOTED from curator to assistant director of the National Museum in July 1881. Initially, the Smithsonian had primarily collected to support scientific research. After 1857, when Joseph Henry accepted responsibility for "the National Cabinet of Curiosities," the Institution installed the first exhibitions. The Centennial Exposition had given Baird and Goode the opportunity to experiment with new techniques and to address a national audience. To give collections "their highest value," Goode explained, "they should be arranged in such a manner that hundreds of thousands of people should profit by their examination instead of a very limited number, and that they should afford a means of culture and instruction to every person, young and old, who may have opportunity to visit the place in which they are preserved."[1]

Goode applied the principles of organization and classification that he had practiced as a biological systematist to the management of the National Museum. Immediately after taking command, he formalized the organizational structure, creating five curatorial divisions, anthropology, zoology, botany, geology, and exploration and experiment, to oversee twenty-two departments—a structure that would evolve over time.[2] The original curatorial staff included some familiar names. William Dall served without pay as honorary curator of invertebrate paleontology, while Charles Rau headed archaeology, Robert Ridgway ornithology, and Edward Foreman ethnology, with Frank Cushing as an aide. Otis Mason would soon replace Foreman and spend the rest of his career with the Smithsonian.[3]

Administration, a non-curatorial division with eleven departments, was responsible for all other aspects of museum operations. Baird appointed Henry Horan superintendent of buildings. Joseph Henry had hired Horan, a native of County Cork, as a janitor in 1857 and quickly promoted him to watchman. Returning from Philadelphia in 1875, where he headed a zoological park, Horan took

George Brown Goode (1851–96), c. 1880s. Goode helped manage the US Commission of Fish and Fisheries and was instrumental in the development of the 1876 Centennial Exposition, the exhibits for the National Museum, and the Smithsonian displays for national expositions. He was appointed assistant secretary for the National Museum in 1887. *Smithsonian Institution Archives*

command of the District of Columbia Armory building, then moved to supervision of the National Museum Building staff.[4]

At Goode's insistence, the men under Horan's command wore uniform blue caps with "U.S. National Museum" in gold letters on the front. Laborers wore white uniform jackets. A doorman greeted visitors entering the museum, clicking his handheld "automatic register" to record each arrival. To ensure that the

nightwatchmen made their regular rounds, they were required to activate each of twelve electrical stations scattered around the building, creating a record in the supervisor's office.[5]

Having created an organization chart, Goode proceeded to issue eighteen "circulars" totaling fifty-seven pages of rules governing everything from mail procedures to the distribution of keys. Grades of employment were defined, complete with descriptions of duties and wage scales for every employee. Every possible question was addressed in the circulars. What color ink should one use? Rule XLVII specified that "every officer of the Museum is required to have upon his desk two types of ink." "Record Ink" (iron gall or carbon ink, not aniline) was to be used on all permanent records, while "Copying Ink" would do for correspondence.[6]

Rising congressional appropriations funded an era of staff expansion. The annual report for 1876 lists 17 officers and assistants, split almost evenly between the Institution and the National Museum. By 1881, the staff roster had grown to 106, with just 19 listed as Smithsonian employees and 87 working for the National Museum. The shift in personnel and funding reflects the reclassification of the research staff from the Institution to the National Museum. In addition to housing its own employees, the new building also provided office space (a reported 130 offices) for collections-based researchers from the Department of Agriculture, the US Geological Survey, the Fish Commission, and, for a time, the Bureau of Ethnology.[7]

By the early spring of 1883, the public spaces were lit with electricity supplied by a dynamo in the engine room. The electrical system also linked each of the 850 windows and 230 doors to a signal board indicating when something intended to be closed was opened. Staff communication was especially difficult in a building with two and a half acres of floor space and offices scattered throughout each of the three-tiered corner towers. Just seven years after the telephone was unveiled at the Centennial Exposition, a central telephone switchboard located inside the north door kept everyone connected, with a telephone on every desk.[8]

The major requirement for the National Museum staff was to fill the new building with exhibits. Goode had begun to shape his vision of a museum worthy of the nation while planning the displays for the Centennial Exposition. He took advantage of his participation in international conferences in Berlin in 1880 and London in 1883 to tour a score of European museums and discuss best practices with their directors.[9]

He noted a trend toward specialization among European museums. Some, like the Louvre, Great Britain's National Gallery, Berlin's Alte Nationalgalerie, and

the Uffizi in Florence, focused on the fine arts. French revolutionary support for natural history, science, and technology led to the establishment of what would become both the Muséum national d'histoire naturelle (1793) and the Musée des Arts et Métiers (1794). The Neues Museum in Berlin displayed Egyptian and ethnographic collections. With the opening of the Natural History Museum in 1881, the British Museum focused its resources on human history and culture.

Goode chose to move in the opposite direction, aiming for a museum offering the breadth of knowledge, "comprehensive and philosophically organized." In 1881, he unveiled his "Scheme of Museum Classification," with all the topics to be presented in the National Museum, from the solar system to microscopic life. There were to be eight divisions, each of which was broken into topics and subtopics. As one observer noted, Goode was providing a "philosophic classification intended to embrace the whole universe."[10]

"The general idea," Goode explained, "is that the collections should form a museum of anthropology, the word 'anthropology' being applied in the most comprehensive sense." The classic natural history collections, "that is to say the collections in pure zoology, geology, and botany . . . shall illustrate and supplement the collections in industrial and economic . . . history." In short, the US National Museum would be centered on human cultures, past and present, and the uses to which they put the natural resources available to them. Objects would be arranged from the earliest and most basic to the latest and most advanced, whether the topic was stone tools, weaving, timekeeping, musical instruments, or transportation. "In the arrangement of the museum," a Washington reporter explained, "man is regarded as the central unit to which everything is referred."[11]

The leaders of the American Association for the Advancement of Science (AAAS) thought the plan "open to the severest criticism" and showing "a definite want of prudence." They chastised Goode for having settled "the future of an institution in which the whole country is more deeply interested than any other of its kind, without allowing the voice and criticisms of scientific men to be heard." The AAAS critics feared that the availability of collections for research would be limited in a museum aimed at a popular audience. In addition, traditional Smithsonian functions might suffer, including publication of research, which was not mentioned. Finally, naturalists objected to placing human needs and resourcefulness at the center of all things.[12]

The critique had little impact on Goode's thinking. Support for collections-based research would remain a critically important function of the National Museum. The publication and exchange programs would continue, although the obligation to diffuse knowledge was no longer limited to putting words on paper.

The museum would be an institution "not intended for the few, but for the enlightenment and education of the masses." Goode was confident that his approach would appeal to visitors. The Institution was in the business of preparing exhibits that would educate, instill values, inspire creativity and invention, shape taste, guide public opinion, and even entertain Americans in the process.[13]

The operation of evolution, both in nature and human societies, would be the fundamental message communicated to visitors. Danish antiquarian and archaeologist Christian Jürgensen Thomsen established the notion of human progress through the Stone, Bronze, and Iron Ages. Goode was particularly impressed by the University of Oxford's Pitt Rivers Museum, where the three-stage evolutionary process was applied to the arrangement of objects. Items were displayed typologically and chronologically within each category, enabling visitors to recognize technological evolution among stone spear points, tools, pottery, and other items. In his 1877 study, *Ancient Society*, the American anthropologist Lewis Henry Morgan, whose early work had been supported and published by the Smithsonian, also argued that human cultures passed through his three stages, based on their command of technologies: savagery (fire, pottery, fabricated weaponry), barbarity (agriculture, the domestication of animals, metal working), and civilization (an alphabet and written language).[14]

Progress was the watchword. The "synoptic series" became the building blocks of exhibits at the National Museum. Otis Mason was the master of this approach. A Smithsonian contributor to the Centennial Exposition while employed by Columbian College, he joined the Institution full-time in 1884 and, like Goode, toured European museums. Particularly impressed by Gustav Klemm, Mason saw ethnology as the history of technology. His displays, whatever the topic, demonstrated improvement over time. He expounded that view in his many publications as well.[15]

With a classification established and a philosophy in place, the time had come to gather the items with which to tell the stories to be presented to visitors. Preparing for the Centennial Exposition, Baird and Goode had dispatched collectors armed with lists of geological, biological, and ethnographic items required to fill the cases. Determined to create a National Museum covering the breadth of human experience, Goode once again cast a wide net, enlisting Philadelphia lawyer Thomas Donaldson, an old friend, to supervise a fresh collections effort, assisted by journalist Barnet Phillips, who would also help to publicize the effort. Donaldson had worked with Baird and Goode to build the mineral collection for the exposition, served with Clarence King and John Wesley Powell on an 1879 commission

to codify the land laws, and, as the *New-York Times* observed, boasted "a larger acquaintance with public men than any other man in the country."[16]

Goode asked Donaldson to put his contacts to work acquiring a wide range of objects, providing "that no restrictions be made by the donors as to the manner of arrangement or their grouping in . . . exhibits." He provided a four-page list of over one hundred required items, from locomotives and Bessemer converters for producing steel to archery equipment, baseball uniforms, electric pens, machine tools, Masonic regalia, models of small boats and ocean-going vessels, pedometers and odometers, rubber clothing, spurs for fighting cocks, and velocipedes.[17]

Once the objects were received, Goode would arrange items in his preferred order and tie them together with thoughtful labels to tell a story. He insisted that clarity of presentation be the first consideration in exhibition design for the National Museum. As in so many other cases, he established stringent rules to guide label writers. "So important is this matter," a perceptive commentator observed, "that it is not too much to say that the Museum is . . . a vast systematic collection of labels illustrated by specimens, just as engravings illustrate the text of a universal encyclopedia." The preparation of carefully worded labels designed to communicate specific messages in clear language was a revolutionary innovation and central to Goode's contribution to exhibition planning.[18]

THE NATIONAL MUSEUM OPENED in its new home in stages. In February 1882, the *Evening Star* reported that a visit to the museum-in-the-making "is like taking a glimpse behind the scenes . . . when a great play is in preparation." While the "vast building" was open to the public, it remained a work in progress. "Here and there cases stand in place, filled with exhibits." Wooden fences barred entry to other areas "where the geologist, the ethnologist, the chemist and the naturalist are industriously at work, while vast stores of curious things from every part of the globe are packed away." Still, 167,455 visitors walked the halls of the National Museum in its first year of operation.[19]

Goode and his curators filled galleries with examples of the animal, vegetable, and mineral wealth of the continent and the world. Against that background, their "stories" described how different people in various times and places processed their environment to meet their needs. They underscored cultural diversity but emphasized the notion of progress, from evolution in nature to the wide range of human cultures passing from "savagery" to civilization. With what weapons and implements had they fought and farmed? What clothes and costumes had they worn? Representations of shelter included Chinese pagodas, Inuit igloos, Sioux tipis, and models of prehistoric dwellings culminating in a detailed model

of the Zuni Pueblo displayed on a platform the size of four pool tables. Exhibits explained industrial processes, from weaving fabric to metalworking, and displayed the products of industry. Examples of land transportation began with an oxcart and ended with the *John Bull*, a British-built locomotive that helped launch the railroad age in America.[20]

The paintings of George Catlin, mounted on the walls of the museum lecture hall, represented ethnology as well as art. Goode rejected the inclusion of "a miscellaneous art gallery of the ordinary type." The opportunity to include art as a technical process, however, was "a favorite project." He displayed a selection of fine art prints, including several from the Marsh Collection, the Smithsonian's first acquisition, together with etching tools, lithographic stone, copper plates, and other items illustrating the practice of graphic reproduction since the early modern era. Examples of modern ceramic art and sculptures dotted the public space. A wall of Japanese theatrical masks, an overhead display of traditional Chinese kites, and cases filled with athletic equipment, gambling paraphernalia, and toys demonstrated the age-old capacity of human beings to amuse themselves.[21]

Goode appointed A. Howard Clark, a Wesleyan colleague, to serve double duty as editor of publications and curator of the history division. Given the press of his editorial duties, his assistant, Paul Edmond Beckwith, did most of the work preparing the exhibit of early American history featuring the "relics" of presidents from George Washington to Ulysses S. Grant, Benjamin Franklin's printing press, and an assortment of items from the collection of the original National Institute.[22]

The National Museum immediately became the magnet for Washingtonians and visitors to the capital. The assistant director had achieved his goal of creating a museum that would introduce Americans to their nation and the world. In the process, he had emerged as an international leader in museum planning and studies. His notion of a museum combining natural history, anthropology, art, science, technology, and history held the seeds of what would grow to become the modern Smithsonian.[23]

Goode pioneered methods of museum practice that served as a new vocabulary for engaging with visitors. No detail escaped his attention. Take the matter of exhibit cases. After consulting with colleagues in London and Berlin, Goode decided that polished wooden cases "seem to be at once the most beautiful and convenient." With the help of Washington architect W. Bruce Gray, the Smithsonian staff developed a series of eleven types of display cases to fit a wide variety of collections and spaces. When possible, they were mounted on wheels so they could be repositioned to meet the needs of changing exhibits. Goode provided working drawings and lists of materials specifying types of wood, specific hardware,

244

Engraving of the repairing room, from *A Handbook to the National Museum under the direction of the Smithsonian Institution, Washington*, 1886. While the Smithsonian did employ women in the nineteenth century, most, like the depicted conservator, were restricted to lower-level positions. *Smithsonian Institution Archives*

SMITHSON'S GAMBLE

construction techniques, the design of storage drawers, the type of glass to be employed, the brackets to support objects, and the means to lock and connect cases to a central alarm system.[24]

He explained the improved process for preparing the human mannequins that played such an important role in exhibitions. Rejecting the "ghastly" wax and plaster figures employed in the antebellum museum, Goode and his craftsmen opted for papier-mâché. "The figures as a whole exhibit such conscientious and painstaking accuracy, and such fidelity to nature in the smallest details," he boasted. He credited William Holmes and Frank Cushing for ensuring the accuracy of both costuming and the craft techniques being illustrated by the figures. Heading the Bureau of Ethnology following Powell's death, Holmes emerged as one of the major contributors to the exhibition effort, both at the museum and as lead ethnographic contributor to many expositions, bringing a sense of life and excitement to a display with realistic figures.[25]

Goode called attention to the work of "Messrs. Shindler and Henley," artists who painted casts of "reptiles, fish, and stone implements." He also praised the skill of his model makers, who produced everything from architectural and nautical items to full-scale and very lifelike models of a giant squid, an octopus, and a whale.[26]

In the first week of April 1887, a large freight wagon delivered the body of a humpback whale that had beached itself and died near Atlantic City to a ramshackle wooden structure next to the National Museum. Model maker and taxidermist William Palmer, son of model maker Joseph Palmer, slung a section of the tail of the creature over his shoulder and carried it through the big doors into the District of Columbia Armory next door, where he would make a plaster cast of the skin. It was not the first project of this kind that William and Joseph Palmer had jointly undertaken.[27]

The model whale in question was thirty-two feet long. The skin had been cast in sections, which became the mold for the full-scale papier-mâché model. Visitors approaching from the front saw the whale; continuing to the other side, they saw that the cast was hollow, with the articulated skeleton of the creature mounted inside. The skeleton of a finback whale and a narwhal were suspended from the ceiling nearby. The skulls and jaws were displayed in the area, along with harpoons and other whaling gear.[28]

Suspending objects of the size and weight of a whale skeleton posed a serious engineering challenge. Goode recruited just the man to solve such problems in 1884. John Elfreth Watkins arrived at the museum as honorary curator of

Engraving of a humpback whale model by F. C. Jones, from *A Handbook to the National Museum under the direction of the Smithsonian Institution, Washington*, 1886. William Palmer, likely depicted here, created a papier-mâché model of a humpback whale for display at the US National Museum. *Smithsonian Institution Archives*

transportation, just in time to double as an engineer capable of suspending whales without bringing down the ceiling. An 1871 graduate of Lafayette College, he served as a construction engineer for the Delaware and Hudson Railway and the Pennsylvania Railroad before losing his right leg almost to the hip in an 1873 accident. After continued service as chief clerk for the Camden and Atlantic and the Amboy division of the Pennsylvania, he joined the museum to supervise the installation of the historic *John Bull* locomotive, which Goode had purchased, and to advise on displays of transportation and engineering. As such, he was responsible for the growing collection of items relating to technology and industry, as well as applying his engineering skills to assist other projects as engineer of property (1888–89) and chief of buildings and superintendence (1896–1903).[29]

Few aspects of the National Museum drew as much attention as the first-rate examples of taxidermy. While Palmer and others had tried their hand at preparing "stuffed" animals for display, William Temple Hornaday, whom Goode hired in 1882, broke the traditional mold and set a much higher standard in the field. In

SMITHSON'S GAMBLE

so doing, he played a critical role in launching the conservation movement in America.

Born in rural Indiana in 1854, Hornaday grew up in the forests near his home and on the rolling prairies of his grandparents' Iowa farm. He entered Oskaloosa College in 1870, moving on to the Iowa State Agricultural College at Ames the following year, mixing courses in the natural sciences with more practical studies in stock breeding, surveying, and mapmaking. Serious preparation for his career began when he tried his hand at taxidermy and was placed in charge of the college museum. In April 1873, a favorite professor called his attention to a note in the latest issue of *The American Naturalist* on Henry Ward of Rochester, New York, and Ward's Natural Science.[30]

The fact that there was a firm in the business of supplying plaster casts of rare fossils, a wide range of stuffed animals, and specimens preserved in alcohol to universities, museums, and collectors came as a revelation to nineteen-year-old Hornaday. Determined to improve his own skills and to find an entry point into the world of museums, he wrote to Ward that evening, asking for the opportunity "to learn taxidermy in all its branches, and salary no object." With letters of support from faculty members and the president of Iowa State Agricultural College, Ward agreed to hire Hornaday, who left college at the end of the term and reported to Rochester in November 1873, ready "to spend at least two years in intensive museology work and study."[31]

Hornaday entered Ward's establishment on College Avenue through a gateway supporting an arch composed of whale jaws. Six buildings on the site housed osteology, taxidermy, and casting operations, together with a museum and a building dedicated to packing and shipping. He joined Ward's "merry-hearted swashbucklers," an international crew of specialists who ensured that a constant flow "of casts, skeletons, and stuffed animals were sent out to the museums of the world—new and old, little and big—as far as Tokio and Calcutta, Berlin and New Zealand."[32]

Within a year, young Hornaday had risen from a lowly apprentice to a position as a field collector of vertebrates, responsible for sending a steady stream of skins and bones back to Rochester for processing. He began his collecting activities in the West Indies and South America, undertaking journeys deep into Amazonia in search of rare specimens. He then spent a year and a half hunting raw material for the taxidermists in India, Ceylon, and Southeast Asia.[33]

Hornaday returned to Rochester in April 1879, determined to use his firsthand knowledge of animal musculature and behavior to revolutionize taxidermy. Dissatisfied with current practice in which skins were wrapped around sticks for

legs and animal bodies simply stuffed with straw, he began using potter's clay mixed with chopped hemp tow to create realistic forms, which he arranged in natural settings.[34] Hornaday spent the summer of 1879 creating a representative scene in which a pair of orangutans that he had killed in Borneo were positioned in jungle foliage battling over a female. Titling it "Fight in the Tree-Tops," Henry Ward shipped the glass case to a meeting of the American Association for the Advancement of Science in Saratoga, New York, where Hornaday was giving a paper on "The Species of Bornean Orangs."[35]

One member of the audience, George Goode, was impressed, recognizing that the young man's knowledge and artistry would be an asset to the National Museum. Hornaday turned down Goode's initial offer in favor of continuing to perfect his technique at Ward's. He inspired his colleagues to form the Society of American Taxidermists in March 1880 and, with Ward's support, staged three annual exhibitions. The result was the emergence of a new school of taxidermy whose goal was "the artistic portrayal of nature's wonderful works."

With that accomplished, Hornaday finally accepted Goode's offer, joining the National Museum as chief taxidermist on March 16, 1882. It was, he thought, "unquestionably the highest position attainable in America by any man in my line of endeavor." He established a workshop in a large wooden shed constructed east of the new National Museum Building. His first projects included preparing a one-thousand-pound circus elephant, Mungo, a victim of "pneumonia and badly baked peanuts." The carefully prepared skin was stretched on a wooden elephant structure covered in his clay-tow mixture. By the close of 1884, Hornaday's team had prepared 83 specimens representing seventy-eight species for display at the World's Industrial and Cotton Centennial Exposition in New Orleans. Their total production for the year included mounting an additional 114 specimens, preserving fifty-seven mammal skins, repairing a collection of sixty Australian fish, and mounting another twenty-four large mammals on new pedestals, all intended for display in the museum.[36]

Hornaday reported to Henry Ward that he was "delighted with my position and my surroundings," adding that Goode was "one of the nicest of men, full of ideas and always open to suggestions." He had little patience, however, for the rules imposed by his immediate supervisor, Frederick True. When True reminded him that his monthly report was due, Hornaday replied that he had no time for clerical work at the expense of taxidermy. Charged with being intentionally disrespectful, Hornaday assured him that "no disrespect was intended, nor can I see that any was implied," concluding that he had "referred the matter to Mr. Goode, . . . who will reply to you."[37]

Over the next several years, Hornaday took command of taxidermic preparations for various expositions and broadened the collection, adding new species through his contacts with circuses, menageries, and hunters willing to donate the remains of dead animals. In addition to authoring a pair of instructional leaflets for amateur naturalists distributed by the Smithsonian, he supplemented his salary ($125 per month) with his first book, *Two Years in the Jungle*, and published a series of articles in popular magazines, including *Cosmopolitan, Youth's Companion*, and *Christian Union*.[38]

THE PUBLICATION OF THEODORE ROOSEVELT'S *Hunting Trips of a Ranchman* in 1885 called the attention of the nation to the approaching extinction of *Bison americanus*. "GONE forever are the mighty herds of the lordly buffalo," he wrote. While a "few solitary individuals and small herds are still to be found scattered here and there in the wilder parts of the plains; . . . the great herds, that for the first three quarters of this century formed the distinguishing and characteristic feature of the Western plains, have vanished forever."[39]

Through 1885 and into early 1886, newspapers across the nation spread the news of the near extinction of an American icon. "In riding across the green turf of the open country," one writer noted, "one sees everywhere white objects which so reflect the strong sunshine. . . . These are the bleaching skulls of buffaloes that used to roam in thousands through the region." Another reporter lamented that "there will be no more buffalo hunts on the Western plains, for the buffalo is so nearly extinct that in less than half a dozen years none will be known except in museums."[40]

Aware of the growing concern, Hornaday inventoried specimens in the collection in March 1886 and discovered that the holdings of the National Museum were pitifully thin, limited to several old and bedraggled mounted females, a moth-eaten head, some skeletal material, and some mangy hides—nothing suitable to represent this iconic American species. A rough census resulting from correspondence with western military officers, hunters, and ranchers confirmed that, between 1868 and 1886, improved weaponry, the coming of the railroad, and a growing market for meat and hides had reduced the population of bison on the Great Plains from an estimated 8 million to "a few scattered hundreds."[41]

Hornaday outlined the situation in a letter to Goode and Baird. Responding that he was "shocked and disturbed," the secretary noted that while "I dislike to be the means of killing any of these last bison, . . . since it is now utterly impossible to prevent their destruction, we simply must take a large series of specimens both for

our own museum and for other museums that sooner or later will want good specimens." He instructed Hornaday to "go West as soon as possible."[42]

Having negotiated free rail transportation, Hornaday left from Washington on May 6, 1886, bound for Montana on what he would always describe as "The Last Buffalo Hunt." He recruited his assistant in the taxidermy lab, Andrew H. Forney, along with his friend, the hunter and master taxidermist George H. Hedley of Medina, New York. Arriving in Miles City, Montana, the trio set out on May 13, equipped by the army quartermaster at nearby Fort Keogh and accompanied by a six-man escort drawn from the Fifth US Infantry Regiment. They were back in Washington a month later with nothing to show for the effort but five bison skeletons, seven skulls, one complete skin, an assortment of skins and bones from smaller mammals, and their prize: a live buffalo calf.[43]

Having negotiated additional railroad passes, however, Hornaday persuaded Baird to allow him to make a return trip in the fall when the bison, if he could find them, would have developed their thick winter coats. On June 26, Secretary Baird asked his adventurous taxidermist to submit a formal report on his trip as "soon as convenient to yourself." Hornaday complied but asked Baird to withhold publication until he had returned from his second hunt "so that the report of it may cover the entire work of the expedition." In late August, as Hornaday prepared to return West, the young bison, pastured with cattle in a suburban field, died because of overeating clover. The *Washington Post* reported that "Mr. Hornaday whose special pet it was, was for a time most inconsolable at its loss."[44]

Back in Miles City on September 24, Hornaday met the university student who would serve as his field assistant and three cowboys who had signed on as hunters. This time the commander of Fort Keogh furnished a four-man escort and a wagon pulled by a six-mule team. In addition, Hornaday's party included ten horses, a light wagon carrying provisions for the men, and two thousand pounds of oats for the horses. They set out on September 27, traveling northeast toward Yellowstone, and established a permanent camp near "a hole of wretchedly bad water" on October 12.[45]

Seven days later, Hornaday wrote Baird, noting his location as "Calf Creek, Yellowstone–Missouri Divide, Dawson County, Montana." Since October 14, he reported, "we [have] tracked down a small herd of buffalo, containing about fourteen head, and by hard work succeeded in killing eight." Four of the animals, he continued, "are magnificent old bulls, in the finest possible condition." In addition, they had brought down a two-year-old bull, two cows, and a yearling calf. "Thus, you see we have already a complete series of specimens." By December 13, when the party returned to Miles City, their haul included twenty-four skins, sixteen

William Temple Hornaday (1854–1937), c. 1886. Hornaday was the chief taxidermist of the United States National Museum as well as curator of the Department of Living Animals and the first superintendent of the National Zoological Park. In 1886, he visited Montana and brought home a baby bison named Sandy, pictured with him in this photograph, that died shortly after arriving in Washington. *Smithsonian Institution Archives*

full skeletons, fifty-one skulls, and the remains of an assortment of other species.[46]

Hornaday told the story of "The Last Buffalo Hunt" in eight installments published in eleven major newspapers from coast to coast between March 6 and April 24, 1887. His full report, "The Extermination of the American Bison," appeared in the *Annual Report of the United States National Museum for 1886–87* and was reprinted in 1895, long after he had left the Institution. The book has been described as "the first important text of the wildlife conservation movement."[47]

Confident of both his skill as a taxidermist and his newly acquired command of bison musculature, Hornaday sketched an ambitious display that included six bison in a single group, from the most impressive bulls to the calf that had died in captivity. Secretary Baird and George Goode approved Hornaday's plan for what was to be both "a monument to the American bison" and "a crucial test of the artistic group idea as adapted to the purposes of scientific museums." To deal with such a large group, he moved out of the cramped taxidermy shed next to the museum and established a new workspace in the armory building.[48]

A string of high-ranking visitors found their way behind the scenes to observe Hornaday and his assistants at work. Generals Philip Sheridan and Stewart Van Vliet, as well as the Bureau of Ethnology's James Stevenson, all familiar with bison from their years of service in the West, expressed their admiration for the effort. Theodore Roosevelt, who had tried his hand at taxidermy, introduced himself to Hornaday while the group was being installed in the museum and pronounced his approval.[49]

The bison group was unveiled in the Hall of Mammals at the National Museum in March 1888. Housed in a four-sided glass case measuring sixteen by twelve feet and standing ten feet tall, the animals stood on a base of imported Montana grasses, sage brush, and prickly pear cactus. A reporter communicated something of the impression it made on visitors: "It is as though a little group of buffalo that had come to drink at a pool had been suddenly struck by some magic spell, each in his natural attitude, and then the section of the prairie, pool, buffalo, and all had been carefully cut out and brought to the National Museum. All this in a huge glass case, the largest ever made for the museum."[50]

Hornaday would present his message to an audience beyond the walls of the museum through a special exhibition. He prepared an eight-hundred-square-foot display for the 1888 Centennial Exposition of the Ohio Valley and Central States. The central element of the presentation that he termed the *Extermination Series* was a case showing the desiccated bones of a bison on real Montana soil. "In a very few years," he explained to visitors, "not even the bleaching bone will remain above

SMITHSON'S GAMBLE

ground to tell the story of the millions that have been utterly destroyed by the senseless, heartless, and wasteful greed of man." Buffalo hides, a stack of mountain goat pelts, a map showing the shrinking habitat of western wildlife, a display of high-powered hunting rifles, and photographs and various works of art illustrating destructive buffalo hunts rounded out the exhibit. "The lesson it teaches," *Forest and Stream* reported, "is both impressive and saddening to every lover of animated nature, and like all the lessons taught by the National Museum collections, it is strictly true."[51]

254

CHAPTER 14

AN IMPERIAL INSTITUTION

SECRETARY BAIRD AND GEORGE GOODE had taken advantage of the Centennial Exposition to place the US National Museum on a solid foundation. They had not expected, however, that the great fair would inspire the four decades of similar extravaganzas that followed. Between 1880 and 1915, the Smithsonian and the bureaus under its broad umbrella would participate in thirty-three local, national, and international exhibitions, expositions, and fairs attended by some 100 million people.[1]

There were elaborate productions that captured national headlines: the World's Columbian Exposition (Chicago, 1893), the Exposition Universelle (Paris, 1900), the Pan-American Exposition (Buffalo, 1901), and the Louisiana Purchase Exposition (Saint Louis, 1904). Others were major regional Southern Exposition (Louisville, 1883), the Cincinnati Industrial Exposition (1884), the World's Industrial and Cotton Centennial Exposition (New Orleans, 1884–85), the Cotton States and International Exposition (Atlanta, 1895), and the Trans-Mississippi and International Exposition (Omaha, 1898). There were expositions commemorating the voyages of Columbus (Chicago and Madrid) and events celebrating the Tennessee Centennial in 1897 and the establishment of Jamestown, Virginia, in 1907 and Marietta, Ohio, in 1888. Specialized fairs recognized fisheries, railroads, and electricity.[2]

Smithsonian exhibits were a constant thread binding the era of the expositions. They played a critical role in the success of the fairs, offering an educational and uplifting element to balance the commercial offerings and allure of the midway. There was a price to be paid for the Institution's commitment to the fairs. Congress, recognizing the value of Smithsonian involvement in these events, directed the Institution to participate and funded the effort. Richard Rathbun, who rose from his initial role as a summer assistant with the Fish Commission to become

assistant secretary of the Smithsonian (1896) and director of the National Museum (1898), admitted that it would appear "almost farcical" if the National Museum, the only federal organization in the business of producing exhibitions, did not contribute to the expositions.

Given the relatively small staff, progress on the museum was "stopped and hindered" while efforts focused on exposition work. George Goode reported in 1892 that the "activities of the entire staff have been in a large degree diverted to exposition work, as they were last year and are likely to be for a year to come." Many of the National Museum galleries were closed, "being needed for the work of mounting and packing the collections." Filling display cases left empty of items bound for an exposition, he continued, "required the utmost ingenuity . . . so that collections may be presentable to the eyes of visitors to Washington, who are quite as numerous this year, and among whom are many from foreign lands."[3] Goode never seriously doubted, however, that the opportunities for popular education provided by participation in the expositions was "too important to be neglected and . . . one for which no outlay of labor and expense can be too great." Ethnologist Walter Hough, an assistant at the museum who would later rise to curator of ethnology, agreed that the participation of the National Museum in the long series of expositions was of "immense significance" to the Institution.[4]

Indeed, the era of the expositions established the Smithsonian as a genuinely national institution and a trusted purveyor of information in an exciting format. The Institution would enter the twentieth century as one of the best-known and most respected voices explaining the natural world to the millions of visitors who toured its galleries and viewed its presentations at expositions across the nation and around the globe. In the process of reaching beyond the nation's capital, Smithsonian exhibits encouraged an interest in natural history, established the authoritative voice of the Institution, and underscored the need for conservation. They also reinforced the values of a Jim Crow society unwilling to guarantee the rights of Black citizens, Asians, and other "lesser orders" at home and abroad. If those who planned the displays sought to encourage an interest in science and learning, they also swam in the social currents of their time.

FOR THE SMITHSONIAN, THE ERA began on January 8, 1880, when Congress appropriated $20,000 to fund the participation of the US Fish Commission in the International Fishery Exhibition to open in Berlin, Germany, on April 20. Secretary Baird placed Goode in charge of the project. With less than three months before opening day, they dispatched most of the commission's Philadelphia exhibit. The

display was a great success. Goode returned to the Smithsonian bearing a large trophy "beautifully worked in silver and gold" for the best display.[5]

Baird and Goode put considerably more effort into their contribution to the International Fisheries Exhibition held in London in 1883. On this occasion, they made full use of the team of artisans they were assembling at the National Museum. An illustrated newspaper image of the exhibit shows the celebrated wall of colorful fish premiered in Philadelphia, surrounded by seventeen large display cases, some with seabirds perched on top. Looming overhead is a very long and realistic giant squid, an *Architeuthis dux* crafted of papier-mâché. Newspapers credited Addison Verrill, Baird's Harvard-trained Fish Commission assistant, with this remarkable full-scale model of an elusive creature that had never been seen in the wild. While Verrill undoubtably guided his efforts, the naturalistic beast was really the handiwork of William Palmer, who also crafted an octopus for the exhibition.[6]

In 1884, facing congressionally mandated participation in fairs in Louisville, Cincinnati, and New Orleans, Baird and Goode realized for the first time the scale of the effort required to supply displays for events following one after the other in short order. While the decision was made to collect items relevant to specific fairs, Goode and his curators established an "exhibition series" of duplicate items from a range of collections that could be used to meet the needs of the expositions. Experienced curators who were prepared to deploy standard displays occasionally developed special exhibits aimed at a particular fair. Goode managed the exposition program until his death in 1896, when Richard Rathbun took on that role. After 1888, Ralph Edward Earll, who had joined the Fish Commission in 1877, also provided continuity in the management of Smithsonian exhibition commitments and was often identified as the agent of the Institution.[7]

Local promoters invariably trumpeted the wonders that the Smithsonian was bringing to town. One Louisiana paper revealed that the Institution had spent $75,000 on its exhibit for the 1884 New Orleans fair. Another explained that the Fish Commission offered the "most interesting [displays] . . . in any of the Exposition buildings. Fish will be hatched from the eggs of numerous species of the finny tribe in the presence of visitors."[8]

Since 1870, Cincinnati had been sponsoring industrial fairs in which manufacturers of every conceivable product, from machine tools to fancy lace, competed for cash premiums. The 1888 event, the Centennial Exposition of the Ohio Valley and Central States, was an early regional celebration and the occasion for a major Smithsonian display. There were six cases of mounted birds, three of insects, and a display of marine invertebrates, including delicate glass models of some species.

Colored examples of American flora shared space with twenty-four engravings, etchings, and other graphic processes, traditional and modern.[9]

Thomas Smillie offered a photographic exhibition, while John Watkins's contribution covered the history of transportation on land and water. Between them, the division of prehistoric anthropology, ethnology, and the Bureau of Ethnology traced human history from the ancient peoples of the Old World to the Zuni of New Mexico, complete with lifelike costumed figures. Frederick True and his colleagues filled a case 140 feet long with skeletons and stuffed examples of "every family of mammals known to science, beginning with the highest order, man, following down through the scale to the lowest, or egg laying mammals." William Hornaday's *Extinction Series* was the centerpiece of this section, emphasizing the importance of conservation, with cases focusing on vanishing species, such as the American bison, elk, moose, mountain sheep, and seals, along with the weapons that were reducing their numbers.[10]

Not to be outdone, the Fish Commission drew attention to its presentation with an indoor waterfall. The display included a catalog of species in American waters, described hatcheries and fish culture, displayed models of the vessels and the equipment used to catch them, and included examples of the "homes of fishermen and fishing capitalists." Suspended over the entire exhibit was the forty-five-foot-long skeleton of a finback whale prepared by William Palmer.[11]

Chicago leaders fought hard for the honor of hosting the first great national fair since 1876. The World's Columbian Exposition, celebrating the four hundredth anniversary of Columbus's first voyage, would demonstrate that their city had risen from the ashes of the great fire of 1871 to become a thriving international metropolis. George Goode, with all the experience gathered through managing the other expositions plus the National Museum, was asked by the commissions of the exposition to take charge of classifying and cataloging the exhibits.[12]

Goode took his charge very seriously. He presented the ultimate decimal version of his system to the Chicago planners in a two-hundred-page document and argued that his decimal system would make wayfinding at the exposition as simple as finding a room in a great hotel. He called for ten departments: Agriculture; Mining and Metallurgy; Marine and Fisheries; Manufactures; Food and Nutrition; the House and its accessories; the Pictorial, Plastic, and Decorative Arts; Social Relations and Public Welfare; Science, Religion, Education, and Human Achievement; and Collective and Governmental Exhibits. Each department would have two divisions, and each division ten sections.[13] He arrived in Chicago on October 1, 1890, to defend his scheme against the stiff opposition of several commissioners who thought the decimal system was both too rigid and too complex.

His critics carried the day, establishing a less precise alphabetical system that would allow for more than ten departments.[14]

With a face-saving dedication of the World's Columbian Exposition on October 21, 1892, that enabled the planners to mark the four hundredth year of the navigator's first voyage, the fair opened to the public on May 1, 1893. Some 270 million people would visit almost two hundred buildings distributed over 690 acres spread along Chicago's lakefront during the six months of the exposition. Designed by several of the nation's leading architects, the fairgrounds were dubbed the White City, given the white exterior of the most important of the Beaux-Arts neoclassical buildings. While visitors crowded the grand exhibition galleries, the wonders of the Midway Plaisance, from the world's first Ferris wheel to the gyrations of Little Egypt (Fatima Djemille), seem to have dominated most memories of a visit to the fair.[15]

Aware that the World's Columbian Exposition required a special effort, the Smithsonian team produced one of their largest exhibitions. Twenty-five boxcars were dispatched to Chicago loaded with 145 tons of objects and exhibit materials. Ralph Earll and Henry Horan, the Institution's building superintendent, supervised the on-site work of sixteen preparators, taxidermists, and skilled mechanics from the National Museum staff and an additional twenty men hired locally. The presentation—in addition to the usual natural history and ethnographic displays— was focused on objects documenting the history of the nation and was well received. Otis Mason drew special attention for his contribution to the Woman's Building, an exhibit describing "the genius, patience, and skill of women in savagery." It became one of the exhibits that was preserved for display at future expositions.[16]

AS IN THE NATIONAL MUSEUM, evolution was the guiding principle of the Institution's exposition displays. It was easy enough when acquainting visitors with the wonders of the natural world, suggesting relationships between creatures, and presenting Hornaday's striking displays arguing the need for wildlife conservation. A far more impressive example of evolution and extinction came in 1904, when staff osteologist Frederic Lucas unveiled full-scale examples of the "terrible lizards" being uncovered in the American West.[17]

Since the antebellum days when Joseph Henry and Spencer Baird had dispatched young men to the fossil beds in the Dakota Badlands, dinosaurs had been of interest to the Smithsonian. It was the "bone war" of 1877–92, pitting Yale's Othniel Marsh against Edward Cope of the Academy of Natural Sciences of Philadelphia, however, that embedded dinosaurs in American popular culture. The two

distinguished men battled to control fossil quarries and amass the larger collection of ancient bones. While the feud embarrassed their colleagues, occasionally threatened to result in gun play between rival collecting teams, and drained the personal fortunes of both men, it produced 360 new species of dinosaurs, including some of the largest creatures ever to walk the earth and some of the most terrifying.[18]

While a vegetarian *Hadrosaurus foulkii* was one thing, the giant *Diplodocus carnegii*, over eighty-five feet long, which steel baron Andrew Carnegie unveiled in his Carnegie Museum in Pittsburgh in 1907, was quite another. Carnegie ensured the international fame of Dippy, as the press dubbed the creature, by presenting skeletal casts to Edward VII for the Natural History Museum in London as well to institutions in Berlin, Paris, Vienna, Bologna, Saint Petersburg, Buenos Aires, Madrid, and Mexico City.[19]

Limited by congressional funding for the National Museum, the Smithsonian could not afford to enter a bidding war with Carnegie or J. P. Morgan, who saw to it that the American Museum of Natural History was well supplied with sauropods. Fortunately, the fossils that Marsh had collected while working with the government geological surveys came to the Smithsonian. In 1903, Frederic Lucas and Smithsonian artisans, working with fossils from the Marsh Collection, created a full-scale papier-mâché model of a species of *Stegosaurus*, a genus identified in 1877. Artist Charles R. Knight, whose paintings of dinosaurs would excite the imaginations around the world and the nightmares of generations of youngsters, also contributed to the project. When a reporter inquired why the curator had chosen that creature, Lucas replied that it was the "showiest and most striking of the dinosaur tribe."[20]

When unveiled at the Louisiana Purchase Exposition in Saint Louis in 1904, the beast drew special attention because of reports that it had been created from "macerated bank notes that have been redeemed by the Government, incalculable millions in cash used in the manufacture." The legend clung to the stegosaur, which remained on view at the National Museum of Natural History into the 1980s. Staff paleontologist and historian Ellis Yochelson reported that Department of the Treasury officials once performed an "autopsy" and determined that the story was false.[21]

IN DEALING WITH CULTURAL EVOLUTION, Smithsonian anthropologists extended the work of Herbert Spencer, Gustav Klemm, Augustus Pitt Rivers, and Lewis Morgan to its logical conclusion. At the outset of the exposition era, Smithsonian archaeologist Charles Rau remarked that "the extreme lowness of our remote

Papier-mâché model of a *Stegosaurus* species shown at the Louisiana Purchase Exposition in Saint Louis, Missouri, 1904. The model, rumored to be constructed of macerated US currency, traveled to different expositions around the country before being displayed at the United States National Museum (now the National Museum of Natural History). *Smithsonian Institution Archives*

ancestors cannot be a source of humiliation; on the contrary, we should glory in our having advanced so far above them, and recognize the great truth that progress is the law that governs the development of mankind." Human history was presented as an inexorable climb from savage depravity to the pinnacle of late nineteenth-century Western civilization, in the process underscoring the inherent superiority of white Euro-Americans. It was a message that Goode and most white Americans assumed to be true.[22]

The equation of improvements in technology with human progress was nowhere clearer than in Smithsonian curator John Watkins's contribution to the 1895 Cotton States and International Exposition in Atlanta. His display was designed to illustrate "the more important stages of improvement through which the appliances now in use for the conveyance of men and goods from place to place have passed before the present high standards of mechanical efficiency were

attained." Surely the locomotive, steamship, telegraph, and telephone were the very definitions of progress.[23]

Otis Mason defined "progress" at the Atlanta fair by presenting "types" (racial groups) of humanity through costumed figures that ranged from a Zulu warrior clad in "an apron of cow tails" wielding an assegai spear to an American Indian in tribal regalia, a Tibetan in "a woolen robe and boots of native manufacture," and an Armenian in "an embroidered coat . . . trousers and robe of blue grosgrain silk shot with gold." While he could have topped the display with a papier-mâché figure of a banker in a Savile Row suit with a monogrammed briefcase, the point was clear enough.[24]

In his presentation for the World's Industrial and Cotton Centennial Exposition that opened in New Orleans in 1884, Mason insisted that "all anthropologists agree to work on the hypothesis of evolution . . . and to regard the delinquent and criminal classes as a return to a primitive type." If criminals represented a return to a "primitive type," what did that say about the character of the Zulu warrior and other groups representing "the lower orders" in an evolutionary sequence? To drive the point home, he exhibited the crania and brains "of the different species of apes and man, arranged in a progressive series," along with those of "defective and delinquent individuals."[25]

By the turn of the century, the practice of measuring other cultures against the yardstick of a white American ideal led anthropologists to plan presentations justifying everything from imperial aspirations to restrictive immigration policy. As archaeologist Bruce Trigger has remarked, nineteenth-century anthropologists were determined "to denigrate the native societies that European colonists were seeking to dominate or replace."[26]

The Buffalo Pan-American Exposition of 1901 provided the anthropologists with an opportunity to show their patriotic support for the government. At the conclusion of the four-month-long "splendid little war" with Spain in 1898, Americans found themselves responsible for territory stretching from Cuba and Puerto Rico in the Caribbean to Hawai'i, Guam, and the Philippines in the far reaches of the Pacific. Philippine guerilla fighters who had been battling Spanish authorities since 1897 turned their attention to their new colonial masters. American troops found themselves involved in a vicious conflict that continued into 1902. Some four thousand American soldiers and twenty thousand Philippine combatants lost their lives. The Filipino civilian death toll is estimated at two hundred thousand, with tens of thousands more falling victim to the waves of epidemic disease that followed. Mark Twain and Andrew Carnegie were among the voices protesting the conflict as an imperialist adventure to extend American power across the Pacific.

AN IMPERIAL INSTITUTION

Philippine Exposition at the Pan-American Exposition in Buffalo, New York, 1901. The Smithsonian display showcased aspects of Filipino culture, which was of interest after the United States annexed the Philippines in 1898. The display included weaponry used against US troops during the Philippine-American War. *Smithsonian Institution Archives*

President Theodore Roosevelt and his powerful congressional supporters offered a vigorous defense.[27]

William I. Buchanan, director general of the Pan-American Exposition, argued that the fair had an obligation to "justify . . . the acquisition of new territory" and demonstrate that "the results to be obtained promise to be for us all ample compensation for the sacrifice already made." William John McGee, Powell's deputy at the Bureau of American Ethnology (or BAE, as the Bureau of Ethnology was known after 1897) affirmed that "one of the gravest tasks of any progressive nation is that of caring for alien wards . . . bearing the White Man's burden . . . performing the Strong Man's duty."[28]

Congress refused to fund an original plan to establish native villages representing the new territories at the fair. The Smithsonian's Frederick True, heading a subcommittee on outlying possessions under the board planning federal involvement in the Pan-American Exposition, ruled that the exhibition would focus on

the Philippines, the most exotic and least familiar of the newly acquired "Outlying Possessions." He allocated $1,000 to fund a collecting party to gather both garments and equipment to outfit seven figures and examples of the material culture of the archipelago. William Holmes instructed the Bureau of American Ethnology collectors, headed by Colonel Frank Frederick Hilder, to concentrate on "the more primitive peoples such as the Negritos, the Moros and the Igoroti [sic]."[29]

The Smithsonian contribution to the Buffalo fair presented aspects of life in the Philippines. The natural history display included stuffed monkeys, iguanas, a boa constrictor, bats, tortoise shells, the head of a water buffalo, assorted deer antlers, and botanical specimens. The anthropologists offered models of Native houses and a large array of objects illustrating life in the islands, from furniture, dress, and housewares to agricultural implements, handicrafts, manufactures, modes of transportation, and amusements. In view of the ongoing conflict, a major portion of the display was devoted to the weaponry being directed at American troops, including traditional spears, bolos, knives, a six-foot blowgun with poisoned darts, and improvised body armor and cannon made with water pipes jacketed with wood and wrapped with wire.[30]

The Louisiana Purchase Exposition of 1904 rivaled the Chicago fair of a decade before in scope and scale. Richard Rathbun saw the Saint Louis extravaganza as an opportunity to move in new directions. The most striking Smithsonian contribution was an enormous aviary, a walk-through birdcage 50 feet tall, 80 feet wide, and 228 feet long. Designed by Frank Baker, director of the National Zoo, it was originally intended to be disassembled and reused at future fairs. When that proved too difficult a task, the city purchased it from the Smithsonian. It remains today a major attraction at the Saint Louis Zoo.[31]

The Fish Commission provided thirty-five fresh- and saltwater tanks filled with "the most interesting of . . . water inhabitants." In addition to the usual artfully stuffed and arranged animals, Frederic Lucas, like Hornaday a veteran of Ward's Natural Science and a great favorite of Goode's, worked with William Palmer to prepare a full-scale model of a blue whale composed of 125 molded sections.[32]

Saint Louis officials hired BAE veteran W J McGee (he insisted that he was W J, with no period after his initials) to manage the ethnological displays at the fair. He represents the extent to which pioneering anthropologists both reflected and reinforced the deep current of racism flowing through American life in the late nineteenth and early twentieth century. A native Iowan born in 1853, McGee spent only a few terms in local schools and took great pride in having educated himself in mathematics, science, law, and languages. He practiced blacksmithing for a

time, patented a corn cultivator, and conducted a personal geological survey of northeastern Iowa. John Powell met the young man at a meeting of the American Association for the Advancement of Science in 1878 and hired him onto the US Geological Survey in 1881, where he prospered.[33]

When western congressional opposition to Powell's views on the limited viability of agriculture in the arid region beyond the one hundredth meridian led to USGS budget cuts after 1892, McGee followed his mentor to the Bureau of Ethnology, where, despite little field experience, he functioned as Powell's second-in-command. He married Anita Newcomb, daughter of astronomer and Washington luminary Simon Newcomb, in whose household the growing McGee family would reside for fourteen years. McGee served on the editorial board of the *National Geographic* and was credited by some with the magazine's growing popularity. He edited the *American Anthropologist* and was a founding member of both the Geological Society of America and the American Anthropological Society.[34]

Resigning from the bureau in 1904 following a dispute, McGee accepted a post as director of the ethnographic department of the Louisiana Purchase Exposition in Saint Louis. The presentations developed under his oversight were intended, he explained, "to show our half of the world how the other half lives; yet not so much to gratify the untrained curiosity . . . as to satisfy the intelligent observer that there is a course of progress running from the lower to higher humanity, and that all the physical and cultural types of man mark stages in that course."[35]

Physical anthropology played an important role at the Saint Louis fair. William Holmes, now the head of both the anthropology division of the National Museum and the BAE, established a Smithsonian presence in the field in 1903 when he hired Aleš Hrdlička, a Czech-born physical anthropologist. Immigrating to the United States with his father in 1882 at the age of thirteen, Hrdlička worked his way through night school laboring in a cigar factory. Graduating at the top of his class from both the Eclectic Medical College of the City of New York (1892) and the New York Homeopathic Medical College and Hospital (1894), the young physician accepted a post with an asylum, the Pathological Institute of the New York State Hospitals (1895).[36]

At the Pathological Institute, he began to make anthropometric measurements of the inmates and to collect human skeletal and autopsy material. He became convinced that criminals, particularly murderers, could be identified by "various physical abnormalities." In 1897, testifying in the appeal of a woman sentenced to the electric chair for killing her husband, he explained that the defendant was not responsible for her actions as "all the measurements of her head are subnormal." She was found not guilty by reason of insanity. Physical

SMITHSON'S GAMBLE

anthropology, or, in this case, the updated and pseudoscientific practice of phrenology, had arrived.[37]

Hrdlička abandoned medicine in 1898, joining an archaeological expedition to the Southwest led by Frederic Ward Putnam, who brought him onto the staff of the American Museum of Natural History the next year. Impressed by his work, William Holmes retrieved the osteological and anatomical collections that Joseph Henry had banished to the Army Medical Museum in 1865, established a division of physical anthropology at the Smithsonian, and placed Hrdlička in charge. Together with Franz Boas of Columbia University, the new Smithsonian assistant curator convinced McGee to establish "laboratories" at the Saint Louis fair, where physical measurements were taken of twenty-five thousand volunteer visitors to determine, "so far as measurements may—the relative physical value of the different races of people."[38]

McGee received special accolades for his "living exhibits," which, as a contemporary noted, "presented to the public a greater variety of natives of many parts of the world than had ever been assembled before, and illustrated their natural environments, customs and products in a most instructive manner."[39]

The director and his staff arranged for representatives of many Native American tribes to live on the site in traditional dwellings. Japanese, Chinese, Chilean, and Irish villages dotted the fairgrounds. None of these human attractions drew more public attention, however, than the residents of the enormous "Philippine Reservation" dominating the west-central side of the fairgrounds.

Governor General William Howard Taft approved a $2 million budget to support a major Philippine delegation to the Saint Louis exposition, hoping to convince Americans of the humanitarian need to lead a backward and benighted people to democracy and a better life. The forty-seven-acre site of the "Philippine Exposition" included four tribal villages housing 1,100 members of four cultural groups, from "the high type beautiful maiden" of the Visayan people to the "Igorot dog-eaters and head hunters, the cannibal Moro, and the aboriginal Negrito."[40]

"The fame of the Philippine Exposition has captured the World's Fair City," the *New York Times* reported. Exposition guards said the most common question from visitors was, "Which way to the Philippines?" There were concerts by a uniformed band and demonstrations of close order drill by members of the Philippine Constabulary, but the public attention focused on the fenced enclosure where the scantily clad, poorly housed Igorot and Negrito people occupied a decidedly uncomfortable human zoo.[41]

One contingent of the human family on display ranked even lower on anthropologists' evolutionary ladder. The Reverend Samuel P. Verner of the Stillman

266

Institute (now Stillman College) brought six Congolese natives to Saint Louis. Billed as Pygmies, their "village" was situated in a "hollow" so fairgoers could literally look down on them from an elevated walkway. "The Batwa Pygmies and other Congolese natives," McGee explained, "were selected especially to illustrate an early stage of human development." The Africans, he continued, "approach more nearly to the ancestral type than any other known people." From facial structure to brain size, he concluded, they were allied "with Simians more closely than with advanced humans."[42]

Even in death the "human exhibits" featured at the Louisiana Purchase Exposition served the cause of "science." Aleš Hrdlička arrived from Washington on July 14, in time to perform autopsies on two "Igorrotes" who had died during the fair. "I secured the brains," he informed Curator of Ethnology Otis Mason, adding that "with the aid of Doctor Horowitz of the Filipino hospital," he had also "secured the brain of a female Moro." The physicians in charge promised to present him with the brains of "any of the natives who may die in the future." Finally, Hrdlička persuaded Assistant Secretary Richard Rathbun to request that the Saint Louis health commissioner offer the Institution the brains of other "individuals belonging to different races" who were to be buried at city expense.[43]

The Smithsonian curator generously offered to share the anatomical largesse with both the American Museum of Natural History and Columbia University. The response of Columbia officials is not known, but leaders of the New York museum chose not to participate in the macabre distribution.[44]

Hrdlička added the three brains to the Smithsonian's growing collection. He remained at the Smithsonian until his retirement in 1942. Rising to international preeminence in physical anthropology, he retained his racist views and ruthless drive to collect bits and pieces of human anatomy, with or without the consent of the individual humans involved, and to preach the value of eugenics at fairs and expositions well into the twentieth century. At the time of his death, Swiss primatologist Adolph Schultz lauded Hrdlička as having "a permanent place in the history of physical anthropology, a science to which he devoted his life with never-failing enthusiasm and energy with enduring results." Seventy years later, his shameful legacy, stored away in the bowels of the Smithsonian's Museum Support Center, would become the flashpoint for public outrage regarding the collection and preservation of human remains acquired under questionable circumstances.[45]

W J McGee's racial attitudes were nothing extraordinary. He represented a nineteenth-century anthropological tradition inspired by flawed evolutionary thinking and an assumption of white supremacy that devalued darker skins and

SMITHSON'S GAMBLE

diverse traditions, providing a "scientific" validation for racial segregation, the limitation of suffrage, restricted immigration policies, and colonial expansion. John Powell operated within that older anthropological tradition as well and had the highest regard for McGee. His Bureau of American Ethnology, however, was nurturing a new generation of researchers who recognized the fundamental importance of fieldwork and offered the first glimmers of appreciation for the value of cultural traditions very different from their own. If the old approach had flourished at the Smithsonian, a new and more enlightened view was visible on the horizon.

CHAPTER 15

THE BUREAU

SECRETARY OF THE INTERIOR CARL SCHURZ had John Powell whispering in his ear as he shaped the provisions of the Sundry Civil Act for 1879, legislation that would consolidate the four competing western surveys into a single US Geological Survey. Schurz also obliged Powell by suggesting to Speaker of the House S. J. Randall that the ethnological research assigned to the Geographical and Geological Survey of the Rocky Mountain Region should be reassigned to the Smithsonian Institution. The bill passed by Congress on March 3, 1879, included $20,000 for "completing and preparing for publication the contributions to North American Ethnology, under the Smithsonian Institution." In addition, the ethnographic materials gathered by Powell's survey were to go to the Institution.[1]

Powell chose to regard congressional approval for the continued publication of the Contributions to Knowledge series he had launched in 1877 as the charter for the establishment of a Bureau of Ethnology. Further testing the intention of the legislators, he issued nine additional volumes of *Contributions to North American Ethnology* by 1893, all published by the Department of the Interior, while he spent the $20,000 appropriation to fund the work of the new bureau and publish its annual reports.[2]

Powell planned an organization that would undertake a comprehensive study of Native American cultures. Language, he believed, was key to such an effort. "Customs, laws, governments, institutions, mythologies, religions, and even arts cannot be properly understood without a fundamental knowledge of the languages which express the ideas and thoughts embodied therein." Compiling dictionaries and grammars and collecting texts were critically important activities.[3]

Powell situated his new professional home in the Smithsonian, where he hoped to escape the bureaucratic and political pressures of the Department of the Interior. He discovered, however, that Spencer Baird would not allow him a free hand in the operation of the bureau. Baird countered Powell's emphasis on

language studies by underscoring the need for ethnographic collections to fill the cases of the National Museum and the many expositions in which the Institution was obliged to participate. As a result, their relationship began with a compromise.

The new bureau was not yet five months old when Powell dispatched the first small Bureau of Ethnology–Smithsonian expedition to the pueblos of New Mexico. Baird, bowing to the language of congressional legislation, noted in the Smithsonian's 1879 annual report that the expedition would gather material both to enrich the holdings of the National Museum and "for the purpose of publication" in Powell's Contributions series.[4]

Powell enlisted Colonel James Stevenson, who had earned a stellar reputation as Ferdinand Hayden's second-in-command, to head the party. A native of Maysville, Kentucky, born on December 24, 1840, Stevenson ran away from home at the age of thirteen to join a group of Hudson's Bay Company traders headed up the Missouri. Hayden, a passenger on the same packet, noted Stevenson's taste for natural history and recruited him. Over the next quarter century, Stevenson would serve as executive officer for both Hayden and Powell, with a four-year break for active service in the Civil War, during which he rose from the rank of private to that of a colonel in the Army of the Potomac. Given his experience in the field, Powell chose him to lead the first Bureau of Ethnology expeditions.[5]

John K. Hillers, a member of Powell's 1871–72 Colorado River journey, would serve as expedition photographer. Stevenson also included his twenty-nine-year-old wife of seven years, Matilda Coxe Stevenson, as his assistant without pay. Although Tilly, as she preferred, had received a genteel education regarded as appropriate for a woman of her time, she also pursued an interest in science at the Army Medical Museum, a block west of the National Museum. Powell appointed her to the bureau staff as an assistant ethnographer following her husband's death in 1888. She died in 1915.

Neil Judd, a longtime curator of anthropology at the Smithsonian, described Tilly Stevenson as "a strong-willed and dominating individual. . . . What she wanted she took—even a chair someone else might be using." Nor did she hesitate to bring congressional influence to bear on issues of concern to her, and she consistently tested Powell's patience.[6] A colleague of Stevenson, William Holmes, recognized the necessity for self-confidence and an insistence on fair treatment in a woman forging a scientific career in a male-dominated world. He characterized her as "able, self-reliant, and fearless, generous, helpful and self-sacrificing." Characteristics that male colleagues regarded as thoughtless and aggressive, he

suggested, were to be expected given the social and professional barriers she faced because of her gender.[7]

Tilly Stevenson once described the fourth member of the party, Frank Cushing, as "the biggest fool and charlatan I ever knew." W J McGee, on the other hand, regarded him as "a man of genius," while Powell praised his "genius for the interpretation of facts" and said that he "loved him as a father loves his son." Claude Lévi-Strauss identified Cushing as "one of the great forerunners of social structural studies." Almost a century and a quarter following his death, Frank Cushing remains the best-known and most controversial American field ethnologist of the pioneering generation. Like Franz Boas, Margaret Mead, and Ruth Benedict who followed, his charismatic personality and literary style established him in the public mind as the personification of an anthropologist.[8]

The last in a line of "Baird's Boys" stretching back almost four decades, Cushing always regarded himself as a Smithsonian man. The other members of the 1879 expedition reported to John Powell; only Cushing wrote to Baird as well as Powell. Born in Pennsylvania in 1857, Cushing grew up in Barre Center and Medina, on the Erie Canal in far western New York. He described himself as a frail child but adventurous. He loved reading and was given to long solitary journeys into the countryside. Many years later, "laughing gaily at the recollection," he regaled friends with an account of jumping from a barn loft with lightweight wings that dropped him to the ground "with terrific force." His desire to fly was broken, he explained, but that "did not deter his irate father from breaking it again." Fascinated by Native American customs and artifacts, young Cushing crafted Indian costumes and reproduced the projectile points and stone tools that he collected during his wanderings across the countryside.[9]

Cushing met George Kennan in Medina in 1871. The twenty-six-year-old Kennan had just returned from service in Siberia as a member of the Russian-American Telegraph Expedition and was basking in the success of his book, *Tent Life in Siberia*. He provided Cushing access to a library that included the latest European books on archaeology and ethnology. The budding ethnologist also sought out Lewis Morgan in nearby Aurora, whose *Systems of Consanguinity and Affinity of the Human Family* (1871), published by the Smithsonian, influenced figures as diverse as Darwin, Marx, and Freud, and whose *Ancient Society* (1877) shaped American anthropological theory in the last quarter of the nineteenth century.[10]

Impressed by Cushing's ability to locate, identify, and reproduce Indian artifacts, Professor C. F. Hartt of Cornell University enrolled him as a student. His university career was cut short in 1874, however, when Spencer Baird published the seventeen-year-old's first paper, "Antiquities of Orleans County, New York," in

the annual report and subsequently hired him. Cushing began his career at the Smithsonian by helping prepare and install the ethnological display at the 1876 Centennial Exposition, then returned to Washington to assist in dealing with the collections arriving from Philadelphia.[11]

Cushing was marking time, anxious to move beyond his role as an assistant and launch a professional career. He had nursed a fascination with Pueblo Indian cultures since discovering a color sketch of a kachina dancer while preparing the Philadelphia exposition. The opportunity to pursue that interest came, as he remembered, on "a hot summer day in 1879" when the secretary called him to his office and offered him the opportunity to join "a collecting party" led by James Stevenson leaving for Pueblo country in four days. The expedition, Baird suggested, might be in the field for three months.[12]

The Stevensons and Cushing left Washington by train on August 5. Meeting Jack Hillers in Saint Louis, they took the Atchison, Topeka and Santa Fe Railway to the end of the line, Las Vegas, New Mexico, where they spent several weeks provisioning, acquiring mules, wagons, and the trade goods they would need to obtain artifacts from the Indians. The trip along the old Spanish trail to the US Army post at Fort Wingate took another three weeks, with a stop in Santa Fe.[13]

The four travelers set out for the Zuni Pueblo, thirty miles to the south, on September 16, having assured Powell that he could "feel easy about our success." Riding ahead of the others, Cushing first glimpsed Zuni in the distance at sunset on September 19, 1879. "Imagine," he wrote, "the numberless long, box-shaped, adobe ranches, connected with one another in extended rows and squares, with others, less and less numerous, piled on them . . . in two, three, even six stories, each receding from the one below it like the steps of a broken stairflight." The multistory structure "bristled with ladder poles . . . [that] leaned at all angles against the roofs. The chimneys . . . were made of bottomless earthen pots, set one upon the other and cemented together with mud, so that they stood up, like many-lobed oriental spires, from every rooftop."[14]

In the seventeenth century, the pueblo had consisted of six considerable villages. Now there was only one, with some 1,600 residents, as reported in the 1880 census, surrounded by three scattered farms occupied during the growing season. Living along Zuni Creek, a small tributary of the Colorado near the New Mexico–Arizona border, they were an agricultural people who tended cornfields and vegetable gardens, raised livestock, and supplemented their diet by hunting. The Zuni were a matrilineal theocracy, with all males belonging to a kachina society, broken into one of six groups, each with an underground kiva, or ceremonial space, and responsibility for designated religious duties. A council of six rain priests presided

THE BUREAU

over the community and appointed a governor who represented the pueblo to government authorities.[15]

Powell had good reasons for selecting Zuni as the destination of the first Bureau of Ethnology expedition. Since the arrival of Francisco Vázquez de Coronado's expedition in 1540, the Zuni Pueblo had a longer continuing relationship with Europeans than any other Indigenous North American community. Through it all, unlike other less isolated Pueblo Indians along the Rio Grande, they had preserved the core of their traditional culture. The Zuni, who call themselves A:shiwi, had weathered Spanish, Mexican, and American occupation. While there were Spanish speakers in the village, Zuni, a unique language unrelated to any other tongue, was universally spoken.[16] The residents had resisted Catholic attempts to lure them away from their centuries-old religious traditions; the Franciscans gave up their attempt in 1821, allowing the mission church to fall into ruin. Reverend Taylor F. Ealy arrived a few months before the Smithsonian party to establish a Presbyterian mission.[17]

Initially, the bureau party lived in tents, the Stevensons in one and Cushing and Hillers in another, with their supplies and trade goods in two more. The Stevensons immediately set up shop, swapping their trade goods for artifacts. "All . . . of the old pieces of pottery are being bought up, to be sent to the Smithsonian," Reverend Ealy reported on September 24, adding that Hillers was capturing "every nook and cranny of the Pueblo" on his glass photographic plates.[18]

Cushing, Stevenson reported, was soon hard at work taking his first steps toward learning the language and taking dimensions for a model of the pueblo for the National Museum. There were problems, however. "I regret that Col. Stevenson and I should have started out with such entirely different impressions regarding my position on this expedition," Cushing wrote to Baird in a note he did not send. Stevenson "has seen fit to regard me as a boy," he complained, although admitting that he was "an able and most excellent *business* manager."[19]

Cushing did not consult Stevenson when, after their first week in camp, he abruptly moved into a room that Stevenson was renting to store collections in the home of Palowahtiwa, also known as Pedro Pino, the former governor and chief civic official of the pueblo. It was the first step in Cushing's effort to insert himself into the pueblo's social, cultural, and religious life. While earlier ethnologists, including Powell, had lived with tribal groups for short periods, Cushing was going a step further. Dr. Washington Matthews, post surgeon at Fort Wingate and a friend of the budding ethnologist, explained the move: "So Cushing, to make a success of his investigations, cannot stand contemplating his subjects from the

273

Frank Hamilton Cushing (1857–1900), in black, participating in a ceremony of the bow priesthood at the Zuni Pueblo in New Mexico, c. 1881. Cushing was a Smithsonian anthropologist and ethnologist who studied Zuni culture through participant observation, an anthropological research method he pioneered. *Smithsonian Institution Archives*

outside, like a spectator at a play. He must go on to the stage, and take his part in the performance."[20]

Frank Cushing was inventing something new: the participant observer approach to research in cultural anthropology. He would live like a Zuni, sleeping, eating, and working as they did, all the while recording what he learned through his experience as an insider. "From most of my party," he remarked, "I received little sympathy in my self-imposed undertaking." Tilly Stevenson certainly did not approve. She was, he explained to Baird, "a presence in our party, who, from the beginning, has been incapable of recognizing in my self-inflicted degradation to the daily life of savages any motive other than . . . low character."[21]

It was a dangerous approach. Success required him to constantly push boundaries, presenting himself with his sketchbook and notepad at ceremonies from which outsiders were barred. When threatened, the occasional flourish of his knife and the appreciation of the Zuni for the fact that he represented government

THE BUREAU

authority saw him through. "Mr. F. H. Cushing has been allowed to witness a number of their religious ceremonies," Reverend Ealy, who most certainly did not approve, noted. "He eats with them, sleeps in their houses, wears their dress and talks the language to young and old. . . . He does not lose an opportunity to talk Zuni. In six months, he might be able to converse upon any subject in the Zuni dialect." Ealy, sure Cushing was encouraging the Pueblo people to resist Christianity in favor of their traditional beliefs, preferred Billy the Kid, whom he knew in Roswell, New Mexico, to the anthropologist.[22]

On October 8, the Stevensons and Hillers left the Zuni Pueblo to visit the abandoned cliff dwellings at Canyon de Chelly and the Hopi reservation in Arizona. Cushing had persuaded the colonel to allow him to remain at the pueblo and to leave his share of the supplies at the mission. When he requested the provisions, however, Reverend Ealy informed him that he had nothing for him. Cushing's survival would depend on Zuni charity. "Little brother," Pino remarked, "you may be a Washington man, but it seems to me you are very poor."[23]

His willingness to share their lives and resources, and his reliance on Native hospitality for his very survival, eased Cushing's transition into Zuni society. "The contrast between the present results of my labors and those . . . secured before the departure of our party," he reported to Baird, "is pronounced." With growing confidence in his ability to live and work in the pueblo, he drafted a letter to Stevenson on October 15, urging that he be allowed to remain at the pueblo when the others returned to Washington. He wrote to Baird on October 29, noting that "if such is not an unfavorable plan to you and Major Powell," he would like to remain for a time on his own. "I am among the last who will ever witness all of this in its purity," he explained, "as the . . . advent of the Railroad next fall will, with its foreign influence, introduce all sorts of innovations." When the officers and their ladies were visiting from Fort Wingate, for example, the Zuni altered a ceremony, "not only cutting it short, but also casting out all of the obscenities—or rather indecent observances—on account of their presence." The entreaties succeeded. "I think very well of the idea of leaving Cushing in Pueblo country to complete his investigations," Baird wrote to Stevenson, who had returned to the Zuni Pueblo in early November.[24]

By November 10, the Stevensons had commandeered Reverend Ealy's "second parlor," displacing the Zuni schoolchildren to make space for packing the collections bound for Washington. That evening, as Cushing told it, Stevenson and his wife stripped the ruins of the Franciscan church "in the dead of night," making off with large wooden carvings of "Our Lady of Guadalupe of the Sacred Heart," two angels, and the centerpiece of the altar. Cushing claimed that the Zuni were

275

SMITHSON'S GAMBLE

outraged and pleaded with the "Wasintona" to return the sacred objects—to no avail. Two years later, when he heard the story from his friend Cushing, Adolph F. Bandelier echoed those sentiments, noting that the church had been "plundered by the Washington party in the most shameless manner."[25] The Stevensons and Ealy, however, reported things differently. Tilly Stevenson said that a Zuni council agreed that "it would be well to have these objects go with the other Zuni material to the 'great house' in Washington where they would be preserved." Taylor Ealy noted in his diary entry for November 10 that "we got the consent of the Casique to give up the images."[26]

Cushing saw the Stevensons off on November 20. They had dispatched their early collections to the Smithsonian in mid-October. "I brought from Zuni yesterday two large wagon loads—loaded up to the bows—comprising the most curious & choice specimens ever gathered from this country," Stevenson wrote to Powell, "& I send the wagons back early in the morning for another large load that I had packed up but could not bring away with me." He hoped to fill two railroad cars "before I get through." He wrote to Major Powell again from Chicago on his way home on December 17, announcing that the entire collection gathered in less than four months weighed 10,512 pounds. The illustrated catalog that Stevenson published the following year listed a total of 42,023 objects.[27]

Cushing's first stay with the Zuni lasted two and a half years. Pedro Pino provided him with Zuni clothes and urged him to give up his hammock in favor of a sleeping blanket. Cushing filled his notebooks with sketches and descriptions of Zuni costumes and ceremonies, visited turquoise mines and archaeological sites, and went on an extended journey through the Rio Grande pueblos. His study of Zuni creation myths, coupled with his knowledge of the southwestern landscape, convinced him that he could retrace their historical journey back through the centuries. It was not an easy life. His letters to Baird were filled with complaints about Zuni food, cold winter temperatures, and his own health. "I have been for more than two months midway between the bed and my feet," he wrote to Baird in the spring of 1880. While complaining of "general debility," he also reported having made "no fewer than six expeditions with and at the urgent demands of the Indians."[28]

In the summer of 1881, Secretary Baird asked Tichkematse (also known as Squint Eyes) to go to the Zuni Pueblo to accompany Cushing on his most ambitious journey on horseback, west through the Hopi reservation and on to visit the Havasupai in the Grand Canyon. The first Native American employee of the Smithsonian, Tichkematse was a Cheyenne captured by the army and held as a prisoner of war at Fort Marion, Florida, from 1875 to 1878. Upon release, he

attended the Hampton Institute before coming to the Smithsonian in 1879, where Secretary Baird arranged for his training in the preparation of bird and animal skins. He had also worked with Cushing to record Indian sign language. He returned to the Cheyenne reservation in Oklahoma in 1880, but retained his connection to the Institution, responding to Baird's request that he assist Cushing on the trip through Arizona.[29]

Cushing was making a place for himself in the community. He shared living space with Pedro Pino, his wife, children, and relatives. He was familiar with the personal relationships of the family and their neighbors. He shared domestic tasks and mastered a range of craft skills. Gradually, he was able not only to study the rituals and ceremonies of the pueblo but also to participate in them. In the fall of 1881, he was inducted as a "Junior Priest of the Bow," which, he explained to Baird, was something akin to "the Masonry of North American Indians."[30]

Baird was particularly pleased with the collections arriving from the Zuni Pueblo. In the spring of 1881, Cushing reported that he had perhaps three thousand objects on hand, but struggled to obtain packing materials and the means of transporting collections to Fort Wingate for shipment to Washington. Like the Stevensons and other ethnologists of the period, he did not hesitate to violate the trust of his hosts by shipping their most sacred ceremonial objects off to Washington without their knowledge or permission. While confident that the National Museum could preserve Zuni material culture more successfully than the Zuni themselves, he was also determined to please Baird and Powell.[31]

Once, apparently in the winter of 1880–81, the Zuni caught Cushing in possession of sacred material obtained without permission. Accused of sorcery, a capital offense, he was required to spread his "dear bought relics" out before a council. His charm and his acknowledged role as a representative of the government allowed him not only to escape punishment but also receive a tutorial on the meaning of his loot.[32]

He discovered his most significant finds in remote shrines in which the Zuni stored the Ahayu:da, sacred representations of twin gods protecting the pueblo. A pair of new wooden effigies were prepared each year, with the previous year's models being retired to hidden open-air shrines where generations of the icons were allowed to decay naturally. Cushing took a pair of Ahayu:da, which he retained in his private collection. In addition, against Zuni tradition, he manufactured at least two replicas, one of which he sold to a Berlin museum and the other of which he presented to E. B. Tylor, an English colleague, who gave it to Oxford's Pitt Rivers Museum. Following his death, Cushing's widow sold the remaining original to the National Museum. Colonel Stevenson had also illicitly acquired an

Ahayu:da for his private collection, which Tilly Stevenson donated to the Smithsonian following his death. After prolonged negotiations, the Smithsonian returned both Ahayu:da to the Zuni in 1987.[33]

CUSHING MET SYLVESTER BAXTER, a reporter with the *Boston Herald*, at Fort Wingate in late May 1881. "[We] saw a striking figure walking across the parade ground," Baxter recalled, "a slender young man in a picturesque costume: . . . knee-breeches, stockings, belt, etc. . . . a purely aboriginal dress, such as had been worn on that ground for ages."[34] Willard Leroy Metcalf, a Boston magazine artist traveling with Baxter, captured what was to become an iconic image of Frank Cushing in his Zuni outfit, complete with shoulder-length hair held in place with a headband, a sash over his shoulder tied at the waist, and hands on his hips.[35]

Baxter would introduce Cushing, "a young gentleman whose name will soon rank with those of famous scientists," to the readers of the *Boston Herald* in an article published on June 16, 1881. Cushing was also aware that Baxter was working on a longer piece focusing on his work at the Zuni Pueblo, illustrated by Metcalf, for *Harper's New Monthly Magazine.* The young ethnologist recognized that the ground was being prepared for a noteworthy return east that might enable him to publicize what he had achieved to date and gather support for continued research.[36]

"I have decided to ask your permission for my return in January with four or five Indians," Cushing wrote to Baird in October 1881, noting that he was arranging free passage for the party at least as far as Chicago, with a promise of additional aid from "enthusiastic friends." As a result of Baxter's publicity, "the ladies of Boston" had extended a "cordial invitation" to visit the city. The Zuni were anxious to make the trip, "begging that I can bring it to pass." Cushing regarded reciprocity as an important feature of his research process. The Zuni had shared their world with him; he wanted to reciprocate.[37]

On February 8, 1882, with both Baird's and Powell's approval, James Pilling, chief clerk of the bureau, approved Cushing's request and explained the transportation and funding procedures for the trip. The party included Pedro Pino, Cushing's oldest Zuni friend; his son Patricio (Palowahtiwa); two fellow members of the bow priesthood; and Nanahe, a Hopi. They arrived at the B&O Railroad depot a block north of the Capitol on the evening of March 3 and lodged at the Tremont House.[38]

Cushing had discarded his Zuni outfit in favor of a business suit and, to the consternation of the Indians, had gotten a haircut. President Chester Arthur greeted the group at the White House. They toured the National Museum and met Baird, Powell, Goode, and the Smithsonian staff. Cushing gave a well-attended

THE BUREAU

lecture on Zuni history and culture at the museum on March 11. James and Tilly Stevenson, who had returned to the Zuni Pueblo in 1880 and 1881, arranged a trip for the group to Mount Vernon. Having exhausted himself climbing up the steps of the still-incomplete Washington monument, ninety-year-old Pedro Pino recuperated in Washington with the Stevensons while the others proceeded to Boston, arriving on March 21.[39]

The visitors were welcomed with a reception at the Old South Church. The Zuni lunched with Julia Ward Howe, met with local artists, visited Wellesley College, toured the Peabody Museum of American Archaeology and Ethnology, and visited Deer Island, where they filled a sacred vessel with ocean water to be carried back to the pueblo. Cushing, once again in Zuni garb, introduced the group to a packed house at Harvard's Hemenway Gymnasium, gave a talk, then joined in "a ceremonial dance." He was, a friend remarked, "epidemic in the culture-circles of New England, that year of 1882. . . . His personal magnetism, his witchcraft of speech, his ardor, . . . the undoubted romance of his life of research . . . were contagious."[40]

"Never was a tour more skillfully managed," one commentator noted. "Perhaps never was another quite so curiously mixed between genuine scholarship and the arts of the showman." In short, Cushing had emerged as a small-scale intellectual P. T. Barnum, sharing his research through the medium of a public performance. His theatricality occasionally proved too much, even for his friends. When he appeared in full regalia to lecture at a meeting of the National Academy of Sciences, Powell told him to "Go home and get dressed." There was no doubt that the Boston tour had been a triumph, however. Edward Everett Hale, Frederic Putnam, Francis Parkman, and other distinguished Bostonians congratulated Baird on the Zuni visit and the quality of Cushing's research. The young ethnologist had put the Zuni, and himself, on the intellectual map.[41]

The group returned to Washington via New York. Following a final round of public events, most of the Zuni boarded a train for New Mexico on April 22, accompanied by Cushing's brother Enos, a physician. Palowahtiwa, Naiiutchi (the senior bow priest), and the Hopi Nanahe remained at the museum for the summer to assist in identifying and cataloging collections.[42]

The summer of 1882 saw a flood of popular articles by and about Cushing. His lecture to the National Academy of Sciences on April 23 was published in the June issue of *Popular Science Monthly*. "The Father of the Pueblos," Sylvester Baxter's long, illustrated account of his 1881 encounter with Cushing and the Zuni, appeared in the June issue of *Harper's New Monthly Magazine*. Baxter's article on the Zuni's eastern adventure, "An Aboriginal Pilgrimage," was published in the May issue of

279

Century magazine. Cushing's "My Adventures in Zuni" appeared in three install-ments of the same magazine in 1882–83. The *Atlantic Monthly* published "The Nation of the Willows," his account of the long journey to the Havasupai, in the September and October 1882 issues.[43] Cushing also finished work on "Zuni Fetiches" that summer, his first contribution to the bureau's annual report. That paper, along with over thirty other scholarly contributions, would establish his professional reputation. Whether writing for colleagues or general readers, he was a gifted sto-ryteller, revealing hidden aspects of another culture in which he had, to an extent, participated.[44]

The critic Edmund Wilson regarded him as "an admirable writer—almost as much a literary man as he was a technical expert. If historians of American litera-ture had seriously done their work . . . [Cushing] would be recognized not merely as a . . . [leader] in the anthropological field but as an artist who had something in common with Doughty of Arabia." His own journey of understanding was often woven into his account of Zuni culture. Frank Cushing wrote anthropology as autobiography.[45]

The articles in popular journals, complete with Willard Metcalf's standing portrait of Cushing in Zuni garb, established his public persona as the "white Indian." It was a notion that would be reinforced over the next decade in photo-graphs, additional magazine illustrations, and Thomas Eakins's iconic 1895 por-trait of Cushing. It was a misleading image. His research strategy required him to live like a Zuni. He was always careful, however, to maintain a critical distance, refusing, for example, to marry a Zuni. Native recognition that he represented a distant and powerful authority was critical not only to the success of his project but also to his very survival.

He would modify his approach when he returned to the pueblo in August 1882. Cushing married Emily Tennison Magill, a banker's daughter, in July. Accompa-nied by Patricio, Naiiutchi, and an African American cook, the newlyweds jour-neyed to New Mexico by way of upstate New York, where they visited the groom's parents and introduced their pueblo friends to the residents of the nearby Seneca reservation. They arrived at the Zuni Pueblo on September 3, where they shared a household with Frank's brother Enos. Emily's sister Margaret arrived several weeks later, escorted by Metcalf, who would stay until the following June. Sylvester Baxter and William E. Curtis, a Chicago newsman, rounded out what Baxter described as "a considerable little American community."[46]

Cushing's initial time with the Zuni was devoted to burrowing into the com-munity and feeding Baird's appetite for more and better collections. His final year

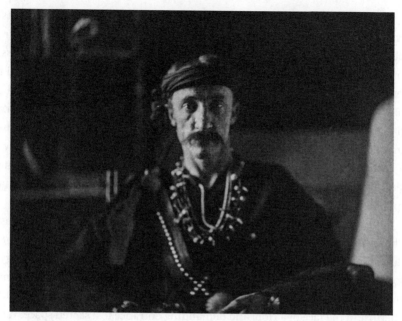

Frank Cushing, photographed by artist Thomas Eakins (1844–1916), c. 1895. Eakins, a well-known painter, photographer, and sculptor, took several photographs of Cushing in his Zuni attire as a study for a standing portrait. *Hirshhorn Museum and Sculpture Garden*

and a half would be dominated by health problems and conflict with an outside world encroaching on the pueblo. An Indian agent accused him of shooting Navajo horses that had strayed onto Zuni land, insisting to the commissioner of Indian affairs that the Justice Department investigate the incident.[47]

Then, in December 1882, Sheldon Jackson, superintendent of Indian schools of the Presbyterian Church, complained to Baird that Cushing had "persistently and unnecessarily thrown his influence against the school and . . . pandered to the lowest passions of the [Zuni] people." Cushing, who had never gotten along with the missionaries, explained to Baird that Jackson was simply throwing "mud and slime" at him.[48]

The summer before, while Cushing was in the east, missionary S. A. Bentley had shared tales of the young ethnologist's "licentious" efforts to undermine the good work of the missionaries with C. H. Howard, a US Indian inspector dispatched by the secretary of the interior to investigate the earlier complaints. Bentley went a step beyond, pointing to an unlikely rumor that Cushing had fathered two children with Zuni women.[49]

The most damaging incident resulted from Cushing's successful efforts to prevent a group of army officers, including Senator John Logan's son-in-law, from establishing a ranch on a disputed piece of Zuni land. Accused by the press of favoring a land grab, Logan charged that Cushing was a fraud and declared his recent publications "groundless fiction . . . a deception and an imposition on the public." Then, as now, the Institution was sensitive to congressional opinion. As Neil Judd noted, "Logan blamed Cushing . . . and bore down heavily on Smithsonian officials. James Pilling, Powell's chief clerk, wrote to Cushing on January 19, 1883, ordering him to settle his affairs in New Mexico and return to Washington, where "the valuable ethnologic material collected by you" could be "put in shape for publication at as early a date as practicable."[50]

While Cushing returned to Washington under a cloud, Tilly Stevenson was in the news, having brought her own Zuni informant to Washington in January 1886 for a six-month stay in her home. Stevenson had joined the Bureau of Ethnology in 1880. As aggressive as Cushing in pursuit of a tempting collection item or admission to a ceremony closed to outsiders, Stevenson was captured by an artist shaking her fist in the face of a Hopi and demanding entrance to a sacred space. While her gender worked against her in the male-dominated bureau, it was an advantage in providing access to the lives of pueblo women and children. She published her 607-page masterwork, *The Zuni Indians*, in the bureau's annual report for 1901–2 and remained an important voice in bureau affairs.[51]

The informant, We'wha, was a Zuni *lhamana*, a term used to describe a biological male who sometimes or always dresses as a woman and performs duties typically ascribed to women. Stevenson had met her on the 1879 research trip and continued to work with her on subsequent visits to the pueblo. By the spring of 1886, We'wha was attracting both attention and curiosity. While a reporter for the *Evening Star* introduced her to readers as "a woman" and a "Zuni maiden," he noted that some "might be disappointed in her "rather masculine" figure, "ample waist," and hands "by no means small." Her presence, however, underscored Stevenson's professional reputation, both with Powell and the public.[52]

Barred from membership in the male-dominated Anthropological Society of Washington, Stevenson organized the Women's Anthropological Society of America (WASA) during We'wha's visit. Her two local female colleagues, Erminnie Smith and Alice Cunningham Fletcher, were both early members and presented papers at meetings. Smith, an authority on the Iroquois, joined the bureau in 1880. Fletcher, an ethnologist trained by Frederic Putnam, collaborated with the bureau and shared a Washington residence with Francis La Flesche, a Native American lawyer and ethnologist who joined the bureau in 1890. Stevenson also recruited

Matilda Coxe Stevenson (1859–1915). Stevenson was the first woman anthropologist in the United States. She worked for the Bureau of Ethnology under John Wesley Powell and pioneered ethnological field research among the Pueblo peoples of the Southwest. *National Anthropological Archives*

local women with an interest in science, from Rose Cleveland, the president's sister and White House hostess, to several congressional wives, women physicians, and teachers. Astronomer Maria Mitchell and archaeologist Sophia Schliemann were among the corresponding members living outside Washington. While WASA met jointly with the men on occasion, they were not invited to merge with them until November 25, 1908.[53]

Cushing struggled with ill-health during his two years at the Smithsonian following his forced return from the Zuni Pueblo in 1884. Dressed in only a loincloth and with thinning hair, he appears an almost skeletal figure in photographs taken at that time of him demonstrating various Native techniques. He took a leave of absence from the bureau and returned to New Mexico and Arizona in December 1886 as head of the Hemenway Southwestern Archaeological Expedition, funded by Mary Tileston Hemenway, a Boston philanthropist. He was accompanied by his wife and her sister, serving as the expedition artist, who would marry Frederick Webb Hodge, field secretary of the expedition.[54]

The Hemenway expedition established an early benchmark in southwestern archaeology. Given Cushing's interest in ethnology as a key to understanding the

past, as well as his mastery of material culture, he might have emerged as an early leader in the study of Pueblo prehistory. His ill-health, failure to develop archaeological procedures, and limitations as a leader, however, led to his replacement by Jesse Walter Fewkes in 1889. Hodge reported that Cushing had failed to keep good notes, absented himself from the dig sites, and "fiddled away his time making flags for the tents and other useless trifles." His most serious charge was that Cushing had used his knowledge of Native materials and techniques to "improve" one of the objects collected. For Cushing, it was back to Washington, where he would remain, while Tilly Stevenson continued her research in the Zuni Pueblo.[55]

Stevenson's feud with Cushing would continue even beyond his death in 1900. The contributions of these two contentious ethnologists remain, however, as the best record of a culture on the threshold of change. Generations of anthropologists would return to the Zuni Pueblo, building on their foundation. In the twentieth century, it arguably became the most studied small community in the history of anthropology. As historian Eliza McFeely notes, anthropologist Ruth Benedict imagined Zuni as a "communal, emotionally moderate alternative to the individualism and emotional excess of Western civilization." Novelist Aldous Huxley presented the pueblo as a counter to the World State of the *Brave New World*, while science fiction writer Robert Heinlein adapted Benedict's Apollonian Zuni as the unspoiled Martian birthplace of the hero of his cult classic, *Stranger in a Strange Land*. Our continuing fascination with the alternative world of Zuni began with Cushing's and Stevenson's accounts of the Zuni.[56]

WHILE POWELL HAD WORKED to ensure that the Bureau of Ethnology would be housed under the protective umbrella of the Smithsonian Institution, the relationship was never an easy one. From the outset, Secretary Baird refused to give Powell a free hand in the operation of the bureau. He insisted on a precise accounting of funds and periodically "borrowed" bureau staffers to support National Museum projects. Powell bridled when Baird insisted on his covering the salaries of National Museum anthropologists and accepting Frank Cushing's transfer to the bureau payroll. In addition, he began to "reserve" $5,000 of the bureau's $20,000 appropriation to support "ethnologic research to be expended more immediately under my own supervision."[57]

When Baird suggested that the bureau focus on collecting activities, Powell responded that he thought it ill-advised to divert bureau research funds to "the building up of the Museum." Baird countered by pointing to "the urgency of securing, at the earliest possible time, the archaeological and ethnographical aboriginal

material which could be carried off to Europe, either by travelers sent out for that purpose, or by dealers in the U.S. collecting material for export."[58]

In 1882, because of the lobbying efforts of mound enthusiasts, Congress required that $5,000 of the bureau's $25,000 appropriation be spent on the investigation of the earthen mounds that had puzzled Americans since the eighteenth century. Powell countered that the bureau had been organized to study western tribes "and therefore did not embrace any plan for archaeological investigations in the eastern portion of the United States, and in particular did not contemplate researches relating to the mounds." Responding to the legislative mandate, however, he established a Division of Mound Exploration. Powell was convinced that at least the effort would confirm his own view that the mound-building people were the ancestors of modern Native Americans.[59]

Powell appointed Wills De Hass assistant ethnologist in charge of the mound work. A native of Pennsylvania, he had built a career defending the authenticity of the Grave Creek Tablet, a small piece of sandstone covered with "Indian hieroglyphics" that was correctly regarded as a hoax. Moreover, he rejected the notion that ancestral Native Americans were the architects of the mounds. Powell dismissed De Hass at the end of the first season when he submitted a report deemed unworthy of publication, replacing him with Cyrus Thomas.[60]

Age fifty-seven, Thomas had practiced medicine, law, and the ministry, served as a superintendent of schools, and founded the Illinois Natural History Society before signing on as an entomologist with the Hayden survey in 1869. He then moved on to the US Geological Survey. As head of the mound division at the bureau, he would spend most of his time in Washington managing three "regular assistants," and five short-term field men who would map, excavate, and dispatch their finds to the National Museum. Thomas oversaw an operation that ranged from Ohio and the Ohio Valley west to Wisconsin, then south through Tennessee, North Carolina, Georgia, Alabama, and Florida.[61]

Like a commanding general, Thomas spent the next few seasons deploying his field men to excavations and collecting activities in selected areas. With fieldwork underway, Powell filled the pages of his annual reports with papers on mound archaeology, all of them supporting his view that "the mound builders were . . . none other than known Indian tribes." In a preliminary report on the mound research published in 1887, Cyrus Thomas remarked that they had found nothing to indicate that the architects of the mounds "had reached a higher culture-status than that attained by some of the Indian tribes found occupying the country at the time of the first arrival of Europeans." He also contributed the fourth in a series of bulletins that the bureau began issuing that year. To date, he

SMITHSON'S GAMBLE

noted, his division had investigated over two thousand mounds and forwarded thirty-eight thousand artifacts to the National Museum. In addition, "the artists of the Bureau" had produced models of mounds and mound burials for display at the 1884 New Orleans exposition and in the National Museum.[62]

The bureau men were not the only ones in the field. Thomas was always careful to credit the work of Frederic Putnam, director of Harvard's Peabody Museum of Archaeology and Ethnology, who conducted an archaeological survey of Ohio during the years 1880–95 and played a key role in preserving the famed Serpent Mound in Adams County, Ohio. Both men recognized that, while the work of a single racial stock, the mounds were the product of several distinct cultures stretching over long periods of time.[63]

Impatient, Powell urged Thomas to prepare his final report. *Mound Explorations of the Bureau of Ethnology* was complete in 1891 but did not appear until 1894. In 742 pages, Thomas described mound-building Native American cultures from Manitoba to the Gulf Coast of Louisiana, and from the Dakotas to Florida. His conclusion confirmed what Powell had supposed, that "the mound-builders of the area designated consisted of a number of tribes or peoples bearing about the same relations to one another and occupying about the same culture-status as did the Indian tribes inhabiting this country when first visited by Europeans." The Division of Mound Exploration closed the era of speculation and mythmaking for all reasonable people and laid a firm foundation for the future of American archaeology.[64]

Frank Cushing ended his career with an archaeological excavation east of the Mississippi as well. Returning to Washington in 1889, he produced another series of papers based on his Zuni research. In 1895, Powell dispatched Cushing, accompanied by his wife and seven workers, to Key Marco, Florida, to excavate a series of shell mounds and the swampy area near a neighboring pond. The expedition resulted in a treasure trove of some one thousand objects, now known to document the lives of the Muspa people. "Ask any archaeologist what the most spectacular Florida archaeological discovery ever made is," notes one authority, "and nine out of ten will say Frank Hamilton Cushing's 1896 excavations at the Key Marco site." He died on April 10, 1900, at age forty-two, having choked on a fish bone and hemorrhaged while on an expedition in Maine.[65]

286

CHAPTER 16

THE THIRD SECRETARY

FOR MOST OF THEIR MARRIED LIFE, Spencer Baird had worried about his wife's ill-health. In the fall of 1885, he began keeping a diary of his own ailments, from frequent headaches to concerns about his heart and kidneys. His continuing struggle with difficult employees did not help. "Heart beat more violently, and frequently," he reported on November 27, 1886. "Apparently . . . a result of a somewhat exciting interview with Mr. Leech a few days ago." The following spring, he complained directly to the clerk, Leech, "I must honestly and conscientiously say that the greater part of my indisposition has been caused by the many controversies in which you have taken part."[1]

Conscious of his declining health, sixty-three-year-old Baird was giving serious thought to his successor and the future of the Institution. The office of secretary, "which represents perhaps the chief scientific prize of the country," ought, he thought, to alternate between the physical and natural sciences. To continue the tradition and maintain balance, he planned to promote George Goode to the rank of assistant secretary for the National Museum and appoint a physical scientist as assistant secretary for institutional affairs, including publications, the exchange service, and administration. Baird assumed that the Board of Regents would appoint the new man as third secretary of the Institution following his own tenure.[2] The difficulty, however, was that most American physical scientists were earning university salaries that placed them out of the Smithsonian's reach. Fortunately, Baird's favorite candidate, Samuel Pierpont Langley, was willing to continue as director of the Allegheny Observatory at Western University of Pennsylvania at his current salary while devoting the three winter months each year to duties at the Smithsonian. The board approved the appointments on January 12, 1887.[3]

Langley was the obvious choice. Since 1869, he had published over one hundred articles and papers in both scientific and popular journals. His studies of the

Sun and solar energy established him as a pioneering astrophysicist. In 1886, the National Academy of Sciences awarded Langley the first Henry Draper Medal, recognizing his "numerous investigations of a high order of merit in solar physics, and especially in the domain of radiant energy." During his career, he was honored with doctorates from Harvard, Princeton, Michigan, and Wisconsin, and he took special pride in honorary degrees from both Oxford and Cambridge. He was awarded the Janssen Medal by the French Academy of Sciences, and was a foreign member of the Royal Society, a correspondent of the Institut de France, and a fellow of the Royal Astronomical Society, the Royal Institution, and the Accademia dei Lincei of Rome.[4]

But Langley was not only a scientist of international standing and a pioneer who developed revolutionary instruments that opened new doors to understanding the physical and chemical nature of the Sun. He also emerged as one of the most effective popularizers of science in his generation, sharing his enthusiasm for new discovery with the readers of newspapers and magazines. In four illustrated articles on "The New Astronomy" published in *Century Illustrated Monthly Magazine* (1884–85), followed by a book of the same title, Langley translated his esoteric research for a popular audience. Finally, he had established a solid record as an administrator of science, transforming a failed amateur observatory into a thriving and well-funded research center.[5]

A NATIVE OF THE BOSTON SUBURB of Roxbury born on August 22, 1834, Samuel Langley was the eldest of three children, including John Williams (1841–1918) and Annie Williams (1847–1930), of Mary Sumner Williams and Samuel Pierpont Langley, a wealthy produce merchant. Young Samuel could trace his Massachusetts lineage to the Great Migration of the 1630s and count such notable Puritans as John Cotton and Richard, Increase, and Cotton Mather among his forebearers. He was educated at a variety of local private schools before spending time at the Boston Latin School and graduating from the public English High School at age seventeen. Interested in engineering and architecture, he apprenticed at an architectural firm rather than attend college. Still living with his family in 1855, twenty-one-year-old Langley identified himself as an architect in a Massachusetts census.[6]

As a standard biographical source notes, "in 1857 [he] went West, where . . . he successfully practiced his profession, chiefly in Chicago and St. Louis." There is some doubt as to just how successful he could have been. George Goode, who knew him well and discussed the matter with him, explained that the Panic of 1857 "interfered seriously with his prospects." In any event, Langley returned to the family in 1864, having decided to steer his life in a very different direction.[7]

"I cannot remember when I was not interested in astronomy," he remarked many years later. "I remember reading books upon the subject as early as nine . . . and learned to make little telescopes and studied the stars through them. Later I made some larger ones . . . and I think myself they were very good for a boy." John Langley, an 1861 Harvard graduate, also returned home in 1864, having spent three years as an assistant surgeon with the US Navy. With the elder brother taking the lead, the Langley boys went to work silvering and grinding a glass mirror, building a tube, contriving a drive mechanism, and acquiring the eyepiece for a reflecting telescope, following the directions published in the Smithsonian annual report for 1864.[8]

In the fall of 1864, the brothers set off on a scientific and cultural grand tour of Europe. Thirty-year-old Samuel's passport indicates that he was five feet ten, with a broad forehead, a small mouth and chin, an aquiline nose, brown eyes, and dark brown hair. In years to come he would hide that weak chin behind a neatly trimmed beard, which, like his hair, would turn white.[9]

While Langley pursued his interest in astronomy with visits to observatories and scientific facilities, he toured galleries and museums as well. That first trip abroad infected Langley with a deep affection for Europe and all things European. During his years as secretary, whatever the state of the Institution or the status of his own experimental projects, Langley embarked on an annual summer trip to Europe to research, lecture, accept honors and awards, and visit colleagues. He treasured his friendships with European intellectuals, particularly the Scottish philosopher and essayist Thomas Carlyle. George Goode remarked that "Mr. Langley, though a Yankee of Yankees . . . has none of the traits . . . supposed to be characteristic of New England but would in Great Briton pass anywhere as an excellent example of the very best English type."[10]

Returning to Boston in 1865, Langley was somehow able, as one puzzled commentator put it, "to have assumed a position in American science in a way at first sight mysterious." Thirty-one years old, a failed businessman-architect without a college education and with no astronomical experience other than as an amateur telescope builder and veteran of a whirlwind tour of European scientific establishments, he persuaded Joseph Winlock to hire him as an assistant at the Harvard College Observatory. Less than a year later, he accepted a post as assistant professor of mathematics at the US Naval Academy, with responsibility for reestablishing an observatory in Annapolis, Maryland. In 1867, he moved on to Pittsburgh as a professor of astronomy and director of the observatory at Western University of Pennsylvania, a position he would retain until the spring of 1891, five and a half years after accepting the invitation to serve as assistant secretary of the Smithsonian.[11]

In 1859, thirty-two citizens of Pittsburgh organized the Allegheny Telescope Association, constructed an observatory building, and, in the fall of 1861, installed a thirteen-inch refractor from New York telescope maker Henry Fitz Jr. With no research agenda, the members were content to satisfy their curiosity with observations of the Moon and planets. By 1867, with membership and interest in decline, the group presented the facility to the Western University of Pennsylvania.[12]

Langley inherited both a building and a telescope in need of repair, with no library, clock, or other instruments. To fund initial improvements, the new director enlisted the support of William Thaw, a major stockholder in the Pennsylvania Railroad. Recognizing that the safe operation of the railroads expanding across the nation depended on accurate scheduling, Langley funded the long-term operation of the observatory by selling accurate time. Beginning with the Pennsylvania Railroad in 1869, the Allegheny System, as it became known, distributed accurate astronomically derived time simultaneously to all stations along the line. By 1885, time signals telegraphed from Pittsburgh were protecting 4,713 miles of track. Profits from the time service, and William Thaw's continued generosity, ensured the financial health of the Allegheny Observatory. Harvard and the Naval Observatory were soon emulating Langley's approach, earning a profit by selling time to railroads and cities across the nation.[13]

With funding in hand, Langley developed a research program suitable for the smoky, hazy skies of industrial Pittsburgh: the study of the Sun. He participated in US Coast Survey expeditions to observe solar eclipses in Oakland, Kentucky (1869); Xeres, Spain (1870); and Pikes Peak, Colorado (1878). At the observatory, he began systematic observations of the photosphere, the visible surface of the Sun. Initially, he projected the solar image on a sheet of white grid paper, as in a camera obscura, revealing prominences, sunspots, and other features and allowing him to track their motion across the surface.[14]

He developed a polarizing eyepiece that enabled him to make detailed visual observations of the surface through the telescope. Having honed his drafting skills as a civil engineer and architect, he produced detailed drawings of the complex solar features that were far more revealing than contemporary celestial photography. As one reporter noted, he captured "with infinite diligence and patience the elusive details which the moments of best vision may allow him to glimpse."[15]

What could be more valuable, Langley asked, than solar research? "Since . . . we are the children of the sun, and our bodies a product of its rays . . . it is a worthy problem to learn how things earthly depend upon the material ruler of our days." He would dedicate his career to the study of the Sun, "not only in the heavens, but . . . in its relations to man." He set out to measure solar radiation and

Sunspot observed on September 21, 1870, drawn by Samuel Pierpont Langley (1834–1906), from *The New Astronomy*, 1888. Langley was a physicist, astronomer, and the third secretary of the Smithsonian. He invented the bolometer and studied infrared radiation from the Sun. His widely printed, detailed drawings were the most accurate depictions of sunspots of the time. *Author's collection*

understand its impact on the Earth and living things.[16] That was not a goal that could be achieved through visual observations of the Sun. The first step would be to understand the transmission of the Sun's energy and its absorption by the atmosphere. As early as 1681, Edme Mariotte demonstrated that while glass was transparent to visible light, it blocked significant heat energy. At the dawn of the nineteenth century, Sir William Herschel used a thermometer to prove the existence of a portion of the spectrum beyond the red that transmitted significant energy. It was an 1872 paper in which M. S. Lamansky demonstrated the scale of atmospheric absorption beyond the visible light spectrum, however, that inspired Langley to begin his pioneering research in astrophysics.[17]

The problem—the development of an improved device to measure minute fluctuations in radiant energy—was perfectly suited to Langley's ability to conceive, design, build, and operate precision instruments. He set to work in 1878 with a $600 Rumford Fund grant from the American Academy of Arts and Sciences. Two years later, he introduced his bolometer.[18]

Light would enter through a tube and pass through a prism, with the resulting spectrum reflected by a concave mirror into the bolometer. The instrument

included a metallic tape, one-third inch long and thinner than a human hair. The slightest change in temperature affected the current flowing through the thread as measured by a galvanometer. This small precision device was capable of measuring differences in radiant energy between individual spectral lines. The most sensitive such instrument developed to date, the bolometer could detect the heat of a cow a quarter of a mile away. "With it," a modern authority explains, Langley "began his explorations of the unknown infrared spectrum of the Sun, mapping, one by one, the solar and terrestrial absorption features in what we now call the near infrared." In recognition of his achievement, the American Academy of Arts and Sciences awarded him the Rumford Prize and the Royal Society its prestigious Rumford Medal, both in 1886.[19]

Langley and Charles G. Abbot, his astronomical assistant (after 1895) who would ultimately become the fifth secretary of the Smithsonian, would devote their scientific careers to measuring the solar constant, or the mean solar radiation reaching a specific area, and seeking to understand the impact of that energy on the Earth. Langley took his place among the leaders in experimental astrophysics, as celebrated in Europe as in America.[20]

IMPORTANT AS IT WAS, SOLAR RESEARCH did not consume all of Samuel Langley's time and energy. In August 1886, he attended the thirty-fifth annual meeting of the American Association for the Advancement of Science. It was a busy time for the man who was preparing to take the helm of the AAAS as president in 1887, but one session, "On Soaring Birds," caught his attention. The soaring birds in question were model gliders designed, built, and flown by Israel Lancaster, an Illinois farmer and naturalist who claimed that his wood-and-cardboard "effigies" had remained in the air for up to fifteen minutes.[21]

The session planners—Octave Chanute, a leading Chicago civil engineer, and Robert Henry Thurston, a Cornell professor of mechanical engineering—regarded the problem of heavier-than-air flight as a technical challenge that could be met, as so many others had been, and were hoping that Lancaster's lecture and demonstration would impress their professional colleagues. Unfortunately, the lecture disappointed, and the models failed to soar. The distinguished attendees, according to one observer, "unanimously joined in reviling and laughing at him."[22]

Far from joining in the revelry, Langley was intrigued. He had long been curious about bird flight. "That . . . bodies . . . many hundred times denser than air, should be suspended in it above our heads sometimes for hours at a time . . . without falling, might seem without misuse of language to be called a physical

miracle," he remarked, "and yet those whose province it is to investigate nature, have hitherto seldom thought it deserving attention, is perhaps the greater wonder."[23]

Surveying additional material on the state of aeronautical research supplied by Chanute and Thurston, Langley recognized an opportunity. Ambitious and self-confident, he had reinvented himself at the age of thirty simply by announcing that he was a scientist, then risen quickly to the top of his field by devising an instrument enabling him to measure the radiation of the Sun. Now, at fifty, he launched a second major experimental program.

For 250 years, the disciples of Sir Isaac Newton had argued that mechanical flight represented an almost intractable problem because the resistance encountered by a flat wing surface moving through a fluid stream of air would vary with the square of the sine of the angle of incidence. In practical terms, that meant that a successful flying machine would require an enormously powerful engine to overcome the resistance of wings large enough to support the craft in flight. The weight of such an engine would require even larger wings to lift it, which would require more power to reach flying speed. If the Newtonians were correct, this spiraling relationship seemed to doom the prospects for mechanical flight.

Yet, Langley recognized, nature had overcome the difficulty. While Lancaster and others struggled to build flying machines, he would focus on discovering if heavier-than-air flight was even possible by calculating the power required to fly. "To prevent misapprehension," he explained, "I do not undertake to explain any art of mechanical flight, but to demonstrate experimentally . . . that such flight under proper direction is practicable."[24]

The basic research tool with which to investigate the accuracy of Newtonian suppositions was at hand. Seventy years earlier, English researcher Sir George Cayley had employed a whirling arm to conduct pioneering aerodynamic studies, swinging test surfaces through the air at the end of a long, pivoted arm with instruments to measure the aerodynamic forces at various speeds and angles of attack. With the continued generous support of William Thaw and a grant from the Bache Fund of the National Academy of Sciences, Langley initially built two small, lightweight whirling tables, as he preferred, then contracted for the full-scale version on the observatory grounds. The finished device featured a single sixty-foot-long arm mounted on a central pivot positioned eight feet in the air to avoid danger at ground level. Driven by an underground shaft powered by a steam engine, the arm could reach speeds approaching seventy miles per hour at its tips, thirty feet from the center.[25]

While he appreciated that curved or cambered wings would be more efficient in an actual flying machine, Langley tested only flat plates to provide data on a uniform plane surface. A basic instrument that he termed a dynamometer chronograph would record the lift, resistance, "and other phenomena" acting on a test surface. In addition, small models with wings of tin or cork were occasionally run on the table for comparison with simple test surfaces. He even "flew" stuffed birds on the end of the arm.[26]

Auxiliary items of equipment included a "suspended plane," "plane dropper," "resultant pressure indicator," "component pressure recorder," "counter-poised plane," and "rolling carriage." Each was designed to measure an aspect of the aerodynamic forces encountered during tests of various surfaces at differing angles, gauging the movement of the center of pressure on a surface, indicating the conditions under which a surface would support its own weight, and exploring the relative efficiency of different aspect ratio wings (length, or span, to width, or chord). Occasionally, the workmen disconnected the transmission and tested electrically powered propellor designs.[27]

He conducted his experiments in aerodynamics from 1887 to 1890. Frank W. Very, an assistant at the observatory, supervised the test program and kept accurate records. Joseph Ludewig, a general mechanic and handyman, operated the engine and transmission and generally maintained things. John Brashear, a one-time steelworker and amateur astronomer, was on call to construct special items and calibrate the instruments.[28]

A perfectionist, Langley expected the same of his research assistants. He insisted on frequent reports from the Allegheny crew while he was in Washington and showed little patience when things did not go well. He blamed the staff, for example, when an accident resulted in slight damage to the whirling table and the destruction of a propeller testing device in the fall of 1888. Frank Very replied in no uncertain terms, complaining of "flimsy apparatus" and concluding that "if I am to be held responsible for all, I prefer to be relieved from the necessity of conducting such experiments."[29]

EVEN AFTER ACCEPTING the position of assistant secretary, Langley assumed that he would spend the lion's share of his time in Pittsburgh providing close supervision of both the astrophysical and aerodynamic work. That would not prove to be the case. In May 1887, hoping that a rest would improve his health, Spencer Baird retreated to Elizabeth, New York, with his wife, Mary, and their daughter, Lucy. The heat and mosquitoes convinced the family to move into their quarters at Woods Hole in July. On August 15, Baird toured the facility that he had

created in a wheelchair, admiring the small fleet of research vessels and greeting biologists at work in the laboratory. He died on August 18. As Lucy reported to William Rhees, "death came gently, and as a fitting end to his calm and peaceful life."[30]

Following funeral services in the Bairds' home in Woods Hole, T. B. Ferguson, the on-site supervisor of the Woods Hole operation, escorted Baird's body home on the train on August 21, accompanied by Smithsonian colleagues. Lucy remained at Woods Hole with her mother, who was too ill to make the trip. Smithsonian buildings were closed and draped in black. Twenty-five carriages formed a procession moving directly to Oak Hill Cemetery, where the remains of Spencer Fullerton Baird were placed in a holding vault. A formal memorial service was held on November 30, attended by family and a small contingent of Smithsonian officials. The casket would rest in a niche immediately below the remains of his father-in-law, General Sylvester Churchill. On September 24, 1888, Congress appropriated $50,000 to be presented to Mary Baird in recognition of her husband's decades of unpaid service to the Fish Commission.[31]

Baird's last rites, like the man himself, were far less pretentious than Joseph Henry's, and drew less attention in the press. Friends and colleagues understood the magnitude of Baird's achievement. John Wesley Powell explained that Baird "had a minute and comprehensive knowledge that no other man has ever acquired. What others had recorded, he knew, and to their discoveries he made a contribution of his own so bounteous, so stupendous, that he is recognized as the master of systematic zoologists." Spencer Fullerton Baird was arguably the most important American natural scientist of the nineteenth century.[32]

A bibliography compiled by George Goode lists 1,063 publications, including Baird's masterful catalogs of North American reptiles (1853), birds (1858, 1864–66, 1874), and mammals (1859), which remain of value to biologists today as a record of historic geographic distributions. Baird is credited with identifying 186 new species of reptiles, seventy birds, fifty-six fish, and forty-nine mammals. Admirers named some forty species in his honor.[33]

In addition to his own research, Baird mentored two generations of young naturalists. "We used to call him Grandfather of us all," David Starr Jordan, founding president of Stanford University, recalled. For "in his day there was no struggling young naturalist to whom in one way or another he had not given assistance." Robert Ridgway spoke for all of Baird's young acolytes when he recalled "with deepest gratitude and reverence, his uniform great kindness of heart, his genial manners, his wise counsels, and his steadfast friendship."[34]

SMITHSON'S GAMBLE

Baird stood at the center of a growing network of correspondents that included his own circle of young naturalists, military officers, volunteer citizen scientists, and the members of the local scientific societies sprouting across the nation. He maintained a staggering correspondence. In 1861, he reported having "written, registered, and copied" 3,050 letters, only 190 of which were drafts for the secretary. By 1875, the number of letters he dispatched annually had climbed to 5,500. As historian Daniel Goldstein notes, "No other naturalist had the time, energy, resources, and breadth of interest to maintain such close contact with so many people."[35]

His correspondence had not only spread the name and influence of the Smithsonian but had also drawn thousands of interested men and women into the fold, redefining and democratizing the scientific community. In addition, it was the key to the growth of a national collection that would define the natural and human history of North America. All of this was in addition to Baird's primary Institutional responsibility to maintain the publications program and exchange system, and despite a secretary who insisted on limiting growth and spending.

While Joseph Henry succeeded in guarding the limited resources of the Smithsonian and ensuring its early survival, he remained wedded to his initial notion of a small organization supporting professional science in America. He spent thirty years in a futile effort to divest himself of responsibility for a large building and a National Museum. Spencer Baird, his eye on a very different future, used participation in the 1876 Centennial Exposition to leverage an expansion of the collection to include the breadth of human activity, establish a worthy National Museum, and send displays to expositions across the nation. His insistence on public education as a primary responsibility of the Institution was the single most important turning point in the history of the Smithsonian.

SPENCER BAIRD HAD WORKED hard to convince Samuel Langley to accept the position of assistant secretary. "I have no wish or ambition to tempt me from giving most of my time to physical investigation," Langley explained. At present, he continued, "I enjoy exceptional facilities for this, together with a freedom which I could not expect in any subordinate position." A move to Washington would take him away from the astrophysical instruments that William Thaw had provided for the observatory as well as the enormous whirling arm and instruments for his aerodynamic research, which could not be moved.[36]

At the same time, he admitted, "both my professional and domestic life here are exceptionally isolated, and I have felt a need of some change which would bring with it along with society, new occupation, if that could be a kind not

296

dissociated from my accustomed pursuits." Baird's assurance that he could retain his position at Allegheny and spend nine months of the year in Pittsburgh pursuing his two research projects convinced Langley to sign on.[37]

Seven months later, Spencer Baird was dead, and Langley, as per agreement, found himself acting secretary. Several regents were in Europe at the time, with others scattered across the country. The board finally met in special session at ten thirty on the morning of November 18, 1887. When Senator Justin Morrill nominated Langley for the permanent position, the nominee left the room while Regent James Clarke Welling, president of Columbian University, presented a statement Langley had prepared "so that the pending question could be considered with entire candor and freedom on all sides."[38]

Langley would accept the position, he explained, "with much misgiving" and despite the "remonstrance" of friends that in accepting an office that might curtail his scientific pursuits, he might "be sacrificing even higher duties and foregoing higher honors than those awaiting him as director of the Institution." While he intended to "give with all fidelity and with all conscientiousness the full measure of time, thought, and care which . . . shall be required by the Institution," he also expected to pursue his own research. He reminded them that both of his predecessors had reserved time to pursue their interests. Dr. Welling responded that the new secretary's "leisure labors" were what fitted him for the post and would serve the purposes of an Institution dedicated to the "increase and diffusion of knowledge." The regents then elected him unanimously.[39]

The two decades of the Langley administration would be a period of expansion, including the establishment of the Smithsonian Astrophysical Observatory and the National Zoo, continued participation in expositions, and the foundation for two new museums. If the new secretary would enjoy some successes, however, he would also struggle with the problems of managing an increasingly complex institution, the devastating public and political embarrassment of a failed attempt to fly, and bitter disappointment at a fiscal scandal resulting from the criminality of one of his most trusted aides. From the outset, it was an era that would be marked by the personality of the new secretary.

CHAPTER 17

THE CHIEF

"IN THIS PERIOD, when kings and emperors have gone a glimmering," Cyrus Adler explained, "it would be difficult to recreate a picture of the awe which surrounded the office of the Secretary of the Smithsonian Institution. . . . In government circles the position was a very high one. The Secretary was invited to dine at the White House, he was on familiar terms with the Chief Justice of the United States. . . . Members of the House of Representatives and sometimes senators waited in his anteroom."[1]

That was the exalted position of Adler's friend Samuel Pierpont Langley as the Smithsonian approached the conclusion of its first half century. Adler was a newly fledged PhD (1887) in Semitics from Johns Hopkins University when he suggested to George Goode that the National Museum should have a section of Oriental antiquities. Goode agreed. While teaching at his alma mater, Adler began making frequent trips to Washington to serve as honorary curator of the new section. He joined the Cosmos Club and befriended Smithsonian colleagues, notably Goode, John Watkins, and Thomas Wilson, who followed Charles Rau as curator of prehistoric archaeology. In 1893, learning that Adler was considering a move to the University of Chicago, Goode urged him to consider full-time work at the Smithsonian. That December, Secretary Langley offered him the position of librarian. Adler later remarked that the secretary was thinking strategically, balancing a staff dominated by the natural sciences with someone representing "the older learning and the humanities."[2]

Their friendship blossomed, Adler noted, when "we chanced upon a common interest: fairy tales, and particularly the Arabian Nights." Langley collected various editions of the tales in English and French and corresponded with Andrew Lang, the popular and prolific Victorian author of fairy stories and folklore. Charles Doolittle Walcott, who would follow Langley as the fourth secretary, recalled Langley's deep interest in the subject: "The studies of metaphysicians and

psychologists attracted his attention and he made a close study of the mysteries of psychical research. He had a passion for investigating the most abstruse, perplexing, and remote subjects of thought. These were to him in the nature of [a] pastime and seemed to quicken his energy for his scientific work."[3]

In the summer of 1901, while on a voyage to Tahiti, "under his private charges in search of rest," Langley pursued one mysterious folk tradition and debunked it. He had read Andrew Lang's article in the *Journal of Psychical Research* on the Polynesian tradition of miraculously walking over hot coals and found a similar account in the work of James Frazer, whose classic work, *The Golden Bough,* had appeared in 1890. Witnessing the ceremony, Langley noticed that while the stones in the bottom of the fourteen-foot-long firepit were dangerously hot, the participants walked across an upper layer of vesicular basalt, a poor heat conductor. Several of his Western traveling companions made the walk in their shoes without difficulty. "It was," the secretary concluded, "a most clever and interesting piece of savage magic but from the evidence I have just given, I am obliged to say (almost regretfully) that it was not a miracle."[4]

"He had a very wide interest in literature," a colleague recalled, and "was an omnivorous reader and had a large knowledge of the fine arts." His love of art led to the creation of an art room on the second floor of the east wing, near his office. Casts of the frieze of the Parthenon circled the room high on the wall. He and Adler were attempting to reacquire the Marsh Collection of European art prints that Joseph Henry had deposited with the Library of Congress and the Corcoran Gallery after the 1865 fire. Some of those may have been among the prints displayed on the wall of the art room.[5]

Langley's aesthetic tastes and self-image are reflected in the clubs with which he chose to affiliate. In Boston, he was a member of the St. Botolph Club, a gathering place for gentlemen interested in the arts, literature, music, and architecture. In New York, he was a nonresident member of The Strollers, whose object was "to establish a bohemian social and theatrical club." With Stanford White as chair of the Admissions Committee, the members ranged from Brooks Adams and John Jacob Astor to Nikola Tesla.[6]

Adler remained with the Institution until 1908, rising to become assistant secretary. He was, perhaps, the closest friend Samuel Langley ever had. He was the secretary's companion of choice for long afternoon rides "in the carriage which was furnished for the use of the Secretary." Given his fondness for Langley, he was anxious to explain what others found to be "a rather haughty and distant individual." The secretary was simply shy, Adler pointed out, and because he had trouble putting names with faces, he often seemed distracted and inattentive. Others took

a dimmer view, including a reporter who remarked that "it is well-known that the professor 'has a way with him' of making his royal personality felt in his big brownstone building."[7]

Andrew Dickson White, historian, diplomat, and cofounder of Cornell University, remarked of his friend Langley, "It cannot be claimed that among the great body of younger men devoted to science he ever aroused any such general affection as they had bestowed on his predecessor." While insisting that the secretary had a kind heart, Charles Greeley Abbot, Langley's astronomical assistant, agreed that "the chief faced the world with a shell of hauteur" and "was often unfairly impatient with assistants, and would betray irascibility by unduly raising his voice when things did not get on to suit him." Indeed, one disaffected employee described him as having a "domineering temper" and "the geniality of an iceberg," while an outside observer commented that "getting along with Secretary Langley is like trying to sleep with a porcupine."[8]

Some incidents that staff members found humorous also serve to underscore his extreme impatience with low-level staffers, including those hired to meet his personal needs. "One day when he was going to some function," Abbot recalled, "he came hurriedly out of his room and said 'William my hat.' The colored man ran and got his derby. 'I said a HAT!' shouted Langley, as he threw the derby down the hall."[9] African American employees like William suffered under the Langley administration. In 1892, all Black employees, including Solomon Brown, were reduced to the status of laborer. Brown, who continued to be responsible for shipping operations, suffered a devastating loss in pay. There can be no doubt that he was referring to Langley in the lines of his poem, "He's a Negro Still."

> Some I've seen with splendid mind,
> Their whole demeanor was refined;
> But yet would come that stubborn will
> And make me hate the Negro still.[10]

In February 1900, C. A. Steuart, general manager of the labor force, ordered that white employees in contact with the public continue to wear the blue uniforms with cap badge prescribed by Goode, while "Colored men," even those stoking the furnaces, were now required to wear white. Efforts to improve their lot came to nothing. In 1886, the US Civil Service Commission ruled that no employee be forced to work more than eight hours a day. At the Smithsonian, where laborers often worked much longer days, administrators cut annual and sick leave benefits. Several laborers asked Meredith Diggs, William Rhees's African American clerk, to draft an appeal, which had no impact. Seven African American laborers

THE CHIEF

petitioned for a salary increase in 1890. The budget, they were told, could not afford to offer raises. Three years later, six laborers, five of whom had signed the first petition, stated their case to Goode and received the same answer.[11]

Women fared little better in the Langley administration. Jane Turner, who had become the first woman professional employee of the Institution in 1858, resigned her post in 1887 when she was placed under male supervision. While her work was praised, "the place . . . may grow to be a controlling one, covering several extensive departments which could not well be subordinated to a woman."[12]

Langley was the sort of administrator who insisted on conducting weekly inspections of all offices, and always had a messenger boy with him as he made his rounds.

> As befitted his chief's dignity, the boy always walked two paces behind, perhaps carrying an overcoat or portfolio [explained a colleague]. In his youthful exuberance, and especially if some crony was looking on, the boy might cut some slightly disrespectful capers. But if so, he reckoned without his chief's knowledge of optics. For observing the boy indistinctly by reflection from the rear of his glasses, Langley would turn around suddenly at a critical moment, to the boy's great discomfiture.

The sight of Langley racing down a hall or up a flight of stairs to prevent an underling from daring to come level with "the chief" became a standard joke among the staff.[13]

LANGLEY WAS THE LAST SMITHSONIAN secretary who could fairly be regarded as the unofficial chief scientist of the United States. He was one of the leading experimental astrophysicists of his generation, devised important new instruments, and, through skillful manipulation of those instruments, provided information and insights of great importance to the field. Unlike Henry and Baird, his selection as secretary of the Smithsonian had little impact on his rate of publication.

Yet, as his friend Henry Adams noted, Langley had difficulty grappling with the strange new world into which physics was moving. The discovery of X-rays by Wilhelm Röntgen (1895) and Antoine Henri Becquerel's description of radioactivity in uranium salts (1896) would have been familiar to him, and puzzling. While he admired the secretary, Adams realized that "Langley said nothing new, and taught nothing that one might not have learned from Lord Bacon, three hundred years before." He "constantly reported that the new forces were anarchical," Adams continued, "and especially that he was not responsible for the new rays, that were little short of parricidal in their wicked spirit towards science."[14]

"The endeavor at the Smithsonian," Adler recalled, "was the protection of the Secretary, so that he might carry on his work in astrophysics and his newer experiments with . . . flying machines." Joseph Henry and Spencer Baird had set their own research careers aside to focus on administering the Smithsonian. In large measure, Samuel Langley pursued his own interests, relying on trusted staff members to manage the daily operations of the Institution.[15]

His colleagues and other staff saw to it "that business bore on him very little." Langley trusted William Wesley Karr, who arrived at the Smithsonian in 1879, to manage the day-to-day financial affairs of the Institution as both dispersing clerk and accountant. The aging chief clerk, William Rhees, who had entered service as Joseph Henry's private secretary in 1853, was eased out of his key administrative post and named chief archivist, where he prepared a two-volume collection of congressional documents relating to the Smithsonian. Jerome H. Kidder of the Fish Commission replaced Rhees as assistant in charge of the office until his own death in 1889, when William Crawford Winlock became "virtually Chief of Staff through whom the Secretary did everything." He was, Adler recalled, "very skillful in warding off visitors from Mr. Langley."[16]

Langley never married, and his own family was widely scattered. While he is rumored to have had a romantic interest in Anita Newcomb, the daughter of astronomer Simon Newcomb, the young lady chose to marry W J McGee of the Bureau of Ethnology. Thus, his inner circle of colleagues came to substitute for his family, a close-knit working group that also socialized together. "As I recollect," Adler explained, "four o' clock was the hour when everybody left his office with great regularity; and through the parks, in our several directions, we walked to the [Cosmos] Club and there, around the big fireplace, and with various forms spiritous inspiration, we talked over many things and never repeated a story."[17] Housed in the Dolley Madison house on Lafayette Square, the Cosmos Club represented, Adler admitted, "the snobbery of the scientific men." A geologist in his twenties would be welcomed into the group, while "a senator had to be very eminent; and as for a rich man, so great was the fear of commercialization, that it was easier for a camel, or rather let me say a rope, to correct the current translation, to enter the eye of a needle, than for a plutocrat to get . . . into the Cosmos Club."[18] Matilda Stevenson, Alice Fletcher, and their female associates were barred as well. Langley and several colleagues also joined a nine-hole golf club near Fort Myer, in Virginia, and became so fond of the game that they often played four days a week, returning to the Castle to work into the evening to make up for lost time. With winter snow on the ground, Adler recalled, they played with a red ball.[19]

THE CHIEF

While Langley preferred to manage the Smithsonian through a layer of senior staff members, when problems arose or he encountered a matter of interest to him, the new secretary never hesitated to intervene. Late in April 1888, for example, he wrote to Goode, noting that while Smithsonian publications "contain some papers of great value, the general impression of scientific men everywhere, so far as I know, is that the bulk of them may be relegated to the back shelf." The growth of specialized scientific journals over the past half century, he argued, meant that "we have been led to go dangerously near to . . . publishing books which have no readers at all." He established an informal advisory committee and continually pushed William B. Taylor, the Smithsonian editor, to solicit papers aimed at interested general readers rather than specialists. It was pressure he would continue to apply to the end of his tenure.[20]

Langley also had no patience for underlings with an independent streak, or who failed to offer what he regarded as appropriate deference. That was certainly true in the case of William Hornaday. A favorite of Baird and Goode, the young taxidermist had played a key role in creating a new generation of exhibitions for the National Museum and the ongoing series of expositions, as well as helping give birth to the emerging conservation movement. The notion of taking the next step, creating a zoo in the nation's capital where bison and other dwindling species could be preserved and perhaps even bred, came to Hornaday in March 1887 "like a thief in the night," as he recalled.[21]

The first American zoological garden was chartered in Philadelphia in 1859 but did not open until July 1, 1874. New York (1864), Chicago (1868), Providence (1872), Cincinnati (1875), and Buffalo (1875) followed. W. H. Tisdale's 1870 proposal to establish a National Zoological Park and Promenade Garden bounded by Thirteenth, Fourteenth, P, and Q Streets failed for lack of funding. That same year, Congress chartered a Washington Zoological Society, with Spencer Baird as one of the incorporators. Once again, the project came to nothing.[22]

Hornaday outlined his plan for a National Zoo managed by the Smithsonian in a letter to Spencer Baird in May 1887. Intrigued, the ailing secretary discussed the issue with Goode, who suggested to Hornaday that they begin on a small scale with "a little try-out zoo" in the south yard behind the Castle. The aspiring zoo-keeper wrote to Goode on June 25, applying for the curatorship of what would initially be known as the Department of Living Animals, and requesting an initial $500 to be spent acquiring resident creatures and feed.[23]

"Never was there an executive more charmingly free from the aches and pains of petty jealousy and egoism or the trammels of red tape," Hornaday explained, "than was G. Brown Goode." Recognizing energy and commitment

303

when he saw it, Goode offered his newly minted curator the opportunity to accompany a train carrying tanks of carp being transported to restock ponds on the West Coast for the Fish Commission. On the way back, Hornaday filled the empty fish tanks and special cages with the first residents of the national menagerie: fifteen live animals, ranging from a cinnamon bear to a prairie dog and a golden eagle.[24]

Corresponding with western ranchers and other suppliers, he continued to grow his collection through the winter. By January 31, 1888, Hornaday and his small crew were caring for fifty-eight animals. The number had almost doubled by April 1. The first two bison, the acquisition of which was "not only desirable but imperative," arrived from Nebraska in April. Valentine T. McGillycuddy, an Indian agent, shipped five more bison to Washington later that spring. President Grover Cleveland donated four golden eagles, gifts from an admirer, while his new wife, twenty-three-year-old Frances Folsom Cleveland, presented a spotted fawn. William F. "Buffalo Bill" Cody contributed an elk.[25]

The animals were housed in a building measuring 106 by 20 feet, built with wood scavenged from one of the temporary structures of the New Orleans exposition. Cages were provided for most of the creatures. The bison and deer could take the air in separate fenced pens south of the west wing of the Castle. Before the end of the year, workmen added a small barn on the east end of the yard between the Castle and the National Museum, along with a fenced pit to accommodate the bears.[26]

Hornaday reported that visitors were soon crowding the area in numbers "so great as to cause general discomfort." From the 9:00 a.m. opening to the 3:00 p.m. closing, "the crowd surges through the building, stopping before the cage in which a colony of squirrels prance, looking with wonder and astonishment on the large jaguar as he takes up his unceasing tramp around the large cage, and paying their respects to the many other strange creatures."[27]

The new secretary could scarcely ignore the crowds swarming through the south yard below his office window. It was Goode, however, who not only encouraged Hornaday but also suggested that a tract in scenic Rock Creek Valley would be the ideal site for the proposed National Zoo. Senator James Beck, a Kentucky Democrat, avid sportsman, and frequent visitor to the menagerie, agreed that Hornaday's "little try-out zoo" had outgrown its temporary home. Having discussed matters with Langley, Beck introduced a bill embodying Goode and Hornaday's ideas on April 23, 1888. It called for an oversight commission that would include the secretary of the Smithsonian, the secretary of the interior, and the president of the Board of Commissioners of the District of Columbia. They were to select and map an area of not more than one hundred acres along Rock Creek,

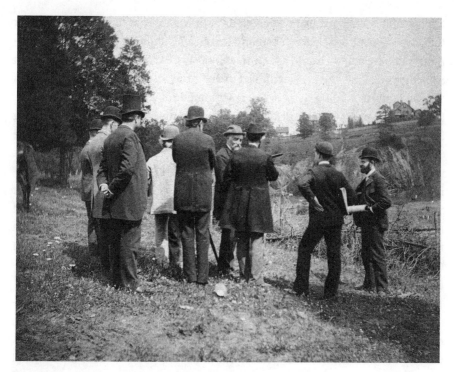

Photograph of (*left to right*) James Taylor, C. W. Schuermann, Frederick Law Olmsted, Frank Baker, Secretary Samuel Langley, William T. Hornaday, Henry W. Dorsey, and W. C. Winlock inspecting the proposed site for the National Zoo, c. 1888. Hornaday helped establish the National Zoological Park after the success of a smaller zoo on the Smithsonian Castle grounds. Congress appropriated funds for the zoo to be built in Rock Creek Park, and Olmstead was chosen as the initial architect for the project. *Smithsonian Institution Archives*

arrange for the purchase of the land, and supervise the construction of suitable facilities. On a motion by Senator Justin S. Morrill, the Senate dedicated $200,000 to fund the zoo, and sent their bill (S. 2572) to the House as an amendment to the sundry civil appropriations bill.[28]

When the House committee rejected the amendment, despite Hornaday's best efforts in testifying before them, the Senate insisted on a House vote. Supporters of the measure presented the standard arguments for the creation of a National Zoo, pointing to Hornaday's *Extinction Series* at the Cincinnati exposition. Several of the speakers praised the curator by name, identifying him as "a very intelligent gentleman, a man of large experience . . . and [with] a patriotic interest in preserving the remaining animals of this country." Others argued that expenses would skyrocket, with residents of Washington being the primary beneficiaries. "Hire a clown . . . and put the menagerie on the road for all citizens to enjoy,"

Representative Richard Bland suggested. "A bear garden is to be established 'for the advancement of Science,'" Benton McMillin of Tennessee complained; "Barnum is to have a new rival in the 'animal industry.'" When the vote was called on September 18, 1888, the measure failed thirty-six to fifty-six.[29]

On January 25, 1889, Senator George Edmunds of Vermont introduced a similar amendment to the District of Columbia appropriations bill, appropriating $200,000 dollars and establishing the three-person commission. Once again, the Senate approved the measure, passing it along to the House. Hornaday was back with a detailed relief map of the proposed park. An amendment to the amendment offered by Representative John Hemphill that called for an appropriation of $1 million to create a much larger national park along Rock Creek, with the zoo at the north end, was defeated. The amendment establishing the zoo, creating the three-person commission, splitting funding between Congress and the District of Columbia, and appropriating $200,000 to fund land acquisition and infrastructure passed on March 2, 1889.[30]

At Langley's invitation, Hornaday attended the first meeting of the commissioners, escorting them out to the 166 acres that he had selected. Working out of an office in the Castle, he set to work negotiating the acquisition of the land for the zoo. On July 12, the commission appointed Hornaday superintendent of the National Zoological Park with an annual salary of $2,500.[31]

From May to October 1889, Hornaday was absorbed in developing a building and fencing plan for the zoo, negotiating land acquisition, and supervising John Powell's surveying crew. He presented an estimate of $92,000 required to get the National Zoo started "in good style" to the commissioners in December 1899. Although both Goode and Langley expected a smaller request, Hornaday was instructed to present a draft bill and once again take charge of congressional negotiations to secure the funds while Langley prepared to leave on his annual summer European trip.[32]

Senator Justin Morrill, of Land-Grant Acts fame, introduced the bill (S. 2284) on January 23, 1890. Two weeks later, the bill reached the desk of Representative Joseph Cannon of the House Appropriations Committee. As Hornaday recalled, Cannon "uncrossed his legs, sourly looked at the carpet and disgustedly said, 'Well, I suppose we will have to pass this d——d bill!'" He amended the House version, however, to require the District of Columbia to fund half the amount. The bill bounced once again between the Senate and House over the question of district funding until April 22, when the Senate "receded from its disagreement" and the bill passed, requiring joint funding and designating that responsibility for the National Zoo now lay solely with the Board of

Regents of the Smithsonian. President Benjamin Harrison signed the bill into law that day. Soon thereafter, Hornaday would recall, "some mighty unpleasant things happened."[33]

"I had observed that the Secretary was a hard man and devilish difficult to get on with," Hornaday explained many years later. "In a real show-down," however, "he was at times fair and frank." That judgment, and the professional opportunities found only at the Smithsonian, kept him on the job. On May 10, 1890, however, he received a "menacing" letter from Langley informing him that all future incoming or outgoing correspondence would be registered and handled by the secretary. In a meeting with Langley that month, he learned that the plans developed over the past two years were "savagely scrapped." Much of the land would be given over to administration: "No, it will not be open to visitors." The secretary was appointing three Smithsonian administrators—Goode, Powell, and likely Frederick True, the curator of mammals—to supervise his work. When Hornaday asked for a six-month trial under Goode alone, Langley "rasped out, 'No, Mr. Hornaday! I—will—NOT!'"[34]

In his annual report for 1890, Secretary Langley noted that William Hornaday's efforts had "assisted the Commission greatly in the selection of the land, and did much to assure the success of the measure before Congress." Unfortunately, he continued, he was then "reluctantly obliged" to accept Hornaday's resignation.[35]

The self-assured Hornaday can only have aggravated the secretary. A born self-promoter, he had filled two scrapbooks to overflowing with news articles from papers across the country during the drive to establish the zoo, most of them underscoring his role in the effort. A clash between the brash, adventuresome taxidermist and the imperious chief who felt his leadership threatened was inevitable. The unpleasant truth, however, is that Langley, who had relied on those qualities in Hornaday to get the job done, chose not only to discard him but to erase him from the record while taking personal credit for the establishment of the zoo.

As early as 1900, for example, the naturalist Ernest Thompson Seton credited Langley with fighting the "fierce battles" with "ignorant and captious politicians." It was "Mr. Langley" who "succeeded in carrying both Houses of Congress . . . to the point of accepting and providing for the scheme." Cyrus Adler claimed that Langley, with his "eager curiosity about animal life," had been the one "to move successfully in establishing the Park." While the 1897 volume covering the first half century of the Smithsonian mentions Hornaday as curator of the Department of Living Animals, "it is with rare judgement" that Secretary Langley "turned his

attention to the picturesque valley of Rock Creek." The standard twentieth-century history of the Institution also mentions Hornaday in passing, but it is Langley who fights "patiently and hard in support of the zoo."[36]

The curtain rose on the third act of William Hornaday's life on January 7, 1896, when he received a letter from Henry Fairfield Osborn, curator of paleontology with the American Museum of Natural History and professor of zoology at Columbia, inviting him to meet with the leaders of the New York Zoological Society to discuss plans for what would become the Bronx Zoo. The leaders of the newly established group, notably Osborn and Madison Grant, a wealthy lawyer and conservationist, were patricians, the social and intellectual leaders of Manhattan society. Hornaday worked well with them, playing the major role in planning, fundraising, and populating the new park, which opened its doors on November 8, 1899.[37]

He would continue as director for thirty years, working with Osborn, Grant, and others to build the Bronx Zoo into one of the city's most popular attractions and becoming a national leader in animal care and the conservation of threatened species. Hornaday remained especially committed to the preservation of the American bison. He established a twenty-acre enclosed pasture in the Bronx where he hoped the small herd of buffalo he had collected would breed, only to discover that the bison, like his first Smithsonian calf, found eastern grasses indigestible. Hornaday burned his pasture and attempted, without success, to grow fodder that the animals would find more acceptable. New York governor Charles Evans Hughes vetoed a $20,000 appropriation to create a buffalo pasture in the Adirondacks, where Hornaday thought the foliage growing at a higher altitude would suit the animals.[38]

The solution to the problem, Hornaday realized, was to reestablish a viable herd of bison living free on a western range. Early in 1905, Theodore Roosevelt had created a game reserve in the Wichita Mountains in southwestern Oklahoma. In November, working with famed Comanche warrior Quanah Parker, who regarded the area as sacred, Hornaday shipped fifteen carefully selected bison to Cache, Oklahoma, where Parker was waiting to move them onto the reserve. The herd thrived. The second calf born was named Hornaday. The *New York Times* noted that he deserved "the gratitude and encouragement of the Nation as the preserver from extinction of the American bison."[39]

Unfortunately, Hornaday's interest in breeding was not limited to wildlife. He, Osborn, and Grant were ardent supporters of the eugenics movement, dedicated advocates of white supremacy, and spokesmen for the need to safeguard racial purity. Osborn wrote prefaces for various editions of Madison Grant's 1916

book, *The Passing of the Great Race*, a racist primer that Adolf Hitler regarded as his "bible."[40]

Those views were sometimes reflected in public presentations. In 1906, for example, Hornaday displayed Ota Benga, a Mbuti Pygmy who W J McGee had displayed at the Saint Louis fair, at the Bronx Zoo. Dressed in a minimal traditional costume and armed with a bow and arrow, he was housed in a cage near the apes, identified with a label to match that of the animals on display.[41]

Hornaday opposed "wretched" labor unions, argued for strict limits on immigration, and predicted disastrous overpopulation by the "lower orders." The man who had sparked a movement to preserve endangered animals in the American West proved far less concerned about some of his fellow human beings. Not long before his death in 1937, he lumped "imbeciles" in with habitual criminals and suggested that "we have yet to learn the A.B.C.s of the lethal chamber as a just and necessary aid to the survival of the fittest."[42]

HAVING MOVED HORNADAY out of the picture, Secretary Langley appointed Dr. Frank Baker as acting superintendent of the National Zoo. A Civil War veteran who had known both Walt Whitman and John Burroughs, he was a graduate of George Washington University with a medical degree from Georgetown. Before accepting the post of acting superintendent on June 1, 1890, Baker had been involved in treating a mortally wounded President Garfield (1881), served as a professor of anatomy at Georgetown (1883), and cofounded the National Geographic Society (1888). William Blackburne joined him at the zoo as the first head keeper in January 1891. Workmen put up the first building on the site—a large barn to shelter the animals—later that year. The inaugural occupants, a pair of male Indian elephants named Dunk and Gold Dust, arrived at the end of April. The staff began transporting the animals from the south yard of the Castle to the zoo grounds two months later.[43]

Secretary Langley had definite ideas regarding the development of the zoo. In pursuit of his goal to preserve the natural beauty of Rock Creek Valley, he hired the famed landscape architect Frederick Law Olmsted to develop a plan that would provide for the animals while preserving the natural setting. His focus was on the aesthetics of the site and on the scientific side of the operation. He envisioned large open areas as "animal preserves," closed to the public, in which herds of bison and other animals could roam. He hoped to find a way to allow bighorn sheep and goats to clamber up and down the rocky cliffs. Early on, he designated the only original structure on the site, the Holt House, for laboratories and offices. The visitor experience was a secondary consideration.[44]

SMITHSON'S GAMBLE

Things would not go as Langley had hoped. Visitation was far higher than expected. Since local funds were paying half the costs, Washingtonians insisted on an attractive entrance, good roads, paths, bridges, and other amenities. The Fifty-First Congress, with a House Republican majority, had supported the zoo project. A Democratically controlled House in the Fifty-Second Congress was less generous. Not only did Senate Republicans fail to convince the members of the House to correct the problem of split funding, but the 1891 request for $35,000 to cover the care and feeding of the animals resulted in an appropriation of only $17,000. Congress also imposed a moratorium on the purchase of new animals.[45]

Langley complained that "the result of this insufficient appropriation . . . was that the Secretary had been called upon to neglect important duties and his care of the general interests of the Institution, in order to devote the larger part of his time to the personal oversight of . . . the Park expenditures." He had only himself to blame for that problem. As one historian notes, "Langley's domination of his Acting Manager was unremitting."[46]

Frank Baker held on. He learned from his contact with more experienced zoo directors and came to rely on William Blackburne's twelve years of experience with the Barnum & Bailey Circus. Promoted to superintendent on November 23, 1893, Baker was able to wriggle free of the secretary's absolute control and learn to live with limited funding. The vision of an urban national park with wide open spaces for the animals to roam gave way to the reality of a more conventional National Zoo combining a public presentation of living animals with a commitment to conservation and the preservation of dwindling species.[47]

QUITE APART FROM THE ZOO, THE SECRETARY took a special interest in introducing young people to the natural world. As early as 1889, he asked Goode to create "a case which might be called the children's case," designed to "attract and amuse and only occasionally to instruct" the youngest visitors. Disappointed with the result, a single unit titled "Birds arranged for Children," the secretary complained that the case was too tall and the labels inappropriate for his target audience of six- to twelve-year-olds. In 1899, he announced that, "after 10 or 12 years waiting," he was appointing himself "honorary curator" and vowed to "direct the doing of something positive."[48] "Knowledge," Langley was sure, "begins in wonder." It was the motto he had painted over the entrance to the Children's Room.

The secretary was at the forefront of what would be called the nature study movement. Rooted in Smithsonian regent George Perkins Marsh's pioneering ecological study, *Man and Nature: Or, Physical Geography as Modified by Human Action* (1864), the proponents argued for the importance of encouraging an appreciation of the

The Children's Room, c. 1901. Samuel Langley created one of the first museum rooms designed for children, located just inside the south door of the Castle. Cases were specifically built to a child's eye level, and the labels simplified. *Smithsonian Institution Archives*

natural world, especially among young people. By the 1890s, educators like Wilbur Jackman, John Coulter, Liberty Hyde Bailey, and Anna Botsford Comstock were developing curricula underscoring the educational value of field trips, collection building, and hands-on natural science education in the home and classroom.[49]

Samuel Langley pioneered this notion in the museum setting. The Smithsonian, he explained to senior curator Frederick True, should approach the project from "outside ordinary museum methods." In so doing, he not only brought the goals of nature study into the exhibition hall but also became perhaps the first museum planner anywhere to realize that a successful exhibition was a complete environment into which visitors are invited and then encouraged to consider a message.[50]

Achieving that end required the efforts of a new kind of museum team. Langley decided to stage his exhibition in the entrance room just inside the south door of the Castle. He commissioned architects Joseph C. Hornblower and James R. Marshall, who were overseeing other alterations to the building, to design special features for the Children's Room, installing larger windows to ensure a light and

airy space and a glass door with delicate iron grilles featuring twining foliage. Grace Lincoln Temple, a pioneering interior decorator, selected a light green paint for the walls, cut stencils following the natural theme of vines and birds for the wall frieze, and decorated the ceiling as an arbor in green and gold, with patches of blue sky peeking through. Langley chose the bright tiles covering the floor to complete the effect.[51]

A pair of large fresh- and saltwater aquaria designed by Hornblower and Marshall dominated the center of the room, with gilded cages housing live songbirds hanging overhead. Low cases lining the walls, as Langley explained to the young readers of *Saint Nicholas*, contained "fascinating and even more marvelous, but silent, wonders." Displays ranging from birds mounted on perches to small habitat groups showing avian families safely ensconced in their nests were arranged "with the reach of younger eyes" in mind. Among the wonders were the smallest egg, that of a hummingbird, next to an ostrich egg. There were corals, sponges, and models of the largest lump of gold and the biggest diamond ever found.[52]

The Children's Room was, one enthusiastic commentator explained, "a marvelous Aladdin's palace of wonder and delight to youthful visitors, just as it holds much instruction for children of a larger growth." Samuel Langley, whose aesthetic taste and commitment to inspiring young imaginations had shaped the gallery, was applauded for having lavished great care on "this apartment full of beautiful and curious natural objects designed at once for the delight and instruction of the juvenile mind." A version of the Children's Room was included in the Smithsonian display at several major fairs.[53]

CHAPTER 18

AD ASTRA PER ARDUA

BOTH JOSEPH HENRY AND SPENCER BAIRD had suggested the need for an astrophysical observatory at the Smithsonian. Samuel Langley lost no time in meeting that need. Astrophysics was his field. "England, France, and Germany have maintained for a number of years, at a considerable expense, observatories for the study of the physical condition of celestial bodies," and as the United States had no such dedicated facility, it was a natural direction for Smithsonian research.[1]

Before his death, Spencer Baird had received commitments from Alexander Graham Bell and his father-in-law, Gardiner Greene Hubbard, to support an astrophysical observatory. Bell believed that they had each pledged $5,000. Hubbard insisted that the agreement had been for only $2,500. In the end, Bell provided $5,000, and Langley applied another $5,000 from the bequest of Dr. Jerome Kidder, a naval surgeon and veteran of the Fish Commission who served as Smithsonian curator of laboratories and exchanges (1888–89).[2]

William Thaw, Langley's Pittsburgh benefactor, agreed to "loan" the instruments that he had provided for the Allegheny Observatory to the Smithsonian. In addition, the secretary purchased a critically important siderostat, an instrument used to keep a moving celestial object in constant view, from the Irish instrument maker Sir Howard Grubb. Unable to persuade the secretary of war to donate two acres of Arlington National Cemetery land for his observatory, Langley decided that the facility could share Rock Creek Valley with the proposed National Zoo.[3]

While congressional action on the National Zoo moved slowly forward, Langley built a wooden observatory building "of the simplest and most temporary character" south of the Castle. Work began on November 30, 1888, and was completed on March 1. Several sturdy brick piers were set in place to support the instruments: Grubb's siderostat, "probably the largest and most powerful instrument of its kind ever constructed"; a new spectrobolometer, also "the largest

313

SMITHSON'S GAMBLE

instrument of its kind"; and a galvanometer "designed for the particular class of work."[4]

In December 1890, the secretary submitted a request to the House Committee on Appropriations for $10,000 to support the construction and equipping of a new observatory. The committee chair, surely at the secretary's suggestion, included a note that the permanent facility would be situated on the grounds of the proposed zoo. On January 27, Representative Benjamin A. Enloe of Tennessee rose in protest, complaining that the astrophysical observatory was simply a means to "give employment to a number of scientific gentlemen, who will have very expensive instruments furnished them at the expense of the government." The following month, the requested funds were included in the Sundry Civil Act for 1892. As Langley explained to the regents, however, "The Congress made the appropriation . . . with the understanding that for the present the observatory should be in a building already actually in the Smithsonian grounds." The secretary spent the congressional funds and held the $10,000 of Bell and Kidder in reserve.[5]

The Smithsonian Astrophysical Observatory would grow in place in the south yard behind the Castle for the next half century. The secretary added an additional small building in 1893, while a larger structure constructed in 1898 was "provided with a double-walled basement of brick and a single story above of wood . . . used for such physical researches as have been crowded out of the old building by the bolographic apparatus and accessories, which fully occupy it." By 1902, the observatory area was hidden behind a solid fence.

The goal of the facility, Langley explained, was to measure the amount and variability of solar radiation reaching the earth and to understand its impact on the weather and living things. The secretary and two assistants struggled with traffic vibrations on B Street (now Independence Avenue) and temperature fluctuations, handicaps imposed by the site, as they attempted to discern minute energy variations in narrow bands of the spectrum.[6]

The secretary acquired a genuine junior partner in 1895 when he hired Charles Abbot, fresh from MIT with a master of science in physics, as his chief astrophysical aide. Abbot would oversee work in the laboratory; accompany the secretary to observe solar events, including a trip to Wadesboro, North Carolina, in 1900; and carry on the investigation of solar radiation after Langley's passing in 1906. He would also serve as the fifth secretary of the Smithsonian from 1928 until 1944. Under Langley and Abbot, the observatory was allowed to drift far from the mainstream, continuing to produce records of the solar constant of little real value. What had been intended as a temporary facility remained the home of the Smithsonian Astrophysical Observatory until 1955, when an affiliation with

Smithsonian Astrophysical Observatory, c. 1909. The Astrophysical Observatory was founded in 1890 by Samuel Langley primarily to study the Sun. It was originally housed in a building just inside the fence of the southeast yard of the Smithsonian Castle grounds. *Smithsonian Institution Archives*

Harvard University and a move to Cambridge, Massachusetts, led to an expansion of the staff and a radical reorientation of its programs to address questions of central interest to astrophysics.[7]

WITH THE DAILY OPERATION OF THE astrophysical observatory in the hands of Charles Abbot, Langley turned his attention to a less traditional research initiative. The aerodynamic tests that he had begun at the Allegheny Observatory early in 1887 were complete by the end of 1890. "The most important general inference from these experiments," Langley concluded, "is that . . . mechanical flight is possible with engines we now possess." In fact, he continued, the power required to maintain flight decreased as the speed increased. In that regard he was incorrect, misled by limitations of his whirling arm. In the early spring of 1891, however, the secretary was eager to inform the world that his experimental data had proven the Newtonian doubters wrong. "What has been done," he assured the readers of *Century*, "is to demonstrate by actual experiment that we have now

acquired the mechanical power to sustain in the air (and at great speeds) bodies thousands of times heavier than the air itself, and that as soon as we have the skill to direct this power, we shall be able to actually fly."[8]

Langley announced the results of his aerodynamic research at the annual meeting of the American Association for the Advancement of Science in May 1891. The fact that the secretary of the Smithsonian believed in the possibility of a flying machine was big news. From *Scientific American* to daily papers across the country, headlines abounded: "Just How Man Will Fly," "Shall We Fly," "The Obstacles to Flight," "Flying Machines." The release that August of his full report, *Experiments in Aerodynamics*, provided the detailed evidence for the possibility of humanity's future in the air.[9]

The professional response was mixed. Lord Rayleigh, the dean of British physicists, pronounced that "the work appears to have been executed with the skill and thoroughness which would naturally be expected of the author, and will doubtless prove of great value to those engaged in such matters." Not all of Langley's distinguished colleagues were so generous. He traveled to England in 1894, receiving an honorary degree from Oxford and reading a paper on his aerodynamic experiments before the annual meeting of the British Association for the Advancement of Science. At the conclusion of his talk, William Thomson, 1st Baron Kelvin, a leading physicist, walked to the blackboard and demonstrated the fallacy in Langley's thinking. Perhaps, Lord Rayleigh responded, but "if Langley succeeded in doing it, then he would be right."[10]

The skepticism of leading physicists convinced Langley of the need to defend his experimental findings by taking a tentative step toward achieving powered winged flight. He was encouraged not only by his own calculations of the power required for flight but also by the work of Israel Lancaster, whose paper on soaring at the 1886 meeting of the AAAS had ignited his interest, and Louis Mouillard, a French aeronautical experimenter living in Cairo whose studies indicated that even large birds with wide wings utilized air currents to remain effortlessly aloft for long periods. Langley published an abridged translation of Mouillard's book in the 1892 Smithsonian annual report.[11]

At the Allegheny Observatory in 1887, and again at the Smithsonian Castle in January 1893, the secretary studied the phenomenon of soaring by raising anemometers on poles into the air to record gusting winds and changing air currents. The results, originally presented to the National Academy of Sciences in 1888 and finally published as a monograph in 1893, convinced him that soaring birds took advantage of "the internal work of the wind," using rising columns of air to maneuver with a minimum expenditure of energy. The implications for

mechanical flight seemed clear. A winged machine, he argued, would be able to soar without the use of a power plant "in order to go any distance—even to circumnavigate the globe without alighting," using an engine and fuel, only "to enable it to take care of itself in exceptionable moments of calm."[12]

Octave Chanute, whose correspondence with flight researchers around the world had established him as the single best-informed authority on aeronautical arts, also urged his new friend Langley to take note of Alphonse Pénaud, a French experimenter who had flown his *Planophore*, the first successful inherently stable powered model airplane, in 1871. Hand launched, and featuring a rear-mounted propeller powered by twisted rubber strands, the little model flew a record distance of 131 feet in eleven seconds. Langley translated an 1872 article of Pénaud's and added a drawing of the *Planophore* in the first of his aeronautical notebooks.[13]

The *Encyclopedia Britannica* had introduced the term *aeronautics* in 1824, and the English experimenter Francis Herbert Wenham had referred to an *aeroplane* in 1866. Nevertheless, after consulting a specialist in Greek, the secretary coined the term *aerodromics* for aeronautical engineering and *aerodrome* for a winged flying machine. While no one followed his lead, he persisted in using his own terms for the rest of his life.

Attempting to move beyond Pénaud, Langley and his workmen tested their first model at Allegheny in April 1887. The wood-framed biplane with paper wings spanning four feet was far too heavy to take to the air powered by a pair of contrarotating propellers driven by twisted rubber strands. An even larger rubber-powered craft tested in June remained firmly on the ground.[14]

The secretary resumed his experiments at the Smithsonian with much smaller rubber-powered flying models inspired by the *Planophore*. Carpenter C. B. Nichols built the craft. Wooden framing gave way to shellacked paper tubes with lightweight wings. Langley built and tested thirty or forty of these hand-launched winged craft between 1889 and 1893. Given the number of modifications and rebuilds, Langley estimated that the total number of distinct designs probably approached one hundred, "some with two propellers, some with one; some with one propeller in front and one behind; some with plane, some with curved, wings; some with single, some with superposed, wings; some with two pairs of wings, one preceding and one following; some with the Pénaud tail, and some with other forms."[15]

The secretary conducted the flight tests in the Great Hall of the Castle. It proved "almost impossible," he wrote, "to build the model light enough to enable it to fly, and at the same time strong enough to withstand the strains which flight

imposed upon it." Flights were few and breakage frequent. Tests also included setting the wings and tail surfaces at differing angles in search of inherent stability. The longest flights lasted only eight seconds and covered no more than one hundred feet.[16]

Samuel Langley had reached a turning point. The aerodynamic tests had been the work of an experimental physicist gathering scientific data on the behavior of flat plates in a fluid stream. The tests with rubber-powered models had been small scale, inexpensive, and had attracted no attention. Unable to match Pénaud's performance, Langley could have walked away from flight research. Moving forward, however, would require a very expensive and time-consuming effort to develop a much larger model powered by a real engine capable of making the first powered, heavier-than-air flight in history, an enterprise that most sober citizens regarded as the domain of fools and mountebanks. Once he started down that path, anything short of success would be disastrous for his reputation and that of the Institution. It was a gamble he was willing to take.[17]

Rather than presenting a detailed plan and requesting the permission of the regents, the secretary raised the matter obliquely, announcing in his 1891 annual report to the board that "certain physical investigations . . . have been made under the personal direction of the Secretary of the Institution at private charge and not at the cost of its funds." He made veiled allusions to the work in his annual reports for the next four years. Obviously, however, the regents and everyone else were fully aware that the secretary was trying to develop a winged flying machine.[18]

The secretary did his best to raise outside funding. Newspaper reports suggested that Langley had received $5,000 from the Bache Fund of the National Academy of Sciences. In reality, the academy had only provided him with Bache Fund grants of around $1,600.

In 1891, Thomas Hodgkins, an Englishman living in Setauket, New York, bequeathed $200,000 to the Institution, with an additional $50,000 upon his death, to create a fund supporting "the increase and diffusion of more exact knowledge in regard to the nature and properties of atmospheric air in connection with the welfare of man." In addition to funding some of his aerodrome work, Langley and the board would use the fund to support an essay contest, establish a medal recognizing achievements in the field, and provide grants for medical studies of tuberculosis and air pollution. Hodgkins's grants also funded Étienne-Jules Marey's photographs of birds in motion, William Abner Eddy's work with meteorological kites, and, in 1917, Robert Goddard's early rocket experiments.[19]

While the secretary insisted that this was a private research project, the Institution would bear most of the cost by supplying all the labor, facilities, and materials. Langley launched the project in the spring of 1890 with a request that John Watkins, the Smithsonian's chief engineer, investigate the possibility of a reaction-propelled flying model. When that approach proved unworkable, Watkins turned his attention to the potential of small, lightweight engines to propel larger flying models.[20]

In March and April, Bentley Rinehart and L. C. Maltby, both staff machinists, each built a small steam engine. Maltby's proved the more successful, weighing four pounds and developing one horsepower. Over the next five years, Langley's team would design and test a variety of engines employing various fuels, burners, boilers, cylinders, and other components, always aiming to reduce weight and increase power.[21]

From the beginning of his experimental program to the end, Langley focused on propulsion and slighted aerodynamic and structural issues. In 1889, the secretary purchased the antique John Stringfellow steam engine, which had been exhibited at the Crystal Palace twenty years before as the power plant for a projected aerial steam carriage. During his annual European trips, the secretary visited Clément Ader (1899) and Hiram Maxim (1900), flying machine experimenters who shared his emphasis on the propulsion rather than aerodynamics or aircraft structures.[22]

In August 1895, Langley spent two days in Berlin with the German gliding pioneer Otto Lilienthal. As early as 1878, Lilienthal, a mechanical engineer and small-scale manufacturer, had begun to conduct aerodynamic experiments at his home in the Berlin suburbs. Unlike Langley, who sought to prove flight theoretically possible, Lilienthal gathered solid information on the lift and resistance of a cambered surface that would be used to design wings that would carry him through the air. Published in 1889, his classic *Der Vogelflug als Grundlage der Fliegekunst* (*Bird Flight as the Basis of Aviation*) provided accurate coefficients of lift and drag that would serve as the starting point for the Wright brothers and others who would build and fly the first practical airplanes.

Langley became aware of Lilienthal's data in 1893 and promptly rejected it. "I do not question that curves are in some degree more efficient [than flat surfaces], but the extreme increase in efficiency in curves over planes . . . asserted by Lilienthal . . . appears to have been associated either with some imperfect enunciation of conditions . . . or with conditions almost impossible for us to obtain in flight." Langley continued to use his flat plate data to calculate the performance of his wings.[23] His failure to recognize the value of Lilienthal's research was a result

SMITHSON'S GAMBLE

of his own view that adequate propulsion was the key factor barring the way to a successful airplane. It also blinded him to the importance of Lilienthal's achievement. Between 1890 and 1896, the German pioneer had made as many as two thousand flights in manned gliders. By the time of Langley's visit, images of "the flying man" gliding down the slope of his artificial hill in a Berlin suburb were familiar around the globe. Langley summed up his account of his visit by noting, "I did not think I learned much." What he had not learned was that soaring flight is possible without an engine, but not possible without efficient wings based on sound aerodynamic principles.[24]

L. C. Maltby built Aerodrome 0, the first attempt to produce an airframe, in 1891. Measuring five feet long, the craft had tandem wings with aluminum frames covered with black silk. The front pair sported fifty square feet of surface, while the rear pair were half that size. The twin propellors produced far too little thrust to get it off the ground. Like the models to follow, it was tested on a whirling table that Langley ordered Watkins to construct in an extension of the West Shed, one of the changing temporary structures just south of the Castle. C. B. Nichols initially operated the device, which featured a five-meter arm mounted six feet above the floor, gathering data on the characteristics and performance of each aerodrome and wing configuration.[25]

The secretary outlined plans for a second aerodrome, No. 1, in a May 1892 letter to Watkins. Details of that craft, and initial plans for a third machine, No. 2, followed on June 13. Those craft proved too light and fragile to test. It was symptomatic of Langley's approach to structural design. He would bounce from a craft that was too light to one that was too heavy, working toward a craft just light enough to fly and just strong enough to hold together in the air.[26] Following Watkins's September 3, 1892, report on the status of the new aerodromes and engines, Langley issued orders on September 29 to begin work on No. 3, which was to be powered by either steam or compressed carbon dioxide gas. By mid-November, Nos. 1 and 2 were nearing completion. No. 1 was two-thirds the size of the first aerodrome, and No. 2 was even smaller. Operating with improved engines, neither craft could lift even one-fifth of its weight (less than four pounds for No. 2). No. 3 incorporated the lessons learned to date and featured a two-cylinder power plant, but was still able to lift only two-thirds of its four-and-a-half-pound weight. Work was underway on No. 4 by mid-December. While things were improving, the year 1892 ended, as Langley noted, "with the feeling on the writer's part that great labor had been incurred, and very little information had been gained."[27]

Confident that success would come, the secretary considered the problem of how to get a machine into the air. An aerodrome would be catapulted into the air

to conserve the limited power supplied by the small boiler and reservoir. Landing in water, he reasoned, would limit damage to the craft. In November 1893, he purchased an unpowered scow measuring twelve by thirty feet and built a cabin on it to house a modest workshop, with a spring-powered catapult on the roof. After considering a variety of areas in which to conduct test flights, he decided to launch his aerodrome from the scow anchored in the Potomac some thirty miles downstream of Washington, in a cove between Chopawamsic Island and Quantico on the Virginia shore. The area was first visited by Captain John Smith in 1609. By the time of Langley's arrival, the Metropolitan Club of Washington, where the secretary resided, owned the island and maintained a hunting and fishing camp.[28]

Luther Reed, head of the Smithsonian carpentry shops, and L. C. Maltby completed work on Aerodrome No. 4 the following spring. It was the first of the classic "Langley types," with tandem wings of equal shape and dimension featuring a total surface area of fourteen square feet, and a cruciform tail featuring vertical and horizontal surfaces. The two-cylinder engine included a force pump feeding water to a double-tube helical-coil boiler. The craft weighed 10.47 pounds (4,750 grams) with fuel and water for a flight of two minutes.

Recognizing the need for a professionally trained assistant, Langley had hired physicist Carl Barus in August 1893. An 1874 graduate of Cincinnati's Woodward High School together with classmate William Howard Taft, he attended Columbia University and earned a doctorate in physics from Würzburg, Germany. A dueling scar on his cheek served as a reminder of his time in university. Returning to the United States, he worked as a geophysicist with the US Geological Survey under Clarence King. When John Powell inherited the survey from King, Barus helped to establish a geophysical laboratory in Washington, where his research earned him membership in the National Academy of Sciences in 1892. Cutbacks at the USGS led him to a series of positions with the US Weather Bureau and Alexander Graham Bell before accepting Langley's offer to serve as a scientific consultant with the Institution.[29]

Barus was focused on two projects: working with Charles Abbot in the observatory and assisting the secretary on the aerodrome project, which consumed most of his time. He was involved in aerodynamic research and more practical work on the aerodromes. He made several trips down the Potomac to participate in failed launches before leaving the Smithsonian in May 1895 to accept a teaching position at Brown University.[30]

On November 16, 1893, the secretary, Reed, Maltby, and Barus traveled by train to Quantico, Virginia, the closest station to the scow's anchorage. "Here," Langley commented, "was met for the first time the difficulty of managing such

an aerodrome in the open air before launching." Even a light morning breeze made it impossible to position the craft on the catapult. By the end of the year, the group would make eight more unsuccessful trips to Quantico.[31]

Langley and his team would struggle for the next two and a half years. Repeated trips downriver resulted in dropping one aerodrome after another into the water due to failures in the structure of the models, the engines, or the launcher. No. 4 was rebuilt to such an extent that the staff renamed it the New No. 4. Further alterations led the secretary to renumber it No. 6. Aerodrome No. 5 was completed by October 1894. As the team had failed to devise a pendulum or gyroscopic mechanism to balance the craft, the new wings were set at a dihedral angle of twenty degrees to provide a measure of inherent stability in roll, while the cruciform tail was attached with a hickory spring to allow it to maintain some pitch stability.[32]

By the fall of 1894, the prospects for success seemed uncertain at best. "These were years of great anxiety," Cyrus Adler recalled, "because some of us, particularly Dr. Goode, felt that Langley had risked his own fair name and the reputation of the Smithsonian by tying himself up with experiments which were denounced everywhere as based upon an entirely false theory and sure to prove disastrous." The rumblings grew more serious by 1895 when Adler reported that a "few of the influential Regents [were being] stimulated by scientific men in the county who . . . sincerely held . . . that Langley's experiments in heavier-than-air machines indicated that he was of unsound mind." As always, the secretary was careful to retain the support of the majority of the regents.[33]

Discouraged, Langley replaced Barus with two experienced flying machine experimenters. Augustus Moore Herring, the secretary's first recruit, had studied engineering at the Stevens Institute of Technology. He attracted some attention in the press in 1893 by building and attempting to fly a monoplane hang glider based on Otto Lilienthal's patent, and he came recommended by Octave Chanute, for whom he had built some flying models. Impressed, Langley hired him in May 1894 to supervise the aerodrome effort.[34]

Langley's second recruit, Edward Chalmers Huffaker, arrived in December 1894. Hailing from the mountains of East Tennessee, he had graduated from Emory & Henry College and then earned a graduate degree in mathematics from the University of Virginia. Interested in the engineering of flying machines, he corresponded with Chanute, who urged him to submit a paper on the advantages of cambered wings to an aeronautical conference organized in conjunction with the 1893 World's Columbian Exposition. Langley hired him on Chanute's recommendation to reinvigorate the aerodrome program.[35]

AD ASTRA PER ARDUA

Huffaker, a trained engineer-physicist, quickly emerged as chief aerodynamicist of the aerodrome project. Working with the whirling table, now relocated to the two-story South Shed behind the Castle, he moved well beyond the data reported in *Experiments in Aerodynamics*, calculating the lift coefficient for a flat plate. More to the point, his tests led him to calculate the increased lift of cambered surfaces. He also studied the movement of the center of pressure on a wing and selected an airfoil ideal for the aerodrome.[36]

Langley once told Adler that while Huffaker had "a good and original mind," he "worried him when he was around, but . . . when he was not around, he was always wanted." The secretary, whose formality edged toward pompous, certainly found his assistant from the mountains of East Tennessee a bit informal for his taste. Dressed in a frock coat and tie, Langley conducted weekly inspections of all offices, often accompanied by Adler. Passing by Huffaker's office door on one such occasion, he found him—jacket off and feet up on his desk—spitting tobacco juice into a spittoon against the far wall. Appalled, Langley turned to Adler and remarked, "Well, Huffaker is as God made him."[37]

Brash and self-confident, Augustus Herring was also bound to clash with the micromanaging secretary. "Even in a few days," Herring wrote to Chanute, "I could foresee a possibility that he and I might not be able to agree." Herring would turn a drawing for an item over to a machinist only to have Langley order the man to change it without discussion. Such behavior, he complained, undermined his authority with the workmen.[38]

Huffaker and Herring made critically important improvements to Nos. 5 and 6, both in terms of cambered wing design and the use of a tail to provide a measure of pitch stability. The team loaded the inverted wings with sand to simulate flight pressures. Herring, however, continued to struggle under Langley's tight control. "One of the disagreeable features," he complained to Chanute, "is Mr. Langley's inability to distinguish between the ideas of other people and his own." A confrontation between the two on the design of the aerodrome wings in November 1895 led Herring to resign.[39]

Those were the wings fitted to Nos. 5 and 6 in the spring of 1896. In its final configuration, No. 5 measured thirteen feet, two inches from the tip of the bowsprit to the rear of the cruciform tail. It featured four tandem wood-framed, silk-covered wings spanning thirteen feet, nine inches, with a surface area, including the tail, of eighteen square feet. The steel tube fuselage housed the single-cylinder steam engine weighing only twenty-six ounces, including a water pump, water jacket, spiral boiler, and alcohol-fueled burner. The little power plant produced one horsepower and drove twin contrarotating silk-covered

323

Aerodrome launch, May 6, 1896. Luther Reed was chief mechanic and head of the Smithsonian shops during Samuel Langley's tenure as secretary. He helped build and oversaw the launch of a series of aerodromes, Langley's efforts to develop a flying machine. This launch of Aerodrome No. 5 on the afternoon of May 6, 1896, marked the first successful flight of a powered, heavier-than-air model aircraft. *National Air and Space Museum Archives*

metal frame propellers. Operating at full power when launched, the engine would gradually lose pressure, limiting the duration of a flight. The machine weighed twenty-five pounds.[40]

Luther Reed traveled downriver with the houseboat and Aerodromes Nos. 5 and 6 on Monday, May 4, 1896. Maltby took the train and joined him at the Metropolitan Club's Mount Vernon Ducking Society, where the Smithsonian crew stayed during flight trials. They met Secretary Langley and Alexander Graham Bell, his friend and supporter, at the train on the afternoon of May 5. Rather than roughing it with the crew, the pair lodged that evening at a hotel in Quantico. Huffaker and Frederick E. Fowle Jr., a photographer and assistant with the Smithsonian Astrophysical Observatory, joined the others on the morning of May 6.

At 1:10 p.m., with Bell and his camera on deck and Fowle set up on shore, No. 6 was propelled down the launch rail, snagged a brace wire, and dropped into the river. No. 5 was then hung from the overhead catapult. Launched at 3:05 p.m., the aerodrome circled, climbing to an estimated altitude of seventy to one hundred

AD ASTRA PER ARDUA

feet, remaining in the air for one minute and twenty seconds, and landing safely in the water 142 yards upstream of the scow, having achieved a speed of twenty to twenty-five miles per hour. "These experiments," Langley reported, "were beyond comparison the most satisfactory which have yet been made and they have probably no parallel in the history of the subject." By 5:10 p.m., No. 5 was relaunched and repeated the performance, climbing to 60 feet and covering a total distance of 2,300 feet.[41]

Alexander Graham Bell provided the most evocative description of the flights, noting that the machine resembled an "enormous bird, soaring in the air with extreme regularity in large curves, sweeping steadily upward in a spiral path, the spirals with a diameter of perhaps 100 yards, until it reached a height of about 100 feet in the air at the end of about half a mile." The machine then "touched the water without any damage, and was immediately picked out and ready to be tried again."[42]

The secretary postponed further test flights until his return from his annual European visit. On November 28, 1896, No. 6 remained aloft over the Potomac for one minute and forty-five seconds, covering a distance of 4,200 feet at a speed of thirty miles per hour. Langley had succeeded in building and flying the first large, powered, heavier-than-air model aircraft capable of remaining aloft on flights of significant length until their fuel was exhausted.[43]

The nation's newspapers trumpeted his achievement. The secretary of the Smithsonian had flown a "Great Bird of Steel" a "Half Mile in the Air," opening the way for "Cloud Tourists." Having taken care to hide his experiments from the press, he was now more than willing to accept the accolades. Samuel Langley's quest to fly became one of the dominant, long-running news sagas of the decade beginning in 1893. As time would demonstrate, however, the seeds of disappointment, failure, and ridicule were rooted in the success of 1896.[44]

CHAPTER 19

THE AERODROME

THE SMITHSONIAN MARKED its fiftieth birthday on August 10, 1896. A handful of newspapers took note of the occasion. The *Evening Times*, a local, applauded this "Great Friend to Science," while the *Omaha Bee* saluted "One of the Greatest Distributers of Knowledge in the World." With the secretary in Europe and few officials braving the heat of the city, no special celebrations were planned. The regents had, however, commissioned a commemorative volume, *The Smithsonian Institution, 1846–1896: The History of its First Half Century*, which was to be edited by Assistant Secretary George Goode and appear the following year.[1]

The editor would not live to hold the book in his hands. On the evening of September 6, 1896, George Brown Goode, age forty-five, died of pneumonia at his home in Lanier Heights in northwest Washington. He was laid to rest in Oak Hill Cemetery just two days later. Secretary Langley and William Winlock were at sea, returning from Europe. Reverend Thomas Childs, chaplain of the Sons of the American Revolution, conducted the ceremony, with William North Rice, acting president of Wesleyan University, offering the eulogy. Frederick True, Otis Mason, Robert Ridgway, Cyrus Adler, and Richard Rathbun were among the pallbearers. Other Smithsonian colleagues in attendance included Dr. Frank Baker, the director of the National Zoo, paleontologist George Perkins Merrill, and paleobotanist Lester Frank Ward, an intellectual leader who would serve as the first president of the American Sociological Association.[2]

A second blow fell on September 26, when word arrived that William Winlock had died in Bay City, New Jersey. Charged with responsibility for the Smithsonian exchange system, and much else, Winlock had traveled to Europe with Langley, where he met with university faculty, the leaders of scientific societies, and museum directors participating in international exchange programs. Upon their return, Winlock was recuperating with his family at the shore when he collapsed. For the second time that month, the Smithsonian staff went into mourning.[3]

326

THE AERODROME

The death of both men represented a deep personal loss to the secretary. Winlock, whose father had given Langley his first professional position in astronomy, had set his own career aside to support the secretary. Goode was "so dear a friend," Langley noted, that he "could not speak of him . . . without pain."[4]

Langley selected Richard Rathbun to replace Goode as assistant secretary for the National Museum. A Dartmouth graduate, Rathbun had served as a scientific assistant to Baird and Goode at the Fish Commission and became curator of invertebrates with the National Museum in 1880. Baird hired his sister, Mary Jane Rathbun, as a clerk in 1884. She would remain with the museum until her retirement in 1915, rising to the rank of assistant curator of crustaceans. Recognizing his managerial skills, Langley appointed Rathbun assistant secretary of the Institution in 1896, responsible for administrative functions, the publishing operation, and the exchange service.

Installing him as assistant secretary of the National Museum would, however, require some artful maneuvering. An employee of the Smithsonian, paid with trust funds, Rathbun was not eligible for the federally funded museum position, which was controlled by the US Civil Service Commission. A minority of the Board of Regents, as Cyrus Adler explained, doubted Langley's judgment and "were making an effort to break the power of the Secretary and have the regents themselves elect an assistant secretary." Langley, not an adept politician, played his cards well on this occasion. He discovered prior to the January 27, 1897, annual meeting that ten individuals had applied for the position of assistant secretary for the National Museum, some of them skirting his office and communicating directly with members of the board. At the meeting, the secretary ignored the applicants, arguing that such an important decision should be carefully considered. He announced that Charles Walcott, director of the US Geological Survey and honorary curator of paleontology with the National Museum, was willing to serve as acting assistant secretary for the museum to allow adequate time to consider all the candidates. He would retain his position with the USGS during this service.[5]

Gardiner Hubbard then suggested on behalf of the Executive Committee that five members of the board, with the secretary sitting ex officio, should be appointed to three special investigative committees charged with "examining into the condition of" the National Museum, Bureau of Ethnology, and National Zoo, "with special reference to what can be done to increase . . . [their] usefulness and value." Chief Justice and Chancellor Melville W. Fuller remarked that the language of the resolutions "struck him as having some implication in it." Hubbard assured the board that he "honored the Secretary" and that no negative implication was

327

SMITHSON'S GAMBLE

intended. The chancellor, suggesting that the group should give some thought to Hubbard's resolutions, adjourned the meeting.[6]

Langley spent the next four days consulting with his friends on the board. When the regents reconvened on February 1, Chancellor Fuller called for the consolidation of Hubbard's investigating commissions into a single body of five members, with the secretary as ex officio, to suggest ways to "promote" the value of the museum, zoo, and Bureau of Ethnology. The secretary then announced that Charles Walcott had only agreed to serve as temporary head of the National Museum and was unwilling to accept even temporary responsibility for the Institution. That being the case, the chancellor accepted the secretary's suggestion that Richard Rathbun, already the assistant secretary of the Institution, be empowered to serve as acting secretary with full responsibility to act in all matters in the absence of the secretary.[7]

In January 1898, the board obtained waivers from the Civil Service Commission for the assistant secretaries and bureau heads. With the obstacle removed, Charles Walcott stepped away from his responsibilities as acting assistant secretary for the museum on July 1, 1898, and Rathbun was appointed to fill that position as well, becoming assistant secretary for the Institution and all the bureaus and acting secretary in Langley's absence. In his eighteen years as secretary, installing Rathbun as his second in command was perhaps Langley's best management decision. Like Spencer Baird under Joseph Henry, Rathbun would manage the daily operations of the Smithsonian, allowing Langley to pursue his own interests.[8]

SAMUEL LANGLEY TOOK GREAT pride in his role in establishing the Smithsonian Astrophysical Observatory and the National Zoo, but he was sure that history would remember him for the 1896 flights of Aerodromes Nos. 5 and 6. In public he insisted that while he had "brought to a close that portion of the work which seemed to be specially mine—the demonstration of the practicability of mechanical flight"—the world would have to "look to others for the commercial and practical development of the idea."[9]

In private, however, he burned to take that final step himself. "If anyone were to put at my disposal the considerable amount—fifty thousand dollars or more— for . . . an aerodrome carrying a man or men with a capacity for some hours of flight," he wrote to Octave Chanute in June 1897, "I feel that I could build it and should enjoy the task." He was confident that he could achieve the dream of the ages "within two or three years from the time the means are put at my disposal." He wrote again in December, reminding Chanute, "If you hear of anyone who is

THE AERODROME

disposed to give the means to such an unselfish end, I should be glad to meet him."[10]

It all seemed so simple. In 1897, he outlined his plans for a Great Aerodrome "that I may be called upon officially to pursue . . . in the interest of the government." Given the success of Nos. 5 and 6, he would make only such "modifications . . . as the changed scale and the presence of a man in the machine may demand."[11]

Langley broadcast the details of his 1896 achievement with lectures at home and abroad, published articles in popular magazines and specialist journals, and did interviews with any newsman who inquired. He discussed potential funding for the renewed effort with publisher Samuel S. McClure; James Means, a wealthy Boston flying machine enthusiast who published an extended account of Langley's aerodromes in *The Aeronautical Annual*; and manufacturer Albert A. Pope, who agreed to be one of fifty investors in the project and offered his shop facilities.[12]

On January 26, 1898, Langley reminded the Board of Regents that "in the intervals of his administrative duties" he had "given attention to the subject of mechanical flight and had solved the problem, so far as the actual performance of long flights with machines built of steel and driven by steam engines can be considered a solution." Now, he continued, "propositions have been made to me" to resume his aeronautical experiments leading to the development of a piloted machine. The board expressed confidence in the secretary and approved Langley's request to fund at least a portion of the cost of a piloted aerodrome from the Hodgkins Fund.[13]

Events in Cuba unexpectedly opened the way for government support of the project. In February 1895, José Martí launched a revolution aimed at ejecting Spain from Cuba. Within a year, the rebels had fifty thousand troops under arms and had wrested effective control of considerable sections of the island. General Valeriano Weyler, the new Spanish governor of Cuba, began moving people from rebel-dominated areas into concentration camps where thousands of Cubans starved or fell victim to disease. In the spring of 1897, Congress appropriated $50,000 to support Cuban Americans on the island. On February 15, 1898, the battleship USS *Maine* exploded in Havana harbor, losing 274 of 354 crew members. While modern studies suggest that the disaster was the result of a fire in the coal bunker, Americans assumed that a Spanish mine had destroyed the ship. The United States went to war with Spain on April 21, 1898.[14]

Langley met with his friend and adviser Charles Walcott on March 21 to discuss the possibility of his resigning as director of the US Geological Survey to accept a full-time administrative post with the Institution. The secretary closed

SMITHSON'S GAMBLE

the conversation by complaining of his ongoing difficulty in funding the aerodrome project. There was every possibility, he explained, "of making it into a possible instrument of war for the government, at least so far as to demonstrate by actual performance that it was capable of carrying a man or men for a flight of an hour or more."[15]

Walcott, while not yet willing to give up his post, was anxious to accommodate his friend Langley and lost no time in raising the matter with the assistant secretaries of war and the navy, George De Rue Meiklejohn and Theodore Roosevelt, respectively. Roosevelt immediately wrote to Secretary of the Navy John D. Long to suggest the appointment of a joint army-navy board to consider the matter.[16] On April 6, the members of the joint committee called at the Smithsonian. Langley, Walcott, and Alexander Graham Bell greeted them, showed them the model aerodromes, and answered their questions. Many years later, Commander C. H. Davis, a member of the committee, recalled that after listening to the secretary's presentation, he and a colleague "were not impressed and looked at each other across the table knowingly." Bell, however, "made such a forceful speech, lending the prestige of his personality and his past accomplishments, that . . . [we] both sent in favorable reports."[17]

On May 26, following a written report from Langley, General Adolphus Greely, head of the Army Signal Corps, recommended that the Board of Ordnance and Fortification (BOF) consider supporting the development of a piloted flying machine. Established by Congress ten years before, the BOF was charged with the maintenance of fortifications and harbor defenses; the acquisition and testing of artillery, gun carriage, and ammunition; and "all needful and proper purchases, investigations, experiments, and tests to ascertain with a view to their utilization by the Government, the most effective guns . . . and other implements and engines of war." As such, the BOF reviewed all plans for armaments submitted to the army.[18]

As the Great Aerodrome project began to move forward, the secretary went in search of an aeronautical assistant. He wrote to Robert Thurston on May 6, asking if he could recommend a "young man who is morally trustworthy ('a good fellow') with some gumption and a professional training" who might be interested in joining the Smithsonian staff. Charles Matthews Manly, a twenty-two-year-old Sibley College senior in mechanical and electrical engineering, arrived at Langley's office door on June 1 with a note from Thurston recommending him as someone likely "to become a helpful aid in your work." Manly accepted the secretary's offer of a position as an "aid in aerodromes" at $1,000 per annum and graduated in absentia.[19]

330

THE AERODROME

A native of Staunton, Virginia, the young engineer had spent a year at the University of Virginia before transferring to Cornell's Sibley College of Mechanical Engineering and Mechanic Arts. Accepting an initial one-year contract, Manly, a brilliant engineer with a patient and even-tempered manner, was the ideal balance for a project headed by impatient, irascible Langley. During the five-year effort to develop, build, and test the Great Aerodrome, he emerged as the project's indispensable man.

While waiting to meet with the BOF, Langley decided that even if government funding failed to materialize, he would "go on with the large aerodrome as far as limited means allow." Sketch plans of the airframe were complete, Luther Reed had the required steel tubing on hand, the old launching scow was being refurbished, and the search for an engine builder was underway.[20] The secretary finally met with the BOF on November 9, 1898. Two days later, the *Washington Post* published an inaccurate report announcing that the BOF had appropriated $25,000 for the project, with General Greely in charge and Langley providing the benefit of his "devisings [*sic*] and advice."[21]

Langley returned on December 12 prepared to sign a memorandum of understanding, contracting to build a piloted aerodrome capable of traveling through the air at a speed of up to fifty miles per hour for $50,000, with delivery within one year of the contract. The following day, General Nelson A. Miles, president of the board of the BOF, instructed Captain Isaac Newton Lewis, the board's recording secretary, to inform Langley that the board accepted his offer. The funds would be paid through General Greely's office, with the first half to be available immediately and the rest when there was evidence of progress toward the finished machine.[22]

With money in hand, planning moved forward. While he considered alternative configurations, including the possibility of a biplane, Langley was determined to stick with a tandem monoplane design that had brought success in 1896. "Mr. Reed," he explained, "is confident he can build the wings proportionally [as] light or lighter . . . as those of the . . . models which have flown." As a result, the Great Aerodrome would be plagued with a relatively weak structure in which four separate wings were bolted to a central framework. Adequate bracing to hold those thin monoplane wings in place and withstand the forces of flight represented a critical challenge.[23]

Edward Huffaker continued his aerodynamic research with the whirling table. Langley, however, was confident that since the wings of Nos. 5 and 6 had carried them aloft, the aerodynamic issues were for the most part resolved. Luther Reed would also refurbish Nos. 5 and 6 for a new round of flight tests and build a "dummy model" to test Huffaker's aerodynamic ideas.

Both Langley and Manly, like many other aerial experimenters, were convinced that it would be impossibly difficult for a pilot to exercise constant control over a machine in the air. Some degree of inherent stability would be required. Like the models, the machine would remain balanced and moving forward until the pilot made a change in direction. Various mechanical means of achieving that goal were considered and rejected. While the pilot of the Great Aerodrome would have some ability to manipulate the tail to control the pitch of his craft, he would rely on the degree of inherent stability provided by the dihedral angle of the wings upturned slightly from the central frame to the wingtips and a slight negative tail angle. That system had worked with Nos. 5 and 6, but it would mean that the operator would be little more than a passenger on the world's largest model airplane.[24]

The first note in Langley's private notebook regarding the details of the Great Aerodrome says simply, "About Horsepower." Convinced that the structural, aerodynamic, and control issues were in hand, the secretary and Manly turned their attention to propulsion. Both were convinced that the development of a suitable internal combustion engine was the most important issue to resolve.[25]

After considering other options, Richard Rathbun wrote on November 19, 1898, to Stephen M. Balzer, a New York–based engineer and inventor, informing him that the Smithsonian "was desirous of promoting the construction of specially light gasolines engines." In 1891, Balzer had built a rotary engine–powered automobile, the first to operate in New York City. He delivered a rotary-powered tricycle to the Smithsonian just two weeks after receiving the inquiry.[26] The advantage of the rotary, in which the entire engine rotates around a fixed crankshaft, is the ability to provide considerable power with very low weight. On December 5, Balzer agreed to provide for $1,500 a rotary engine weighing not over one hundred pounds and developing twelve horsepower, with delivery in ten weeks.[27]

Charles Manly advised that they develop a new means of getting the machine into the air, but the secretary was anxious to follow the pattern that had led to success. He ordered the crew to retrieve and refurbish the scow used in the 1896 trials for continued tests of model aircraft. Luther Reed prepared drawings for a larger unpowered "house boat" measuring sixty by forty feet for use with the full-scale craft. Construction began in December and was complete by May 1899. A large shed covering most of the deck would double as a workshop, sleeping quarters, and hangar for the disassembled aerodrome. The rooftop launcher would be much heavier and more complex than the system in use with the models. When complete, the new launcher rested on a turntable weighing fifteen tons that could be turned into the wind without maneuvering the boat. The Great Aerodrome, sitting

on a lightweight launching car, would be propelled by streetcar springs down eighty feet of five-foot-gauge track and, hopefully, into the air.[28]

The original launch boat was towed back down to the anchorage at Chopawamsic Island in the spring of 1899. The crew conducted flight tests with the refurbished Nos. 5 and 6 between June and August, achieving distances of up to 2,500 feet. Reed also tested a one-eighth scale unpowered "dummy" model that August. The tests demonstrated the value of a new launch mechanism intended for use with the Great Aerodrome in which the models rested on the track rather than dangling beneath it, as in 1896.[29]

By the spring of 1899, the secretary of the Smithsonian was back in the headlines, his name and face familiar to the readers of American newspapers. He was "Langley, Aeronaut," the man charged with "Aerial Navigation Work by the Government." His aerodrome, one paper predicted, would be a "Combined Airship and Dynamite Thrower" that "Flies and Fights," the "most powerful engine of war known to man."[30]

The publicity attracted letters from would-be aviators anxious to reveal the true secret of flight, if only they could share the Smithsonian's largess. Occasionally, a correspondent asked only for advice. Richard Rathbun, handling the secretary's mail, received a letter from one such person in June 1899. Assuring the recipient that he was "an enthusiast but not a crank," Wilbur Wright explained that he was convinced that "human flight is possible and practicable." He was "about to begin a systematic study of the subject in preparation for practical work to which I will devote what time I can spare from my regular business," hoping only to "add my mite [sic] to help on the future worker who will attain the final success." Outlining what reading he had done, Wright asked for any available Smithsonian publications on flight as well as other recommended readings, offering to "remit the price."[31]

Rathbun replied on June 22, enclosing pamphlets by Langley, Huffaker, Otto Lilienthal, and Louis Mouillard, along with suggested additional items. Wilbur responded with his thanks and a dollar for the purchase of a copy of *Experiments in Aerodynamics*. While the exchange must have seemed all in a day's work to the assistant secretary, Wilbur Wright's letter was an historic document, the first public announcement of his entry into the field.[32]

That fall, the first set of full-scale wings for the Great Aerodrome buckled when inverted and loaded with sand to simulate the pressures encountered in flight. Langley had visited Clément Ader's Paris workshop that summer and been impressed by his strong, lightweight construction techniques. When Reed tested a new set built on Ader's principles, secured as they would be on the finished craft, each wing supported 231 pounds of sand without deforming.[33]

SMITHSON'S GAMBLE

With the structure taking shape, Manly's attention turned to the status of work on the rotary engine underway in Stephen Balzer's machine shop. Progress had been slower than expected, and Balzer was complaining of financial problems. Unable to advance any more government money until the full-scale engine was complete, that October Langley supplied additional cash for the construction of a smaller, simpler internal combustion engine developing just one and a half horsepower to power a final test aerodrome one-quarter the size of the full-scale aircraft.[34]

Langley's account books show that he had spent $24,765.63 of the army's money by September 7, 1899. Captain Lewis responded to the secretary's request for the second $25,000 installment by explaining that the BOF required a visit and inspection before the second allocation could be approved. Manly spent time ensuring that the new houseboat was in order and that Balzer and his engine were in Washington in time for the meeting with the board.[35]

Langley, Manly, Walcott, and Bell met a committee of four members of the BOF on November 21, 1899. The group inspected the finished portions of the Great Aerodrome and Balzer's unfinished engine, as well as the new houseboat moored at the Eighth Street wharf, complete with the turntable and launcher mounted on the roof. Manly was pleased to report that the group appeared "very much interested and pleased with the progress of the work and the intricacy of the problems connected with it." Money would continue to flow.[36]

BALZER RETURNED TO NEW YORK IMMEDIATELY following the inspection, promising a test of horsepower within the week. When that had not occurred by January 3, 1900, Langley dispatched Manly to speed things along. Promised that an additional $400 would produce a working engine, the secretary's limited patience was stretched to the breaking point. Manly and George Wells, a Smithsonian machinist, accompanied Langley to England and France that summer to consult with authorities on lightweight gasoline engines. Langley remained in France into September, visiting the circus tent hangar of Alberto Santos-Dumont, the Brazilian experimenter who was the talk of Paris for cruising low over the city in his one-man dirigible airships.[37]

Discovering that Balzer was still struggling to complete the engine that August, an exasperated Manly ordered it packed and shipped to the Smithsonian along with the unfinished quarter-scale motor. Having taken personal command of the propulsion problem, he transformed the rotary engine into a five-cylinder fixed, water-cooled, radial power plant, increasing the weight but opening the way to greater power. In the months to come, Manly and a team of machinists added

new and larger cylinders, an improved ignition system, and other modifications. During a visit by Captain Lewis on June 28, 1901, the engine produced more than thirty horsepower.[38]

The work on both the full-scale and quarter-scale engines, as well as the airframes, required expanded shop facilities in the South Shed. Seven machinists and three carpenters were hard at work on aspects of the project. Manly was employed full-time on the enterprise, with Langley, Watkins, and Rathbun devoting a great deal of time to the effort. The secretary maintained tight control over the operation. Manly and the key workmen kept waste books in which the secretary expected to see a close account of daily activities.[39]

Langley's correspondence with Octave Chanute enabled him to keep track of other experimenters. The Chicago engineer was especially anxious to ensure that the secretary remain abreast of Wilbur and Orville Wright. In December 1901, Chanute sent a long letter describing the brothers' glider in detail and providing a record of their flights from Big Kill Devil Hill on the Outer Banks of North Carolina that season. In October 1902, he commented that the Wrights "have acquired so much of the art of the birds that I think they should proceed further."[40]

Langley also corresponded with a circle of Boston-based aeronautical enthusiasts: James Means, Harvard meteorologist Abbot Lawrence Rotch, and kite specialist C. H. Lamson. The secretary acquired a series of experimental kites from Lamson and considered hiring him to construct a set of wings for testing. He drew on the Hodgkins Fund to support Boston-based inventor and educator A. A. Merrill's aerodynamic research. Manly corresponded with Chanute as well. At Chanute's suggestion, the Smithsonian engineer visited an Atlantic City display of a large monoplane constructed by machinist Gustave Whitehead in September 1901. He judged the craft "so flimsy that I doubt whether the framework would hold together."[41]

Manly focused efforts on the engine for the quarter-scale aerodrome in the spring of 1901, modifying it from a rotary engine to a fixed radial fueled with naphtha. The model was intended to be a final test of the balance and aerodynamic qualities of the Great Aerodrome. The engine would operate without a cooling system, as Manly was unwilling to put more time and effort into the model. Flight tested at the usual anchorage on June 19, 1901, the craft covered 350 feet. The little engine was unable to keep the model aloft for a longer flight.[42]

On October 15, 1901, Manly reported that all $50,000 of government money had been spent and provided a status report. With Alexander Graham Bell's approval, the secretary applied the $10,000 of the Bell-Kidder fund originally intended to support astrophysical research to keep the aerodrome project moving.

Six months later, in April 1902, he reported that they had spent $4,057.10 of the fund to date. In addition, Langley would spend $13,000 of Hodgkins Fund money to carry the project through to the end.[43] By November 1902, Langley could finally report to Captain Lewis that "everything is ready, and were there still time this season, a flight would be made, but I do not expect one until after the ice has gone." He warned, however, that he had never known a first test to go "without some mischance" and suggested the possibility of a "first smash."[44]

The secretary spent some weeks that fall photographing birds in flight over the National Zoo. Langley had carried on a yearslong discussion on the mechanics of bird flight with Robert Ridgway. To answer questions regarding the alterations in the wings of birds maneuvering aloft, Ridgway had developed his own version of the gun camera invented by Étienne-Jules Marey to capture the details of animals and humans in motion. With the gun butt nestled firmly against his shoulder and a magazine of film mounted on the device, he could aim and shoot, capturing split-second images of nature's wings in action.

Langley was in Europe on July 15, 1903, when Manly, Reed, and the crew moved down the Potomac aboard the large houseboat, the cabin loaded with the disassembled Great Aerodrome. Manly reported to Rathbun that a second flight test of the quarter-scale aerodrome on the morning of August 8 "was entirely successful." While the small craft flew for only eighteen seconds, "I am entirely re-assured as to the equilibrium, power and supporting surfaces of the large machine." He spent considerable time drilling the crew in procedures for mounting the Great Aerodrome on the launcher. Given the small deck area, the process of assembly required the transfer of the frame first and then the wings and tail to a raft, then raising them to the roof. The effort, he noted, involved "great difficulty . . . with great risk of injury."[45]

Mid-August brought bad weather and high winds that forced the houseboat from its mooring three times. Manly wrote to the secretary on August 12, noting with some pride that the engine was producing fifty-two horsepower. Langley replied three days later, suggesting that the astounding horsepower might not be sufficient for flight, concluding that he was "deeply troubled" and "almost ready to ask if it is desirable to try the momentous experiment at all, under such conditions, or might the flight be tried without the weight of an aeronaut." While he tried to allay the secretary's concerns, Manly had to report another month's delay when a propeller broke at the hub and then smashed into the frame during a test on September 7.[46]

With the wind gusting from twelve to eighteen miles per hour, October 7, 1903, was not the best day for a test flight. Manly, however, had waited long enough

Machinists (*left to right*) R. S. Newham, Fred Hewitt, Luther Reed, George MacDonald, William Endriss, Charles Darcy, and Harvey Webb, December 8, 1903. The Smithsonian employed a number of machinists to build Langley's aerodromes, culminating in an unsuccessful December 1903 launch. Here, they pose aboard the Aerodrome's launching houseboat on the Potomac River in Washington, DC. *National Air and Space Museum Archives*

for the perfect weather. G. H. Powell, who had replaced Isaac Lewis as secretary of the Board of Ordnance and Fortification, arrived that morning accompanied by board member Major Montgomery Macomb and Dr. F. S. Nash, an army contract surgeon. Smithsonian photographer Thomas Smillie was on hand with two assistants. Captain Stehman Forney of the US Coast and Geodetic Survey had come downriver with a launch and crew to assist. Luther Reed, who had supervised construction of the Great Aerodrome, head mechanic McDonald, and Smillie remained on board. The other workmen were split between two tugs, the *D. M. Key* and the *Bartholdi*, one stationed within hailing distance of the houseboat and the other, optimistically, a mile to the south. Reporters were gathered on shore and in small boats.[47]

Sitting on the launcher, the Great Aerodrome measured fifty-six feet, five inches from the tip of the bowsprit to the spot where the cruciform tail met the fuselage. Two pyramid guy posts on top of the machine and two below held the wings in place. The four wings, each built with ten ribs, leading edge, and central spar, spanned forty-eight feet, five inches. The craft weighed 750 pounds with the pilot on board.

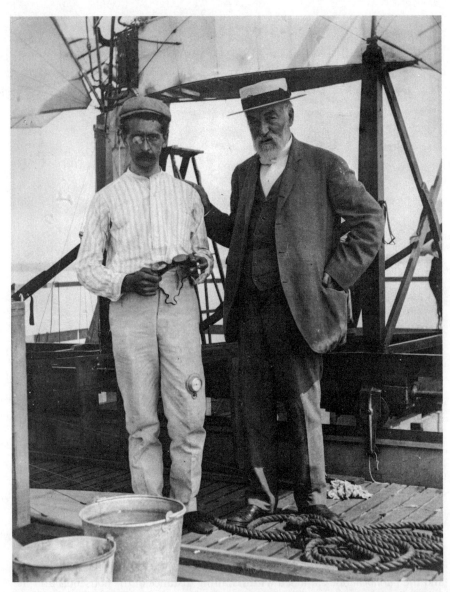

Charles Manly (1876–1927) with Samuel Langley, December 8, 1903. Manly, an engineer and inventor, was instrumental in helping Langley build the Great Aerodrome and even volunteered to pilot the machine. Here, Manly (*left*), in his flying togs, stands with Langley before the attempted launch of the pioneering manned flying machine on December 8, 1903. *National Air and Space Museum Archives*

THE AERODROME

The five-cylinder, water-cooled Manly-Balzer engine turned a pair of contrarotating two-bladed propellers.[48]

The operator occupied a canvas-covered "car" between and below the forward wings. Sitting facing the left wing, he could operate two small wheels that would hopefully enable him some pitch control. The possibility of strapping him into place had been abandoned in favor of allowing for a quick exit from the machine in an emergency. It was a wise decision. The operator's car was the lowest part of the craft. In the event of a completely successful flight, with the machine traveling through the air a mile down the Potomac and settling gently to a stop in the river, the would-be aviator would be under water.[49]

Manly was dressed for the occasion in a shirt, light trousers, cap, canvas shoes, and a cork jacket. The secretary had considered other candidates for the honor of piloting the craft, but Manly, who knew the Great Aerodrome better than anyone else, was the obvious choice. He assured Langley that "I fully recognize the danger to which I should be subjected to in free flight and I do so entirely at my own suggestion and of my own free will."[50]

It was over in seconds. At Manly's signal, the machine rushed down the track and plunged into the river, as one reporter noted, "with all the rude directness of an unsupported brickbat." Pulled from the water, the would-be aviator immediately wired the secretary: "Experiment today at 1220 unsuccessful balancing incorrect too heavy in front struck water 100 yards from the boat no injuries whatever. Expect me at the institution tomorrow."[51]

The newspaper coverage was merciless: "'Buzzard' A Complete Wreck," "Airship is a Failure," "Airship Still Airless," they quipped regarding "Professor Langley's Hot Air Ship." Langley and Manly were both convinced that the launcher had failed to release the machine properly. Thomas Smillie's photo, taken looking straight up from the houseboat deck as the machine rushed down the rail, clearly shows seriously deformed front wings and failing rear wings. The image suggests that catastrophic failure was well underway before the aerodrome reached the end of the rail.[52]

The carpentry and machine shops required two months to rebuild the craft. While it seemed sensible to wait until spring for another trial, the secretary decided to make a second attempt before the end of the year. He may have feared that the ridicule directed at him would solidify and somehow blunt a success if it came in the spring. His real concern, however, was financial. With the coffers empty, he could not afford to keep on the payroll the dozen or so skilled workers who had built the craft and were familiar with launch procedures.

339

SMITHSON'S GAMBLE

Rather than attempt winter operations downriver, the secretary decided to conduct his second trial in a wide part of the Potomac near Arsenal Point. With repairs to the aerodrome complete by early December, Langley and Manly waited for reasonable weather. December 8, 1903, dawned clear and cold, with temperatures predicted to rise into the upper forties by late afternoon. At 2:00 p.m., the *Bartholdi* nudged the houseboat, with the central frame of the Great Aerodrome mounted on its roof, away from the Eighth Street wharf.[53]

General Wallace, now head of the BOF; G. H. Powell; and a Dr. Faust were on hand. The Smithsonian contingent, which included both Langley and Cyrus Adler, was larger. Onlookers gathered along the seawall of the Washington Arsenal. A party of officers from the Washington barracks watched from a government tender anchored nearby. The *Washington Post* reported that a "fleet of launches, sailboats, and rowboats gathered around the spot, determined to be in at the finish."[54]

Aboard the houseboat, Manly, Reed, and the crew struggled to attach the wings and tail in a shifting wind, "so that the aerodrome was at one moment pointed directly into it and at the next moment side gusts striking under the port or starboard wings would wrench the frame severely, thus tending to twist the whole machine from its fastenings on the launching car." Manly gave the signal to release the craft at 4:45 p.m. Later, he described what happened:

> The writer . . . found the machine dashing ahead with its bow rising at a very rapid rate, and that he, therefore, swung the wheel which controls the Pénaud tail to its extreme downward limit of motion. Finding that this had absolutely no effect, and that by this time the machine had passed its vertical position and was beginning to fall backwards, he swung himself around on his arms, from which he supported himself, so that in striking the water with the machine on top of him he would strike feet foremost.[55]

Manly freed himself from the tangled wreckage and made his way to the surface. Fred Hewitt, a Smithsonian workman, jumped into frigid water to help him. Private Adelson of the Army Signal Corps pulled both men into his skiff. A few minutes later, Manly, cut out of his wet clothes, wrapped in a warm blanket, and fortified with whiskey, delivered a "most voluble series of blasphemies."[56]

Cyrus Adler, anxious to correct the general impression "that this accident broke Mr. Langley's heart," reported that the secretary was "in perfectly good humor and quite philosophical" when they dined on the evening of December 8. The astronomer and instrument maker John Brashear, a close friend from

Launch of the Great Aerodrome, December 8, 1903. Just seconds after the launch of Langley's Great Aerodrome, the machine fell apart and crashed into the Potomac River, reduced to a tangle of wood, wire, and fabric. The pilot, engineer Charles Manly, survived unscathed.
National Air and Space Museum Archives

Pittsburgh days, met with a very different Samuel Langley shortly after the crash. "As I entered his office at the Smithsonian Professor Langley met me . . . grasped both of my hands and said 'Brashear, I'm ruined, my life is a failure.' . . . He cried like a child."[57]

THE SECRETARY AND MANLY WERE CONVINCED that on both occasions the launcher had failed, allowing the aerodrome to scrape along the rail, destroying the lower front guying pyramid on the first test and the rear structure in December. Major Macomb, who wrote the official War Department account of the aerodrome project, agreed."[58]

Modern authorities, based on an analysis of the structure, have a different view. Raymond Bisplinghoff, Holt Ashley, and Robert L. Halfman, in their classic text, *Aeroelasticity*, concluded that "in the light of modern knowledge, it seems likely that the unfortunate wing failure which wrecked Langley's machine . . . in 1903 could be described as wing torsional divergence." In simple terms, the air pressure on the structure was greater than its resistance to torsional forces and twisted the wings off the frame.[59] NASA engineers performing a wind tunnel test on a replica of the aerodrome wing in 1981 confirmed that in view of an "overall lack of structural rigidity, especially torsional rigidity of the wing and fuselage, it [is] highly probable that the collapse of the machine during launch can be attributed to . . . overload due to elastic deformations." In 2004, with the cooperation of the National Air and Space Museum, Lorenzo Auriti, a graduate engineering student at the University of Toronto, conducted a full analysis of the aerodynamic qualities of the Great Aerodrome, concluding that it "was not capable of flight as launched off the houseboat. The wing loads found were higher than the structure could support."[60]

CHAPTER 20

THE END OF AN ERA

"YOU DOUBTLESS SAW IN THE NEWSPAPERS on Saturday . . . the report that the Wright brothers had flown a distance of 3 miles on December 17," Charles Manly wrote to Secretary Langley on December 23. Manly had written to Octave Chanute as well, who confirmed that the brothers had indeed made four flights, the longest lasting fifty-seven seconds. Manly had to admit, while the newspapers had exaggerated, "this makes quite an advance." Two years later, when the Wrights had dropped from public view to continue developing their machine in the security of an Ohio cow pasture, Manly urged Langley to make a third try, this time reconfiguring the Great Aerodrome to operate from land, without the catapult. The secretary dismissed the notion. Having suffered at the hands of both the press and Congress, he had put the dream of flight behind him.[1]

The failure of the Great Aerodrome brought the wrath of Congress down on the Board of Ordnance and Fortification. On January 23, 1904, Representative James M. Robinson attacked the board for having "permitted an expenditure . . . of thousands in a vain attempt to breathe life into an air-ship project which never had a substantial basis." Langley, he suggested, was "wandering in his dreams of flight . . . given to building castles in the air." Representative Gilbert Hitchcock inquired of James Hemenway, chairman of the House Committee on Appropriations, "If it is to cost us $73,000 to construct a mud duck, how much is it going to cost to build a real flying machine?"[2]

Hemenway did his best to defend the BOF, noting that members of the House "got up and laughed" when the appropriation for the telegraph was under discussion. Robinson retorted that, as a military weapon, "a regiment of them [aerodromes] would not conquer the Fiji Islands, except, perhaps, by scaring their people to death." The *Brooklyn Daily Eagle* quoted Hitchcock as saying, "You can tell Professor Langley for me . . . that the only thing he ever made fly was government money." When the secretary returned to the BOF for funds with which to mount

another try, his request was rejected. Langley's quarter century of flying machine experiments was at an end.[3]

Cyrus Adler reported an attempt to remove Langley from office in the wake of the aerodrome disaster. The secretary responded that while he "liked the place as Secretary of the Smithsonian . . . I shall never fight for it . . . I shall not lift a finger." Adler concluded that "I and others did lift our fingers and the attempts to remove him were aborted."[4]

LANGLEY TURNED FROM THE bitter disappointment of the aerodrome project to face other problems. Like Baird, he struggled to manage the Bureau of Ethnology. From the outset, Langley let the anthropologists know who was in charge. Early in 1891, he issued a confidential memo announcing that the bureau would be treated as a unit of the Smithsonian like the museum, the astrophysical observatory, or the zoo. The secretary would henceforth handle personnel issues, control the purse strings by insisting that all purchases be made through the Smithsonian's disbursing clerk, and expect Director John Wesley Powell to confer more frequently.[5]

Powell gave serious thought to the matter before replying on June 11. After tracing the history of the bureau, underscoring the fact that it was his creation, he commented that the proposed changes "would add to the labor and responsibility of the Secretary and relieve the Director of the same." Noting the absence of fiscal or managerial problems under his leadership, he closed by calling on the "favor of your friendship, which I have had for many years, I hope to retain, even though I speak so frankly and freely." Langley raised the issue with the Executive Committee of the board on June 12. While they upheld Langley, he was advised "to remove any misapprehension on the part of the Director of the Bureau." There would be increased fiscal controls, a continuation of $5,000 of the budget at the secretary's disposal, and more frequent consultation, but Powell would continue to lead the bureau as he always had and became one of the secretary's trusted advisers.[6]

Shifting perspectives in the Bureau of Ethnology made both men nervous. Lewis Henry Morgan's theory of cultural evolution guided the work of Powell's bureau. In this view, the goal was to salvage the language and material culture of Native Americans because their inevitable progress from savagery to civilization guaranteed assimilation and the disappearance of traditional ways. Like his colleague Frank Cushing, James Mooney, who began as a Powell disciple, came to recognize the limitations of the old paradigm. As a result of extended field experience, both men developed an appreciation for different traditions and reacted against social evolution. They were taking the first steps toward cultural relativism, a

cornerstone of professional anthropology established by Franz Boas early in the twentieth century.[7]

The son of Irish Catholic immigrants, Mooney was born in Richmond, Indiana, in 1861. Educated in local schools, he went to work as a typesetter and editorial writer for the *Richmond Palladium* in 1880, but he was determined to pursue his childhood fascination with Native Americans and make a career in ethnology. When three years of letters to the bureau failed to gain a position, Mooney traveled to Washington and met with Powell in person. Impressed by the young man's commitment and enthusiasm, Powell offered to take him on as an unpaid volunteer until the next appropriation. He began work in the office on April 24, 1885, and was finally sworn in as a government employee in August 1886.[8]

It was in his fieldwork with the Eastern Cherokee (1888–90) that Mooney began to distance himself from bureau orthodoxy and appreciate the deeper meaning of cultural traditions. "In the study of . . . Indian medicine," he wrote in 1890, "disappointment at the misconceived ideas of diseases, and the lack of practical therapeutic results, soon gives way to admiration of the systematic consistency of theory and practice, and respect for the deep religious spirit which animates it all."[9]

By 1890, Americans assumed that the centuries of conflict with Native Americans were behind them. That October, however, newspapers reported discord sweeping across the reservations. Wovoka, a Paiute visionary in western Nevada, began prophesying that a time would come when the white man would be gone, death would be vanquished, and Indians living and dead would again roam the plains as they once had. Rituals, including a circular Ghost Dance, would speed that day. Messianic fervor spread from tribe to tribe, as a defeated people grasped at the possibility of reversing the tide of history. Sioux warriors on the Standing Rock and Pine Ridge reservations began wearing Ghost shirts said to protect them from the white man's bullets. As Mooney later emphasized, the movement was peaceful and the threat of violence was largely imagined by panicked and incompetent Indian agents, until a disastrous series of encounters in Lakota territory.

On December 29, 1890, an ill-considered attempt on the part of a group of Seventh Cavalry troopers to disarm a refuge-seeking band of Miniconjou Lakota led to a massacre along Wounded Knee Creek in South Dakota. Between 250 and 300 Native American men, women, and children, mostly unarmed, were killed or wounded. Twenty-five soldiers died, most victims of friendly fire in the confused melee. But the Wounded Knee Massacre did not end the Ghost Dance movement.[10]

Powell dispatched James Mooney to investigate the Ghost Dance phenomenon late in 1890. Mooney made six field trips from 1890 to 1893, during which he spent

twenty-two months on the road, traveled thirty-two thousand miles, and visited some twenty tribes. He found active adherents among the Arapaho, Sioux, Cheyenne, Kiowa, Comanche, Apache, and Caddo, and interviewed the prophet Wovoka. He participated in the Ghost Dance on at least one occasion. The result of his effort, *The Ghost-Dance Religion and the Sioux Outbreak of 1890*, was perhaps the finest research report issued during Powell's tenure at the bureau. Mooney began by tracing the history of prophecy and resistance to white encroachment among Native Americans, then covered the rise and impact of the Ghost Dance, the crisis of 1890, and the continuation of the movement. He provided a record of Ghost Dance songs and chants in the second half of the volume.[11]

Mooney closed the narrative half of his book by drawing parallels between the Ghost Dance and similar phenomena in "other systems," including Christianity. Speaking of Jesus Christ, he wrote, "In the transfiguration on the mountain, when 'his face did shine as the sun,' and in the agony of Gethsemane, with its mental anguish and bloody sweat, we see the same phenomena that appear in the lives of religious enthusiasts from Mohammed and Joan of Arc down to George Fox and the prophets of the Ghost dance."[12]

Secretary Langley saw the page proofs of Mooney's book in May 1897, just before publication, and immediately wrote to Powell. While he admired Mooney's "literary skill" and appreciated his "large sympathy" with the Ghost Dance believers, he was aghast that a Smithsonian employee made an "explicit statement that the doctrines of the Christian religion and the practices of its prominent sects among us, are essentially those of the Indian Ghost dance, and like that, founded on the illusion of dreams." He feared the reaction of congressmen when their devout constituents found their cherished beliefs "wounded in a government publication." That portion of Mooney's manuscript "had better been left unwritten," he commented, asking, "Is it quite too late to modify this?"[13]

Powell admitted that the section in question was "likely to provoke criticism," adding that, alas, it was too late to make a change. He had obviously seen Mooney's manuscript from an early stage and done nothing to edit or censor it, indicating that he was simply mollifying the secretary.[14] That did not mean, however, that Powell agreed with Mooney's approach or conclusions. The author's central argument was that the Ghost Dance was the latest in a string of messianic religious movements to be found in a wide variety of cultural traditions stretching back to the Old Testament. He flew in the face of Powell, W J McGee, and the social evolutionists of the bureau and the museum. This key episode indicates the laudable degree of intellectual freedom that marked Powell's bureau. The issue was moot,

however. Far from opening the Institution to attack, Mooney's book drew high praise from all quarters.

Mooney was involved in a genuine controversy in the summer of 1903 when he and his friend George Dorsey of the Field Museum attended a Sun Dance at the Cheyenne reservation in Montana. The ceremony involves a demonstration of personal sacrifice to bring honor and good fortune to the family. An Indian agent accused the anthropologists of paying a participant to walk through camp dragging a cow skull attached by a line to skewers through his chest muscles so they could photograph him. An investigation by federal officials cleared the scientists. Mooney remained with the bureau until his death in 1922, an active contributor to scientific publications and research-based displays for six major exhibitions.[15]

ON OCCASION, AN EXASPERATED LANGLEY was forced to step in to resolve problems beyond Powell's control. On June 3, 1901, Matilda Coxe Stevenson wrote to Major Powell requesting to be sent back into the field to conduct research among the San Juan and Santa Clara peoples. The "one thing that would restore me to my old condition of health," she noted, "would be a return to the dry clear climate of the Rocky Mountain region." Her note crossed paths in the mail with a letter from W J McGee explaining that Powell was furloughing Stevenson and would be paying her "on the basis of the purchase of manuscript rather than on a monthly basis."[16]

Powell finally responded to Stevenson's note on June 20, expressing his deep sympathy "with you for your loss of health and I can appreciate it the more because my daughter is troubled in the same manner with neurasthenia." His advice was "to seek that rest and retirement from active life which will conduce to your restoration to health." McGee, Powell concluded, had begun "editorial work" to prepare her Zuni manuscript for publication. McGee wrote again on July 20, giving official notice of her furlough.[17]

Tilly Stevenson was not a shrinking flower given to neurasthenia. It was apparent to her that Powell had decided to replace a "difficult" woman with a younger male ethnologist. She responded through her attorneys on July 31, "emphatically" protesting the furlough, objecting to any alterations to her Zuni manuscript, and demanding to be reinstated as a salaried ethnologist. Unless her rights were restored, she promised to "lay the matter before Congress." Losing control of the issue, Powell briefed the secretary, who wrote to Stevenson on December 28, concluding, "I cannot feel that any injustice has been done you."[18]

As promised, Tilly shared the correspondence with the White House, Pennsylvania representative and Smithsonian regent Robert Adams Jr., and Colorado

senator Henry M. Teller. On January 16, Langley sent a memo to Powell describing a visit from Teller, concluding, "I have promised the Senator that the matter shall have my full consideration." Tilly Stevenson was soon back on staff with full pay and finished her masterwork on Zuni without the assistance of W J McGee.[19]

JOHN WESLEY POWELL, AGE SIXTY-EIGHT, died of a stroke at his vacation home in Maine on September 23, 1902. He was, the *Washington Post* noted, "one of the world's great scientists." Private services were held at the Powell home on M Street NW on the morning of September 26, followed by a public commemoration that afternoon in the lecture hall of the National Museum. Secretary Langley headed the list of honorary pallbearers, which included Walcott, McGee, Frank Baker, and William Dall. William Holmes, Cyrus Thomas, and bureau photographer Jack Hilliard were among the active pallbearers. He was laid to rest in Arlington National Cemetery, as a bugler from Fort Myer blew taps.[20]

Not all of the major was interred at Arlington, however. Powell and McGee had a running debate as to whose brain was larger and agreed that the question would be settled after death. McGee, Baker, and Dr. Daniel S. Lamb of the Army Medical Museum arranged for Dr. Edward Anthony Spitzka, a leading anatomist, to autopsy Powell and study and preserve his brain. True to their agreement, Spitzka also preserved and weighed McGee's brain following his death at the Cosmos Club on September 4, 1912. Powell won the bet, with a brain weight of 1,448 grams as opposed to 1,410 for McGee.[21]

Powell's declining health had caused some concern on Capitol Hill. On February 18, 1902, Joseph Cannon, the all-powerful chairman of the House Committee on Appropriations, told Secretary Langley, "I shall wish to know that you have a direct charge over there, and will trust you to see that things go right." Langley realized that Powell's death would provide an opportunity to tighten his control of the bureau. The day after Cannon's visit, Langley told Holmes that, when the time came, he, not McGee, would head the Bureau of American Ethnology (BAE).[22]

Holmes was reluctant to accept the promotion. McGee was a close friend and an ally in skirmishes with Frederic Putnam, Charles Abbot, and others who believed that Paleolithic humans had reached North America. Holmes and McGee's arguments against ancient Americans drove proponents from the field. Aleš Hrdlička would join their campaign in 1902 and remained unyielding on the question, even when archaeological finds in the 1920s clearly proved him wrong. The secretary insisted that Holmes take charge of the bureau while remaining the head of anthropology with the National Museum. The dual appointment would draw the bureau closer to the Institution.[23]

THE END OF AN ERA

Langley's opposition to McGee was deep-seated and long-standing. He had opposed his transfer from the US Geological Survey to the bureau in 1893. "Now that I have known him for ten years," he commented to Rathbun, "I see no reason to change my opinion." Sensing Langley's attitude, McGee sought to strengthen his position by visiting Alexander Graham Bell, a member of the regents' Executive Committee, at his home in Baddeck, Nova Scotia. On September 27, 1902, just four days after Powell's death, he wrote to the secretary requesting that "my designation be changed . . . to Director of the Bureau of American Ethnology." The same day, Bell addressed a letter to Langley offering enthusiastic approval for McGee's suggestions for expanding the bureau's portfolio to include the study of inhabitants of the new American overseas empire as well as "all the races that inhabit the United States . . . [and] the blending of the races into a new people."[24]

Learning that he had been passed over, that Holmes's title would be reduced from "director" to "chief," and that the bureau would be treated as other Smithsonian departments, McGee organized a campaign to reverse the decision. A groundswell of letters and telegrams from anthropologists, university presidents, and state and national political figures poured into Langley's office and to the Board of Regents through October and November, all insisting that McGee was the man for the job and urging that the bureau retain a degree of independence from the Castle.[25] The weight of a score of letters from highly placed academics and politicians could not persuade Langley to change his mind on McGee. Franz Boas launched an assault in the pages of *Science*, applauding McGee for the "ability, straightforwardness and success with which he has conducted the Bureau under peculiarly difficult conditions." He agreed with McGee's plan to radically expand the portfolio of the BAE to include a study of the "physical and mental characteristics of Indian half-bloods, of negroes and mulattoes, and the effects of adaptation and amalgamation of the many European nationalities that settle in our country."[26]

Alexander Graham Bell had supported Langley, funded his research, and applauded his successes. Langley had disappointed him in failing to offer enthusiastic support for the establishment of a national university, or for his notion of pooling all government scientific resources and inviting private researchers to make use of them. Now, Bell led an attack from within the board. At a special meeting on March 12, 1903, he proposed that a committee be appointed to consider resolutions that would require the "advice and consent" of the board for all appointments to congressionally funded bureaus. He went a step further on December 8, insisting that, while the secretary had full charge of the Smithsonian, "it rested with the Board of Regents to make appointments in the Governmental

349

SMITHSON'S GAMBLE

bureaus down to the smallest detail." Langley responded that his "action in appointing a successor to the head of the Bureau of [American] Ethnology was in the strictest accordance with precedent." The chancellor closed the issue by remarking that Langley was "perfectly correct."[27]

The secretary seized on the discovery that Frank Barnet, chief clerk of the bureau under McGee's leadership, had forged checks and misappropriated federal funds. He appointed an internal committee of loyalists to investigate the management of the bureau. It was chaired by Cyrus Adler and included Frank Baker and William deC. Ravenel, administrative assistant for the National Museum since 1902. The hearings ran from May 11 to the end of July and included abundant testimony as to the loose management of the BAE.[28]

Aware that his prospects with the bureau were limited, McGee requested a three-month leave of absence on July 31 to accept the position of director of anthropology at the Louisiana Purchase Exposition. Holmes refused, as instructed. McGee presented a letter of resignation that Rathbun immediately accepted. Following the exposition, McGee worked with the Soil Conservation Division of the Department of Agriculture. His wife, Anita McGee, entrusted the care of their two children with a private nurse, earned a medical degree, and spent the years 1904 and 1905 organizing the medical service for the Japanese army during the Russo-Japanese War. William John McGee died of cancer in 1912.[29]

DESPITE THE FAILURE OF THE Great Aerodrome and a taxing battle for the bureau, the secretary could point to some genuine successes. On December 2, 1901, steel baron and philanthropist Andrew Carnegie called on President Roosevelt and then, at the president's suggestion, met with Langley. He followed his visit with a letter to the secretary dated December 27, asking him to join a board of trustees who were to advise a Carnegie Foundation that he was endowing with $10 million of 5 percent bonds "for the encouragement of research and kindred purposes." Presenting the matter to the board on January 20, the secretary commented that "scarcely since the foundation of the Institution has any event occurred of more interest to it than this Carnegie bequest." With the approval of the board, Langley became a founding trustee of a second Washington institution that would shape the future of American science and public policy.[30]

The expansion of the US National Museum into a second building devoted to research and the display of collections was a major step forward for the Institution. As early as 1882, Spencer Baird noted that as "large and capacious as is the new Museum building, it had proved already inadequate to the existing requirements of the National Museum." In 1877, Congress appropriated $250,000 for a large

350

Samuel Langley (with shovel) breaking ground for the US National Museum (now the National Museum of Natural History), June 15, 1904. Smithsonian employees Richard Rathbun, William deC. Ravenel, and Charles Walcott drove the creation of the museum, working with Congress to develop a plan and secure funding. *Smithsonian Institution Archives*

storehouse, with no additional exhibition space. Senator Justin Morrill, a regent, persuaded the Senate to vote $500,000 in 1888, 1890, and 1892 and $250,000 in 1896 for a new museum. The House refused to consider the measures. After considerable negotiations, and with the strong support of Charles Walcott, the Sundry Civil Appropriations Act of June 28, 1902, included funds for planning the new building, the construction of which was not to exceed $1.5 million.[31]

Langley, focused on the aerodrome project, had little to do with the drive to create a new National Museum Building. Richard Rathbun, administrative assistant Ravenel, and Walcott, working with a committee of congressional regents, developed a plan and report offering two choices that was delivered to the House Committee on Appropriations on January 22, 1903. It called for a "fireproof steel-frame brick and terracotta" building to rise between Ninth and Twelfth Streets NW. Congress, choosing the more expensive option, appropriated $3 million for the project on January 30, 1903. The architects Hornblower & Marshall designed a neoclassical building with an ornate dome that Langley opposed. Architects Charles McKim and his partner Daniel Burnham, members of the McMillan Commission charged with the beautification of the Mall, resolved the dispute with the design of a lower, tiled dome and a columned entrance facing the Mall.[32]

Secretary Langley turned the first shovel of earth for the new building on June 15, 1904. Richard Rathbun; Joseph Henry's only surviving daughter, Caroline; and Solomon G. Brown, the first African American employee hired fifty-two years before, were invited to participate. Now seventy-four, Brown was still chief of the shipping division. He would retire in 1906. He remarked to a reporter that he was sorry to see a grove of trees destroyed to make room for the new building. "I remember well the first tree that was set out, a tree from Scotland imported by Mr. [Andrew Jackson] Downing and Prof. Henry," he recalled.[33]

The opportunity for the Langley administration to establish an additional new museum was quite unexpected. At the January 25, 1905, annual meeting of the board, the secretary reported that he had, over the past year, discussed the possible gift of a considerable collection of art with Charles Lang Freer. Born in 1854 in Kingston. New York, young Freer quit school in the seventh grade and was clerking in a store when he met Frank J. Hecker, who hired him as accountant and paymaster for a local railroad. By 1880, twenty-six-year-old Freer had relocated to Detroit and worked with his mentor to found a firm producing railroad rolling stock. In 1899, he arranged the merger of thirteen firms to create the American Car and Foundry Company. Having made his fortune, he retired.

A print collector for some years, Freer met James Abbott McNeill Whistler in March 1890 and arranged to purchase a copy of every print the artist produced. He also began acquiring paintings by the artist. Whistler's grateful wife, Beatrice, made a pen-and-ink sketch of Freer with a halo in the early 1890s. He also acquired works by contemporary American painters, including Abbott Handerson Thayer, Dwight William Tryon, Thomas Wilmer Dewing, and Albert Pinkham Ryder. In 1894, Freer made the first of several tours of the Middle East, South Asia, China, and Japan, which marked the beginning of what would become one of the world's greatest collections of Egyptian, Islamic, and Asian art.[34]

In 1902, Charles Moore, who had been administrative assistant to Michigan senator James McMillan, first discussed with Freer the possibility of donating his collection to the Smithsonian. Freer visited the secretary in the spring of 1903 and described the collection, which included 885 paintings and works on paper as well as the famous Peacock Room, all by Whistler; fifty works by other American painters; and thousands of works of Asian art on paper and wood, screens, 950 pieces of pottery, bronzes, lacquerware, and wood carving dating from the tenth to the nineteenth century. Freer also agreed to pay $500,000 to the regents for the construction of a museum to house the works.[35]

There were conditions. Freer insisted on including the Peacock Room and on designing the interior spaces of his museum in cooperation with the regents.

THE END OF AN ERA

Noting that the collection had been assembled with great care, and with the relationships of the individual items in mind, Freer insisted that no additions or deletions be made after his death, no other items were ever to be exhibited with the collection, none of his items were ever to be loaned, no admission was to be charged, and the building "shall always bear my name in some modest and appropriate form."[36]

Langley, Bell, and two other regents visited Freer's home in Detroit where he produced items one at a time for their admiration. The regents certainly wanted to accept Freer's offer but balked at the conditions that would constrain the use of the collection. Discussions stalled until late in 1905 when Charles Moore described the situation to President Roosevelt. On December 4, 1905, Senator John Henderson of the Executive Committee ordered Cyrus Adler and William Holmes to accompany him to a meeting on the Freer Collection with the president at the White House. In no uncertain terms, Roosevelt announced that "the gift ought to be accepted, with conditions or without them."[37]

On December 6, Roosevelt wrote to Freer: "I desire to speak to you about the magnificent gift you desire to make to the government and which I wish to see accepted without haggling or quibbling." The "haggling and quibbling" would continue for another year. Once again, Langley stepped aside while Bell took command of negotiating a final agreement, which was unanimously accepted by the board on January 24, 1906.

JUNE 5, 1905, RANKED WITH THE Aerodrome crashes as the worst day of the Langley administration. The secretary was informed that the Institution's bank account showed a deficiency of $362.80 rather than a balance of $46,644.23, as shown on the books. Alerted, Rathbun immediately questioned P. M. Dorsey and a second clerk in the accounting and dispersing office. The evidence pointed to William Wesley Karr, who arrived at the Smithsonian in 1878 and was one of the secretary's most trusted advisers.[38] "Everybody was afraid of Langley, except Mr. Karr," Charles Abbot recalled. "Mr. Karr had no fear of addressing him, and Langley could never browbeat him." Clearly, a bit of browbeating would have been in order. Langley swore out a warrant on June 7, and Karr was taken into custody at his home that evening.[39]

Under Henry and Baird, an assistant secretary and the secretary had signed all checks. Langley was unwilling to spend the time at such a mundane task and assigned Karr to sign in his place. As both accountant and dispersing clerk, Karr was responsible for the day-to-day management of the Institution's financial affairs. Due to the loose oversight of Langley and the failure of the Executive

353

Committee to adequately audit the accounts that they reported each year, Karr had been robbing the Smithsonian since July 13, 1901, when he had increased a semimonthly payroll check from $494.57 to $5,494.57, pocketing $5,000 from a single pay period. Between July 1891 and May 31, 1905, the Smithsonian income was $1,146,051.32, of which Karr had deposited $1,087,184.19.[40]

When the full accounting was complete, Rathbun reported to the Executive Committee that Karr had stolen $68,558.61 from monies received by the Institution; $5,000 from the raised payroll check; $7,400 in appropriated funds for the National Museum; $4,691.48 from the funds intended for transmission to the Royal Society for the support of the International Catalogue of Scientific Literature, an international bibliographic project that Cyrus Adler was handling on behalf of the US government; and the rest from trust funds. The board negotiated a $10,000 loan to get through the crisis, which was paid off in a month, and voted to pay their debt to the Royal Society, and repaid the appropriated funds. Karr's bond repaid some of the missing federal dollars. Additional funds came from the seizure of Karr's property. He was indicted by a federal grand jury on June 9, 1905, and sentenced to five years in federal prison at Moundsville, West Virginia, for the theft of the appropriated funds.[41]

Less than three weeks after the discovery of the theft, the editors of the Nation voiced exasperation, writing that the "astonishing defalcation at the Smithsonian Institution must raise the question whether the policy of the Congress in dealing with that establishment ought not to be radically changed." The amount stolen, the editorial continued, exceeded the annual income of the funds that James Smithson had entrusted to the United States. Given the failure of the secretary and the board to have instituted "some system of keeping accounts that would make impossible such an occurrence," perhaps Congress should "relieve them from any responsibility for the administration of Government expenditures."[42]

Devastated by what he viewed as Karr's personal betrayal, Langley refused to accept any further salary. He suffered a stroke in a meeting with Adler on November 8, followed by what the newspapers described as "a nervous collapse" brought on by overwork in January 1906. On February 5, he left to recuperate in Aiken, South Carolina, accompanied by his niece, Mary Herrick, and Dr. Riley, his personal physician. He suffered a second stroke on February 26 and died at 1:00 p.m. the next day.[43]

Edward Hale presided over the services at Washington's All Souls Church on March 2. Alexander Graham Bell gave a heartfelt eulogy. Chief Justice and Chancellor Melville Fuller, Vice President Charles W. Fairbanks, Senator Henry Cabot Lodge, Speaker Joseph G. Cannon, Henry Adams, and Charles Walcott were among

THE END OF AN ERA

the honorary pallbearers, while Rathbun, Adler, Holmes, Charles Abbot, Frank Baker, and Henry Dorsey, a special assistant to the secretary, carried the casket of their chief. Samuel Pierpont Langley was laid to rest with his parents in Boston's Forest Hills Cemetery later that month.[44]

On March 6, 1906, the Board of Regents unanimously elected Henry Fairfield Osborn as the fourth secretary of the Institution. They had acted too quickly. Osborn, perfectly satisfied with his Columbia professorship and position of leadership at the American Museum of Natural History, had no interest in giving up the excitement of New York for the slower pace of Washington. Richard Rathbun would remain acting secretary until January 23, 1907, when the board made a wiser choice, Charles Walcott, a man who knew the Institution from the inside and had demonstrated managerial skills.[45]

Collections-based research, publications, and the exchange service continued to build the Institution's scientific reputation during the Langley years. The assistant secretaries, researchers, managers, and craftspeople from across the Institution dispatched splendid displays to local, regional, and national expositions and fairs. The establishment of the National Zoo and the effort required to fund and plan a new National Museum Building and a gallery to house Charles Lang Freer's collection pointed the way to future expansion. While Secretary Langley deserved little credit for those achievements, he was the man in charge and maintained the support of the majority of the regents during one of the longest tenures in Smithsonian history.

Despite his short temper, lordly demeaner, and impatience in dealing with underlings, Langley inspired loyalty and deep friendship in Cyrus Adler, John Wesley Powell, Alexander Graham Bell, Charles Walcott, and others. While many regarded his drive to achieve piloted flight in a powered, heavier-than-air machine as ill-suited to the Smithsonian's strengths and traditions, the effort did inspire several colleagues to follow him into aeronautical research. In 1907, a year after Langley's death, Alexander Graham Bell and his wife, Mabel, established the Aerial Experiment Association, supporting a handful of young Canadian and American enthusiasts determined to fly. The results of the effort included the first airplane to fly in Canada and the successes that laid the foundation for the establishment of the Curtiss Aeroplane and Motor Company, the leading American manufacturer of aircraft through World War I.

While Charles Walcott brought stability to an institution struggling to move beyond the trauma of the Langley years, he refused to accept the failure of the 1903 Aerodrome. His ill-considered 1914 decision to assist in rebuilding and testing the old craft resulted in a bitter, forty-year public feud with Orville Wright that

concluded with a belated admission of defeat on the part of the Smithsonian. That embarrassment, however, was offset by Walcott's fight to establish and lead the National Advisory Committee for Aeronautics, a new kind of federal agency that would provide a research foundation for the growth of American air power. It was his most important contribution to the nation and, with a laboratory named for Langley, a suitable monument to his friend's vision.

EPILOGUE

DURING HIS TWENTY YEARS AS SECRETARY, Charles Walcott completed two criti-
cally important projects begun under his predecessor's administration, the open-
ing of the National Museum Building and the Freer Gallery. Turning toward the
future, he planned the Smithsonian's first capital campaign and a 1927 conference
to develop the first strategic plan for the Institution. In addition to his efforts on
behalf of the Smithsonian, he led the Carnegie Institution, was a founder of the
National Research Council, and served as president of both the National Academy
of Sciences and the American Association for the Advancement of Science.

Charles Abbot, who replaced Walcott as secretary, had served as Langley's
astrophysical assistant. He remained director of the observatory and focused on
research during his tenure, while ornithologist Alexander Wetmore directed the
National Museum and took significant responsibility for the management of the
Institution. Walcott and Wetmore were able to avoid massive layoffs during the Great
Depression, although federal budget cuts meant a reduction in hours and salary
and a halt to fieldwork and publications.[1]

With the advent of war, Secretary Abbot ordered the transfer of sixty tons of
national treasures away from potential danger in Washington to storage in a
National Park Service warehouse near Luray, Virginia. A Smithsonian War Com-
mittee sought ways in which the Institution could support the national effort.
An Ethnographic Board organized by the National Research Council to provide
anthropological information and advice to the military took up quarters in the
Castle. Visitation, which had dropped early in the war, rebounded to 1,532,765 in
1944. Forty percent of the visitors were members of the armed services and their
families.[2]

I was among that influx of wartime tourists. I used to have a faded snapshot of
a one-and-a-half-year-old Tom Crouch in a blue-and-white metal stroller with
wooden wheels in front of the Castle. It was the late spring of 1945. My father was

SMITHSON'S GAMBLE

back from combat in the Pacific aboard the USS *Knapp* (DD-653). He and his ship-mates had seen action in the Marshall and Mariana Islands and at the Battle of the Philippine Sea. They had steamed through the Formosa Strait, faced repeated aerial attacks, rescued downed American and Japanese pilots, and survived a typhoon that claimed three other destroyers. After almost a year in action, my dad was offered the choice of a promotion or reassignment stateside. He was packed and ready to depart within the hour.

He traveled halfway around the world, stopping in Medway, Ohio, to pick up my mom and me, and proceeded to his new posting at the Anacostia Naval Air Station in Washington, DC. Faced with the wartime housing crisis, the three of us spent the closing months of World War II living near the base in a single rented room with a shared kitchen and bath. My parents had fond memories of their time in Washington. In that last wartime summer, we went everywhere. Their warmest memories were of time spent in the Smithsonian.

IN THE EIGHTY YEARS SINCE ABBOT'S TERM as secretary ended, eight more men would fill that office. Their number has included two ornithologists, a psychologist, archaeologist, law professor, businessman, engineer, cardiologist, and historian. They led the Institution through a postwar era of incredible growth and expansion.

No matter who is at the helm, however, the men and women of the Smithsonian continue to probe the mysteries of life and the cosmos and excel in the study of the natural and earth sciences. They seek to conserve endangered species and landscapes and study the relationship of living things to one another and their environment. They illuminate human cultures, past and present, and specialize in historical studies of art, science and technology, material culture, and our national history. Smithsonian conservators not only apply their skills to maintain their own collections but travel the globe to the sites of natural and human disasters, working to preserve humanity's threatened cultural treasures. The staff of the Institution delights in finding new ways to share their discoveries and insights with the widest possible audience. After 175 years, their goal remains the increase and diffusion of knowledge among the peoples of the world. James Smithson's gamble succeeded to an extent that he could scarcely have imagined.

358

A BIBLIOGRAPHIC NOTE

IN ADDITION TO THE NOTES, it seems useful to point to the sources of most value to any student of the early Smithsonian. Keys to the Smithsonian chronology and governance in this period are the published annual reports of the Board of Regents (cited as AR and the year the report was issued in the following notes), the minutes of the board meetings (Record Unit, or RU, 1 in the Smithsonian Institution Archives, cited as SIA), and two works compiled and edited by William J. Rhees, *The Smithsonian Institution: Journals of the Board of Regents, Reports of Committees, Statistics, Etc.* (Washington, DC: Smithsonian Institution, 1879; cited as Rhees, *Journals*) and the two-volume *The Smithsonian Institution: Documents Relative to Its Origin and History, 1835–1899* (Washington, DC: Government Printing Office, 1901; cited as Rhees, *Documents*).

The *Smithsonian Institution 1846–1896: The History of its First Half Century* (Washington, DC: Smithsonian Institution, 1897), edited by George Brown Goode, includes useful essays on the first three secretaries and aspects of Smithsonian research. Geoffrey T. Hellman's *The Smithsonian: Octopus on the Mall* (Philadelphia: J. B. Lippincott, 1966) offers a popular overview of the Institution, while Paul H. Oehser's *The Smithsonian Institution* (New York: Praeger, 1970) presents the useful view of a longtime insider.

Heather Ewing's seminal *The Lost World of James Smithson: Science, Revolution, and the Birth of the Smithsonian* (New York: Bloomsbury, 2007; cited as Ewing, *Lost World*) gives a detailed account of the founder's life. The six volumes of *The Papers of Joseph Henry* (Washington, DC: Smithsonian Institution Press, 1992–2007; cited as *Papers*) covering Henry's Smithsonian years, masterfully edited and annotated by Marc Rothenberg et al., are the foundation for studies of the life and career of the first Smithsonian secretary. Biographies of Henry include Thomas Coulson's *Joseph Henry: His Life & Work* (Princeton, NJ: Princeton University Press, 1950) and Albert E. Moyer's *Joseph Henry: The Rise of an American Scientist* (Washington, DC: Smithsonian Institution Press, 1997).

Those biographies focus exclusively on Henry and pay scant attention to the fundamental shift in the direction of the Smithsonian already underway under Assistant Secretary Spencer Fullerton Baird. The Baird Papers are held by the SIA (RU 7002). E. F. Rivinus and E. M. Youseff offer a fine biography, *Spencer Baird of the Smithsonian* (Washington, DC: Smithsonian Institution Press, 1992). William Healey Dall's tome, *Spencer Fullerton Baird: A Biography* (Philadelphia:

359

A BIBLIOGRAPHIC NOTE

J. B. Lippincott, 1915), is also indispensable. *The Origins of Natural Science in America: The Essays of George Brown Goode* (Washington, DC: Smithsonian Institution Press, 1991), edited by Sally Gregory Kohlstedt, combines Goode's classic essays on the history of American science and museums with an introduction and commentary that illuminates his career and that of Spencer Baird.

Robert V. Bruce's *The Launching of American Science, 1846–1876* (New York: Alfred A. Knopf, 1987) considers the role of the Smithsonian Institution in the context of American science. His emphasis on Spencer Baird's role is especially useful. Also of interest are A. Hunter Dupree's *Science in the Federal Government: A History of Policies and Activities to 1940* (Cambridge, MA: Belknap Press of Harvard University, 1957), Nathan Reingold's *Science in Nineteenth-Century America: A Documentary History* (New York: Hill and Wang, 1964), and George H. Daniels's *Science in American Society: A Social History* (New York: Alfred A. Knopf, 1971).

There is no satisfactory biography of Samuel Pierpont Langley. Researchers pursuing the life, times, and work of the third secretary should focus on the archival resources, starting with the Samuel P. Langley Papers, RU 7003 SIA. As in the case of Henry and Baird, research should continue with his secretarial records and those of his professional associates, all held by the SIA. The Samuel Langley Collection of the National Air and Space Museum Archives, masterfully curated and fully available digitally, provides complete documentation of Langley's aeronautical work from beginning to end. The notes provided in this book serve as an introduction to the published literature on both the personal and professional life of Samuel Langley.

OTHER ABBREVIATIONS IN NOTES

Smithsonian Institution is abbreviated as SI
Smithsonian Institution Press is abbreviated as SIP
Smithsonian Books is abbreviated as SB
Smithsonian Institution Scholarly Press is abbreviated as SISP
Government Printing Office is abbreviated as GPO

Commonly cited names are also shortened throughout the notes. Among the most frequent are J. Henry for Joseph Henry, S. F. Baird for Spencer Fullerton Baird, S. P. Langley for Samuel Pierpont Langley, W. J. Rhees for William Jones Rhees, G. B. Goode for George Brown Goode, and W. H. Dall for William Healey Dall.

NOTES

INTRODUCTION

1 All statistics for 2023 from www.si.edu/dashboard.

CHAPTER 1

1 RU 7000, box 7, folder 7, SIA.
2 Rhees, *Documents* , vol. 1, pp. 5–6.
3 J. Henry to A. Gray, June 7, 1850, in *Papers*, vol. 8, p. 56.
4 AR 1880 (Washington, DC: GPO, 1881), p. 164.
5 J. Fletcher to S. P. Langley, July 25, 1891, RU 7000, box 4, folder 1, SIA.
6 S. P. Langley to G. B. Goode, August 9, 1891, RU 7000, box 4, folder 1, SIA; AR 1896 (Washington, DC: GPO, 1898), p. 16.
7 E. A. Le Mesurier to S. P. Langley, November 22, 1900, in S. P. Langley, "The Removal of the Remains of James Smithson," in *Smithsonian Miscellaneous Collections*, vol. 45 (Washington, DC: SI, 1904), p. 244; copy in RU 7000, box 4, folder 2, SIA.
8 A. G. Bell to M. Bell, March 2, 1901, Alexander Graham Bell Papers, Manuscript Division, Library of Congress.
9 Robert V. Bruce, *Bell: Alexander Graham Bell and the Conquest of Solitude* (Ithaca, NY: Cornell University Press, 1990), p. 338.
10 Gilbert Grosvenor, "Shall the Tomb of James Smithson Be Brought to America?" *New York Herald*, March 1, 1903.
11 Articles on Smithson and the controversy over his final resting place can be found in RU 7000, box 7, folder 9, SIA.
12 "Removal of Smithson's Remains," AR 1904 (Washington, DC: GPO, 1905), pp. XVI–XVII.
13 Nina Burleigh, *The Stranger and the Statesman: James Smithson, John Quincy Adams, and the Making of America's Greatest Museum, The Smithsonian* (New York: HarperCollins, 2009), pp. 6–7.
14 A. G. Bell to S. P. Langley, February 10, 1904, Alexander Graham Bell Papers, Manuscript Division, Library of Congress, box 60, Langley.
15 A. G. Bell to S. P. Langley, February 10, 1904, Alexander Graham Bell Papers, Manuscript Division, Library of Congress, box 60, Langley.
16 Alexander Graham Bell, "Report of the Committee on the Transfer of James Smithson's Remains to the United States," AR 1904, pp. XX–XXV.
17 "Smithson's Body Here on Ocean Liner," unidentified clipping, January 21, 1904, RU 7000, box 7, folder 9, SIA; "Smithson's Bones Sent to Capital," unidentified clipping, n.d., RU 7000, box 7, folder 9, SIA.
18 "Smithson's Body Here on Ocean Liner" and "Smithson's Bones Sent to Capital," RU 7000, box 7, folder 9, SIA.
19 Alexander Graham Bell, "Report of the Committee on the Transfer of James Smithson's Remains to the United States," AR 1904, pp. XXIV–XXV.
20 "Removal of Smithson's Remains," AR 1904, pp. XVIII–XX.
21 "Report of Special Committee on the Disposition of the Remains of James Smithson," AR 1904, p. XX.
22 F. W. Hackett to R. Rathbun, August 9, 1904, RU 7000, box 7, folder 5, SIA.
23 Richard Stamm, "Smithson's Crypt," unpublished manuscript, in author's collection; "Final Disposition of Smithson's Remains," AR 1905 (Washington, DC: GPO, 1906), p. XIX.
24 "Obituary Notice of James Smithson," *Gentleman's Magazine*, vol. C (March 1830), p. 275; Ewing, *Lost World*, pp. 312–13.
25 Walter R. Johnson, "Memoir on the Scientific Character and Researches of James Smithson, Esq. F.R.S." in *Smithsonian Miscellaneous Collections*, vol. 21 (Washington, DC: SI, 1880).
26 J. Henry to C. Babbage, March 16, 1852, in *Papers*, vol. 8, p. 294.
27 J. Henry to A. Gray, July 7, 1850, in *Papers*, vol. 8, p. 56; J. Henry to C. Babbage, March 16, 1852, in *Papers*, vol. 8, p. 294.
28 John Robin McDaniel Irby, "On the Works and Character of James Smithson," RU 7000, box 9, folder 1, SIA; "Information is respectively desired relating to the late James Smithson, F.R.S.," RU 7000, box 9, folder 3, SIA.
29 *Smithsonian Miscellaneous Collections*, vol. 21.
30 S. P. Langley, "James Smithson," in *The Smithsonian Institution, 1846–1896: The History of its First Half Century*, ed. G. B. Goode (Washington, DC: SI, 1897), pp. 1–24.
31 James M. Goode, "Memorandum for the Record," RU 613, box 139, folder 5, SIA.
32 John Sherwood, "Smithson Skeleton Unearthed," *Washington Star-News*, October 5, 1973.

361

NOTES

33 Pamela Henson and Tammy Peters, "Smithsonian Skeletons in the Closet: Robert Kennicott and James Smithson," unpublished paper, n.d., in author's collection.

34 Ewing, *Lost World*, p. xx.

35 Ewing, *Lost World*, p. 19.

36 An undated quote found in Ewing, *Lost World*, p. 1.

37 James Smithson, "On a Saline Substance from Mount Vesuvius," Royal Society Archives, L&P/30/13, quoted in Steven Turner, *The Science of James Smithson: Discoveries from the Smithsonian Founder* (Washington, DC: SB, 2020), pp. 7–8.

38 Ewing, *Lost World*, p. 64.

39 For details of the trip, see Barthélemy Faujas de Saint-Fond, *A Journey Through England and Scotland to the Hebrides in 1784* (Cambridge, UK: Cambridge University Press, 2014).

40 Ewing, *Lost World*, p. 126.

41 J. Lawrence Angel, "The Skeleton of James Smithson (1765–1829)," RU 613, box 139, folder 5, SIA.

42 Ewing, *Lost World*, pp. 267–69.

43 Ewing, *Lost World*, p. 136; Turner, *Science of James Smithson*, p. 53.

44 AR 1884 (Washington, DC: GPO, 1885), p. 4.

45 Ewing, *Lost World*, pp. 240–52.

46 Irby, "On the Works and Character of James Smithson," p. 148.

47 Hans Christian Ørsted in Ewing, *Lost World*, p. 284.

48 "Obituary Notice of James Smithson," *Gentleman's Magazine*, p. 541; W. J. Rhees, *James Smithson and His Bequest* in *Smithsonian Miscellaneous Collections*, vol. 21, no. 330 (Washington, DC: SI, 1880).

49 James Smithson, "An Examination of some Egyptian Colors," in *Scientific Writings of James Smithson*, ed. W. J. Rhees, pp. 101–3.

50 James Smithson, "Some Observations on Mr. Penn's Theory concerning the formation of the Kirkdale Cave," in *Scientific Writings of James Smithson*, ed. W. J. Rhees, pp. 103–117.

51 Ewing, *Lost World*, pp. 202–4.

52 François Arago, "Eulogy on Ampère," AR 1872 (Washington, DC: GPO, 1873), pp. 124–25; the American astronomer Benjamin Gould confirmed that the individual to whom his friend referred was James Smithson; S. P. Langley, "Memorandum," September 14, 1894, RU 7000, box 5, folder 3, SIA.

53 Smithson quoted in Arago, "Eulogy on Ampère," p. 125.

54 Ewing, *Lost World*, pp. 14, 195.

55 siarchives.si.edu/history/featured-topics/stories/last-will-and-testament-october-23-1826.

56 siarchives.si.edu/history/featured-topics/stories/last-will-and-testament-october-23-1826.

57 Ewing, *Lost World*, p. 300.

58 Turner, *Science of James Smithson*, p. 16.

59 Ewing, *Lost World*, p. 1.

60 library.si.edu/collection/smithson-library, list of the books in Smithson's library; Isaac Weld Jr., *Travels through the States of North America and the Provinces of Upper and Lower Canada* (London: Printed for John Stockdale, 1799).

CHAPTER 2

1 "WILL OF THE LATE JAMES SMITHSON," *[London] Morning Post*, December 10, 1829; "Summary," *[Utica, NY] Western Recorder*, February 6, 1830.

2 Ewing, *Lost World*, p. 316.

3 B. W. Leigh, Report, January 5, 1836, in Rhees, *Documents*, vol. 1, pp. 125–29; J. Q. Adams, Report, in Rhees, *Documents*, vol. 1, pp. 130–34.

4 W. C. Preston, April 30, 1836, in Rhees, *Documents*, vol. 1, p. 136; J. C. Calhoun, April 30, 1835, in Rhees, *Documents*, vol. 1, p. 138.

5 The results of the vote, in Rhees, *Documents*, vol. 1, p. 141; "Smithson Legacy," *Daily National Intelligencer*, May 2, 1836.

6 A. J. Donelson to the Senate, July 2, 1836, in Rhees, *Documents*, vol. 1, p. 147.

7 J. H. Powell, *Richard Rush: Republican Diplomat, 1790–1859* (Philadelphia: University of Pennsylvania Press, reprint 2016 edition of 1942 original); Anthony Brescia, "Richard Rush (1780–1859): A Checklist of Sources," *Princeton University Library Chronicle*, vol. 52, no. 3 (Spring 1971): pp. 145–52.

8 R. Rush to J. Forsyth, February 2, 1837; February 16, 1836; October 27, 1837; December 16, 1837; February 12, 1838, all in Rhees, *Documents*, vol. 1, pp. 20–46; Ewing, *Lost World*, pp. 322–23.

9 R. Rush to J. Forsyth, February 9, 1839; February 12, 1828; April 24, 1838; May 3, 1838; and May 12, 1838, in Court of Chancery, May 12, 1838, *President of the United States v. Drummond*, Order on Further Directions, all in Rhees, *Documents*, vol. 1, pp. 45–59.

NOTES

10 R. Rush to J. Forsyth, June 13, 1836, in Rhees, *Documents*, vol. 1, p. 61–64; G. B. Goode, ed., *The Smithsonian Institution, 1846–1896: The History of its First Half Century* (Washington, DC: SI, 1897), p. 31.

11 "Schedule of the personal effects of James Smithson . . . ," in Rhees, *Documents*, vol. 1, pp. 107–8; Goode, *History*, p. 30.

12 Martin Van Buren, "Message of the President of the United States," December 6, 1838, in Rhees, *Documents*, vol. 1, pp. 145–46.

13 Bernard DeVoto, *The Year of Decision 1846* (Boston: Little, Brown, 1943), p. 215.

14 Asher Robbins, January 10, 1839, in Rhees, *Documents*, vol. 1, pp. 163–89.

15 J. Q. Adams, March 5, 1840, in Rhees, *Documents*, vol. 1, p. 191.

16 J. Q. Adams Diary, October 26, 1839, quoted in Rhees, *Documents*, vol. 1, pp. 774–75; John Calhoun quoted in Rhees, *Documents*, vol. 1, pp. 173, 177.

17 Rhees, *Documents*, vol. 1, 143–73; J. Q. Adams Diary, June 24, 1838, in Rhees, *Documents*, vol. 1, p. 708.

18 "The Smithson Bequest," *Christian Register and Boston Observer*, November 23, 1839.

19 "The Smithson Bequest."

20 J. Q. Adams Diary, June 11, 1842, in Rhees, *Documents*, vol. 1, pp. 788–89.

21 J. Henry to B. Pierce, November 25, 1845, in *Papers.*, vol. 6, p. xxvi; A. Hunter Dupree, *Science in the Federal Government: A History of Policies and Activities*, rev. ed. (Baltimore: Johns Hopkins University Press, 1986), pp. 76–77.

22 Rhees, *Documents*, vol. 1, pp. 417, 322–26.

23 Rhees, *Documents*, vol. 1, p. 417; Rhees, *Documents*, vol, 1, p. 332.

24 Rhees, *Documents*, vol. 1, pp. 423–27.

25 Goode, *History*, p. 59.

26 Undated memorandum by Robert Owen on Robert Dale Owen's role in creating the Smithsonian, RU 7000, box 4, folder 5, SIA; August 10, 1846, "An Act to establish the 'Smithsonian Institution' for the increase and diffusion of knowledge among men," in Rhees, *Documents*, vol. 1, p. 429–31.

27 Rhees, *Documents*, vol. 1, pp. 423–27, 428, 429–34, August 10, 1846; *New York Evening Post*, quoted in Margaret Christman, *1846: Portrait of a Nation* (Washington, DC: SIP, 1996), p. 11.

28 Kenneth Hafertepe, *America's Castle: The Evolution of the Smithsonian Building and Its Institution, 1840–1878* (Washington, DC: SIP, 1994), p. 27.

29 *Daily National Intelligencer*, September 7, 1846.

30 Rhees, *Journals*, vol. 18, pp. 1–5; William J. Hough and Benjamin B. French, "Proceedings of the First Session of the Board of Regents of the Smithsonian Institution," *Daily National Intelligencer*, September 22, 1846.

31 Rhees, *Journals*, pp. 2–4; Christman, *1846*, p. 16.

32 Hafertepe, *America's Castle*, pp. 18–19.

33 *Daily National Intelligencer*, September 10, 1846.

34 *Daily National Intelligencer*, September 10, 1846.

35 Nathan Reingold, ed., *Science in Nineteenth-Century America: A Documentary History* (New York: Hill and Wang, 1964), p. 127; Dupree, *Science in the Federal Government*, p. 80.

36 Thomas Coulson, *Joseph Henry: His Life & Work* (Princeton, NJ: Princeton University Press, 1950), pp. 155–56.

37 Robert V. Bruce, *The Launching of Modern American Science, 1846–1876* (New York: Alfred A. Knopf, 1987), pp. 219–20; Reingold, *Science in American Life*, p. 127; Dupree, *Science in the Federal Government*, p. 80.

38 J. Henry to A. D. Bache, September 5, 1846, in *Papers*, vol. 6, pp. 493–500.

39 J. Henry to A. D. Bache, September 5, 1846, in *Papers*.

40 J. Henry to A. D. Bache, September 5, 1846, in *Papers*.

41 "The Smithsonian Institution," *[Philadelphia] North American*, December 5, 1846; "A Memoir on the Smithsonian Institution," *North American*, December 7, 1846.

42 J. Henry to P. Bullions, October 14, 1846, in *Papers*, vol. 6, p. 516.

43 A. Dean to J. Henry, October 15, 1846, in *Papers*, vol. 6, pp. 518–20; J. Henry to A. Dean, October 19, 1846, in *Papers*, vol. 6, pp. 523–24.

44 J. Henry to A. D. Bache, September 1, 1846, in *Papers*, vol. 6, pp. 492–93.

45 Undated memorandum by Robert Owen . . . , RU 7000, box 4, folder 5, SIA; F. Markoe Jr. to R. Rush, August 19, 1846, in *Papers*, vol. 6, pp. 482–83; *Newark Daily Advertiser*, December 4, 1846; for a list of twenty-seven known candidates, see *Papers*, vol. 6, pp. 548–50.

46 Rhees, *Journals*, p. 7.

47 *Washington Daily Union*, December 5, 1846; *Daily National Intelligencer*, December 8, 1846; *Papers*, vol. 6, p. 557.

48 "The Smithsonian Institution," *North American*, December 5, 1846.

49 Rhees, *Journals*, pp. 10–11.

50 *Papers*, vol. 7, p. xv.

NOTES

51 "Secretaryship of the Smithsonian Institute," *New York Observer and Chronicle*, December 19, 1846; "Professor Henry," *Daily National Intelligencer*, December 14, 1846.

52 J. Henry to H. Henry, January 23, 1847, in *Papers*, vol. 7, pp. 22–23.

CHAPTER 3

1 J. Henry to A. Gray, December 2, 1846, in *Papers*, vol. 6, p. 586; J. Henry to H. Henry, December 17, 1846, in *Papers*, vol. 6, p. 591.

2 Henry Adams, *The Education of Henry Adams* (Boston: Houghton Mifflin, 1918), p. 44; Charles Dickens, *American Notes for General Circulation* (London: Chapman & Hall, 1850), p. 81.

3 Adams, *Education of Henry Adams*, p. 44.

4 Mary Kay Ricks, *Escape on the Pearl: The Heroic Bid for Freedom on the Underground Railroad* (New York: William Morrow, 2007), p. 28.

5 Ricks, *Escape on the Pearl*, p. 120.

6 Solomon Northup, *Twelve Years a Slave* (Auburn, NY: Derby and Miller, 1853), pp. 42–43.

7 Northrup, *Twelve Years a Slave*, p. 56.

8 emancipation.dc.gov/page/ending-slavery-district-columbia.

9 For details of Joseph Henry's life, see Thomas Coulson, *Joseph Henry: His Life and Work* (Princeton, NJ: Princeton University Press, 1950); Asa Gray, "Biographical Memorial," in *A Memorial of Joseph Henry*, in *Smithsonian Miscellaneous Collections*, vol. 21 (Washington, DC: SI, 1881). p. 8.

10 George Gregory, *Lectures on Experimental Philosophy, Astronomy, and Chemistry, Intended Chiefly for the Use of Students and Young Persons* (London: Longman, Hurst, Rees, Orme, and Brown, 1820); Asa Gray, "Biographical Memorial," in *A Memorial of Joseph Henry*, p. 56.

11 Coulson, *Joseph Henry*, pp. 17–19.

12 Robert V. Bruce, *The Launching of Modern American Science, 1846–1876* (New York: Alfred A. Knopf, 1987), p. 16.

13 Coulson, *Joseph Henry*, pp. 18–21.

14 Bruce, *Modern American Science*, p. 16.

15 J. Henry, "Description of a Galvanic Battery for Producing Electricity of Different Intensities," *Transactions of the American Philosophical Society*, New Series, vol. 5, article IX (Philadelphia: James Kay, Jun. & Brother, 1837), pp. 217–22; Coulson, *Joseph Henry*, p. 41.

16 J. Henry, "Description of a Galvanic Battery," pp. 217–22.

17 Mary Henry, "America's Part in the Discovery of Magneto-Electricity—a Study of the World of Faraday and Henry—I," *Electrical Engineer*, vol. 13, no. 193 (January 13, 1892), p. 183.

18 Coulson, *Joseph Henry*, p. 87; Mary Henry, "America's Part in the Discovery of Magneto-Electricity—a Study of the Work of Faraday and Henry—II," *Electrical Engineer*, vol. 13, no. 194 (January 20, 1892), p. 53; J. Henry, "On Electro-Dynamic Induction," *Transactions of the American Philosophical Society*, vol. 6 (1839), pp. 303–37.

19 J. Henry, "On a Reciprocating Motion Produced by Magnetic Attraction and Repulsion," *American Journal of Science*, vol. 20 (July 1831), pp. 340–43.

20 Albert E. Moyer, *Joseph Henry: The Rise of an American Scientist* (Washington, DC: SIP, 1997), pp. 68–69.

21 Moyer, *Joseph Henry*, pp. 205–23.

22 Henry, "Description of a Galvanic Battery," pp. 217–22; J. Henry, "On the Influence of a Spiral Conductor in Increasing the Intensity of Electricity from a Galvanic Arrangement of a Single Pair," *Transactions of the American Philosophical Society*, vol. 5 (1837), pp. 223–31; J. Henry, "On Electro-Dynamic Induction," *Transactions of the American Philosophical Society*, vol. 6 (1839), pp. 303–37; J. Henry, "On Electro-Dynamic Induction (Continued)," *Transactions of the American Philosophical Society*, vol. 8 (1843), pp. 1–35; J. Henry, "On Induction From Ordinary Electricity," *Proceedings of the American Philosophical Society*, vol. 2, no. 22 (May, June, July 1842), pp. 193–96.

23 Coulson, *Joseph Henry*, p. 127.

24 "Communication from Prof. Henry, Secretary of the Smithsonian Institution, Relative to a Publication by Prof. Morse," AR 1857 (Washington, DC: William A. Harris, 1858), pp. 85–117; Moyer, *Joseph Henry*, pp. 240–41.

25 Coulson, *Joseph Henry*, p. 242; J. Henry to Jabez D. Hammond, mid-June 1849, in *Papers*, vol. 7, p. 561.

26 Alfred Vail, *The American Electro Magnetic Telegraph: with the Reports of Congress, and a Description of All Telegraphs Known, Employing Electricity or Galvanism* (Philadelphia: Lea & Blanchard, 1845).

27 J. Henry to J. Varnum, June 22, 1847, in *Papers*, vol. 7, p. 121; locked book entry, January 25, 1865, RU 7001, box 39, folder 3, SIA; J. Henry to Professor Leslie, January 12, 1877, in "Programme of the Organization of the Smithsonian Institution," RU 7081, box 38, folder 1, SIA.

28 Wilcomb E. Washburn, "Joseph Henry's Conception of the Purpose of the Smithsonian Institution," in *A Cabinet of Curiosities: Five Episodes in the Evolution of American Museums* (Charlottesville: University of Virginia Press, 1967), p. 118.

364

NOTES

29 Washburn, "Joseph Henry's Conception," pp. 114, 118; J. Henry to R. Hare, December 29, 1846, in *Papers*, vol. 6, pp. 616–17.

30 J. Henry to A. Gray, December 12, 1846, in *Papers*, vol. 6, p. 586; J. Henry to A. D. Bache, June 25, 1847, in *Papers*, vol. 7, p. 128; *National Whig*, June 23, 1847; R. Owen to A. D. Bache, August 5, 1847, in *Papers*, vol. 7, 152–53.

31 J. Henry to A. D. Bache, June 25, 1847, in *Papers*, vol. 7, p. 128.

32 *Papers*, vol. 7, p. 12 fn. 5.

33 Rhees, *Journals*, p. 26.

34 J. Henry to H. Henry, January 16–17, 1847, in *Papers*, vol. 7, p. 10; Rhees, *Journals*, p. 26.

35 Rhees, *Journals*, pp. 24–29.

36 Reuben A. Guild, "Biographical Notice of Charles Coffin Jewett," in Rhees, *Journals*, p. 337; "An act to establish the 'Smithsonian Institution' for the increase and diffusion of knowledge among men," in Rhees, *Documents*, vol. 1, p. 427.

37 Library of Congress, comp., *The Card Catalogue: Books, Cards, and Literary Treasures* (San Francisco: Chronicle Books, 2017), loc. 682 of 1726, Kindle.

38 "Report of the Executive Committee, on the State of Funds," in *First Report of the Secretary of the Smithsonian Institution to the Board of Regents* (Washington: Ritchie & Heiss, 1848), sec. 23, p. 23.

39 J. Henry to H. Henry, January 26, 1847, in *Papers*, vol. 7, p.26; J. Henry to H. Henry, January 20, 1847, in *Papers*, vol. 7, p. 19; J. Henry to A. Gray, December 12, 1846, in Kenneth Hafertepe, *America's Castle: The Evolution of the Smithsonian Building and Its Institution, 1840–1878* (Washington, DC: SIP, 1994), p. 44.

40 Board of Regents meeting, January 21–22, 1847, in Rhees, *Journals*, pp. 23–24.

41 J. Henry to H. Henry, January 27, 1847, in *Papers*, vol. 7, p. 29 fn. 1.

42 J. Henry to H. Henry, January 27, 1848, in *Papers*, vol. 7, p. 28.

43 Hafertepe, *America's Castle*, p. 66; J. Henry to H. Henry, March 15, 1847, in *Papers*, vol. 7, p. 53; Minutes of the meeting of the Building Committee, March 20, 1847, in Rhees, *Journals*, p. 627.

44 *Report of the Organization Committee of the Smithsonian Institution . . .* (Washington, DC: Blair & Rives, 1847).

45 Minutes of the meeting of the Board of Regents, January 26, 1847, in Rhees, *Journals*, pp. 25–27.

46 Washburn, "Joseph Henry's Conception," p. 115; J. Henry to A. D. Bache, September 5, 1846, in *Papers*, vol. 6, p. 494; Hafertepe, *America's Castle*, p. 60.

47 J. Q. Adams Diary, May 5, 1847, in *The Great Design: Two Lectures on the Smithson Bequest by John Quincy Adams*, ed. Wilcomb E. Washburn (Washington, DC: SI, 1965), p. 30.

48 J. Henry to E. Sabine, August 13, 1847, in *Papers*, vol. 7, pp. 163–65; Washburn, *The Great Design*, pp. 31–32.

49 "Programme of Organization of the Smithsonian Institution," in *First Report of the Secretary of the Smithsonian Institution to the Board of Regents . . .* (Washington, DC: Ritchie & Heiss, 1848), pp. 3–20.

50 "Programme of Organization," in *First Report*, pp. 4–20.

51 "Programme of Organization," in *First Report*, p. 20.

52 J. Henry to A. Gray, January 10, 1848, in *Papers*, vol. 7, pp. 256–57.

53 J. Henry to H. Henry, May 1, 1847, in *Papers*, vol. 7, p. 92; for A. Vail's rumor, see *Papers*, vol. 7, p. 94 fn. 1.

54 "Smithsonian Institution," *National Whig*, May 6, 1847.

55 "Smithsonian Institution," *National Whig*, May 6, 1847; *Daily National Intelligencer*, May 2, 1847.

56 A. Vail to S. Morse, May 17, 1847, in *Papers*, vol. 7, p. 95.

57 Rhees, *Journals*, pp. 680–85; "The Smithsonian Institute," *New York Observer and Chronicle*, May 8, 1847; J. Henry to H. Henry, May 1, 1847, in *Papers*, vol. 7, p. 93.

58 Hafertepe, *America's Castle*, 66.

59 Garrett Peck, *The Smithsonian Castle and the Seneca Quarry* (Charlestown, SC: History Press, 2013), pp. 42–57.

60 Peck, *Smithsonian Castle*, pp. 42–57.

61 *National Whig*, May 19, 1847; Peck, *Smithsonian Castle*, p. 52.

62 AR 1865 (Washington, DC: GPO, 1866), p. 14–15; Hafertepe, *America's Castle*, pp. 100–112.

63 Rhees, *Journals*, pp. 75–76, 78–83; J. Henry to A. Gray, November 6-11, 1852, in *Papers*, vol. 8, pp. 399–402.

64 Hafertepe, *America's Castle*, p. 77.

65 Hafertepe, *America's Castle*, p. 85.

66 Robert Dale Owen, *Hints on Public Architecture, Containing, Among Other Illustrations, Views and Plans of the Smithsonian Institution* (New York: George P. Putnam, 1848).

CHAPTER 4

1 E. G. Squier to J. Henry, March 24, 1847, in *Papers*, vol. 7, pp. 57–59; "On the Mounds and Relics of the Ancient Nations of America," *American Journal of Science and Arts*, ser. 2, no. 5 (September 1846), pp. 284–88.

2 J. Henry to E. G. Squier, April 3, 1847, in *Papers*, vol. 7, p. 76; J. Henry quoted in Curtis M. Hinsley Jr., *Savages and Scientists: The Smithsonian Institution and the Development of American Anthropology, 1846–1910* (Washington, DC: SIP, 1981), pp. 34–35.

NOTES

3 Samuel F. Haven, *Archaeology of the United States, or Sketches, Historical and Biographical, of the Progress of Information and Opinion Respecting Vestiges of Antiquity in the United States*, Smithsonian Contributions to Knowledge, vol. 8, art. 2 (Washington DC: SIP, 1856), p. 31.

4 Robert Silverberg, *Mound Builders of Ancient America: The Archaeology of a Myth* (Greenwich, CT: New York Graphic Society, 1968), p. 71.

5 J. Henry to Anonymous, December 5, 1853, in *Papers*, vol. 8, p. 499.

6 J. Henry to A. Gallatin, June 2, 1847, in *Report of the Board of Regents of the Smithsonian Institution*, 30th Congress, 1st Session, Misc. No. 23, January 6, 1848, p. 20.

7 G. P. Marsh to J. Henry, in *Report of the Board of Regents of the Smithsonian Institution*, 30th Congress, p. 22.

8 E. Davis to J. Henry, May 8, 1849, in *Papers*, vol. 7, p. 524; Terry A. Barnhart, *American Antiquities: Revisiting the Origins of American Archaeology* (Lincoln: University of Nebraska Press, 2015), pp. 254–55, 295–96, 299–301.

9 J. Henry to E. G. Squier, June 28, 1848, in *Papers*, vol. 7, p. 345.

10 E. G. Squier to B. Mayer, March 1, 1849, in *Papers*, vol. 7, p. xxiv; A. Gallatin to G. P. Marsh, August 7, 1848, in *Papers*, vol. 7, pp. 376–77.

11 *Papers*, vol. 7, p. xxxvi; G. P. Marsh to J. R. Bartlett, March 31, 1848, in *Papers*, vol. 7, p. 207.

12 Barnhart, *American Antiquities*, pp. 307–8.

13 Ephraim George Squier, "Aboriginal Monuments of the State of New York," Smithsonian Contributions to Knowledge, vol. 2, art. 9 (Washington, DC: SI, 1851); I. A. Lapham, *The Antiquities of Wisconsin, as surveyed and described by I. A. Lapham, Civil Engineer, etc., on behalf of the American Antiquarian Society* (Washington, DC: SI, June 1855); Haven, *Archaeology of the United States*; J. Henry to I. Lapham, November 22, 1851, quoted in Hinsley Jr., *Savages and Scientists*, p. 37.

14 Stephen R. Riggs, *Grammar and Dictionary of the Dakota Language* (New York: G. P. Putnam for SI, 1852).

15 Lewis H. Morgan, *Systems of Consanguinity and Affinity of the Human Family*, Smithsonian Contributions to Knowledge vol. 17, art. 2 (Washington, DC: SI, 1871).

16 wikipedia.org/wiki/Grave_Creek_Stone; Marshall McKusick, *The Davenport Conspiracy* (Iowa City: Office of the State Archaeologist, 1970); Robert Alrutz, "The Newark Holy Stones: The History of an Archaeological Tragedy," *Journal of the Scientific Laboratories, Denison University*, vol. 57 (1980), pp. 1–57.

17 Neil Judd, *The Bureau of American Ethnology: A Partial History* (Norman: University of Oklahoma Press, 1967), p. 19.

18 W. C. Winlock, "The International Exchange System," in *The Smithsonian Institution, 1846-1896: The History of its First Half Century*, ed. G. B. Goode (Washington, DC: SI, 1897), p. 400.

19 Nancy Gwinn, "The Origin and Development of International Publications Exchange in Nineteenth Century America" (PhD diss., George Washington University, 1968); Nancy Gwinn, "The Library of Congress and the Smithsonian Institution and the Global Exchange of Government Documents, 1834–1889," *Libraries and the Cultural Record*, vol. 45, no. 1 (2010); Essays in Honor of John Y. Cole; George Boehmer, "The International Exchange System," AR 1881 (Washington, DC: SI, 1882), pp. 723–24.

20 George Boehmer, "The International Exchange System," pp. 709–56; "Appendix No. 1: Foreign Distribution of Vol. I, of Smithsonian Contributions to Knowledge," AR 1850 (Washington, DC: n.p., 1851), pp. 72–77.

21 Civil and Diplomatic Act for 1851, September 30, 1851, in Rhees, *Documents*, vol. 1, p. 480.

22 "Appendix No. 1," AR 1850, pp. 72–77.

23 Boehmer, "The International Exchange System," pp. 711–12.

24 Boehmer, "The International Exchange System," pp. 723–24.

25 J. Henry to T. Edwards, December 18, 1847, in *Papers*, vol. 7, p. 251; Sara J. Grossman, *Immeasurable Weather: Meteorological Data and Settler Colonialism from 1820 to Hurricane Sandy* (Durham, NC: Duke University Press, 2023).

26 J. Henry, "Correspondence," AR 1871 (Washington, DC: GPO, 1873), p. 35.

27 Daniel Goldstein, "'Yours for Science': The Smithsonian Institution's Correspondents and the Shape of the Scientific Community in Nineteenth-Century America," *Isis*, vol. 85, no. 4 (December 1994), pp. 573–99.

28 "Extract from a communication from Professor Espy on the subject of Meteorology," *First Report of the Secretary of the Smithsonian Institution to the Board of Regents, Giving a Programme of Organization and an Account of the Operations during the Year, Presented December 8, 1847* (Washington, DC: Ritchie & Heiss, 1848), Appendix No. 3, pp. 47–48; Marcus Benjamin, "Meteorology," in *The Smithsonian Institution, 1845-1896*, ed. Goode, pp. 647–78.

29 Benjamin, "Meteorology," p. 654; J. Henry and J. P. Espy, "Circular on Meteorology," in *Papers*, vol. 7, p. 419.

30 AR 1848 (Washington, DC: Tippin & Streeper, 1849), p. 15.

31 AR 1848, p. 16.

32 Finding aid, RU 7216, Edward R. Foreman Papers, SIA; *Papers*, vol. 7, pp. 453–54.

33 AR 1858 (Washington, DC: James B. Steedman, 1859), pp. 32–33.

34 AR 1857 (Washington, DC: William A. Harris, 1858), p. 27; *Papers*, vol. 7, p. xxxvii; AR 1848, 30th Congress, 2nd Session, Misc. No. 48, p. 15; James R. Fleming, "Meteorology at the Smithsonian Institution, 1847–1874: the Natural History Connection." *Archives of Natural History*, vol. 16, no. 3 (1989), pp. 275–84.

35 *Papers*, vol. 7, p. xxiv.

NOTES

36 "Address Delivered Before the Agricultural Society of Rutland County, Sept. 30, 1847," by George Perkins Marsh, (Rutland, VT: printed at the Herald Office, 1848), p. 11.

37 Helena Wright, *The First Smithsonian Collection: The European Engravings of George Perkins Marsh and the Role of Prints in the US National Museum* (Washington, DC: SISP, 2015).

38 E. F. Rivinus and E. M. Youssef, *Spencer Baird of the Smithsonian* (Washington, DC: SIP, 1992), pp. 43–44.

39 W. H. Dall, *Spencer Fullerton Baird: A Biography* (Philadelphia: J.B. Lippincott, 1915), p. 148; Rivinus and Youssef, *Spencer Baird of the Smithsonian*, p 27.

40 Dall, *Spencer Fullerton Baird*, p. 148; Rivinus and Youssef, *Spencer Baird of the Smithsonian*, pp. 26–28.

41 Rivinus and Youssef, *Spencer Baird of the Smithsonian*, p. 26–28.

42 George H. Daniels, *Science in American Life: A Social History* (New York: Alfred A. Knopf, 1971), pp. 14–15.

43 Rivinus and Youssef, *Spencer Baird of the Smithsonian*, pp. 25–28, 30–31; G. B. Goode, "The Three Secretaries" in *The Smithsonian Institution, 1846–1896*, pp. 157–66; Ruthven Deane, "Unpublished Letters of John James Audubon and Spencer F. Baird," *The Auk*, vol. 21, no. 2 (1904), pp. 198–99.

44 Rivinus and Youssef, *Spencer Baird of the Smithsonian*, p. 35.

45 S. F. Baird to J. Henry, February 25, 1847, in *Papers*, vol. 7, pp. 48–51; Rivinus and Youssef, *Spencer Baird of the Smithsonian*, pp. 32–33.

46 J. Henry to A. D. Bache, March 31, 1848, in *Papers*, vol. 7, pp. 295–96.

47 J. D. Dana to S.F. Baird, August 27, 1849, in Dall, *Spencer Fullerton Baird*, p. 189; T. R. Peale to J. F. Frazer, July 3, 1848, in Wilcomb E. Washburn, "Joseph Henry's Conception of the Purpose of the Smithsonian Institution," in *A Cabinet of Curiosities: Five Episodes in the Evolution of American Museums* (Charlottesville: University of Virginia Press, 1967), pp. 146–47.

48 J. Henry to F. S. Baird, March 7, 1847, in *Papers*, vol. 7, p. 51.

49 Dall, *Spencer Fullerton Baird*, pp. 150–51; Rivinus and Youseff, *Spencer Baird of the Smithsonian*, pp. 36–39.

50 Rivinus and Youssef, *Spencer Baird of the Smithsonian*, pp. 42–44.

51 S. F. Baird to J. Henry, June 9, 1849, and J. Henry to S. F. Baird, June 13, 1849, in Dall, *Spencer Fullerton Baird*, pp. 187–89.

52 J. Henry to S. F. Baird, October 2, 1848, in *Papers* , vol. 7, pp. 412–13; J. Henry to S. F. Baird, November 1, 1849, in *Papers*, vol. 7, pp. 618–19; S. F. Baird to J. Henry, December 1, 1849, in *Papers*, vol. 7, pp. 644–46; J. Henry to S. F. Baird, December 11, 1849, in *Papers*, vol. 7, pp. 647–49.

53 AR 1850, pp. 20–21.

54 J. Henry to S. F. Baird, April 23, 1850, in *Papers*, vol. 8, pp. 39–40.

55 J. Henry to S. F. Baird, April 23, 1850, in *Papers*, vol. 8, pp. 39–40.

56 J. Henry to S. F. Baird, July 5, 1850, in *Papers*, vol. 8, p. 67; C. C. Jewett to S. F. Baird, July 5, 1850, in Dall, *Spencer Fullerton Baird*, p. 211; J. Henry to S. F. Baird, July 8, 1850, in *Papers*, vol. 8, pp. 69–70.

57 AR 1850, pp. 42–43.

58 Dall, *Spencer Fullerton Baird*, pp. 226–27.

59 Rivinus and Youssef, *Spencer Baird of the Smithsonian*, pp. 42–43, 60; *Papers*, vol. 8, p. 199 fn. 3.

60 AR 1849 (Washington, DC: Senate Printers, 1850), p. 16; Rivinus and Youssef, *Spencer Baird of the Smithsonian*, p. 60.

61 "List of the More Important Explorations and Expeditions, the Collections of Which Have Constituted the Principal Sources of Supply to the National Museum . . . ," AR 1877 (Washington, DC: GPO, 1878), pp. 105–17.

62 "Explorations," AR 1850, p. 19.

63 David Dale Owen, *Report of a Geological Survey of Wisconsin, Iowa, and Minnesota; and Incidentally of a Portion of Nebraska Territory, Made under Instructions from the United States Treasury Department* (Philadelphia: J. B. Lippincott, Grambo, 1852), pp. 197–98; "Explorations," AR 1850, p. 19.

64 "Explorations," AR 1850, pp. 19–20.

65 Thaddeus A. Culbertson, "Journal of an Expedition to the Mauvais Terres and the Upper Missouri in 1850," Appendix No. 4, AR 1850, p. 94.

66 Thaddeus A. Culbertson, "An Explanation of the Tabular View of the Indian Tribes of the Upper Missouri," AR 1850, pp. 138–145; Culbertson, "Journal," pp. 103–32.

67 "Explorations," AR 1850, p. 19; Joseph Leidy, "Report Upon Some Fossil Mammalia and Chelonia from Nebraska," AR 1851 (Washington, DC: A. Boyd Hamilton, 1852), pp. 63–65; Joseph Leidy, "The Ancient Fauna of Nebraska, or a Description of Remains of Extinct Mammalia and Chelonia from the Mauvais Terres of Nebraska," Smithsonian Contributions to Knowledge, vol. 6, art. 7 (Washington, DC: SI, 1852).

68 AR 1853 (Washington, DC: Beverley Tucker, 1854), p. 221.

69 J. Henry to S. F. Baird, April 23, 1850, in *Papers*, vol. 8, pp. 39–40; William A. Deiss, "Spencer F. Baird and His Collectors," *Journal of the Society for the Bibliography of Natural History*, vol. 9, no. 4 (1980), pp. 635–45.

70 Rivinus and Youssef, *Spencer Baird of the Smithsonian*, p. 84; Herman J. Viola, *Exploring the West* (Washington, DC: SB, 1987), pp. 87, 163.

NOTES

71 Rivinus and Youssef, *Spencer Baird of the Smithsonian*, p. 60; William H. Goetzmann, *Exploration and Empire: The Explorer and Scientist in the Winning of the American West* (New York: W. W. Norton, 1966), p. 323; William Fitzhugh, foreword to *Science in the Subarctic: Trappers, Traders, and the Smithsonian Institution*, by Debra Lindsay (Washington, DC: SIP, 1993), pp. 4–5.

72 Rivinus and Youssef, *Spencer Baird of the Smithsonian*, p. 59.

73 Daniel Hutchinson and Gail Sylvia Lowe, comps., *"Kind Regards of S.G. Brown": Selected Poems of Solomon G. Brown* (Washington, DC: SIP, 1983).

74 "Solomon G. Brown: A Renaissance Man," in Hutchinson and Lowe, *"Kind Regards,"* pp. 3–5; T. Gibson, "'There are whole lots of things I know, but I never say anything . . .': African American Employees and the Smithsonian, 1852–1920," accession 07-214, SIA.

75 Gibson, "'There are whole lots of things I know . . . ,'" p. 9.

76 Gibson, "'There are whole lots of things I know . . . ,'" pp. 13–17.

77 Yvonne Ffrench, *The Great Exhibition 1851* (London: Harvill Press, 1950); *Papers*, vol. 8, p. 51 fn. 2.

78 J. Henry to A. Gray, April 3, 1851, in *Papers*, vol. 8, pp. 159–70.

79 Marcus Cunliffe, "America at the Great Exhibition of 1851," *American Quarterly*, vol. 3 (Summer 1951), pp. 115–126.

80 W. J. Rhees to S. F. Baird, August 18, 1855, RU 7002, box 31, folder 26, SIA; siarchives.si.edu/collections/siris_arc _217239; Senate, April 23, 1884, in Rhees, *Documents*, vol. 1, p. 952.

CHAPTER 5

1 Thomas Coulson, *Joseph Henry: His Life & Work* (Princeton, NJ: Princeton University Press, 1950), p. 208; Senate, Isaac P. Walker, January 28 and 30, 1851, in Rhees, *Documents*, vol. 1, p. 470.

2 Senate, Jefferson Davis, January 30, 1851, in Rhees, *Documents*, vol. 1, pp. 471–74.

3 J. Henry to A. D. Bache, June 25–July 9, 1852, in *Papers*, vol. 8, p. 344; J. Henry quoted in *Daily National Intelligencer*, June 26, 1852, in *Papers*, vol. 8, p. xix.

4 J. Henry to G. P. Marsh, November 18, 1851, in *Papers*, vol. 8, pp. 260–61; Douglas quoted in the *Baltimore Sun*, October 25, 1851, in *Papers*, vol. 8, p. 262 fn. 2.

5 "Smithsonian Institute," *Ohio Observer*, February 12, 1851; "The Smithsonian Institution," *[Washington] Daily Evening Star*, July 21, 1853.

6 "Smithsonian Library," *Weekly National Intelligencer*, November 26, 1853; "The Smithsonian Institution," *Daily National Intelligencer*, January 13, 1854; "The Smithsonian and the Authors," *Daily Evening Star*, January 5, 1853.

7 Cyrus Adler, "The Smithsonian Library" in *The Smithsonian Institution 1846–1896: The History of its First Half Century*, ed. G. B. Goode (Washington, DC: SI, 1897), p. 278.

8 *Papers*, vol. 8, p. 256 fn. 2.

9 Wilcomb E. Washburn, "Joseph Henry's Conception of the Purpose of the Smithsonian Institution," in *A Cabinet of Curiosities: Five Episodes in the Evolution of American Museums* (Charlottesville: University of Virginia Press, 1967), pp. 125–26.

10 AR 1851 (Washington, DC: A. Boyd Hamilton, 1852), pp. 21–22; J. Henry to A. Gray, January 10, 1853, in *Papers*, vol. 8, p. 422.

11 AR 1851, pp. 21–22; Rhees, *Journals*, pp. 91–92.

12 R. Choate to C. Cushing, January 8, 1854, in *Papers*, vol. 9, p. 5.

13 Rhees, *Journals*, pp. 94, 96, 98.

14 S. F. Baird to G. P. Marsh, February 5, 1854, in Kenneth Hafertepe, *America's Castle: The Evolution of the Smithsonian Building and Its Institution, 1840–1878* (Washington, DC: SIP, 1984), p. 120; S. F. Baird to G. P. Marsh, May 6, 1854, in *Papers*, vol. 9, pp. 64–65.

15 J. Henry to J. Leidy, March 23, 1854, in *Papers*, vol. 9, p. 24.

16 *Papers*, vol. 9, pp. 25–26 fn. 3.

17 US House, 33rd Congress, 2nd Session, Smithsonian Institution History Bibliography, House Reports, no. 141 (1855).

18 J. Henry, "To the Special Committee of the Regents of the Smithsonian Institution," March 29, 1854, in *Papers*, vol. 9, p. 28.

19 J. Henry, "To the Special Committee," in *Papers*, vol. 9, pp. 28–55.

20 "The Smithsonian Institution," *Washington Sentinel*, January 18, 1854.

21 Letter to the editor, *Washington Sentinel*, January 21, 1854.

22 "The Smithsonian Institution," *Washington Sentinel*, January 26, 1854; "The Smithsonian Institution," January 28, 1854; "The Smithsonian Institution," March 30, 1854.

23 *New-York Daily Tribune* quoted in the *Scientific American* (January 1, 1855); "Smithsonian Institute," *Boston Atlas*, July 21, 1854; "The Smithsonian Institute," *Ohio Observer*, March 15, 1854; "The Smithsonian Institution," *Putnam's Monthly*, vol. 4, no. 20 (August 1854), p. 129.

368

NOTES

24 Hafertepe, *America's Castle*, pp. 122–23.

25 Rhees, *Journals*, pp. 101–12; "The Smithsonian Institution: Proceedings of the Board of Regents," *Daily National Intelligencer*, January 17, 1855.

26 Rhees, *Journals*, July 8, 1854, pp. 112–14.

27 C. C. Jewett to the Board of Regents, July 3, 1854, in *Papers*, vol. 8, pp. 119–20; Rhees, *Journals*, p. 117.

28 House of Representatives, January 18, 1855, in Rhees, *Documents*, vol. 1, p. 540.

29 Senate, February 5, 1855, in Rhees, *Documents*, vol. 1, p. 541

30 Senate, February 5, 1855, in Rhees, *Documents*, vol. 1, p. 541; Rhees, *Documents*, vol. 1, pp. 554–57.

31 J. Henry to J. Leidy, March 15, 1855, in *Papers*, vol. 9, p. 225.

32 W. H. Dall, *Spencer Fullerton Baird: A Biography* (Philadelphia: J.B. Lippincott, 1915), pp. 388–89.

33 "Minutes of the Board of Regents," March 1, 1865, in Rhees, *Journals*, pp. 210–11.

34 *Papers*, vol. 8, pp. xviii–xx; J. Henry, "Statement of Professor Henry in Reference to Lorin Blodget," mid-February 1855, in *Papers*, vol. 9, pp. 197–203.

35 J. Henry to A. D. Bache, October 16, 1854, in *Papers*, vol. 9, pp. 134–36; "The Veto and the Ego Power in the Smithsonian Institute," *Daily Missouri Democrat*, December 2, 1854; "Smithsonian Institution," *Boston Atlas*, July 18, 1854.

36 J. Henry to J. Leidy, March 15, 1855, in *Papers*, vol. 9, p. 225; "The Smithsonian Institute," *New-York Daily Tribune*, January 19, 1855.

37 pbs.org/wgbh/aia/part4/4h2933t.html; "Smithsonian Institute," *New-York Daily Tribune*, January 19, 1854; "Smithsonian Institute," *New-York Daily Tribune*, February 13, 1855.

38 S. F. B. Morse, "To the Editors of the *New-York Daily Times*," July 19, 1854, in *Papers*, vol. 8, p. 111.

39 J. Henry to A. D. Bache, March 13, 1855, in *Papers*, vol. 9, pp. 218–21; R. B. Taney to J. Henry, March 23, 1855, in *Papers*, vol. 9, pp. 227–28; Rhees, *Journals*, May 19, 1855, pp. 138–50.

40 S. F. B. Morse "To the Editors of the *New-York Daily Times*," July 19, 1854, in *Papers*, vol. 8, p. 111.

41 J. Henry to J. D. Dana, September 11, 1855, in *Papers*, vol. 9, p. 283.

42 Nathan Reingold, ed., *Science in Nineteenth-Century America: A Documentary History* (New York: Hill and Wang, 1964), pp. 145–46.

43 Geoffrey T. Hellman, *The Smithsonian: Octopus on the Mall* (Philadelphia: J. B. Lippincott, 1967), 62–63; Sears C. Walker, "Researches Relative to the Planet Neptune," Smithsonian Contributions to Knowledge, vol. 2, art. 1 (Washington, DC: SI, 1851), pp. 4–60.

44 M. F. Maury to S. P. Langley, September 20, 1847, in *Papers*, vol. 7, pp. 190–91; S. P. Langley to M. F. Maury, October 11, 1847, in *Papers*, vol. 7, 196–97.

45 M. F. Maury quoted in *Papers*, vol. 7, p. 275 fn. 24.

46 *Papers*, vol. 8, p. 317 fn. 5.

47 AR 1857 (Washington, DC: William A. Harris, 1858), p. 28.

48 James H. Coffin, "The Winds of the Northern Hemisphere," Smithsonian Contributions to Knowledge, vol. 6, art. 6 (Washington, DC: SI, 1854), pp. 8-198.

49 Neil Harris, *Humbug: The Art of P. T. Barnum* (Boston: Little, Brown, 1973), p. 34; John C. Green, *American Science in the Age of Jefferson* (Ames: Iowa State University Press, 1994), pp. 231–35; Robert V. Bruce, *The Launching of Modern American Science, 1846–1876* (New York: Alfred A. Knopf, 1987), p. 48.

50 J. Henry to A. D. Bache, October 17, 1853, in *Papers*, vol. 8. pp. 484–85; J. Henry to J. H. Lerfroy, November 9, 1853, in *Papers*, vol. 8, p. 489; AR 1849 (Washington, DC: Senate Printers, 1850), pp. 20–21.

51 Joel J. Orosz, "Disloyalty, Dismissal, and a Deal: The Development of the National Museum and the Smithsonian Institution, 1846–1855," *Museum Studies Journal*, vol. 2, no. 2 (Spring 1986), pp. 22–33.

52 Rhees, *Documents*, vol. 1, March 3, 1857, June 2, 1858, pp. 603, 607.

CHAPTER 6

1 J. Henry to H. Henry, February 4, 1847, in *Papers*, vol. 7, p. 40; J. Henry to H. Henry, May 3, 1847, in *Papers*, vol. 8, p. 99; J. Henry to A. D. Bache, June 25, 1847, in *Papers*, vol. 7, p. 128.

2 Mary E. Howard Schoolcraft to J. Henry, March 12, 1852, in *Papers*, vol. 8, pp. 290–92.

3 J. Henry to A. D. Bache, July 31–August 4, 1855, in *Papers*, vol. 9, p. 271; J. Henry to A. Gray, April 2, 1849, in *Papers*, vol. 7, p. 495; "The Smithsonian Institute," *Alexandria Gazette*, May 16, 1849; J. Henry to A. D. Bache, January 18, 1850, in *Papers*, vol. 8, pp. 7–8.

4 "Smithsonian Institution," *[Washington] Weekly Union*, May 16, 1848; "Smithsonian Lectures," *Daily National Whig*, May 3, 1849.

5 Richard E. Stamm, *The Castle: An Illustrated History of the Smithsonian Building*, 2nd ed. (Washington, DC: SB, 2012), p. 40.

6 J. Henry to A. D. Bache, January 18, 1850, in *Papers*, vol. 8, pp. 7–8.

7 "Smithsonian Lectures," *Weekly National Intelligencer*, January 3, 1852.

369

NOTES

8 Ken McGoogan, *Race to the Polar Sea: The Heroic Adventures of Elisha Kent Kane* (Berkeley, CA: Counterpoint Press, 2009), loc. 1491 of 5830, Kindle.

9 "Smithsonian Lectures," *Weekly National Intelligencer,* January 3, 1852; "Smithsonian Lectures," *Alexandria Gazette,* January 7, 1852; Henry Desk Diaries, January 1, 1852, in *Papers,* vol. 7, p. 272.

10 Smithsonian Lecture," *[Washington] Daily Evening Star,* January 31, 1853.

11 For a study of the Magnetic Crusade, see John Cawood, "The Magnetic Crusade: Science and Politics in Early Victorian Britain," *Isis,* vol. 70, no. 4 (December 1979), pp. 492–518.

12 AR 1853 (Washington, DC: Beverley Tucker, 1854), pp. 20–22.

13 Meeting of the Board of Regents, February 3, 1853, in Rhees, *Journals,* pp. 88–89; J. Henry to E. Sabine, February 9, 1853, in *Papers,* vol. 8, p. 427 fn. 2.

14 Meeting of the Board of Regents, January 28, 1853, in Rhees, *Journals,* pp. 87–88; J. Henry and A. D. Bache to John Pendleton Kennedy, December 1, 1852, in *Papers,* vol. 8, pp. 408–10.

15 Elijah Kent Kane, *Arctic Explorations: The Second Grinnell Expedition in Search of Sir John Franklin* (Chicago: R. R. Donnelley & Sons, 1996).

16 Stamm, *The Castle,* pp. 72, 110.

17 "Arctic Expedition of Dr. Kane," in AR 1856 (Washington, DC: A.O.P. Nicholson, 1856), p. 26; AR 1856, p. 82; Elisha Kent Kane, "Magnetical Observations in the Arctic Sea," Smithsonian Contributions to Knowledge, vol. 10, art. 3 (Washington, DC: SI, 1858).

18 AR 1851 (Washington, DC: n.p., 1851), pp. 25–26; "Smithsonian Lecture," *Daily Evening Star,* January 31, 1853; J. Henry to A. D. Bache, October 16, 1854, in *Papers,* vol. 9, p. 136.

19 AR 1856, p. 234; Stamm, *The Castle,* pp. 77–78.

20 Rhees, *Journals,* March 12, 1853, p. 91.

21 Stamm, *The Castle,* pp. 42–50.

22 Stamm, *The Castle,* pp. 41–42; S. G. Brown to S. F. Baird, September 26, 1856, in *Papers,* vol. 9, p. 396.

23 S. G. Brown to S. F. Baird, August 22, 1857, and W. J. Rhees to S. F. Baird, September 1, 1857, both in Stamm, *The Castle,* p. 45.

24 J. Henry to Mrs. Bache, October 6, 1857, RU 7001, box 67, folder 9, SIA; J. Henry to H. Henry, September 25, 1867, RU 7001, box 57, folder 9, SIA.

25 J. Henry to A. D. Bache, August 21, 1862, in *Papers,* vol. 10, p. 280.

26 J. Henry to S. F. Baird, August 24, 1863, in *Papers,* vol. 10, pp. 335 fns., 336; J. Henry to A. D. Bache, July 29, 1848, in *Papers,* vol. 7, pp. 363–65; Patricia Jahns, *Matthew Fontaine Maury & Joseph Henry: Scientists of the Civil War* (New York: Hastings House, 1961), p. 129.

27 Curtis M. Hinsley Jr., *Savages and Scientists: The Smithsonian Institution and the Development of American Anthropology, 1846–1910* (Washington, DC: SIP, 1981), p. 49.

28 Pamela Henson, "Jane Wadden Turner, Smithsonian Librarian and Pioneer," *Connect: Smithsonian Libraries* (Summer 2014), pp. 16–17.

29 J. Henry to J. C. Dobbin, December 28, 1853, in *Papers,* vol. 8, pp. 505–7.

30 Ralph W. Dexter, "The 'Salem Secession' of Agassiz Zoologists," *Essex Institute Historical Collections,* vol. 101 (1965), pp. 27–39.

31 W. J. Holland, "The Carnegie Museum," *Popular Science Monthly,* vol. 59, no. 1 (May 1901), p. 13.

32 George Black, *Empire of Shadows: The Epic Story of Yellowstone* (New York: St. Martin's Press, 2012), p. 72.

33 Annual reports for the years indicated: 1855, p. 65; 1856, pp. 50–51; 1857, p. 47; and 1858, p. 54; William H. Goetzmann, *Exploration and Empire: The Explorer and the Scientist in the Winning of the West* (New York: W. W. Norton, 1966), 309–10; J. Henry to J. Hall, August 2, 1858, in *Papers,* vol. 10, pp. 43–44, 44 fn. 3; Black, *Empire of Shadows,* p. 73.

34 Lucy Baird quoted in W. H. Dall, *Spencer Fullerton Baird: A Biography* (Philadelphia: J. P. Lippincott, 1915), p. 230; *Papers,* vol. 10, p. 336 fn. 3; R. Kennicott to Charles Kennicott, February 17, 1863, quoted in Stamm, *The Castle,* p. 74; also, Herman J. Viola, *Exploring the West* (Washington, DC: SB, 1987), p. 147.

35 Lucy Baird quoted in Dall, *Spencer Fullerton Baird,* p. 240.

36 Lucy Baird quoted in *Papers,* vol. 10, p. 336 fn. 3; R. Kennicott to Charles Kennicott, February 17, 1863, quoted in Stamm, *The Castle,* p. 74; also, Viola, *Exploring the West,* p. 147.

37 B. Kennicott to James Redfield, April 14, 1863, in Stamm, *The Castle,* p. 74.

38 AR 1861 (Washington, DC: GPO, 1862), p. 61; E. D. Cope correspondence, letter 52, January 4, 1863, Archives of the American Museum of Natural History; Dexter, "The 'Salem Secession.'"

39 J. Henry to S. F. Baird, August 24, 1863, in *Papers,* vol. 10, p. 335.

40 "Addresses," RU 7081, box 10, folder 1, "Employees," SIA.

41 Richard Rathbun, *The National Gallery of Art: Department of Fine Arts of the National Museum* (Washington, DC: GPO, 1909), pp. 30–31; "Washington Museum," *Daily National Intelligencer,* July 4, 1836.

NOTES

42 Rathbun, *National Gallery of Art*, p. 37; americanhistory.si.edu/souvenir-nation/vardens-washington-museum.

43 Rathbun, *National Gallery of Art*, p. 37.

44 W. J. Rhees, *An Account of the Smithsonian Institution, its Founder, Building, Operations, Etc., . . .* (Washington, DC: Thomas McGill, 1859), p. 22.

45 "The Smithsonian Museum," *Washington Union*, November 24, 1857.

46 Rhees, *An Account of the Smithsonian Institution*, p. 61.

47 Rhees, *An Account of the Smithsonian Institution*, p. 69.

48 J. Varden to S. F. Baird, August 9, 1862, and September 20, 1862, Spencer Fullerton Baird Papers, Incoming Correspondence, 1829–1863, RU 7002, box 35-U-W, SIA, quoted in Stamm, *The Castle*, pp. 70–71.

49 Rhees, *An Account of the Smithsonian Institution*, pp. 24–26.

50 "Local News," *Washington Union*, November 25, 1857; "The Smithsonian Institution," *National Intelligencer*, November 2, 1857; "Local Matters," *Daily National Intelligencer*, November 26, 1857.

51 AR 1851, p. 197

52 AR 1856, p. 44; J. Brooks Joyner, *Artists of the American West, 1830–1940* (n.p.: Palace Editions, 2003), p. 100.

53 Joyner, *Artists*, p. 70; Herman J. Viola, *The Indian Legacy of Charles Bird King* (Washington, DC: SIP, 1976).

54 J. Henry to Felix Flügel, August 17, 1868, quoted in Stamm, *The Castle*, p. 93; J. Henry to L. Agassiz, January 30, 1865, in *Papers*, vol. 11, pp. 466–67.

55 AR 1856, p. 31.

56 AR 1856, p. 31.

57 Debra Lindsay, *Science in the Subarctic: Trappers, Traders, and the Smithsonian Institution* (Washington, DC: SIP, 1993), p. 16.

58 W. H. Dall, "Professor Baird in Science," in AR 1888 (Washington, DC: GPO, 1890), p. 736.

59 Kuang-chi Huang, "The Place That 'Offers Greatest Interest': Northeast Asia and the Making of Asa Gray's Disjunction Thesis," *Harvard Papers in Botany*, vol. 13, no. 2 (December 2010), pp. 231–76.

60 J. Henry to T. Stevens, December 13, 1865, in *Papers*, vol. 10, p. 566.

61 Hinsley Jr., *Savages and Scientists*, pp. 24–27; . J. Henry, to S. Haven, December 14, 1855, in *Papers*, vol. 9, pp. 298–99; J. Henry to S. Haven, April 3, 1856, in *Papers*, vol. 9, pp. 334–36.

62 AR 1851, p. 148; Therese O'Malley, "A Public Museum of Trees: Mid-Nineteenth Century Plans for the Mall," *Studies in the History of Art*, vol. 30 (1991), 61–76; Wilcomb Washburn, "Vision of Life for the Mall," *Journal of the American Institute of Architects*, vol. 47, no. 3 (March 1967), p. 5.

63 O'Malley, "A Public Museum of Trees," p. 68.

64 J. Henry to A. D. Bache, January 18, 1850, in *Papers*, vol. 8, p. 7; Richard M. Lee, *Mr. Lincoln's City: An Illustrated Guide to the Civil War Sites of Washington* (McLean, VA: EPM Publications, 1981), p. 83.

65 Constance Green, *Washington: A History of the Nation's Capital* (Princeton, NJ: Princeton University Press, 1962), p. 212; O'Malley, "A Public Museum of Trees," p. 61.

66 AR 1857 (Washington, DC: William A. Harris, 1858), p. 36.

67 AR 1860 (Washington, DC: George W. Bowman, 1861), pp. 35, 75; J. Henry to E. Sabine, November 10, 1860, in *Papers*, vol. 10, p. 176.

68 AR 1860, pp. 65–70, 79.

69 Brad Tennant, "The 1864 Sully Expedition and the Death of Captain John Feilner," *American Nineteenth Century History*, vol. 9, no. 2 (2008), 183–90; AR 1860, pp. 68, 82, 84.

CHAPTER 7

1 J. Henry to A. Gray, December 7, 1860, in *Papers*, vol. 10, p. 183; Pamela Henson and Hannah Byrne, "The Smithsonian and Slavery," Institutional History Division, SIA, in author's collection.

2 J. Henry to J. Torrey, November 27, 1860, in *Papers*, vol. 10, p. 178.

3 J. Henry to A. Gray, December 7, 1860, in *Papers*, vol. 10, p. 183; Robert V. Bruce, *The Launching of Modern American Science, 1846–1876* (New York: Alfred A. Knopf, 1987), pp. 78, 124, 271, 275.

4 Locked book entry, December 18, 1864, in *Papers*, vol. 10, p. 452; William Irvine, *Apes, Angels, and Victorians: The Story of Darwin, Huxley, and Evolution* (New York: Time, 1955), p. 169; locked book entry, October 23, 1863, in *Papers*, vol. 10, p. 341.

5 J. Henry to J. Torrey, November 27, 1860, in *Papers*, vol. 10, p. 178; locked book entry, October 23, 1863, in *Papers*, vol. 10, p. 341; locked book entry, April 25, 1862, in *Papers*, vol. 10, p. 256.

6 J. Henry to A. Gray, July 12, 1861, in *Papers*, vol. 10, p. 220.

7 J. Henry to A. Gray, December 7, 1860, in *Papers*, vol. 10, pp. 182–83; J. Henry to A. Gray, May 22, 1862, in *Papers*, vol. 10, p. 266. AR 1860 (Washington, DC: George W. Bowman, 1861), pp. 10–11.

8 J. Henry to Felix Flügel, March 23, 1865, in *Papers*, vol. 10, p. 492.

NOTES

9 J. Henry to S. Alexander, April 29, 1861, in *Papers*, vol. 10, pp. 206–7; "The Evil of the Times," *Daily National Intelligencer*, April 22, 1861; J. Henry to J. Torrey, January 31, 1861, in *Papers*, vol. 10, p. 195; J. Henry to A. Gray, April 29, 1861, in *Papers*, vol. 10, p. 208.

10 S. F. Baird to W. J. Allen, May 11, 1861, RU 7002, box 13, folder 17, SIA; S. F. Baird to S. Churchill, June 17, 1864, RU 7002, box 28, folder 17, SIA.

11 S. F. Baird to W. J. Allen, May 11, 1861, RU 7002, box 13, folder 17, SIA.

12 J. Henry to J. H. Lefroy, October 26, 1860, in *Papers*, vol. 10, p. 169; Thomas Coulson, *Joseph Henry: His Life & Work* (Princeton, NJ: Princeton University Press, 1950), p. 238.

13 Mary Henry Diary, April 15, 1861, RU 7001, box 51, folder, 3, SIA.

14 Simon Cameron's order, April 20, 1861, RU 7001, box 39, folder 31, SIA; AR 1861 (Washington, DC: GPO, 1862), p. 13.

15 John P. Hale, Senate, June 25, 1860, in Rhees, *Documents*, vol. 1, pp. 618–19.

16 Simon Cameron, Senate, June 25, 1860, in Rhees, *Documents*, vol. 1, p. 625.

17 AR 1861, pp. 13–15; J. Henry to S. P. Chase, June 22, 1864, in *Papers*, vol. 10, pp, 378–79 fn. 1.

18 AR 1861, pp. 14–15.

19 J. Henry to J. Torrey, December 30–January 4, 1861, in *Papers*, vol. 10, pp. 186–87; Baird quoted in Kathleen W. Dorman, "Interruptions and Embarrassments: The Smithsonian During the Civil War," siris-sihistory.si.edu/ipac20/ipac.jsp?&uri=full=3100001-!12612-!0, copy in author's collection.

20 AR 1861, p. 15; AR 1861, p. 166; AR 1862 (Washington, DC: GPO, 1863), p. 89; AR 1864 (Washington, DC: GPO, 1865), p. 112.

21 AR 1862, p. 14.

22 "Advertisement," in *Smithsonian Miscellaneous Collections*, vol. 1 (Washington, DC: SI, 1862), p. vii; *Papers*, vol. 11, p. xxx.

23 J. Henry Desk Diary, April 9, 1865, in *Papers*, vol. 10, p. 498.

24 *Papers*, vol. 10, p. 234 fn. 1.

25 Mary Schoolcraft to J. Henry, April 7, 1865, in *Papers*, vol. 10, pp. 496–97.

26 *National Republican*, May 17, 1861; O. W. Gills to A. D. Bache, February 2, 1862, quoted in Michael F. Conlin, "The Smithsonian Abolition Lecture Controversy: The Clash of Antislavery Politics with American Science in Wartime Washington," *Civil War History*, vol. 46, no. 4 (December 2000), p. 308; O. W. Gibbs to A. D. Bache, February 2, 1862, in *Papers*, vol. 10, pp. 234–35.

27 Carl Sandburg, *Abraham Lincoln: The Prairie Years and the War Years* (New York: Harcourt Brace, 1926), vol. 2, pp. 113–14.

28 Noah Brooks, *Washington in Lincoln's Time* (New York: Rinehart & Company, 1958), pp. 11–13.

29 *Papers*, vol. 10, p. 431 fns. 4 and 5, p. 431.

30 J. Henry to Mary Henry, May 30, 1863, in *Papers*, vol. 10, p. 314; J. Henry to A. D. Bache, August 21, 1864, in *Papers*, vol. 10, p. 402.

31 Coulson, *Joseph Henry*, pp. 238–39.

32 AR 1861, p. 47; "Smithsonian Lecture," *Daily National Intelligencer*, February 15, 1860; Conlin, "Smithsonian Abolition Lecture Controversy," p. 305.

33 AR 1861, p. 47; Conlin, "Smithsonian Abolition Lecture Controversy," p. 308.

34 Conlin, "Smithsonian Abolition Lecture Controversy," pp. 308–9.

35 "Washington Lecture Association," *Daily National Intelligencer*, December 16, 1861, quoted in Conlin, "Smithsonian Abolition Lecture Controversy," p. 310.

36 Conlin, "Smithsonian Abolition Lecture Controversy," p. 312.

37 Conlin, "Smithsonian Abolition Lecture Controversy," p. 312.

38 J. Henry to A. D. Bache, April 4, 1862, in *Papers*, vol. 10, pp. 249–50; *Papers*, vol. 10, p. 280 fn. 5; washingtonpost.com/news/retropolis/wp/2018/02/14/frederick-douglass-needed-to-see-lincoln-would-the-president-meet-with-a-former-slave/.

39 "Washington Becoming a Free City," *National Republic*, December 16, 1861; Ben Perley Poore, *Perley's Reminiscences of Sixty Years of the National Metropolis* (Philadelphia: Hubbard Brothers, 1886), vol. 2, pp. 123–24.

40 *New-York Times*, January 6, 1862; *New York Herald*, January 7, March 23, 1862; Conlin, "Smithsonian Abolition Lecture Controversy," p. 315.

41 Conlin, "Smithsonian Abolition Lecture Controversy," p. 318.

42 AR 1862, p. 43.

43 *Papers*, vol. 6, p. 379 fn. 5.

44 *Papers*, vol. 8, p. xxxiv.

45 Coulson, *Joseph Henry*, pp. 251–54.

46 *Papers*, vol. 10, pp. xxxvi–xxxvii.

47 J. Henry to M. Henry, September 4, 1856, in *Papers*, vol. 9, p. 389.

48 John Wise, *Through the Air: A Narrative of Forty Years' Experience as an Aeronaut* (Philadelphia: To-Day Printing and Publishing, 1873, dedication page.

NOTES

49 J. Henry to H. Henry, August 1, 1837, in *Papers*, vol. 3, pp. 427–30.

50 Wise, *Through the Air*, p. 393.

51 John Wise, "Thunder and Thunderstorms," copy in RU 7081, box 1, folder 2, SIA.

52 J. Henry to J. Wise, August 13, 1858, in *Papers*, vol. 10, p. 15.

53 John Wise, "Thunder and Thunderstorms"; *Papers*, vol. 2, p. 387; J. Henry to E. Loomis, November 17, 1858, Loomis Papers, Beinecke Library, Yale University.

54 J. Henry to J. Wise, early July 1873, in *Papers*, vol. 11, pp. 460–61.

55 J. Henry to J. C. Cresson, I. Lea, and others, March 11, 1861, in Rhees, *Journals*, pp. 170–71; J. Henry to T. S. C. Lowe, March 11, 1861, in *Papers*, vol. 10, p. 201.

56 Tom D. Crouch, *Eagle Aloft: Two Centuries of the Balloon in America* (Washington, DC: SIP, 1983), pp. 278–79.

57 Crouch, *Eagle Aloft*, p. 279.

58 Crouch, *Eagle Aloft*, pp. 342–43.

59 J. Henry to T. S. C. Lowe, May 28, 1861, in *Papers*, vol. 10, pp. 212–13.

60 J. Henry to T. S. C. Lowe, May 28, 1861, in *Papers*, vol. 10, pp. 212–13, 213 fn. 4.

61 Crouch, *Eagle Aloft*, p. 346.

62 F. Stansbury Hayden, *Aeronautics in the Union and Confederate Armies: With a Survey of Military Aeronautics prior to 1861* (Baltimore: Johns Hopkins Press, 1941), pp. 174–75; *The War of the Rebellion: A Compilation of the Official Records of the Union and Confederate Armies* (Washington, DC: GPO, 1899), vol. 3, p. 254.

63 Mary Henry Diary, June 18, 1861; T. S. C. Lowe, "My Balloons in Peace and War" (unpublished manuscript) TL639. L37x 1910, National Air and Space Library, pp. 60–61.

64 Crouch, *Eagle Aloft*, pp. 350–53; J. Henry to S. Cameron, June 21, 1861, in *Papers*, vol. 10, pp. 214–15.

65 T. S. C. Lowe to J. Henry, July 15, 1863, in *Papers*, vol. 10, pp. 322, 323 fn. 1; J. Henry to Edwin Stanton, July 21, 1863, in *Papers*, vol. 10, p. 322.

66 J. Henry to Benjamin B. French, April 30, 1864, in *Papers*, vol. 10, p. 371.

67 J. Henry to G. B. McClellan, October 18, 1861, in *Papers*, vol. 10, p. 228.

CHAPTER 8

1 J. Henry to J. Hall, January 2, 1863, in *Papers*, vol. 11, p. 292.

2 J. Henry to J. Hall, January 2, 1863, in *Papers*, vol. 11, p. 292; *Papers*, vol. 11, p. 111.

3 "Military and Naval Inventions," *Scientific American*, vol. 4, no. 18 (May 4, 1861), p. 281.

4 Rear Admiral David Dixon Porter, quoted in John Grady, "Mine Warfare in the Civil War," armyhistory.org/mine -warfare-in-the-civil-war/.

5 Locked book entry, October 28, 1863, in *Papers*, vol. 11, pp. 342–44.

6 J. Henry to G. V. Fox, February 7, 1863, in *Papers*, vol. 11, pp. 294–95; Nathan Reingold, "Science in the Civil War: The Permanent Commission of the Navy Department," *Isis*, vol. 49, no. 3 (September 1958), pp. 307–18.

7 Nathan Reingold, *Science in Nineteenth-Century America: A Documentary History* (New York: Hill and Wang, 1964), pp. 200–203; Robert V. Bruce, *The Launching of Modern American Science, 1846–1876* (New York: Alfred A. Knopf, 1987), p. 303.

8 Bruce, *Modern American Science*, p. 303.

9 Bruce, *Modern American Science*, p. 303.

10 J. Henry to S. Alexander, March 9, 1863, in *Papers*, vol. 11, p. 296.

11 Robert V. Bruce, *Lincoln and the Tools of War* (Indianapolis: Bobbs-Merrill, 1956), p. 224.

12 Reingold, "Science in the Civil War," p. 310; Mary Henry Diary, passim, RU 7001, box 51, folder 3, SIA; locked book entry, March 8, 1862, in *Papers*, vol. 11, pp. 236–37.

13 "Minutes of the Permanent Commission of the Navy Department, Meeting XXV, May 28, 1863, in *Papers*, vol. 11, p. 312; Mark Ragan, *Submarine Warfare and the Civil War* (Cambridge, MA: De Capo Press, 2002), pp. 118–23; C. Davis to E. N. Horsford, July 27, 1863, in Reports of the Permanent Commission, RU 45, entry 193, National Archives and Records Administration (NARA), in Ragan, *Submarine Warfare*, p. 124; J. Henry to A. D. Bache, August 19, 1863, in *Papers*, vol. 11, pp. 328–29.

14 J. Henry to A. D. Bache, July 30, 1864, in *Papers*, vol. 11, pp. 390–91.

15 Solomon Andrews, *The Art of Flying* (New York: John F. Trow, 1865), p. 12.

16 Andrews, *Art of Flying*, p. 8.

17 F. H. Watson to S. Andrews, September 8, 1862, and S. Andrews to E. Stanton, September 22, 1862, both in Andrews, *Art of Flying*, pp. 7–8; "Aerial Navigation," *New York Herald*, September 8, 1863; H. Fonda to A. Lincoln, October 11, 1863, in Andrews, *Art of Flying*, p. 14.

18 Andrews, *Art of Flying*, p. 24.

19 Locked book entry, March 22, 1862, Joseph Henry Papers Project, item SIA2012-3313, SIA.

NOTES

20 A. D. Bache, J. Henry, and I. C Woodruff, "Report of the Scientific Commission," July 22, 1864, in Andrews, *Art of Flying*, p. 26.

21 Tom D. Crouch, "Dreams of Aerial Navigation," in Barton C. Hacker, *Astride Two Worlds: Technology and the Civil War* (Washington, DC: SISP, 2016), pp. 205–44; Tom D. Crouch, *Eagle Aloft: Two Centuries of the Balloon in America* (Washington, DC: SIP, 1983).

22 Bruce, *Modern American Science*, pp. 279–81.

23 S. F. Baird's correspondence with John Xántus, RU 7002, box 36, folder 12, SIA; William A. Deiss, "Spencer F. Baird and His Collectors," *Journal of the Society for the Bibliography of Natural History*, vol. 9, no. 4 (1980), pp. 636–46; János Xántus (John Xántus) Papers are held by the SIA in RU 7212; see also, Henry Miller Madden, *Xántus: Hungarian Naturalist in the Pioneer West* (Linz, Austria: priv. published, 1949).

24 Deiss, "Baird and His Collectors."

25 AR 1861 (Washington, DC: GPO, 1862), p. 39.

26 en.wikipedia.org/wiki/John_Xantus; J. Henry to S. F. Baird, August 23, 1864, RU 7002, box 25, folder 9, SIA.

27 J. Feilner to S. F. Baird, January 30, 1859, RU 52, Incoming correspondence of S. F. Baird as assistant secretary, 1850–1877, vol. 21:37, SIA (hereafter RU 52 incoming).

28 US Army Register of Enlistments, 1798–1814, record for John Feilner, Veterans Records–Military File Record Group 94, NARA.

29 S. F. Baird to J. Feilner, April 16, 1859, RU 53, Outgoing correspondence of S. F. Baird, 1850–1877, vol. 18:563, SIA (hereafter RU 53 outgoing); J. Feilner to S. F. Baird, April 27, 1859, RU 52 incoming, vol. 21:29; S. F. Baird to J. Feilner, November (n.d.), 1859, RU 53 outgoing, vol. 20:75; S. F. Baird to J. Feilner, March 31, 1860, RU 53 outgoing, vol. 21:400.

30 John Feilner, "Exploration in Upper California in 1860, Under the Auspices of the Smithsonian Institution," AR 1864 (Washington, DC: GPO, 1865), pp. 421–30; J. Feilner to S. F. Baird, September 1, 1860, RU 52 incoming, vol 21.

31 J. Feilner to S. F. Baird, July 16, 1860, RU 52 incoming, vol. 21:39; J. Feilner to S. F. Baird, November 20, 1860, RU 52 incoming, vol. 21:40; S. F. Baird to S. Cameron, April 18, 1861, RU 53 outgoing, vol. 21:38; *Official Army Register for September 1861* (Washington, DC: Adjutant General's Office, 1861), p. 21.

32 Loring White, *Frontier Patrol: The Army and the Indians in Northeastern California, 1861* (Chico, CA: Association for Northern California Records and Research, 1974), pp. 4–21.

33 *The War of the Rebellion: Official Records of the Civil War*, serial 013, chap. XXIII, p. 0044 (hereafter *OR*); *OR*, serial 049, chap. XLI, p. 0424; Ancestry.com, *Cook County, Illinois, US, Marriage and Death Indexes, 1833–1889* [database online]; original data: Sam Fink, comp., *Sam Fink's Chicago Marriage and Death Index*, Chicago, IL, USA.

34 S. F. Baird to J. Pope, April 2, 1864, RU 53 outgoing, vol. 30:504.

35 *OR*, serial 063, chap. XX, p. 0168.

36 Alfred Sully to Adjutant General, Dept. N.W., June 30, 1864, RG 94, NARA, Records of the Adjutant General's Office, Appointment, Commission and Personnel Branch, P601 C. B. 1864—John Pope.

37 Ancestry.com, *New York, US, Episcopal Diocese of New York Church Records, 1767–1970* [database online]. Lehi, UT, USA: Ancestry.com Operations Inc., 2017. Original data from Episcopal Diocese of New York Church Records, New York.; Deiss, "Baird and His Collectors," pp. 640–41; Herman J. Viola, *Exploring the West* (Washington, DC: SIP, 1987), p. 134.

38 S. M. Rothhammer to S. F. Baird, March 9, 1865, in Deiss, "Baird and His Collectors," p. 641.

39 E. F. Rivinus and E. M. Youssef, *Spencer Baird of the Smithsonian* (Washington, DC: SIP, 1992), pp. 165–68.

40 Paul Russell Cutright and Michael J. Brodhead, *Elliott Coues: Naturalist and Frontier Historian* (Urbana: University of Illinois Press, 1981), p. 285.

41 Rivinus and Youssef, *Spencer Baird of the Smithsonian*, p. 81; wikipedia.org/wiki/Elliott_Coues.

42 Ronald S. Vasile, "The Early Career of Robert Kennicott, Illinois' Pioneering Naturalist," *Illinois Historical Journal*, vol. 87, no. 3 (Fall 1994), pp. 150–70; Ronald S. Vasile, *William Stimpson and the Golden Age of American Natural History* (DeKalb: Northern Illinois University Press, 2018); Sandra Spatz Schlachtmeyer, *A Death Decoded: Robert Kennicott and the Alaska Telegraph* (Alexandria, VA: Voyage Publishing, 2010).

43 Vasile, "Early Career of Robert Kennicott," p. 157.

44 Robert Kennicott, "The Quadrupeds of Illinois," *Report of the Commissioner of Patents for the Year 1856* (Washington, DC: A.O.P. Nicholson, 1857), p. 53; Robert Kennicott, "Winter Birds of Northern Illinois," *Prairie Farmer*, vol. 16 (1856), p. 35.

45 Vasile, "Early Career of Robert Kennicott," pp. 156 fn. 15, 157, 159; AR 1853 (Washington, DC: Beverley Tucker, 1854), p. 58; AR 1854 (Washington, DC: Beverley Tucker, 1855), p. 44.

46 AR 1856 (Washington, DC: A.O.P. Nicholson, 1856), pp. 33, 46; Vasile, "Early Career of Robert Kennicott," p. 168.

47 W. H. Dall, *Spencer Fullerton Baird: A Biography* (Philadelphia: J.B. Lippincott, 1915), p. 231.

48 AR 1859 (Washington, DC: Thomas H. Ford, 1860), p. 55; Robert Kennicott quoted in Viola, *Exploring the West*, p. 147.

49 Dall, *Spencer Fullerton Baird*, p. 334.

50 Dall, *Spencer Fullerton Baird*, p. 334.

NOTES

51 Debra Lindsay, *Science in the Subarctic: Trappers, Traders, and the Smithsonian Institution* (Washington, DC: SIP, 1993), pp. 41–63.
52 Lindsay, *Science in the Subarctic*, p. 59.
53 Kennicott quoted in Viola, *Exploring the West*, p. 192; Schlachtmeyer, *A Death Decoded*, p. 22.
54 Viola, *Exploring the West*, p. 192; Vasile, "Early Career of Robert Kennicott," p. 169.
55 Lindsay, *Science in the Subarctic*, pp. 89–90.
56 B. Ross to S. F. Baird, March 21, 1860, quoted in Lindsay, *Science in the Subarctic*, p. 93.
57 R. Kennicott to S. Baird, November 17, 1859, RU 7215, box 13, SIA.
58 Lindsay, *Science in the Subarctic*, pp. 78–79; Curtis M. Hinsley Jr., *Savages and Scientists: The Smithsonian Institution and the Development of American Anthropology, 1846–1910* (Washington, DC: SIP, 1981), pp. 52–53.
59 Richard M. Lee, *Mr. Lincoln's City: An Illustrated Guide to the Civil War Sites of Washington* (Maclean, VA: EPM Publications, 1981), p. 14.
60 AR 1862 (Washington, DC: GPO, 1863), p. 39.
61 J. Henry to A. D. Bache, August 8, 1865, in *Papers*, vol. 11, pp. 534–35; J. Henry to Richard Wallach, May 4, 1865, in *Papers*, vol. 11, p. 515, 516 fn. 2.
62 AR 1861, p. 44; AR 1863 (Washington, DC: GPO, 1864), p. 38.
63 AR 1865 (Washington, DC: GPO, 1866), p. 60.
64 Joel Orosz, *Curators and Culture: The Museum Movement in America, 1740–1870* (Tuscaloosa: University of Alabama Press, 1990), pp. 206–10.

CHAPTER 9

1 Henry Desk Diary, January 24, 1865, in *Papers*, vol. 11, pp. 459–60.
2 "Local News," *[Washington] Evening Star*, January 25, 1865; wikipedia.org/wiki/History_of_the_District_of_Columbia_Fire_and_Emergency_Medical_Services_Department.
3 "Deplorable Catastrophe," *Daily National Intelligencer*, January 25, 1865; "Our Neighbor Gardner," *Daily National Intelligencer*, January 26, 1865; Mary Henry Diary, January 25, 1865, RU 7001, box 51, folder, 3, SIA.
4 Mary Henry Diary, January 26, 1865.
5 "Report of the Committee of the Board of Regents of the Smithsonian Institution Relative to the Fire," Senate, February 21, 1865, in Rhees, *Documents*, vol. 1, pp. 641–44.
6 B. S. Alexander to J. Henry, January 25, 1865, in *Papers*, vol. 10, pp. 460–61.
7 "Report of the Secretary," AR 1865 (Washington, DC: GPO, 1866), pp. 22–23.
8 Rhees, *Journals*, pp. 245.
9 "Residuary Bequest of James Smithson," in Rhees, *Documents*, vol. 1, p. 118.
10 Regent's minutes, March 24, 1866, and April 28, 1866, in Rhees, *Journals*, pp. 245–48; House of Representatives, March 2, 1865, in Rhees, *Journals*, p. 645; House of Representatives, February 1, 1867, in Rhees, *Journals*, p. 664; Rhees, *Documents*, vol. 1, pp. 118–19.
11 J. Henry to L. Agassiz, January 30, 1865, in *Papers*, vol. 11, pp. 463–65.
12 Richard E. Stamm, *The Castle: An Illustrated History of the Smithsonian Building*, 2nd ed. (Washington, DC: SB, 2012), pp. 72–73; "Report of the Committee," in Rhees, *Documents*, vol. 1, pp. 641–44; J. Henry to L. Agassiz, January 30, 1865, in *Papers*, vol. 10, pp. 466–67; *Papers*, vol. 11, p. xxiii; AR 1870 (Washington, DC: GPO, 1871), p. 13.
13 Rhees, *Journals*, pp. 719–20; adolf-cluss.org; wikipedia.org/wiki/Adolf_Cluss; Stamm, *The Castle*, passim.
14 Rhees, *Documents*, vol. 1, pp. 608, 660–61.
15 J. Henry to A. Gray, February 28, 1866, in *Papers*, vol. 11, pp. 16–17.
16 "Report of the Secretary," AR 1868 (Washington, DC: GPO, 1869), p. 14.
17 "Report of the Secretary," AR 1868, p. 15.
18 AR 1874 (Washington, DC: GPO, 1875), p. 44.
19 "Report of the Secretary," AR 1869 (Washington, DC: GPO, 1872), p. 15.
20 *Papers*, vol. 11, pp. xxi and xxix.
21 AR 1865, pp. 56–57.
22 J. Henry to H. E. Paine, January 10, 1870, in *Papers*, vol. 11, pp. 274–76 fns. 2–4, 276.
23 J. Henry to Nancy Clara Fowler Bache, April 20, 1866, in *Papers*, vol. 11, p. 48.
24 Board of Regents meeting, March 9, 1871, in Rhees, *Journals*, p. 357; House of Representatives, March 20, 1871, in Rhees, *Documents*, vol. 1, pp. 688–89; 53rd Congress, 2nd Session, 28 Stat. 41 (1894).
25 Mary Henry Diary, 1864–1868, January 19, April 14, May 11, and December 19, 1866.
26 Joseph Le Conte, *The Race Problem in the South* (New York: D. Appleton, 1892), pp. 359, 376; Joseph Le Conte, *The Autobiography of Joseph Le Conte*, ed. William Dallam Armes (New York: D. Appleton, 1903), pp. 165, 200–201, 239; J. Le Conte to J. Henry, August 13, 1868, in *Papers*, vol. 11, pp. 200–201; J. Henry to S. F. Butterworth, in *Papers*,

375

NOTES

vol. 11, p. 201; *Papers*, vol. 11, p. 201 fns. 1–5; news.berkeley.edu/2020/11/18/uc-berkeleys-leconte-and-barrows-halls -lose-their-names/.

27 siarchives.si.edu/collections/siris_sic_317.

28 J. Henry to A. Gray, March 8, 1867, in *Papers*, vol. 10, pp. 118–19; *Papers*, vol. 11, p. xxi.

29 Debra Lindsay, *Science in the Subarctic: Trappers, Traders, and the Smithsonian Institution* (Washington, DC: SIP, 1993), p. 105; W. H. Dall, *Spencer Fullerton Baird: A Biography* (Philadelphia: J.B. Lippincott, 1915), p. 358.

30 Sandra Spatz Schlachtmeyer, *A Death Decoded: Robert Kennicott and the Alaska Telegraph* (Alexandria, VA: Voyage Publishing, 2010), p. 24; Herman J. Viola, *Exploring the West* (Washington, DC: SB, 1987), p. 193.

31 Dall, *Spencer Fullerton Baird*, p. 369.

32 Photo of Kennicott in uniform, Schlachtmeyer, *A Death Decoded*, p. 43.

33 Schlachtmeyer, *A Death Decoded*, pp. 31–33.

34 J. Henry quoted in Schlachtmeyer, *A Death Decoded*, p. 34.

35 W. H. Dall to S. F. Baird July 1, 1866, "Western Union Telegraph Expedition, Papers from W. H. Dall to R. Kennicott," William H. Dall Papers, RU 7073, box 1, Kennicott folder, SIA.

36 Schlachtmeyer, *A Death Decoded*, pp. 59–99; Lindsay, *Science in the Subarctic*, pp. 118–19.

37 Schlachtmeyer, *A Death Decoded*, p. 120.

38 "The Overland Telegraph: The Sudden Death of a Persevering Naturalist . . . ," *New-York Times*, October 19, 1866; Schlachtmeyer, *A Death Decoded*, p. 111.

39 Schlachtmeyer, *A Death Decoded*, pp. 98–113.

40 wikipedia.org/wiki/William_Healey_Dall.

41 Elmer C. Herber, "Spencer Fullerton Baird and the Purchase of Alaska," *Proceedings of the American Philosophical Society*, vol. 98, no. 2 (April 15, 1954), p. 139; Viola, *Exploring the West*, p. 191.

42 *Papers*, vol. 11, pp. 127–28 fns. 1–7; Herber, "Baird and the Purchase of Alaska," p. 139.

43 Herber, "Baird and the Purchase of Alaska," p. 140.

44 Herber, "Baird and the Purchase of Alaska," p. 141.

45 W. H. Seward to J. Henry, April 10, 1867, in *Papers*, vol. 11, p. 127 fn. 1; J. Henry to W. H. Seward, April 17, 1867, in *Papers*, vol. 11, pp. 126–27.

46 W. H. Seward to J. Henry, April 10, 1867, in *Papers*, vol. 11, p. 127 fn. 1; J. Henry to W. H. Seward, April 17, 1867, in *Papers*, vol. 11, pp. 126–27.

47 "Suggestions Relative to Objects of Scientific Investigation in Russian America May 1867," in *Smithsonian Miscellaneous Collections*, vol. 8 (Washington, DC: SI, 1869), pp. 1–10.

48 Herber, "Baird and the Purchase of Alaska," p. 142; Viola, *Exploring the West*, p. 191.

49 J. Henry to Daniel Willard Fiske, March 16, 1869, in *Papers*, vol. 10, p. 141.

50 *Evening Star*, January 8, 1858; AR 1859 (Washington, DC: Thomas H. Ford, 1860), p. 113; Joseph Henry, introduction to *Physical Observations of the Arctic Seas*, by Isaac I. Hayes, p. vii, in Smithsonian Contributions to Knowledge, vol. 15 (Washington, DC: SI, 1867).

51 Pierre Berton, *The Arctic Grail: The Search for the Northwest Passage and the North Pole, 1818–1909* (New York: Lyons, 2001), pp. 353–54.

52 J. Henry Desk Diary, April 8, 1870, in *Papers*, vol. 11, p. 288 fn. 5.

53 J. Henry Desk Diary, April 8, 1870, in *Papers*, vol. 11, p. 287.

54 Chauncey C. Loomis, *Weird and Tragic Shores: The Story of Charles Francis Hall, Explorer* (New York: Alfred A. Knopf, 1971), pp. 27–37.

55 Loomis, *Weird and Tragic Shores*, p. 39; Russell A. Potter, *Finding Franklin: The Untold Story of a 165-Year Search* (Montreal: McGill-Queen's College University Press, 2016), p. 101.

56 Loomis, *Weird and Tragic Shores*, pp. 104–9; Berton, *The Arctic Grail*, p. 383; "Barnum's American Museum," *New York Herald*, November 17, 1862.

57 Berton, *The Arctic Grail*, pp. 345–80; AR 1871 (Washington, DC: GPO, 1873), pp. 35, 45; Potter, *Finding Franklin*, p. 26.

58 Potter, Finding Franklin, p. 35.

59 Berton, *The Arctic Grail*, p. 365; *Papers*, vol. 11, p. 355 fn. 6; Loomis, *Weird and Tragic Shores*, pp. 251–52; Berton, *The Arctic Grail*, p. 385.

60 Berton, *The Arctic Grail*, p. 389.

61 Berton, *The Arctic Grail*, p. 391.

62 Loomis, *Weird and Tragic Shores*, pp. 291–96.

63 Loomis, *Weird and Tragic Shores*, pp. 297–331, 329.

64 "The Story of the Ice," *New York Herald*, September 21, 1873; "Dispatches from Dundee, Scotland," *Alexandria Gazette*, September 22, 1873; *Semi-Weekly South Kentuckian*, January 19, 1886.

65 collections.dartmouth.edu/teitexts/arctica/diplomatic/EA15-11-diplomatic.html; AR 1873 (Washington, DC: GPO, 1874), pp. 37–38.

NOTES

66 Rhees, *Documents*, vol. 1, p. 725; For Hall's diary, see Charles Francis Hall Papers, Archives Center, National Museum of American History, NMAH.AC.0703; Charles Francis Hall Papers.

67 Sheila B. Nickerson, *Midnight to the North: The Inuit Woman Who Saved the Polaris Expedition* (New York: Tarcher/Penguin Putnam, 2002).

68 Emil Bessels, *Scientific Results of the United States Arctic Expedition*, vol. 1, *Physical Observations* (Washington, DC: GPO, 1876); Emil Bessels, *Die Amerikanische Nordpol-Expedition* (Leipzig: Wilhelm Engelmann, 1879); "Bessels Scientific Report," in Rhees, *Documents*, vol.1, pp. 865–69.

69 Loomis, *Weird and Tragic Shores*, pp. 350–52.

70 Loomis, *Weird and Tragic Shores*, p. 344.

71 Edward S. Cooper, *Vinnie Ream: An American Sculptor* (Chicago: Academy Chicago Publishers, 2004), pp. 159–60.

72 Cooper, *Vinnie Ream*, pp. 159–60.

73 Potter, *Finding Franklin*, p. 114.

CHAPTER 10

1 AR 1849 (Washington, DC: Senate Printers, 1850), p. 16; E. F. Rivinus and E. M. Youssef, *Spencer Baird of the Smithsonian* (Washington, DC: SIP, 1992), p. 60.

2 Mari Sandoz, "The Homestead in Perspective," in *Sandhill Sundays and Other Recollections* (Lincoln: University of Nebraska Press, 1970), pp. 11–27.

3 Stephen E. Ambrose, *Nothing Like It in the World: The Men Who Built the Transcontinental Railroad 1863–1869* (New York: Simon and Schuster, 2010).

4 D. W. Meinig, *The Shaping of America: A Geographical Perspective on 500 Years of History*, vol. 2, *Continental America, 1800–1867* (New Haven: Yale University Press, 1965), p. 76; William H. Goetzmann, *Exploration and Empire: The Explorer and the Scientist in the Winning of the American West* (New York: W. W. Norton, 1966), pp. 50–51; Washington Irving, *Astoria, or Anecdotes of an Enterprise Beyond the Rocky Mountains* (Norman: University of Oklahoma Press, 1964), p. 210.

5 Wallace Stegner, *Beyond the Hundredth Meridian: John Wesley Powell and the Second Opening of the West* (New York: Penguin, 1992), pp. 23–28.

6 William Gilpin, *The Central Gold Region: the Grain, Pastoral, and Gold Regions of North America* . . . (Philadelphia: Sower, Barnes, 1860), pp. x, xi, 111, 123.

7 Gilpin, *Central Gold Region*, p. 123.

8 Robert V. Bruce, *The Launching of Modern American Science, 1846–1876* (New York: Alfred A. Knopf, 1987), pp. 115–22 passim and Goetzmann, *Exploration and Empire*, pp. 355–57 offer a good introduction to the state geological surveys.

9 Goetzmann, *Exploration and Empire*, p. 357.

10 Goetzmann, *Exploration and Empire*, p. 360–62; Robert H. Dott Jr., "Lyell in America: His Lectures, Field Work, and Mutual Influences, 1841–1853," *Earth Sciences History*, vol. 15, no. 2 (1996), pp. 101–40; J. J. Berzelius, *The Use of the Blowpipe in Chemistry and Minerology*, trans. J. D. Whitney (Boston: William D. Ticknor, 1855).

11 J. Henry to A. S. Bache, April 23, 1860, in *Papers*, vol. 10, pp. 148–49; Goetzmann, *Exploration and Empire*, pp. 360–65; Martha A. Sandweiss, *Passing Strange: A Gilded Age Tale of Love and Deception Across the Color Line* (New York: Penguin, 2010), pp. 17–25.

12 Clarence King, *Mountaineering in the Sierra Nevada* (Boston: James R. Osgood, 1871); Henry Adams, *The Education of Henry Adams: An Autobiography* (Boston: Houghton Mifflin, 1918), p. 312; Goetzmann, *Exploration and Empire*, p. 432.

13 Mike Foster, *Strange Genius: The Life of Ferdinand Vandeveer Hayden* (Dublin, Republic of Ireland: Roberts Rinehart, 1994), pp. 154–55.

14 AR 1867 (Washington, DC: GPO, 1868), p. 45.

15 Sandweiss, *Passing Strange*, pp. 36–37.

16 Richard A. Bartlett, *Great Surveys of the American West* (Norman: University of Oklahoma Press, 1962), pp. 151–52.

17 Robert Ridgway quoted in Harry Harris, "Robert Ridgway: With a Bibliography of His Published Writings and Fifty Illustrations," *The Condor*, vol. 30, no. 1 (January–February 1928), pp. 24–25.

18 Herman J. Viola, *Exploring the West* (Washington, DC: SB, 1987), p. 152.

19 Bartlett, *Great Surveys*, pp. 10–11.

20 Viola, *Exploring the West*, p. 153; AR 1868 (Washington, DC: GPO, 1869), p. 25; Henry Desk Diary, December 15, 1868, in *Papers*, vol. 11, p. 215.

21 Bartlett, *Great Surveys*, pp. 17, 62; AR 1869 (Washington, DC: GPO, 1872), p. 30; "Cyrus Thomas," *American Anthropologist*, vol. 12, no. 2 (April–June 1910), pp. 337–43; Bartlett, *Great Surveys*, p. 17.

22 Weston J. Naef, James N. Wood, and Therese Thau Heyman, *Era of Exploration: The Rise of Landscape Photography in the West, 1860–1885* (New York: Albright-Knox Art Gallery/Metropolitan Museum of Art, 1975); Bartlett, *Great Surveys*, p. 23.

23 Bartlett, *Great Surveys*, pp. 23, 41–43.

NOTES

24 Bartlett, *Great Surveys*, pp. 336–37.

25 Bartlett, *Great Surveys*, pp. 338–39.

26 Goetzmann, *Exploration and Empire*, pp. 467–69; Bartlett, *Great Surveys*, pp. 350–51.

27 Henry Crécy Yarrow Papers, RU 7166, SIA; Bartlett, *Great Surveys*, pp. 350–56.

28 "Powell's Exploration," June 10, 1872 (Stat., XVII, 350), in Rhees, *Documents*, vol. 1, p. 699.

29 John F. Ross, *The Promise of the Grand Canyon: John Wesley Powell's Perilous Journey and His Vision for the American West* (New York: Penguin, 2019), pp. 7–10.

30 Ross, *Promise of the Grand Canyon*, p. 29.

31 William Culp Darrah, *Powell of the Colorado* (Princeton, NJ: Princeton University Press, 1951), pp. 37–45.

32 Ross, *Promise of the Grand Canyon*, pp. 39–44.

33 Darrah, *Powell of the Colorado*, pp. 47–56.

34 Darrah, *Powell of the Colorado*, pp. 56–72.

35 Ross, *Promise of the Grand Canyon*, pp. 75–76.

36 Ross, *Promise of the Grand Canyon*, p. 77; J. Henry to E. Stanton, April 23, 1867, RU 33, box 2, reel 7, SIA.

37 Goetzmann, *Exploration and Empire*, p. 535.

38 Goetzmann, *Exploration and Empire*, pp. 534–36.

39 Ross, *Promise of the Grand Canyon*, pp. 89–91; "Powell's Exploration," June 11, 1868, in Rhees, *Documents*, vol. 1, p. 679.

40 Darrah, *Powell of the Colorado*, pp. 95–98.

41 Darrah, *Powell of the Colorado*, pp. 98–105.

42 J. S. Newberry, "Geological Report," p. 55, in J. C. Ives, *Report of the Colorado River of the West* (Washington, DC: GPO, 1861).

43 Goetzmann, *Exploration and Empire*, p. 541.

44 Darrah, *Powell of the Colorado*, pp. 112–13.

45 J. W. Powell, *Exploration of the Colorado River of the West and its Tributaries: Explored in 1869, 1870, 1871, and 1872, Under the Direction of the Secretary of the Smithsonian Institution* (Washington, DC: GPO, 1875).

46 Powell, *Exploration of the Colorado River*, p. 99.

47 *Deseret News*, September 7, 1869; "The Powell Expedition," *Chicago Tribune*, September 21, 1869; "The Powell Expedition—Interesting Details," *Daily National Intelligencer*, September 22, 1869; "The Grand Canyon of the Colorado," *Frank Leslie's Illustrated Newspaper*, November 6, 1869.

48 "The Powell Expedition—Interesting Details," *Daily National Intelligencer*, September 22, 1869.

49 J. Henry to J. Garfield, May 3, 1870, in *Papers*, vol. 11, pp. 291–92; "Powell's Exploration," July 12, 1870, in Rhees, *Documents*, vol. 1, p. 686.

50 Darrah, *Powell of the Colorado*, pp. 144–61.

51 Darrah, *Powell of the Colorado*, pp. 160–87.

52 "Powell's Exploration," June 11, 1868, in Rhees, *Documents*, vol. 1, p. 699; Darrah, *Powell of the Colorado*, pp. 206–310; Ross, *Promise of the Grand Canyon*, p. 209.

53 Bartlett, *Great Surveys*, pp. 187–205.

54 *San Francisco Chronicle*, November 28, 1872, and *Mining Review*, vol. 1, no. 4 (December 18, 1872) both cited in Bartlett, *Great Surveys*, pp. 187–205.

55 Bartlett, *Great Surveys*, p. 209; AR 1870 (Washington DC: GPO, 1871), p. 23; Mark Jaffe, *The Gilded Dinosaur: The Fossil War Between E. D. Cope and O. C. Marsh and the Rise of American Science* (New York: Three Rivers Press, 2000), p. 210.

56 Ross, *Promise of the Grand Canyon*, p, 221; Goetzmann, *Exploration and Empire*, p. 473.

57 *Geographical and Geological Surveys West of the Mississippi River*, 43rd Congress, 1st Session, House of Representatives Report 612 (Washington, DC: GPO, 1875); Bartlett, *Great Surveys*, pp. 310–11; Goetzmann, *Exploration and Empire*, pp. 478–79.

58 Goetzmann, *Exploration and Empire*, pp. 478–79.

59 J. W. Powell, "The Canons of the Colorado," *Scribner's Monthly*, vol. 9 (1875), pp. 293, 394, 523; "Extreme Classics: The 100 Greatest Adventure Books of All Time," *National Geographic Adventure* (May 2004), thegreatestbooks.org/lists /17#google_vignette.

60 Darrah, *Powell of the Colorado*, p. 184.

61 *Bulletin of the Philosophical Society of Washington* (Washington, DC: SI, 1874), p. vi.

62 Paul H. Oehser, "The Cosmos Club of Washington: A Brief History," *Records of the Columbia Historical Society* (Washington, DC: Historical Society of Washington), vol. 60/62 (1960/1962), pp. 250–65; Wilcomb E. Washburn, *The Cosmos Club of Washington: A Centennial History, 1878–1978* (Washington, DC: Cosmos Club, 1978); Baird's invitation, J. W. Powell to S .F. Baird, November 18, 1878, can be found in RU 7002, box 31, folder 15, SIA.

63 Bartlett, *Great Surveys*, p. 311.

64 Darrah, *Powell of the Colorado*, p. 222; 43rd Congress, 1st Session, House of Representatives Report 612, April 10, 1874, p. 10.

NOTES

65 *New-York Tribune*, April 28, 1877; Darrah, *Powell of the Colorado*, pp. 226–27; Ross, *Promise of the Grand Canyon*, p. 1.
66 Goetzmann, *Exploration and Empire*, p. 581.
67 Goetzmann, *Exploration and Empire*, p. 581.
68 Goetzmann, *Exploration and Empire*, pp. 527–28.
69 Rhees, *Documents*, vol. 1, pp. 810–11.
70 Bartlett, *Great Surveys*, pp. 354–55; Jaffe, *The Gilded Dinosaur*, p. 206.
71 Jaffe, *The Gilded Dinosaur* provides a solid account of the Cope-Marsh feud.
72 Darrah, *Powell of the Colorado*, pp. 243–51.
73 Darrah, *Powell of the Colorado*, p. 251.
74 Historical Statistics of the United States, census.gov/library/publications/1975/compendia/hist_stats_colonial-1970 /hist_stats_colonial-1970p1-chF.pdf, table F1–5, p. 224.
75 Historical Statistics of the United States, Gross Domestic Product, 1790–2002, hsus-cambridge-org.smithsonian.idm .oclc.org/HSUSWeb/table/showtable_essay.do?id=Ca9-19&seriesid=Ca13&swidth=1536.
76 46th Congress, March 3, 1879 (Stat., XX, 397), in Rhees, *Documents*, vol. 1, p. 818; Darrah, *Powell of the Colorado*, p. 251; Neil Judd, *The Bureau of American Ethnology: A Partial History* (Norman: University of Oklahoma Press, 1967), pp. 3–4.
77 George Black, *Empire of Shadows: The Epic Story of Yellowstone* (New York: St. Martin's Press, 2012), p. 73.
78 Patricia O'Toole, *The Five of Hearts: An Intimate Portrait of Henry Adams and His Friends, 1880–1918* (New York: Simon and Schuster, 2006); Sandweiss, *Passing Strange* offers the best account of the marriage of Clarence and Ada Copeland Todd King.
79 Sandweiss, *Passing Strange*, 274–99.

CHAPTER 11

1 W. H. Dall, *Spencer Fullerton Baird: A Biography* (Philadelphia: J. B. Lippincott, 1915), pp. 388–89; S. F. Baird to Peter Parker, February 13, 1873, in E. F. Rivinus and E. M. Youssef, *Spencer Baird of the Smithsonian* (Washington, DC: SIP, 1984), p. 77.
2 J. Henry to A. Gray, November 6, 1876, in *Papers*, vol. 11, pp. 584–85.
3 AR 1877 (Washington, DC: GPO, 1878), p. 8; J. Henry to J. Tyndall, November 9, 1870, in *Papers*, vol. 11, p. 321.
4 AR 1870 (Washington, DC: GPO, 1871), p. 34.
5 41st Congress, July 15, 1870 (Stat., XVI, 294), in Rhees, *Documents*, vol. 1, p. 686.
6 W. J. Rhees to S. F. Baird, July 11, 1872, RU 7002, box 31, folder 25, SIA.
7 AR 1871 (Washington, DC: GPO, 1873), pp. 37–38; J. Henry to W. H. Dall, March 13, 1872, in *Papers*, vol. 11, p. 395.
8 J. Henry to W. H. Dall, October 22, 1872, in *Papers*, vol. 11, pp. 423–24; AR 1869 (Washington, DC: GPO, 1872), p.17.
9 J. Henry to Timothy Otis Howe, in *Papers*, vol. 11, pp. 479–81.
10 Benita Eisler, *The Red Man's Bones: George Catlin, Artist and Showman* (New York: W. W. Norton, 2013); see Thomas Donaldson, "The George Catlin Indian Gallery in the United States National Museum . . . ," Appendix (Part V), in AR 1885, pt. II (Washington, DC: GPO, 1886).
11 House, July 24, 1846, and Senate, February 27, 1847, in Rhees, *Documents*, vol. 1, pp. 435–36.
12 Eisler, *The Red Man's Bones*, p. 402; J. Henry to Mary C. Kinney, July 17, 1865, in *Papers*, vol. 10, pp. 528–29; J. Henry to E. Catlin, March 16, 1866, in *Papers*, vol. 11, pp. 22–23; americanexperience.si.edu/wp-content/uploads/2015/02 /George-Catlin-and-the-American-Indians.pdf.
13 "Catlin's Indian Cartoons," *[Washington] Evening Star*, March 20, 1872; "Personal," "More Big Indians Coming," *Evening Star*, September 28, 1872.
14 AR 1871, pp. 37–38, 40–41; *Papers*, vol. 11, pp. 479–82.
15 J. Henry to Charles Rau, December 10, 1869, in *Papers*, vol. 11, pp. 267–68.
16 David B. Weishampel and Luther Young, *Dinosaurs of the East Coast* (Baltimore: Johns Hopkins University Press, 1996), pp. 56–61.
17 Valerie Bramwell and Robert M. Peck, *All in the Bones: A Biography of Benjamin Waterhouse Hawkins* (Philadelphia: Academy of Natural Sciences, 2008).
18 Benjamin Waterhouse Hawkins, "On Visual Education as Applied to Geology," *Journal of the Society of the Arts*, vol. 2, no. 78 (1854), p. 444.
19 Mark Witton and Ellinor Michel, *The Art and Science of the Crystal Palace Dinosaurs* (Ramsbury, Wiltshire, UK: Crowood Press, 2022), p. 31–32.
20 Hawkins, "On Visual Education as Applied to Geology," p. 447.
21 Weishampel and Young, *Dinosaurs of the East Coast*, pp. 53–56; W. J. T. Mitchell, *The Last Dinosaur Book: The Life and Times of a Cultural Icon* (Chicago: University of Chicago Press, 1998), pp. 94–99; Robert M. Peck, "The Art of Bones," *Natural History*, vol. 117, no. 10 (December 2008–January 2009), pp. 24–29.
22 Adrian J. Desmond, *The Hot-Blooded Dinosaurs: A Revolution in Paleontology* (New York: Dial Press, 1975), pp. 29–34.

NOTES

23 Benjamin Waterhouse Hawkins, "Report of Progress of Work Accomplished at the Paleozoic Museum, in Central Park, New York," March 6, 1871, *Proceedings of the Lyceum of Natural History in the City of New York* (New York: Lyceum of Natural History, n.d.), pp. 179–86; "Mr. Waterhouse Hawkins Lectures on Natural History," *New-York Times*, March 25, 1868; "The Animal Kingdom," *New-York Times*, March 21, 1868.

24 Benjamin Waterhouse Hawkins, "Report on the Progress of the Fossil Exhibition," *Twelfth Annual Report of the Board of Commissioners of the Central Park for the Year Ending December 31, 1868* (New York: Evening Post Steam Presses, n.d.), pp. 135–38.

25 Hawkins, "Report of Progress . . . at Paleozoic Museum," pp. 182–83; Richard C. Ryder, "Dusting Off America's First Dinosaur," *American Heritage*, vol. 39, no. 2 (March 1988).

26 "The Central Park Museum—Destruction of Mr. Hawkins' Restorations," *New-York Times*, February 16, 1872.

27 B. W. Hawkins to J. Henry, May 18, 1872, SIA, Acc. 11-032 MO 81; "Scientific Lectures," *Evening Star*, February 22, 1870; AR 1870, p. 88; AR 1871, p. 39.

28 B. W. Hawkins to J. Henry, March 30, 1872, SIA Acc. 11-032, control number 76427, batch M250; April 10, 1871, SIA, Acc. 11-032, control number 16653, batch M081.

29 B. W. Hawkins to J. Henry, March 30, 1872; April 10, 1871, SIA, Acc. 11-032, control number 76427, batch M250; April 10, 1871, SIA, Acc. 11-032, control number 16653, batch M081.

30 B. W. Hawkins to J. Henry, April 24, 1872, RU 33, reel 45, SIA.

31 AR 1870, p. 33.

32 W. J. Rhees to S. F. Baird, June 30, 1872, RU 7002, box 31, folders 25, 26-34, SIA; B. W. Hawkins to J. Henry, June 17, 1872, RU 33, reel 46, SIA; J. Henry to B. W. Hawkins, July 1, 1872, outgoing correspondence, RU 33, reel 47, SIA.

33 Bramwell and Peck, *All in the Bones*, pp. 41, 46–47; wikipedia.org/wiki/Benjamin_Waterhouse_Hawkins.

34 Dall, *Spencer Fullerton Baird*, pp. 388–89

35 Dall, *Spencer Fullerton Baird*, pp. 388–89; S. F. Baird to W. T. Sherman, November 24, 1882, RU 7002, box 9, folder 2, SIA; Rivinus and Youssef, *Spencer Baird of the Smithsonian*, p. 112.

36 Lucy Baird quoted in Dall, *Spencer Fullerton Baird*, pp. 416–17; Dean C. Allard, "Spencer Baird and the Scientific Investigation of the Northwest Atlantic, 1871–1887," *The Northern Mariner/Le Marin du Nord*, vol. 7, no. 2 (April 1997), pp. 31–39.

37 Dall, *Spencer Fullerton Baird*, p. 423.

38 Dall, *Spencer Fullerton Baird*, p. 425.

39 Allard, "Spencer Baird and the Scientific Investigation of the Northwest Atlantic, 1871–1887," p. 35; Rivinus and Youssef, *Spencer Baird of the Smithsonian*, p. 147.

40 Dall, *Spencer Fullerton Baird*, pp. 429–30; G. B. Goode et al., *The Fisheries and Fishery Industries of the United States: Prepared through the Co-operation of the Commissioner of Fisheries and the Superintendent of the Tenth Census*, 8 vols. (Washington, DC: GPO, 1884–87).

41 Sally G. Kohlstedt, "History in a Natural History Museum: George Brown Goode and the Smithsonian Institution," *The Public Historian*, vol. 10, no. 2 (Spring 1988), p. 9.

42 Dall, *Spencer Fullerton Baird*, pp. 418–23; S. P. Langley, "Memoir of George Brown Goode, 1851–1896," *A Memorial of George Brown Goode, Together with a Selection of his Papers on Museums and on the History of Science in America* (Washington, DC: GPO, 1901), p. 43.

43 Langley, "Memoir of George Brown Goode," p. 45; G. B. Goode, *Virginia Cousins: A Study of the Ancestry and Posterity of John Goode of Whitby, a Virginia Colonist of the Seventeenth Century* (Richmond, VA: J. W. Randolph & English, 1887).

44 Langley, "Memoir of George Brown Goode," p. 43.

45 Henry Desk Diary, December 30, 1871, and January 6–10, 1872, in *Papers*, vol. 11, p. 378; S. F. Baird to J. Henry, January 9, 1872, in *Papers*, vol. 11, p. 379 fn. 1.

46 Dall, *Spencer Fullerton Baird*, pp. 388–89.

47 Langley, "Memoir of George Brown Goode," p. 45; for employee count, see AR 1878 (Washington, DC: GPO, 1879), p. 12.

48 Rivinus and Youssef, *Spencer Baird of the Smithsonian*, p. 118.

49 Rivinus and Youssef, *Spencer Baird of the Smithsonian*, p. 118.

50 AR 1874 (Washington, DC: GPO, 1875), p. 121; AR 1871, p. 39; B. W. Hawkins to J. Henry, March 30, 1869, SIA, Acc. 16653, M06.

51 Bill Bryson, *A Short History of Nearly Everything* (New York: Broadway Books, 2003), pp. 87–90; Carin Berkowitz and Bernard Lightman, eds., *Science Museums in Transition: Cultures of Display in Nineteenth-Century Britain and America* (Pittsburgh: University of Pittsburgh Press, 2017).

52 nhm.ac.uk/discover/alfred-waterhouse-museum-building-cathedral-to-nature.html.

53 Douglas Preston, *Dinosaurs in the Attic: An Excursion into the American Museum of Natural History* (New York: St. Martin's Press, 1989), pp. 13–20.

54 "Lectures Last Evening," *National Republican*, February 18, 1864.

NOTES

55 Alan Nevins, *Hamilton Fish: The Inner History of the Grant Administration* (New York: Dodd, Mead, 1936), vol. 2, p. 811.

56 41st Congress, May 3, 1871 (Stat., XVI, 670), in Rhees, *Documents*, vol. 1, pp. 687–88; Rydell, *All the World's a Fair: Visions of Empire at American International Expositions, 1876–1918* (Chicago: University of Chicago Press, 1984), pp. 17–19.

57 Sundry Civil Act for 1876, Stat. XVIII, Pt. 3, 400, 43rd Congress, March 3, 1875, in Rhees, *Documents*, vol. 1, pp. 704–5.

58 AR 1875 (Washington, DC: GPO, 1876), p. 68.

59 J. Henry to S. C. Lyford, November 17, 1874, in *Papers*, vol. 11, p. 505.

60 AR 1875, pp. 61–64.

61 C. Rau to J. Henry, November 29, 1867, in *Papers*, vol. 11, p. 194 fn. 1; John Kelly, "Charles Rau: Developments in the Career of a Nineteenth-Century German-American Archaeologist," in *New Perspectives on the Origins of Americanist Archaeology*, eds. David Browman and Stephen Williams (Tuscaloosa: University of Alabama Press, 2009), pp. 117–34; Liam C. Murphy, "The Unsung Evolutionist: Charles Rau's Swiss Lake Dwelling Collection at the Smithsonian Institution" (master's thesis, University of Wisconsin, 2016); Curtis M. Hinsley Jr., *The Smithsonian and the American Indian: Making a Moral Anthropology in Victorian America* (Washington, DC: SIP, 1981), p. 42.

62 Murphy, "The Unsung Evolutionist," pp. 112–13; "List of Anthropological Publications by Charles Rau, 1859–1882" in *Proceedings of the United States National Museum*, vol. IV, 1881 (Washington, DC: SI, 1882), pp. 455–58; J. Henry to C. Rau, September 20, 1859, RU 7070, box 1, folder 4, SIA.

63 A. Morlot, "General Views on Archaeology," AR 1860 (Washington, DC: George W. Bowman, 1861), pp. 284–343.

64 J. Henry to C. Rau, May 10, 1875, RU 7070, box 1, folder 6, SIA.

65 Lucy Baird undated memories of her father, RU 7078, box 1, folder 11, SIA.

66 Hinsley Jr., *Smithsonian and the American Indian*, p. 41; Jesse Green, ed., *Cushing at Zuni: The Correspondence and Journals of Frank Hamilton Cushing, 1879–1884* (Albuquerque: University of New Mexico Press, 1990), p. 2; Otis T. Mason, *Ethnological Directions Relative to the Indian Tribes of the United States* (Washington, DC: GPO, 1875).

67 C. Rau to S. F. Baird, July 10, 1875, RU 7002, box 31, folder 23, SIA.

68 C. Rau to S. F. Baird, July 30, August 12, and September 1, 1875, RU 7002, box 31, folder 23, SIA.

69 AR 1875, p. 69.

70 Richard E. Stamm, *The Castle: An Illustrated History of the Smithsonian Building*, 2nd ed. (Washington, DC: SB, 2012), p. 166.

71 G. B. Goode to S. F. Baird, May 6, 1876, RU 7002, box 22, folder marked 1876, SIA.

72 G. B. Goode to S. F. Baird, April 2, 1876, RU 7002, box 22, folder marked 1876, SIA.

73 "The Nation's Centennial, Smithsonian Institute Exhibit," *New-York Times*, April 2, 1876; "The Centennial: The Government Exhibition," *New-York Times*, May 29, 1876.

CHAPTER 12

1 Nathaniel Philbrick, *The Last Stand: Custer, Sitting Bull, and the Battle of the Little Bighorn* (New York: Penguin, 2010), p. 9; Linda P. Gross and Theresa R. Snyder, *Philadelphia's 1876 Centennial Exhibition* (Charlestown, SC: Arcadia, 2005), loc. 132 of 818, Kindle.

2 Gross and Snyder, *Philadelphia's 1876 Centennial Exhibition*, loc. 65.

3 Robert W. Rydell, *All the World's a Fair: Visions of Empire at American International Expositions, 1876–1918* (Chicago: University of Chicago Press, 1984), p. 28.

4 Frank H. Norton, ed., *Frank Leslie's Historical Register of the Centennial Exposition, 1876* (New York: Frank Leslie's Publishing Company, 1877), pp. 98–103; Robert Post, ed., *1876: A Centennial Exhibition* (Washington, DC: National Museum of American History, 1976), pp. 77–79.

5 G. B. Goode to S. F. Baird, October 6, 1876, RU 7002, box 21, folder 26, SIA.

6 S. F. Baird to J. Henry, January 18, 1877, in Rhees, *Documents*, vol. 1, pp. 755–61; AR 1876 (Washington, DC: GPO, 1877), pp. 81–83.

7 "The Nation's Centennial," *New-York Times*, April 7, 1876.

8 John Dale, *What Ben Beverly Saw at the Great Exhibition* (Chicago: Moses Warren, 1877), p. 117.

9 Dale, *What Ben Beverly Saw*, pp. 114–15; Rydell, *All the World's a Fair*, p. 25; Norton, *Frank Leslie's Historical Register of the Centennial Exposition, 1876*, p. 104; library.si.edu/digital-library/book/frankleslieshisoolesl.

10 Dale, *What Ben Beverly Saw*, p. 115; Rydell, *All the World's a Fair*, p. 25.

11 Locked book entry, April 25, 1862, in *Papers* vol. 10, p. 256; S. F. Baird, "Appendix to the Report of the Secretary," AR 1876, p. 70.

12 Curtis M. Hinsley Jr., *Savages and Scientists: The Smithsonian Institution and the Development of American Anthropology, 1846–1910* (Washington, DC: SIP, 1981), p. 70.

13 J. Henry to S. F. Baird, July 9, 1873, in *Papers*, vol. 11, pp. 462–63.

14 *Papers*, vol. 11, p. 463 fn. 3; Rydell, *All the World's a Fair*, pp. 22–29 passim for other fairs; Hinsley Jr., *Savages and Scientists*, p. 74 passim for other fairs; Robert A. Trennert, "A Grand Failure: The Centennial Indian Exhibition of 1876," *Prologue*, vol. 6, no. 2 (1974), pp. 118–29; Judy Braun Zegas, "North American Indian Exhibition at the 1876

NOTES

Centennial Exposition," *Curator: The Museum Journal*, vol. 19, no. 2 (May 2010), pp. 162–73; Christine Welch, "Savagery on Show: The Popular Visual Representation of Native American Peoples and their Lifeways at the World's Fairs (1851–1904) and in Buffalo Bill's Wild West (1884–1904)," *Journal of Early Popular Visual Culture*, vol. 9, no. 4 (December 2011).

15 AR 1874 (Washington, DC: GPO, 1875), pp. 8–9; Richard Rathbun, "Expositions in Which the National Museum Has Participated, 1876–1906," RU 55, box 19, folder 10, p. 3, SIA.

16 J. Henry to A. Gray, January 12, 1876, in *Papers*, vol. 11, pp. 557–58; Asa Gray, "Report of the Special Committee," AR 1876, pp. 124–28.

17 S. F. Baird, "National Museum," AR 1878 (Washington, DC: GPO, 1879), p. 39.

18 "Report of Professor Baird on the Centennial Exposition of 1876," AR 1876, p. 67.

19 S. F. Baird, circular letter to Centennial Exposition exhibitors, February 1, 1876, RU 7081, box 44, folder 20, SIA; E. F. Rivinus and E. M. Youssef, *Spencer Baird of the Smithsonian* (Washington, DC: SIP, 1984), p. 125.

20 Rhees, *Documents*, vol. 1, pp. 751–67.

21 J. Henry to A. Gray, November 6, 1876, in *Papers*, vol. 11, p. 586; S.F. Baird to J. Henry, November 9, 1876, in *Papers*, vol. 11, pp. 588–89; AR 1876, p. 43.

22 Rathbun, "Exhibitions in Which the National Museum has Participated," pp. 18, 31–32; airandspace.si.edu/stories /editorial/exploring-history-our-chinese-kite-collection.

23 Rhees, *Documents*, vol. 1, pp. 768–78.

24 G. B. Goode to S. P. Langley, 1886, RU 7081, box 28, folder 5, SIA.

25 Note by J. Henry, "On Paralytic Attack," December 19, 1877, in *Papers*, vol. 11, p. 637 fn. 1; J. Henry to R. S. McCulloh, January 28, 1878, in *Papers*, vol. 11, pp. 644–45.

26 Leonard Carmichael, "Joseph Henry and the National Academy of Sciences," *Proceedings of the National Academy of Sciences*, vol. 58, no. 1 (July 15, 1967); note from J. Henry dated December 19, 1877, in *Papers*, vol. 11, pp. 637–38; Joseph Patterson to J. Henry, December 22, 1877, in *Papers*, vol. 11, p. 638; "The Henry Endowment Fund," *[Washington] Evening Post*, May 14, 1878.

27 "Professor Joseph Henry," *Scientific American*, vol. 36, no. 22 (June 1, 1878); Journal of Maria Mitchell, April 1878, in *Papers*, vol. 11, p. 653; S. F. Baird Diary, May 13, 1878, RU 7002, box 41, folder 5, SIA.

28 AR 1858 (Washington, DC: James B. Steedman, 1859), p. 133; "The End of a Busy Life," *Washington Post*, May 17, 1878.

29 "A Great Scientist Gone," *Washington Post*, May 14, 1878; "Professor Joseph Henry, LL.D.," *New York Observer and Chronicle*, May 16, 1878; "A City in Mourning," *Washington Post*, May 15, 1876; "Prof. Henry's Funeral," *New York Observer and Chronicle*, May 23, 1878; Rhees, *Documents*, vol. 1, p. 823; "Professor Henry's Statue," *Washington Post*, April 19, 1883; "A History of the Statue," *Washington Post*, April 20, 1883.

30 "Great Loss to Science," *National Republican*, August 20, 1887.

31 Dr. Allen T. Greenlee, report on the health of Mary Baird in Rivinus and Youssef, *Spencer Baird of the Smithsonian*, pp. 47–49.

32 S. F. Baird to J. B. Bowman, May 7, 1868, RU 7002, box 3, folder 4, SIA; G. B. Goode, "The Three Secretaries" in *The Smithsonian Institution, 1846–1896: The History of its First Half Century*, ed. G. B. Goode (Washington, DC: SI, 1897), p. 194.

33 Lucy Baird, Untitled Notes on Her Father, RU 7078, box 1, folder 11, SIA; Lucy Baird quoted in W. H. Dall, *Spencer Fullerton Baird: A Biography* (Philadelphia: J. P. Lippincott, 1915), p. 149.

34 "General Comment," *Washington Post*, August 28, 1887.

35 "Report of the Executive Committee . . . ," AR 1874, pp. 118–22; "Report of the Executive Committee . . . ," AR 1880 (Washington, DC: GPO, 1881), pp. 158–62; "Report of the Executive Committee . . . ," AR 1884 (Washington, DC: GPO, 1885), pp. xvi–xviii.

36 John S. Billings, *Memoir of Spencer Fullerton Baird, 1823–1887* (Washington, DC: Judd & Detweiler, 1889), p. 155.

37 "National Museum Building Commission," AR 1879 (Washington, DC: GPO, 1880), pp. 125–26.

38 "New Building for the National Museum, Washington, DC," RU 71, box 14, folder 6, SIA; "National Museum Building Commission," AR 1879, p. 127.

39 "The New National Museum," *Washington Post*, July 26, 1879; "National Museum Building Commission," AR 1879, p. 127; "The Brick Work Completed," *Washington Post*, November 14, 1859; siarchives.si.edu/blog/smithsonian-goes -telephonic-1878.

40 si-siris.blogspot.com/2016/02/president-garfield-and-smithsonian.html.

41 "The Ball and Reception," *Washington Post*, May 5, 1881; "A Beautiful Ball-Room: The Goddess of Liberty as a Centerpiece," *Washington Post*, May 5, 1881.

42 S. F. Baird, Memorandum, December 17, 1884, RU 7081, box 9, folder 5, SIA.

43 W. J. Rhees to S. F. Baird, "Remarks relative to the Organization of the Smithsonian Institution," December 27, 1884, RU 7081, box 9, folder 5, pp. 2–3.

44 W. J. Rhees to S. F. Baird, "Remarks relative to the Organization of the Smithsonian Institution," p. 6.

NOTES

45 S. F. Baird to W. J. Rhees, September 9, 1884, RU 7002, box 10, folder 3, SIA.

46 Rivinus and Youssef, *Spencer Baird of the Smithsonian*, p. 149; "The Steamer Fish Hawk," *Report of the [Fish] Commissioner for 1884* (Washington, DC: GPO, 1886), pp. xx–xxi.

47 S. F. Baird to J. D. [*sic*] Chenoweth, September 28, 1885, RU 7002, box 17, folder 19, SIA.

48 "Auditor Chenoweth Arraigns Professor Baird," unidentified and undated newspaper article; "Fish Commission Affairs Give Out Unpleasant Odor," unidentified newspaper, October 20, 1885; and "Pure Prodigality," *Pittsburgh Dispatch*, September 28, 1885, all in RU 7002, box 67, folder 14, SIA; Letters, drafts, and correspondence, RU 7002, box 67, folder 3, SIA; see also, Rivinus and Youssef, *Spencer Baird of the Smithsonian*, pp. 150–51.

CHAPTER 13

1 G. B. Goode, "Report of the Assistant Director of the United States National Museum," AR 1881 (Washington, DC: GPO, 1883), pp. 81–82.

2 "Organization and Administration of the US National Museum," in *Proceedings of the United States National Museum* (Washington DC: GPO, 1882), vol. 4, Appendices 1–18; Pamela Henson, "Objects of Curious Research: The History of Science and Technology at the Smithsonian," *Isis*, vol. 90, no. S2 (1999), pp. S249–69.

3 Goode, "Report of the Assistant Director of the National Museum," AR 1881, pp. 99–111; Curtis M. Hinsley Jr., *The Smithsonian and the American Indian: Making a Moral Anthropology in Victorian America* (Washington, DC: SIP, 1981), pp. 84–91, 94–100, 109–17.

4 Hinsley Jr., *The Smithsonian and the American Indian*, p. 97; S. F. Baird, General Order No. 1, RU 7081, box 9, folder 1, SIA; S. F. Baird, General Order No. 2, June 28, 1881, RU 7081, box 9, folder 1, SIA; Goode, "Report of the Assistant Director of the National Museum," AR 1881, pp. 102–11; siarchives.si.edu/blog/spotlight-henry-joseph-horan-superintendent-buildings.

5 "The National Museum," *[Washington] Evening Star*, February 11, 1882.

6 "Organization of the National Museum," p. 25.

7 "Smithsonian Institution," RU 7081, box 9, folder 1, SIA; "List of Officers and Employees of the US National Museum," RU 7081, box 10, folder 4, SIA; "Appendix A—A List of Officers, January 1, 1882," AR 1881, p. 111; "The National Museum," *Evening Star*, February 11, 1882.

8 "Electricity in the National Museum," *Evening Star*, March 28, 1883.

9 Goode, "Report of the Assistant Director of the National Museum," AR 1881, p. 84.

10 G. B. Goode, "Museum-History and Museums of History," *A Memorial of George Brown Goode, Together with a Selection of His Papers on Museums and on the History of Science in America* (Washington, DC: GPO, 1901), pp. 71, 79; Goode, "Report of the Assistant Director of the United States National Museum," AR 1897, pt. II (Washington, DC: GPO, 1901), pp. 89–90.

11 Goode, "Report of the Assistant Director of the National Museum," AR 1881, p. 111; *Evening Star*, February 11, 1882.

12 "The US National Museum I," *Science*, vol. 2, no. 24 (July 20, 1883), pp. 63–66; "The US National Museum II," *Science*, vol. 2, no. 26 (August 3, 1883), pp. 119–23.

13 G. B. Goode, "Report of the Assistant Secretary in Charge of the National Museum," *Report of the US National Museum . . . for the Year Ending June 30, 1893* (Washington, DC: GPO, 1895), p. 18; Pamela Henson, "A Nursery of Living Thoughts: G. Brown Goode's Vision for a National Museum in the Late Nineteenth-Century United States," in Corin Berkowitz and Bernard Lightman, *Science Museums in Transition: Cultures on Display in Nineteenth-Century Britain and America* (Pittsburgh: University of Pittsburgh Press, 2017), pp. 165–87; Steven Conn, *Museums and American Intellectual Life, 1876–1926* (Chicago: University of Chicago Press, 1998), pp. 20–22.

14 Lewis H. Morgan, *Ancient Society or Researches in the Lines of Human Progress from Savagery, Through Barbarism to Civilization* (New York: Henry Holt, 1877).

15 Otis T. Mason, *The Origins of Invention: A Study of Industry Among Primitive Peoples* (Cambridge, MA: MIT Press, 1966); Otis T. Mason, "The Educational Aspects of the United States Museum," in *Notes Supplementary to the Johns Hopkins University Studies in Historical and Political Sciences, 1890*, no. 4 (Baltimore: Johns Hopkins University Press, 1890), p. 14; Sally Kohlstedt, "Otis T. Mason's Tour of Europe: Observation, Exchange, and Standardization in Museums, 1889, *Museum History Journal*, vol. 1, no. 2 (July 2008), pp. 181–208.

16 rbhayes.org/research/thomas-corwin-donaldson/.

17 G. B. Goode, "Objects which it is desirable for Mr. Donaldson to obtain . . . ," RU 189, box 32, folder 2, SIA.

18 Ernest Ingersoll, "The Making of a Museum," *Century Magazine*, vol. 29, no. 35 (January 1885), p. 369.

19 "The National Museum: What Can Be Seen in the Building," *Evening Star*, February 11, 1882; "The Cranks," *Memphis Daily Appeal*, September 9, 1884; Pamela Henson, "A National Science and a National Museum," *Proceedings of the California Academy of Sciences*, vol. 55, no. 3, supplement 1 (2004), p. 52.

20 Henson, "A National Science and a National Museum," p. 52.

383

NOTES

21 Henson, "A National Science and a National Museum," p. 52; Helena E. Wright, *The First Smithsonian Collection: The European Engravings of George Perkins Marsh and the Role of Prints in the U.S. National Museum* (Washington, DC: SISP, 2015), p. 132.

22 Henson, "Objects of Curious Research," p. 256.

23 Edward P. Alexander, "George Brown Goode and the Smithsonian Museums: A National Museum of Cultural History," in Alexander, *Museum Masters: Their Museums and Their Influence* (Nashville: American Association for State and Local History, 1983), p. 9.

24 Goode, "Report of the Assistant Director of the National Museum," AR 1881, p. 95; G. B. Goode, "II. Recent Advances in Museum Method," AR 1893 (Washington, DC: GPO, 1895), pp. 23–33.

25 G. B. Goode, "II. Recent Advances in Museum Method," pp. 52–58.

26 Goode, "Report of the Assistant Director of the National Museum," AR 1881, p. 96.

27 "Whales and Their Ways: Marine Monsters in the Museum," *Washington Star*, April 6, 1887.

28 "Whales and Their Ways," *Washington Star*, April 6, 1887; AR 1883 (Washington, DC: GPO, 1883), p. 125.

29 en.wikipedia.org/wiki/J._Elfreth_Watkins; en.wikipedia.org/wiki/John_Bull_(locomotive); siarchives.si.edu/collections/siris_arc_217425; John H. White Jr., *The John Bull: 150 Years a Locomotive* (Washington, DC: SIP, 1981).

30 William T. Hornaday, "Eighty Fascinating Years: An Autobiography," chap. I, pp. 1–2, William T. Hornaday Papers, box 112, file 1, Manuscript Division, Library of Congress; Hornaday, "Eighty Fascinating Years," chap. II; "Notes," *American Naturalist*, vol. 7, no. 4 (April 1873), pp. 249–56.

31 Hornaday, "Eighty Fascinating Years," chap. II.

32 Hornaday, "Eighty Fascinating Years," chap. III; "Notes," *American Naturalist*.

33 Hornaday, "Eighty Fascinating Years," chaps. IV–VII.

34 Hornaday, "Eighty Fascinating Years," chaps. IV–VII.

35 Hornaday, "Eighty Fascinating Years," chap. VIII.

36 Hornaday, "Eighty Fascinating Years," chap. VIII; *Alexandria Gazette*, April 10, 1882; "A Dead Elephant," "Knocking Stuffing into Elephants, Together with Bears and Other Quadrupeds," undated clippings in "Personal Notices of William T. Hornaday, 1875–1893, 1902, 1934," William T. Hornaday Papers, box 114, folder "Miscellaneous Contributions by W. T. Hornaday," Manuscript Division, Library of Congress; "The Work of Museum Preparators, Taxidermists," in AR 1884, pt. II (Washington, DC: GPO, 1885), pp. 41–45.

37 W. T. Hornaday to H. A. Ward, May 4, 1882, quoted in James A. Dolph, "Bringing Wildlife to the Millions: William Temple Hornaday, The Early Years, 1854–1896" (unpublished PhD diss., University of Massachusetts, 1975), p. 350, copy in box 112, W. T. Hornaday Papers, Manuscript Division, Library of Congress; F. W. True to W. T. Hornaday, March 2, 1883; W. T. Hornaday to F. W, True, April 1, 1883; F. W. True to W. T. Hornaday, n. d.; and W. T. Hornaday to F. W. True, December 4, 1883, all in RU 210, box 2, file 7, SIA.

38 William T. Hornaday, *Two Years in the Jungle: The Experiences of a Hunter and Naturalist in India, the Malay Peninsula and Borneo* (New York: Charles Scribner Sons, 1885); William T. Hornaday, "Brief Directions for Removing and Preserving the Skins of Mammals," in *Proceedings of the United States National Museum*, vol. 4, pp. 103–5; W. T. Hornaday, "How to Collect Skins for Purposes of Study and for Mounting," in AR 1886, pt. II (Washington, DC: GPO, 1889), pp. 659–70; Mary Anne Andrei, *Nature's Mirror: How Taxidermists Shaped America's Natural History Museums and Saved Endangered Species* (Chicago: University of Chicago Press, 2020).

39 Theodore Roosevelt, *Hunting Trips of a Ranchman: Sketches of Sport on the Northern Cattle Plains* (New York: G. P. Putnam's Sons, 1885), p. 241.

40 "Disappearance of the Buffalo," *The Cultivator and Country Gentleman,* November 11, 1886, p. 51; see also, "Nearly Exterminated," *Yorkville [South Carolina] Enquirer,* February 11, 1886; "Extinction of the Bison," *[New Orleans] Times-Democrat,* June 14, 1886; "Not so Bad, After All," *Daily Dispatch [Montgomery, Alabama],* March 2, 1886.

41 Hornaday, "Eighty Fascinating Years," chap. X, p. 1.

42 Hornaday, "Eighty Fascinating Years," chap. X, p. 4.

43 William T. Hornaday, "The Extermination of the American Bison, with A Sketch of Its Discovery and Life History," in AR 1893, Report of the U.S. National Museum, pp. 529–34.

44 S. F. Baird to W. T. Hornaday, June 26, 1888, and W. T. Hornaday to S. F. Baird, June 29, 1888, both in RU 210, box 1, folder 2, SIA; W. T. Hornaday, "Progress Report of Explorations for Buffalo in the Northwest," July 19, 1886, RU 201, box 14, folder 13, SIA; "A Buffalo Dies in Clover," *Washington Post,* August 30, 1886.

45 Hornaday, "The Extermination of the American Bison," pp. 535–46; W. T. Hornaday to S. F. Baird, October 19, 1886, RU 208, box 9, folder 1, SIA.

46 W. T. Hornaday to S. F. Baird, October 19, 1886, RU 208, box 9, folder 1, SIA; Hornaday, "Eighty Fascinating Years," chap. X, p. 35.

47 AR 1893, Report of the U.S. National Museum, pp. 307–540; Mary Anne Andrei, "The Accidental Conservationist: William T. Hornaday, the Smithsonian Bison Expeditions and the US National Zoo," *Endeavour*, vol. 29, no. 3 (September 2005), pp. 109–13.

NOTES

48 Dolph, "Bringing Wildlife to the Millions," p. 462.

49 Dolph, "Bringing Wildlife to the Millions," p. 468.

50 Harry P. Godwin, "A Scene from Montana," *Washington Star*, March 10, 1888.

51 siarchives.si.edu/blog/reconstructing-william-temple-hornaday-1888-extermination-series; *Official Guide of the Centennial Exposition of the Ohio Valley and Central States* (Cincinnati: John F. C. Mullen), p. 71; AR 1889, Report of the National Museum (Washington, DC: GPO, 1891), pp. 418–19.

CHAPTER 14

1 Robert W. Rydell, *All the World's a Fair: Visions of Empire at American International Expositions, 1876–1916* (Chicago: University of Chicago Press, 1987), p. 2.

2 Richard Rathbun, "Expositions in Which the National Museum Has Participated," RU 55, box 19, folder 10, SIA.

3 Rathbun, "Expositions," pp. 5–7; G. B. Goode, "Special Topics of the Year," AR 1893, Report of the U.S. National Museum (Washington, DC: GPO, 1895), p. 59.

4 G. B. Goode, "Special Topics of the Year" quoted in Rathbun, "Expositions," p. 25; Hough quoted in Rydell, *All the World's a Fair*, p. 6.

5 Joint Resolution, 46th Congress, January 16, 1881 (Stat., XXI, 301), in Rhees, *Documents*, vol. 1, pp. 824–25; siarchives .si.edu/collections/siris_sic_621.

6 Richard Ellis, "The Models of Architeuthis," *The Curator*, vol. 40, no. 1 (March 1997), pp. 30–55; S. F. Baird, "Report of the Secretary," AR 1883 (Washington, DC: GPO, 1885), pp. 43–45.

7 "Report of Professor Baird," AR 1884 (Washington, DC: GPO, 1885), p. 44.

8 *Donaldsonville Chief*, September 13, 1894; *Louisiana Democrat*, August 28, 1884.

9 "Exhibit of the Smithsonian Institution Including the National Museum," *Official Guide of the Centennial Exposition of the Ohio Valley and Central States* (Cincinnati: John F. C. Mullen, 1888), pp, 68–80.

10 "Exhibit of the Smithsonian Institution," *Official Guide*, pp. 69–80.

11 "Exhibit of the Smithsonian Institution," *Official Guide*, pp. 69–80; undated "Partial Copy" of a memo on the World's Columbian Exposition, RU 70, box 31, folder 1, SIA.

12 "World's Fair Offices Tendered," *Chicago Daily Tribune*, July 28, 1890.

13 G. B. Goode, "First Draft of a System of Classification for the World's Columbian Exposition," AR 1891, Report of the U.S. National Museum (Washington, DC: GPO, 1892), pp. 649-735.

14 "A System of Classification," *Chicago Daily Tribune*, September 16, 1890; "Prof. Goode in the City," *Chicago Daily News*, Oct. 1, 1890; "Schemes of Classification," *Chicago Herald*, Oct. 3, 1890.

15 wikipedia.org/wiki/World%27sColumbian_Exposition#References.

16 "Partial Copy," p. 5; G. B. Goode, "The Exhibit of the Smithsonian Institution at the Cotton States Exposition, Atlanta, 1895" (Atlanta: n. p., 1895).

17 "Verifying the Biblical Story of Jonah and the Whale at the World's Fair," *St. Louis Post-Dispatch*, August 7, 1904; M. J. Lowenstein, *Official Guide to the Louisiana Purchase Exposition at the City of St. Louis* . . . (Saint Louis: Official Guide Co., 1904), p. 99.

18 Mark Jaffe, *The Gilded Dinosaur: The Fossil War Between E. D. Cope and O. C. Marsh and the Rise of American Science* (New York: Three Rivers Press, 2000) is a good introduction to the subject.

19 wikipedia.org/wiki/Dippy.

20 "Life-Size Stegosaurus," *Washington Post*, May 3, 1903.

21 Lowenstein, *Guide to the Louisiana Purchase Exposition*, p. 98; Ellis L. Yochelson, *The National Museum of Natural History: 75 Years in the Natural History Building*, ed. Mary Jarrett (Washington, DC: SIP, 1990), p. 125.

22 Lewis H. Morgan, *Ancient Society or Researches in the Lines of Human Progress from Savagery, Through Barbarism to Civilization* (New York: Henry Holt, 1877); C. Rau quoted in Rydell, *All the World's a Fair*, p. 24.

23 G. B. Goode, *Report Upon the Exhibit of the Smithsonian Institution and the United States National Museum at the Cotton States and International Exposition, Atlanta, GA, 1895* (Washington, DC: USGS, 1898), p. 30.

24 Goode, *Report Upon the Smithsonian Institution and National Museum*, pp. 15–16.

25 Otis T. Mason, "Circular Relative to the Ethnological Exhibit at the World's Industrial and Cotton Exposition," RU 70, box 12, folder 3, SIA.

26 Bruce Trigger quoted in Sharman Apt Russell, *When the Land Was Young: Reflections on American Archaeology* (n.p.: Open Road Media, 2022), p. 13, Kindle.

27 Leon Wolff, *Little Brown Brother: How the United States Purchased and Pacified the Philippine Islands at the Century's Turn* (New York: History Book Club, 1961).

28 J. H. Brigham to Wallace H. Hills, December 5, 1899, and Wallace H. Hills to J. H. Brigham, December 6, 1899, both in RU 70, box 47, folder 2, SIA; W J McGee quoted in Rydell, *All the World's a Fair*, p. 167.

29 W. H. Holmes, untitled instructions for collectors, January 1, 1890, RU 70, box 52, folder 4, SIA.

385

NOTES

30 F. True, "United States Government Philippine Exhibit," undated manuscript, RU 70, box 52, folder 2, SIA.
31 atlasobscura.com/places/1904-worlds-fair-flight-cage.
32 "Verifying the Biblical Story of Jonah and the Whale at the World's Fair," *St. Louis Post-Dispatch*, August 7, 1904; Lowenstein, *Guide to the Louisiana Purchase Exposition*, p. 99.
33 Whitney R. Cross, "W J McGee and the Idea of Conservation," *The Historian*, vol. 15, no. 2 (March 1953), pp. 148–62; N. H. Darton, "Memoir of W J McGee," *Annals of the Association of American Geographers*, vol. 3 (1913), pp. 103–10.
34 Darton, "Memoir of W J McGee."
35 W J McGee, "Anthropology at the Louisiana Purchase Exposition," *Science*, vol. 22, no. 573 (December 22, 1905), p. 826.
36 Adolph H. Schultz, "Biographical Memoir of Aleš Hrdlička, 1869–1943," *National Academy of Sciences of the United States Biographical Memoirs*, vol. 23, 12th memoir (Washington, DC: National Academy of Sciences, 1944), pp. 305–16.
37 Aleš Hrdlička, "The Medico-Legal Aspect of the Case of Maria Barbella," *State Hospitals Bulletin*, vol. 2, no. 2 (1897), pp. 213–300.
38 Schultz, "Memoir of Hrdlička," p. 307; Rydell, *All the World's a Fair*, p. 164.
39 Darton, "Memoir of W J McGee," p. 106; "To Exhibit Man at St. Louis Fair: Dr. McGee Gathering Types and Freaks from Every Land," *St. Louis Republic*, June 30, 1904.
40 "Native Filipinos in a Natural Environment," *New York Times*, July 17, 1904.
41 "Native Filipinos in a Natural Environment."
42 "Pygmies May be the Missing Link," *St. Louis Republic*, July 10, 1904.
43 A. Hrdlička to O. Mason, July 14, 1904, RU 70, box 68, folder 3, SIA.
44 A. Hrdlička to O. Mason, July 14, 1904; Rydell, *All the World's a Fair*, p. 165.
45 wv.pbslearningmedia.org/resource/1904-worlds-fair-exhibition-of-the-igorot-people/asian-americans/; Nicola Dungca and Claire Healy, "Revealing the Smithsonian's 'Racial Brain Collection,'" *Washington Post*, August 20, 2022.

CHAPTER 15

1 45th Congress, March 3, 1879 (Stat., XX, 397), in Rhees, *Documents*, vol., p. 818.
2 William Culp Darrah, *Powell of the Colorado* (Princeton, NJ: Princeton University Press, 1951), p. 55.
3 J. W. Powell, *First Annual Report of the Bureau of Ethnology to the Secretary of the Smithsonian Institution 1879–'80* (Washington, DC: GPO, 1881), p. XV.
4 AR 1879 (Washington, DC: GPO, 1880), p. 39.
5 Neil Judd, *The Bureau of American Ethnology: A Partial History* (Norman: University of Oklahoma Press, 1967), p. 58; untitled manuscript notes on James Stevenson, RU 7084, series 1, box 4, folder 2, SIA.
6 Judd, *The Bureau of American Ethnology*, p. 57.
7 W. H. Holmes, "In Memoriam: Matilda Coxe Stevenson," *American Anthropologist*, vol. 18, no. 4 (October–December 1916), pp. 552–59.
8 Matilda Coxe Stevenson quoted in Jesse Green, ed., *Zuñi: Selected Writings of Frank Hamilton Cushing*, (Lincoln: University of Nebraska Press, 1979), p. 24; C. Lévi-Strauss quoted in Green, *Zuñi*, p. xii; W J McGee and J. W. Powell quoted in "In Memoriam: Frank Hamilton Cushing," *American Anthropologist*, vol. 2, no. 2 (1900), pp. 354, 366–67; Nancy J. Parezo, "Reassessing Anthropology's Maverick: The Archaeological Fieldwork of Frank Hamilton Cushing," *American Ethnologist*, vol. 34, no. 3 (August 2007), pp. 575–80.
9 W. H. Holmes remarks in "In Memoriam: Frank Hamilton Cushing," pp. 356–58.
10 George Keenan quoted in Frederic W. Gleach, "Cushing at Cornell: The Early Years of a Pioneering Anthropologist," in *Histories of Anthropology Annual*, eds. Regna Darnell and Frederic W. Gleach (Lincoln: University of Nebraska Press, 2007), vol. 3, p. 107; Lewis H. Morgan, *Systems of Consanguinity and Affinity of the Human Family*, Smithsonian Contributions to Knowledge, vol. 17 (Washington, DC: SI, 1871); Lewis H. Morgan, *Ancient Society or Researches in the Lines of Human Progress from Savagery, Through Barbarism to Civilization* (New York: Henry Holt, 1877).
11 Frank H. Cushing, "Antiquities of Orleans County, New York," AR 1874 (Washington, DC: GPO, 1875), pp. 375–77.
12 Keenan quoted in Gleach, "Cushing at Cornell," p. 111.
13 Green, *Zuñi*, p. 45.
14 Frank H. Cushing, *My Adventures in Zuni* (Palmer Lake, CO: Filter Press Publishing, 1998), p. 2; J. Stevenson to J. W. Powell, September 16, 1878, Records of the Bureau of American Ethnology (RBAE), letters received, box 86, folder James Stevenson, 1879–80, National Anthropological Archives (NAA).
15 Will Roscoe, *The Zuni Man-Woman* (Albuquerque: University of New Mexico Press, 1992), pp. 12–13.
16 Roscoe, *The Zuni Man-Woman*, pp. 11–12.
17 Norman Bender, ed., *Missionaries, Outlaws, and Indians: Taylor F. Ealy at Lincoln and Zuni, 1878–1881* (Albuquerque: University of New Mexico Press, 1984).
18 Bender, *Missionaries, Outlaws, and Indians*, p. 124.

386

NOTES

19 F. H. Cushing to S. F. Baird, October 15, 1879, quoted in Jesse Green, ed., *Cushing at Zuni: The Correspondence and Journals of Frank Hamilton Cushing, 1879–1884* (Albuquerque: University of New Mexico Press, 1990), p. 44.

20 W. Matthews quoted in Sylvester Baxter, "The Father of the Pueblos," *Harper's New Monthly Magazine*, vol. 65 (June 1882), p. 74.

21 F. H. Cushing to S. F. Baird quoted in Green, *Cushing at Zuni*, p. 7.

22 Ealy quoted in Bender, *Missionaries, Outlaws, and Indians*, pp. 137–38.

23 Cushing, *My Adventures in Zuni*, p. 14.

24 F. H. Cushing to S. F. Baird, October 29, 1879, quoted in Green, *Cushing at Zuni*, p. 59; S. F. Baird to J. Stevenson, November 18, 1879, quoted in Green, *Cushing at Zuni*, p. 63.

25 J. Stevenson to J. Pilling, November 21, 1879, RBAE, letters received, box 86, folder James Stevenson, 1879–80, NAA; Frank H. Cushing, "Outlines of Zuñi Creation Myths," *Thirteenth Annual Report of the Bureau of Ethnology to the Secretary of the Smithsonian Institution, 1891–'92* (Washington, DC: GPO, 1896), p. 337; A. Bandelier quoted in Darlis Miller, *Matilda Coxe Stevenson: Pioneering Anthropologist* (Norman: University of Oklahoma Press, 2007), p 44.

26 Miller, *Matilda Coxe Stevenson*, p. 44; Bender, *Missionaries, Outlaws, and Indians*, p. 127.

27 J. Stevenson to J. Pilling, October 12, 1879, RBAE, letters received, box 86, folder James Stevenson, 1879–80, NAA; J. Stevenson to J. W. Powell, December 17, 1879, RBAE, letters received, box 86, folder James Stevenson, 1879–80, NAA; James Stevenson, "Illustrated Catalogue of the Collections Obtained from the Indians of New Mexico and Arizona in 1879," *Second Annual Report of the Bureau of Ethnology to the Secretary of the Smithsonian Institution 1880–'81* (Washington, DC: GPO, 1883), pp. 311–422.

28 F. Cushing to S. F. Baird, May 5, 1880, in Green, *Cushing at Zuni*, p. 92.

29 Green, *Cushing at Zuni*, pp. 162 fn. 54, 359; smithsonianmag.com/blogs/smithsonian-libraries-and-archives/2021/11 /29/tichkematse-a-great-favorite-at-the-smithsonian/.

30 F. Cushing to S. F. Baird, October 12, 1881, RBAE, letters received, box 65, folder Cushing, NAA.

31 Miller, *Matilda Coxe Stevenson*, pp 55–57.

32 Green, *Cushing at Zuni*, p. 140; Cushing, "Extract from Catalogue of Prehistoric and Zuni Cave Remains," in Green. *Cushing at Zuni*, p. 343.

33 F. Cushing to S. F. Baird, March 12, 1881, in Green, *Zuñi*, p. 147; Chip Colwell, *Plundered Skulls and Stolen Spirits: Inside the Fight to Reclaim Native America's Culture* (Chicago: University of Chicago Press, 2017), p. 25; William Merrill et al., "The Return of the Ahayu:da: Lessons for Repatriation from Zuni Pueblo and the Smithsonian Institution," *Current Anthropology*, vol. 34, no. 5 (December 1993), pp. 523–67; Nancy J. Parezo, "Cushing as Part of a Team: The Collecting Activities of the Smithsonian Institution," *American Ethnologist*, vol. 12, no. 4 (November 1985), pp. 763–74; Gwyneira Isaac, "Anthropology and Its Embodiments: 19th Century Museum Ethnography and the Re-enactment of Indigenous Knowledge," *Ethnofor*, vol. 22, no. 1 (2010), pp. 11–29.

34 Sylvester Baxter, "The Father of the Pueblos," *Harper's New Monthly Magazine*, vol. 65 (June 1883), p. 74.

35 Baxter, "The Father of the Pueblos," p. 74.

36 Sylvester Baxter, "SOLVED AT LAST: Mysteries of Ancient Aztec History Unveiled by an Explorer for the Smithsonian Institution. Wonderful Achievements of Frank H. Cushing," *Boston Herald*, June 16, 1881.

37 F. H. Cushing to S. F. Baird, October 12, 1881, RBAE, letters received, box 65, folder Cushing, NAA.

38 S. F. Baird to J. W. Powell, October 27, 1881, RBAE, letters received, box 65, folder Cushing, NAA; J. Pilling to F. H. Cushing, February 8, 1882, in Green, *Cushing at Zuni*, p. 318; "A Delegation of Zuni Indians," *Washington Post*, March 4, 1882.

39 "The Zuni Delegation," *Washington Post*, March 5, 1882; "A Delegation of Zuni Indians," *Washington Post*, March 4, 1882; "The Zuni Race," *[Washington] Evening Star*, March 11, 1882; Miller, *Matilda Coxe Stevenson*, pp. 58–59.

40 Sylvester Baxter, "An Aboriginal Pilgrimage," *Century*, vol. 24 (May 1882), pp. 526–36; Charles F. Loomis, "The White Indian," *Land of Sunshine*, vol. 13 (June–December 1900), pp. 10–11; "Zealous Zunis," *Boston Daily Globe*, March 29, 1882; "The Pueblo Builders," *Boston Daily Globe*, March 31, 1882.

41 Judd, *The Bureau of American Ethnology*, pp. 62–63; Cushing to F. W. Putnam, March 16, 1882; S. F. Baird to F. W. Putnam, April 8, 1882; F. Parkman to J. W. Powell, April 12, 1882; and E. E. Hale to F. H. Cushing, May 5, 1882, all in Green, *Cushing at Zuni*, pp. 222–23.

42 Green, *Cushing at Zuni*, p. 237.

43 F. H. Cushing, "The Zuñi Social, Mythic, and Religious Systems," *Popular Science Monthly*, vol. 21 (June 1882), pp. 186–92; Baxter, "The Father of the Pueblos," pp. 72–91; Baxter, "An Aboriginal Pilgrimage," pp. 526–36; F. H. Cushing, "My Adventures in Zuñi," *Century*, vol. 25 (December 1882), pp. 191–207; vol. 24 (February 1883), pp. 500–511; and vol. 26 (May 1883), pp. 28–47, all reprinted in Cushing, *My Adventures in Zuñi*; F. H. Cushing, "The Nation of the Willows," *Atlantic Monthly*, vol. 50 (September–October, 1882), pp. 362–74, 541–59.

44 F. H. Cushing, "Zuni Fetiches," *Second Annual Report of the Bureau of Ethnology 1880–'81*, pp. 9–45; F. H. Cushing, "Zuñi Breadstuff," *Millstone*, vol. 9, nos. 1–12, vol. 10, nos. 1–4, 6–8; F. H. Cushing, "A Study of Pueblo Pottery as Illustrative of

387

NOTES

Zuñi Cultural Growth," *Fourth Annual Report of the Bureau of Ethnology to the Secretary of the Smithsonian Institution 1882–'83* (Washington, DC: GPO, 1884), pp. 467–521; F. H. Cushing, *Zuni Folk Tales* (New York: G.P. Putnam's Sons, 1901).

45 Edmund Wilson, *Red, Black, Blond, and Olive: Four Civilizations: Zūni, Haiti, Soviet Russia, Israel* (New York: Oxford University Press, 1956), pp. 15–19.

46 Green, *Cushing in Zuni*, p. 237.

47 Triloki Nath Pandey, "Anthropologists at Zuni," *Proceedings of the American Philosophical Society*, vol. 116, no. 4 (August 15, 1972), pp. 324–25; F. H. Cushing to S. F. Baird, December 4, 1881, in Pandey, "Anthropologists at Zuni," p. 324.

48 S. Jackson to S. F. Baird, December 22, 1882, in Green, *Cushing at Zuni*, p. 262; F. H. Cushing to S.F. Baird, December 4, 1881, in Pandey, "Anthropologists at Zuni," p. 323; Sylvester Baxter, "Zuni Revisited," *American Architecture and Building News*, vol. 13, no. 377 (March 17, 1883), pp. 124–26.

49 John P. Wilson, "Cushing at Zuni: Another View," in Regge N. Wiseman et al., *Forward into the Past: Papers in Honor of Teddy Lou and Francis Stickney* (Albuquerque: Archaeological Society of New Mexico, 2002), vol. 28, pp. 141–46.

50 Pandey, "Anthropologists at Zuni," pp. 325–26; J. Pilling to F. C. Cushing, January 19, 1884, in Green, *Cushing at Zuni*, p. 316.

51 *Illustrated Police News*, March 6, 1886.

52 Roscoe, *The Zuni Man-Woman*; "Making an Indian Blanket: We'Wah, the Zuni Princess, at Work in the National Museum," *Evening Star*, June 12, 1886.

53 Miller, *Matilda Coxe Stevenson*, p. 74; Daniel S. Lamb, "The Story of the Anthropological Society of Washington," *American Anthropologist*, vol. 8, no. 3 (July–September 1906), p. 577.

54 Green, *Zuñi*, p. 26 fn. 11; siarchives.si.edu/blog/sneak-peek-4-20-2020.

55 Curtis M. Hinsley Jr., *Savages and Scientists: The Smithsonian Institution and the Development of American Anthropology, 1846–1910* (Washington, DC: SIP, 1981), p. 202.

56 Eliza McFeely, *Zuni and the American Imagination* (New York: Hill and Wang, 2001), p. 2; Shaun Reno, "The Zuni Indian Tribe: A Model for *Stranger in a Strange Land*'s Martian Culture," *Extrapolation*, vol. 36, no. 2 (Summer 1995), pp. 151–59.

57 S. F. Baird to G. B. Goode, August 10, 1882, RU 7002, box 22, folder 4, SIA; S. F. Baird to J. W. Powell, November 8, 1883, RU 7081, box 11, folder 1, SIA; E. F. Rivinus and E. M. Youssef, *Spencer Baird of the Smithsonian* (Washington, DC: SIP, 1992,) pp. 133–34; Donald Worster, *A River Running West: The Life of John Wesley Powell* (New York: Oxford University Press, 2001), p. 403; "Classification of Expenditures . . . ," *Second Annual Report of the Bureau of Ethnology 1880–'81*, p. XXXVII.

58 S. F. Baird to J. W. Powell, November 8, 1883, RU 7081, box 11, folder 1, SIA.

59 J. W. Powell, "Mound Explorations," *Fourth Annual Report of the Bureau of Ethnology 1882–'83*, pp. XXIX–XXXIII; Powell, "Limitations to the Use of Anthropological Date," *First Annual Report of the Bureau of Ethnology 1879–'80*, p. 74.

60 Scott Tribble, "Mounds, Myths, and Grave Mistakes: Wills De Hass and the Growing Pains of Nineteenth-Century Archaeology," *West Virginia History*, vol. 7, no. 1 (Spring 2013), pp. 23–37.

61 Judd, *The Bureau of American Ethnology*, pp. 18–19.

62 W. H. Holmes, "Burial Mounds of the Northern Sections of the United States," *Fifth Annual Report of the Bureau of Ethnology to the Secretary of the Smithsonian Institution 1883–'84* (Washington, DC: GPO, 1887), p. 108; Cyrus Thomas, *Work in Mound Exploration of the Bureau of Ethnology*, vol. 4 (Washington, DC: GPO, 1887).

63 Robert Silverberg, *Mound Builders of Ancient America: The Archaeology of a Myth* (Greenwich, CT: New York Graphic Society, 1968), pp. 197–98.

64 Cyrus Thomas, "Report on the Mound Explorations of the Bureau of Ethnology," *Twelfth Annual Report of the Bureau of Ethnology to the Secretary of the Smithsonian Institution 1890–'91* (Washington, DC: GPO, 1894), p. 17.

65 Jerald T. Milanich, foreword to *The Florida Journals of Frank Hamilton Cushing*, by Phyllis E. Kolianos and Brent Weisman (Gainesville: University of Florida Press, 2005), p. xii.

CHAPTER 16

1 E. F. Rivinus and E. M. Youssef, *Spencer Baird of the Smithsonian* (Washington, DC: SIP, 1992), p. 180.

2 S. F. Baird, Memorandum, T90082, box 1, file Langley, SIA.

3 S. F. Baird, Memorandum, November 19, 1886, T90082, box 1, file Langley, SIA; S. Langley to S. F. Baird, November 27, 1886, T90082, box 1, file Langley, SIA; S. F. Baird, Memorandum to the Board of Regents, January 12, 1887, T90082, box 1, file Langley, SIA; Minutes of the Annual Meeting of the Board of Regents, January 12, 1887, AR 1887 (Washington, DC: GPO, 1889), p. XIV.

4 Charles D. Walcott, "Biographical Memoir of Samuel Pierpont Langley, 1834–1906," *National Academy of Sciences Biographical Memoirs*, vol. 7 (Washington, DC: National Academy of Sciences, 1913), p. 257.

5 S. P. Langley, *The New Astronomy* (Boston: Ticknor, 1888).

6 S. P. Langley, "Uncompleted Memoire of S. P. Langley Written at Aiken, South Carolina, from February 8 to February 20, 1906," RU 7003, box 26, file Langley's Memoirs (incomplete), SIA; Ancestry.com Massachusetts State Census 1855.

NOTES

7 Chicago City Directory Supplement (Chicago: Robert Fergus, 1856), p. 9; G. B. Goode, "The Three Secretaries," in *The Smithsonian Institution, 1846–1896: The History of its First Half Century*, ed. G. B. Goode (Washington, DC: SI, 1897), p. 201.

8 S. P. Langley quoted in E. Scott Barr, "The Infrared Pioneers—III. Samuel Pierpont Langley," *Infrared Physics*, vol. 3, no. 4 (December 1963), p. 200; T. B. Webb, "Draper's Telescope," AR 1864 (Washington, DC: GPO, 1865), pp. 62–66.

9 S. P. Langley, passport application, Boston, November 1864, National Archives and Records Administration (NARA) Series, Passport Applications, 1795–1905, roll no. 125, September 1–November 30, 1864.

10 Goode, "Three Secretaries," pp. 209–10; Andrew D. White, "Samuel Pierpont Langley," S. P. Langley: Memorial Meeting, December 3, 1906, in *Smithsonian Miscellaneous Collections*, vol. 49 (Washington, DC: GPO, 1907), p. 18.

11 White, "Langley," p. 9; sites.pitt.edu/~aobsvtry/history.html; Goode, "Three Secretaries," pp. 201–2.

12 sites.pitt.edu/~aobsvtry/history.html.

13 Walcott, "Memoir of Samuel Pierpont Langley," p. 248.

14 Langley, *The New Astronomy*, pp. 17–19.

15 Langley, *The New Astronomy*, p. 17–19; Edward S. Holden, "Sketch of Professor S. P. Langley," *Popular Science Monthly*, vol. 27 (July 1, 1885), p. 29.

16 Langley, *The New Astronomy*, p. 75.

17 Barr, "The Infrared Pioneers," p. 196; M. S. Lamansky, "On the Heat-Spectrum of the Sun and the Lime-Light," *Philosophical Magazine and Journal of Science*, vol. 43 (January–June 1872), pp. 282–89.

18 S. P. Langley, "The Astrophysical Observatory" in *The Smithsonian Institution, 1846–1896*, ed. Goode, p. 432.

19 Barr, "The Infrared Pioneers," p. 196; John A. Eddy, "Founding the Astrophysical Observatory: The Langley Years," *Journal for the History of Astronomy*, vol. 21, no. 1 (February 1990), p. 114.

20 Langley, *The New Astronomy*; for Langley's popular articles on astronomy, see Walcott, "Memoir of Samuel Pierpont Langley," pp. 258–68.

21 Tom D. Crouch, *A Dream of Wings: Americans and the Airplane, 1875–1905* (New York: W. W. Norton, 1981), pp. 37–41.

22 *Buffalo Courier*, August 26, 1886; see also, Program of the Thirty-Fifth Annual Meeting of the American Association for the Advancement of Sciences (August 1886), pp. 48, 109.

23 S. P. Langley, *The Internal Work of the Wind* (Washington, DC: SI, 1893), Smithsonian Contributions to Knowledge, no. 884, p. 1.

24 S. P. Langley, *Experiments in Aerodynamics* (Washington, DC: SI, 1891), Smithsonian Contributions to Knowledge, no. 801; O. Chanute to S. P. Langley, June 9, 1887, Octave Chanute Papers, box 21, reel 7, Manuscript Division, Library of Congress; R. H. Thurston to S. P. Langley, March 27, 1887, NASM 0494-M0000153-00020, National Air and Space Museum Archives (NASMA).

25 Langley, *Experiments in Aerodynamics*, p. 7; S. P. Langley, "The Story of Experiments in Mechanical Flight," in *The Aeronautical Annual 1897*, ed. James Means (Boston: W. B. Clarke, 1897), p, 13; Crouch, *A Dream of Wings*, pp. 48–50.

26 See Langley, *Experiments in Aerodynamics*, passim for a description of all the instruments employed.

27 John D. Anderson Jr., *A History of Aerodynamics and Its Impact on Flying Machines* (Cambridge, UK: Cambridge University Press, 1997), pp. 164–80.

28 Langley, *Experiments in Aerodynamics*, p. 44; Crouch, *A Dream of Wings*, pp. 52–53.

29 F. W. Very to S. P. Langley, November 10, 1888, RU 7003, box 29, SIA.

30 Lucy Baird to W. J. Rhees, August 23, 1887, RU 64, box 3, SIA.

31 Rivinus and Youssef, *Spencer Baird of the Smithsonian*, pp. 182–83; "The Death of Prof. Baird," *Washington Post*, August 20, 1887; "Death of Spencer Fullerton Baird at Woods Hole," *National Republican*, August 20, 1887; "Death of Prof. Baird," *National Tribune*, September 1, 1888.

32 J. W. Powell, "The Personal Characteristics of Professor Baird," AR 1888 (Washington, DC: GPO, 1890), p. 739.

33 G. B. Goode, *The Published Writings of Spencer Fullerton Baird, 1843–1882* (Washington, DC: GPO, 1883), pp. v–xiii.

34 David S. Jordan quoted in Rivinus and Youssef, *Spencer Baird of the Smithsonian*, p. 184; Robert Ridgway, "Spencer Fullerton Baird," AR 1888, p. 713.

35 Rivinus and Youssef, *Spencer Baird of the Smithsonian*, p. 60; Daniel Goldstein, "'Yours for Science': The Smithsonian Institution's Correspondents and the Shape of the Scientific Community in Nineteenth-Century America," *Isis*, vol. 85, no. 4 (1994), p. 576.

36 S. P. Langley to S. F. Baird, November 27, 1886, T90082, box 1, file Samuel P. Langley, SIA.

37 S. P. Langley to S. F. Baird, November 27, 1886.

38 Minutes, Board of Regents, Special Meeting, November 18, 1887, RU 1, series 1, box 1, 1880-July 1897, from the Annual Reports, SIA.

39 Minutes, Board of Regents, Special Meeting, November 18, 1887.

CHAPTER 17

1 Cyrus Adler, *I Have Considered the Days* (Philadelphia: Jewish Publication Society of America, 1941), pp. 181–83.

NOTES

2 Adler, *I Have Considered the Days*, pp. 181–83.

3 Adler, *I Have Considered the Days*, p. 183; Charles D. Walcott, Biographical Memoir of Samuel Pierpont Langley, (Washington, DC: The National Academy of Sciences, 1912), p. 257.

4 S. P. Langley, "The Fire Walk Ceremony in Tahiti," AR 1901 (Washington, DC: GPO, 1902), pp. 18, 539–44.

5 Helena E. Wright, *The First Smithsonian Collection: The European Engravings of George Perkins Marsh and the Role of Prints in the U.S. National Museum* (Washington, DC: SISP, 2015), pp. 145–47; quotes from untitled memoir of S. P. Langley, RU 7003, box 26, file Langley's Memoirs (incomplete), SIA.

6 *The Strollers* (New York: T. W. R. Ripley, 1903), copy in RU 7003, box 14, file The Strollers Constitution and By-Laws, SIA.

7 Adler, *I Have Considered the Days*, pp. 183–84; Cyrus Adler, "Samuel Pierpont Langley," AR 1906 (Washington, DC: GPO, 1907), p. 532; *The Capital*, October 21, 1893.

8 Andrew D. White, "Samuel Pierpont Langley," S. P. Langley: Memorial Meeting, December 3, 1906, in *Smithsonian Miscellaneous Collections*, vol. 49 (Washington, DC: GPO, 1907), p. 23; William T. Hornaday, "Eighty Fascinating Years: An Autobiography," chap. IX, n.p., William T. Hornaday Papers, box 112, file 1, Manuscript Division, Library of Congress.

9 C. G. Abbot, "Samuel Pierpont Langley," in *Smithsonian Miscellaneous Collections*, vol. 92 (Washington, DC: SI, 1935), p. 93.

10 Accession 06-209, Personnel Records, 1846–1966, box 1, Employee Card, Solomon G. Brown, SIA; S. P. Langley to S. G. Brown, November 25, 1892, RU 34, box 32, reel 109, vol. 11.1, p. 370, SIA; W. Winlock to S. Brown, April 10, 1895, RU 34, box 32, reel 111, vol. 11.4, p. 172, SIA.

11 Terrica Gibson, "'There are whole lots of things I know but I never say anything . . .': African American Employees and the Smithsonian, 1852–1920," Accession 07-214, SIA.

12 siarchives.si.edu/blog/smithsonian%E2%80%99s-first-woman-employee-jane-w-turner-librarian.

13 Abbot, "Langley," p. 93.

14 Henry Adams, *The Education of Henry Adams* (Boston: Houghton Mifflin, 1918), p. 379.

15 Adler, *I Have Considered the Days*, p. 187.

16 Adler, *I Have Considered the Days*, pp. 187–89.

17 Adler, *I Have Considered the Days*, pp. 186, 257; Account Book, 1888–1906, passim, RU 7003, box 19, SIA; on Anita Newcomb, see Whitney R. Cross, "W J McGee and the Idea of Conservation," *The Historian*, vol. 13, no. 2 (Spring 1953), p. 153.

18 Adler, *I Have Considered the Days*, p. 185.

19 Adler, *I Have Considered the Days*, p. 185.

20 S. P. Langley to G. B. Goode, February 8, 1888; S. P. Langley to W. B. Taylor, May 3, 1888; September 14, 1888; June 3, 1889; April 5, 1890; and September 17, 1891, all in RU 64, box 12, folder Misc. letters, 1863–1893, SIA.

21 Hornaday, "Eighty Fascinating Years," chap. IX, p. 1.

22 "A Brief Plan for the Establishment of the National Zoological and Promenade Gardens," RU 201, box 14, folder 5, SIA; James A. Dolph, "Bringing Wildlife to the Millions: William Temple Hornaday, the Early Years: 1854–1896" (unpublished PhD diss., University of Massachusetts, 1975), p. 481, William T. Hornaday Papers, box 12, Manuscript Division, Library of Congress.

23 Hornaday, "Eighty Fascinating Years," chap. IX, n.p.; Dolph, "Bringing Wildlife to the Millions," p. 569; W. T. Hornaday to G. B. Goode, June 25, 1887, RU 201, box 14, folder 15, SIA.

24 Hornaday, "Eighty Fascinating Years," chap. IX, n.p.

25 Hornaday, "Eighty Fascinating Years," chap. IX, n.p.; Dolph, "Bringing Wildlife to the Millions," p. 569; W. T. Hornaday to G. B. Goode, June 25, 1887, and December 2, 1887, RU 201, box 14, folder 15, SIA; *Nation Tribune*, May 31, 1888; W. T. Hornaday, "Report on the Department of Living Animals in the U.S. National Museum, 1888," AR 1888, Report of the U.S. National Museum (Washington, DC: GPO, 1890), p. 214; "The Zoological Park: A Measure of National Importance," *American Field*, February 9, 1889.

26 W. T. Hornaday, "Report on the Department of Living Animals in the U.S. National Museum, 1889," AR 1889, Report of the U.S. National Museum (Washington, DC: GPO, 1891), p. 417.

27 "The Zoological Garden," *Washington Critic*, May 26, 1888; Hornaday, "Report on the Department of Living Animals, 1889," AR 1889, p. 417; Hornaday, "Eighty Fascinating Years," chap. IX, n.p.; "Looking at the Animals," *Washington Star*, December 14, 1889.

28 Rhees, *Documents*, vol. 2, pp. 1149–51; Dolph, "Bringing Wildlife to the Millions," pp. 584–86; Hornaday, "Eighty Fascinating Years," chap. IX, n.p.

29 Representative David B. Henderson (R-Iowa), House of Representatives, September 12, 1888, in Rhees, *Documents*, vol. 2, p. 1202; quotes drawn from the record of the debate, 50th Congress, 1st Session, September 12, 1888, in Rhees, *Documents*, vol. 2, pp. 1151–71, 1196.

30 Dolph, "Bringing Wildlife to the Millions," pp. 594–98; Rhees, *Documents*, vol. 2, p. 1218; Stat., XXV, 808, 50th Congress, 2nd Session (1889).

NOTES

31 Dolph, "Bringing Wildlife to the Millions," p. 604; "In Charge of the Zoo," *Washington Post*, July 4, 1889.

32 Dolph, "Bringing Wildlife to the Millions," p. 618–19.

33 Rhees, *Documents*, vol. 2, pp. 1333, 1343, 1480; Hornaday, "Eighty Fascinating Years," chap. IX, n.p.; S. 2284, 51st Congress (April 22, 1890).

34 Hornaday, "Eighty Fascinating Years," chap. IX, n.p.

35 S. P. Langley, "Report of the Secretary," AR 1890 (Washington, DC: GPO, 1891), p. 41.

36 E. T. Seton, "The National Zoo at Washington," *Century Illustrated Monthly Magazine*, vol. 15, no. 5 (March 1900), p. 652; C. Adler quoted in Paul H. Oehser, *The Smithsonian Institution* (New York: Praeger, 1970), p. 104, modern comment on Zoo, p. 105; Frank Baker, "The National Zoological Park," in *The Smithsonian Institution, 1846–1896: The History of its First Half Century*, ed. G .B. Goode (Washington, DC: SI, 1897), p. 448.

37 Gregory J. Dehler, *The Most Defiant Devil: William Temple Hornaday & His Controversial Crusade to Save American Wildlife* (Charlottesville: University of Virginia Press, 2013), pp. 74–75.

38 "The Bison Appropriation," *New York Times*, July 16, 1907.

39 Stefan Bechtel, *Mr. Hornaday's War* (Boston: Beacon, 2012), pp. 181–90; "Bison Preserves," *New York Times*, November 3, 1907.

40 wikipedia.org/wiki/The_Passing_of_the_Great_Race; "Hitler's Debt to America," theguardian.com/uk/2004/feb/06/race.usa.

41 Helen L. Horowitz, "Animal and Man in the New York Zoological Park," *New York History*, vol. 56, no. 4 (October 1975), pp. 426–55; Bechtel, *Mr. Hornaday's War*, p. 160.

42 W. T. Hornaday, "Chapter 5, Be Sensible or Perish," William T. Hornaday Papers, box 112, Manuscript Division, Library of Congress.

43 wikipedia.org/wiki/Frank_Baker_(physician); siarchives.si.edu/collections/siris_arc_216681.

44 Helen L. Horowitz, "The National Zoological Park: 'City of Refuge' or Zoo?" *Records of the Columbia Historical Society*, vol. 19 (1973–74), pp. 403–29.

45 AR 1892 (Washington: GPO, 1893), pp. 34–35; Minutes of the Board of Regents, October 21, 1891, RU 1, series 1, box 1, 1880-July 1897, from the Annual Reports, SIA.

46 Horowitz, "The National Zoological Park," p. 424.

47 Minutes of the Board of Regents, October 21, 1891, p. 34, RU 1, series 1, box 1, 1880-July 1897, from the Annual Reports, SIA; Horowitz, "The National Zoological Park," pp. 405–29.

48 S. P. Langley to R. Rathbun, November 30, 1889, RU 55, box 17, SIA.

49 Sally Gregory Kohlstedt, "Nature, Not Books: Scientists and the Origins of the Nature Study Movement in the 1890s," *Isis*, vol. 96, no. 3 (September 2005), pp. 324–52.

50 Linda NeCastro, "The Children's Room of 1901," n.p., in author's collection.

51 NeCastro, "The Children's Room of 1901."

52 Albert Bigelow Paine, "The Children's Room at the Smithsonian," *St. Nicholas*, vol, XXVII, no. 11 (September 1901), pp. 963–73.

53 "Guiding Youthful Minds," *The [Washington] Times*, September 2, 1901; "Nature's Wonders Arrayed for Young Eyes," *The Times*, September 23, 1901.

CHAPTER 18

1 G. B. Goode, ed., *The Smithsonian Institution, 1846–1896: The History of its First Half Century* (Washington, DC: SI, 1897), p. 426 fn. 1.

2 A. G. Bell to G. G. Hubbard, June 6, 1890, and A. G. Bell to S. P. Langley, June 6, 1890, both in RU 7003, box 26, folder Letters to Langley, SIA; Richard Rathbun, "Jerome H. Kidder," *Bulletin of the Philosophical Society of Washington*, vol. 11 (1890), pp. 480–88.

3 S. P. Langley to Sir Howard Grubb, September 5, 1888, RU 7003, box 24, folder outgoing correspondence, SIA; Bessie Zaban Jones, *Lighthouse of the Skies: The Smithsonian Astrophysical Observatory . . . 1846–1955* (Washington, DC: SI, 1965), p. 114; Jones, *Lighthouse of the Skies*, p. 119.

4 S. P. Langley, "Research," AR 1890 (Washington, DC: GPO, 1891), p. 11.

5 Rhees, *Documents*, vol. 2, pp. 1416–23, 1544–46; Minutes of the Board of Regents, January 29, 1891, RU 1, series 1, box 2, SIA; "Prof. Langley Acts," *Washington Post*, January 29, 1891; "Prof. Langley Makes a Reply to Mr. Enloe," *Washington Post*, January 30, 1891.

6 S. P. Langley, assisted by C. G. Abbot, *Annals of the Astrophysical Observatory of the Smithsonian Institution*, vol. 1 (Washington, DC: GPO, 1900), pp. 1–4.

7 Jones, *Lighthouse of the Skies* and David DeVorkin, *Fred Whipple's Empire: The Smithsonian Astrophysical Observatory, 1955-1974* (Washington, DC: SISP, 2018).

391

NOTES

8 S. P. Langley, *Experiments in Aerodynamics*, Contributions to Knowledge, no. 801 (Washington, DC: SI, 1891), p. 107; S. P. Langley, "The Possibility of Mechanical Flight," *Century*, vol. XLII, New Series vol. XX, no. 1 (September 1891), p. 783.

9 "Just How Man Will Fly," *The [New York] Sun*, May 17, 1891; "Shall We Fly," *Delaware Gazette and State Journal*, September 10, 1891; "The Obstacles to Flight," *Pittsburgh Dispatch*, May 3, 1891; "Flying Machines," *Wichita Daily Eagle*, May 22, 1891.

10 Lord Rayleigh, "Experiments in Aerodynamics," *Nature*, vol. 45 (December 3, 1891), p. 108; Cyrus Adler, *I Have Considered the Days* (Philadelphia: Jewish Publication Society of America, 1941), p. 201; "British Lord Tells His Hopes for Wireless Telegraphy," *Newark Advocate*, April 26, 1902.

11 L. Mouillard, "The Empire of the Air: An Ornithological Essay on the Flight of Birds," AR 1892 (Washington, DC: GPO, 1893), pp. 397–413.

12 S. P. Langley, *The Internal Work of the Wind* (Washington, DC: GPO, 1893), p. 23.

13 Simien Short, *Flight Not Impossible: Octave Chanute and the Worldwide Race Toward Flight* (Cham, Switzerland: Springer, 2023); Tom D. Crouch, *A Dream of Wings: Americans and the Airplane, 1875–1905* (New York: W. W. Norton, 1981), passim; A. Pénaud, "Aeroplane Automoeur," *L'Aeronaut*, vol. 5, no. 1 (January 1872), pp. 2–9; Waste Book 1, pp. 49, 75, Samuel P. Langley Collection, box 1, folder 1, National Air and Space Museum Archives (NASMA).

14 S. P. Langley, *Langley Memoir on Mechanical Flight*, pt. I, ed. Charles M. Manly, Smithsonian Contributions to Knowledge, vol. 27, no. 3 (Washington, DC: SI, 1911), pp. 11–12.

15 Langley, *Memoir on Mechanical Flight*, p. 13; see also, Aeronautical work—miscellaneous notes, memos, bills, drawings, Samuel P. Langley Collection, box 34, folder 18, NASMA.

16 Langley, *Memoir of Mechanical Flight*, p. 13.

17 Aeronautical work—miscellaneous notes . . . , Langley Collection, box 34, folder 18, NASMA.

18 AR 1891 (Washington, DC: GPO, 1893), p. 7; Adler, *I Have Considered the Days*, pp. 187–88.

19 "The Hodgkins Fund Prize," *Journal of the American Medical Society* (September 1, 1894), p. 355; on the early history of the Hodgkins Fund, see Accession 05-156, SIA; RU 34, box 38, reels 128–30, SIA.

20 S. P. Langley to J. E. Watkins, Oct. 21, 1890; S. P. Langley to J. E. Watkins, March 19, 1891; and J. E. Watkins to S. P. Langley, July 1891, all in Samuel P. Langley Collection, box 38, folder 51, NASMA; L. C Maltby to S. P. Langley, March 13, 1891, and J. E. Watkins to L. C. Maltby, n.d., both in Samuel P. Langley Collection, box 39, folder 63, NASMA.

21 Langley, *Memoir on Mechanical Flight*, pp. 56–60.

22 Charles H. Gibbs-Smith, *The Invention of the Aeroplane, 1790–1909* (London: Faber and Faber, 1969).

23 Langley quoted in John D. Anderson Jr., *A History of Aerodynamics, and Its Impact on Flying Machines* (Cambridge, UK: Cambridge University Press, 1997), p. 186.

24 S. P. Langley to A. M. Herring, August 10, 1895, RU 7003, box 19, folder outgoing correspondence, SIA.

25 S. P. Langley to J. E. Watkins, November 7, 1890, Samuel P. Langley Collection, box 38, folder 51, NASMA; Crouch, *A Dream of Wings*, p. 137.

26 S. P. Langley to J. E. Watkins, May 30, June 16, 1892, Samuel P. Langley Collection, box 38, folder 52, NASMA.

27 S. P. Langley to J. E. Watkins, June 3, 1892; S. P. Langley to J. E. Watkins, June 13, 1892; and S. P. Watkins to W. C. Winlock, September 1, 1892, all in Samuel P. Langley Collection, box 36, folder 22, NASMA; Crouch, *A Dream of Wings*, p. 137.

28 Langley, *Memoir on Mechanical Flight*, p. 93.

29 R. B. Lindsay, "Biographical Memoir of Carl Barus, 1856–1935," *National Academy of Sciences Biographical Memoirs*, vol. 22, 9th memoir (Washington, DC: National Academy of Sciences, 1941), pp. 171–213.

30 Lindsay, "Carl Barus," p. 178.

31 Waste Book 11, pp. 201–24, Samuel P. Langley Collection, box 5, folder 5, NASMA.

32 Waste Book 15, pp. 26–38, Samuel P. Langley Collection, box 7, folder 5, NASMA.

33 Adler, *I Have Considered the Days*, pp. 187–88, 191.

34 Crouch, *A Dream of Wings*, passim.

35 archives.etsu.edu/agents/people/242; Crouch, A *Dream of Wings*, pp. 85–86, 144–45, 239–40.

36 Anderson Jr., *A History of Aerodynamics*, pp. 188–91; Waste Book of E. C. Huffaker, Samuel P. Langley Collection, box 8, vol. 8, NASMA.

37 Adler, *I Have Considered the Days*, p. 251.

38 A. M. Herring to O. Chanute, May 25, 1895, Octave Chanute Papers, box 1, Manuscript Division, Library of Congress.

39 A. M. Herring to O. Chanute, November 10, 1895, Octave Chanute Papers, box 1, Manuscript Division, Library of Congress; Aerodromics 24, p. 391, Samuel P. Langley Collection, box 16, vol. 24, NASMA.

40 S. P. Langley, "The Development of the Aerodrome," Samuel P. Langley Collection, box 41, folder 1, NASMA.

41 Waste Book 24, pp. 390–91, Samuel P. Langley Collection, box 16, folder 24, pp. 390–91, NASMA.

42 A. G. Bell to the editor of *Science*, May 12, 1896, Alexander Graham Bell Family Papers, box 131, folder 1, Manuscript Division, Library of Congress. loc.gov/resource/magbell.14700203.

NOTES

43 Aerodromics 24, pp. 122–26; Crouch, A *Dream of Wings*, pp. 153–56.

44 "Great Bird of Steel," *Washington Post*, June 7, 1896; "Half a Mile in the Air," *Washington Post*, May 13, 1896; "Cloud Tourists," *Topeka State Journal*, July 18, 1896.

CHAPTER 19

1 "Great Friend to Science," *[Washington] Evening Times*, September 6, 1896; "Founder of a Great Work," *Omaha Daily Bee*, September 14, 1896.

2 "A Loss to Science," *[Washington] Evening Star*, September 7, 1896; "Laid Away to Rest," *Evening Star*, September 8, 1896.

3 "Prof. Winlock is Dead," *Washington Post*, September 22, 1896; "Deplore Death of Prof. Winlock," *Washington Post*, September 23, 1896.

4 S. P. Langley, "Opening Address," *A Memorial of George Brown Goode, Together with a Selection of his Papers on Museums and on the History of Science in America* (Washington, DC: GPO, 1901), p. 8; Sarah Goode to S. P. Langley, n.d., RU 7003, box 19, folder personal correspondence, 1889–1897, SIA.

5 Cyrus Adler, *I Have Considered the Days* (Philadelphia: Jewish Publication Society of America, 1941), p. 191; Board of Regents, Minutes of the Annual Meeting, January 27, 1897, series 1, box 2, pp. 177–83.

6 Board of Regents, Minutes of the Annual Meeting, January 27, 1897, RU 1, series 1, box 2, pp. 191–95.

7 Board of Regents, Minutes of the Annual Meeting, January 27, 1896 (continued on February 1, 1896), RU 1, series 1, box 2, pp. 196–201, SIA.

8 Board of Regents, Minutes of the Annual Meeting, January 26, 1898, p. 225, RU 1, series 1, box 2, SIA.

9 S. P. Langley, "The 'Flying Machine,'" *McClure's Magazine*, vol. 9, no. 2 (June 1897), p. 660.

10 S. P. Langley to O. Chanute, June 8, 1897, and December [n.d.], 1897, Octave Chanute Papers, box 2, folder Langley, Manuscript Division, Library of Congress.

11 S. P. Langley, "Memorandum on Enlarging Aerodrome Work to Enable the Machine to Carry a Man," Waste Book, pp. 2–10, Samuel P. Langley Collection, box 16, folder 25, National Air and Space Museum Archives (NASMA).

12 Langley, "The 'Flying Machine,'" pp. 648–59; S. P. Langley, "The New Flying Machine," *The Strand*, vol. 13, no. 78 (June 1887), pp. 718–19; S. P. Langley, "Story of Experiments in Mechanical Flight," *The Aeronautical Annual 1897*, ed. James Means (Boston: W. B. Clarke, 1897), pp. 11–29; Scrapbook Containing a Summary of Principal Events relating to Langley's Aerodromic Work in the Order of Dates Beginning with 1897, RU 7003, box 25, folder "Scrapbook . . . ,"SIA (hereafter Scrapbook).

13 Board of Regents, Minutes of the Annual Meeting, January 26, 1898, RU 1, series 1, box 2, SIA.

14 For details, see G. J. A. O'Toole, *The Spanish War: An American Epic 1898* (New York: W. W. Norton, 1986).

15 S. P. Langley memo for the record, March 21, 1898, Scrapbook.

16 Memoranda, March 28, March 30, and April 6, 1898, and W. McKinley to C. D. Walcott, March 26, 1898, all in Scrapbook.

17 C. H. Davis quoted in David Fairchild, *The World Was My Garden: Travels of a Plant Explorer* (New York: Charles Scribner's Sons, 1938), p. 333.

18 *Report of the Board on Fortifications or Other Defenses Appointed by the President of the United States Under the Provisions of the Act of Congress Approved March 3, 1885*, 49th Congress, 1st Session, House Exec. Doc. 49, GPO 1886.

19 Robert B. Meyer Jr., ed., *Langley's Aero Engine of 1903* (Washington, DC: SIP, 1971), p. 31; R. H. Thurston to S. P. Langley, June 1, 1898, RU 31, box 63, folder 13, SIA.

20 S. P. Langley, Private Waste Book, p. 4, Samuel P. Langley Collection, box 17, book 26, NASMA.

21 S. P. Langley, "Memorandum of verbal statements made to the Board of Ordnance and Fortification, November 9, 1896; S. P. Langley to I. N. Lewis, Nov. 12, 1898; and C. D. Walcott to S. P. Langley, Nov. 12, 1898, all in Scrapbook; "Flying Machines in War," *Washington Post*, November 11, 1898; Entry, November 14, 1898, Langley, Private Waste Book.

22 S. P. Langley, Undated notes for an agreement and N. Miles to I. N. Lewis, December 13, 1898, both in Scrapbook.

23 S. P. Langley, November 1897, Scrapbook.

24 Charles M. Manly, ed., *Langley Memoir on Mechanical Flight*, Contributions to Knowledge, vol. 27, no. 1 (Washington, DC: SI, 1911), pp. 211–14.

25 Langley, Private Waste Book, p. 10.

26 Meyer, *Langley's Aero Engine*, p. 30.

27 Meyer, *Langley's Aero Engine*, pp. 29–35.

28 Manly, *Memoir on Mechanical Flight*, pp. 156–63; Langley, Private Waste Book, p. 34.

29 Langley, Private Waste Book, p. 88.

30 "Langley, Aeronaut," *New-York Tribune Illustrated Supplement*, November 27, 1898; "Aerial Navigation Work by the Government," *Los Angeles Tribune*, December 26, 1898; "It Flies and Fights," *Holland [Arizona] Argus*, September 16, 1899; "Wings Needed to Fly," *Mower County Transcript [Lansing, Michigan]*, December 19, 1900.

NOTES

31 Wilbur Wright to Secretary Samuel P. Langley, May 30, 1899, RU 31, SIA; Marvin W. McFarland, *The Papers of Wilbur and Orville Wright*, vol. 1 (New York: McGraw-Hill, 1953), p. 4.

32 McFarland, in *Papers*, p. 5 fn. 7.

33 Langley, Private Waste Book, p. 90.

34 Meyer, *Langley's Aero Engine*, pp. 9–27.

35 I. N. Lewis to S. P. Langley, October 8, 1899, RU 31, box 43, folder 5, SIA; Tom D. Crouch, *A Dream of Wings: Americans and the Airplane, 1875–1905* (New York: W. W. Norton, 1981), p. 240.

36 Waste Book of C. M. Manly, box 14, vol. 21, Samuel Langley Papers, NASMA; Langley, Private Waste Book, pp. 26, 96, 99, 116.

37 S. P. Langley to C. M. Manly, July 1, 1900, in Langley, Private Waste Book, pp. 182–96; Meyer, *Langley's Aero Engine*, pp. 65–67.

38 Langley, Private Waste Book, pp. 210–12; George Wells Diary, April 29 to October 2, 1901; and Waste Book entry, November 8, 1901, all in Meyer, *Langley's Aero Engine*, pp. 99–107.

39 S. P. Langley to C. M. Manly, September 3, 1900, and February 1, 1901, Langley Correspondence Book 3, Samuel P. Langley Collection, box 18, vol. 29, NASMA.

40 O. Chanute to S. P. Langley, December 6, 1901, and October 25, 1902, RU 31, box 18, folder 8, SIA.

41 Crouch, *A Dream of Wings*, p. 122.

42 Manly, *Memoir on Mechanical Flight*, pp. 227–33.

43 C. M. Manly to S. P. Langley, October 15, 1901, and April 26, 1902, in Langley, Private Waste Book; p. 324; Crouch, *A Dream of Wings*, p. 124.

44 S. P. Langley to I. N. Lewis, November 10, 1902, in Meyer, *Langley's Aero Engine*, p. 122.

45 C. M. Manly to R. Rathbun, August 8, 1903, RU 31, box 45, folder 16, SIA; Manly, *Memoir on Mechanical Flight*, pp. 156–58.

46 C. M. Manly to S. P. Langley, August 12, 1903, and S. P. Langley to C. M. Manly, August 15, 1903, both in RU 31, box 65, folder 16, SIA; C. M. Manly, undated fragment of memorandum, RU 31, box 45, folder 17, SIA.

47 "'Buzzard' a Complete Wreck," *Washington Times*, December 9, 1903; Manly, undated memorandum.

48 airandspace.si.edu/collection-objects/langley-aerodrome/nasm_A19180001000.

49 Author's study of the great *Aerodrome* on display at the NASM's Udvar-Hazy Center.

50 C. M. Manly to S. P. Langley, June 1, 1901, RU 31, box 45, folder 14, SIA.

51 C. M. Manly to S. P. Langley, October 7, 1903, RU 31, box 45, folder 16, SIA.

52 "'Buzzard' a Complete Wreck," *Washington Times*, December 9, 1903, "Airship is a Failure," [Iowa] *Evening Times Republican*, December 9, 1903; "Airship Still Airless," *Stark County Democrat*," December 12, 1903; "Professor Langley's Hot Air Ship," *Bisbee Daily Review*, December 8, 1903; "Professor Langley's Flying Machine Failed twice to Fly," *Evening Star*, January 1, 1904.

53 "Weather," *Washington Post*, December 8, 1903; "Airship Total Wreck," *Washington Post*, December 9, 1903.

54 "Airship Total Wreck," *Washington Post*, December 9, 1903.

55 Manly, *Memoir on Mechanical Flight*, pp. 272–73.

56 "Airship Fails to Fly," *Evening Star*, December 9, 1903; Adler, *I Have Considered the Days*, pp. 256–57.

57 Adler, *I Have Considered the Days*, p. 257; John Brashear quoted in Fairchild, *The World Was My Garden*, pp. 332–33.

58 Major Montgomery M. Macomb in Manly, *Memoir on Mechanical Flight*, p. 279.

59 Raymond L. Bisplinghoff, Holt Ashley, and Robert L. Halfman, *Aeroelasticity* (New York: Addison-Wesley, 1955), p. 3.

60 Lorenzo Auriti and James DeLaurier, "Analysis of the Flight Attempt by Samuel Langley's 'Great Aerodrome,' *Journal of Aircraft*, vol. 41, no. 6 (November–December 2004).

CHAPTER 20

1 C. M. Manly to S. P. Langley, December 23, 1907, and March 28, 1905, both in RU 31, box 45, folder 18, SIA.

2 Congressional Record, January 23, 1904, and January 27, 1904, p. 1364, pp. 1365–66.

3 "Fads, Frauds and Follies Cripple the Nation's Finances," *Brooklyn Daily Eagle*, March 13, 1904.

4 Cyrus Adler, *I Have Considered the Days* (Philadelphia: Jewish Publication Society of America, 1941), p. 258.

5 Minutes of the Board of Regents, January 11, 1888, RU 1, series 1, box 1, 1880–July 1897, from the Annual Reports, SIA.

6 J. W. Powell to S. P. Langley, June 11, 1891, RU 31, box 44, folder 16, SIA; Minutes of the Executive Committee of the Board of Regents, June 12, 1891, RU 1, series 1, box 1, 1880–July 1897, from the Annual Reports, SIA.

7 Curtis M. Hinsley Jr., *Savages and Scientists: The Smithsonian Institution and the Development of American Anthropology, 1846–1910* (Washington, DC: SIP, 1981), pp. 207–30.

8 Lester George Moses, *The Indian Man: A Biography of James Mooney* (Urbana: University of Illinois Press, 1984); William Munn Colby, *Route to the Rainy Mountain: A Biography of James Mooney* (unpublished PhD diss., University of Wisconsin-Madison, 1977); Anonymous, "James Mooney," *American Anthropologist*, vol. 24, no. 2 (April–June 1922), pp. 209–14; Michael A. Elliott, "Ethnography, Reform, and the Problem of the Real: James Mooney's Ghost-Dance Religion,"

394

NOTES

American Quarterly, vol. 50, no. 2 (June 1998), pp. 201–33; Hinsley Jr., *Savages and Scientists,* pp. 222–24; Moses, *Indian Man,* pp. 1–19.

9 James Mooney, "Cherokee Theory and Practice of Medicine," *Journal of American Folk-Lore,* vol. 3, no. 8 (1890), pp. 44–50, 49.

10 Louis S. Warren, *God's Red Son: The Ghost Dance Religion and the Making of Modern America* (New York: Basic Books, 2017) is the best modern account of the Ghost Dance.

11 James Mooney, *The Ghost-Dance Religion and the Sioux Outbreak of 1890,* in *Fourteenth Annual Report of the Bureau of Ethnology to the Secretary of the Smithsonian Institution 1892–1893* (Washington, DC: GPO, 1896), pp. 693–1104.

12 Mooney, *The Ghost-Dance Religion,* p. 930.

13 S. P. Langley to J. W. Powell, May 25, 1897, RU 31, box 53, folder 22, pp. 60–61, SIA.

14 J. W. Powell to S. P. Langley, May 26, 1897, RU 31, box 75, folder 9, SIA.

15 "Sun Dance Investigation," *Washington Post,* August 9, 1903; "Sun-Dance Charges," *[Washington] Evening Star,* August 25, 1903.

16 M. C. Stevenson to J. W. Powell, June 3, 1901, Bureau of American Ethnology (BAE) letters received, Matilda Coxe Stevenson, National Anthropological Archives; W J McGee to M. C. Stevenson, June 3, 1891, RU 31, box 62, folder 4, SIA.

17 J. W. Powell to M. C. Stevenson, June 20, 1901, RU 31, box 62, folder 4, SIA; W J McGee to M. C. Stevenson, July 20, 1901, RU 31, box 65, folder 4, SIA.

18 M. C. Stevenson to the director of the Bureau of American Ethnology, July 31, 1901, and S. P. Langley to M. C. Stevenson, December 28, 1901, both in RU 31, box 62, folder 4, SIA.

19 S. P. Langley to J. W. Powell, January 16, 1902, RU 31, box 62, folder 4, SIA.

20 "John W. Powell Dead," *Washington Post,* September 24, 1902; "Maj. Powell's Body Here," *Washington Post,* September 26, 1902.

21 E. A. Spitzka, "A Study of the Brain of the Late Major J. W. Powell," *American Anthropologist,* vol. 5, no. 4 (October–December 1903), pp. 585–643; E. A. Spitzka, "A Death Mask of W J McGee," *American Anthropologist,* vol. 15, no. 3 (July–September 1913), pp. 536–38.

22 Private memo [from R. Rathbun?], February 18, 1902, and S. P. Langley, Private memo, February 19, 1902, both in RU 31, box 44, folder 16, SIA.

23 blogs.bu.edu/runnels/2022/01/02/dr-charles-conrad-abbott-and-the-curious-case-of-the-american-palaeolithic; Rachel Morgan, *Sins of the Shovel: Looting, Murder, and the Evolution of American Archaeology* (Chicago: University of Chicago Press, 2023), p. 25; Neil Judd, *The Bureau of American Ethnology: A Partial History* (Norman: University of Oklahoma Press, 1967), pp. 69–70.

24 Hinsley Jr., *Savages and Scientists,* p. 248; W J McGee to S. P. Langley, September 27, 1902, RU 31, box 44, folder 16, SIA; A. G. Bell to S. P. Langley, September 27, 1902, RU 31, box 12, folder 13, SIA.

25 Assorted letters to S. P. Langley, RU 31, box 44, folder 16, SIA.

26 A. G. Bell to S. P. Langley, October 12, 1902, RU 31, box 45, folder 16, SIA; Franz Boas, "The Bureau of American Ethnology," *Science,* vol. 16, no. 412 (November 21, 1902), pp. 828–31.

27 Minutes of the Special Meeting of the Board of Regents, March 12, 1903, RU 1, box 2, pp. 355–61; Annual Meeting of the Board of Regents, December 8, 1903, RU 1, series 1, box 2, pp. 362–72, SIA.

28 Moses, *Indian Man,* 141–45.

29 wikipedia.org/wiki/Anita_Newcomb_McGee.

30 A. Carnegie to S. P. Langley, December 27, 1901, and S. P. Langley to A. Carnegie, December 31, 1901, both in Minutes of the Annual Meeting of the Board of Regents, January 22, 1902, RU 1, box 2, typescripts, SIA.

31 AR 1882 (Washington, DC: GPO, 1884), p. 7; Richard Rathbun, "An Account of the Buildings Occupied by the National Collections," in AR 1903, Report of the U.S. National Museum (Washington, DC: GPO, 1905), pp. 288–89.

32 Rathbun, "An Account of the Buildings," pp. 284–96; Heather Ewing and Amy Ballard, *A Guide to Smithsonian Architecture* (Washington, DC: SB, 2009), pp. 56–57.

33 "Axman Invades Mall," *Washington Post,* June 19, 1904.

34 Thomas Lawton and Linda Merrill, *Freer: A Legacy of Art* (Washington, DC: Freer Gallery of Art with Harry Abrams, 1993), pp. 13–59.

35 Minutes of the Annual Meeting of the Board of Regents, January 24, 1905, RU 1, box 3, SIA.

36 Minutes of the Annual Meeting of the Board of Regents, January 24, 1905, RU 1, box 3, SIA.

37 "Confidential memorandum of a conference held at the White House, dictated by Dr. Adler, December 6, 1905, RU 31, box 93, folder 15, SIA.

38 Minutes of the Meeting of the Board of Regents, December 5, 1905, RU 1, box 2, pp. 7–11, SIA; "Bad Use of Checks," *Washington Post,* June 8, 1905.

39 Charles G. Abbot, *Adventures in the World of Science* (Washington, DC: Public Affairs Press, 1958), p. 42; "Bad Use of Checks," *Washington Post,* June 8, 1905.

NOTES

40 Minutes of the Annual Meeting of the Board of Regents, January 24, 1906, RU 1, box 3, pp. 18–19, SIA.

41 Minutes of the Annual Meeting of the Board of Regents, January 24, 1906, pp. 20-21; "Grand Jury Indictments," *Washington Post,* June 9, 1905; "Karr Gets Five Years," *Washington Post,* November 3, 1905.

42 "The Smithsonian Institution," *Nation,* vol. 80, no. 2087 (June 29, 1905), pp. 516–17.

43 S. P. Langley to R. Rathbun, July 25, 1905, RU 31, box 56, folder 9, SIA; "Prof. Langley Breaks Down," *Washington Post,* February 4, 1906; "Prof. Langley Is Dead," *Washington Post,* February 28, 1906.

44 "Langley Obsequies To-Day," *Washington Post,* March 2, 1906; "Burial in Boston," *Washington Post,* March 1, 1906; "Funeral of Prof. Langley," *Washington Post,* March 4, 1906.

45 Minutes of the Special Meeting of the Board of Regents, March 6, 1906; RU 1, box 3, p. 46, SIA; Minutes of the Annual Meeting of the Board of Regents, January 23, 1907, RU 1, box 3, p. 70, SIA.

EPILOGUE

1 Pamela Henson, "The Smithsonian & the Great Depression," A PowerPoint presentation to the National Zoological Park staff, November 20210, personal communication from the presenter.

2 AR 1944 (Washington, DC: GPO, 1945), p. 13.

INDEX

Page numbers in *italics* indicate illustrations; n indicates a note.

Abbot, Charles Greeley
 background, 314
 Holmes skirmishes, 348
 Langley and, 292, 300, 353, 355
 Smithsonian Astrophysical
 Observatory, 314–315, 321, 357
Academy of Natural Sciences of
 Philadelphia, 8, 76, 77, 97, 209,
 259–260
Adams, Brooks, 299
Adams, Charles Francis, 162
Adams, Henry, 39, 202, 301, 354–355
Adams, John (Civil War commander), 148
Adams, John (president), 111
Adams, John Quincy, 22, 23, 25–28, 30,
 52, 66
Adams, Louisa Catherine, 39
Adams, Robert, Jr., 347–348
Adelson, Private, 340
Ader, Clément, 319, 333
Adler, Cyrus
 Bureau of Ethnology investigation, 350
 Freer Collection, 353
 Goode's funeral, 326
 International Catalogue of Scientific
 Literature, 354
 on Jewett, 85
 on Langley delegating administrative
 tasks, 302
 on Langley establishing National Zoo,
 307
 Langley friendship, 9, 298–300, 302, 355
 Langley's aerodynamic research, 322,
 323, 340, 344
 Langley's funeral, 355
 on Langley's relationship with Board of
 Regents, 327
 as Smithsonian librarian, 9, 298
African American employees, 79–80, 81,
 109, 300–301. *see also specific people*
Agassiz, Louis
 assistants, 217
 Baird and, 72, 73, 107, 110, 143
 Goode and, 214
 Harvard University museum, 97
 Henry and, 92, 162
 National Academy of Sciences, 142, 143
 on Smithson, 16
 students, 79, 107, 110, 169
airships, 130–138, *136*, 144–146
Airy, George, 26
Alaska, US purchase of, 171–174
Alexander, Barton S., 56, 161
Alexander, Czar, 171–172
Alexander, Harriet. *see* Henry, Harriet
 Alexander
Alexander, Stephen, 100, 120, 143
Allard, Dean, 214
Allen, James, 134
American bison, 250–254, *252*, 304, 308
American Museum of Natural History,
 217–218, 260, 266, 267
Ames, Alfred A. H., 79
Ancient Monuments of the Mississippi Valley
 (Squier and E. H. Davis), 51, 58–64,
 68, 115, 206
Anderson, Charles Frederick, 126
Anderson, John, 19
Andersonian Institution, 19

Andreani, Count Paolo, 14
Andrews, Solomon, 144–146
Angel, J. Lawrence, 10–11, 14–15, 16
Arago, François, 18
archaeology
 mound archaeology, 53, 59–63, 68, 187,
 220, 285–286
 as Smithsonian field of research, 53,
 168, 220
Archaeology of the United States (Haven), 60
Arctic expeditions, 100–102, 103, *153*,
 154–156, 168–180, *178*
Armory Building, 228–229, 239, 246, 253
Arnot, David, 50, 57
Arthur, Chester A., 231, 278
Arts and Industries Building. *see* National
 Museum Building
Ashley, Holt, 342
Astor, John Jacob, 299
Atwater, Caleb, 60
Audubon, John James, 71
Augur, Christopher C., 160
Auriti, Lorenzo, 342

Babbage, Charles, 8–9, 44
Bache, Alexander Dallas, *31*
 background, 33
 Castle design and construction, 50,
 57, 104
 Civil War, 142, 144, 145, 147
 Davis friendship, 57
 Henry correspondence, 81, 82
 Henry friendship, 39, 44, 81, 82, 99,
 125–126
 Henry's Programme of Organization for
 the Smithsonian Institution, 53
 Henry's selection as Smithsonian
 secretary, 31, 33, 35–39
 magnetic observatory, 102
 named to Board of Regents, 30
 National Academy of Sciences, 142,
 143, 168
 organization committee, 32, 51
 racism, 119
 Smithsonian library oversight, 86
 Smithsonian purchase of Marsh
 prints, 68
 US Lighthouse Board, 129
 vision for Smithsonian Institution, 46, 48
Bache, Hartman, 134
Bache, Nancy, 39, 44, 106
Bacon, Francis, 70
Baird, Lucy (daughter), 72, 74, 108–109,
 212, 232, 294–295
Baird, Mary Helen Churchill (wife), 72, 74,
 231, 287, 294, 295
Baird, Spencer Fullerton
 as amateur naturalist, 70–74
 Arctic expeditions and, 169–171, 176–177,
 179–180
 Art Room, 112–113
 audit, 236–237
 background, 70, 71, 72
 biographies of, 359–360
 Brown and, 79–80, 81
 Bureau of Ethnology, 202, 284–285
 Castle paintings, 160
 Centennial Exposition, 218, 219–224,
 226–229, 238, 242, 296

character traits, 231–232
 Civil War years, 121, 123, 124, 146–148
 collection-building, 78, 97, 103, 117,
 146–156, 158, 168–171, 181, 182, 184–185,
 187, 189, 195
 correspondence, 79, 80, 296
 Cushing and, 271–281
 death, 295, 297
 dinosaur exhibitions, 211
 expositions, 256–257
 financial management, 353
 health problems, 287, 294–295
 Henry and, 68–73, 93, 97
 Henry's death, 230–231
 Henry's managerial shortcomings, 204
 hired as assistant secretary, 73–74
 hiring Turner as librarian, 106
 legacy, 69, 295–296
 marriage and children, 72, 74, 212, 231
 as mentor, 107, *108*, 109–110, 151, 154, 155,
 169, 179–180, 185, 295
 museum display principles, 111, 113–114,
 207–208
 named secretary of Smithsonian
 Institution, 231–233
 National Academy of Sciences and, 143
 National Museum administration, 238
 National Museum bison exhibition,
 250–251, 253
 National Museum Building
 construction, 233–234, *234*
 as National Museum director, 215–216,
 228–229
 National Museum expansion, 350
 National Zoo, 303
 Pacific Railroad Surveys, 109–110
 Palmer (Edward) and, 226
 Philosophical Society of Washington,
 198
 portraits, *69*, *186*
 Powell and, 269–270, 284–285
 publications and translations by, 72, 73,
 78–79, 295
 publications exchanges, 74–75, 79
 public-speaking abilities, 231–232
 research/museum/library funding
 battle, 87, 88, 92
 scientific expeditions and, 75–79, 107
 Smithsonian Astrophysical
 Observatory, 313
 Smithson research, 9
 Smithson's tomb, 2
 spending priorities, 232–233
 staff relations, 235–237
 successor, 287, 296–297
 tenure as secretary, 69
 Tichkematse and, 277
 US Commission of Fish and Fisheries,
 212–215, 294–295, 327
 US purchase of Alaska and, 172–174
 vision for Smithsonian Institution, x, 74,
 98, 157, 215–216
 western expeditions, 181, 182, 184–185,
 187, 189, 195
Baird, Will, 70–71
Baker, Frank, 264, *305*, 309–310, 326, 348,
 350, 355
balloons and airships, 130–138, *136*,
 144–146

397

INDEX

Balzer, Stephen M., 332, 334
Bandelier, Adolph F., 276
Banks, Joseph, 14, 15–16, 17–18
Banks, Nathaniel, 174
Bannister, Henry Martyn, 169–170, 172, 174
Barlow, Peter, 44
Barnet, Frank, 350
Barnum, P. T., 208
Bartlett, John Russell, 62
Barus, Carl, 321–322
Baxter, Sylvester, 278, 279–280
Beck, James, 304–305
Beckwith, Paul Edmond, 244
Beechman, Mr., 95–96
Bell, Alexander Graham
 Aerial Experiment Association, 355
 Barus and, 321
 Freer Collection, 353
 Langley, disappointment with, 349–350
 Langley friendship, 355
 Langley's aerodynamic research, 324–325, 330, 334, 335
 Langley's funeral, 354
 philanthropy, 4
 Smithsonian Astrophysical Observatory, 313, 314
 Smithson's tomb, 3, 4–7
Bell, John, 121
Bell, Mabel, 3, 4, 5–6, 355
Benedict, Ruth, 271, 284
Bentley, S. A., 281
Berzelius, J. J., 184
Bessels, Emil, 177–180
Beudant, François, 18
Bickmore, Albert S., 217–218
Billings, John, 233
Bischoff, Ferdinand, 169–170
Bishop, William, 5–6
bison, 250–254, 252, 304, 308
Bisplinghoff, Raymond, 342
Black, Joseph, 14
Blackburne, William, 309, 310
Blaine, James G., 2
Blake, George, 149
Blake, William Phipps, 219, 222
Bland, Richard, 306
Bledsoe, Albert T., 127
Blodget, Lorin, 68, 93, 94–95
Boas, Franz, 266, 271, 345, 349
Bodmer, Karl, 77
Brady, Mathew, 31, 81–82
Brashear, John, 294, 340, 342
Breckinridge, John C., 124
Breese, Sidney, 30
Brewer, William, 184
Bronx Zoo, 308–309
Brooks, Noah, 126
Brooks, Robert, 10
Brown, Solomon Galleon, 79–80, 81, 105–106, 205, 232, 300, 352
Brownson, Orestes, 128
Bruce, Robert V., 42, 119, 360
Bryan, R. W. D., 178–179
Bryant, Henry, 107, 108
Buberl, Caspar, 234
Buchanan, James, 148
Buchanan, William I., 263
Buckland, William, 17
Buford, John, 149
Building Committee, 33, 36, 50, 54, 57–58, 115
Bulkley, Charles, 169
Bunch, Lonnie G., III, vii–viii
Bureau of Ethnology
 Barnet's misappropriation of funds, 350
 expositions, 258
 fieldwork, 268, 270–282, 274, 283
 foundation of, 156, 202
 Holmes as chief, 246, 348, 349–350
 Langley's management, 344, 347–350
 McGee's resignation, 350

mound research, 63, 285–286
Powell's tenure, 193, 265, 269–270
Smithsonian Institution relationship, 284–285
Burnham, Daniel, 351
Burns, George, 135
Byers, William, 191

Calhoun, John C., 22, 25–26, 29
Cameron, Gilbert, 56
Cameron, Simon, 122, 134, 135, 148–149
Campbell, John L., 218–219
Campbell, William W., 206
Cannon, Joseph G., 306, 348, 354–355
Carlyle, Thomas, 289
Carnegie, Andrew, 260, 262, 350
Cassin, John, 71
Castle
 Apparatus Room, 112, 159, 160
 art gallery, 159, 160, 206–207
 Art Room, 112–113, 160–161
 Children's Room, 310–312, 311
 Civil War years, 122, 125, 126
 cornerstone ceremony, 54–55
 design and construction, 32–33, 36–37, 50–51, 55–58, 73
 employee and scientific residents, 106–110, 108, 159–160, 226
 fire (1865), 8, 105, 113, 159–163, 161
 Henry family quarters, 42, 99, 104–107, 121–122, 159
 Henry's concerns, x, 49–50
 Henry's office, 57, 159
 lecture hall, 100–102, 104, 105, 126–129, 160, 174
 museum, 111–113, 157, 160, 162–163, 205–206, 217
 Smithson's tomb, 3, 6–8, 10–11
Catalogue of North American Reptiles (Baird), 78–79
Catlin, George, 206–207, 244
Cavendish, Henry, 14
Cayley, Sir George, 293
Centennial Exposition, 218–229, 225, 240, 242, 255, 272, 296
Centennial Exposition of the Ohio Valley and Central States (1888), 257–258
Chanute, Octave, 292–293, 317, 322, 323, 328–329, 335, 343
Chase, Salmon Portland, 128, 134, 162, 195, 198
Chenoweth, James Q., 236–237
Cheyenne reservation, 347
Chicago Academy of Sciences, 152, 169
Childs, Thomas, 326
Choate, Rufus
 Board of Regents, 30, 32, 38, 86–87, 89, 90
 Henry's Programme of Organization for the Smithsonian Institution, 53
 Report of the Organization Committee, 51
 Smithsonian library and, 32, 38, 86
 vision for Smithsonian Institution, 27–28, 46, 48
Churchill, Mary Helen. see Baird, Mary Helen Churchill
Churchill, Sylvester, 78, 147, 295
Cincinnati Industrial Exposition (1884), 255, 257, 305
citizen scientists, 65–68, 76–78, 93, 117
Civil War
 Baird's views, 121
 balloons and airships, 134–138, 136, 144–146
 battles, 127, 135, 136, 139, 149, 191
 Capitol dome construction, 182
 collection-building during, 146–151, 158
 Henry's contributions, 130–131, 133–138, 140–142, 144–146
 Henry's views, 120–121

impact on Smithsonian, 122–129, 125, 156–157
 naval innovations, 140–142, 143–144
 onset, 121–122
 Powell's service, 190–191
 US Lighthouse Board, 130
Clark, A. Howard, 244
Clark, John H., 78
Clayton, John M., 80, 206
Cleveland, Frances Folsom, 304
Cleveland, Grover, 236, 304
Cleveland, Rose, 283
Cluss, Adolf, 163, 205, 233, 234
Clymer, Hiester, 228
Cobb, Howell, 124
Cocking, Robert, 132
Cody, William F. "Buffalo Bill," 304
Coffin, James H., 96
Colfax, Schuyler, 127, 193
Collins, Perry McDonough, 168
Colter, John, 188
Compensated Emancipation Act (1862), 40
Compromise of 1850, 40
Connor, John, 92–93, 105
Contributions to Knowledge. see Smithsonian Contributions to Knowledge
Cooke, George, 113
Cooper, Edward, 180
Cooper, James Graham, 109–110
Cope, Edward Drinker, 110, 189, 200–201, 259–260
Copeland, Ada, 202–203
Corcoran, William Wilson, 115, 164
Cosmos Club, 198, 298, 302, 348
Couch, Darius N., 78
Coues, Elliott, 110, 117, 150–151
Cowles, Willard, 85–86
Cresson, John, 130–131, 133
Croffut, William, 127
Crookham, George, 190
Crouch, Tom, 357–358
Crystal Palace Exhibition, 80–82, 218
Culbertson, Alexander, 76–78
Culbertson, Thaddeus, 76–78, 108
cultural relativism, 344–345
Curtis, William E., 280
Cushing, Caleb, 36, 86–87
Cushing, Emily Tennison Magill, 280, 283, 286
Cushing, Enos, 279, 280
Cushing, Frank Hamilton
 Bureau of Ethnology expeditions, 271–284, 286
 Centennial Exposition, 221–222, 226
 cultural relativism, 344–345
 death, 286
 health problems, 281, 283, 284
 Hemenway expedition, 283–284
 marriage, 280
 National Museum, 238, 246
 participant observation, 110, 273–275, 274, 280
 portrait, 280, 281
 theatricality, 279

Dakota War, 149
Dall, William Healey
 on Baird (Mary), 72
 career overview, 171
 on Henry's managerial shortcomings, 204
 Kennicott expeditions, 110, 154, 169–171
 National Museum, 238
 Philosophical Society of Washington, 198
 Powell's funeral, 348
 works by, 359–360
Dallas, George Mifflin, 30, 33, 36, 48, 54–55
Dalton, John, 17

398

INDEX

Dana, James Dwight, 71, 95, 168
Darcy, Charles, 337
Darwin, Charles, 114, 208, 216
Davenport, Thomas, 44–45
Davis, Charles Henry, 142, 330
Davis, Edwin Hamilton, 59–62, 68. *see also Ancient Monuments of the Mississippi Valley* (Squier and Davis)
Davis, Jefferson, 57, 83, 94, 119, 121
De Beust, Margaret, 106
De Beust, William, 105, 106, 159, 160
De Hass, Wills, 285
de la Batut, George Henry, 5
de la Batut, Mary Ann Coates Dickinson (Smithson's sister-in-law), 21, 23–24, 123, 162
de la Batut, Théodore, 21
Dewing, Thomas Wilmer, 352
Dickens, Charles, 39
Dickinson, Elizabeth Hungerford Keate Macie (Smithson's mother), 11–12, 18–19
Dickinson, Henry James (Smithson's nephew), 1–2, 5, 6, 18, 19, 21, 23–24
Dickinson, Henry Louis (Smithson's brother), 11, 12, 18, 23–24
Diggs, Meredith, 300
dinosaur exhibitions, 208–212, 211, 216, 259–260, 261
District of Columbia Armory, 228–229, 239, 246, 253
Dix, Dorothea, 121
Dolphin, USS, 6
Donaldson, Thomas Corwin, 228, 242–243
Donelson, Andrew Jackson, 22–23
Dorsey, George, 347
Dorsey, Henry W., 305, 355
Dorsey, P. M., 353
Douglas, Stephen A., 83–84, 93
Douglass, Frederick, viii, 49, 128
Downing, Andrew Jackson, 115–116, 352
Dred Scott decision, 94, 119
Drexler, C., 112
Drum, Richard, 146
Durand, Mortimer, 7

Eakins, Thomas, 280, 281
Ealy, Taylor F., 273, 275–276
Earll, Ralph Edward, 257, 259
Eaton, Amos, 42
Eddy, William Abner, 318
Edmunds, George F., 172, 212–213, 306
Edwards, Tryon, 65
Elliott, Henry Wood, 110, 169–170, 174, 187–188, 213
Endriss, William, 337
English, William Hayden, 87, 89, 90, 92
Enloe, Benjamin A., 314
enslaved people. *see* slavery
Espy, James, 66
eugenics, 308–309
Evans, George, 29, 30
Evans, John, 76, 77–78, 108
evolution, as guiding principle in exposition displays, 259–262
Ewing, Heather, 11, 359
exposition era, 255–266, 261, 263. *see also* Centennial Exposition

Fairbanks, Charles W., 354–355
Faraday, Michael, 43, 44
Farragut, David G., 78
Faujas de Saint-Fond, Barthélemy, 14
Feilner, John, 117, 147–150, 151
Felton, Cornelius Conway, 92, 128
Ferguson, T. B., 295
Ferguson, Thomas, 236
Fessenden, William, 127
Fewkes, Jesse Walter, 284
Field, Cyrus West, 168, 171
Fillmore, Millard, 115, 129

Firpo, Giovanni Battista, 6
Fisher, Henry, 170, 171
Fitall, John, 8, 19
Fitch, Graham Newell, 86
Fitz, Henry, Jr., 290
Fletcher, Alice Cunningham, 282, 302
Fletcher, James, 2
Flügel, Felix, 123
Force, Peter, 80–81
Foreman, Edward R., 67–68, 79, 82, 221, 238
Forney, Andrew H., 251
Forney, Stehman, 337
Forsyth, John, 22, 23
Foulke, William Parker, 209
Fowle, Frederick E., Jr., 324–325
Fox, Gustavus V., 142
Franklin, Lady Jane, 102
Franklin, Sir John, 101–103, 175–176, 179
Frazer, James, 299
Freemasons, 54–55
Freer, Charles Lang, 352–353, 355
Freer Gallery, 357
Frémont, John Charles, 182, 191
French, B. B., 55
French, Benjamin Brown, 32
Frobisher, Martin, 176
Frye, William P., 7
Fugitive Slave Act (1850), 94
Fuller, Melville W., 327–328, 354–355

Gale, Leonard, 45
Gallatin, Albert, 60–62
Galle, Johann, 95
Gannon, Joseph, 40
Gant, James Thomas, 80
Gardner, Alexander, 160, 161
Garfield, James A., 192, 195, 199, 202, 234–235, 309
Garrison, William Lloyd, 128
Gartrell, Lucius Jeremiah, 124
Genoa, Italy, 1–7
geological surveys, 76, 183–185, 187–203
Ghost Dance movement, 345–346
Gibbs, George, IV, 156, 173, 220
Gibbs, Oliver Wolcott, 125
Giffard, Henri, 144
Gilbert, Davies, 8, 15, 17
Gill, Theodore, 106
Gilpin, William, 182–183
Girard, Charles Frédéric, 79, 105
Gliddon, George, 114–115
Goddard, Robert, 318
Goetzmann, William H., 183
Goldstein, Daniel, 296
Goode, George Brown, 239
Adler friendship, 298
as assistant secretary, 287
on Baird, 232
career overview, 239
Centennial Exposition, 218, 220, 222–224, 227, 238, 242
Children's Room, 310
death, 326–327
exposition work, 256–257, 258–259
Langley and, 288, 289, 322
marriage and children, 215
National Museum collection-building, 242–243
National Museum exhibitions, 237, 238, 240–248, 250–251, 253
National Museum ichthyology collection, 214–215
National Museum organization, 238–241
National Museum Oriental antiquities section, 298
National Museum roots, 230
National Museum staff, 239, 249, 300, 301
National Museum visitors, 238, 242, 278
National Zoo, 303–304, 306, 307

Smithsonian publications and, 303, 326
US Fish Commission, 214, 224, 237, 327
works by, 214, 237, 295, 359, 360
Goode, James M., 9–11
Goodyear, Charles, 82
Gould, Benjamin, 142, 362n52
Grammar and Dictionary of the Dakota Language (Riggs), 62–63
Grant, Madison, 308–309
Grant, Ulysses S., 176, 191, 192, 199, 218, 219, 223
Gray, Asa
Baird and, 71
Henry friendship, 8, 39, 41, 46, 53, 81, 100, 119, 120–121, 163, 204, 227–228
Langley and, 230
plant studies, 114, 164
students, 169
Gray, W. Bruce, 244
Great Exhibition of the Works of Industry of All Nations, 80–82, 218
Greeley, Horace, 57, 128
Greely, Adolphus, 330, 331
Green, Charles, 132
Gregory, George, 41–42
Greville, Charles, 15, 18
Grinnell, Henry, 102, 175
Grinnell expeditions, 101, 102, 103, 174
Grosvenor, Elsie, 6
Grosvenor, Gilbert, 4, 6
Grubb, Sir Howard, 313
Guise, Alexander, 148
Guyot, Arnold, 212

Hackett, Frank W., 7
Hale, Edward Everett, 279, 354
Hale, John P., 122
Halfman, Robert L., 342
Hall, Charles Francis, 175–180, 178
Hall, James, 107, 139–140, 183
Hall, Mercy, 175, 179
Halstead, Murat, 133, 134
Hamilton, William, 15
Hamlin, Hannibal, 127
Hammond, William Alexander, 147
Hancock, Winfield Scott, 160
Hare, Robert, 46, 106, 112, 160
Harlan, James, 96
Harrison, Benjamin, 307
Harrison, Joseph, 206, 207
Hart, Emma, 15
Hartt, C. F., 271
Haüy, René-Just, 15
Haven, Edwin De, 102
Haven, Samuel, 60, 62, 115
Haviland, John, 50
Hawkins, Benjamin Waterhouse, 208–212, 216
Hawley, William, 30, 32
Hay, John, 137, 202, 203
Hayden, Ferdinand Vandeveer
background, 107–108
Civil War years, 146, 187
death, 202
Philosophical Society of Washington, 198
Smithsonian collection contributions, 108, 117, 187, 209
US Geographic and Geological Survey of the Territories, 151, 187–188, 197, 199–202, 270
Hayes, Isaac Israel, 174–175, 176
Hayes, Rutherford B., 199, 202, 218, 229–230, 231
Hecker, Frank J., 352
Hedley, George H., 251
Heinlein, Robert, 284
Helme, William H., 137
Hemenway, James, 343
Hemenway, Mary Tileston, 283
Hemphill, John, 306

399

INDEX

Henderson, John, 353
Henry, Caroline (daughter), 42, 99, 139, *141*, 230, 352
Henry, Harriet Alexander (wife), 42, 50, 55, 99, 106, 139, *141*
Henry, Helen Louisa (daughter), 42, 99, 139, *141*
Henry, Joseph, 47
 appearance, 40–41
 appreciation in *Smithsonian Miscellaneous Collections*, 9
 Arctic expeditions and, 174–175, 176–177
 Bache friendship, 39, 44, 81, 82, 99, 125–126
 background, 33–34, 41–44, 47
 Baird introduced to, 68–73
 balloons and, 130–138, 145–146
 biographies of, 359
 Board of Regents relationship, 46, 48, 53, 57, 73, 79, 127
 Castle art gallery, 206
 Castle construction, 50, 54–55, 56
 Castle design concerns, 48–51
 Castle fire, 159–163
 Castle lecture hall, 100, 104, 126–129
 Castle office, 57, 159
 Castle residence, 42, 99, 104–107, 121–122
 Castle residents and, 110
 Catlin collection, 207
 Centennial Exposition, 219, 220, 227
 citizen scientists, 65–68, 78, 117
 Civil War years, 120–131, 133–142, 144–147, 157–158
 Darwinism, 114, 119–120, 168
 death, 54, 230–231
 dinosaur exhibitions, 210–212
 electromagnetism studies, 34, 42–45, 102
 financial management, 232–233, 353
 Great Exhibition of the Works of Industry of All Nations, 81–82
 grudges and personal attacks on, 94–95
 guiding principle, 83, 204
 introduction, x
 Jewett and, 58, 86, 87–90, 91
 legacy, 232
 library responsibilities, 54, 73, 84–86, 163–164
 on Lincoln, 121, 126
 magnetic observatory, 102–103
 managerial shortcomings, 61–62, 92–93, 204
 marriage and children, 42, 99, 139–140, *141*
 museum, ambivalence about, 96–98, 113–114, 157, 162–163, 204–205, 227–228, 296
 museum, collection, 154, 169–171, 187, 238
 museum, control of, 73–74, 204, 215
 museum, dedicated building for, 229–230
 museum, display principles, 207–208
 museum, reconstruction after fire, 162–163
 National Academy of Sciences, 142–143, 146, 168, 176, 230
 on National Institute, 27
 National Mall improvement efforts, 115–117, 352
 papers, 359
 Philosophical Society of Washington, 198
 Programme of Organization for the Smithsonian Institution, 51–54
 racism, vii–viii, 79, 115, 119–120, 128, 166–167, 226
 Report of the Organization Committee, 51
 research/museum/library funding battle, 86–92
 research program, 65–68, 75, 76, 84, 94–96

selected as secretary, 31, 33–39
on Smithson, 2, 8–9
Smithsonian Art Room, 112–113
Smithsonian Astrophysical Observatory, 313
Smithsonian Contributions to Knowledge, 51, 58, 59–64, 95, 206
Smithsonian grounds, 156–157
 statue, 231
 tenure as secretary, 47, 53
US Lighthouse Board, 112, 129–130, 146, 168, 215, 230
US purchase of Alaska and, 173
vision for Smithsonian Institution, x, 34–35, 37, 45–46, 48, 51, 53–54, 58, 63–65, 157, 215–216
western expeditions, 181, 183–185, 187, 191, 192, 194, 195
Xántus and, 147
Henry, Mary Anna (daughter)
 Castle fire, 159, 160
 Castle residence, 42, 99, 104, 107
 on Civil War, 121, 122
 with family, *141*
 racism, 166–167
 Smithsonian collection, 188
 Washington summers, 139
Henry, William Alexander (son), 42, 99, 139–140
Herrick, Mary, 354
Herring, Augustus Moore, 322–323
Herschel, Sir William, 291
Hewitt, Abram, 199, 200
Hewitt, Fred, *337*
Higginbotham, A. Leon, Jr., 166
Hilder, Frank Frederick, 264
Hillers, John K., 270, 272–273, 275
Hilliard, George, 53
Hilliard, Henry, 30, 32
Hilliard, Jack, 348
Hilton, Henry, 210
Hinsley, Curtis, Jr., 115
Hints on Public Architecture (R.D. Owen), 57–58
Hitchcock, Edward, 100, 183
Hitchcock, Gilbert, 343
Hitler, Adolf, 309
Hodge, Frederick Webb, 283, 284
Hodgkins, Thomas, 318
Hoffman, Walter James, 189
Holmes, William Henry
 as Bureau of Ethnology chief, 265, 348, 349, 350
 Freer Collection, 353
 Hayden survey, 188, 200
 Hrdlička and, 265, 266
 Langley's funeral, 355
 McGee and, 348
 museum exhibitions, 246, 264
 on Stevenson (Tilly), 270–271
Holt, Joseph, 148
homesteaders, 181–182, 201–202
Horan, Henry, 159, 238–239, 259
Hornaday, William Temple
 background, 248
 bison expedition, 251–254, *252*
 Bronx Zoo, 308–309
 eugenics, 308–309
 exposition displays, 258, 259, 305
 Langley and, 303
 National Zoo, 252, 303–308, *305*
 taxidermy, 247, 248–250, 253
Hornblower, Joseph C., 311–312
Hornblower & Marshall (architectural firm), 7, 311–312, 351
Horsford, Eben Norton, 144
hot air balloons, 130–138, *136*, 144–146
Hough, Walter, 256
Hough, William Jervis, 28, 30, 32, 33, 36
Howard, C. H., 281
Howard, Mary. *see* Schoolcraft, Mary Howard

Howard, W. A., 173
Howe, Julia Ward, 279
Howland, Oramel, 191, 192
Hrdlička, Aleš, 265–266, 267, 348
Hubbard, Gardiner Greene, 4, 313, 327–328
Huffaker, Edward Chalmers, 322–324, 331, 333
Hughes, Charles Evans, 308
Humphreys, Andrew Atkinson, 188–189, 197
Hungerford family, 9, 11–12, 18
Hutton, James, 14
Huxley, Aldous, 284
Huxley, Thomas Henry, 120, 216

Inuit, 174, 175–176, 177, 179
Ipirvik (Inuit man), 175–176, 177, 179
Irby, John Robin McDaniel, 9, 16
Ives, Joseph Christmas, 193, 197

Jackson, Andrew, 22–23
Jackson, Sheldon, 281
Jackson, William Henry, 188
James, Edwin, 182
James Dixon and Company, 51
Jefferson, Thomas, 49, 60, 111
Jewett, Charles Coffin, *91*
 background, 48–49
 Baird and, 72, 74, 87
 Henry on *Hints on Public Architecture* (R.D. Owen), 58
 Henry's vision for Smithsonian Institution, 53
 library art displays, 112
 library collection, 84
 Marsh and, 57, 68
 research/museum/library funding battle, 73, 74, 87–90, 92
 union catalog, 84–86
 vision for Smithsonian library, 38, 49, 84
Johns, Henri-Joseph, 13
Johnson, Andrew, 166, 172, 173, 174, 192
Johnson, Walter D., 81
Johnson, Walter R., 8
Jones, F. C., 247
Jordan, David Starr, 295
Joseph Henry Fund, 230
Judd, Neil, 270, 282
Judd, Orange, 214
Judd, Sarah Ford, 214, 215

Kane, Elisha Kent, 100–104, *101*, 174, 224
Kansas-Nebraska Act, 93
Karr, William Wesley, 302, 353–354
Keene, William, 5
Kelvin, Lord, 316
Kennan, George, 271
Kennedy, Joseph C. G., 81
Kennerly, Caleb, 109
Kennicott, Bruno, 109
Kennicott, Robert
 Arctic expeditions, 110, 117, 169–171
 background, 151
 Baird and, 107, 146, 151, 169
 collecting for Smithsonian, 107, 151–156, *153*
 death, 170–171
 Megatherium Club, 107, *108*, 109
Key Marco, Florida, 286
Kidder, Jerome H., 302, 313, 314, 335
King, Ada Copeland Todd, 202–203
King, Charles Bird, 113, 160, 206
King, Clarence Rivers, 184–185, 189, 196–197, 199, 202–203, 242–243, 321
Kirtland, Jared P., 151
Klemm, Gustav, 242, 260
Knight, Charles R., 260

La Flesche, Francis, 282
Lamansky, M. S., 291

400

INDEX

Lamb, Daniel S., 348
LaMountain, John, 134
Lamson, C. H., 335
Lancaster, Israel, 292, 293, 316
Lang, Andrew, 298, 299
Langley, John (brother), 288, 289
Langley, Samuel Pierpont
 Adler friendship, 298–300, 302, 355
 aerodynamic research, 292–294, 296, 302, 315–325, *324*, 328–342, *337*, *338*, *341*, 355–356
 aerodynamic research, failure of Great Aerodrome, 339–344
 aesthetic tastes, 299, 312
 astrophysics research, 288, 290–292, *291*, 296, 301–302
 background, 287–290
 on Baird-Goode relationship, 215
 as Baird's chosen successor, 287, 296–297
 Board of Regents relationship, 327–328
 Bureau of Ethnology management, 344, 346, 347–350
 Carnegie Foundation, 350
 Children's Room, 310–312, *311*
 death, 354–355
 delegating administrative tasks, 302, 303
 Freer Collection, 352–353
 friendships, 302, 327, 355
 introduction, x
 Karr's theft of Smithsonian funds, 353–354
 legacy, 297, 355
 McGee and, 348–349
 metaphysical studies, 298–299
 named assistant secretary, 230
 National Museum Building, 351, *351*, 352
 National Zoo, 304, *305*, 306–310
 nature study movement, 310–311
 papers, 360
 personality, 297, 299–300, 301, 307, 323, 355
 Powell's death, 348
 Rhees and, 82
 Smithson account, 9
 Smithsonian Astrophysical Observatory, 313–315
 Smithsonian publications, 303
 Smithsonian's fiftieth birthday, 326
 Smithson's tomb, 2–4, 5, 6, 7, 10
 staff relations, 300–301, 303, 307, 310, 323, 353, 355
Lapham, I. Allen, 62
Lavoisier, Antoine, 14, 15
Lazzaroni, 34, 142
Lea, Isaac, 131
LeConte, John and Joseph, 167
Lectures on Experimental Philosophy, Astronomy, and Chemistry (Gregory), 41–42
Lee, Robert E., 139
Leech, Daniel, *234*, 236, 287
Lees, Noel, 1, 6
Leidy, Joseph, 76, 77, 209
Leigh, Benjamin Watkins, 22
Lévi-Strauss, Claude, 271
Lewis, Isaac Newton, 331, 334, 335, 336, 337
Lewis, James Otto, 113
Lewis, William, 12
Lilienthal, Otto, 319–320, 322, 333
Lincoln, Abraham
 cabinet, 148
 Castle fire, 161
 Civil War, 121, 126, 134, 135, 144–145, 182
 Dakota War, 149
 DC abolition bill, 129
 Douglass and, 128
 election, 121, 124
 foreign ministers, 68

National Academy of Sciences, 142
WLA lectures, 128
Linnaeus, Carl, 70–71
Little Crow (Dakota chief), 149
Lodge, Henry Cabot, 354–355
Logan, John, 282
Long, John D., 330
Long, Stephen, 182
Loomis, Chauncey, 180
Loomis, Elias, 66, 143, 165
Loomis, Francis, 7
The Lost World of James Smithson (Ewing), 11
Louisiana Purchase Exposition (Saint Louis, 1904), 255, 260, *261*, 264–267, 309
Lovejoy, Elijah, 127
Lovejoy, Owen, 127
Lowe, Thaddeus, 130–131, 133–137, *136*, 156
Lucas, Frederic, 259, 260, 264
Ludewig, Joseph, 294

MacDonald, George, 337, *337*
MacFarlane, Roderick, 155, 169
Macie, Elizabeth. *see* Dickinson, Elizabeth Hungerford Keate Macie
Macie, James Lewis. *see* Smithson, James
Macie, John, 12
Macomb, Montgomery, 337, 342
Magill, Emily Tennison. *see* Cushing, Emily Tennison Magill
Magill, Margaret, 280, 283
magnetic observatory, 102–103
magnetic surveys, 52, 102–103
Maine, USS, 329
Mall. *see* National Mall
Maltby, L. C., 319, 320, 321–322, 324
Man and Nature (Marsh), 68, 310–311
Manly, Charles Matthews, 330–332, 334–340, *338*, *341*, 342, 343
Marey, Étienne-Jules, 318, 336
Mariotte, Edme, 291
Markoe, Francis, 36, 37
Marriott, Margaret Goodwin, 11
Marsh, George Perkins
 art collection, 112, 164, 244, 299
 background, 68
 Baird and, 68–70, 72, 75, 87
 Board of Regents, 57, 59, 61, 68, 87
 diplomatic career, 68
 on Henry's managerial shortcomings, 61–62
 Man and Nature, 68, 310–311
 Smithsonian library oversight, 86
 vision for Smithsonian Institution, 46, 48
Marsh, Othniel Charles, 110, 200–201, 259–260
Marshall, James R., 311–312. *see also* Hornblower & Marshall
Martí, José, 329
Marx, Karl, 63, 163
Mason, Charles, 97
Mason, John Murray, 90, 93–94, 124
Mason, Otis Tufton, 220–221, 226, 238, 242, 259, 262, 267, 326
Masonic order, 54–55
Matthews, Washington, 273–274
Maury, Matthew Fontaine, 95–96, 140
Maxim, Hiram, 319
McClellan, George B., 78, 109–110, 137, 139, 156, 196
McClure, Samuel S., 329
McCulloch, Hugh, 173
McFeely, Eliza, 284
McGee, Anita, 350
McGee, W J, 263–268, 271, 302, 309, 346–350
McGillycuddy, Valentine T., 304
McKenney, Thomas L., 113
McKenzie, Mr., 76–77
McKim, Charles, 351

McMillin, Benton, 306
McPeak, Mrs., 106, 109
McPeak, William, 32, 68, 106
Meacham, James, 87, 89–90
Means, James, 329, 335
Mearns, David C., 49
Mediator (ship), 24
Meek, Fielding Bradford, 108, 146, 187–189, 197, 198, 200
Megatherium Club, 107, 108, *108*, 109, 112, 154, 155
Meigs, Montgomery C., 104, 126, 233, *234*
Meiklejohn, George De Rue, 330
Merrill, A. A., 335
Merrill, George Perkins, 326
Metcalf, Willard Leroy, 278, 280
meteorology
 Blodget's work, 94–95
 as Smithsonian field of research, 52, 65–68, 93–96, 117, 132, 165–166
 War Department responsibilities, 165–166
Meyer, Frederick, 178–179
Miles, Nelson A., 331
Mills, Clark, 231
Mills, Robert, 30, 32–33
Milner, James W., 236
Mississippi Valley mounds, 53, 59–62
Missouri Compromise, 93
Mitchell, Maria, 230, 283
Moody, Pliny, 208
Mooney, James, 344–347
Moore, Charles, 352, 353
Moran, Thomas, 188
Morgan, J. P., 260
Morgan, Lewis H., 63, 242, 260, 271, 344
Morlot, Adolph von, 62, 220
Morrill, Justin S., 297, 305, 306, 351
Morse, Samuel Finley Breese, 45, 54, 55, 79, 94
Morton, Samuel G., 71
Morton, Samuel George, 114–115
Mouillard, Louis, 316, 333
mound archaeology, 53, 59–63, 68, 187, 220, 285–286

Naiiutchi (Zuni priest), 279, 280
Nanahe (Hopi), 278–279
Napier, Lord Francis, 154
Napoleonic Wars, 15–16, 125
Nash, F. S., 337
National Academy of Sciences
 Arctic expeditions, 176
 Bache Fund, 293, 318
 creation of, 142–143
 Cushing's lecture, 279
 Henry's funeral, 231
 Henry's role, 142–143, 146, 168
 Joseph Henry Fund, 230
 Langley's aerodynamic research, 316, 318
National Geographic Society, 4, 265, 309
National Indian Portrait Gallery, 113
National Institute for the Promotion of Science
 Board of Regents members, 29, 30
 collection, 244
 Great Exhibition of the Works of Industry of All Nations, 80–81
 Smithson's bequest and, 8, 27, 32
 Varden collection, 111
National Mall, 115–117, *141*, 156–157, 351, *352*
National Museum
 Baird as director, 215–216, 228–229
 bison exhibition, 250–254
 budget, 233
 buildings, 229–230, 350–351
 Bureau of Ethnology and, 284
 Centennial Exposition, 219–229, *225*, 238, 242
 collection policy, 240–243

401

INDEX

National Museum (cont.)
congressional appropriations, 98
criticism of, 241
dinosaur exhibitions, 210–212
electricity, 240
exhibition design, 111–112, 207–208, 242, 243–244, 246
exposition work, 255–263
Goode as assistant director, 238–244, 246–247
guidebooks, 82, 92, *105*, 111
Henry's ambivalence, 204–205, 227–228
legislation concerning, 202
organizational structure, 238–240
Rathbun as assistant secretary, 327
repairing room, *245*
staff, 238–240, 244, *245*, 246, 249
taxidermy, 247–248, 249–253
Varden's role, 110–111
visitors, 243, 244
whale model, 246–247, *247*
National Museum Building (now National Museum of Natural History)
design and construction, 233–234
Garfield's inaugural ball, 234–235
groundbreaking, *351*, 352
opening of, 357
staff, 239
National Museum Building Commission, 233, *234*
National Museum of Natural History. *see also* National Museum Building
dinosaurs, 260, *261*
forensic analysis of Smithson's bones, 10–11, 14–15, 16
groundbreaking, *351*
Hall's papers, 179
Kennicott's remains, 171
National Zoo
Baker as superintendent, 309–310
establishment of, x, 305–308, 309–310
exposition era, 264
funding, 305–306, 310
Hornaday's role, 252, 303–308, *305*
initial plans, 303–305
Smithsonian Astrophysical Observatory and, 313–314
Native American cultures
Centennial Exposition, 224–226, *225*
Dakota War, 149
Ghost Dance movement, 345–346
Smithsonian study and presentation of, 113, 156, 224–226, *225*, 344–345
nature study movement, 310–311
Naval Observatory, 28
Nelson, Horatio, 15
Newberry, John Strong, 193–194, 199–200
Newcomb, Anita, 265, 302
Newcomb, Simon, 265, 302
Newham, R. S., *337*
Newtonians, 293, 315
Nichols, C. B., 317, 320
Norman, John, 50
Northumberland, Elizabeth Seymour Percy, Duchess of, 11
Northumberland, Hugh Percy, Duke of (Smithson's father), 11–12, 18, 19
Northup, Solomon, 40
Nott, Josiah C., 114–115

Ohio Valley mounds, 59–62, 63, 285–286
Olmsted, Frederick Law, *305*, 309
Orosz, Joel, 97
Ørsted, Hans Christian, 16–17
Osborn, Henry Fairfield, 308–309, 355
O'Sullivan, Timothy, 185, 189, 197
Ota Benga (Mbuti Pygmy), 309
Owen, David Dale, 32–33, 55, 76
Owen, Richard, 208–209, 216–217
Owen, Robert (father), 28
Owen, Robert Dale (son)

Board of Regents, 30, 32–33, 57
Castle Building design, 32–33, 50, 55, 57, 100
Henry's Programme of Organization for the Smithsonian Institution, 53
Hints on Public Architecture, 57–58
legislation establishing Smithsonian, 28–29, 30
secretary selection, 36, 37
vision for Smithsonian Institution, 46, 48, 57
Owsley, Douglas, 171

Pacific Railroad Surveys, 78, 109–110, 156
Page, Charles Grafton, 45
Paine, Halbert Eleazur, 165
paleontology expeditions, 75–78, *77*, 108, 168, 200–201
Palmer, Edward, 226–227
Palmer, Joseph, 211, 216, 221, 224, 246
Palmer, William, 246, *247*, 257, 258, 264
Palowahtiwa, 273, 275–280
Pan-American Exposition (Buffalo, 1901), 255, 262–264, *263*
Parker, Peter, 231, 233, 234
Parker, Quanah, 308
participant observation, 110, 273–275, *274*, 280
Patterson, Thomas, 201
Peale, Charles Willson, 97
Peale, Titian Ramsay, 72, *141*
Pearce, James A., 49, 87, 89, 90, 92, 94
Pearl (schooner), 40
Pease, Charles, 169–170
Peirce, Benjamin, 92, 142
Pembroke College, Oxford University, 3, 9, 12
Pénaud, Alphonse, 317, 318
Penn, Granville, 17
Pennypacker, Isaac S., 30, 32
Percy, Baroness, 11
Peter, John Parke Custis, 55–56
Phillips, Barnet, 242
Phillips, Wendell, 129
Pickering, Charles, 36, 37
Pierpont, John, 128
Pike, Zebulon, 182
Pilling, James, 278, 282
Pino, Patricio (Palowahtiwa), 278–279, 280
Pino, Pedro (Palowahtiwa), 273, 275–279
Platt, Thomas C., 7
Poinsett, Joel Roberts, 27
Polk, James K., 29, 32, 54
Pope, Albert A., 329
Pope, Frank, 170
Pope, John, 117, 149–150
Porter, David Dixon, 117
Powell, Emma, 191–192, 194, 196
Powell, G. H., 337, 340
Powell, John Wesley
background, 189–191
BAE, conflicts with Baird, 202, 236, 269–270, 284–285
BAE, expeditions, 270–276, 278, 282, *283*, 285–286, 345–346
BAE, Langley and, 344, 346, 347–348
BAE, shifting perspectives, 344–347
BAE, staff, 265, 268, 282, 347–348
BAE, Zuni visit, 278–279
Baird and, 295
brain size, 348
Bureau of Ethnology control, 202, 269–270
Centennial Exposition, 219
Civil War service, 191
commission to codify land laws, 242–243
death, 246, 348
Langley and, 344, 346, 355
National Zoo, 306, 307
Philosophical Society of Washington, 198

survey expeditions, 189, 191–202, *193*, 269
USGS, 171, 202, 237, 265, 269, 321
Powell, Mary (daughter), 196
Powell, Walter (brother), 192, 194–195
Preston, William C., 22, 26, 30
Princess Irene (steamship), 6, 7
Princeton, USS, 34
Programme of Organization for the Smithsonian Institution, 51–54
Putnam, Frederic, 266, 279, 282, 286, 348

racism. *see also* slavery
Board of Regents, 93–94, 119
eugenics, 308–309
Henry's, vii–viii, 79, 115, 119–120, 128, 166–167, 226
Native American exhibitions, 226–227
"progress" exhibitions, 256, 260–262, 264, 265, 266–267
"scientific" basis, 114–115, 119–120, 167, 266, 267–268
segregation, 223
twenty-first-century outrage, 167, 267
Randall, S. J., 269
Randolph, William Beverly, 54–55
Rathbun, Mary Jane, 327
Rathbun, Richard
as acting secretary, 328, 355
background, 327
career overview, 255–256, 327
Centennial Exposition, 227, 255
expositions, 257, 264, 267
Goode's funeral, 326
Karr's theft of Smithsonian funds, 353–354
Langley's aerodynamic research, 332, 333, 335, 336
Langley's funeral, 355
Langley's opinion of McGee, 349
National Museum Building, 351, 352
Smithson's tomb, 7
Rau, Charles, 220–222, 226, 238, 260–261
Ravenel, William deC., 350, 351
Rayleigh, Lord, 316
Ream, Vinnie, 180
Reed, Luther, 321–322, 324, *324*, 331–333, 336, 337, *337*, 340
Renwick, James, Jr., 33, 36–37, 50, 55, 56, 100, 104
Report of the Organization Committee, 51
Rhees, William Jones, 236
African Americans employees and, 300
Baird and, 235–236
Baird's death, 295
Bessels's eviction, 180
career overview, 236
Castle fire, 159
Castle residence, 106
as chief archivist, 302
Civil War years, 134
guidebook, 92, 111
Henry and, 80, 82, 139
National Museum Building Commission, *234*
works by, 9, 359
Rice, William North, 235
Richard, John H., 224
Richards, A. C., 160
Ridgway, Robert, 110, 185, 197, 238, 295, 326, 336
Riggs, Stephen, 62–63
Riley, Dr., 354
Rinehart, Bentley, 319
Ripley, Sidney Dillon, II, 10, 11
Rivinus, E. F., 151, 359
Robbins, Asher, 25
Roberts, John, 14
Robeson, George, 177–178
Robey, Washington, *41*
Robinson, Herbert, 135

402

INDEX

Robinson, James M., 343
Rogers, John, 78
Roosevelt, Theodore
 bison, concerns about, 250, 253, 308
 Carnegie and, 350
 Freer Collection, 353
 Langley's aerodynamic research, 330
 Pan-American Exposition, 263
 Smithson's tomb, 6, 7
Ross, Bernard, 154–156
Rotch, Abbot Lawrence, 335
Rothenberg, Marc, 140, 359
Rothhammer, S. M., 150
Rothrock, Joseph Trimble, 169–170
Royal Institution, 17–18, 19, 44
Royal Society
 governing council, 18
 International Catalogue of Scientific
 Literature, 354
 Philosophical Transactions, 16
 presidents, 14, 15
 publications exchanges, 64
 Rumford Medal, 292
 Sabine's presidency, 117
 Smithson as member of, 14, 15–16, 18,
 124–125
 Smithson's papers, 12
Rush, Richard, 23–24, 26, 27, 30, 32, 36,
 102
Russell, Charles P., 68
Ryder, Albert Pinkham, 352

Sabine, Edward, 52, 102–103, 117
Sandburg, Carl, 126
Sandoz, Mari, 181
Santos-Dumont, Alberto, 334
Sargent, Aaron A., 228
Schenck, Robert C., 145–146
Schliemann, Sophia, 283
Schoolcraft, Henry Rowe, 63, 99
Schoolcraft, Mary Howard, 99, 125
Schott, Charles, 174–175
Schuermann, C. W., 305
Schultz, Adolph, 267
Schurz, Carl, 199, 201, 269
Seaton, William Winston, 30, 32, 50
Seton, Ernest Thompson, 307
Seward, William Henry, 171–173
Seymour, Elizabeth, 11
Sheridan, Philip, 253
Sherman, William Tecumseh, 146, 191, 231,
 233, 234
Sherwood, John, 10–11
Sibley, Hiram, 168–169
Silliman, Benjamin, 43, 45, 71
Simpson, Sir George, 154
slavery
 Board of Regents, 119
 emancipation, 120, 129, 166
 lectures on, 127–129
 legislation, 40, 93–94, 181
 sandstone quarries, 56
 "scientific" basis, 115
 Washington, DC, 39–40, 41, 99, 129
Smillie, Thomas, 179, 217, 221, 224, 258,
 337, 339
Smith, Erminnie, 282
Smithson, Dorothy Percy (Smithson's half
 sister), 18
Smithson, Hugh (father), 11–12, 18, 19
Smithson, James
 alma mater, 3, 9, 12
 bequest, vii, ix, 1–2, 18–24, 51, 52, 162,
 230
 birth and childhood, 12, 15
 character traits, 14
 death, 1
 disinterment and forensic analysis,
 10–11, 14–15, 16, 171
 family background, 11–12, 18–19
 gambling, 18, 20

library, 19–20
mineral collection, 12, 14
name change, 12
Napoleonic Wars, 15–16
papers, 8, 12, 16, 17, 27, 160
portraits, 8, 10, 13, 14
possessions, 8
Royal Institution, 17–18, 19
Royal Society, 12, 14, 15–16, 18, 124–125
 scientific career, 12, 14–18, 34, 184
 Smithsonian research into, 8–11
 tomb, 1–8, 3, 10
Smithsonian Astrophysical Observatory, x,
 313–315, 315, 321, 324, 357
Smithsonian Castle. *see* Castle
Smithsonian Contributions to Knowledge
 anthropology volumes, 51, 58–64, 68,
 115, 206, 269
 Badlands fossils (Leidy), 77
 budget, 233
 Civil War years, 124
 distribution, 52, 64, 75
 "Magnetical Observations in the Arctic
 Seas" (Kane), 103
 Physical Observations in the Arctic Seas, 175
 plan for, 48
 second volume, 95
 Winds of the Northern Hemisphere (Coffin),
 96
Smithsonian Institution, about
 administrative organization, 48, 53
 archivist, 82
 Centennial Exposition, 219
 fiftieth birthday, 326
 herbarium transferred to Department
 of Agriculture, 164
 legislation establishing, 2, 25–30, 32, 35,
 48, 49, 51, 83
 principal objective, 52
 publications exchanges, 63–65, 74–75,
 79, 84
 research areas, 52–53
 research-museum conflicts, 86–92, 241
 statistics, ix
Smithsonian Institution collections
 Arctic expeditions, 174–175, 176
 Baird's, 74
 Baird's collection-building, 78, 97, 103,
 117, 146–156, 158, 168–171, 181, 182,
 184–185, 187, 189, 195
 Catlin paintings, 207
 Centennial Exposition, 228–229
 exploring expeditions, 77, 103, 111, 117,
 154–156, 168–171
 fossils, 108
 giant sloth, 107
 Marsh Collection, 244
 National Institute collection, 110–111,
 244
 Native American items, 156
 transfers to other agencies, 164–165
Smithsonian Institution library, 85
 Adler as librarian, 298
 collection, 84
 Henry (Will) as employee, 139
 Henry's vision, 54
 Jewett's vision, 38, 49, 84
 legislation establishing, 48–49
 projects, 53
 proposals for, 28, 32, 33, 35, 37, 38
 publications exchange, 84, 85
 purpose, 88
 research/museum/library funding
 battle, 73, 74, 86–92
 transfer to Library of Congress, 163–164
 Turner hired, 106
 union catalog, 84–86
Smithsonian International Exchange
 Service Program staff, 81
Smithsonian Miscellaneous Collections, 9, 124
Smithsonian Pleasure Garden, 116

Spanish-American War (1898), 262–263,
 329–331
Spencer, Edward, 132
Spitzka, Edward Anthony, 348
Sprague, William, IV, 134
Squier, Ephraim George, 59–62, 68. *see also*
 *Ancient Monuments of the Mississippi
 Valley* (Squier and Davis)
Squint Eyes (Tichkematse), 276–277
Stanley, John Mix, 113, 160, 206
Stanton, Edwin, 137, 191, 192
Star-Spangled Banner, ix
Steuart, C. A., 300
Stevens, Thaddeus, 114, 166
Stevenson, James, 187, 188, 253, 270,
 272–279
Stevenson, Job E., 176
Stevenson, Matilda Coxe "Tilly," 270–276,
 278, 279, 282–284, 283, 302, 347–348
Stimpson, William, 107, 108, 112, 146, 152,
 154, 159–160, 169
Stoeckl, Edouard de, 171–172
Stone, Charles, 117
Story, William Wetmore, 231
Stowe, Harriet Beecher, 49
Stuart, David, 89
Stuart, Gilbert, 111
Sturgeon, William, 43, 44
Sullivan, Roger, 105
Sully, Alfred, 149, 150
Sumner, Charles, 128, 172–173
Sumner, Jack, 191, 192–193
Sun Dance, 347
Swanson, Stephan, 171
Sylvester, Sewell, 169
Symmes, John Cleves, Jr., 132
Systema Naturae (Linnaeus), 70–71
*Systems of Consanguinity and Affinity of the
 Human Family* (Morgan), 63

Taft, William Howard, 266, 321
Taney, Roger Brooke, 30, 94, 119
Tappan, Benjamin, 27–28
Taqulittuq (Inuit woman), 175–176,
 177, 179
Taylor, James, 305
Taylor, John, 92
Taylor, William B., 303
Taylor, Zachary, 68
telegraphy, 45, 66–67, 79, 94, 168–169, 171
Teller, Henry M., 348
Temple, Grace Lincoln, 312
Tesla, Nikola, 299
Thaw, William, 290, 293, 296, 313
Thayer, Abbott Handerson, 352
Thomas, Cyrus, 63, 187, 285–286, 348
Thompson, Jacob, 124
Thompson, Waddy, Jr., 26
Thomsen, Christian Jürgensen, 242
Thomson, William (Lord Kelvin), 316
Thomson, William (mineralogist), 15
Thoreau, Henry David, 49
Thornton, William, 14
Thurston, Robert Henry, 292–293, 330
Tichkematse (Squint Eyes), 276–277
Tisdale, W. H., 303
Torrey, John, 119, 121, 164
Totten, Joseph Gilbert, 30, 32, 36, 117
Townsend, Edward D., 145
*Travels through the States of North America and
 the Provinces of Upper and Lower Canada*
 (Weld), 19–20
Tree, Lambert, 79–80
Trigger, Bruce, 262
True, Frederick, 249, 258, 263–264, 307,
 311, 326
Trumbull, Lyman, 127
Tryon, Dwight William, 352
Turner, Jane Wadden, 107, 301
Turner, Steven, 16
Turner, William Wadden, 62–63, 106

403

INDEX

Tweed, William Magear, 210
Tyler, John, 34
Tylor, E. B., 277

Ulke, Henry, 107, *108*
United States Exploring Expedition
(Wilkes expedition), 27, 36, 71, 72, 111, 156
Upham, Charles W., 90, 92
US Commission of Fish and Fisheries
Baird's leadership, 212–215, 294–295, 327
Centennial Exposition, 219, 224
creation of, 212–213
expositions, 256–258, 264
problems, 227, 236–237
Woods Hole station, 213, *213*, 237, 294–295
US Geological Survey (USGS)
budget cuts, 265
Cope at, 110
creation of, 201, 269
King as director, 202, 321
office space, 240
Powell as director, 171, 202, 237, 265, 321
Walcott as acting director, 327
US Lighthouse Board, 112, 129–130, 146, 168, 215, 230, 231

Vail, Aaron, 21–22
Vail, Alfred, 45, 54, 55, 79
Van Buren, Martin, 25, 26
Van Vliet, Stewart, 253
Varden, John, 80, 110–111, 112, 160
Vaux, Calvert, 115
Verner, Samuel P., 266–267
Verrill, Addison Emery, 110, 213, 257
Very, Frank W., 294
Victoria, Queen, 176, 208

Waite, Morrison R., 230–231
Walcott, Charles Doolittle, 298–299, 327–330, 334, 348, 351, 354–357
Walker, David, 177

Walker, Isaac P., 83
Walker, Robert, 33
Walker, Sears C., 95
Wallace, General, 340
Walter, Thomas Ustick, 111
Ward, Henry, 216, *217*, 248–249
Ward, Lester Frank, 326
Warren, Gouverneur K., 78, 108, 187
Warren, Owen, 50
WASA (Women's Anthropological Society of America), 282–283
Washburn, Wilcomb, 53
Washington, George, ix, 54, 55, 111
Washington Lecture Association (WLA), 127–129
Watkins, John Elfreth, 246–247, 258, 261–262, 298, 319, 320, 335
Watson, Sereno, 197
Webb, Harvey, *337*
Weld, Isaac, Jr., 19–20
Welles, Gideon, 140–142, *143*
Welling, James Clarke, 297
Wells, George, 334
Wells, Joseph, 50
Wells, William, 10
Wesley, William, 9
Westcott, James, 206–207
western expeditions, 181–203, *193*
Western Union Telegraph Expedition, 168–171, 188
Wetmore, Alexander, 357
We'wha (Zuni *Ihamana*), 282
Weyler, Valeriano, 329
Wheatstone, Charles, 16, 44
Wheeler, George Montague, 188–189, 197, 199–201, 219
Whistler, Beatrice, 352
Whistler, James Abbott McNeill, 352
White, Andrew Dickson, 300
White, Stanford, 299
Whitehead, Gustave, 335
white supremacy. *see* racism
Whitney, Josiah Dwight, 183–184
Whymper, Frederick, 170

Wilkes, Charles, 71, 72, 81, 111, 156
Williams, William, 40
Wilson, Edmund, 280
Wilson, Henry, 142, 192
Wilson, Thomas, 298
Winds of the Northern Hemisphere (Coffin), 96
Winlock, Joseph, 289
Winlock, William Crawford, 302, *305*, 326–327
Wise, John, 131, 132–133, 134, *135*
Witte, William, 92
WLA (Washington Lecture Association), 127–129
Woltz, Tobias N., 160
women, discrimination against, 245, 282, 301, 302, 347–348
Women's Anthropological Society of America (WASA), 282–283
Wood, W. M., 236
Woodbury, Levi, 24, 27
Woodhouse, Samuel Washington, 79
Woodruff, Israel C., 145
World's Columbian Exposition (Chicago, 1893), 258–259, 322
World's Industrial and Cotton Centennial Exposition (New Orleans, 1884–85), 255, 257, 262
World War II, 357–358
Wounded Knee Massacre, 345
Wovoka (Paiute visionary), 345, *346*
Wright brothers, 319, 333, 335, 343, 355–356

Xántus de Vesey, John, 147–148, 151

Yarrow, Henry Crécy, 189
Yochelson, Ellis, 260
Young, Brigham, 29, 195
Young, John H., 36
Youssef, E. M., 151, 359

zoo. *see* National Zoo
Zuni Pueblo, 272–284, 274, 347–348

404